GALICIA
NO TEMPO

ISBN: 84-453-0177-2
Dep. Legal: M-47065-1990

GALICIA
NO TEMPO

MONASTERY OF SAN MARTIÑO PINARIO
SANTIAGO DE COMPOSTELA. 1991

ARCEBISPADO DE SANTIAGO DIÓCESES DE GALICIA

XUNTA DE GALICIA CONSELLERÍA DE CULTURA E XUVENTUDE

Dirección Xeral do Patrimonio Histórico e Documental

HIS MAJESTY THE KING JUAN CARLOS I

HER MAJESTY THE QUEEN SOFIA

Most Excellent Victorino Núñez Rodríguez
President of the Galician Parliament

Most Excellent Manuel Fraga Iribarne
President of the Galician Government

Most Excellent and Reverend Antonio María Rouco Varela
Archbishop of Santiago de Compostela

HONOUR COMMITTEE

PRESIDENT
Most Excellent Daniel Barata Quintas
Minister of Culture and Youth

ADVISORS:
Most Excellent Domingo García Sabell
Representative of the Central Government in Galicia

Illustrious Xerardo Estévez Fernández
Mayor of the City of Santiago de Compostela

Most Excellent Juan Piñeiro Permuy
Minister of Education

Most Excellent Ramón Vázquez Sández
President of the Superior Court of Justice of Galicia

Most Excellent José Cora Rodríguez
Comissioner of Galicia

Most Exceller and Reverend Antonio Briva Miravent
Bishop of Astorga

Most Exceller and Reverend Sr. D. José Cerviño Cerviño
Bishop of Tui-Vigo

Most Exceller and Reverend José Gea Escolano
Bishop of Mondoñedo-Ferrol

Most Exceller and Reverend José Gómez González
Bishop of de Lugo

Most Exceller and Reverend José Diéguez Reboredo
Bishop of Ourense

Most Exceller and Reverend Ricardo Blázquez Pérez
Auxiliary Bishop of Santiago de Compostela

Most Exceller José Esmorís Cambón
Honorauble President of Mayor Seminary of Santiago de Compostela

Most Exceller Ramón Villares Paz
Honourable President of the University of Santiago de Compostela

Illustrious Ramón Villot Villot
General Director of R.T.V.G.

EXECUTIVE COMMITTEE

PRESIDENT:
D. José Vicente Solarat López
General Director of the Historical and Documentary Patrimony

CHIEF DIRECTOR:
D. José Manuel García Iglesias

ADVISORS:
D. Angel Sicart Giménez
Director of the Exposition

D. Eugenio Romero Pose
Director of Centre for Jacobean Studies

D. Francisco Fariña Busto
Director of the Exposition

D. José Carlos Valle Pérez
Director of Exposition

D. Salvador Ares Espada
President of the Diocesan Comission of Sacred Art

D. Salvador Domato Búa
Secretary of the Archbishopric of Santiago de Compostela

SECRETARY:
D. José Carlos Sierra Rodríguez
General Subdirector of the Historical and Documentary Patrimony

COLLABORATION
ORGANISMS AND INDIVIDUALS

ARZOBISPADO DE SANTIAGO DE COMPOSTELA
D. Antonio María Rouco Varela
AYUNTAMIENTO DE BARCELONA
D. Pascual Maragall
AYUNTAMIENTO DE LA CORUÑA
D. Francisco Vázquez
AYUNTAMIENTO DE SANTIAGO DE COMPOSTELA
D. Xerardo Estévez Fernández
AYUNTAMIENTO DE VIVERO
D. César Aja Mariño
CATEDRAL DE LUGO
CATEDRAL DE MONDOÑEDO
CATEDRAL DE OURENSE
CATEDRAL DE SANTIAGO DE COMPOSTELA
CATEDRAL DE TUI
CENTRO DE ARTE REINA SOFIA - MADRID
D. Tomás Llorens
COLEGIATA DE SANTA MARIA DEL CAMPO
A CORUÑA
D. Rafael Taboada
CONVENTO AGUSTINAS DE VISTALEGRE
VILAGARCIA DE AROUSA - PONTEVEDRA
Sor Rosario Rodeiro Pampín
CONVENTO DE SANTA CLARA - ALLARIZ - OURENSE
Sor María Dolores Vila Pena
CONVENTO DE SAN ANTONIO - HERBON - A CORUÑA
D. Martín Carbajo Núñez
DEPARTAMENTO DE DIDACTICA Y ORGANIZACION
ESCOLAR
UNIVERSIDAD DE SANTIAGO DE COMPOSTELA
D. Miguel Angel Zabalza Beraza
D. Rodolfo Luis Ferradas Blanco
DIPUTACION DE LUGO
D. Francisco Cacharro Pardo
DIPUTACION DE OURENSE
D. José Luis Baltar Pumar
DIPUTACION DE PONTEVEDRA
D. César Mera Rodríguez
ESCUELA DE ARTES Y OFICIOS. MAESTRO MATEO.
SANTIAGO DE COMPOSTELA
DÑA. María Eloísa Enríquez Morales
FUNDACION CAIXA GALICIA - A CORUÑA
FUNDACION RODRIGO DE CASTRO
MONFORTE DE LEMOS - LUGO
FUNDACION SANTA MARIA DE TEMES - OURENSE
GALERIA GAMARRA Y GARRIGUES - MADRID
Dña. Carmen Gamarra
Dña. Isabel Garrigues
GENERALITAT DE CATALUNYA
HOSTAL DE LOS REYES CATOLICOS
SANTIAGO DE COMPOSTELA
D. Emilio Martín Manzanas
INSTITUTO DE CIENCIAS DE LA EDUCACION
D. Manuel Bermejo Patiño
IGLESIA DE SAN AGUSTIN - SANTIAGO DE
COMPOSTELA
D. Dacio Fernández García
MONASTERIO DE OSEIRA - OURENSE
D. José Luis Santas Gómez
MONASTERIO DE SAMOS - LUGO
D. Agustín Miguélez Vecillas
MONASTERIO DE SANTA CLARA. MONFORTE DE
LEMOS. LUGO
Madre Clara del Santísimo
MONASTERIO DE SOBRADO DOS MONXES - A CORUÑA
D. Salvador Toro Jiménez
MUSEO ARQUEOLOGICO E HISTORICO
«CASTELO DE SAN ANTON» - A CORUÑA
D. Felipe Senén López
MUSEO ARQUEOLOGICO NACIONAL - MADRID
D. José María Luzón Nogué
MUSEO ARQUEOLOGICO Y PROVINCIAL - OURENSE
D. Francisco Fariña Busto
MUSEO DE ARTE DE CATALUÑA - BARCELONA
D. Joan Sureda y Pons
MUSEO FREDERIC MARES - BARCELONA
D. Frederic Marés
Dña. Dolores Farró

MUSEO ARQUEOLOGICO DO CASTRO DE VILADONGA
LUGO
D. Felipe Arias Vilas
MUSEO DO CASTRO DE SANTA TREGA - PONTEVEDRA
D. Xoan Martínez Tamuxe
MUSEO DO POBO GALEGO
SANTIAGO DE COMPOSTELA
D. Antonio Fraguas y Fraguas
MUSEO MUNICIPAL QUIÑONES DE LEON
CASTRELOS - PONTEVEDRA
D. Armesto Fagines
MUSEO DE LAS PEREGRINACIONES
SANTIAGO DE COMPOSTELA
Dña. Elena Varela
MUSEO PROVINCIAL - LUGO
D. Juan Balboa
MUSEO PROVINCIAL - PONTEVEDRA
D. José Carlos Valle Pérez
OBISPADO DE ASTORGA
D. Antonio Briva Miravent
OBISPADO DE LUGO
D. José Gómez González
OBISPADO DE MONDOÑEDO-FERROL
D. José Gea Escolano
OBISPADO DE OURENSE
D. José Diéguez Reboredo
OBISPADO DE TUI-VIGO
D. José Cerviño Cerviño
PARROQUIA DE BERREDO - OURENSE
D. Antonio García Díaz
PARROQUIA DE BRIVES - A CORUÑA
D. Santiago Sánchez Castro
PARROQUIA DE CASOIO - OURENSE
D. Francisco Estévez
PARROQUIA DE PUNXIN - OURENSE
D. Emilio Outomouro Vázquez
PARROQUIA DE RIOS - OURENSE
D. Antonio Barja Vázquez
PARROQUIA DE SAAMASAS - LUGO
D. Gonzalo Mateo Vázquez
PARROQUIA DE SAN ANDRES DE VEA - PONTEVEDRA
D. Antonio González Vázquez
PARROQUIA DE SAN COSME DE ANTES - A CORUÑA
D. José Carballo
PARROQUIA DE SAN ESTEBAN DE RIVAS DE SIL
OURENSE
D. Mateo Miranda López
PARROQUIA DE SAN FELIX DE SOLOVIO
SANTIAGO DE COMPOSTELA
D. Miguel Botana Vaamonde
PARROQUIA DE SAN FIZ DE CANGAS - LUGO
D. Jesús Angel Barreiro Vázquez
PARROQUIA DE SAN MARCOS - CORCUBION
A CORUÑA
D. Ramón Dosil Martínez
PARROQUIA DE SAN MARTIÑO DO RIO
LANCARA - LUGO
D. Pedro Arrojo Fernández
PARROQUIA DE SAN MARTIÑO DE MONDOÑEDO
LUGO
D. Serafín Rodríguez García
PARROQUIA DE SAN PEDRO DE MOREIRAS
OURENSE
D. Manuel Armada Rodríguez
PARROQUIA DE SAN PEDRO DA PORTA
SOBRADO DOS MONXES - A CORUÑA
D. Fernando Casal Campo
PARROQUIA DE SAN SALVADOR DE TOLDAOS - LUGO
D. Emilio Coego Varel
PARROQUIA DE SANTA EUFEMIA DE MANIN
OURENSE
D. José Formoso Salgado
PARROQUIA DE SANTO DOMINGO
SANTA EUFEMIA - OURENSE
D. Emilio Lorenzo Rodríguez
PARROQUIA DE SANTA EULALIA DE BANGA
OURENSE
D. Francisco Lovelle Alvarez
PARROQUIA DE SANTA MARIA DEL AZOGUE
A CORUÑA
D. José Manuel Iglesias González
PARROQUIA DE SANTA MARIA DE BEADE - OURENSE
D. Emilio Alvarez Pérez
PARROQUIA DE SANTA MARIA DO CAMIÑO
SANTIAGO DE COMPOSTELA
D. José Lage Radío

PARROQUIA DE SANTA MARIA DE CONXO
SANTIAGO DE COMPOSTELA
D. Francisco Gavilés Fernández
PARROQUIA DE SANTA MARIA DE MONTEDERRAMO
OURENSE
D. José Iglesias Mojón
PARROQUIA DE SANTA MARIA DE TEMES - LUGO
D. Segundo Capón
PARROQUIA DE SANTA MARIA DE VELLE - OURENSE
D. Manuel Pérez González
PARROQUIA DE SANTIAGO DE BETANZOS
A CORUÑA
D. Manuel López Castro
PARROQUIA DE SANTIAGO DE GUSTEI - OURENSE
D. Antonio Suárez Cid
PARROQUIA DE SANTIAGO DE PONTEDEUME
A CORUÑA
D. José Ramón Cascón Raposo
PARROQUIA DE VILANOVA DE LOURENZA - LUGO
D. Manuel Anllo
PARROQUIA DE VIANA DO BOLO - OURENSE
D. José Manuel Alvarez
PARROQUIA DE ZORELLE - OURENSE
D. José Blanco Formoso
D. ANGEL GONZALEZ FERNANDEZ
D. ANTONIO HERNANDEZ MATIAS - TUI
D. ANTONIO LISTE RODRIGUEZ - CAMBADOS
PONTEVEDRA
D. ANTONIO SINEIRO PADIN
SANTIAGO DE COMPOSTELA
D. ANTONIO VICENTE FERREIROS
SANTIAGO DE COMPOSTELA
D. BIEITO PEREZ OUTEIRIÑO
SANTIAGO DE COMPOSTELA
DÑA. CRISTINA JATO RODRIGUEZ
SANTIAGO DE COMPOSTELA
COLECCION PIÑEIRO - PONTEVEDRA
D. ENRIQUE FERNANDEZ CASTIÑEIRAS
SANTIAGO DE COMPOSTELA
D. ERNESTO IGLESIAS ALMEIDA - TUI
D. EUGENIO GONZALEZ DOMINGUEZ
SANTIAGO DE COMPOSTELA
FAMILIA DE LA TORRE NAVARRO
SANTIAGO DE COMPOSTELA
FAMILIA GIL VARELA - LUGO
FAMILIA RISCO - OURENSE
D. FRANCISCO FROJAN MADERO
SANTIAGO DE COMPOSTELA
D. GABRIEL QUIROGA BARRO
SANTIAGO DE COMPOSTELA
D. JAIME DELGADO - LUGO
D. JACOBO VAQUERO LASTRES
SANTIAGO DE COMPOSTELA
D. JOSE CARDESO LIÑARES
SANTIAGO DE COMPOSTELA
D. JOSE LUIS GONZALEZ SOBRAL
SANTIAGO DE COMPOSTELA
D. JOSE LUIS REGUEIRO - CELANOVA - OURENSE
D. JOSE SUAREZ MARIÑO - OURENSE
D. LEONARDO LEMOS MONTANET
SANTIAGO DE COMPOSTELA
D. LUIS OTERO OUTES - SANTIAGO DE COMPOSTELA
D. MANUEL FERNANDEZ GALLEGO
SANTIAGO DE COMPOSTELA
D. MANUEL FERNANDEZ GARCIA - VERIN - OURENSE
D. MANUEL FERREIRO MENDEZ
SANTIAGO DE COMPOSTELA
D. MANUEL LOMBAO - MADRID
D. MANUEL SALGUEIRO CORBACHO
SANTIAGO DE COMPOSTELA
DÑA. MARTA GONZALEZ VAZQUEZ
SANTIAGO DE COMPOSTELA
D. MIGUEL ANGEL FAILDE BERMEJO - OURENSE
D. RAMON SANCHEZ RODRIGUEZ
SANTIAGO DE COMPOSTELA
D. ROBERTO PENA PUENTES
SANTIAGO DE COMPOSTELA
D. ROGELIO GONZALEZ ABRALDES
SANTIAGO DE COMPOSTELA
D. RICARDO VIQUEIRA OTERO - SANTIAGO DE
COMPOSTELA

After many individual samples and a good number of monographic studies the moment has come to provide an overall vision, ambitious and complex, like that which is projected in GALICIA THROUGH TIME.

This Exposition, a Cultural Project, would not be possible without the institutional cooperation of the Church with the Xunta of galicia. The cession of the temple and part of the monastery of San Martiño Pinario, as well as an exceptional religious legacy of sculpture and metal work, constitute the ecclesiastic contribution. Cathedrals and monasteries, convents and parish churches, have loaned their treasures so as to provide outstanding testimonies of past eras.

Various museums, foundations and individuals have also ceded outstanding artistic goods that complete the global image—from sculpture and metal work—which refers to mentalities and styles, praiseworthy craftsmen and intelligent patrons.

GALICIA THROUGH TIME, through Art, aspires to become a great bridge which, as Heidegger wished, would bring the shores of the river closer together: the one corresponding to the past, in its diverse formulations, and the one corresponding to the present, with its intuitions for the future.

MANUEL FRAGA IRIBARNE
President of the Xunta of Galicia

The exposition GALICIA THROUGH TIME presents a beautiful "conspectus" of the history of Galicia. The space that holds it—the monastery of San Martiño Pinario—and the pieces which come from all the dioceses of the Galician territory, are a visible example of how profoundly Christianity has penetrated the life of our people.

GALICIA THROUGH TIME shows with the inimitable language of Art the long, road of Christianity in Galicia throughout the centuries. Both realities were intimately and fruitfully united from the beginning.

"The Roots," "The Way," together with "The Splendor"—chapters in our collective being and sections of the Exposition—show us the legacy received—a legacy with more lights than shadows—and move us to thank God for the treasures of Faith and humanity which he has given us through the church.

Artistic expression constitutes the most universal form of communication when illuminating the wealth of humankind, created in the image of God. I invite you to contemplate this synthesis of the rich patrimony of Galicia in light of the Constitution of the Sacred Liturgy of the Vatican II Council: "Among the noblest activities of the human mind are, rightfully, the fine arts, principally religious art and its height, which is sacred art. These, because of their nature, are related to the infinite beauty of God, which they attempt to express in some manner by human works (SC.n.122).

Finally, I wish to thank the civil institutions with all my heart, and very especially the Xunta of Galicia, for the extraordinary effort in preparing this Exposition, which has had the generous collaboration of all the Galician dioceses and which undoubtedly will provide an inestimable service to the cultural future of our land. Pope John Paul II encouraged us from the Cathedral of the Apostle Santiago, on a memorable date, to nourish our roots so as not to forget our history and in this way improve our future. May GALICIA THROUGH TIME help us revive these roots—Christian roots—in the hearts of our youth! In this way we will insure a prosperous future for our people.

With my most cordial greeting and blessing.

ANTONIO MARIA ROUCO VARELA
Archbishop of Santiago de Compostela

GALICIA THROUGH TIME has been planned as a portico where the religious and the profane, the ancient and the modern, individual creation and collective impulse flow together and are shown.

The desire to protect, exhibit and teach our artistic patrimony is the moving force which has caused the birth and maturation of this cultural project. Thus a good portion of the church and monastery of San Martiño Pinario have been rehabilitated, and many of the most important samples of Galician sculpture and metalwork have been the object of necessary work toward their preservation.

GALICIA THROUGH TIME takes up the ancient roots of a land, the way which structures in relation to an entire world, the splendor of centuries of good fortune and a present which looks optimistically toward tomorrow.

An attractive design and assembly attempt to emphasize both the value of the extraordinary frame which holds the exposition as well as the aesthetic validity of a singular grouping of pieces linked by the thread of a history. Galicia speaks, from here, in the seven languages in which its catalogue is written in an effort to reach out everywhere with the message of its artistic trajectory.

DANIEL BARATA QUINTAS
Minister of Culture and Youth

GALICIA THROUGH TIME

José Manuel García Iglesias

I. OBJETIVES

1. The execution of an ambitious exposition of Galician art

The decision to undertake a task of this sort required, from the beginning, the selection of certain parcels of artistic activity, as well as individual pieces, from which a good account could be provided of the level of validity of the area of the exposition that would be organized.

In this manner the sample of a good part of the best exponents of Galician sculpture and metal work throughout time was to become the proposal which, in regard to the exposition, would be made from the beginning: GALICIA THROUGH TIME.

The selection of the works was done trying to include the different eras of history and their important styles and artists, seeking, in the selection of the pieces, thematic content, sometimes serving as models, and others, attractive for their exceptional nature.

The search for a line of argument, which would give coherence to what was to be exhibited, would also from the beginning be a carefully studied question. But the intention was not only to tell a story with the best protagonists possible; it is necessary that ours create a special atmosphere, that it introduce the exhibited items in a frame of great enough grandiosity so as to make the potential spectator feel completely immersed in GALICIA THROUGH TIME.

2. The conditioning of a perfect frame: San Martiño Pinario

The selection of a part of an old monastery, in the very heart of Santiago de Compostela, near the Cathedral, is a proposal full of the planned meaning of GALICIA THROGH TIME.

The church of San Martiño Pinario already had been practically unused for daily worship for some years. Its impressive construction, and the unforgettable collection of altar pieces, choir and mural painting, was in such a deteriorated state that it began to cause concern. The monastical spaces which surround the temple—the oratory of Saint Philip Neri, statio, vestry, chapel of relics, spaces over the side chapels—as well as the eastern wing of the regular cloister—would be presented as the natural continuation of an exhibit circuit which would begin with the temple itself.

From the very beginning, GALICIA THROUGH TIME considers the rehabilitation of

the church of San Martiño and its surrounding area a major task to be carried out. Thus, a monument of highest importance in the historical patrimony of Galicia, with a privileged site in the overall geography of the country, will become the seat of the exposition. With this, the great responsibility that goes with the complex work of preparing the monumental setting and adequately integrating the samples in the building in question, was assumed as well.

That the monument itself was going to be major part of the exposition is a theme that was accepted from the very moment when the site was chosen. And the dialogue between sculpture and metal work, chosen for the sample, with the historical-artistic whole that San Martiño Pinario signified, was thus going to become one of the questions which had to be carefully addressed.

3. Participation in the preservation and revaluation of the Galician historical patrimony.

GALICIA THROUGH TIME attempts to develop a model effort from its participation in the preservation of the historical patrimony. Thus there was an effort to plan, with exemplary criteria, the revitalization of the area of the monastery where the exposition is located.

An entire range of aspects have been taken into account when making decisions as to the plan for the work to be done in San Martiño Pinario. Thus we have considered the in depth knowledge of the building in its different historical stages, have had maximum respect for the value of testimony of the past, and the development of a project of rehabilitation which so greatly accepts that past as the future usage of the spaces that are now occupied.

In order to carry out this rehabilitation reports of various types were solicited. In this way, we received from an analysis of the state of different building materials, to archeological examinations, in confronting the search of a sufficiently valid solution to the treatment of the floor in the eastern wing of the lay cloister.

The treatment of the wood—in altar pieces, choir, lattices, caissons, floors, doors—has been especially difficult. Knowing that it was impossible to face a complete restoration in a relatively short period of time, we began with the criterion of carrying out in an overall approach, a work of cleaning, prevention and consolidation. For this effort a large team of specialists was needed, who at all times adapted their work to uniform criteria of action. The work in this area is of greatest importance. The enormous Benedictine legacy which San Martiño Pinario signifies has been revitalized, recuperating the tone of its original grandeur.

The desire to preserve has also been included in the treatment of the works to be exhibited. Both in sculpture and in metal work there has been an intense campaign to repair the pieces, which has been especially beneficial in the case of the work in wood, treated with criteria similar to those for the overall exposition area of San Martiño Pinario. This concern for the curing and consolidation of the artistic manifestations, received as loans, demanded, in order that the proposed plan be carried out, that they be deposited in the exposition site five months prior to the opening.

In some cases—for example, the sarcophagus of Vilanova de Lourenzá—the decision to bring such pieces to GALICIA THROUGH TIME requires enormous effort. The piece from Vilanova de Lourenzá, extremely heavy, was set in a space which only allowed its front side to be seen... In general the work that is shown, within the exposition, has never been previously shown and nevertheless, is a fundamental part of the Galician historical patrimony. The effort of preservation applied to such worthy exponents of artistic activity thus has great importance.

The fact that the plans for preservation—whether in the area of the altar piece and the care of the wood in general, or in that of the mural painting—which the Executive Committee of Historical and Documentary Patrimony of the Ministry of Culture and Youth of the Xunta of Galicia proposes to carry out, begin in 1990 with various problems which have to do specifically with San Martiño Pinario, almost emblematically signifies the desire to begin a phase which systematically improve, rationalizing the effort to the maximum, the

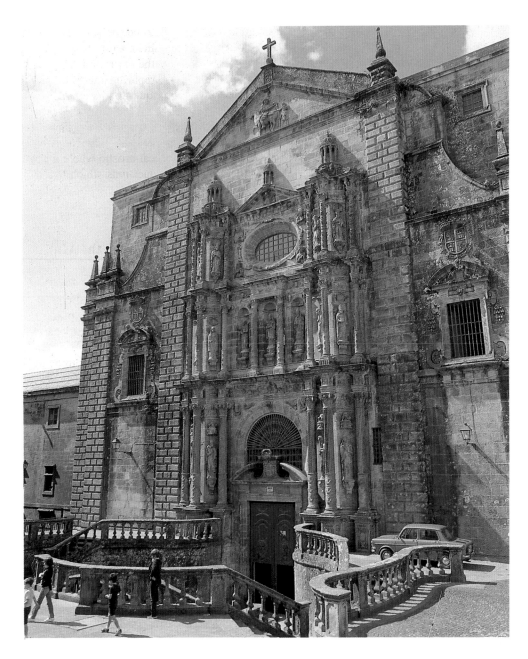

degree of preservation of Galician historical patrimony. Without a doubt GALICIA THROUGH TIME benefits from this plan, precisely at the moment when it begins, and gives its cooperation signifying, in the area of preservation of artistic wealth, rules for behavior that must be taken into account in the future.

4. The sufficient diffusion of a cultural enterprise

The creation of this catalogue, which tries to be a faithful reflection of the content of GALICIA THROUGH TIME, is seen as the basic step in the promotion of the event. Its edition in seven different languages—Galician, Spanish, French, English, Italian, Portuguese and German—shows the desire for it to be present in a good number of libraries of different countries. The publication of the brochure, also in various languages, and various posters are an attempt to inform the public of the purpose and message of this exposition.

The supposed presence of scholars of different levels who will visit GALICIA THROUGH

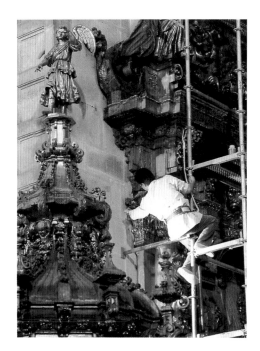

Study of maintenance and treatment of the Main Altarpiece.

TIME led to the preparation of didactic material which would enrich the education of this type of spectator.

In the same manner two types of information have been prepared which are available to any visitor before beginning the viewing of the exposition. These are an audiovisual presentation and a video which may be seen, in different rooms, precisely in the entryway to the showing.

The audiovisual is projected on a monoscreen with six projectors and synchronized sound. In ten minutes it tries to give a synoptic vision of what GALICIA THROUGH TIME includes.

The video, which lasts thirty minutes, tries, through synthesis and the area of the image, to be an alternative to the catalogue, so that in addition to being valued as 'pre-information', before the visit, it can be seen as a document which will remind all those who acquire a copy of the exposition's message.

The crew of Galician Television in charge of creating the video, from the very beginnings of the project, has taken on a large task, which consists both in the execution of documentaries which extract the following of the preparation of this exhibit and in the panorama of a vision of the History of Art in Galicia, in fifteen thirty-minute chapters, which are shown in Galicia during the development of the exhibit, under the generic title of GALICIA THROUGH TIME. Also possible is the edition of three more chapters which, as summary, will present the most significant aspects of this series.

This wide range of work, in collaboration with Galician Television, is of great interest because of its importance for the formation of an audience for the history itself, at the same time as it promotes, through its presence on the screen, with an appropriate arrangement of information, the existence of a public for GALICIA THROUGH TIME. The presence on other television channels of some of the work done—video of the Exposition, the one dealing with its circuit, the three that summarize—may both support the diffusion of an exposition and the knowledge of the contribution of the Galician people to the history of culture.

The series of GALICIA THROUGH TIME is developed on television following three perspectives related to the presentation of the theme. One part of the chapters refer

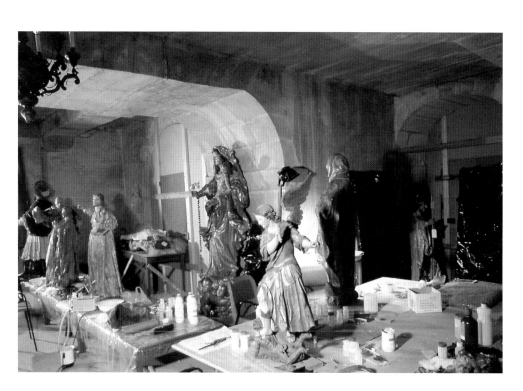

Study of maintenance and treatment of the works prior to the exhibition.

fundamentally to "the land"; from that perspective, for example, the world of the castros, the roads and villas of Rome, or the world of the pazos are analyzed. A second type of narration is offered by "the people", and thus there are approaches to such relevant figures as Master Mateo, Francisco de Moure or Fernando de Casas. The third vision of the Galician nature is developed from "the work", or, if we wish, from the analysis of the patrimony itself; in this manner the spectator approaches the value of the mural painting, the altar pieces, the metal work. The intention is that the vision resulting from the entire series offer a didactic and attractive approach to the Galician artistic patrimony; its posterior value, as a source of complementary information in different education centers, makes the enterprise undertaken even more positive.

The presence of specialized guides who can accompany the potential spectators, brought together according to their level of education and interests, has as its objective the facilitation, as far as possible, of the best approach to the values which this exposition contains.

The exposition also has personnel for public relations, as well as its own press cabinet. The desire to present the information which GALICIA THROUGH TIME generates, as well as to facilitate in general the informative task of the press, more than justifies the existence of this service.

5. The configuration of an infrastructure in favor of the Galician historical patrimony

The formation of the human crew which serves GALICIA THROUGH TIME has been a carefully watched goal. In addition to the Director of the exposition there has been the continuous presence of a large group of documentarians, restorers, photographers, translators, personnel specializing in museums and expositions, television crew, press cabinet, administration, There has been an effort, in the daily dealing with different professionals, to make this exposition a center for perfecting the process followed in each task. We believe that this goal can have very good results, in support of Galicia, in the future. The interest in specializing a large group of personnel linked to restoration in Galicia or, in practice, young people with degrees with the experience of an ambitious exposition, or adapting the services of a television crew to such a unique area, like that of bringing to the public the knowledge of the artistic patrimony, in each case contains its own value... and all of them, undertaken together, aspire to better serve the care, study and diffusion of the value of an entire culture.

It should be pointed out that at all times the human crew which is in charge of GALICIA THROUGH TIME has had the complete support of the Ministry of Culture and Youth and very particularly with the General Committee of the Historical and Documentary Patrimony. The Minister himself and the General Director, in each one of their divisions—Archeology, Architecture and Museums and Archives—have made valuable contributions without which the exposition would not have achieved the level it has. The support of this exposition itself, must have undoubtedly been a great satisfaction for the General Committee and a good experience for future projects.

But, in addition to the better formation of human crews, GALICIA THROUGH TIME contains another great meaning concerning the consolidation of infrastructures. It must be seen as a great task of preparation, basically, of part of a great monument, which will make possible future uses in support of the ecclesiastical historical patrimony itself. In that sense we must view the recuperation of a very significant part of the building, with all its historical value and meaning, the preserving efforts carried out on its altar pieces, choir, imagery, fundamental base of a possible great Museum of Sacred Art, the valuing of certain spaces as very appropriate show rooms of permanent character, and other parts with a special vocation for expositions of temporal nature. The possibility that another good portion of that eastern wing of the regular cloister—the upper part—might be used in the future as the site of a great archive should not be overlooked either.

II. MEANS

The execution of GALICIA THROUGH TIME would be an impossible task if, from the very moment when it was planned, there had not been a close sense of collaboration for the

Inscription alluding to the restoration of one of the altarpieces of San Martiño Pinario, carried out in the 19th Century.

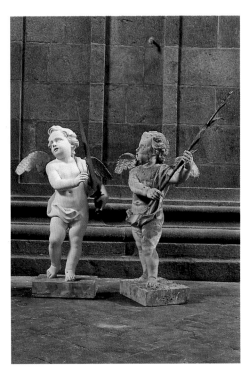

Angels from the monument of Maundy Thrusday. San Martiño Pinario.

accomplishment of such an exposition, between the governments of the Xunta and the Catholic Church in Galicia.

The contribution of the Church is fundamentally of a patrimonial nature. Not only does the building of San Martiño belong to it but also a good portion of the work which is to be shown. In achieving the loan of all this patrimony, there was total support from the archbishop of Compostela and the rest of the bishops of Galicia, with the generous assistance of the Cathedral chapters, the monastical orders and convents, the parishes, the brotherhoods... But besides the loan of items with artistic value, the Church's support was always present, through the constructive opinion of three religious advisors selected for the purpose by the archbishop of Santiago.

The Xunta of Galicia, in addition to the exposition project, contributed the crew that carried it out, as well as the financial basis which makes the whole long, complex task possible, from the rehabilitation of the building used as site of the exposition to the diffusion of the cultural enterprise.

The financial effort required must be recognized as very important. But we must also consider its great profitability, from a cultural point of view. The objectives of GALICIA THROUGH TIME do not stop with possible brilliance of a specific moment. After the exposition there will much more than a trace in the memory of the visitors. Its work of restoring and revaluing the patrimony, of diffuser of its value, its interest in creating infrastructures in the service of Galician culture, are contributions which should not be forgotten.

III. THE MESSAGE OF "GALICIA THROUGH TIME".

The graphic image which has been used to identify GALICIA THROUGH TIME blends its denomination—toward the center—with two allusions, one to the nature itself of Galicia and the other to its history. The color and texture of the granite—in the upper part—speaks to us of a certain physical configuration; there is no monotony in the grey of the stone since it is "touched" by the path of time. The identification of the granite with the Galician land can be as obvious as that of the colors which are visible on the lower part—white and blue—which refer to its flag. Galicia, a place and a history, a space that has seen the passage of time with its own accents. And GALICIA THROUGH TIME wishes to emphasize this reality through the very image that has been chosen as an emblem of the task undertaken.

The development of the exposition brings together two proposals which are closely linked: the revitalization of a monumental setting and the presentation of a repertoire of works of sculpture and metal work. The treatment of the items has attempted to achieve a specific relationship between the evaluation of a certain spatial frame and the pieces which are in its catalogue; in that relationship there has not been a unified criterion used for the whole circuit. Each time to be represented and each space in which a determined temporality is located have been conceived with its own criterion. Because what we seek at all times is to transmit, as far as possible, the magic of each moment through the creation of a specific atmosphere, very planned, that will bring the contemplation of a repertoire of pieces alive in a special way.

But there is always the building which inevitably demands our admiration. Thus the spectator on only a very few occasions can lose the sense of the space where the exposition is situated. And also for this reason, the design of the circuit precisely tries to promote a great number of points of contemplation throughout.

It can thus be said that San Martiño Pinario is the main work that we are trying to exhibit here, forming part of that GALICIA THROUGH TIME in which it has been especially important in the years of the Modern Age. The great building impulse of this monastery in that period is definitely the best symbol possible of the splendor of an era in GALICIA THROUGH TIME. And it is for that reason that, through the monastical church itself, reference is made to the SPLENDOR as a phase of the history of Galicia, thus using a space which masterfully identifies it and which, in this case, is executed still more with works from the same period of construction and adornment of this temple.

On beginning the route through the history of Galicia precisely in those years of the SPLENDOR, following the dictates of the building in which the exposition is located, we are foregoing a linear treatment of the passing of time. The question thus consists simply of expressing the peculiarity of the Galician nature through four keys which succinctly express the being, the virtuality of each time that was lived and became an artistic shaping from Galicia.

THE ROOTS allude to the origins and take us from Prehistory to Romanization with which the process of Christianization must be associated. This is a dark world, full of enigmas, intuited, nevertheless, from the understanding of certain pieces which the exposition contains.

THE WAY is the key concept which brings together a long stage that begins in the IXth century and will bring pilgrim Europe to Compostela. It includes through the XVth century.

THE NEW IDENTITY is the name chosen for the final phase of the exposition and alludes to the last period of a history which, if contemplated from San Martiño, goes from the time od the collapse of the socio-economic system which sheltered monastical life up to the present day, on the very threshold of a new millennium. Here we are trying to show a personal, open way, hopeful for our collective future.

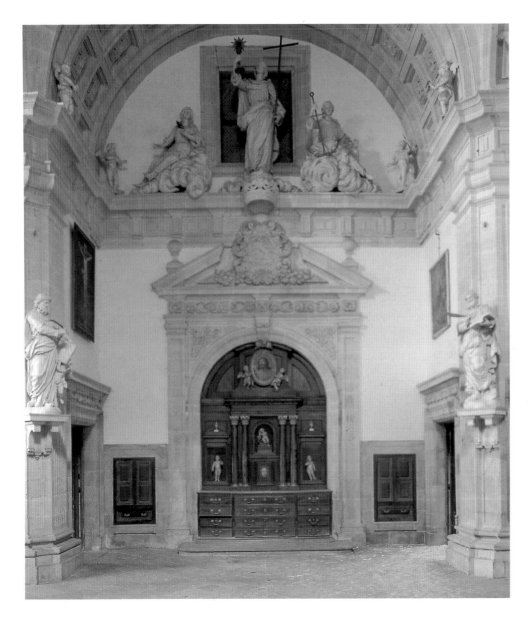

Vestry of San Martiño Pinario.

After contemplating THE SPLENDOR, THE ROOTS and THE WAY, we will again proceed to the spaces of THE SPLENDOR in order to recover in this manner the thread of History. Thus, contemplation acquires all its coherence before beginning the route through this last stage of THE NEW IDENTITY.

There are thus four times which are differentiated here, attempting to signify, in each one of them, a particular way of viewing GALICIA THROUGH TIME. And this is, through this exposition, its commitment: to be the expression, with the correct clarity, of a perspective and a cultural contribution characteristic of Galicia, in its yesterday but also in its present.

CHRISTIANITY AS THE SOUL
OF A HISTORY

E. Romero Pose

"""Neither tomorrow -nor yesterday- is written"
(A. Machado)

The Greek and Latin literary references as to the ancient kallaikoi or callaeci are not enough to pull the nebulous andd distant historical, social, and cultural reality of the Hispanic Northwest, which with Romanization would receive the name of Gallaecia, out of the shadows.

It is difficult to recover from the times before Romanization the soul—the being and living—of the ethnic groups with the only aid of archeology and the surviving forms that arose in the periods preceeding those we usually call history. The most we can do is take a glimpse at the ever-captivating attraction of the arcane in which the unknown does not give us a guiding thread to achieve a homogeneous interpretation.

In the laborious process of Romanization the profile of Gallaeciaa's geographical limits as a province of the Empire is favored, and slowly an ethnic and cultural plurality was agglutinated around those limits. Rome was preparing the way for Gallaecia, in communication with and ready for a unifiying encounter, to find a new shaping principle in the early Christianization. "Rome teaches the use of one language. And Rome gives one religion, and above all, a Church that is the symbol of unity." (J.R. Barreiro)

For a world dispersed in Pre-Roman obscurity, Christianity will provide a cosmovision without which, with the passing of centuries, it would be impossible to reread the global history of Galicia and its collective being. The evangelical predication would take root to such an extent in the cultural past that it would become a people within the frame of Roman universalism. Thus western Fisterra (Land's End) would widen its possibilities upon embracing the contributions of the new religion and what was Galician would be dignified by becoming creditor and inheritor of the most pristine traditions by believing itself to be land evangelized by Santiago the Greater.

Its beginnings would be as simple as its development grandiose. Galicia becomes a chapter of western history under the care of Rome and opens itself to a future led by Christianity. It joins the group of peoples under the sign of Christian Gallaecia.

We are not able to reveal the secret of the implantation of the first seed that would become the robust oak of the first Christianized Gallaecia. What is certain is that if not in the early times of Christianity, at least in the Autumn of 254, we find the trail of an early Christianization in Epistle 67 of Saint Ciprian. The bishop of Carthage testifies to the presence and influence of Christian Africa in the first western-Hispanic communities in Galician Astúrica (Astorga). The limits of Gallaecia were at that time larger than those indicated by later political configurations.

The Roman roads served as a course of communication and transmission of the beginning theology's explanation and the first Christian plastic-cultural manifestations. The

slow awakening of the cities saw the appearance of expressions and regions which, without ceasing to be Roman, were molded by the Christian contribution.

Thus, Rome and the Evangel would be the inequivocal reference points for this rapid growth which reached its height in the IVth century with the eclosion of the Priscilianist version of Christianity, one of the most difficult moments which the post-Constantinian church has to confront. The rootedness and expansion of the Priscilianist movement located chiefly in Galicia would be unexplainable if a terrain were not already prepared, a terrain which so deeply connected with the doctrinal program and content of the heterodoxal bishop from Avila, the first "spiritual" individual tried and condemned by the secular arm. But Gallaecia managed to overcome the drama of Priscilian, accepting help from the major personalities of the time: Saint Augustine in Hipona, Saint Ambrose in Milan, Saint Martin of Tours. Rome, Treveris, and Bourdeaux are attentive to the events in Gallaecia.

The Scripture and its exegesis, and the liturgy, offer an original vision of the life and death, and the latter will be sculpted so that it could be contemplated and understood by a society that was in the process of shaping its personality to the Christian religion. Significant examples, among others, are the monogram of Christ of Quiroga, the sarcophagus of Temes and the stele of Victorino (Tines). Architecture again takes up and recreates forms at the same time as Galicia appears sown with signs that make new paths possible. The provinces of Braga and Lugo become foci of irradiation and the Orient becomes present there; the toponymy and lives of the saints are enriched with the news from other geographical areas. The monastical order emerges like a reforming echo and a an existential reference the people look to and learn from. Gallaecia is offered the link to the theological knowledge of eastern Christianity, especially in its anthropological sense. In this panorama the memoirs of the wandering Egeria are not at all strange.

This is the time when we receive the pre-announcement of the Way in the middle centuries. Before the Ways reached Land's End, the westernmost area tried to open a route to Orient and the rest of Christianity. This is the glorious period of late antiquity in the Hispanic Northwest, in which pilgrims of knowledge and historians flourished. Orosio and Idacio, who knew the past, although with a pessimistic viewpoint or an optimistic vision in the face of the fall of the empire, write the first universal History and decide to accompany the avatars of a people in the course of the Suevian period. The tradition of a pilgrim Gallaecia provokes others attracted from the limits of Christianity to come as pilgrims to the westernmost region of the known world. From the Orient Saint Martin arrives, and adopted by Galicia will earn the name of the Dumian. His evangelizing and reevangelizing efforrts, with thir cultural repercussions, his support for the surprising conversion of the Suevian kingdom, would be the paradigm for the Visigothic project. Braga, echoing the oriental problem—originism—finds the formula for a peaceful co-existence among Roman Christians and those of Arrian tendency. The anti-Priscilian conciliary praxis, and later the solutions of Braga, the support given by the Church in Galicia to the understanding between the gens hispana and the gens gothorum would be seen in the culture in all areas of the Galician geography, which would not be cut off from the flourishing period of Toledo. The Parochiale Suevum constitutes a significant reference. This testimony allows us to see the ecclesiastical organization of Gallaecia that was the basis of social structures which have come down to our time.

The roots of Christianization and their social realization would be the best guarantee for the success of one of the most important events of the medieval west: the discovery of the apostle's sepulcher, the birth of Compostela and the European Way.

Astur-Leonese literature and its reception in Galicia, the acceptance of knowledge beyond the Hispanic March, the overcoming of Toledan syncretisms of the VIIIth century, the capturing of Carolingian intuitions, in a word, being fertile ground for universality, made it possible for Galicia, organized around the memory of the Apostle Santiago, to offer a new Way to the peoples of Christian tradition.

Saint James' Way and the Compostela of the Way, signify the continuity with open routes for Romanization, now reinforced with the Traditio christiana. The Way is the sign of the miracle of peoples joined beneath a common denominator of one faith. It is the offer of future and the more polished realization of the intuitions of the great Pope Gregory and the aspirations of the Sevillians Saint Leander and Saint Isidore. Europe is no longer a dream, and in spite of the threat of invaders and fragmentation, the Way becomes reality.

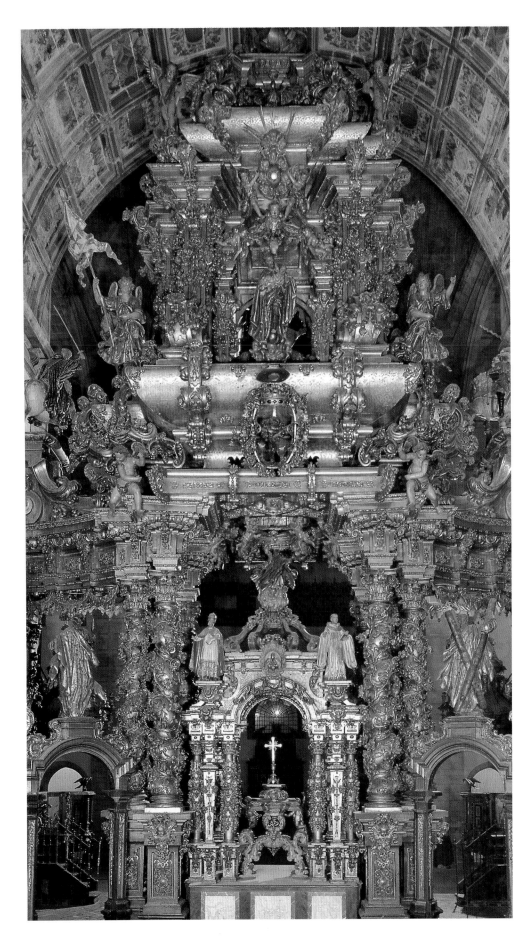

Main Altarpiece of the church of San Martiño Pinario.

With the advance of the Route of the stars set at the end of the world, again East and West construct a common dwelling place of shared knowledge and expressions.

In the apocalyptic high medieval period, after the millenarianisms are overcome and the dispersed traditions harmoniously collected, architecture, sculpture and music give hope to society and allow it to be recognized and to meet in the forming of unitarian styles, encouraged and sustained by a common feeling.

Galicia of medieval Compostela will be the continuer of Gallaecia. The Compostela of Santiago and the Way is the greatest of its contributions to history. Its best expression is the "shining hour" (Otero Pedrayo) of Romanesque and Protogothic. Kings and prelates will erect churches and enrich the goal and high points of the Way. By merely writing their names we evoke their contributions from the days of Charlemagne, Alphonse III the Great, Don Cresconio, Don Diego Peláez, Xelmírez, Suárez de Deza... And beside the patron the names of the masters, Master Bernardo and Mateo, members of the cathedral school sent to Paris and Bologna. The cast of the grandiose legacies that arose under the protection of the Jacobean miracle, paradigm of Galicianness and representation of a "movement of vital awareness that created the only unity of Europe still a reality today" (Otero Pedrayo) would be long. The Compostela of the pilgrims, proud of its beginnings and in tune with the first centuries, learned from the monastical. In the shadow of the monasteries, building and community, and with the spirit of the religious orders, it makes the best of their creations its own. The Cister and Cluny will find a land where they can perpetuate their message. But the Compostela of Santiago is more than a passing event; in it and its history it carries the strength of the traveler, of Ultreia and Esuseia. Santiago of the Fonsecas, and with Compostela, Galicia, will face its future fitting its Renaissance to the Plateresque style and showing distantly the scisions of Lutheran Reform. The Agustine reformer bitterly attacks Santiago and its Way. Compostela, set granitically in its past, barely suffers the onslaught. Not so its Way. Still, the Galicia of Santiago was able to take a step forward in the modern period, with its Baroque splendor. It binds the new to the old, remodels the medieval expressions with new images. It softly covers the tradition with its present as if wishing to conserve the past without aggressive persecution. The lights of the centuries of Reason, the Enlightenment, and the break will leave few marks on the post-reformist solutions supported by the popular influence of the modern religious orders which will foment the memory and living roots without first paying attention—because of the nearness of the goal—to the meaning of the Jacobean Way, but without losing sight, on the other hand, of its legacy.

At the end of a new millennium humanity cannot look toward the future if it loses its memory, if it does not recover its past. Memory and the past, roots and the Way, will be creators if the soul that has given them life, the spirit that makes Creation more human and habitable, is not wounded. "Two thousand years of Christian history have marked the face of Europe" (Cardenal König). In order not to disfigure the face of Galicia we cannot do without its Christian history. May I recall the cry that the first pilgrim Pope gave from the heart of Galicia on November 9, 1982: "I, Bishop of Rome and Pastor of the Universal Church, launch a cry of love to you, old Europe, from Santiago. Find yourself anew. Be yourself. Discover your origins. Strengthen your roots. Revive those authentic values that made your history glorious and your presence on the rest of the continents charitable. Rebuild your spiritual unity in a climate of full respect for other religions and true freedoms." We can receive the cry to Europe as a cry to the land of Compostela.

SAN MARTIÑO PINARIO
IN THE ERA OF AN EXPOSITION

Angel Sicart Giménez

The temporal exposition in essence represents a remembrance of another time which can reach the present. This flexibility which allows all types of license and manifestly underlines its ephimeral condition, is accompanied by a heterogeneous concept which becomes one of the essential bases which sustain it.

An exposition of which we know ahead of time when it is born and dies feeds criteria more and more divergent from the permanency and unchangingness of the stable halls of a museum, which does not mean an irreversible break, as the museographical and museological concepts come from a common trunk more and more distant from an antiquated tradition, in favor of theories adapted to the needs of today's society which is definitely the generator and impulse of a cultural exigency derived from a different development. At the base of all this, the survival of analogous goals of a temporary exposition and another permanent one is questionable, although the means might be notoriously different, characterized in the first case by a heterodoxical accent able to break with formal harmony, without that signifying the renouncing at times of the legitimately assumed comfortable orthodoxy.

The framework in which a temporal exposition is born is diverse and broad. In the shadow of historical events an entire series of manifestations occur which end up becoming simple scenery or dressing of a fact at times distant. Nevertheless, certainly anniversaries and centennials follow one another to make visible certain personalities which cover all fields of science, technology and the humanities, in addition to celebrations which evoke the birth of a monument or emphasize singular facts that affect the local or national history in which a people is immersed. Probably never before have people had the chance to get to know people so well.

The birth of GALICIA THROUGH TIME is precisely in the protagonism of time through sculpture, but not understood under the theoretical concept of physics, but rather that of the daily sum of human existence and of the person who is witness to the spirit of those we call artists today, long maintained by the tangibility of the difficult survival of the work, installed in a time whose daughter it is, a time to which we are indebted, but in search of a serene analysis, being privileged witnesses to a profoundly religious happening that renews and transforms, from its own spirit as well, in easy coexistence with the superficial functional objects of always and those works of our time, which is not that time, but undoubtedly based on a profound, long, and on occasion, inevitable spiritual sediment of an old country.

The history of Galicia is a discontinuous line, not broken, that wriggles through a sum of times and seeks witnesses who will affirm it. Its Art History finds the best definition, although not the only one, in the testimony of sculpture and metalwork. Through one and the other the times follow one another without solution of continuity, like daughters of eras of light and shadow in which the guiding thread, tenuous, nearly imperceptible at times, is maintained and slowly becomes stronger in the protection of a Christian world which, like a torrent, channels them.

THE ARCHITECTURAL FRAMEWORK

Time, sculpture, and metalwork, like axes of the temporal exposition, demand a framework for their development, extremely conditioned by the conceptual imperative of the sample itself.

Evading a specific architecture in order to include the multiple works, that is, created ephimerally for the occasion, the primary concept also brings with it a symbol and paradigm of the bases of western culture. The inevitable claim of an architecture which contains the sum of symbols goes, undoubtedly, to San Martiño Pinario. Its own history goes beyond the architecture which has reached us, like the sublime frame which leads it to become the coffer of a valuable legacy.

The responsibility of the cult of Santiago, shared if one wishes with San Paio de Antealtares, falls on a monastery that secularly stood on the doorstep of the Apostle's residence and with a spiritual link that is greater than the physical proximity of the monastical dependencies. After the city had become one of the three centers of pilgrimage in medieval Christianity, together with Jerusalem and Rome, San Martiño Pinario grew and multiplied its responsibility in the Jacobean sphere.

Only written documents take us back to the medieval greatness of the religious center, since it was the modern world which knew its second great period of splendor. In addition to the monastical dependencies, a great symbol stands out from the whole: the Church. Its

Nave of San Martiño Pinario

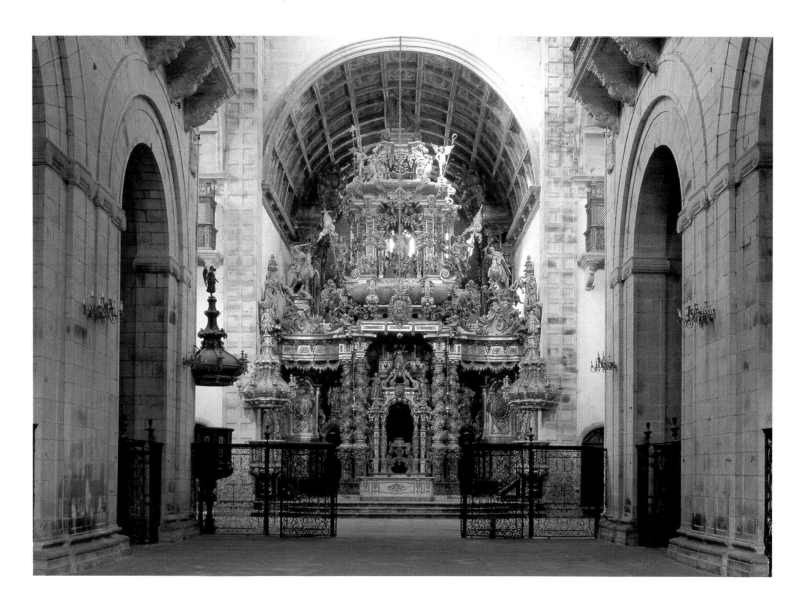

30

construction, dominated by a Trentian spirit and with a nearby area extraordinarily rich in space, from a conceptual perspective its architecture represents, the hinge between a worn out tradition from the medieval world and an innovative spirit able to understand preceding periods and at the same time project itself toward a future that it would not reach until far into the XXth century.

It is thus necessary to have a primary space that contains the temporal sequences of sculpture, that goes beyond a receptive architecture or a sufficiently broad continent where the dense elected discourse of the History of Art may be situated. To its urban location, in the heart of the city, with a privileged access surrounded by the flourishing of the city of Santiago over the centuries, San Martiño Pinario continues to be the sublime space protected by historical memory. Around it, and from here, we can explain that passing through time, occasionally in a direct manner through works, artists or legacies of Compostela, at other times as reflection and echo of the westernmost epicenter of Europe, which goes beyond the apostolic walls coining the beginning of universality. It is precisely that long ecumenicalism which contains and explains the foreign and the native, which sometimes are fused, leading to some singular characteristics which in Galicia acquire their own features.

Thus, the church with its six chapels and especially its main nave and transept, justify a first design of the exposition, since form and content are joined justifying the concept. Nevertheless, the spaces which literally embrace this primigenial architecture and linearly can be considered secondary, also become necessary, but more as a simplistic formula in comparison with the major one, than as a product of the architectural reality and even of the discourse of the exposition. Such is the case of the chapel of San Felipe Neri, the vestry, the high choir or the sheds, although it is true that above the side chapels rooms have been created that are in the process of rehabilitation and which have meant the recovery of important idle spaces.

From the first, the ambitious nature of the project develops an important complexity concerning the temporal order which should dominate the exposition. It is not a matter of creating a great lesson on the History of Art, but of walking toward it after having previously established an order. This nevertheless depends to a great extent on the architecture itself, creator of a sublime spiritual and material space, which should not be given up, but rather must be included, as already noted, in order to understand the range of the exposition.

Obviously, the church with its angular form is acting as an rigid conditioner which imprisons and dictates the exposition's discourse. Because of its temporality, it would have been possible to give up this architecture, and it could even be legimimate, but undoubtedly the concept would have been different. Creating an architecture within another, multiple ad hoc spaces would have been designed for each piece, introducing the spectator into an artificial subworld through which he/she would have to circulate only according to the works exhibited and their tiny context, only endowed with agility by the chronological sequences which rhythmically would follow one another.

Thus, assuming the symbol and force of the church of San Martiño Pinario, the long discourse in Baroque code is born with strong Classicist accents, already installed in the doorway itself of the area. A great Baroque time is imposed, as a main axis which is felt slowly embraced by the other times installed in the adjoining spaces. In fact, these will demand a rigorous adaptation to what already exists, with such clear dependencies, which will force the adoption of solutions that are daring enough so as not to break the dynamism of the route. With the intention that this in principle secondary space survive beyond the time of the exposition, it has been necessary to act upon it designing and rehabilitating with imagination.

Undoubtedly the circuit set should constantly justify a coherence and above all an order. At no time of the travel through the exposition should there be the least break in the itinerary, since the physical path should be inserted perfectly into the intellectual discourse; thus the difficulties arising when this path leaves the physical frame of the church to continue in a surrounding endowed with multiple spaces, some finished off and closed, while it is necessary to recreate others, which are secondary areas needing an alreday noted rehabilitation in order to adapt them to the obligations imposed by the project. The finding and fitting of one to another has priority in order to reach the final goal of the long pilgrimage.

DISCOURSE AND EXPOSITION

From a museographical and museological point of view, the spaces of the church represent a sum of complex problems coming from the visual amplitude made necessary by the work itself. Without doubt, they act as a loan and as such allow us to see the difficulties tyical of an area which was never conceived for exposition and of which, moreover, the intention is to maintain the essential features, already noted.

It is certain that from this perspective the church of San Martiño Pinario can be divided in three parts that are museographically different: the main nave, the transept, and the chapels. The latter, because of their dimensions and altar pieces, in themselves form a small unit with sculptural and architectural coherence, including that of the Virgin of Aid, endowed with a templar entity and a surprising autonomy within the overall area. All this signifies a more generous accommodation to any action within its area, because the great contribution of the altar pieces with their sculptures, transforms into objects furniture integrated into the frame of the exposition and in a way act as orientation to situate the foreign pieces which may be closest, not only in time, at times secondary when it is a matter of short periods of the history of art, but also in the iconography.

The transept, dominated by the symbolic cupola, is the second great center of attention of the church, always from an expositive point of view. In it the alpha and omega are concentrated through the golden force represented by the three altar pieces with sculptures, which signify a permanent and secular exposition of continuous vibrations of light, capable of drilling in transparencies the monumental main altar piece, whose life is prolonged beyond it in search of the choir and its symphony, as Fernando de Casas projected it.

It is undeniable that this is museographically privileged space, which created itself until it was shaped in its definitive form. Thus, the unchanging is incorporated firstly to justify as well the temporal nature of the occasion.

Finally, the main nave and its meeting with the transept becomes, by its own characteristics, one of the most important axes of the exposition. Previously the sublime space was indicated and underlined, and not only the physical, which this architecture imposed, and the fact is that its great amplitude, laden with an asceptic austerity, causes a series of premises to be furthered museographically, which may even make the meaning of the representation itself vary.

To keep the force of the architecture without changing means formulating another project for exposition with clearly different goals. On the other hand, to fully give up this plan is to take away a component which is also ideological, which justifies the long sculptural discourse. Undoubtedly, from the museographical viewpoint, the great nave cancels with its potency any asceptic order applied to the sculptures destined there, thus it is necessary to limit the great space by creating others destined to shelter an important number of pieces.

As a consequence, the design of an ephemeral architecture is imposed, which will be adequate to the existing environment dominated by an dominant axiality. This means a giving up, but only partial, and as an inevitable tribute, since the force of the idea of what the ample metaphorical space of the way of the human being to God signifies survives.

This ephemeral "prodigious apparatus" which is encrusted like a foreign element in the axis of the temple, at no time is supposed to be in affable dialogue with the surroundings; rather, it is the opposite, because it must act, on the one hand, as generator of small areas in which each sculpture finds its own space, markedly decontextualized, and on the other, as a surprising element endowed with a functionality able to find new perspectives in architecture and, in a special way, in the altar pieces, which even if were they sufficiently unreal so as to not survive the exposition itself. To surprise the spectator today may be as legitimate as it was in the Baroque period, with the fastuous, ephemeral architectures which were kept standing all the time the commemoration lasted.

With the ecclesiastical space officially ordered according to criteria similar to those described above, a complementary and essential chapter, conceptually, is the light. It is not necessary to allude to the equilibrium of openings of the monastery of San Martiño Pinario. Nevertheless, I believe that neither is it necessary to recall the substantial alteration of functions which is now being imposed upon it.

Tile of the chapel of Saint Philip Neri at San Martiño Pinario.

It is evident that the importance of the light goes beyond the punctual changes done to the stone, in the manner of a traditional exposition, since by means of this there is an attempt to enhance the architectural and sculptural elements that are especially outstanding. The light will also recreate a new scenography which will have its effect on the spectators and surprise their discovery of new perspectives, especially because of the altar pieces, as impressive machines which rise in search of luminosity toward the wide windows which slash the wall surfaces.In the shadow of a frame thus designed, but shining with its own light, the foreign sculptors become another great chapter which closes the ecclesiastical circle. It was already indicated how the chapels constituted museographically almost closed elements, but with the sufficient generosity so as to form a coherent discourse.

The chapel of the Virgin of Aid assumes a Marian cycle linked to the passion of Christ, supported by figures such as Gregorio Fernández or Mateo de Prado, all in Baroque code, in the same manner as the main nave holds the work of Francisco de Moure and the transept those of Gambino and Silveira. Nevertheless, the effort has been to respect the stylistic change that the passage of time promoted in the church itself; it was impossible to forego, in spite of the Baroque atmosphere, giving special emphasis to the Neoclassical chapels of Saint Scholastica and Saint Gertrude, works by the sculptor Ferreiro.

The discourse of the exposition continues with the thesaurus, a space adapted for the occasion in the oratory of San Felipe Neri and which includes all the Christian metalwork as a summary of a group of times which in reality are one and the same and, as contradictory as it may seem, which remain intemporal.

With shining evocations of donations, legacies, difficult enterprises and ecclesiastical prestige, the gleam and light already justify a manner, undoubtedly traditional, of exhibiting the pieces. Between the mythical material value and with the hope of the spiritual, the salon is adapted to a systematic succession of glass cases with an order partially proportioned by the architecture and in an environment of light and shadow to search for the fascination of a public that must understand this salon as the old "thesaurus" of the churches, where they kept the most precious items and which represented the prestige of the institution before Christianity.

The low choir, situated as already noted behind the monumental main altar piece, museographically requires a precise informational treatment. The splendid reliefs, in a theological discourse impregnated with Baroque elements, represent a group of events which in a simple way are projected over the spectator, but the truth is that the exposition is situated at this point before the great temporal break.

After this place begins a new time which represents the beginning of other new ones. Evidently, a scenography of break is imposed in a neutral space within the framework of San Martiño Pinario. The "statio", the antevestry as place of passage, holds the dark times of History to open onto the Christianization in the sacristy and to shelter the pre-Christian metalwork in the tiny chapel of relics.

From this site, the tour of the exposition represents literally the constant embrace of the church. Through a splendid stairway from 1696, one enters a series of spaces which become the rooms of the Romanesque and Gothic, dominated by a respected rustic appearance after an outstanding rehabilitation. These clearly secondary spaces in the general architecture of the building are intended, by their roughness, to emphasize the almost exclusively stone pieces exhibited there, which requires the development of minor treatment important enough so as not to drown the works through the architecture.

In the long pilgrimage which the itinerary of the exposition has become, a surprising reencounter with the grandiosity of the church is achieved through the high choir. The sculptures of the Renaissance do not deplete this splendid environment, since its discretion so emphasizes this first vaulted space open to the natural light through a window, as in the wide stage in which the entire nave is transformed until it meets the main altar piece. Museographically, the spectators break the rhythmic walk in their encounter with the sculpture to be again surprised by the rediscovery of the church from a definitely different angle from that seen up until now, so that, having consciously sought it, the first Renaissance which one finds in the pieces there is transformed more into a superficial introduction to the new era than into a dense dictate that could be hidden by the architecture's grandiosity.

In reality, the salons of the Renaissance, with a similar treatment to that of the immediately preceding periods, reproduce concepts of the exposition, since again it is the high rooms of the chapels which are conditioned to hold the most outstanding of the period.

After this place time is different. It has already been noted that the objective is more a meeting with the History of Art, propelled by the splendid continent which is the church of San Martiño Pinario, than a meticulous composition dictated by a rigorous temporal order. From the Baroque and Neoclassical which which it began, with the thesaurus as bridge, we continue with the long pilgrimage from Prehistorical times to the now ended Renaissance. Logically, the time which opens up is different, is the contemporary world which reached our time.

The encounter is carried out descending by stairs conceived and executed for the exposition, which indicate a passage with a frame opposite that noted up until now. In front of that Baroque stairway is another product of the rehabilitation of the building, with a modern spirit but wisely integrated into the context in which it is born with a projection toward the future, vital for the destiny of the vecinity of the church. Thus, the stairway of the sheds situates the spectator in this old space also recovered to hold the contemporary sculpture.

In reality, the first two rooms of the sheds date from 1740, while the spaces which follow were erected in late Classicism. Adapted for the exposition, each work had its own spatial environment in which its rustic appearance is ennobled by the materials surrounding it. In truth, the cadence of vaults and an adequate illumination recreate a new meaning for the sculptures, exhibited in a frame dominated by an accentuated axiality which leads the spectator to the final point of the exposition taking him/her to the feet of the Azabacheria.

THE PUBLIC AND THE EXPOSITION

The open character of the temporal exposition makes for a broad and diverse public, at least seen from a generic framework. Besides, from the concrete aspect of the conceptual design already in its first phase, the observer should be the primordial goal of all the initial force. In reality, what has been affirmed up to now frequently depends on museographic principles conceived for the spectator on the basis of practical solutions which make the

Process of cleaning of the choir.

passage through the rooms easy. Nevertheless, there is a theoretical museological component which is also born with the first ideas of the design.

The final goal of GALICIA THROUGH TIME is, chiefly, the public. Its obviousness does not signify silence, since on this basis the public germinates an idea, it is developed and made reality, communicated like a message framed by careful didactic development, at the same time as the aesthetic enjoyment is encouraged and the means of development of research in various fields of history is motivated.

Hence with the base of a heterogeneous people which approached the diffierent stages of the History of Art in Galicia, it is important that the first visual impact surprise us, thus the global appreciation of the church with its more than noteworthy magnitude, which is achieved upon entering the area. From this moment on, the spectator passes from the generic to the particular and will continue to discover the objects according to the option selected to approach the development of the exposition.

In this sense the information must be of the right kind and sufficiently concise so as not to overwhelm and produce sporadic interruptions along the route. Excessive texts with broad literature produce in such a long itinerary a weariness, and as the visit transpires there is greater disinterest of the spectators at the same time as they begin to feel the "fleeing syndrome", that is, the strong need to free themselves as soon as possible from that which they had begun with interest. The weight of this rejection also discourages them from coming back at another time to develop those points which they know have remained diffuse; this return must be another aspiration of the exposition, given the breadth of the project.

This succint but clear information, previously guided from the beginning of the circuit through audiovisual means of short duration, but explanatory of the whole, close an important basic chapter that is prolonged in the edition of guides and brochures, as well as the catalogue which is a scientific support for a posterior individual enlargement of concepts by the visitor.

Introducing the spectator into a strange circuit, as he/she advances, the intinerary becomes more labyrinthine and diffuse. This situation is frequent in the expositions held in historical buildings whose physical characteristics make them adapt to conditions that are not very satisfactory. The spectators definitely reach a moment of the trajectory in which they do not know where to situate the entry and even the exit in relation to the principle nucleus. In other words, they are lost, without points of reference.

San Martiño Pinario is not unaffected by this aspect. In certain environments, the church is not concealed and the person who approaches it for the first time immediately enters into it because of the diaphanous nature of its structure. When the secondary structures, which the church embraces, are rached the labyrinth effect reproduces situations already discussed.

Nevertheless, turning to one of the modern museographical principles, based on the permanent knowledge of the spectator of the place in which he/she is within the museum area, along that second route opening oriented toward different parts of the church open up, so that the visitor may have a place of reference and remain oriented at all times.

On the other hand, in such a dense circle, it was necessary to prepare certain spaces as places of rest in intermediate points which serve as a joining element of the rooms, which gives the public a peaceful passage that avoids arriving at the end of the exposition and with attention beginning to wander because of tiredness, thus losing interest in the works exhibited and rapidly searching for the exit in a second "flight syndrome".

THE OBJECT OF THE EXPOSITION

The long chronological period which the sculpture covers within the exposition GALICIA THROUGH TIME makes it necessary to have a prior elaboration of a study of the state of conservation of the pieces since the materials are diverse and the treatments different, according to the period in which they were produced.

Wood, stone and metal are the essential materials, with diverse origin and with some of the pieces as loans from state and private museums. From the beginning a prophylaxis was

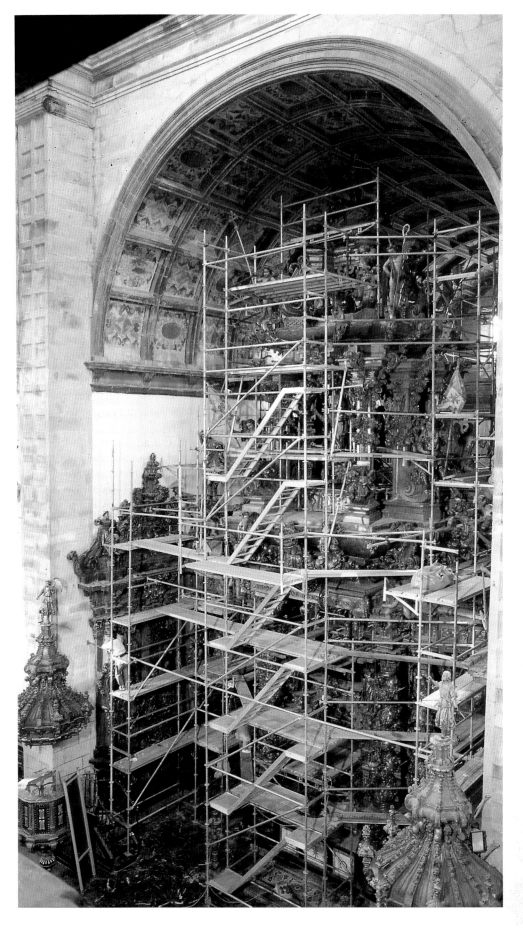

Scaffold for the cleaning of the Main Altarpiece.

Process of rehabilitations spaces over the South side chapels.

opted to avoid contamination between the different objects. It is certain that, intially, a cleaning and consolidation could be sufficient for the stone and metal, but the wood presents other problems that make total action necessary for all the statuary.

At the beginning the altar pieces and sculptures of San Martiño Pinario showed clear traces of time, thus the need for a first action. On the other hand, it was decided to create a permanent workshop for restoration in the dependencies of the monastery in order to treat the sculpture during the months preceding the opening of the exposition. Under the direction and execution of expert restorers, a program was set up based essentially on de-insectifying all the wood pieces, in the same way as a process of cleaning and consolidation was begun to establish a diagnosis that will later allow the carrying out of a process of profound restoration, without the logical limitations caused by time.

Plans of the main cloister of San Martiño Pinario. 1627.

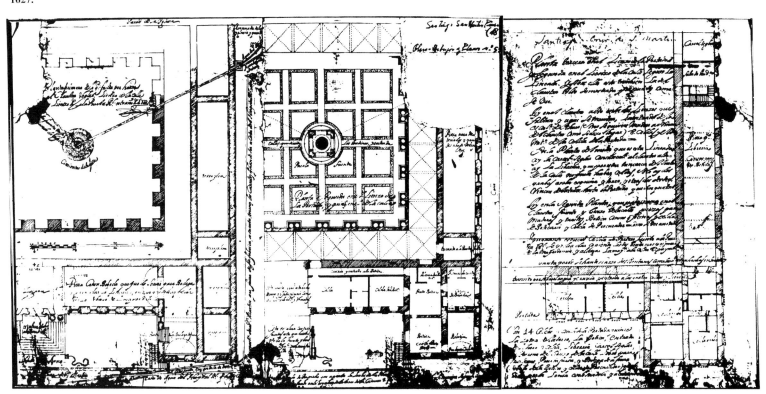

ARCHITECTURE:
RESTORATION AND REHABILITATION

Iago Seara Morales
In collaboration with Gonzalo Rey Lama (Engineer)

I. TIME, THE GREAT ARCHITECT

The day an architecture is completed, which it could almost be said is never, its life in a certain sense begins. The first phases are overcome, in which, by means of diverse cares and concerns, it was taken from the slow materiality of the materials to the humanized form of its social or religious functionality.

Later stages, throughout the course of the centuries, through the alternatives of usage, adoration, admiration, love, disdain or indifference, will slowly develop it into a new state of materiality from the masters of the different trades removed it, in the service of the ideological, liturgical or religious objectives of its "promoters."

On the way, the architectural forms, constructed for the most diverse functions of a collectivism and in commitment to a clear aesthetic purpose, suffered in their own way the equivalent of weariness, aging, misfortune. They changed, just as a person changes with the passing of time.

The conditions of anonymous existence, including abandonment, in which these forms passed the centuries until some historical or aesthetic moment noticed them to return them to us or make them object of restorations (good or clumsy, harmful or beneficial), the authentic or false dirtiness or patina, the continuous completions, even the atmosphere itself and the light which surrounds it, are the same, or the silence, the same odor in which they are placed, add to the marking forever of its constructed, overconstructed or destructed body.

Some of the modifications or completions even come to be sublime. Beauty as such was conceived by different masters and trades, an era, a specific form of society, is increased when the necessities of adaptation to the new ideological, religious or liturgical demands wrap it in a new involuntary beauty associated with the avatars of later history to the beginnings and other natural effects of the passing of time.

There are even cases in which deteriorated buildings were the object of such an adequate ruin that, even though this does not justify the fact for future realities, a new work is born from their remains, perfect because of its very segmentation (this is the case of the Towers of the West), a profile in which beauty survives in a complete absence of human or divine

anecdote, a canvas of corrupted features uncovered in an excavation and which is halfway between urban architecture and the piece that surrounded it and was witness to dreams, pleasures or displeasures, tastes or disappointments, individual or collective meditations, etc...

Such structures, decorated by time and evolution, traumatic or not, of a city or the architecture itself of the building at times make us evoke landscapes of rocks like those of Pena Cornera (Ourense) or forests of oaks in which their wholes are joined, but eroded by the wind, the rain, the waves, natural disasters, etc...

Sensitive historians, respectful architects, familiar with the architectural discipline and definitely sensitivity as heritage of Society, not belonging to anyone in particular, do not

doubt: that at the same time indefinite and insinuating gesture, that sequence, which is lost in one place and recovered in another, can only come from a hand which intentionally makes us understand and explain an obscure stage of the history of the architectures which converge in a building or its constitution, in a metaproject which at times transcends the intentions themselves (of relative appearance) of an era (almost always due to the shaping of promoter and architects of that same era).

All of humanity is there, "reconnected" in intelligent collaboration with the Universe, in struggle against itself in the final defeat in which the spirit and the matter which served as its support perish almost at the same time as it does, although the intention of that metaproject does not perish. Its spiritual intention, whatever it might be, is affirmed until the end, even in the ruins of its materiality.

Other times, by chance, a building or city owes its new beauty or new historical value to social violence, to the push that knocked it from the pedestal, the aggression which broke them and impregnated them with history... This, together with the erosion and other physical or functional pathologies, creates a new appearance without equal that no longer belongs to any style or era.

The generations before us replaced or "purified" our heritage. Today we only suggest the simple cleanliness, the consolidation, the flight of falsities and elimination of protheses... Our continuers, in turn, may do something else... Is it possible to separate an historical analysis from the criteria of conservation as cultural and disciplinary facts of the dominant ideologies of each period? I sincerely believe not.

That exaggerated restoring criterion which in general terms was the guiding and in a sense graceful thread from the Renaissance to our days, is undoubtedly born out of deeply rooted reasons, far from ignorance, formalism or prejudice of a "simple cleaning or consolidation."

Within the dynamic of a metaproject, an ideal of beauty, a total and unitarian concept of life, certainly could not see nor accept those scars of violence and the death of the work of art, piece of total art, forced by the corset of the same tradition, Hellenistic culture.

Out of coherence and a bit of compassion, those who care for history and, above all, those who care for antiquity, restored and preserved. Out of coherence, and also because of

Tullas (Granary).

another type of compassion, we lament their work and if we allowed ourselves to be tempted, we would undo what they did.

We doubt, and that is the basic and cautious principle of Preservation, after the break provoked by the Modern Movement of Architecture (today also "Tradition"), the reproduction of taste or the human spirit, the static nature of a discipline, an architecture which allows a Stirling or a Moneo to replace or finish something that a Friar Gabriel de Las Casas left unfinished or not begun.

Today we accept with greater ease that situation lodged in the metamuseum which an historical city can become be a beauty with scars, at times with mutilations, or whatever, including a partial work. New organs should only be transplanted when a new use of the work to be rehabilitated demands it, thus taking up once more those metaprojects which in the darkness of history remain in hibernation and only in hibernation, in order to make the buildings themselves more lovely, exciting and interesting now to today's contemplation.

Of all the changes that buildings and historical cities undergo, none will affect us like the change in taste of its users since, both city and building are inconceivable, as architectures, without the use and wear of people.

II. THE WORK OF ART: A MILESTONE THAT CANNOT BE REPRODUCED

Because of all this we believe, with Césare Brandi, that "restoration, in order to represent a legitimate operation, should not consider time nor the abolition of history as irreversible."

Restoration should be delimited in its context... "Is another question possible?" ... , be interpreted as another sediment , delimited as complete, inserting itself in the process of transmission of the work of art to new generations.

This practical and historical demand should be translated not only in the differentiation of new zones, but also in the differentiation of the new space in the face of a new usage, as long as it is not incompatible, and always with respect to the possible final spatial patinas which time deposits over the work.

We consider it appropriate that a monument be returned or maintained in the state which it had reached through history, with its bringing up to date and completions as a whole, as metaproject, that is, that there be returned to it the aspect which the work of art reached as material of history and witness to the various times which passed through it.

The construction or completion will be more acceptable the further it is from addition and the more it tends to be a unit, contemporary and new, over the old one.

The inept interventions are also history, documents, although they may be the product of an error of human activity, and form part of the history of Humanity as such; thus, as Césare Brandi states: "they should not be destroyed or eliminated, but at the most, isolated." Nevertheless, we believe that the maintenance of this principle cannot contradict the aesthetic situation, always negatively delimited by the principle of that historical non restoration. "What was it like? Where was it?" are questions which are often asked with the intention of replacing an object or a building now situated and integrated in a different place from the original. This constitutes a disdain for the history of one's own discipline, whether that be painting, sculpture, architecture, an insult to aesthetics, since it inconceivably considers time to be reversible and the work of art reproducible.

Before an infrequent concept in Galicia, although it was for a long time during the years of the autonomic administration, was the practice of preventive restoration. When the Universal Conscience is personified in a synthetic way in the work of art, we must demand the obligation to preserve and transmit this work of art to the next generations. This unrenounceable and moral imperative is what delimits preventive restoration as tutelage, protection against any possible impact and total precaution as far as making the conditions of conservation more favorable.

Preventive restoration is more imperative and necessary than that of the "urgent" sort, since it tends to impede the need for the latter and, with that, to conquer a better usage of the economic and financial resources of a responsible administration, or an owner, who thus try to preserve and transfer a valuable heritage to future generations.

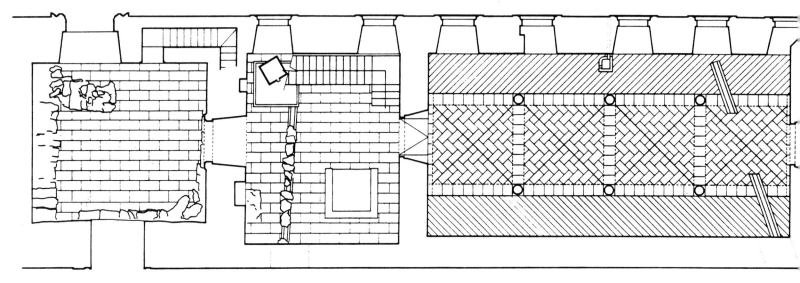

Tullas. Plan

The maximum efforts must be directed to preventive restoration since in the end this also leads to conservation without adulterations oriented toward our historico-critical awareness.

San Martiño Pinario, cause of all these reflections, is the necessary point of reference. There is another type of Preventive Restoration that is the maintenance of the functional parts, which permits the conservation of the external or internal environment. In addition to this, in the face of the encysted use of some parts, or the whole, of some of our monuments, we see how the preventive restoration or rehabilitation of the monument or part of it, but always a rehabilitation that is an extirpation of a usage, or as dynamization toward others which, compatible with the aesthetic and historical moment of the monument itself, are capable of valuing and rediscovering it.

Rehabilitation as such, now a moral imperative, situates us in the use of protection, of the immunization against possible impacts and in the convergence of various favorable conditions, in addition to synthesizing universal awareness of the monument as such which is reformulated and makes it comprehensible to today's users and those of future generations. With the rehabilitation of a monument the owner institutions, besides insuring its preservation, project the monument toward a broader social distribution than that of the cultural good itself. The encysted uses come to be one more component of the history of the monument. The Administration responsible for goods of cultural value cannot take better advantage of its investment dynamic although the results are beyond the short range of time which its political executive sometimes are faced with.

In the architectural monument, possessor of spaces that articulate functions and which were the content of aesthetic purpose and witness to history, definitely material memory, it is impossible to have better preventive restoration than rehabilitation. Thus, rehabilitation is, in these cases, an unrenounceable and moral imperative.

In San Martiño Pinario, with the preventive restoration that was done in different orders and, in particular, in the different architectures, the imperatives are no longer such and become a new time which tries, although perhaps it doesn't manage, to move us. With its rehabilitation the attempt was made to excite our historico-critical awareness of preservation without alteration, with the affection of those small controlled sediments which the new use imposed upon us. The opportunity to point out those spatial historical sediments that were not justly valued or were hidden by others was not lost, incorporating them with the valuing of its historical presence but emphasizing them with aesthetic demands, and not precisely for museistic or didactic need.

In the practice of this rehabilitation, in spite of the speed with which the project and the works themselves had to be done, a contemplative and investigative attitude could be

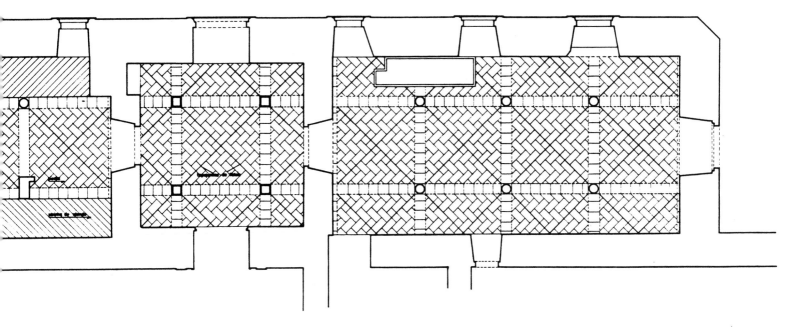

observed regarding the monument which can only be synthesized in the architectural result itself; in it those requirements of the restorative and architectural discipline could be obeyed but heeding the opinions of the monument itself; we can avoid thoughts and feelings that the metaarchitecture of San Martiño Pinario caused us, and take advantage of the silences which the rich architectures, some of them, including those such as Pons Sorolla, very recently gave us. In spite of the acceleration which the "proceedings" demanded we tried not to rush after easy things, we were able to learn the true value of each thing and tried to polish it not trying to exhibit it as we would not exhibit a cheap ring. All that with the search for attitudes in a sense oriental and rejecting western practices that liberalism is following with architecture, a restoration turned practice of exclusively formal references (postmodernism), crisis of disciplines, moral and ethical imperatives, which seeks notoriety and not permanent construction of a monument.

The value of San Martiño Pinario, nevertheless, is in the succession of the different "architects" who knew how to give an institutional metaproject different contents which, without giving up their functionality and classical nature, allow different philological analyses which do not destroy the rehabilitation, synthesis of historical analysis and research.

But we must protest against a simply monolithic spirit of the times as well as avoid our own sensitivity which, although it would be shared, as in all periods, by our cultural era or time, would also become rapidly obsolete. The architecture that results from an intervention must interpret the echo of the ancient architectures, their affinities, and carry out analogical rehabilitation that seeks a logical constitution, rigorous and beautiful, with the old one. The unrenounceable and archeological difference will come out by its own accord in the search for balance and syntonization with a historical and aesthetic moment that in any event is irreversible... Thus, there was an attempt to do a job which would imbricate the levels of lucidity, prudence, culture and subtlety that the Monastery accumulated through Ginés Martínez, Bartolomé Fernández Lechuga, Friar Gabriel de las Casas, Friar Tomás Alonso and even from the more recent work of Pons Sorolla. Always trying to be closer to the architectural discipline than the tendencies.

The architecture resulting from rehabilitation is proposed as a reflection and synthesis in the search for the articulation of the spaces of the east wing, San Martiño Pinario Square, Moeda Vella Street, Inmaculada Square, with the dependencies of the church, vestry, high choir and spaces beneath the roofs of both for their utilization as future Diocesan Museum and Archive. All that within a global hypothesis of circulation and different philological analyses of the different "architectures" which succeed one another like historico-spatial sediments.

In addition to the strictly cleansing objectives of the different spaces and the pathologies which they could suffer from and which, as preventive restoration, we employ in the adaptation to their new uses, it was definitely necessary to concentrate the efforts of architectural reflection on the synthesizing of an articulating space that, as axis of vertical communications, would resolve the itinerary which at different points arose from the preventive restoration for the Museum and Archive of the Archbishopric.

This creation of a new space in San Martiño Pinario, exponent of these uses that are compatible with the historical ones, concerned the Directors of the exposition GALICIA THROUGH TIME which will inaugurate the dependencies rehabilitated for the Museum. Xosé Manuel García Iglesias, Anxo Sicart and the team which was personally organizing this restorative work which went faster than caution advised in these cases, coincided, without great differences, in the global conception of the itinerary based on the different architectures and the placement of the articulation which the vertical axis should establish among the various levels of the high parts of the church and the east wing and between these two.

Regarding this reflective synthesis there was, by way of an architectural proposal, a plan for thefaçade and cloister of the Monastery of San Martiño Pinario, second floor, of 1721 (National Historical Archive, Madrid), published by Antonio Bonet Correa (Antonio Bonet Correa, *La Arquitectura en Galicia durante el siglo XVII*, Instituto Padre Sarmiento) and reproduced by Salvador Domato in offset in the Archive of the Archbishopric of Santiago. The detailed analysis of the space, second longitudinal corridor of this wing, indicates hidden signs of occupations of a stairway such as that described. The environment, the architectural atmosphere impregnated with the "impossibility" of that usage, soon invaded the objectives of our project.

There was then an attempt to coordinate, within the totality of the vertical space, from the ground level to the ceiling, an elevator-freightlift, the lookout stairway and the platform of access and distribution for both and for the spaces that converge in this axis. The first floor of this wing, sketched in another plan of 1727 for the lower level and the cloister, and with the same references as the previous one, situates this space as a "room for materials or comfort... " and is missing, for lack of other documents of the project's floor plan for San Martiño Pinario, the lines of columns and references to the solution of its cross vaulted ceiling done in masonry of stone slabs and revoked in its final finish. The cross vault, in the middle, rises from pendentive arches of carved granite which, like the columns, partially contain a Classicism and nobility that is only reflection of the Classicism which characterizes all the spaces of San Martiño Pinario, and is finished off with side half vaults which rest on the interior and exterior walls of the side of Moeda Vella Street.

The stairs in the space of this same floor, which the plan calls "passage to the door" and which leads to the cloister, indicate to us that the parallel street, Moeda Vella, was on a higher level.

The fact that part of this space of the lower level, full of classicism, is cited in the plan as dependencies of the "vaulted kitchen" and the "back room of the apothecary," and not connected to the rest, indicates that it was later than 1727 and acquired its final physiognomy in another project and intervention.

The "passage to the door" connects the exterior, Moeda Vella, with the cloister and at the same time the north part of this wing (from the church) and the southern part (the Immaculate Virgin). Its set of columns, of rectangular section, is different than the columns of the dependencies of the two areas mentioned previously (circular in this case).

In the time that passes between 1727 and the abandon caused by Disentailment, these architectures acquire their final physiognomy. The text of the resolution of the suit between San Martiño Pinario and the church chapter seem to confirm this hypothesis (Antonio Bonet Correa, op. cit.). For this reason we are not surprised by the unevenness of levels between the bases of the columns and the thresholds of the entryways from one dependency to another, nor by their different level than the line of foundation of the two façades, both interior and exterior. Their unfinished state remains obvious with the non-existence of the vault of the room on this ground floor on the north side, and next to the church as well as passage between the street and the cloister.

In these unfinished spaces the restorative intervention as "preventive restoration" is carried out with greater risk, only overcome by an architectural answer to a new use compatible with the historical ones. The criteria of the intervention in these spaces of the east wing synthesize the whole of the intervention and can be summarized in the following points:

1) The intervention arises from the historical analysis and the language of the very history of the construction of the monastery of San Martiño Pinario.

2) Respect for history is the primordial objective but without this meaning submission to it when it is a matter of completions and adaptations of the architectures that are encysted or in disuse to the new needs.

3) The intention is that the intervention be like a cultural sedimentation but without deteriorating or eliminating the different spaces and constructive techniques that already exist.

4) An effort is made to render the space, with different historical uses, adequate to a new use (museum, salon for expositions, archive) which will be compatible with the whole of the monastery.

5) There is an attempt to conquer the reversibility of the new spatial and constructive materialization as an understanding of the patrimonial indissolubility of the overall monastery.

6) The new intervention has to become a cultural contribution, like a NEW TIME, and in accordance with the historical values that are proper to the monument.

For this new time a formal reply was sought near the world of personal poetics. This, in addition to other considerations, makes the architectural contribution, which is obligatorily sedimented, something which cannot be given up, involve everyone, from the Administration to the owners and the authors. From the perspective of a culture, architecture resolves concrete circumstances and spatial needs for a collectivity, and it will have to be constructed but, in addition, its component of cultural manifestation will give it a concrete shape, an exhibition of the authorship of this time.

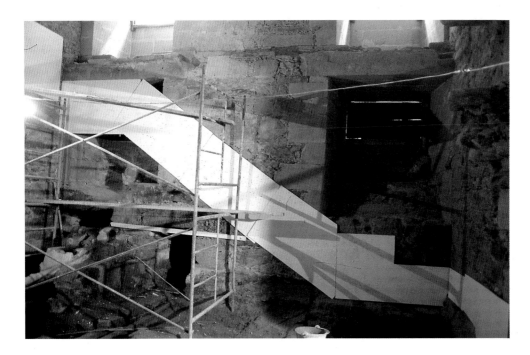

Beginning of the works in order to build a stair at the Tullas.

45

Connection stairs between the Tullas and the high chapels. Section.

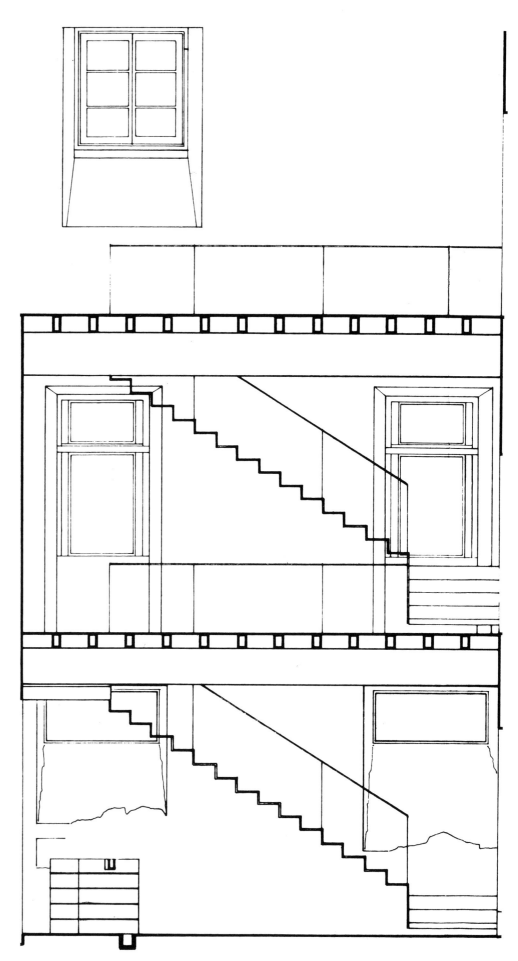

III. SAN MARTIÑO PINARIO: CONCRETE ACTIONS

In the plans of 1727 cited above we can see a water duct which, coming from the Moeda Vella Street, crosses the walls of the side parallel to this street and goes under the pavement of the sector of the lay cloister finished in 1733, to the present fountain situated in the middle. This fountain was moved in the action of Pons Sorolla from other dependencies of the monastery in which it was previously deposited (office cloister).

During the work of curing, cleaning and preparation of the terrain of these spaces for the placement of the necessary pavement that the new use required, we had occasion to uncover, under the supervision of the Service of Archeology of the Dirección Xeral do Patrimonio and with the constant observation of Professors Sicart and García Iglesias, the mentioned duct and another, further south, which was routed from the same street, passing by the east-south corner of the lay cloister, possibly toward the Palace of Xelmírez.

This second channeling, composed of stone canals inserted in one another and with covers of stone slabs, has its passage through the cloister indicated by a false vault (or hole) of triangular elevation which differentiates it from the first (low barrel vault).

These channelings, plus the remains of other architectures of this wing of San Martiño Pinario, which were uncovered with rehabilitation, were composed in the new pavement seeking the force of its historical moment and making them transcend the aesthetic moments which are joined together in the overall salon.

The same intention is that for all those signs of previous occupations or uses which, valued in an interdisciplinary way, we opted for emphasizing beyond the merely pedagogical, that is, we tried to incorporate them as compositional, formal elements, with a clear aesthetic purpose.

The design of the volume of communications needs, because of the amplitude of the intervention, a justification of its own. The stairs of this monasterial space are splendid and are due possibly to the decided, learned hands of Friar Gabriel de Casas (vestry, 1696), also possibly (west of the main façade), and to Friar Tomás Alonso again (1681, western part). All of them are different, but with rectangular or square area, and with a single section ramp and landing places, constructed in pieces of stone, set into the walls of the box, either in the function of a corbel and/or vault.

The option taken in the rehabilitation is that composed of two sections of string-piece of the white concrete staircase set into the walls of rectangular semi-frame, perpendicular to the sides of the façade, which serve as brackets set into the walls. Both are set in like a beam (the whole acts as a beam), the string-piece of the staircase parallel to the wall of Moeda Vella Street without contact of any type. In this way, each section of the stairs is continuous and independent from the rest since the sections of exit and access do not touch the landings-railings, which are independent.

With this solution there is an attempt to incorporate a modern technology and culture but in such a way that, in essence, it contains the most significant concepts of the stairs in abstract form, preexisting in the monasterial whole (fundamentally the stairs of the vestry).

The material of white reinforced concrete is complemented with the superimposed pavement of wood in "footprints" and "counterfootprints," the same material is used in the railings which are combined with complementary pieces of stainless steel.

The elevator has two basic purposes: to allow access by handicapped persons to the various floors and to provide service for the transporting of heavy items to the new floor, future documental deposit for an historical archive. Because of the impossibility of meeting the present norms, the solution of a hydraulic elevator is adopted, avoiding the higher position of the machinery. Its capacity for six persons and its most interesting feature is that the two sides of the cabin are panoramic.

The box of the elevator constitutes a rectangular prism of white reinforced concrete, completely free in all its height, with two lateral glassed holes that are parallel to the route of the cabin and the front is covered with the same steel layer as the doors.

The relationship of the masonry walls, preserved in all their naked expressiveness, with the light and perspectives of the interior and exterior holes with glass, with the murmur of the water and modern materials incorporated, will create a dynamic and suggestive space, appropriate for the passage from one room to another.

In the same way, the entry of the old assault of water to fountains and convents" of the city, is organized so that it conserves the murmur and the visible running of the stream, as a live element within the monumental mass of these spaces.

The wooden beams, simply supported, are placed on the lintels of concrete on a metallic box that, standing out from the facing, will suggest the rationality of the solution.

A new floor is created, beneath a cover, at the level of the lower truss-rod of the existing metallic frame. This requires the reformation of these skeleton frames, eliminating one of its vertical truss-rods in order to organize a corridor along the entire floor, and strongly rigidify the whole structure.

The cover, which will be seen in its structure, was isolated with injected polyurethane and covered with a false ceiling of painted virothem to make this new space usable. In each opening between frames a velux window is placed and, besides the curtain of light it will provide, will help alleviate the slightly overwhelming sensation due to the situation of the space.

The plates of fibrocement, placed in the intervention of Pons, were given a coat of expanded polyurethane of 3 cm., and this was finished with an insulating false ceiling, of compressed shavings, at the level with the belts of the structure which supports these plates. This support structure (skeleton frames and steel beams) properly treated and painted, are visible as testimony to the intervention of Pons and the maximum expression of his aesthetic demand is sought.

Laminated wood is used in the structure of beams which substitute those already in the rest of the east wing.

The pavement of the third floor and attic is wood and that of the first and second is stone. The lower floor, on which the old plan defines as "a storage house for materials and comfort," has in the parts adjacent to the walls that form it, stained wood flooring, just as the lining behind the walls of the different spaces.

There was also an effort to insulate the flooring from humidity by means of a system of drainage and water-proofing of the lot previous to the stone pavement. At the same time the floor at the level of the cloister was given a radiant heating system beneath the flooring, with the stone acting as accumulator.

This is truly an adaption of rooms of strong architectural expressiveness using traditional materials that do not contrast violently with the existing ones, without hiding the historical readings of walls and spaces; the creation of protected and neutral environments that serve as a support for both a temporal exposition, with its ephemeral furnishings, and a museistic installation that is permanent, offering the visitor the horizon of the interior perspectives, the inside-outside dialogue of the street and cloister and the play of surprise and movement in such singular elements as a mysterious staircase and murmuring water.

As for the Chapel of San Felipe Neri, since its state of preservation was good, the intervention is reduced to lessening what appeared inadequate in it, seeking a better combination of the facings of seating, the correct finish of the existing plastering and the cleaning of carpentry and locks.

The most important intervention in this room is the substitution of the wood and carpet floorings, deteriorated by recent use, with new ones and, perhaps, more careful; and also in the covering of the blind arches with wood. All this is to create a warm atmosphere that will accompany the re-encircled stones and vaults and the heated facings.

The installations in this case place special emphasis on the lighting of the vault and the sculpted medallions, in order to achieve a space that will respond to the attentions of the architect that created it.

In the church the windows of the transparent of the altar piece of Santa Scholastica, walled up in an earlier intervention, were reopened and that situated behind the organ of Aid, with which the characteristic illumination of this church, which is so singular, will be freed. Likewise, some windows of the church, vestry, and chapel of Aid were made usable, fixed in the already mentioned intervention, in order to make possible an adequate ventilation of the spaces to avoid the problems of condensation which cause the appearance of mosses, fungi, etc.

Walled up passage holes are reopened and others are closed with tempered glass which at all times allows the visitor to situate him/herself within the complex whole of the church.

Time will act, as we believe, to slowly fuse one intervention with another... It will be dissolved in the different Classicisms these interventions which tried at all times not to exhibit themselves like a cheap ring.

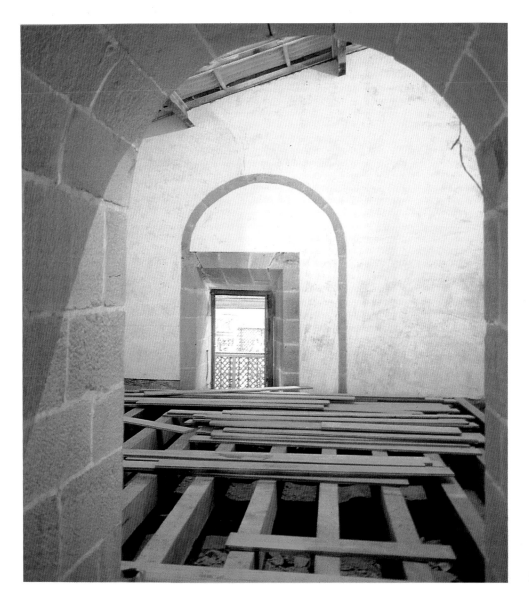

Restoration of the high chapels.

TECHNICAL REPORT ON CONSERVATION OF ALTAR PIECES AND IMAGERY

Josep María Xarrié i Rovira

The preservation and conservation of these altar pieces, unique in their great importance, has been an intense, arduous task, and above all complex. More than forty professionals have intervened, devoting the major part of the time to fixing the gilded plates in the process of coming loose. We cannot, therefore, speak of conventional restoration, but rather of recovery and reintegration of the original polychromy which, with a very few more years would have been inexorably lost forever. Nevertheless, we need to speak of protection because the treatment against wood-eating insects insures its self-defense for some years. No treatment is eternal and this is a good time ro remember that it is absolutely necessary to repeat these processes periodically and avoid the state of deficient preservation they were in.

After the taking of samples for the corresponding physical-chemical nalysis and the organoelectric examination of each one of the major Baroque altar pieces (the Elder, Saint Benito, the English Virgin, and Our Lady of Aid, a report was written including the first sections of analysis and examination, as well as a proposal for intervention which included the aspects of protection (disinfection and prevention against the attack of wood-eating insects), conservation (fixing of the layers formed by the coat of plaster and glue and the gold plate on the wood stand), final presentation, of a strong archeological nature, since it proposed the simple application of a neutral coat for the polychromies or the pure imitation of the bole in the gilded areas. In this conservation proposal it was also noted that it was very important to study the state of preservation, which implies an approach to the specific problematic of the altar piece. We insist on the concept of approach to the problematic of the altar piece because it is the first and unavoidable step, not only for this particular intervention, but it also represents the indispensable basis for posterior ones, if we wish to keep this unique set of pieces in optimal conditions of preservation for the future. This proposal underlined the importance of accurately consolidating the structure, reinforcing some areas disintegrated by the wood-eating insects, as well as the reinsertion of some lost elements. A special emphasis was placed in this proposal on the long process of the fixing of the pictorial polychromy or the large areas of gilding which, because of impregnation by water from the cover—now definitely solved—, these layers had completely come loose on the upper part of the four altar pieces or were about to do so. In the same proposal for conservation, which in time was given over to the Comissary of the Exposition GALICIA NO TEMPO (Galicia Through Time) a final protection of all the items with a film of acrylic resin was also mentioned. This would serve to help fix the pictorial layer as it filtered through the cracks caused in great part by the natural movement of dilation of the wood in the stand.

To this point we have commented the proposals for intervention formulated to those responsible for GALICIA THROUGH TIME. Starting at this moment the difficulties specific to each area would lead us to test and select the materials and operative techniques that were most appropriate for each case.

It would make no sense to explain the restoration procedures selected (all of them within the most basic norms of professional ethics) for the conservation and restoration of cultural

goods and chattels, if we do not take into account as well the context in which these processes were carried out. The time factor, understood as the available chronological time, could have made a certain part of the work difficult, but in this case it has been calculated that the use of certain materials or operative techniques did not affect their future, given the reversibility of the situation. It is recommended to those responsible for the preservation of these altar pieces that they observe and maintain them annually, especially the parts corresponding to the upper third, not only in the "post-operative" period, but also practically for life, since as it is known, it is easier and more economical to preserve than to restore.

To approach the process of preservation of a main altar piece of such extraordinary dimensions and in a very deteriorated state in more than 40% of the polychromy of its upper part, poses an authentic challenge. The base of the preparation composed of calcium sulfate and a temper of cartilage glue was totally separated from the wooden stand. This especially affected the three gilded areas with gold leaf on the fine layers of ochre bole on the base of plaster-glue and red bole in contact with the indeleble leak of fine gold.

Both the skin of the angels and the saints as well as that of the sculptural groups which flank the upper central volume of the altar piece are painted with an oily agglutinant, which allowed for good resistance against the temporary dampness which the whole piece suffered.

The architectural structure of the altar piece, constructed in walnut, chestnut, and pine, with attachments and truss-bars in iron and a marble base, has a volume of 22 m. high by 12.5 wide and 7 deep. It was designed to be contemplated both from the front and the back. Its most common scarfings are the "swallow-tail", the "half swallow-tail", as "testa" and unglued joints such as the angels' wings and the hands of the saints. We also have the application of various iron nails and staples. We find as ornamental elements other metals such as tin and bronze. We may say that the general structure is in good shape. Only in the parts in which the dampness and temperature conditions were for a time perfect for the activity of wood-eating insects is it possible to detect the openings at the ends of the burrows. These zones occasionally coincide with those where there is a massive loosening of the plaster-glue base and consequently of the gold leaf. The most affected woods are those of lesser quality, as in the case of the pine, and its destruction corresponds principally to the knots or defective areas. The loss of adhering properties of the glues and the natural

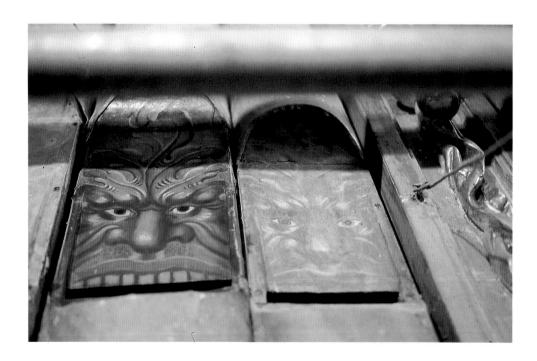

movements of the woods have produced cracks of 1 to 2 cm. The chapter corresponding to the previous interventions presents a curious collection of anecdotes of grafitti which has been duly photographed, although the most interesting pertain to two or three general cleanings done between 1888 and 1960. These cleanings also covered up the the spaces in the plaster preparation due to the loss of gold, with a roughly applied ochre color.

It is necessary to refer to the large quantity of dust accumulated in the upper flat parts of the cornices and figures. In some places it is thicker than 1 cm, which generally distorted and darkened the original aesthetic appearance, although certain currents of opinion, of Romantic inspiration, prefer to read the aesthetic message through a grey veil set down through the years. Another element which must be taken into account when speaking of materials that do not belong to the original work, is the fine layer of orangey shellac that covers the whole altar piece. Its elimination with diluted alcohol would have been relatively easy from a technical point of view, but the process would be slow. The major problem lay in the fact that in some figures the elimination of the fine layer of shellac removed large repainted areas which, without being incorrect, would have had to be repeated in order to achieve a good overall reading.

In some corners of the table fragments of unconnected structural elements have been found, such as fragments of angels' wings missing the part which would have connected to the body. As the plan of action proposed could not, for lack of time, consider volumetric reintegration, these elements have been deposited in a sealed box to be intervened partially and exhaustively on another occasion.

As for the preserving intervention, the first and major instruction given to the technicians was that they fix as much as possible all the polychromy that was coming loose or had come loose, and that could be saved. Several adhesives were used for this, such as Primal, Movvilit, rabbit glue, gelatine and wax-resin. After several trials Movvilit, in a 10% solution, was selected, the proportion varying according to the thicknesses of the preparation layers to be applied. The work methodology consisted of first opening the pores of the preparation base in the area to be adhered, by injecting a solution of alcohol and water with syringe and hypodermic needle to soften the plaster and then injecting the adhesive, without hypodermic needle. At the same time pressure was applied with an absorbent cotton ball

covered with fine plastic. The big problem of this operation was that the majority of the time it could not be done after eliminating the dust, because in spite of the great care and attention used, the scarce film to be fixed could be lost. The fixing and elimination of the thick layer of dust needed to be alternated according to each case. After this patient work of fixing, cleaning with only distilled water and cotton was begun, then applying an acrylic copomylene, Paraloid B-72, in percentages varying between 5%, for the lower thirds of the altar pieces, to 15%, to consolidate the wood attacked by wood-eating insects in the upper parts. Paraloid B-72 is a product with proven results; for cases of aging and transparency in the last thirty years consolidation, fixing, and final protection with semi-matte varnish is used, and its dissolvent and proportion can vary according to each specific case.

The bevelled peripheral stuccoing of the fixed areas, and the reintegration of the spaces in the plaster glue with neutral ink were the last operations. Regarding the elements of wood which were endangered as to their stability, a specialized wood carver carried out their consolidation and attachment.

The upper parts of the pulpits or sounding-boards were treated in the same way and once the trap doors in the part nearest the corner of the wall were lifted, several kilos of dust accumulated through the years or centuries were extracted.

In the Altar pieces of San Benito and the English Virgin the deterioration was quite similar to that of the main altar piece, that is, an acceptable state of preservation of the two lower thirds and a high degree of deterioration in the upper third corresponding to the pinnacles. Of considerable volume—18.5 high by 11 wide and 2.20 m. deep—they are made of walnut and chestnut. For secondary, non sculptural use, other woods such as pine were also employed. In the wall attachments we can see a certain deterioration of the wood which nevertheless is not relevant in either altar piece since they only affect the surface. Some wood attachments were reinforced with others of the same material to avoid the substitution of original elements and thus insure the stability of the whole. We are referring to the attachments to the adjacent walls. Another theme of much greater importance is the noting of all the altar pieces that require an exhaustive examination by a specialized architect. It is clear that both in the altar piece of the English Virgin as well as in that of San Benito there has been a give of some centimeters, disconnecting a part of the whole of these pieces. It is known that the preservation of these cultural goods is a multidisciplinary activity and requires, as in this case, the work of several specialists.

In some places where the forged nails had rusted they were sanded for later protection and were preserved with the same copomylene. The bases, which reach the altar, are of granitic stone with polychromy in imitation of marble, in pink, green, and grey which were pictorially reintegrated by an illusionist system. The pictorial technique of the skin areas and some other elements also have an oily medium. The treatment, essentially in the fixing of all the layers that were peeling off, was done with the same materials, techniques and proportions as in the main altar piece. Most of the time the dust could not be eliminated before fixing because the simple contact of the brush loosened the layer of plaster-glue with gold. A final protection of acrylic copomylene, easily reversible with acetone, was applied in the same range of proportions with respect to xylene as in the main altar piece.

The altar piece of Our Lady of Aid was the first to be treated and several tests were done for the fixing of the plates of gilded plaster-glue that were in the process of coming loose. the techniques and materials tried were as diverse as gelatine, Primal, Movvilit, rabbit glue, Paraloid B-72 and wax resin. According to the areas these products had better or poorer results, although in general rabbit glue and gelatine were used. It should be pointed out that although the deterioration in the area of the pinnacle was very pronounced, with parts in ruinous state, the procedures and materials were nearly never suitable for the three large altar pieces due to the thickness of the layers of preparation or plaster-glue, which in some places were 3 mm. thick.

We must also note that this altar piece was not entirely protected: only the upper part, with acrylic copomylene, little more was done than the cleaning, fixing, and pictorial reintegration of the blank spots in an archeological manner. Later it was treated by a specialist with Xilamon.

The choir was treated for insects by the same specialists and finally was protected with wax for later burnishing which would give it a truly pleasant appearance.

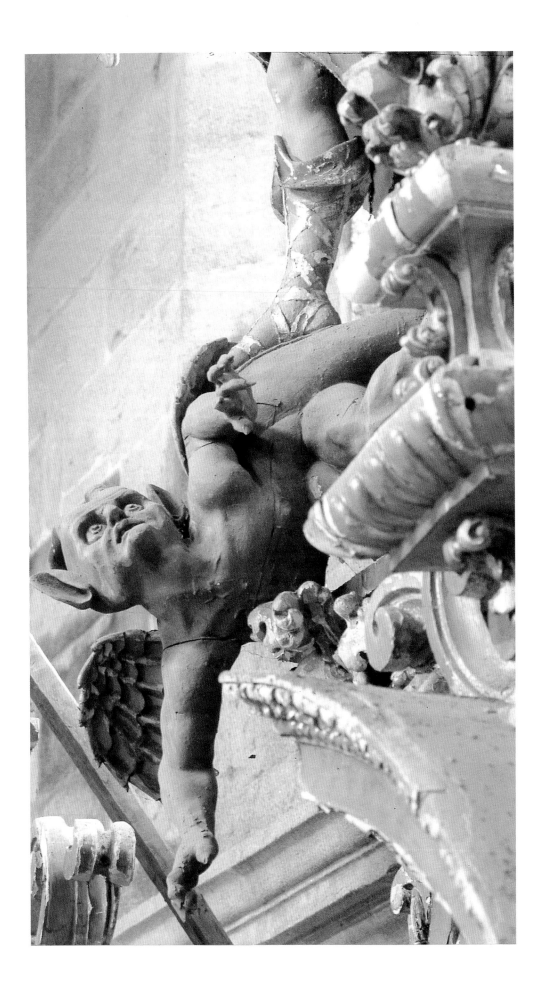

The gilded surface of the organs that was coming off was fixed, and although we are aware that the disease has not been totally cured, since some loose areas may remain—although may be difficult to see at first glance—more than 80% was patiently treated by a team of over twenty restorers. In the lower part of the middle pipes of the organ, some decorative plates that dust and dirt had eclipsed reappeared in all their original splendor. Also in the case of the organs we recommended for the future the maintenance and stepping up of the work begun at this time, which could be done with a simple tower platform on wheels. Examination by a restorer specializing in organ parts is also recommended, in order to carry out a study for the purpose of recuperating as much as possible the disperse elements that still exist today.

The altar pieces of Saint Scholastica, the Crucifix and Saint Gertrude were cleaned and disinfected by treating the wood that was not polychromed with Xilamon. Later a group of restorers reintegrated some small pictorial lacunae that made observation of the whole difficult.

At the same time as the items in the Church of San Martiño Pinario were being treated, an entire group of polychromed sculptures from various places in Galicia was also treated. This important intervention offered, as a parallel task to the "approach to the problematic" of the large altar pieces, a very serious study of the state of preservation of all these sculptures. Generalizing, we can say that very few of them have the original polychromy as a visible layer. We can also speak of the loss of attributes, staffs, books, etc., and the loss or mutilation of hands. A team of professionals was devoted with Franciscan patience to fixing with gelatine, rabbit glue and polyvinyl acetate, according to each case, the polychromies that were peeling off. An initial insect extermination was done by the injection of Xilamón in each one of the holes produced by the wood-eating insects.

The consolidation of some wood supports, converted to a strange material somewhere between sponge and sawdust by the destructive effect of wood-borers, were treated progressively with Paraloid B-72 in 5% solution and later 7% solution.

The cleaning of the painted surfaces of waxed wood was done chiefly by White Sprite, acetone, and other solvents. The polychromies painted in distemper, of which there was a good representation here of works brough from all over Galicia, were the hardest to treat, both in their cleaning and fixing.

THE DESIGN OF THE EXPOSITION

J.I. Macua and P. García-Ramos

The first and most peculiar problem of the exposition GALICIA THROUGH TIME, from the museographical point of view, was presented by the unavoidable need to locate it in an unusual space because of its architectonic potential, its great volume and, above all, because it was clearly devoted to religious use. We should add to that the fact that the building itself, or at least its most important components, form part of the discourse of the exposition.

From the very beginning we attempted to resolve this possible contradiction with great respect for the setting, intervening as little as possible and trying to have all its elements, even those that did not form part of the exposition's narration, be contemplated by the visitors in all their grandeur.

On the other hand, an exposition is essentially a visual message based on the communicative and expressive value of the objects which are exhibited there and in the cohesion, order and hierarchy which is established among them. This logically forces us to consider the design from two basic perspectives: each piece must be treated individually so that its "reading" is as complete as possible, and the pleasure of its contemplation must arise without difficulty or obstacle. In turn, each piece is a link within a discourse and if the physical needs force this to be distorted, the break in continuity must obvious enough so that the spectator is able to resolve it easily and comfortably.

From these perspectives we approached the design of this exposition. Thus, when we had to resolve the placement of a series of sculptures, in the central nave of the church, in which everything is planned so that all gazes are irremissibly concentrated on the main altar and on its magnificent retable which on the other hand is the main piece of the exposition, we proposed a break in the dialogue which would allow that ambivalence. We accentuated the visibility of the altar piece, removing its aspect of object of a cult and we emphasized its artistic value, its membership in the exposition. For that we constructed a platform which would allow us to contemplate it from unusual viewpoints, closer to the way in which the elements of an exposition are seen or should be seen, up close and as a whole, which are ultimately conceived as the promotion of the spirit of prayer. The platform is reached by a ramp which follows the backbone of the nave, like a via sacra, now that of an exposition, and which serves as a support for the specific and characteristic spaces that each piece needs.

Each one of the works creates around it an unreal space that is nevertheless strongly outlined. Thus we are always forced to present each sculpture independently, with no visual obstacle disturbing its space. But at the same time we must allow for the easy establishment of orderings and relationships which arise from the whole. The grandiose space of the temple and the distance of walls and ceilings add difficulties to the point where it is nearly impossible to provide adequate, proportioned lighting for each image without the aid of other elements. This has been solved with the creation of some ephemeral spaces, ideals areas, where the pieces take refuge in order to express themselves in all their capacity without ceasing to belong to a well-spun, coherent discourse.

Scale model of the ramp and platform of the nave.

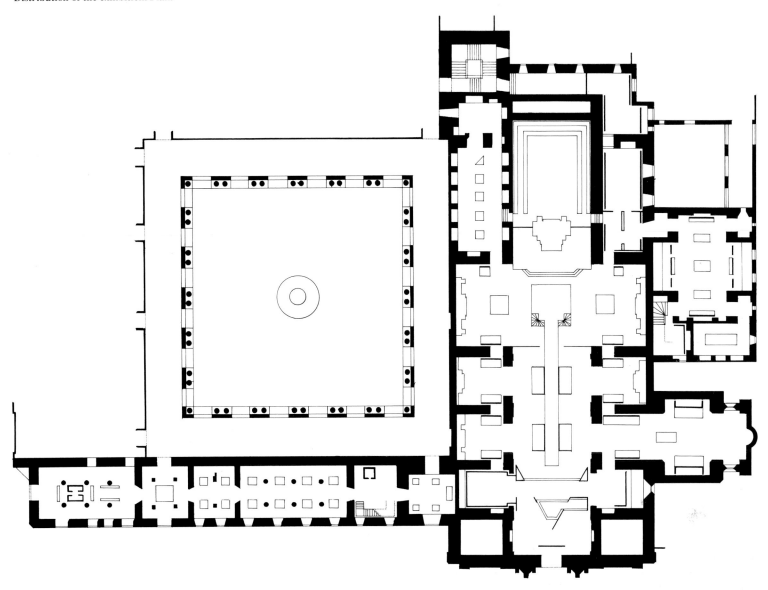

Another request for easy comprehension, conventionality and the good sense of the visitor are imposed on us by the security and preservation of some of the pieces which, because of their size or delicate nature, must be placed behind glass. Our intention is that these pieces be as unnoticed as possible and that they not interrupt nor disturb the contemplation of what is exhibited.

We have placed the lighting according to the same two perspectives: so that each piece's values stand out and its environment be appropriate. For example, the brilliance and luminosity of the space which holds "the splendor" is broken or truncated by the chiaroscuro of the "roots," where the light increases the world of mystery that surrounds that period.

We would like to emphasize that on organizing the exposition we have tried, in spite of the differences in treatment, to have it all respond to a criterion of viewing comfort, elegance and austerity in the interventions and we have only carried them out at those points where they seemed basic and always trying to have them flow easily within the discourse, remaining in the background, at the service of the items exhibited.

With that same spirit we have conceived the placement of the sculptures of today, allowing them to spread their expressiveness and contemporary efficiency of communica-

tion, in comparison with the "grain sheds," a space of great beauty which has now been recovered.

And so that the visitor might "read" with great clarity the exposition, we have not skimped on signs, texts and the aid of videos and audiovisual presentations, attempting to have them occupy their place, help interpret and serve as a guide for the spectator, but without interfering in the discourse of the exposition nor in the pleasure which we hope will be produced by the contemplation of the works shown there nor the comprehension of the message that is communicated: the history of a people told by its sculpture.

Distribution of the exhibition at the High Chapels Plan.

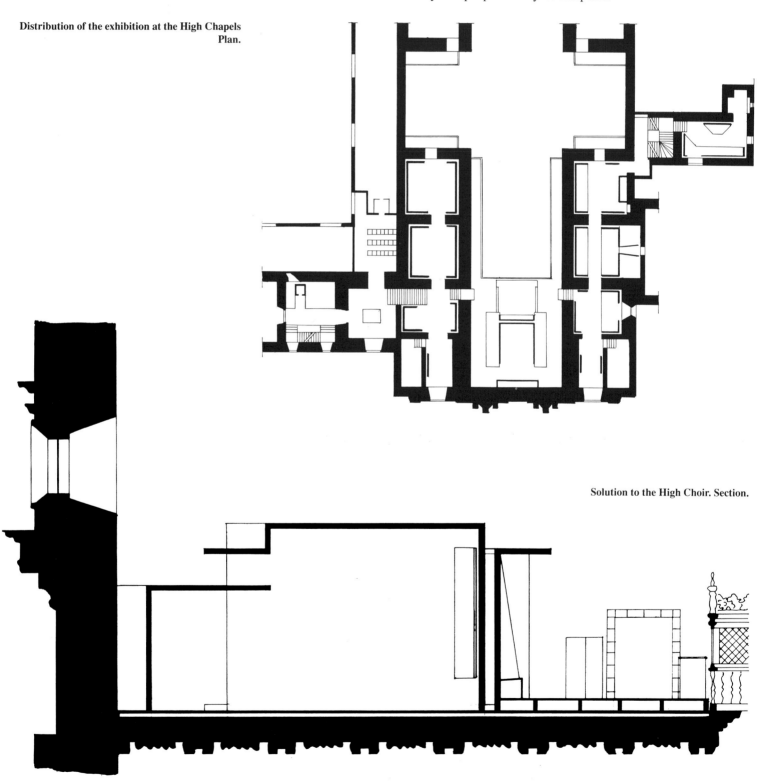

Solution to the High Choir. Section.

SAN MARTIÑO PINARIO IN ITS PAST: THE MIDDLE AGES

Francisco Fariña Busto

Still today the curious traveler who goes about Compostela is impressed upon seeing on the façade of numerous houses of what has been the historical section of Santiago until the XIXth century a shield that identifies the owner: a full pine tree flanked by scallop shells, which is the proper one or another simpler one with a pine and the letters S.M. The rich proprietor of Compostela was none other than the Benedictine community of San Martiño Pinario. The large number testifies to the wealth accumulated, which overflowed the apostolic city to extend domains, properties and jurisdictional control throughout many parts of Galicia and even beyond its frontiers.

That capital and growth accumulated by the monastery which became the head of the Galician Benedictine monasteries incorporated by the Reform promoted by the Catholic Kings into the dependency of the Congregation of San Benito of Valladolid permitted the realization of great works and it seems odd that today, although obliged to follow an entire process of recuperation and rehabilitation, all coincide in indicating San Martiño Pinario as the most grandiose construction and historico-artistic whole in Compostela after, of course, the Cathedral.

And in history Cathedral and Monastery lived united for a long time until they began to separate. But before addressing that relationship, we must not omit the work of recuperation of this singular moment which throughout the XVIIth and XVIIIth centuries has seen the birth of a new factory to the point of not discovering practically any of its architectural values and previous sculptors.

Undoubtedly the passing of time has done its job, but also the avatars which it suffered after the Disentailment of 1837 following its initial abandonment and the partial dedication of this great building to multiple tasks and uses until the date when, by exchange with the State for the Collegiate Church of San Clemente, Cardinal García Cuesta recovered it to dedicate it to the Conciliary Seminar, later undertaking diverse remodelings without a global intervention criterion but with actions which resolved provisional situations without offending the totality, altering the general sense of the beginning which had to be substituted by another which contemplated all the possible dedications in any case distant in time and sense from the one for which they were established. For that very reason one of the proclaimed objectives of this exposition is rooted in offering the public the possibility of directly getting to know some spaces of the artistic whole, beginning with the church itself, the vestry or the vaults of the side chapels, integrated into a single circuit that will have later uses without interfering with the rest of the functions that occupy other areas of the vast grouping, whose amplitude is greater than twenty two thousand square meters, in the interior of the urban plan. That action makes necessary, even strong interventions, in the existing spaces—basically through the construction of a new access which functionally articulates the salons recovered without turning to the great Baroque floats very distant from this sector of the building—but respecting the meaning of these and even taking advantage of their technical qualities so that they act as historical referential frame for the pieces themselves which are now exhibited or may be in the future.

Façade of the Monastery.

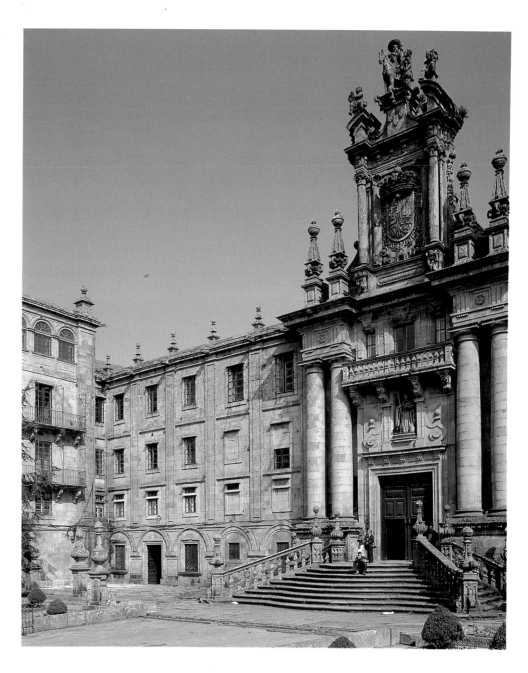

But let us return to the history; we already indicated that there were close ties between the Monastery and the apostolic basilica; let us be more specific now. The origins of the monastery and the community of San Martiño Pinario are wrapped in the mists, but it is a good idea to see them as related to the fact of the intervention/discovery of the sepulcher of the Apostle Santiago. The documentation we have is not very plentiful, but the facts coincide basically in their points of reference, since the diplomas of Ordoño II and Sisnando of the year 912, like the information provided by the Historia Compostellana and the privilege of D. Diego Xelmírez in 1115, trace the major features of the community's life in that period, but they maintain the unknown aspect of its origins, which writers of the XVIIth century try to clarify by turning to tradition.

The first documents related to the discovery of the apostolic sepulcher allow us to see that in order to organize the cult a series of canons and a community of monks, traditionally considered to have come from Oviedo with the King, which are the origin of the community of Antealtares, which came to Compostela from Iria.

Both the royal donation of Ordoño the II to the monks of the houses of Besutro, where the church of San Martiño is located, and the lands of Valdediós and Valdoinferno, in the

area of Pinario, outside the walls—thus the name San Martiño de Fora, with which the house appears in numerous documents—and the confirmation of a whole series of possessions in the area of Arousa, some of which had been attributed in other royal donations to the church of Santiago do not clarify the origin of the community, although they inform us that its church was Santa María de Corticela, with its altars of Santa Columba, San Silvestre, and San Esteban and that around those years in 912 it had already been established there for some time.

The time of the establishment is not clear and if some understand that it is shortly before that endowment, others consider it to be very ancient, having even served Friar Justo Pérez de Urbe I to open a controversial polemic as to its prior existence. In any case, it seems evident that its birth is tied to the discovery of the tomb of the Zebedean, and as Lucas Alvarez proposes, it would not be strange for the Galician monks to have established a community under their protection, with a situation that did not allow them to compete with the canons of Iria nor the monks of Antealtares. This reason would explain the proximity and its nature beyond the apostolic church. The Galician origin of the community, in opposition to the one from Oviedo of Antealtares, is affirmed by the tradition that makes them proceed from Cálogo, which leads Lucas to believe that it is a new foundation, tied to the monastery of Cálogo as shown by the territorial relationship of its initial possessions, all on the river edge and nearby. The devotion and link with the community which served the apostolic cult will appear reinforced afterward by the dispositions which D. Sisnando himself executes.

In order to promote the apostolic cult, Sisnando organized a total of three different monastical communities that were intimately related to the church chapter itself: Antealtares, Pinario and Bolovia, with their different characteristics. As a counterpart of the obligations which they received he endows them with goods that were from the church itself and requests that King Ordoño accept as his own those endowment confirmations, in addition to expanding them himself afterward.

One of those communities organized is that governed by the abbot Guto and which is located in Santa María da Corticela, where its space is limited. So that it can carry out the new tasks that have been assigned, they are given a new place to develop more adequately and according to the objectives this reform is established without losing their former site. The esteem for the abbot and the community leads several years later to the new monasteries he instituted on the side of Monte Ilicino, those of San Sebastián and San Lorenzo, becoming dependencies, within the program of general rehabilitation of the places in relation to the tradition which surrounds the arrival of the body of Santiago, as López Alsina showed.

The monastical community, now organized around San Martiño, kept growing, and as the introduction of the Xelmirian privilege reveals, new cloisters and divine offices were constructed, although the carrying out of the hours and divine rites continued, from San Martiño de Fora or Pinario to the church of the Corticela. Possibly the development itself of the obligations to obey the cannons chosen by Sisnando in his old age imposed harsh conditions, which together with those caused by the razing of Almanzor, motivated bishop San Pedro de Mezonzo to allow them to follow the hours of the cult in a church of the monastery although they still went to the Corticela, which occurs around 992.

Some years later, the growth of the community forced it to think of a larger scale work, whose description is partially reported in the Historia Compostelana and in a very vivid way in the privilege conceded by Xelmírez in 1115, which testifies to the good relationship which the monastery of San Martiño had with the church chapter as opposed to the constant suits and differences with San Paio de Antealtares.

A document of great importance for the history of San Martiño Pinario is the Privilege given by Diego de Xelmírez to the monastery in 1115, whose importance stands out even for the fact that it includes among the persons signing it Queen Urraca herself. In addition to referring to the facts which we have mentioned, it includes in the first parts information about the decision to construct a new church which would substitute the one erected by San Pedro de Mezonzo, fact which corresponded to the decision of abbot Araúlfo around 1050. He was succeeded by Leovigildo, who continued the work until in 1102 the consecration of the temple could take place, done by Xelmírez himself and the then bishop of Ourense, Don Diego, who began the work on the factory that was an episcopal palace and today is the provincial museum of that city and splendid example of Romanesque civil architecture. Also

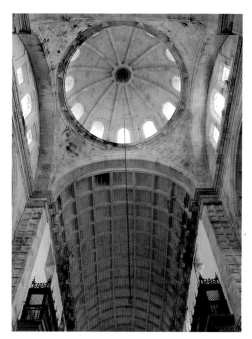

Dome and vault of the church.

important must have been the church consecrated by Xelmírez and the buildings of the monastery itself, which survived until the XVIIth century when both Father Yepes and Cardinal Jerónimo del Hoyo managed to see them, and whose observations we have, allowing us to imagine what they were like.

Father Yepes observes: "and so the construction of a great church began which for that time was very wide and very capable, and is the ancient one we now see in San Martiño of Santiago." A little later he completes the description: "The buildings are not sumptuous and haughty, but the house is very capable, with different cloisters, and an effort has been made to build cells and offices for the monks, more for service and use than show; the church they used to have in the time of D. Diego Xelmírez was good and sufficient; but as the house is so rich and powerful (as we have seen), they wished to pay tribute to God by making a church worthy of such a qualified and major convent. Thus the abbots began one of the best and largest temples of the best architecture there is in our Order. I saw some chapels that were done and finished and part of the transept and the doorway, and I was amazed to see work of such majesty and grandeur, which can be compared to the best buildings of Spain." Up to here the information of the Benedictine historian who saw the Romanesque building around the first years of the XVIIth century (c. 1603/1604).

The contribution of Cardinal Jerónimo del Hoyo, who writes in 1615, coincides so much that it appears taken from the same work, although it may be that he still saw the building standing. He says in the section of the history and referring to the document which served us as reference also: "At that time Adulfo was abbot, holy man who must have lived around 1050, more or less, and together with his holiness he had courage and valor and thus began to build another church, wider and more capable than the old one, which we now see in San Martiño of Santiago, which for those times was very large and he began it with property of the house and some alms from the devout... ".

Now nothing of the old building remains standing nor is there evidence any more of the wealth and capacity of the church and Romanesque cloisters except for the series of architectural elements reused all over in the foundations of the present-day Baroque constructions, spiral lines with spheres, others with taqueados, columns, etc., are visible in the lower part which looks onto the street that begins at the Azabachería and runs toward the Faculty of Medicine, others in the grain shed and the visible foundations of the church. It is a pity we cannot see the singular example that its construction must have produced, nor know if, as it would be logical to think, new works were added to the primitive Romanesque work over the years of the medieval period.

The privilege of Xelmírez also confirms the possessions of the Monastery of San Martiño and even increases them. Its reason for being is based perhaps on the good relations the bishop always had with the community, but the dates suggest that we also find the gratitude of Xelmírez for the behavior of the monks of San Martiño in the two previous years because of the revolts of the Compostelan bourgeoisie.

Some years later the Monastery receives the donation of a hospital created by Sarracino González, antecedent of that other hospital that the Catholic Kings would establish in the final years of the XVth century.

After the middle years of this XIIth century, life in the Monastery continues its course with a progressive growth of its landholdings as can be followed in the documentation gathered by Professor Lucas Alvarez. The procedure is at times purchase, others donations, of which the least are royal, and the most, from first the nobility and then the military, especially all through the XIIIth century.

Parallel to the process of enrichment and accumulation of possessions we can observe in the documentation a certain lack of concern for the maintenance of the Corticela, with some problems arising with the church chapter, such as those which occurred in the middle of the XIIIth century from which it is deduced that the monastery was little or not at all worried about its initial see, with the exception of the major festivities and the fact that the church chapter had two chaplains and a director. This demonstrates a certain loosening of observance, also indicated by other sources.

But some years before these events and controversy with the church chapter, a relevant event takes place. Around 1214 a Francis of Assisi travels to Santiago in pilgrimage and desiring to found a convent solicits the cession of lands to do so in the area of Valdediós.

The legend says that the saint addressed the abbot of San Martiño to request this and that upon hearing his question as to what he offered him, he responded that a small basket of fishes from the river each year, with the condition that they can be taken. The abbot accepted and the foro was maintained for many years. López Ferreiro indicates the existence of a receipt from 1773 which tells of the tradition and Morales even points out the existence in the Archive of San Paio de Antealtares of the receipt with the signature of the Seraph, which was presented to Philip II when he traveled to Santiago. The tradition associates the fact with San Paio de Antealtares, but both the mention of abbot Martín, who governed in San Martiño from 1212 to 1229, and the situation of the Franciscan foundation on the lands which Sisnando and Ordoño conceded to San Martiño, make it more reasonable to think that the relationship was with the monastery of Pinario itself rather than with Antealtares. The fact, which all the historians of the convent underline, is the motive of one of the altar pieces of the church transept.

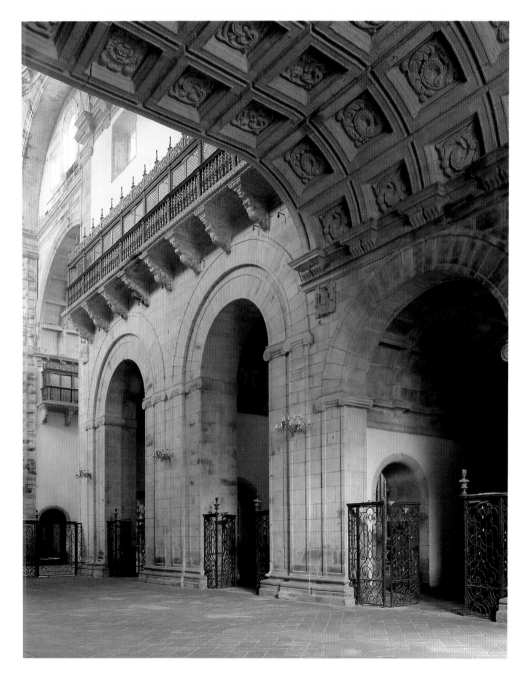

Low choir and lateral chapels of the church.

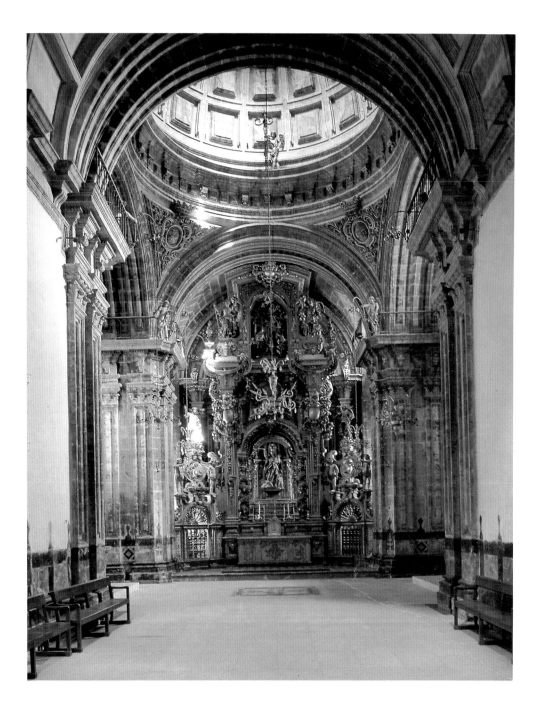

Throughout the XIIIth century, nevertheless, there is a certain relaxation which is only detained in the abbotship of D. Juan de Dios (1272-1315). This abbot receives in his first years, a confirmation of the privileges of the house of Pope Gregory X, and shortly after, the documentation, always following Lucas, allows us to see the attempts at renovation of a religious life which had reached scandalous conditions.

The XIVth century represents the beginning of the interference of the lords and the middle nobility in the dominions of the monastery and also that of the constant protests of the monastery, the first of the suits against those who usurped its lands dating from 1328, attacked its seignorial rights, and took their financial means away.

The religious renovation seems to have continued, we do not know if a fruit of the obstacles and this better observance is in the origin of some annexations which occur in the last years of the century and will continue in the first third of the following: First that of the monastery of San Miguel de Couselo, in 1390, with Juan Fernández as abbot; later the con-

vent of nuns of Dormeá in 1404, or the incorporation in 1438 of the monastery of Saint Martin de Canduás by the archbishop Don Lope, also protector of the monastery of San Martiño in previous years in the suit that this monastery had concerning the conservation of fish on the island of Arousa.

The monastery of Pinario also suffered throughout the XVth century with the presence of commendatory abbots, the most influential of which was undoubtedly the bishop of Tui, Don Diego de Muros I, who held the position until the incorporation of the monastery into the reform decreed by the Catholic king and queen takes places.

The king and queen, in their visit to Galicia in 1486, learned of the situation which, with complaints and lamentations, the various Galician monasteries presented to them, and they decided to incorporate them into the reform they had begun, progressively tying them to the congregation of San Benito of Valladolid. But before this initiative, they had promoted another by means of which, adding the income of San Martiño and San Pedro de Fora, they decided to build a hospital for the poor and pilgrims. But after this initial plan, they obtained a bull from Innocent VIII so that all those who gave alms for a royal hospital would receive full indulgence, which made it unnecessary to turn to the goods of the monasteries.

The decision of the Catholic king and queen to incorporate the Galician monasteries into the reform which they had promoted through the congregation of San Benito of Valladolid was ratified by the Pope a few years later and, although initially the bishops of Avila, Córdoba, Segovia and León took theoretical charge of it, the most active efforts corresponded to those responsible within the Orders, the abbot of San Benito of Valladolid, Friar Juan of Saint-Jean-de-Luz (1488-97) and for the monasteries of Benedictine monks and nuns and the General reformer of the Observant Order of Castile, Friar Sebastián de Padilla, for the Cistercians.

The reform met great difficulties, some caused by the monasteries themselves, who were losing their independence, others by the titulars of the ecclesiastical benefits which they had lost, and other difficulties caused by the church prelates themselves, as seen in the suit years later, in 1515, by the archbishop of Compostela against the privilege of the monasteries.

Although the bull of Innocent VIII did not explicitly authorize the annexation of the monasteries, this was a natural consequence of the reform. Thus, the first monastery incorporated was San Martiño Pinario, which did so in 1487, but which still took a few years to join the congregation of Valladolid, since the commendatary abbot D. Diego de Muros resisted ceding his rights, later exercised by Cardinal Pallavicini until he gave them up. Slowly, although with many ups and downs, Friar Rodrigo de Valencia continued the reform and incorporation of the reformed monasteries to the congregation of San Benito of Valladolid.

Between 1487 and 1515 the reform advances considerably and San Martiño becomes the great Galician abby where the other monasteries are assembled, up to twenty abbeys and priorates, which indicates an increase in the number of monks, but also of resources and needs for organization and administration, as well as new possibilities.

The reform ended up being clearly established and San Martiño Pinario became a great center of education and culture, religion and charity, along the line of the tradition which the life and figure of the patron saint established. For years it grew and its guests were monks and scientific and naturalist laymen, literati, masters of philosophy and theology, architects and master builders, illustrious personalities such as King Philip II and anonymous visitors to Compostela. House of prayer, but also of jurisdictional and worldly dominion; it had a church and archive, library and museum. All this allowed the existence of a monumental whole like that which we can see and whose construction can be seen. History has not been closed; it continues and attempts to recover and give meaning to what it has been so that it can continue to be, today as yesterday, point of approach to the people who search for a new identity in its history.

SAN MARTIÑO PINARIO IN ITS PAST: THE SPLENDOR OF A MONASTERY

M.ª Dolores Vila Jato

The disastrous spiritual and material situation through which the Galician monasteries passed in the Late Middle Age was remedied by the action of the Catholic King and Queen who, in a risky but efficient intervention in the religious politics of their time, dtermined the disappearance of the Commendatary Abbots and the incorporation of the Monasteries to a higher community that in the case Galicia was the Congregation of Valladolid, which in General Assembly would name the abbots of the monasteries with the obligation to reside in them.

The Monastery of San Martiño was incorporated into the Congregation of Valladolid in 1493 and acquired legal confirmation five years later; after this the true splendor of the Pinarian community begins, and would increase spiritually with the growing number of its monks and territorially with the annexation of several monasteries, preserves and lands until it was the msot important in Galicia. Thus the material bases were set for the enormous artistic activity that would begin in the building years later and would lead to the construction and reformation of the entire former temple.

The work of enlarging and reconstruction of the Monastery of San Martín Pinario was to begin, apart from some necessary interventions for consolidation or addition of some monastical dependency, with the grandiose Church, living nucleus of monastical life and whose planning and direction was charged to the Portuguese architect Mateo Lopes, at the time active in Pontevedra and who had previously worked for other Benedictine monasteries like Poio, Lérez or Tenorio (Pontevedra).

The building process of the church of San Martiño Pinario is still wrapped in a profound mystery, given the dearth of documentary references and the contradictory character of many of these. In 1590 the Benedictine community already had Mateo Lopes in its service, since in the Meeting of the Congregation of Valladolid in that year a formal protest is received from the archbishop of Santiago, who opposes the construction of the new church which Mateo Lopes was building. This indicates that already from the beginning moment of the Monastery's expansion the distrustful Compostelan church chapter showed its strong opposition, looking enviously upon the aggrandisement of the building and starting a struggle which would last a century. What is certain is that this warning must not have had much effect since three years later, in 1593, Mateo Lopes contracts to do four chapels, in 1597 he is commissioned to do the main façade and a year later the community contracts with him for the entire church, thus completing the charge that had been begun almost a decade before.

The Portuguese architect would direct the work of the church of San Martiño until his death in 1606, and to him must be attributed the general plan of construction, the "universal plan" referred to by the church chapter of the cathedral in the suit of 1676, when it speaks of the fact that the monastery wants to finish off the parts begun "according to the plan and blueprint that was done when the work was outlined." Therefore, Mateo Lopes would also

draw up the scheme of the entire church, which would then be respected by his successors, except in the cupola which crowns the transept. This problem was perhaps complex for Mateo Lopes in its realization and would only be resolved by an architect of much more complex and complete formation, like the Andalusian Bartolomé Fernández Lechuga.

For the floorplan of the church, Mateo Lopes was inspired by constructions in the North of Portugal, specifically in the area of Viana, where the taste for the wide spatiousness of the nave, the uncommon development of the main wall or the use of the Ionic order is frequent. A building to be taken into account, aside from the already familiar one of Santo Domingo in Viana do Castelo, is the Monastery of San Gonzalo in Amarante, also in the North of the neighboring country and place where Mateo Lopes worked.

The general floor plan is controlled by a marked horizontal tension toward the main altar and cupola, expressed in a masterful manner by the placement in the access to the main chapel, of the grandiose altar piece of Fernando de Casas y Novoa; this directional sense responds fully to the needs and above all to the aesthetic sense of Classicism and the liturgy of

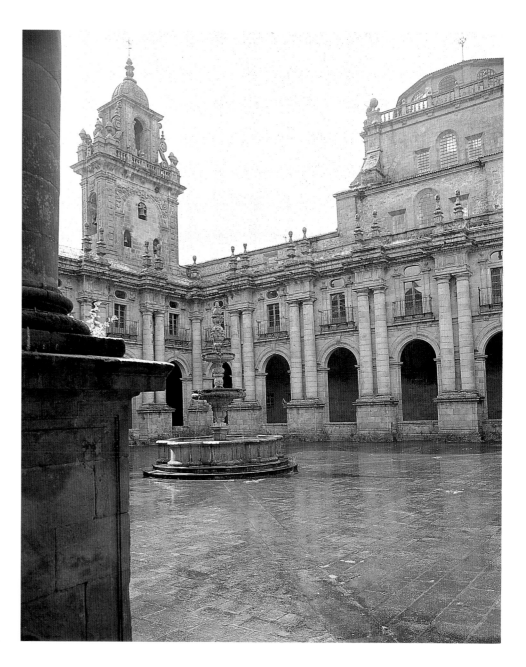

Cloister of the Monastery.

the Counter Reformation, which returns to a concept of ecclesia, of wide, practicable nave, naked of decoration, which would place the faithful closer to the Divinity.

The immense nave, a warmly evoking space covered by the barrel vault of false caissons, is complemented by the addition of three lateral chapels attached to one another and also covered with caisson vaults, to open into the transept and into the profound presbyterium of the straight headwall and lower than the nave. The tension towards the main altar and the diaphanousness of the interior of the temple, from the penumbra of the first two sections beneath the flat vault supported by the high choir, to the greater amplitude of the barrel vault of the nave which culminates in the arch of the transept, supported on pillars and above which the cupola rises; if in these aspects the building is treated with a decanted Classicism, certainly the configuration of the high wall is later, because the Ionic comlumns only support the bent round arches for entry to the chapels, but there is no order that dictates the rhythmic distribution of the sections and support of the vault.

Mateo Lopes also received the charge of raising the church façade, an immense altar piece of stone devoted to visualizing the glories of the Benedictine Order, placed under the protection of Mary and Saint Martin. The wall surface, with its exuberant decoration, is divided by bolsterwork columns in three bodies which reflect that interior structure of the space. In the middle is the altar piece, in which a broad, complex iconographical program is intended to emphasize the role of the Virgin as Ecclesia, in a Marian apotheosis well liked by the Benedictine Order, whose most renowned sons surround the Virgin in the central body.

This façade is surprising for its concept of the altar piece, already fallen into disuse in these last years of the century in Spain; its singularity is also explained by the precedents that doubtlessly Mateo Lopes himself used: the façade of Santa María of Pontevedra, that of São Domingos of Viana do Castelo and very especially, that of the convent of São Gonçalo of Amarante (Portugal), exactly the same as San Martiño.

With the death of Mateo Lopes in 1606, the church of San Martiño Pinario must have been completely planned and, in my opinion, the high walls of nave, transept and main chapel designed, forming a united whole in which succesive master builders would work according to the primitive plan, which nevertheless must not have managed to solve the crucial problem of the interior space, the cover of the transept, most likely because of the enormous proportions that the body of the church had taken on and the subsequent difficulty in building the half of an orange.

I thus believe that the intervention of Ginés Martínez must have altered the primitive design little or not at all, nor would it that of his successor as master builder, Benito Gonzalez de Araújo. In fact, I believe it quite probable that we must attribute to Mateo Lopes himself the two retangular spaces that flank the headwall and that must have been used as subordinate dependencies pf the church. The first of these is the location now known as the oratorio of San Felipe Neri, whose first usage is still unknown today, although because of its constructive typology and its proximity to the church it could have been, at first, the vestry (that explains the succession of round arcades that distributed the wall space and that would hold the drawers) until Fernando de Casas built the new one, at which time the old location began to be used as a Chapter-house, until it was converted to an oratory or domestic chapel.

The oratory is a rectangular room covered by a barrel vault of false caissons exactly the same as those which cover the chapels of the nave, and the walls are hollowed out by round arches on which a moulding runs, like an entablature held by enormous brackets decorated with busts of the Kings of Judah, among which are Solomon, David, and the Queen of Saba, made similarly to the faces of the prophets on the church façade.

In correspondence with this chapel another one like it was built on the North side of the headwall of the church. We do not know its use, but it could have been a statio or passage space between the church and the former monastical dependencies which would have been situated in this northern part of the area. The only difference between both rooms is that in this one there are no busts with brackets, perhaps because it was an area of lesser importance in the ritual of monasterial daily life.

The death of Mateo Lopes must not have meant a substantial alteration of his primitive project, continued by his collaborators; there is only one question to explain in the course of

this first building phase, which is the range of the intervention by the Andalusian architect Ginés Martínez. The performance of this architect from Jaén, brought to Santiago by archbishop D. Maximiliano of Austria, is shown by a citation from the Book of Visitors of San Martiño, which in 1611 records the order of the general of the Benecdictines in the sense that the main work of the church was to be continued following the same plans and model of Ginés Martínez. In spite of the convincing nature of the affirmation, I believe that Ginés Martínez limited himself to contuing the work of Mateo Lopes, following his plan, while he attended to the construction of other locations necessary to the monastery; in fact, parallelly to the construction of the church it must have been the intention of the monastical community to carry out the complementary works which furthered the monastery's new splendor, and that explains the drawing out of the finishing of the church, as well as the continuous reprimands of the generals and Inspectors of the Order who insisted that the religious space be concluded before starting new constructions, an order not always followed by the abbots.

Ginés Martínez must have designed and directed the works of the shed or barn, located on the East side of the monastery following the church, a magnificent vaulted area, recovered for this Exposition and which has two parts of three sections each with vaults supported by propped arches on severe Tuscan columns, plus a central access, which would serve as entryway from the outside and which, treated as a vestibule, has vaults supported by cuadriangular pillars. The whole shows a fully assimilated Classicism, even in a fundamentally utilitarian work.

From the beginning of the construction of San Martiño, Mateo Lopes had the help of his nephew Benito González de Araújo as overseer, post in which he continued until the death of his uncle and master in 1606, since in that year he appears cited as "master builder of San Martín," post which he held until 1620. I believe that this presence of Benito Araújo at the head of the construction as its main master proves the theory of a marginal intervention by Ginés Martínez at the same time as it corroborates the unitarian sense given to the building from the first moment.

A new phase in the events of the Monastery opens in 1626 when the architect from Granada Bartolomé Fernández Lechuga comes to Santiago at the summons of the Abbot Diego de Hevia. He brought to the artistic environment of Compostela an air of newness based on the the utilization of construction formulas inherited from Siloé or Vandelvira, with a verticalizing rhythm, that unified the different elements, or a taste for geometrizing ornamentation unknown until then in the Compostelan architecture.

Brought to Santiago by the Benedictine community, he spent his entire stay in Compostela in relation to its works; in 1627 he already figures as master builder of San Martiño; in 1633 he is charged with the continuation of the church, the plans of the new cloister and the continuation of what was already begun. As it appears, the first intervention of Fernández Lechuga must have been that of drawing up and directing the works of the cloister of the offices, today two stories high, with two apartments each (?), although only the first section can be adscribed to Bartolomé Lechuga, still strongly Classicist in his wall articulation, with six spans on the larger sides and four on the smaller, organized by means of the pattern of doble Tuscan pillars on the lower apartment, which leave round arches with protruding spandrels between them and a first floor with rectangular windows with transoms.

The second body of this cloister has double caissoned pillars with rectangular windows and transoms; in the center of the entablature on the South side is the date 1677, which indicates that this patio was constructed in two stages, leading us to think that the author of the addition was the then master builder of the Monastery, Friar Tomás Alonso. As we shall see, he worked basically in this southwestern area of the building, where during those years dependencies of utilitarian character were constructed, such as the refectory or the kitchen, while the large or processional cloister is more an area for community liturgical celebrations.

Undoubtedly the work which brought Lechuga to Santiago was the conclusion of the church of the Monastery of San Martiño, continuously sought by the Inspectors of the Order and of which they still must have needed to finish the central part of the transept with its corresponding cupola, essential element of the building both from an architectural point of view and from a symbolical one, since the transept is the focal point of the ecclesiastical

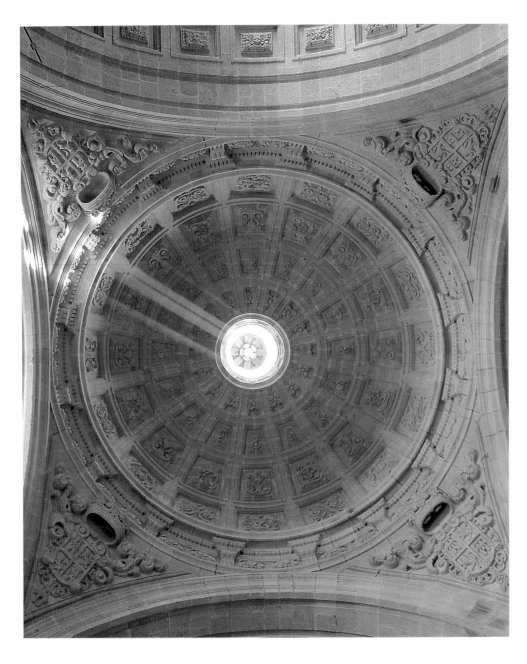

whole and the epicenter in which the horizontal tensions of the nave and the vertical ones of the cupola are balanced.

In spite of the fact that at the time of Lechuga's departure from Santiago, in 1637, the church had not been completely finished (the works continued until 1648, when the holy sacrament was transferred to the church), it is certain that the construction of the cupola crowned the nave of the area, achieving a spatial amplitude, a radiant, graduated light that faded into penumbra from the side chapels, only comparable to the great Roman buildings. Undoubtedly this effect was achieved by the different height of the vaultings of the rest of the church, subduing the diaphanous effect of the cupola that rises above squinches and clearly shows the Siloesque affiliation of their author, as well as the interpretation of the placement of openings usual in Vandelvira, and which Lechuga uses in the three-sided cavity which is formed to solve the difference in height of the naves.

The arch is divided by twelve ribs which create between them another twelve sections with their corresponding window, reducing the wall to the indispensable minimum and

making the cupola appear to be suspended in the air. Outside the cimborium presents a square cavity with balustrade and above it the half orange, the technical display which the construction of this cupola meant, at such considerable height that the architect from Granada had to devise a complex system of exterior supports, soon hidden by the surface of the processional cloister that Bartolomé Lechuga also began to construct.

The cloister of the doorway or processional cloister was drawn up by Bartolomé Fernández Lechuga, who began it at the northern wing (the one next to the church), although it was not concluded until a century later. Of impressive beauty and large proportions, this cloister, very novel in the artistic context of Compostela, had a strong impact on architects such as José de la Peña Toro (master builder of San Martiño, where he is mentioned between 1652 and 1666), Friar Gabriel de Casas or Garcia de Quiñones.

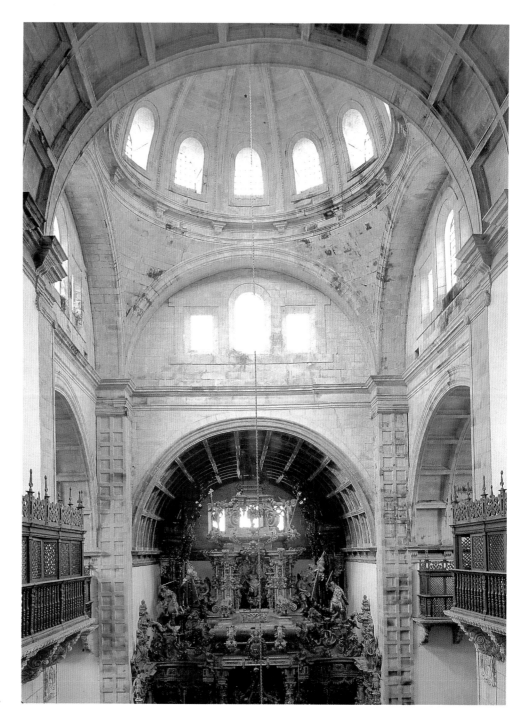

Nave of the Church.

The cloister has two levels joined in height by Doric columns of gigantic proportions which rise from a solid base; between them, the moulded round arches and in the second part the balconies elevated by an oval skylight, partly hidden from view or darkened by the ledge of a cornice. The monumental whole finishes off with a rhythmic succession of pinnacles, two over each span.

In 1637, when Lechuga left for Granada, very little of this cloister must have been constructed, perhaps no more than three or four passages on the North side, where in the entablature we can read the date 1636. The monks again turned their attention to the church and the cloister must have passed through a stage of semiabandonment, possibly motivated by the need to buy lands on which to continue building it, a situation which changes toward the middle of the century and which coincides with the presence of Peña de Toro at the head of the works of the Monastery, in a labor of consolidation of the church, a design of some towers that were never constructed, and in all probability, working on the cloister, since on the west side we read the date of 1660.

The Salmantine architect José de la Peña de Toro was called by the Benecdictine community of San Martiño Pinario in 1652, and was assigned a series of works of contention and repare in the church, concretely in the cupula, whose walls had sagged. This was not the only reason for calling Peña de Toro to Santiago, because the monks also assigned him a substantial reform of the church's façade which, if it had been concluded, would have changed the Classsicist appearance of the wall; between 1653 and 1657 he was assigned with the towers that would flank the façade and of which only the bases were constructed, as the church chapter of the Cathedral again opposed all that might suppose an increase in the visual wealth of the building.

The part of the towers that was constructed reaches the height of the rest of the façade, but the most interesting part are the two windows that Peña de Toro opened in its second level and which have the date of 1652. Formerly attributed to Friar Tomas Alonso, there is no doubt now as to the exactitude of this date, and the analysis of the constituting elements of the windows, the type of finishing off of the split pediment, the ball pinnacles match other works by Peña de Toro, in the same manner as the strings of fruits and vegetal elements which surround them are much flatter and more schematic than those usually executed by Friar Tomás Alonso.

Perhaps Peña de Toro is also the author of the plan for the Refectory (at least that of the monks, because that of the laymen appears to be a later work), which began construction in 1663. Francisco Gutiérrez de Lamasoa, from Burgos, works on it, and in 1669 contracted to construct the eight vaults of the refectory.

It is surprising to note that in these middle years of the XVIIth century the monastical community seems to concentrate its construction efforts on the interior of the building, instead of trying to conclude it on the outside on the part which bordered the cathedral. The explanation is double: on the one hand, the monastery had to struggle to buy land and houses for expansion (in 1650 they buy the lot that had been the old Hospital), and on the other hand, it had to battle the church chapter of the Cathedral, always fearful of territorial growth by the Benedictines, to the point where in 1677 they were led to a suit with the pretext that the façade which was planned for the Monastery took light and air from the cathedral.

The intervention of Friar Tomás Alonso in the Monastery of San Martiño Pinario shows the beginning of a new building phase which reaches the first years of the XVIIIth century and on which almost exclusively Benedictine monks expert in architecture will work.

We do not know the exact moment when Friar Tomás Alonso took charge of the works of the Monastery, since there are no contracts of the work, but again the stones remind us of the process of human labor: the tower of the cloister of the doorway has the date 1675, the passages of the southwestern angle of the cloister that of 1676, and the stairway which leads to the refectory, 1681.

Friar Thomas Alonso was an exremely interesting personality, more expert in decoration than in the solution of architectural problems. He pertained to the generation of the high Compostelan Baroque, that of Andrade, Diego de Romay, or Monteagudo, who are able to interpret and control our granite, transforming it in pure decorative pride; with them, but especially with Friar Tomás, adornment, nature made stone, is fused with architecture in a symbiosis that has never been improved upon.

Friar Tomás Alonso would thus continue the work of the main cloister, so often begun anew, with an absolute respect for the original plan, imitating mouldings and decoration until he achieved a unified impression in this second cloister wing. At the same time he must have built the bell-tower and the magnificent stairway that leads to the refectory in this same Northwest angle. The bell-tower, dated on its base 1675, has a rectangular shape, very narrow smaller sides, and two decreasing bodies. The first has pseudo-Doric pillars with caissons and the strong wall barely pierced by the hollows of the bells, and above the balustrade, a new rectangular body, smaller, surrounded by large prominent wings. This bell-tower, with exhuberant naturalistic decoration of plant swirls, and its play of volumes and hollows, is the first truly Baroque work which is carried out in the monastery, later continued by the same Friar Tomás in the stairs of the refectory, in the northeast angle of the main cloister, dated 1681.

The stairway has an opening into the air; that is, it is supported only laterally and has a square cavity with four sections, covered by an octogonal cupola on cradles. If the technical display of this stairway has a masterful plan, no less so is the richness and unusual nature of the decoration on its balustrades and buttresses, with swollen, sensual forms, where beside the usual cabbages and curled leaves are human figures which strangely recall the Spanish American decorative motifs, in particular the "indiates" of Peruvian Baroque; nevertheless, it does not seem very probable that Friar Tomás knew these decorative patterns, but rather that in both cases there was a sharing of a common graphical source, some text with illustrations from the Mannerist period.

The cupola is full of decoration: shields of the Order borne by angels on the buttresses, and on the ring mythological figures together with an explosion of plant motifs: ears of corn, bunches of grapes, pomegranates, curled leaves, etc., which cover the entire surface and once and for all overcome all the difficulties granite poses for carving these designs.

During the abbotship of Friar Isidro de Arriaga (1685-1689), Friar Tomás Alonso began an important reform in the interior of the church, consisting of the construction of a high choir and the lateral balconies which lead to the nave and transept. Previous to this intervention, perhaps there was an elevated choir at the feet of the church, most likely wooden, which now is expanded and monumentalized in correspondence with the grandiosity of the church and with the increase in the number of monks. The flat vault of the choir is decorated with lush flowers similar to those used by Friar Tomás Alonso in door keystones or on the refectory stairs, while the consoles that support the balconies are completely similar to those which he had done previously for the balconies of the Royal Hospital.

In 1681 an agreement was reached between the church chapter of the Cathedral and the Monastery of San Martiño, which allowed the latter to finally begin the construction of the south façade the Monastery, for what would be the most important work, now had the difficult task of purchasing the necessary land, and thus had to overcome the slow negotiations with the neighbors and frequent opposition of the Town Hall. Finally, in 1697 Friar Gabriel de Casas, layman in the same Monastery, is placed in charge of constructing the new floor of the missing part of the building.

Friar Gabriel de Casas represents, in the architectural context of Compostela, a Classicistic opposition, contrary to the ornamental exuberances of his contemporaries Andrade or Tomás Alonso, since above all they conceived the building as a mass, as a plastic volume which dominates by its grandiosity and perfect stereotomy.

The façade of the monastery is, in its design, the clearest proof of the author's Classicism, who thus knew how to harmonize the whole of the Monastery, from the church to the processional cloister, on which he continued to work during those years. The façade is divided in three parts, with an axis in the main entryway: on each side an enormous wall of four floors, the first with blind arches and the rest joined above by giant Tuscan columns that end in a graceful pinnacle and at the angles a protruding body in the form of a tower with five bodies, which makes it stand out, breaking the horizontalism and monotony of the façade. The main door stands out by emphasizing both its greater monumentality and the differentiated treatment of its articulation, with double Tuscan columns, very similar to those of the processional cloister which must have served as model for Friar Gabriel. They frame the central part of the doorway, where there is a door, a niche decorated with beautiful curved

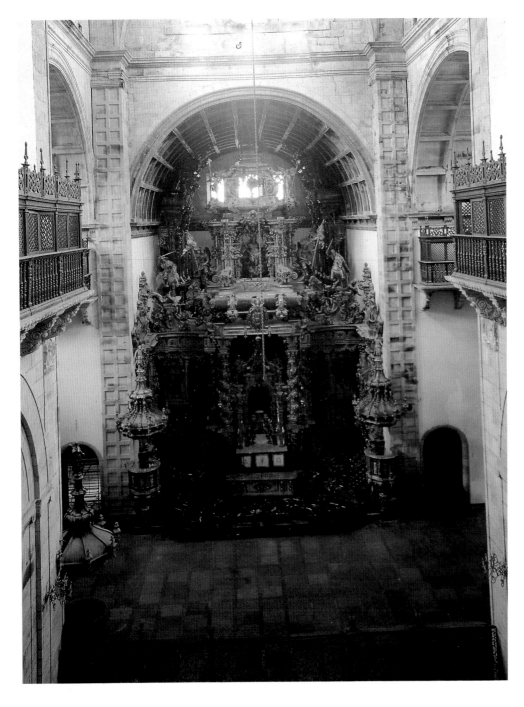

wings which shelters the image of Saint Benedict and the impressive triple balcony, with strong stone balustrade supported by grotesque faces. Over the columns is the entablature designed with substantial correctness and above the flying cornice launches itself weightlessly into the open space, like the Baroque rubric of the entire building, the comb designed by Fernando de Casas y Novoa years later (specifically, in 1738). This rectangular comb is occupied by the royal shield and above, riding the wind on the split pediment, San Martiño sharing his cape with the poor man. Again two distinct architectural concepts come together in the building in complete proximity, and again a serene architecture triumphs between the the Classicism of the façade and the Baroque thrust of the eighteenth detail.

Around the same years when Friar Gabriel was designing the monastical façade, he also designed a stairway next to the church, on the North side of the head wall (today it is next to the vestry from the XVIIIth century) and which at its base bears the date 1696. Of mostly

functional nature, it must have served for access and communication among the monastery's dependencies, which were still used in the Northern part, and the church tribunal. This stairway, its use now recuperated, must have been an experiment for the architect before beginning the more sumptuous and complex chamber stairs, situated in the southwestern angle of the processional cloister and dated 1700.

This stairway also has a rectangular floor with four open floors and a stone railing with balustrades decorated by plant themes and strings of fruit, which may seem strange in an architect so little inclined to decoration as Friar Gabriel, who must have introduced this ornamental concession because of the important purpose of these stairs, which led to the abbot's chamber, and to harmonize (again harmony controlled the work of San Martiño) with that of Friar Tomas Alonso, located on the other side of the cloister. The sections of stairs are covered with flat arches with prominent caissons and the cavity with a flat vault decorated with floral motifs.

Fernando de Casas y Novoa was a disciple of Friar Gabriel de Casas; with him a new stage in the construction of San Martiño is opened, and is prolonged throughout the entire XVIIIth century. After Friar Gabriel de Casas died, work continued on the monastical dependencies in the Western part, which faces the convent of San Francisco, according to the list of abbots San Martiño.

Fernando de Casas y Novoa must have continued the work begun in the Monastery by his master Friar Gabriel, although he is not expressly cited as heading any work until 1730, when he is commissioned to do the design of the main altar piece for the church. It is probable that during the previous years Casas was working on projects that his successor had left unfinished, probably in the cloister, which on the North side bears the date 1743 and which must correspond to its conclusion, faithfully respecting the first design of Bartolomé Lechuga.

Casas must also be attributed the remodeling of the North wing of the cloister, that is, of the dependencies constructed as a grainery at the beginning of the XVIIth century, and where there is a magnificent chimney, grand as all those of Santiago and comparable to the Monastery of San Pelaio, of rectangular base and with semicircular plates as finish. Next to the church façade, on the same street of Rúa da Moeda Vella (Old Coin Street), fernando de casas opened the Cart Door, which communicated the outside with the processional cloister, precisely in the space between the church and the grain shed. This door, which has the date 1740, is monumentalized on the outside by the rectangular educle flanked by volutes, where there is a relief of Bishop San Martiño and which is finished off with a semicircular split pediment from which the shield of the Order was to have emerged, but was not done.

We also owe to Fernando de Casas the construction, prolonging the surface of the second chapel of the church epistle, of the Chapel of the Virgin of Aid, supported by the brotherhood of this appellation and of great importance in the Compostelan cult of the time. Its floor plan, although not centralized, tends to seek control of the central space, crowned by a luminous cupola and in the chancel there is an altar piece-closet which evokes the main altar of the church as well as the chapel of the Virgin of the Big Eyes in the Cathedral of Lugo, designed by him some years before. Once again, the similarity to the Triumph erected in the Cathedral of Seville with the Canonization of Ferdinand III the Holy dominates the organization of this closet, in which Casas places all his usual decorative language. The spatial organization of the interior also follows his peculiar architectural concept, with large Corinthian pillars and the entablature that juts out, as well as the use of polychromy on the walls with the inclusion of different materials, using a decorative sense that Casas himself had tried first in the Chapel of the Pillar of the Cathedral of Santiago.

In 1740 another of the capital works of architecture by Fernando de Casas in San Martiño was concluded: the vestry, located on the North side of the church. As interpreted by the information in the list of abbots of San Martiño, in the three years from 1694 to 1697 they "devoted themselves to doing the Church's vestry," for which it appears that the work, example of eurhythm and proportion, totally follows the typology of Fernando de Casas. Its floor plan is a Greek cross with striated pseudo-Tuscan pillars that act as a support for the copula, similar in their caissoned placement to that of the Chapel of Aid or of the Virgin of the Big Eyes, checking their forces with four barrel vaults with caissons decorated with floral themes.

When the processional cloister was completed, only its symbolic functioning had to be finished, placing a fountain in the center, the "fountain of life" customary in all monasteries and which was commissioned to Fernando de Casas in 1747.

The conclusion of the cloister and the main façade also showed the monks the necessity of enlarging the main entry of the Monastery with the construction of a stairway that with its broad tripart form would go to meet the passerby in the direction of what today is the Square of the Immaculate Virgin. When the construction of this monumental access was decided in 1751, Fernando de Casas had already died and he was succeeded as master builder in San Martiño by the Dominican Friar Manuel de los Mártires, who designed this stairway typologically adding the experiences learned by Friar Manuel de Fernando de Casas (the type of pinnacle) and Simón Ridríguez (the use of cylindrical plates or springer of the pedestals with rolled volutes). It is likewise possible that Friar Manuel de los Mártires himself intervened in the reorganization of the Manstery's vestibule, where the type of circular plate used by him on several occasions is repeated.

At this stage of the progress in time of San Martiño Pinario, it seems very little remained to be done: the Monastery had been finished, the Church had been endowed with rich altar pieces and choir seats, and nevertheless, there was still new remodeling remainings as late as 1771, since Friar Manuel de los Mártires is commissioned to do the reform of the Church façade, that stone altar piece by Mateo Lopes, with the purpose of eliminating the inner stairs that spanned the difference in levels between the panel and the nave of the church. For this the square facing the façade was lowered considerably and the façade was changed, converting the old door into a mirror and opening a new door on a lower level, in front of which a scenographic stairway of curved lines and palatial air unfolded, a true swan song of the Compostelan Baroque.

Before the sorrowful times of decadence and abandon came, the monks continued to enlarge the church with altar pieces and images commissioned to the sculptor José Ferreiro. But the end was near: the French invasion, the suppression of monasteries, and the Secularization ended monastical life, but the stones, mute testimony to history, remain and will remain standing beyond the end of time.

THE FILES OF THE CATALOGUE HAVE BEEN WRITTEN BY

A.-A.F.R.	Aser Angel Fernández Rey
A.-A.R.V.	Andrés A. Rosende Valdés
A.-B.B.	Alejandro Benito Barral
A.C.F.	Alicia Carpente Fernández
A.G.T.	Angeles García Terrón
B.D.R.	Belén Domínguez Román
B.P.O.	Bieito Pérez Outeiriño
C.G.F.	Carmen Gallego Fernández
C.P.A.	Cruz Piñeiro Alvarez
C.P.V.	Carmen Pérez Vicente
F.A.V.	Felipe Arias Vilas
F.C.L.	Francisco Calo Lourido
F.F.B.	Francisco Fariña Busto
F.-J.L.G.	Francisco Javier Limia Gardón
I.-G.B.T.	Isidro Gonzalo Bango Torviso
J.-M.B.D.	José María Bello Diéguez
J.-C.V.P.	José Carlos Valle Pérez
J.-M.L.V.	José Manuel López Vázquez
J.-M.M.M.	Juan Manuel Monterroso Montero
J.S.O.	José Suárez Otero
J.Y.L.	Joaquín Yarza Luaces
L.C.	Ladislao Castro
M.-A.G.G.	Miguel Angel González García
M.-C.F. de la C.	María del Carmen Folgar de la Calle
M.-D.V.J.	María Dolores Vila Jato
M.L.L.	Mariel Larriba Leira
M.-L.M.-S.LL.	María Lourdes Martínez-Sapiña Llanas
M.-L.S.M.	María Luisa Sobrino Manzanares
M.R.	Manuel Real
M.-S.O.R.	María Socorro Ortega Romero
M.-V.C.-C.R.	María Victoria Carballo-Calero Ramos
M.X.R.	Manuel Xusto Rodríguez
P.A.F.	Paloma Acuña Fernández
R.C.G.	Raquel Casal García
R.Y.P.	Ramón Yzquierdo Perrín
R.G.G.-L.	Rosa Gimeno García-Lomas
S.A.E.	Salvador Ares Espada
Y.B.L.	Yolanda Barriocanal López

THE ROOTS

THE ROOTS

FROM THE ORIGINS TO ROMANIZATION

F. Calo Lourido

Although this catalogue has the purpose of offering a panorama of the sculpture and metalcrafting of GALICIA THROUGH TIME, this first section of Prehistory, Protohistory, Romanization and the Paleo-Christian period cannot be limited to the present-day boundaries of Galicia. Thus, on using this term, we will always be referring to the entire peninsular Northwest.

THE PALEOLITHIC

From the artistic point of view, this territory appears lacking in manifestations in the most obscure times of the Paleolithic and Epipaleolithic, well represented in discoveries and lithic ergology, but in which, for now, and in spite of the increasingly abundant appearance and prospection of caves, especially in the eastern zone, it has not offered examples of wall painting art that would allow us to fit onto the Cantabrian artistic family tree. The only known object which could have had artistic pretensions is a pendant of stone found in the shelter of A Pena Grande (Xermade), which was dated in the last of the Magdalenian period or the Cantabrian Azilian.

MEGALITHIC

We have to wait for the appearance of the Megalithic period to see the Northwest related to the entire European Atlantic façade from Sweden to Andalusia, but above all with Normandy, Brittany, Ireland, England, Euskadi and Portugal. Without attempting to evaluate constructive differentialisms, we can say that Galicia, from the second half of the fourth millennium until at least 2000, is not an isolated Land's End, but rather participates intensely in an entire European culture. It will be in this period that we can speak of a true art in the Northwest. From this long period we have a large number of burials, but we have still not had the good fortune of finding the dwelling places; thus what we know of thse people is very fragmentary and polarized.

Their artistic manifestations are reduced to wall painting on the slabs of the antas or dolmens (menhirs) and to the art of household objects represented by "idoliforms." In Galicia we have several thousand Megalithic sepulchers, but either in an institutional manner, as in the case of the scholar Vázquez de Orxas, who at the beginning of the XVIIth century, thanks to a Royal Decree, destroyed a quantity of tombs of "gentiles galigrescos", or because of the "furtive" search for treasures, the result was that many menhirs were destroyed. Another destructive factor was the cultivation, especially of low lands, for agricultural use.

Nevertheless, we can count around 20 tombs with remains of engravings, and to a lesser extent, for obvious reasons of preservation, of painting. The most frequent motifs are vertical serpentiform lines, alone or parallel, vertical as well as horizontal, followed by helioforms and in zig-zag. Motifs of this type are seen in Pedra Cuberta, Dombate, Espiñaredo, Mámoa do Rei, Roza das Modias, Parada de Alperiz, Codesás, etc.

Because they appear in tomb slabs, there was an effort to see in these motifs a symbolic value of the funeral-religious type, interpreting the curving horizontal lines as aquatic representations, the vertical ones, in the case of Parada de Alperiz (Lalín) appears clear, as serpentiform, and the weapons and others as apotropaic.

The colors used on the slabs are red, black, and to a lesser degree, white.

In dolmens such as Argalo, Dombate, Parxueira, Axeitos... a large quantity of smoothed stones with a V-shaped opening or even as a typological variant, vg. in Parxueira, plates of steliform type still under study were taken out of the excavations. All of these were interpreted as idoliform, these being the first freestanding sculptural manifestations of the Northwest, which in fact place us in connection with the southern peninsula.

The limits between art and craft are often very diffuse, especially in Prehistory, but limiting ourselves to the guiding thread of the exposition, we are not going to pause at the beauty of bell-shaped vases, linked to the introduction of metallurgy in Galicia, and which once again are showing us that the Northwest actively participates in the artistic tendencies of the Peninsula and the Atlantic, to pass directly to a new period.

THE BRONZE AGE

The beginnings of this stage are still not satisfactorily defined here, but in general terms they are coetaneous with the Argarican Culture of the peninsular Southwest, in the IInd Bronze Age (Santa-Olalla) or Proto-Atlantic (Mc. White). Perhaps it is more clarifying to say that chronologically we can see a first stage that begins around 1800 B.C., in which we can distinguish different horizons through exclusively ergological parameters, according to the greater incidence of meridional or Atlantic and western influences, these last entering the middle Bronze period and ending with a final Bronze age between 1200 and 600 B.C. Obviously, we have just simplified things, since there is a great variety of subdivisions according to the different archeologists who study this period. We recommend that the interested reader the best synthesis and systematization we know: Sierra (n/d): 209-214.

The artistic manifestations of the Bronze Age are reduced to bone art and metalwork.

With respect to the first we can say that the Megalithic sepulchers stop being produced and the rectangular cists of small dimensions appear, some of them, as in Carnota, Rodeiro, Dombate, etc., with decoration on the stone slabs. We must point out that the cists were not exclusive of Galicia, but until now the decoration is only found on those of the Northwest. Thus we continue immersed in the peninsular and European world, but the Bronze Age in Galicia has a uniqueness that differentiates and makes it stand out with respect to the rest of Spain and Europe.

It is very possible that the decorated megaliths are from the latest ones, while the cistas with engraving were classified as from the early Bronze, so that the "tradition" or continuity seems evident.

The best known sculptural manifestations of the Bronze Age are the petroglyphs or engravings in exposed stones. If we look at a map of the area we can see its presence in the four Galician provinces, in addition to the Miño and Douro coasts of Portugal, but the large concentration appears in the province of Pontevedra and more specifically in the mid valley of the Lérez River and the fiords of Pontevedra and Vigo. The geometric and seminatural motifs are varied, the most outstanding being the repetition of bosses of shields, concentric circles, spirals, labyrinths, halberds, daggers, idoliforms, plaetas, deer, serpents, scenes of horse-back riding, podomorphs, a hand, etc.

We should stress that the clearest parallels appear outside the Peninsula, specifically in England, and in the Alps, it being impossible today to speak of relationships, original nucleus, disperson or coincidence. As for the chronology, the question also is far from being

resolved. It is possible that some engravings were done already in the final Megalithic and that many belong to the later Culture of the Castros. In the last works the halberds, daggers and swords have been hypothetically incardinated in the beginning of the Bronze Age, the cylinder-idols in the Calcolithic, like some spirals, labyrinths and ladles in the late Bronze Age, the shield bosses, stags and others in the Bronze Age, without specifying. As we can see, it is all very provisional and we ourselves have had the occasion to examine some engravings with ladles in rocks that the wash-out mining, done under Rome, left visible in the area of Tres Minas (Three Mines) (Portugal), which gives us a term post quem (I-II c.A.D.) for these motifs in particular.

Much has been written about the possible meaning of the petroglyphs, but the reality is that they are all hypotheses, until now unverified. We know that they are there, but we do not know the purpose for which they were engraved.

The other great artistic manifestation of the Bronze Age is metalwork. Already from the beginning phase we find a great variety of gold objects: armlets, diadems and plain bracelets or others decorated by embossing or relief. We can cite for this period the echinus pieces associated with daggers of flat blade from the cist of Atio (Porriño), the diadems of Cícere (Santa Comba) and Veiga dos Mouros (Vilavella-As Pontes de García Rodríguez), the armlets, chokers with strips and bracelets from Cícere, Goiás, Caldas de Reis, Lalín, etc. The decorative motifs used were parallel incisions, stippled, raised, triangles, rhombuses, zig-zag, possible embossings and echinus. Precisely echinus pieces like those of Atio place us in relation to similar jewels of the Scottish or Wessex Bronze Age, which again shows us the Atlantic relations of this period.

The treasures of A Golada and Caldas de Reis deserve special attention, the first comprised of a choker and two cylindrical solid bracelets; that of Caldas is formed by 36 pieces with a total of 20 Kg. of gold of over 20 carats, but it is calculated that the whole set (many were sold) could have reached 50 Kg. Of the jewels that remain we should note a comb with curved teeth, whose prototypes in wood appeared in Europe in a Palafittic environment; two bitrunco-conical bowls with side handle, a double-trunked conical cup with handle, a rigid necklace, 28 bracelets, etc. Traditionally all the treasure was considered to be from the late Bronze Age, but what has been said of the comb and its technique of elaboration (hammered to join the pellets, followed by an external polishing) lead the treasure to be included today in the beginning to the middle Bronze Age.

What does pertain to the late Bronze Age is the helmet of Leiro (Rianxo). In this last phase, metalwork is enriched with new motifs, such as incisions of straight and curved lines, circles, semispheres, tall, stippled, wavy lines, series of "SS", concentric circles. All this is common not only to Central Europe, but also to the northern Bronze Age. In the middle of Europe the end of the Bronze Age coincides with Hallstattization, there are great movements and exchanges and the Mediterranean influences of the orientalizing phase of Greek and Etruscan art, vg. the Krater of Vix and the pitchers with spouts which go up through the north of Italy and the Alps. The helmet of Leiro is a clear example of this period, with its decoration of semispheres and parallel mouldings, made with embossing technique. The closest parallels are the bowls of Axtroki (Guipúzcoa), and already in Europe, we can cite, among many, the bowls of the treasure of Messingwerk-Eberswalde (Germany), or the pieces of the treasure of Lavindsgaard Mose (Denmark).

In summary, we can say that from the beginning of the Bronze Age, and as we approach the late Bronze Age, we find pieces that can be related one by one to the entire Atlantic and continental world of Europe. The relations are much clearer and differentiated than in the previous Megalithic period. On the other hand, in this stage the Northwest has a character that is markedly different from the rest of the Hispanic area. If we had to translate this into the present world, we would say that Galicia is much more Atlantic and European than the rest of the peninsula.

The last stages of the late Bronze Age show a strong development of the Northwest, in which not only are foreign influences being received, i.e. pistil-form and carp tongue swords, but also new forms are being created. The production and exportation of manufactured metal products testify to a great activity. The abundant axes with binary heel (copper-tin) and ternary axes (copper-tin-lead) and a great variety of ceramic types proves the importance of Galicia in this period.

THE CULTURE OF THE CASTROS

At the end of the VIth century, a profound transformation is produced in the Northwest. On the base of the late Bronze Age, enormously dynamic, as we have just seen, Hallstatt elements will arrive, along with Mediterranean influences which will define what we know as the Culture of the Castros.

The contributions of Hallstatt are more and more evident, both in the Alpiarça ceramics, found in the most ancient level of Castromao (Celanova), in the ditches of Monte Mesigo (O Carballiño), or in discoveries of the north of Portugal, i.e., in the group of ditches of Tapado de Caldeira, near the confluence of the Támega and Duero Rivers, among others, as in the high region of Borneiro, in the funeral urn of Santa Adega (Vilamarín), or in the creation, starting with the "carp-tongue" swords, of the antenna daggers, whose oldest examples are found in the piece of Isorna (Ría de Arousa) and the Ría do Burgo (A Coruña), already a dagger, but with a blade still in form of "carp's tongue", until we reach the most evolved pieces in which the antenna handle—Hallstatt influence—and the blade will be cast at the same time, even in iron, like those from San Cibrao de Lás, Santa Trega, etc.

We also see Hallstattizing currents in fibulas of the Sabroso, Santa Luzia or Trasmontan type, derived from the "Fussierfibeln" or fibulas with a high foot with button, that appear in Wurttemberg and Badem (Germany). Much the same can be said of the metalwork, with pieces such as the already mentioned helmet of Leiro, the bracelet of O Neixón, comparable to the Swiss ones of Fahrwagen (Lenzburg, Aargan), that of Cantonha (Costa, Guimarães), or those of Lebuçao, Moimenta,.... The pendants in "sanguisuga", like the piece from A Lanzada, with parallels in the meseta, and, of course, the torques, clearly Hallstattic and developed in Europe in the La Tène Period.

The European influence of the Hallstatt period is well enough reflected in the above examples.

In relation to the contacts with the Mediterranean, we can say that they took place very possibly at first through Tartessos, already in the late Bronze Age, and after the battle of Alalia (Sardinia), around 535 B.C., through the Punics. The painted ceramics of Gadir are a fruit of this trade (VIth century B.C.), found in A Lanzada, the fragment of arybalus of the same century from O Neixón and the painted ceramics from A Facha. It is very possible that it was Punics who brought the Greek ceramics with red figures of A Facha and Fozara, the fibula of Alobre, the pivot fibula needle from Castromao, the bracelet of Braganza, the coins from the castro Lupario or Francos, and an increasingly long etcetera. The great Castro metalwork will be the product of the conjunction of Hallstattism with the meridional influences which will contribute formal variants, like the triangular ends, and new techniques like beading and filigree; we see this world of the South above all in the earrings (arracadas) and jointed necklaces or in Toén or Estremoz type bracelets.

Late Bronze Age. Hallstatt and Mediterranean and new stage, coinciding with the introduction of iron work, is born in the Northwest.

The most obvious manifestation of this period will be that of high settlements protected by walls, the castro, to the point where it gave its name to all the culture. This is not the place to speak of the great complexity of the age of the castro, but we do believe that it is of interest to note what the most significant features are, in order to articulate what hic et nunc interests us: plastic art and metalwork.

The Castro Culture will include from the VIth century B.C. (some authors prefer the VIIth, and others the Vth), until the second half of the Ist c. A.D. Obviously, throughout these 600 or 700 years, the Castro period evolved, so that we have several partially coinciding and partially very different periodizations, according to the elements which served as guiding thread to the respective authors. We are not going to develop them here, but it is just to say that the first archeologist who took the trouble to do this was Maluquer (1973: 340-341), and id. (1975: 276-277). Ferreira de Almeida, basing himself on architecture, speaks of an ancient Castro Culture, which would go from the IVth c. B.C. (before, he says, there are no stone houses) to Caesar, a middle Castro period of Caesar Augustus, a recent Castro period under Augustus, and a late Castro period in the Flavian period (Almeida, 1983: 190); another periodization insists on a period of formation (VIIth century, VIth, Vth, depending on the discoveries, until the IVth century B.C.), a classical castro period (IVth century-IInd

century B.C.) and a late castro period from the end of the second century B.C. until the change in era, or the middle of the first century A.D. (Fariña et al., 1983: 120-126). Finally, Ferreira da Silva sees a first phase which goes to 900 B.C., a second one from 500 B.C., and a third or last one, from the expedition of Brutus to the second half of the first century A.D. (Silva, 1986: 33-65).

With respect to the geographical limits, there is also a variety of opinion, and we coincide with that already stated by López Cuevillas in 1933. For this author, the eastern limit is marked by a line which runs along the Serra do Rañadoiro and eastern hills of Galicia, entering Portugal along the dividing line between Tua and Támega; the southern limit would go along the Vouga River (López Cuevillas, 1933: 105-106). As for us, we only state that it cannot be a line, but rather a spot which delimits, since necessarily, and López Cuevillas also referred to this, there are always "hinterlands", but this eastern limit is satisfactory to us and we believe that the Vouga crossed over as far as the Serra do Caramulo, bordering the highlands of Viseu.

If we take into account the geographical extension of this culture, in addition to its easy localization in closed areas and the large number of settlements already excavated, it is obvious to say that we know a large variety of manifestations which made great syntheses possible, going from the already classical one of López Cuevillas (1953) to the present-day doctoral theses with a totalizing focus (Cf. Silva, 1986), or even regarding partial aspects. We could, then write about defensive or domestic architecture, about the fibulas, ceramicware, utensils, adornments, arms, religion... and even with more and more facts, about the society; but this would take us away from the central theme, which in this case is metalwork and the plastic arts.

One of the most attractive manifestations of this culture is the abundance and variety of jewelry which has reached our time. The Northwest is a land rich in gold (later on we will speak of the quantity which the Romans took out during many years), and the inhabitants of the castros, following a well-documented tradition in the Bronze Age, worked the secondary placers and at least under the power of Rome, also the primary ones to make their jewelry, related to those of continental Europe and the Mediterranean, but with a differentiating seal of their own.

In the previous period we pointed out the presence of the Halstatt Age in many pieces and those Central European influences will bring many models, types, and decorations which will be imposed upon the tradition of work in gold of the Bronze Age. Halstatt D, dated by the fibulas between 525 and 470 B.C., and thus contemporary to La Tène I, will contribute the technique of embossing and engraving jewely, considered masculine in the Northwest, as the torques, bracelets, diadems and amulets. A Mediterranean trend will act upon this metalwork, bringing filigree and beading and new types, perhaps feminine, like the earrings or jointed necklaces. It is still not sufficently clear if the influence of the Mediterranean came directly from the southern peninsula, by land or sea, through Punic trade, or whether from Central Europe, which in turn would receive it together with the beaks pitchers and the Kratera of Vix, from the Etruscans, which already in the VIIth century B.C. according to Alain Hus, used the beading technique. We can even think about a meeting of roads.

Let's stop for a moment, even though in a necessarily synthetic manner, to look at one of the groups of jewelry.

The torques, name which etymologically designated only funicular pieces of rolled wire, are stiff necklaces which curve without closing. The section of the ribbon, decorated or plain, may be circular, rhomboidal or square, and the ends, always volumetric and often decorated, have the form of a double scotia, double cone trunk, with pearl, campanula, tulip, and other shaped terminals. Even without finishing the inventory, it is calculated that those known are more than a hundred; some examples of bronze, eight of silver (Bagunte, Cortinhas, Mondoñedo) and the rest, the large majority, of gold. They appear throughout the Northwest, but there are two areas of high concentration, one delimited by the line which would join the Navia River with the Ulla, with more than 50% of the total catalogued, and the other situated between the Limia, Túa and Douro Rivers. They are thus much more abundant in the northern zone of the castro region than in the south, We refer to the bibliography in order to see the origin of the pieces,

citing only as one of the best examples the one found in Burela, with 1790 gr. of virtually natural gold.

The diadems, perhaps a masculine adornment which we do not know how it was placed on the head, appear mostly in the western part of Asturias, in castro territory and in the north-northeast of Galicia. They are made by the "Hallstattic" technique of embossing and engraving; because of its decoration that of the treasure of Bedoia (Museum of Pontevedra) and that from Ribadeo or perhaps better from the area of Oscos, are outstanding. The one from the Bedoia treasure, so called because of the owner's last name, since we do not know his origin (near Ferrol? Noalla, in the Salnés?), is a plate of very fine gold—0.1 mm. thick—finished with handles, with a total longitude of 410 mm. and a width of 27 mm. at the ends and 54 mm. in the middle. The second, with pieces in the National Archeological Museum, Museum of the Louvre and the Institute of Valencia of D. Juan develops a theme, perhaps of the narrative type, with horseback riders, fish, aquatic birds and peons with large cauldrons.

We do not know if the arracadas, around 40 examples of which are catalogued in the Northwest, were women's jewelry, the most acceptaed idea, or if, as in the plateau, men used them as well. In none of the castro warriors, adorned with torques and bracelets, does this jewelry appear, but this negative fact is not conclusive. The castro earrings (arracadas), quite different from those of the rest of the peninsula, may be a type of "arriñonado" (kidney-shaped) or in "sanguesuga," smooth or partitioned, a morphotype which extends through the north of Galicia, appearing until now in the castro of Baroña (Porto do Son); another group has an appendix or distal part in triangular form, and a third has a volumetric distal part. These morphotypes are found mostly in the southern area of the culture of the castros and, to cite one example of each, in Vilar de Santos (Ourense) and in Briteiros (Guimarães), respectively.

The chief problem which castro metalwork presents is that of its chronology. Both the models and the decorative techniques and elements may be traced in continental Europe and the Mediterranean, although here the result may be original; but the difficulty lies in the lack of knowledge of the precise era in which these pieces, those we know today, begin to be made. The reality is that all of them either appeared decontextualized or in finds of castros in contact with or under the control of Rome. The archeologists who are inclined to think that the chronologies are ancient interpret this as a result of a "treasurization", of lucky discoveries or family jewelry which reached this period, while in other cases it is said that they were made around the change of Era, at a moment of maximum splendor of the Castro Culture.

In the southern sub-area (north of Portugal), in these last few years a series of statue-menhirs have been appearing (sierra of Boulhosa, Faiôes, Chaves, Ermida, etc.) which some wish to see as antecedents of the great statuary of the castros. Their decontextualization and the chronology which they have been assigned normally—the Bronze Age—together with the lack of intermediate steps to reach the pieces which we are now discussing make us think, for now, that there is no relationship between them.

At a specific moment of the Castro Culture, which we can situate in its high point, that is, in contact with the Romans, or what is the same, which was traditionally considered classical or strong castro culture, sculptural manifestations will appear. This fact in itself is not strange or original, since the recent discoveries and revisions are showing the same thing for the great European sculpture and most specifically for that known as Galo-Roman. Thus, to speak of pre-Roman castro sculpture has no basis, because the pieces, whether found out of context or appearing always in discoveries, the largest ones, dated at the time of the change in Era and in the first century A.D. It is for this reason which we will study the plasticity in that Romanizing environment and will thereby follow the familiar division in Galician warriors, human and animal heads, seated figures, architectural decorations and various figures. We do not include the section of verracos or berrones, because all the pieces of this type were found in the area of Tras-os-Montes, outside those of the castro culture and in direct relationship with the "Culture of the Verracos of the highlands.

The Galician warrior icon is the representation in the standing position of a castro warrior in the time of the conquest. In this case the iconography testifies to the descriptions of them by Strabo and Giodoro of Sicily. They were sculpted full length, sometimes in a lar-

ger than life size, and end in a plinth for inserting them into a space. Only four preserve the head and most lack feet, because of normal breakage, since they are made of granite. The heads, with or without beard, have short hair and all the facial features; they are wearing torques and virias, armor and sagum, belt, and sometimes stockings; some pieces appear with footwear and others do not; they carry a caetra, dagger and some a sword over their chest; some have decorated clothing and others do not, although we might think that originally it was painted.

We do not dare to group them in schools, but the four of Lesenho may be related in twos, one from Santa Comba de Basto and, at least, one other from Armea bear a parazolium or sword on the chest; three from Lesenho and those of Cendufe, Vilaverde, Monte Mozinho and Meixedo have clothing with engraved decoration; the ones from Cendufe and Monte Mozinho are barefoot; and finally, the one from Meixedo has an inscription on the sagum and leg, while one from Santa Comba, from Vilaverde and the partially disappeared one from Rubiás have the inscription on the caetra. The one from Vilaverde says: MALCEI-NO/DOVILONIS/F., and that of Rubiás, ADRONO / VEROTI / F. CALUBRIGENS / ES ET ABIANIS / F.C.

What do these statues mean? It was said that they were funeral, votive, deified heroes, gods, etc. Keeping in mind that they were under Roman control and that, like the bases of Sanfins testify, were placed at the entries to the castros, we have to think that Rome, which promoted many of these settlements, not only allowed but even favored the production of these icons dedicated to specific persons, which for us is only explicable from the point of view of collaborationism. Rome pays the one who serves her; if the control is accepted a recompense is received, and a sybilline way of culturizing is to consent, and possibly incite, the important persons of the castros to erect their statues dressed with "regional costume" in imitation of the Roman statues which the natives begin to see in cities like Braga. This fits perfectly with the coetaneous appearance in epigraphy if the "Ɔ" as castellum or castro. The native can cite in his or her origin the belonging to a specific castro, but of course in the language of the invader under the permissive tutelage of the Pax Romana. Warriors stopped being made and the "Ɔ" being used when after the reforms of the Flavii, the castro people are so immersed in the Roman world that these facts lack value and meaning.

A far as plasticity, we must point out and underline the importance of the warriors, taking into account that they are high relief works of great size, made in granite by craftsmen who are inventing, at least in stone, an icon, and that they are able to do so in detail and even with preciosismo, as is seen in the best preserved ones. They live in the Northwest at the time of the change of Era and the first century A.D.

All those known were found in the southern area, in which, perhaps since the time of Augustus, it would be the "Juridical Convent of Braga," just as what happens with the architectural decoration.

In fact, the great castros of Braga (Briteiros, Santa Trega, Armea, Sanfins, San Cibrao de Lás) will provide, around the same period, several hundred decorated stones, both in public buildings and in domestic architecture. We are referring in the first place to the so-called pedras formosas (beautiful stones), which served not as a façade as is often said, but as an interior dividing wall, for semi-buried constructions which were explained as crematory ovens, places for water cults, etc. but which today are considered to be saunas or baths. In the Northwest the Roman thermal baths were reinterpreted in these constructions, which have an oven, a room which is entered by a small semicircular passage, another room with a normal door, and an open space with a fountain with a channel of water, all placed along a longitudinal axis. In essence they would be, after the oven, a caldarium, a tepidarium and a frigidarium. The pedra formosa provides access to the caldarium and that name, at first exclusive of the first discovery in Briteiros, with a decoration that covers it entirely, amor infiniti, would extend to those which were appearing, although the decoration of the later ones is much simpler and more concrete.

There are ovens, as they have also been called, with decorated stone, in Briteiros, Sanfins, Galegos, and Freixo, but there are also ovens in Asturias and Galicia: Pendia, Coaña, Santa Mariña de Augas Santas (Armeá), all of these without decoration. The one from Armeá has a stone with signs and/or decoration, but we must doubt their antiquity,

since it was reused and Christianized and perhaps was not a pedra formosa but the one of access to the tepidarium.

The work of the housing may or may not have a utilitarian purpose, which is the case of the door-hinges and hitching posts. The most abundant motifs are the swastikas, cording, chained and interwoven arrow heads, with multiple combinations. It is the same grammar which we find in the metalwork, and there was always an attempt to see in them a symbolism of the religious sort, tracing the various themes to the Arian world. We are convinced that, independently of the fact that they were created with that purpose in mind, the stones of our castros, whose prototypes are found in the eastern Mediterranean (they are the favorite themes of Mycenae and Crete), had no other function than an ornamental one. Otherwise we cannot explain how they are made in the first half of the first century A.D. and are broken and reused as building material after the 70s in the Flavian urban reordering. The indigenous gods continue for several centuries in the epigraphy and if the decorated pieces had a symbolic significance they would not have been broken up shortly after having been made.

The survival of the motifs reaches our days, especially in the works of popular craftmanship in stone and wood and in the learned recreations.

Another sculptural manifestation are the freestanding human heads or faces engraved in stone. This type of pieces is more abundant in the sub-area north of the castro culture, with works such as those of Barán, Cortes, Ocastro... , but, contrary to what has been said many times, they are also found in the convent of Braga, Santa Iria, San Cibrao de Lás, Gaxate, Armeá... We also have bifaces and quatrifaces: Amorín, Pontedeume... These latter are interpreted as Hermata, as in the rest of the Mediterranean, while of the others there has been doubt as to whether they were "têtes coupées", heads of dead people, gods without body, apotropaic divinities etc. More and more similar heads are appearing not only in the Peninsula but throughout all of Europe, and all those that have been able to be dated (Baelo, Chiusi, Tarento, Hofheim, Fontes de Sena) have a chronology from the middle of the first century A.D. Regarding the heads from the castros, that from San Cibrao may be from the change of Era, that of Tres Minas was found in a Roman mining area, that of Monte Mozinho is from the first century A.D.

We have to think that the heads from the castros may be, as those of Baelo and Tarentum, sub imagine representations of deceased persons and, far from taking us to pre-Romanism, would indicate that the Northwest in the first century A.D. is immersed in a Roman-Mediterranean artistic koiné.

The animal heads (Santa Trega, Cabanca, Paderne, Sabroso, Florderrei Vello...) appear freestanding or in the end of a block of stone; possibly all of them were made in this manner, to be set into a wall. The most perfect of all (Eirexario o Vila de Sen) represents a pig, but we should note that it appeared outside the limits of the castro in direct contact with "Culture of the verracos." The animal which the rest represent is not sufficiently clear, and oxen, sheep, dogs and pigs have been suggested. They have been considered apotropaic or manifestations of some type of zoolatric cult.

In the Northwest there are three seated statues in granite, a small one from Lanhoso and two larger ones, better made, from Xinzo de Limia. The three, today missing the head, are sitting in chairs, with a hole underneath in the first of those cited. The other two show both figures dressed with armor, sagguam, armillae and torques (one of them disappeared with the head), for which reason we consider them masculine. This is another Mediterranean type, where the majority of these pieces (Dama de Baza...) are feminine, so that the fact that the castro pieces are masculine shows us the value of people in this society. They were interpreted as representations of matres, but we believe that they are funeral figures, and even that of Lanhoso, with the hollow in its base, indicates a possible function as an urn for ashes. If we consider that cremation leads to burial at the beginning of the IInd century A.D., it is not too risky to venture a chronology of the first century A.D. for these pieces.

One last group would be formed by different sculptures, but this is not the place to study them individually. There are phallic pieces like those of Genço and Elviña, and even phalluses in stone in Monte Mozinho, Troña and Elviña itself. There are two figures from Logrosa which were related to altars to Jupiter. A female figure of the castro of Sendim with rounded belly, open legs and emphasized and also open sex, which we interpret as a votive piece, which may also be the so-called idol of Vilapedre. The figure of "Vestio Alonieco" by

Lourizán is possibly a representation of the cthonic psicopompus Mercury, similar to others found in France. Other pieces, several in Santa Trega and one in Zêzere, are probably representations of togaed figures, etc.

Thus, there is, a varied plastic art which appears without context or in live and thriving castros in the first century A.D. To speak of Pre-Romanism is pure speculation, since some times the chronology is clear and others, following the comparative method, we can find parallels within the peninsular and European Roman world. We believe, then, that the Culture of the Castros under Rome will elaborate a provincial plasticity fitting the taste of the gentes incolae, but that often it contains a great technical and expressive quality, which makes the Northwest a true artistic province within the Roman Empire, as we shall continue to see in the following section.

THE CONQUEST AND THE INTEGRATION OF THE NORTHWEST IN THE ROMAN EMPIRE

F. Arias Vilas

The Galician lands, long known by the Punic and Roman traders, especially in the coastal strip, were visited already in the second century B.C. by the Roman army, thus beginning the so-called Lusitanian phase of the conquest. The milestones of this phase are situated in 139 (incursion of Servilio Cepión), 137 (expedition of Decimus Junius Brutus, who crosses the Limia and reaches the Miño), 94-92 and 74 (Crasus and Perpenna, respectively), and finally 61-60, with the exploration, based on desires for prestige and wealth, of Julius Caesar, who reaches Brigantium.

Between the years 29 and 19 B.C., the Astur-Cantabrian phase of this conquest is developed, which will conclude with the inclusion of present-day Galicia in the Roman Empire. There were several causes which moved Augustus to this enterprise: besides the desire for personal prestige of the new "Imperator," there was an intent to extend the frontiers of Rome to their natural limits (the Atlantic Ocean in this case), to thus protect the privileges that the lands conquered in the plateau meant, and finally, to be able to explore the resources, especially mineral ones (gold, tin, iron...) of the Northwest, already of known fame in that era.

The wartime vicissitudes of the conquest were told, from their particular point of view (of relative reliability) by the Roman writers (Dión Cassius, Floro, Strabo, Orosius, etc.), and in this conquest three legions participated, which according to these sources would end the indigenous resistance in the heroic and possibly magnified episode of Mount Medulio.

What is really important and transcendent about these war facts is the result that came from this integration into the Roman Empire. The reactions of the world of the castros, of the pre-Roman natives, were undoubtedly varying, according to the attitude toward the conqueror and the permeability during the new events (variable in relation to the areas and social groups).

There had to be, in cases of military resistance, a forced abandoning of the castros, producing heroisms and/or recruiting of soldiers and slaves. On other occasions, this abandoning would be voluntary, through tacit or expressed agreements and the offer of new lands in flat areas. In the Galaico-Roman material culture itself there are examples, also artistic, of a "collaborationism" in certain social groups (especially the indigenous aristocracy(?)).

We also know that, in other cases, the survival in the castros was a real fact, although at times their function was changed to be complemented by settlements of a new sort in the low lands of the valleys. Several of these castros are even reoccupied and develop in the late Roman period (III-V c.A.D.), precisely parallel to the culmination of the villas or mansions, mostly rural, which follow Italic models. The existence at any rate of Romanized castros is archeologically proven (at times in truly aleatory manner) in the appearance of elements such as coins, bronzes, glass pieces, Roman ceramics, "tegula" covering in houses of square floor plan, etc.

The castros of the mining regions of the eastern strip constitute a special case, and are an example of the settlement of the new floor plan decided by Rome, but following the previous

lines (with better techniques) and meant for the mineworkers, possibly the majority of which were native.

Other new settlements should also be cited, of military origin (encampments such as Cidadela or Bande), which later became wayside mansions when they were not in true nuclei of nearly urban population, without managing to compete with the cities recently founded by Augustus or in the period of the Flavii.

The conquest thus produced transformations in almost all walks of life in which both the confluence of elements (castro and Roman) and a series of "evolutionary stimuli" which dynamicized the indigenous substratum, played an important role. We have to speak of of an acculturation, an assimilation, of "Romanization," in a word, which for some authors is slow, soft and not very consistent, while for others it is relatively strong and profound almost from the first moments of the conquest and especially from the Flavian period on (last third of the first century A.D.), with the conceding of the Ius Latii to the Hispani by the emperor Vespation. In any event, this Romanization would occur to different degrees according to the different areas and places (urban centers or rural sector), social groups (more or less favored), and of course, the period. Once military control was established by the three legions of the conquest and afterward by the Legio VII Gemina (in León) and its auxiliary units, the political-administrative organization of Rome was soon based (perhaps already with Augustus) on the implantation of the conventos iuridicus, where a large part of that military control was centralized. Also located there was the burocratic network, the administration of economic practices (directed by a Procurator), and the organization of the imperial cults (of undoubtedly political content regarding both the Emperor and gods such as Jupiter), and of course the judiciary function. Later on, with Caracalla (beginning of the III c.), and definitely with Diocletian (end of the same century), Gallaecia acquires the character of a province, when the empire is already beginning to lose power and the political-administrative organization itself suffered certain loosening.

One of the primary concerns of Rome was to organize good means of communication which would promote the economic exploitation and trade, at the same time as it facilitated the entry and assimilation of new material and ideological elements. In addition to the three routes cited in the Itinerary of Antoninus (the XVIII, XIX, and XX, from Braga to Astorga crossing the Northwest at different levels), there was an entire network of transversal and secondary roads, not always well documented, but of great economic importance and which had an effect on the organization of the territory. This network would now be modified in accordance with the communications and the economic and political needs of the Empire.

The cities (the three capitals mentioned, with supposed but not well proven municipal character, and some others), were the nuclei of a territorial network where the castros themselves and, later, the vici and villae played an important role. The fact that the sign ("Ɔ"), meaning castellum or castro, appears in the inscriptions until well into the IInd c.A.D., may be interpreted as a logical evolution of a social (and territorial) organization of the native communities, which is later used and reconverted by Rome into a new articulation of space, where the interests of administrative and economic control take precedent over the different populi of Gallaecia.

Nevertheless, the tolerance of the Roman dominators regarding the ways of life, customs, artistic and craft manifestations, beliefs and religion (partially) and onomastics, is already considered almost axiomatic in the Romanization of the Northwest. On the other hand, everything relative to the control of the great economic resources, that is, all that is directly or indirectly "profitable," is well taken care of and directed by Rome. A good example of this is the concern for having good public works, basically functional. In Roman Galicia there are no known theaters, amphitheaters, circuses or temples (and only to a small extent public baths), but there are documented roads and bridges (as an example, the still original bridge of the Bibei), lighthouses (Tower of Hercules), walls (Lugo), ports (Bares, A Coruña...), etc.

Parallel to the transformation of the habitat and evolution of the landscape, a series of economic changes is produced: with the broader occupation of the plains (including without completely leaving the castros), agriculture becomes more intensive (without forgetting the role of the pecuario).

The consolidation of trade by new routes (land, sea and even river) acts as an important Romanizing agent, at the same time cause and effect of the new order: the diffusion of Roman currency (very numerous from the third century), the terra sigillata (table pottery), the utilitarian, domestic or religious bronzes, and other materials, set the pattern for this commercial activity.

But it is perhaps in the mining exploitations where we see the change so well reflected: the small gold-extracting industry on river placers (the aureanas (gold-seekers) of the Sil and other rivers) will be followed by a complex network of exploitations in gallery and in open sites over primary gold deposits (on rock) and secondary ones (on alluvial). More than twenty thousand pounds of gold a year (in the first and second centuries A.D.) left for Rome from the regions of the Courel, Fonsagrada, Montefurado and the valley of the Sil, Barbantes and the Astur-Leonese zones (then part of Gallaecia) of Salave, As Médulas and A Cabreira, among other zones of lesser importance. In addition to the purely economic factor, to understand this activity on grand scale we must think of the presence of a military control and Roman engineers, as well as the existence of an abundant labor force settled in the mining castros mentioned earlier and perfectly communicated and related.

Changes are also logically produced in the society. On the one hand, there is a new social element which is Roman (or better, Italic, tied to the militia and/or the administration and which goes from high posts with certain name and prestige (in the provinces) to imperial emancipated slaves, both documented in the epigraphy and, for example, in Lugo. This group, which exercises an active Romanizing influence, directly or indirectly (v.gr. provoking mimetisms as a means of social ascent), is the one which will consume the cultured art and part of the plebeian, always with provincial Roman character.

At their height, the "Romanized" groups (native atistocracy, titled soldiers from other areas of the Empire, etc.) will try, and at times will succeed in, establishing themselves, although only with the relative social mobility of the Galaico-Roman community. To them belonged possibly a great part of the art of the Roman period in Galicia, from the warriors to the funeral steles, that is, the plebeian art tinged with previous or posterior native features and components.

In addition to the slaves, we must consider still another group, possibly numerous, of the native population, which was little or not at all imitative of Roman tastes, anchored in the castros and which perhaps did not have a lasting "Art", only certain elements of lasting crafts (with forms and techniques known to plebeian art). But this may only be more a suspicion than something that con be proven at this time with archeological data.

Finally, there is also an acculturation in the ideological and religious aspects; that is, a syncretism among pre-Roman cults and recently arrived ones, without forgetting that the Indo-European base of both is, to a great extent, the same. The indigenous deities live together with or are assimilated to the classically Roman divinities, including by transposition or apposition of names. Alongside a Bandua Veigebreaeco there is a Mercury or a Mars, Cariocieco, and the Lares Viales appear to assume the role of other indigenous deities and not only those of the roads. This is without citing the placement of certain gods in forms and forces of the physical world.

A separate case is constituted by the cults to the Emperor (mostly political) and Jupiter (as incarnator of the recognition of Roman power by the communities and individuals). We have reflections of this assimilation and importation of cults in the epigraphy, but also in sculpture: the funeral beliefs and cultural and iconographic models are perpetuated in the sculptures and steles (especially "plebeian") and the classical divinities are represented and consumed above all in the form of bronzes of cultured typology.

THE ARTISTIC MANIFESTATIONS IN ROMAN GALICIA

We should approach the artistic manifestations of this period, especially the sculptural, with two previous qualifications: on the one hand, we must speak of art of the Roman period "in Galicia," and not "from Galicia," since in the latter case we would only include the native productions (in a native artistic language), while in the other sense, besides these cities,

we must consider pieces imported, but "consumed" here, and all the others which were made with any plastic language in this particular era.

On the other hand, art here can also be considered "crafts," in the purest sense and the least degenerated of the concept, that is, authors and workers of the image-making trade (or casting or in other techniques), who work by assignment for a certain clientele, which is not always homogeneous, but which lives in a definite geographic and historical context within the Iberian Peninsula.

These concepts, already expressed by Balil in interpretation of Bianchi-Bandinelli for the Galician case, will be combined with the idea (and the fact) of the difficulty of differentiating on many occasions the pieces that are properly Galaico-Roman from those always attributed to the pre-Roman castro culture. Disregarding classicist and Mediterraneanizing aesthetics, Galaico-Roman sculpture is different because its plans and goals are different, with less and less space left for the "ignorance in representing" and more to a taste and demands that are determined by the cultural formation of the clientele which solicits it.

In this way in Gallaecia we find at least two phases of Roman art: cultured art and plebeyan, both within the consideration of provincial plastic, that is, not capitaline Roman, and the second, without any positive consideration at all, but rather only an identificatory one at the social level.

The artistic manifestations of the cultured sort belong to a clientele which wants to resemble the official and aulic Roman world; it is the Roman or Romanized bourgeois world of the cities generally, but not always, foreigners settled in Galicia. It is not a sculpture abundant in stone, but relatively well represented in bronze. This cultured current has an iconographic program and a formal and technical treatment that is to a great extent common to all the Empire, where it is at the service of the same social elite, immigrated or native.

The plebeian artistic productions are for the gentes and incolae (that is, for the non-Patricians or non-"ilustres"), who prefer more accessible themes, closer to their personality and education, without renouncing cultured iconographic programs, interpreted (to what extent by the artist or by the client?) in their own way. These are formed in a specific manner, very marked by the artistic language and by the pre-Roman techniques (carving in wood and stone, metalwork) of the same area.

This provincial art is the most abundant in Roman Galicia and is consumed by both Romans ("adapted") and, above all, by the indigenous groups most permeable to Roman acculturization.

We could still speak, if we knew them well, of another group of artistic (or more accurately, craft) productions which would thus allow us to include the totality of Galaico-Roman sculpture. This would be the Galician art of this period in which the indigenous "substratum" is stimulated and enriched by the formal experience and Roman technique, and which only some definitory elements allow to be assigned to the moment of the imperial domination. This would be the case of the famous warriors, already cited when speaking of the castro sculpture.

As we have been saying, and as in other areas of the Empire, the different artistic productions have a diverse demand and clientele, according to their social and economic position and their "cultural" formation (their own and/or acquired), according to their degree of acculturation to Romanity and their "Romanization" (in spite of the discussion of this term), whether this is original, mimetic or even nonexistent.

At the same time, the social consideration and the integration of the artists/artisans will also vary according to the different classes of artistic manifestation; if the producers of cultured art tend to form part of the workers, sometimes itinerant, singularized within the society, it is possible that authors of more purely plebeian and "popular" works were somewhat more integrated and related to their own clients.

On the other hand, we cannot give the name of any of those authors, anonymous for us except in the cases of an already mentioned Galician warrior and except for the case of the engineer "artists" like the architect of the Tower of Hercules, the Lusitanian C. Sevius Lupus.

Some artistic workshops are better documented. Working in sculpture and fundamentally in funeral steles, we find a workshop functioning in the southern Atlantic Galician coast (between the second and third c.A.D.), and perhaps with its center in Vigo, judging by the

greater concentration of finds in this city. The anorganicism, flat relief, geometrization, the inclusion of scenes beneath arches and other features make it paradigmatic of that Galaico-Roman plebeian art.

Another stele workshop could be localized more to the north and the interior of the country, with a production more tinged with features of the indigenous sort and to which the steles of Ouzande, Paradela, Troitosende and Bermás would belong.

A workshop, perhaps itinerant, devoted to sculpting funeral reliefs, must have functioned in the central zone of Lugo, according to what the findings of Río, Ponte Neira, Vilar de Sarria and even the later one of Adai seem to indicate. The base was probably in Lucus Augusti. In any case, it is a workshop which is familiar with and uses themes and programs that are rather cultured, and which would employ them with varying results in the granite of the region, at a time not before the third c.A.D.

Other workshops known in Roman Galicia are not for sculpture. One of them did mosaics of aquatic theme ("oceanic") and probably acts around the transversal road Lugo-Braga (around the area of Ourense). Another casts and sculpts domestic bronzes and above all for the religious and funeral cult in the southern enclave of Taboexa (As Neves). Beside it, the existence of examples of bronzes imported from Hispanic workshops or even extrapeninsular ones, is evident.

It is not too much to cite here other artistic or craft samples or simply material culture which form part of the Galaico-Roman world.

In metalwork, for example, we have to consider the survival of elements of clear pre-Roman tradition which subsist now and can even be made after the conquest: some torques and earrings clearly fit into contexts that are even late Roman without, as we already said when talking about the Castro Culture, knowing today if they are residual (or votive?) pieces or productions coetaneous to that Romanized context in which they are found.

As far as the stones of rings, there is little singularity in the Galician pieces, which are relatively abundant. The type of gem and setting is the same as that of other pieces of the same sort in the rest of the Empire. The Roman stereotypes were widely spread and although at first must have been of almost privileged use in Gallaecia, later they would become more common objects and appear both in the urban medium and in castros of the rural area, albeit authentically Romanized. But unfortunately, they tend to be pieces of a collection without specific or certain archeological context.

The world of bronzes (sculptural and otherwise) is, as was said, symptomatic of the parallelism of the Northwest with other areas of the Empire, although with its singularities. In any case, they reflect a relatively important commercial activity, some specific religious cults (mostly classical), a particular social organization (the case of the tesserae hospitalis), concrete economic and/or domestic uses (horse bits, candleholders, flasks for balsam, phalerae (armor ornament), etc.), and even some casting techniques already well known (essentially the lost wax procedure).

The mosaics correspond clearly to the cultured and Romanized groups and appear in cities (v.gr. Lucus) and the towns, especially late ones, in the rural areas (A Cigarrosa, Parada de Outeiro, Cirro, Doncide...) or the coast (Centroña, Panxón...), and are indicative of a relatively well off social and economic level.

The same could be said of the remains of stucco painting, except for the singular and unique case of Santa Eulalia de Bóveda, pagan setting of architecture, sculpture and painting from the IVth c.A.D., afterward reused.

Finally, elements such as ceramics (terra sigillata, fine walls) and other domestic or decorative utensils of bronze (fibulas and brooches), glass, jet (rings and beads), etc., are at times halfway between the "industrial" production generally foreign to Galicia, and the production of artisan workshops of very diverse origin and entity.

The exemples

In this exposition there are different samples which exemplify the various forms of Galician art from the Roman period which has been discussed here, and which we analyze in

a global form (vid. their respective bibliographies in the annotations which correspond to each piece).

As was said, the funeral steles are the group of sculpture which possibly best represents provincial and plebeian art in Galicia, although at times it has certain features of indigenism or "popularism." In them, the cultured themes, like that of the duo of Dionysus and Ampelos (in the stele of Vigo) or that of equestrian heroization (in that of Fisteus), receive their own inorganic interpretation, represented by a flat, schematic, geometrizing relief so characteristic of the northwestern part of the Peninsula. This abstract and schematising desire reaches its most important height in some specific workshop or in pieces like those of As Coroas of Reigosa.

The importance of this plastic (and ideological) manifestation is obvious if we think that approximately 80% of the funeral monuments in the three judicial convents of the Hispanic Northwest are precisely steles (of different types) and that in Galicia they are propagated as much or more in the rural medium than in the cities (Vigo and to a much lesser extent, Lugo). Perhaps we must see in this last a relationship or memory of the iconic portraits of the "cut heads," with the warriors or even another type of anthropomorphic figures.

The reliefs, for their part, may be grouped in two large blocks: the funeral and those of a military nature. The funeral reliefs (and here we would include the sitting ones of Xinzo de Limia in spite of being freestanding sculpture) have a clear connotation of plebeian art, but in some of them the theme is semicultured or manifestly cultured. Thus, in the relief with lost epigraph from Río, the flat frontal cut of the figures dominates the fact that they are wearing a sort of togae (as in the stele of Ponte Neira in Lugo). On the other hand, the cases of Vilar de Sarria or Adai, their reverses refer to "classical" scenes and programs, and even in the first of these was considered Neoplatonic. The possible existence of a workshop responsible for this group of works was already mentioned.

Other reliefs are of military nature and thus in some way may be included in the official (and cultured) art, but this is only clearly seen in pieces of marble (like the vexillarium of Lugo), but not in others of granite (the relief of Porta Nova in the same city), where the support must have decisively affected the type of carving and plastic expression (in addition to its poor preservation).

Freestanding sculpture that is not funeral is more than anything cultured and this is not unrelated to the fact that they are sculpted in marble, of very different quality. The comparison of the group of Dionysus and Ampelos represented in the stele of Vigo and the piece of Mourazos is paradigmatic. The head of Venus of Lugo is better preserved. Here Balil cited the influence of wood carving in a piece of marble from quarries of Lugo and which was intended to be exquisite. The curious example of Amiadoso and other pieces not exhibited also enter into this group of cultured provincial sculpture.

Regarding the objects of metalcraft, there is little to add to that already stated. The "standardized" and cultured character of the carving of the rings offers no doubt and we would only have to discern, if this could be done, the social classification of their users, possibly members of the bourgeoisie and Romans at first, later extending among the more plebeian groups, but in any case imitative of the artistic tastes of that other group.

THE PALEOCHRISTIAN WORLD

If we had to summarize in a few lines the fact of the Christianization of the Northwest, we would have to turn to several ideas: Christianization has for a long time been considered of African origin and at times joined to military elements, on the one hand, and apostolic ones on the other. What must be emphasized here is that Christianization is in a certain manner and in certain areas and groups, a phenomenon probably overlapping with Romanization itself (and to Latinization, we might add). Its routes of entry appear to be the same, and its diffusion would be carried out from the most Romanized cities and nuclei (Lucus, Bracara, Iria Flavia, Tyde...), but what is certain is that in the rural medium important Paleochristian cells are also documented, according to the archeological remains cited later.

On other occasions the role of Priscilianism in the character and early organization and

evolution of Christianity in Gallaecia has also been pointed out, and the component of social rebellion, agglutinator of discontents which that moment had, is well known.

What is certain is that, in this context, from the third century on we have information about the Paleo-Christian world in Galicia. In the cities, paradoxically, and in the light of what was previously explained, there are fewer material remains (archeological and artistic) of this type and era than in the rural medium, perhaps because of the continuous successive losses suffered in the urban centers, compensated by a greater abundance, relative to documentation or written references, normally of episcopal themes.

On the other hand, in certain parts of the rural context, still partly of the castro culture, and in an isolated but sufficiently significant manner, artistic or archeological Paleo-Christian elements appear, possibly linked to Roman or Romanized groups (the late potentiores) and of undoubtedly cultured nature, able to an extreme to assign works to Italic workshops (the case of the sarcophagus of Temes).

These elements are situated, on the other hand, in places or regions that seem to be key ones, for example, in the basin of the Sil (important entry route from the plateau of material and ideological influences—Quiroga, Temes—), in that of the Ulla (passageway from the coast to the interior of the country and with recollections of the apostolic legend, —Iria—), or in other points to a good extent neuralgic ones for the network of roads (Castillós, for example).

We will simply refer here to two sites which generally are cited on speaking of the Christianization of Gallaecia: Compostela and Bóveda. In Santiago, apart from the unsolved problems relative to apostolic predication and burial, we must think about the existence, among other things, of a necropolis and a mausoleum of that era without hardly any preserved artistic remains. In Bóveda, to the Roman character of the building and its decoration has been attributed and its decoration has been given an interpretation based on some features (of painting, for example), understood as precursors of Asturian Pre-Romanesque. In any case, the Christian reuse of the monument continues to be almost as "enigmatic" as its pagan function.

We have unique examples of this Paleo-Christian art, some of them in the Exposition. These artistic manifestations are closely linked on the one hand to the Christian funeral beliefs (in particular the sarcophagi) and on the other, to the elements of the liturgy.

The sepulchers belong clearly to a cultured art and context, and in general are imported, either at the time they are made (Temes, at the beginning of the IVth century), or in a later period (Lourenzá, made in the V-VIth century, but brought to Galicia in the tenth century, for which it only has a relative contextual historic value).

The steles, like the Galaico-Roman ones, are tinged with plebeian and "popular" features (in the sense of simple symbols simply carved or cut), and those of the discoid type with cross, represented in Manín or Castillós (probably from the IVth century), and with parallels in all the north of the peninsula until well into the Middle Ages. Another variant are the steles, of anthropomorphic similarity, like that of Tins (with inscription, datable at the end of the IVth century), which was placed in relation to the similar, properly Galaico-Roman pieces.

Among the liturgical elements we should underline the extraordinary piece of A Ermida, in the frontier zone of Quiroga in the Sil, through which the artist (and the poet?, both learned) could have arrived at the beginning of the Vth century to make an offering table in local marble (probably from the neighboring quarry of the Incio). A Ermida is a castro enclave, then very Romanized-Christianized and possibly related to the discoveries of the area, as Penadominga, in a period in which the gold exploitations in the Courel and Sil would have ceased.

The fact that the monogram of Christ in Quiroga recalls the symbolic and decorative motifs in the liturgical patens can serve us as a link to speak of the continuity of certain Galaico-Roman and Paleochristian artistic variants during the Suevo-Visigothic era. Using those old traditions, but with new stimuli of Germanic roots (very visible in the elements of objects of art), we will find the reliefs of As Saamasas (VI-VII c., with Palestinian and/or Ravennic themes "readapted" by local masters who recall the carving of the steles but now in marble), or liturgical (like the paten of Sarria) and utilitarian objects (like the bronze of Baamorto), also from the VI - VII century, as a starting point, one of those possible, for Pre-Roman art in Galicia.

1

Idols from Dombate

Middle of IIIrd Millennium B.C.

First: granite; second: boulder of indeterminate
composition
First: 325 x 108 x 63 mm.;
second: 100 x 75 x 47 mm.
Megalithic monument from Dombate. Cabana
(A Coruña)

ARCHEOLOGICAL AND HISTORICAL MUSEUM.
A CORUÑA

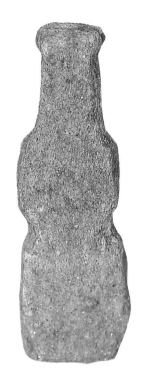

The Megalithic monument of Dombate is a
good representation of the height of the megalithic
culture that evolved in Galicia. Its internal
Megalithic structure is formed by a polygonal
chamber of seven orthostats, one of them with a
height of 464 cms., and with a corridor of three
sections. Some slabs of the chamber have
engravings and all of them, in the chamber as well
as in the corridor, have pictorial remains. This
Megalithic structure is integrated into a tumulus of
irregular shape, some 22 m. in diameter
constructed with dirt. Its surface is covered with
an armor of more or less imbricated stones, and the
perimeter is delimited by larger flat stones placed
horizontally. The tumulus and its armor are
interrupted across from the door of the corridor,
leading to an uncovered, paved passageway with
small, well-packed stone. At the outside limit of
this corridor, complementing the perimeter of the
tumulus where the armor was interrupted, there is
a row of twenty small idles of different types and
materials, set in vertically, of which seventeen
were in situ and the other three, moved a short
distance away.

In the northern part, the tumulus of Dombate
makes use of the remains of a previous monument
of smaller size, composed in turn by a chamber
and tumulus. This fact, as well as the architectural
complexity of the monument and the
characteristics of the disinterred objects, lead us to
consider its dating in periods posterior to the
beginning of the Megalithic age in Galicia.

The existence of small idols within the group of
objects typically in the Galician aisle megaliths
was already known, since they had appeared in the
Cova da Moura of Argalo (Noia), in the Mina da
Parxubeira (Mazaricos), and they had appeared on
the surface in the monument of Axeitos (Ribeira),
all of these in the province of A Coruña. On the
one hand, the interest of the group of idols of
Dombate lies in the appearance of new types,
unknown until that time in the archeology of the
peninsula, as is the case of the two presented here.
On the other hand, it lies in their almost complete
position in situ, forming the threshold of the
monument, which suggests an apotropaic and
defining purpose of the interior and exterior
worlds in relation to the sacred funeral space, and
it seems to indicate a non ritual mission, which
transcends that of simple placement of remains,

becoming a new structural element integrated into
the complex architecture of the height of the
Megalithic age.

In the conception of its overall form, idol
number 1 recalls the type II-F of Almagro Idol,
frequent in the peninsular southwest, also with
great differences, the most obvious being the size,
which here is much greater. Still, the
Mediterranean echoes are clear: the overall
schematized anthropomorphic form, with oblique
head, long neck, arms over the chest and the
indication of a waistline, already appears in the
ancient Megalithic of Greece (Attica) and Cyprus
(Kirokitia), and continues in later periods (recent
phases of the eponymous discoveries of Seskio-

Dimini, Grotta-Pelos, etc.), but it is not an
importation, which we do not at all mean to
suggest. In this case, the use of granite clearly
reveals its creation in the same area.

Idol number 2 is done on a boulder, also from
the area. The use of boulders as idols becomes the
norm for the Galician megaliths with corridor, but
the motif engraved here with punch-dots is not one
of the most frequent (simple oblique openings or
incisions in the upper third of the piece), and
although it also suggests Mediterranean
reflections, it has much closer parallels in
geographical areas that are nearer. The hatching
on the front side appear repeatedly in the plaque
idols of the southwestern peninsula (Llano de la

Idol from Parxubeira
2500-2000 B.C.

Amphibolite
125 x 95 x 65 mm.
Parxubeira. Eirón, Mazaricos (A Coruña)

ARCHEOLOGICAL AND HISTORICAL MUSEUM.
A CORUÑA

Idol on boulder, with irregular form, between elliptical and rhomboidal, and with oval section. It has engravings of narrow, rough lines, two or three grooves on each side of the two surfaces of the piece. The engravings are on the upper part, in the form of oblique lines set opposite each other; they define an idol with a possible anthropomorphic nature.

It appeared along with seven other idols, set in a row, at the foot of a prehistoric burial site, facing the entryway to the corridor of the dolmen which the site contained. It formed part of an atrium type of structure, complementary to the burial site, for which it we may attribute a cultural significance to it in relation to the world of the dead. These idols thus have an imprecise function, possibly of divine protection, but clearly related to the funereal ideological environment. This context, achieved by valuable field work, situates the piece in the advanced stages of the megalithic phenomenon. The dolmens of developed forms and at times large size seem mostly to correspond, according to the few facts we have at this time, to the second half of the third millennium B.C. at a time of strong push from the communities settled in the Northwest, with an important implantation of cultural characteristics from the southern Iberian peninsula, and which can already be considered Calcolithic in that the presence of metal among them seems to be visible.

Relationships with the southern peninsula are also verified in the ideological field, precisely where we will try to find the formal parameters for an idol like the one we are analyzing, which lacks specific parallels in its geographical area. Thus, in its formal aspects it recalls betyl idols of irregular shape, while the designs seem to point to other iconographic formulations, which, like some types of plaque idols, attempt to provide an anthropomorphic representation, especially present in the definition of the upper part of the body: differentiation of the head and thorax, marking the shoulders and/or a particular type of dress with certain symbolic connotations.

The ambivalence when defining this idol within the typological variety of the southern peninsula leads it to be identified as typical of the northwestern area. Although, as we already indicated, there are no examples that may be integrated into the same type at this time, there are formal and technical elements that place it in broader taxonomical classifications, as a family

Lámpara-Almeria, Montefrío-Granada) and in the south and center of Portugal: Montum (Melides), Jazigo de Alcarapinha (Elvas), Indanha Nova (Algarve), Comenda da Igreja (Alemtejo), etc. This argument reinforces the idea, always intuitive, that the Megalithic phenomenon arrives in Galicia from Portugal, increasing the growing number of analogies, both structural and material, not only with the North of Portugal but also with more southern zones such as the Beiras or Alemtejo.

In both cases it seems to be a reinterpretation, using different local materials, techniques and formal conceptions, of exotic stimuli from further south and the Mediterranean. The emphasis on

this link in a world which is often conceived of as purely Atlantic, at the same time as the peculiarities of the Megalithic group of the peninsular Northwest, as well as what it means for the increase of our knowledge of the ritual aspects of the Megalithic phenomenon, are points of interest which these little idols offer, in addition to the fact that idol 1 is perhaps the first manifestation in Galicia of freestanding sculpture that is clearly anthropomorphic.

(J.-M.B.D.)

BIBLIOGRAPHY
Unpublished. In press by X.M. Diéguez.

or species, and to interpret it following criteria of local revision of foreign models. This is seen in its undoubted convergence in form and, to a certain extent, in technique, with the idols of the type of Argalo-As Forcadas, from which it would only be distanced by substituting openings with lines; this appears to suggest an advance, or simply a mutation, in the figurative field. A possible reflection of the confusion and/or iconographic evolution between the two models is offered by an idol of Dombate, seen in this exposition: an idol on a boulder which substitutes lines for openings, but which to a great extent preserves the figurative scheme.

(J.S.O.)

BIBLIOGRAPHY
Rodríguez Casal, A. (1988).

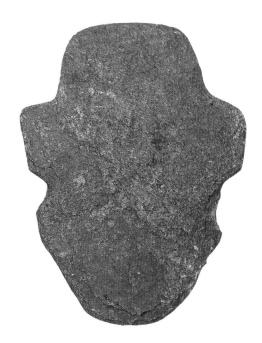

3
Idol from Parxubeira
2500-2000 B.C.

Granitic gneiss
420 x 320 x 50 mm.
Parxubeira. Eirón, Mazaricos (A Coruña)

ARCHEOLOGICAL AND HISTORICAL MUSEUM. A CORUÑA

Idol based on a stone plate of irregular section. The upper part is convex, with a flat end, and stands out from the rest of the piece. In the middle part are small arms indicated by a shoulder and basal openings which separate them from the convex lower end with a pointed termination.

Its contextualization is identical to that of the other piece in this exposition: at the foot of the entry to the dolmen A Mina da Parxubeira, forming a group with seven other idoliforms. We refer to the commentary about the other piece as far as chronology, the second half of the third millennium B.C. and function, related to the funerary world. This idol, in contrast with the other, is not unique, but rather expresses a morphology which affects a total of four representations of this type.

The basic separation between both pieces is nevertheless a formal one. The separation may be extended to the rest of the idols that we know up to this time in all the Northwest. Thus this piece is, together with the other three from Parxubeira that are similar, a type of idol that only appears in this dolmen. It could be characterized by a cruciform appearance, with flat section and larger dimensions than in the other known types.

Understanding its special configuration means referring to models of different but related cultural parameters. Because of its simplicity and above all the use of openings, its creation seems related to the most frequent idol in the Northwest, that of Argalo. The form is related to the cruciform idols of the peninsular South, thus appearing to resemble, like the Argalo type of idols, the others of the Parxubeira type, with the influence of the strong cultural centers of Mediterranean affiliation in the southwestern peninsula and central Portugal. Nevertheless, its dimensions distance it from Megalithic idols in general, and lead it to be associated with later cultural expressions, like the steliforms of the early part of the Bronze Age.

The explanation of this fact is still not within our reach. We can only identify the piece with a reply to influences/presences of the Mediterranean environment, perhaps in this case with a more advanced chronology (Ca. 2100-2000 B.C.). In this sense we must note the difficulties in establishing a temporal relationship among these pieces and the use of the megalithic as a funeral site, which goes from its construction to an indeterminate moment, around 2500 B.C., to the presence of the campaniform (Ca. 2000 B.C.).

(J.S.O.)

BIBLIOGRAPHY
Rodríguez Casal, A. (1988).

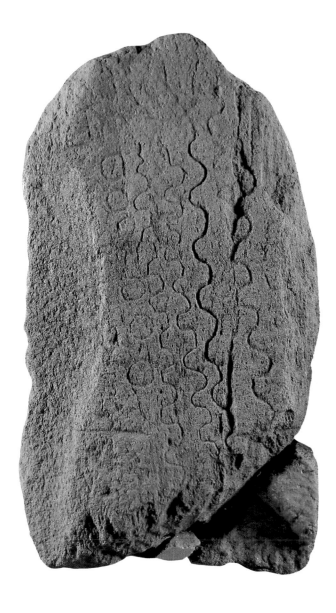

and expressions from Calcolithic horizons of the southern peninsula.

This case is surprising because of its relationship, as already indicated, with a probable settlement which also presents an ergology that is homologous with the already-mentioned megaliths. There are materials, especially ceramics, which certify a clear relationship with the center of Portugal and the southern peninsula in general, at the same time as a chronology centered in the second half of the third millennium B.C.

In those Mediterranean areas of the peninsula we find the formal referents of the idol of the Argalo-As Forcadas type. Undoubtedly it is the El Garcel type of idol, with a similar if not identical morphology, which introduces our form in a Mediterranean trend which has its distant prototypes on the eastern shore of that sea.

(J.S.O.).

BIBLIOGRAPHY
Unpublished.

5
Barrow from a Braña
IIIrd millennium B.C.

Micaceous schist
98 x 60 x 30 cm.
Dolmen of A Braña. San Paio de Refoxos, Silleda (Pontevedra)

PROVINCIAL MUSEUM OF PONTEVEDRA

Slab 2 is one of the several decorated elements which comprised the dolmen chamber destroyed by agricultural tasks in a field at one end of A Braña in the parish of San Paio de Refoxos (Silleda, Pontevedra). This funeral monument, known as the barrow from Portacanizo, is an example of a large necropolis with as many as twenty seven burial sites, none of which has been sufficiently explored from an archeological point of view.

The barrows, mounds of earth which surround a dolmen chamber, suffered a strong pressure which led to the destruction of many of them, as much due to the slow intensification of agricultural activity as to the intentional searches, especially those arising from the news of discoveries of a metal piece, or even due to the incidence of the conquest of America, since the treasures of the indigenous peoples hidden in tombs, which some associated with the barrows, motivated a systematic attempt to explore that is in the origin of the controversial argument set forth by the scholar Vázquez de Orjas in the middle of the XVIIth century.

This stone is a slab from the funeral chamber of the collective burial site which preserves one of the first testimonies of artistic activity in Galicia. It formed a decorative arrangement with other slabs of

4
Idol from As Forcadas
2500-2000 B.C.

Granitic gneiss
231 x 155 x 73 mm.
As Forcadas (Pontevedra)

PRIVATE COLLECTION

Oval boulder with very flat elliptical section. There are two openings on either side at the high part of the piece, the upper two joined by a groove which runs across one of the surfaces. It was found in 1977 by José Suárez Mariño along with campaniform and pressed-incision ceramic pieces and triangular arrow heads, probably remains of a settlement along the estuary of Vigo.

This piece corresponds to a type of idoliform of simple morphology, which today seems to be the most frequent in Calcolithic contexts of the Northwest. It appears associated with dolmens with corridor, such as that of Argalo, chronologically placeable around 2700-2600 to 2300-2200 B.C., and from the cultural perspective in which it may be interpreted as a Calcolithic facies, in compliance with an ergology which seems to consider the existence of metal, or at least, evident influences

the same chamber. The engravings show five central undulations, surrounded by a row of circles of different sizes to the left and four—three incomplete—on the right. On the upper part there is one similar to a sun which is linked to the wavy lines.

The decorative panel which has formal similarities with other decorated slabs of Galician dolmens, has elements in common with all the Megalithic cultures of the Atlantic land's ends. We can only venture interpretive hypotheses as to its meaning such as those which link the undulations to serpents or waves of water. The circle with rays is associated with the sun. Such relationships allow us to suggest possible beliefs in ideas of fertility and renovation associated with the funeral cult.

However, although their number is growing through new 'finds and investigations, we should point out that quantitatively the engravings preserved are few—barely fifty—if we compare them with the quantity of megalithic funeral monuments that are catalogued.

The chronology attributed to these artistic manifestations includes the third millennium B.C. and even is prolonged into the beginning of the second, with the survival of the use of decorative systems on the slabs of the funeral cists of the first stage of the metal-using cultures, which substitute the collective burial sites of this period, begun in the fourth millennium, as is revealed by an ever greater number of absolute datings by Carbon 14.

(F.F.B.)

BIBLIOGRAPHY
Carballo Arceo, L.X.; Vázquez Varela, X.M. (1984); Filgueira Valverde, J.; García Alén, A. (1977); García Alén, A.; Peña Santos, A. de la (1981).

6
Engraved Stele from Poio
2500 B.C.

Granite
210 x 66 x 30 cm.
Area near the Church of San Salvador of Poio
(Pontevedra)

PROVINCIAL MUSEUM OF PONTEVEDRA

This granite piece served as a sepulcher cover for a medieval tomb of stone slabs in the necropolis that existed in the area around the Church of Saint Salvador of Poio, discovered as a result of the renovation of the atrium. This led to the archeological excavation of recovery, during which several burial sites are identified. In one of them, serving as an inscribed tombstone, this piece appeared with the smooth part visible. The surprise came when it was taken out and it was seen that it had an interesting decoration on the hidden side.

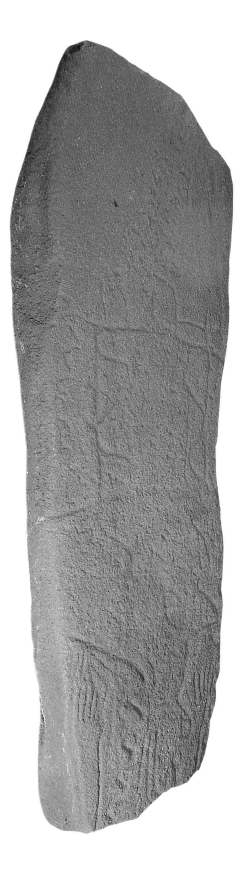

The geometrical decoration of wavy lines, the anthropomorphic figuration and other decorative elements of difficult interpretation which complement it, lead us to link the stele to the representations which appeared in the vertical stones of the Megalithic chambers, rather than with the decorations of the menhir steles, because of the formal fact that the latter have a general anthropomorphic configuration which the slab does not have, in spite of the fact that its adaptation for a tomb cover of a sarcophagus meant the breaking of the upper portion—although not to a great degree—and also that of the lower part, and modified the general appearance of the piece. Fortunately, on the sides no similar cut marks are visible.

The decoration combines incisions and picket marks, such as that on top of the anthropomorphic figure. This is recognizable by the features of the face, schematized but clear, the general configuration of the body in a squared shape, although it is linked to the two wavy lines that are extended to the low part, where there are other figures, which we cannot interpret accurately.

The symbolic importance of these representations is hardly univocal and we cannot advance beyond the simple hypotheses of the effort to relate it to the cult of the dead which develops in the collective burials represented by the Megalithic chambers, such as that we suppose this piece to belong to and which could be any one of the many existing in the

Megalithic necropolises documented in the region of the medieval necropolis where it was found.

(R.G.G.- L.)

BIBLIOGRAPHY
Gimeno García-Lomas, R.; Perles Fontao, J.J. (1990).

7
Idol from Paredes
1700-1400 B.C. Early/ Middle Bronze Age

Granite
22 x 16 x 22 x 4 cm.
Paredes de Abaixo, Paradela (Lugo)

PROVINCIAL MUSEUM OF LUGO

Anthropomorphic representation schematically engraved on stone plate, nearly rectangular with flat section (notice the lesser thickness). The figure is defined by a series of more or less straight linear marks which appear to adapt to the morphology of the base and which may be interpreted as the

representation of clothing, completing the schematic human face on the upper part of one of its surfaces. A slash on the base part was interpreted by one author as the expression of the female character of the idol.

It is difficult to provide a chronological and cultural reading of the piece, unique in the repertoire of figurative representations of prehistoric peninsular art; if we focus on formal attributes we find an interpretive tradition generated by its uniqueness.

In the possible Megalithic or tumular context, the piece was found in an area of prehistoric burial sites, and a very short distance from one of them (2 ms.); its flat shape and even its dimensions remind us of idols of steliform appearance from the dolmen of Parxubeira (a relationship already discussed when commenting one of these idols). Nevertheless, we cannot forget the lack of knowledge of the precise context: the relationship of the idol to the funeral structures; the chronological and cultural breadth of the tumular phenomenon, which transcends the Megalithic to be assigned to post-Megalithic funerary phenomenologies of the late Calcolithic, Early Bronze and, perhaps, later periods of the Bronze Age; finally, a fundamental difference between the piece from Paredes and those of Parxubeira, such as the relationship between figuration and base, since while in the latter they are equivalent, in Paredes the base is part of a representation which was transferred or imprinted through the engraving.

This conceptual feature, besides clear similarities in the motifs and the engraved composition, is related to the idol of Paredes with anthropomorphic representations, which either separate, as the Portuguese steles of Crato and Nossa Senhora da Esperanza, or painted or engraved on rocks, as in the case of the idol of Peñatu in Asturias, seem to have a clear placement in the Bronze Age, although there is no agreement as to a precise chronological assignment: one tendency situates it in the height of the Bronze Age (1500-1200 B.C.), but we think that a dating somewhat earlier than this is better—the middle and late centuries of the Early Bronze Age (1700-1500 B.C.)

The possible evaluation of the stele-idol from Paredes does not end here, since another feature based on the relationship figuration-support again distances these pieces conceptually from those of the Early Bronze Age. It would mean the expansion of the engraved motifs on the entire base stone, and the parallel usage of its shape in the iconographic objective being sought. To a certain extent this active role of the base again recovers the first relationship proposed (Paredes and Parxubeira), at the same time as it makes us to look at steles of the anthropomorphic type from late and final periods of the Bronze Age (Late Bronze: 1200-700 B.C.)

In summary, to culturally interpret the morphology of the stele-idol of Paredes confronts us with an interrelationship of formal and conceptual characteristics which point in different directions, but none of these seem definitive. We can only conclude by stating some hypothetical notes in regard to the cultural heuristics. Since the

dimensions and figuration seem to reject the last relationship proposed (Paredes and anthropomorphic steles from the Late Bronze Age), we would have to give this piece an autochthonous reading which would have its explanation in the evolution undergone by forms of the High Calcolithic (Parxubeira) in the new ideological and artistic environments of the beginning of the Bronze Age (Peñatú, Crato...). Thus there would be continuity: the tumular context and active role of the base in the configuration of the idol, and discontinuity: a new way of understanding the figuration, both in the elements which comprise it as well as in the final result. An interpretation of changes and continuity in the symbolic and artistic features starting with a geographically defined cultural behavior.

<div align="right">(J.S.O.)</div>

BIBLIOGRAPHY

Bueno, P.; Fernández, M. (1980); Jordá Cerdá, F. (1978); Vázquez Seijas, M. (1936).

8
Torso from Armeá
Ist century A.D.

Granite
70 x 55 x 18 cm.
Castro of Armeá. Allariz (Ourense)

PROVINCIAL MUSEUM OF ARCHEOLOGY
OF OURENSE

The torso was used as a cover for a little stream in the castro de Armeá. It was previously on the edge of the balcony of a house in Outeiro da Laxe.

Torso of a Galician warrior cut off below the waist. It is known that the head was lost in this century when it was reused to cover a channel of water. The abrasion on the back must have been made by the sae water and perhaps by piling tools on it. He is wearing a shirt with short sleeves, armlets, caetra, belt and a parazollum sword at the chest, which relates it to a piece from Refojos de Basto (Portugal).

The Galician warrior icon caused abundant bibliography since the last century, when the statues from Meixedo, Lesenho, Basto, Fafe and Vizela, all in Portugal, were found, which is not strange when we consider Martins Sarmento's work and his relationship with Hübner. In view of the inscription of the statue from Meixedo, these authors did not hesitate to place them chronologically in the Ist century A.D. and to consider them funeral. Others think that they were boundary statues or tutelar divinities of the cities. They were related to the Greek funeral statues. It was said that they were eponymous heroes, godlike heroes, protective spirits, votive honorary pieces, representations of a warlike god, funeral monuments erected to castro soldiers in the service of Rome, consecration of the war activity and representations of princes. As for the chronology, they are pre-Roman for some authors, for others Roman and a few hold that they are pre-Roman but they continue to be made in Rome.

According to what is known today, all the statues found in a concrete context or that they can be assign to a specific castro, as in the case of the torso of Armeá, belong to the Ist century A.D., which at first impression could seem shocking. In our opinion, these pieces were made under the Roman dominion at the moment of the greatest development of the castros, and Rome not only permitted them, but even inspired and promoted their construction because it fit its plans for assimilation. We refer to the text in which the meaning of the Galician warriors is explained as a clear case of collaboration with Rome.

The statues that appear in pairs in the same

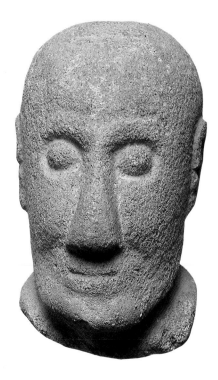

It is a head of good quality in which the artist tries to carve carefully all the anatomical elements. The big and very protruding eyes are framed by the respective lines of the frown; the prominent wide nose stands out from the plane of the forehead; the cheeks are symmetrical and softly rounded; the mouth closed and the lips marked; the jaws well represented; anatomically well formed ears; hair marked in the back and torques on the neck. Despite the decontextualization of the finding, we do not hesitate to assign the piece to the Galician-Roman period, considering that the place of Rubiás is located in the homonymous castro where, besides carved stones, a little bronze eagle, a capital and an inscription to Trajan were recovered. A secondary route of Roman road XVIII went through there, which started from the near Aquis Querquernis mansion.

We are certain that it is the head of a Galician warrior, but we are not going to give an interpretation of it, since we do this with the piece from Armea, included in this catalogue. What is interesting now is to follow the history of this sculpture. The first reference to a stone human sculpture in the castro of Rubiás is that of Castellá (1609) who carries out a perfect description of a Galician warrior and says that there was an inscription on the shield ADRONO/VEROTI. F. Huerta y Vega takes it up again in 1733 and Ceán Bermúdez repeats it in 1832. Everything is clear up to this point, Castellá sees a statue dedicated to Adrono and the same is said two centuries later, but in 1898 López Ferreiro publishes a document of Odino from the year 982 in which Saint Comba is donated to the monastery of Celanova and, on establishing the limits, an "efigiem hominis sculpta in petra" appears. Cuevillas who does not know the document, places the castro of Rubiás on the Monte das Neves in Celanova and says that the "Adrono" appeared there. Bouza, unacquainted with the area but not with the document, mentions the mistaken localization of Cuevillas and notes that this "efigiem" must be the one mentioned by Castellá. In 1935 the Provincial Monument Committee of Ourense discovers the true castro of Rubiás and finds the head, which immediately is associated with the "Adrono". Three years later Cuevillas and Lorenzo write an article in which they try to show, contrary to Bouza, that the "efigiem" of the Xth century and the "Adrono" of Castellá cannot be the same statue, since the first one was in an open field and the second inside the castro. Poor argument since from the year 982 to 1609 might have been moved. Summarizing all that has been previously said, we have to conclude that we do not know if there were three statues (the "efigiem", the "Adrono", and the head of Rubiás) or if the "efigiem" was taken to the place of Rubiás, later cut and today only the head remains.

(F.C.L.)

finding are already numerous, which is explained by their placement at its entrances, and the torso discussed here also has a parallel in another piece, much more mutilated, of the same origin and present-day site, with which it was paired in the balcony of a house in Outeiro da Laxe.

(F.C.L.)

BIBLIOGRAPHY
Conde-Valvís, F. (1950-51); López Cuevillas, F. (1951) (1953); Taboada Chivite, J. (1965).

9
Head from Rubiás
Ist century A.D.

Granite
30 x 20 x 30 cm.
Rubiás. Bande (Ourense). Found during the official visit of the Provincial Monument Committee of Ourense

PROVINCIAL MUSEUM OF ARCHEOLOGY OF OURENSE

BIBLIOGRAPHY
Bouza Brey, F. (1932); Castellá Ferrer, M. (1609); López Cuevillas, F. (1951) (III)

10
Torso of warrior
Ist century A.D.

Granite
18 x 20 x 15 cm.
Castromao. Celanova (Ourense)

PRIVATE COLLECTION. MR. JOSÉ LUIS
REGUEIRO. (CELANOVA, OURENSE)

This piece, fragment of a statue of a Galician warrior, smaller than life size, which relates it to that of the castro of Saint Adega, was found by the owner in the wall of the properties that are located in the low part of the finding of Castromao.

It is part of a torso of the warrior, that includes from the neck to the chest, where the upper part of the caetra—the rounded shield of the inhabitants of the castros that the warriors display frequently—is seen. The torques is clearly noticed with its pear-shaped ends, as are the openings shaping the dress. The arms are broken almost from their base.

Typologically it is a representation of the most well known "warriors", with the additional interest of its configuration and of its appearance in the lower parts of a castro such as that of Castromao. This archeological site offered important findings along the excavations done there. These findings allow us to establish a period of residence in the castro area from the VIth century B.C. (the older radiocarbon dating reaches the second millennium) until the IInd century A.D., when it was a Roman city already, named COELIO-BRICA, documented in the text of a tessera hospitalis on bronze dated in the year 132. The Roman city extended over the lower parts of the hill where the castro and the successive terraces toward the west are.

(F.F.B.)

BIBLIOGRAPHY
Unpublished.

11
Head from Ocastro
Ist century A.D.

Steatite
23 x 12 x 10 cm.
Found in the slopes of the area of Ocastro.
(Silleda, Pontevedra)

PROVINCIAL MUSEUM OF PONTEVEDRA

In the context of the castro art there is a singular group formed by heads of high relief or faces in relief from the castros of Armea, Barán, Cortes, Santa Iria, Monte Mozinho, San Cibrán de Las, etc.

This piece stands out among them , not only for its good preservation, but also for its simplicity of features, with a typical face of those called visage de chouette, and for having the tall neck rest on a pedestal or polyhedral pillar of rounded peaks. The artist suceeds in shaping the expression of a human face, indicating only the defining planes and communicating them a vividness that makes us think of works that range from cubism to the present material tendencies.

In analogy with the French Mediterranean world it was thought that the heads fron the Northwest depicted trophy-heads or "têtes coupées", just like those from Entremont, Bringasses (Les Baux), etc.. They wonder if they were apotropaic, moulds for funeral masks or images, faces of the dead in the Roman style, bodiless gods, idols and even fetishes. All these interpretations were always made from the perspective of the northwestern Celtism and looking for a link with the literary data and artistic similarities of Gallia. At the same time that in the castro area more pieces appeared, others were found in Andalusia (Cerro Salomón and Aroche), Barcelona (Sant Martí Sarroca), Cáceres (Plasencia), Levant, the Central Plateau... as well, in other words, all across the Peninsula. And, now the Galician pieces, which already have become a thing of reality, will be the ones that shape the rest. But never was there an effort, maybe because of inertia, to study our pieces in their own context. We can say that the few that appeared in a concrete archeological milieu take us inevitably to the change in the period or Ist century A.D. , at the moment in which the boom of the big castros with Roman influence takes place. In this new perspective similarities are found with the same chronology and funeral function through the Roman world from Chiusi to Baelo Claudia; this is why we

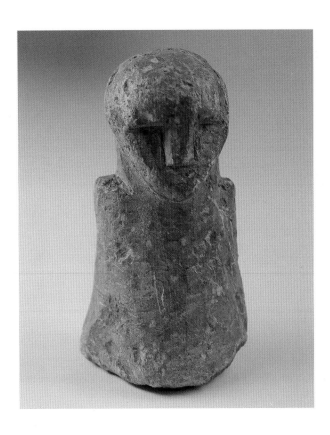

believe that this head from Ocastro, like the other ones from castros, has the same funeral art, and to insist upon a pre-Romanism or/and Celtism is out of place.

(F.C.L.)

BIBLIOGRAPHY
Blanco Freijeiro, A. (1956); Bouza Brey, F. (1951); Carballo Arceo, L.J. (1986); Taboada Chivite, J. (1965).

12
Hinge from Armeá
Ist century B.C. - Ist century A.D.

Granite
23,5 x 13,5 x 7,5 cm.
Castro of Armeá. Allariz (Ourense)

PROVINCIAL MUSEUM OF ARCHEOLOGY
OF OURENSE

In the discoveries of the southern subarea of the Castro Culture many pieces of similar form may be found, decorated or not, and which could have different functions. They all receive the generic name of hinges and have a circular form at the end of a carved or simply smoothed arm, which would be set in a wall. The circle may be perforated or not; in the second case the use would supposedly be as a hanger, while those which have a hole offer two variants of the same: plain circular or circular on the ends and square in the center of the piece. We suppose that the functions would also be different. The few that have been found in situ were placed either on the outer side of a wall or on the inside, in areas considered to have been animal stables or indefectibl,y because of the circular part, they were in a vertical position in relation to the ground. It is possible that some were true door hinges, but the majority would be hitching points for animals or, placed in pairs at a certain distance, supports of horizontal sticks to hang something.

The Armea hinge was found broken, but it is the one which has the most complete and varied decoration of all those known. On the curved face is a Grecian fret slogan, unusual in the decorative grammar of the castros, more given to curved lines than angles, and on the other side it has signs of decoration, but the motifs cannot be distinguished. It is obvious that this type of pieces repeats, as scheomorphus, the metal rings.

As a curious note, we may point out that the archeologist who discovered and published the piece from Armeá only saw the frontal frets, without noticing the braiding on one of the side surfaces.

(F.C.L.)

BIBLIOGRAPHY
Conde-Valvís, F. (1950-51).

13
Seated figure from Xinzo de Limia
Ist century A.D.

Granite
67 x 40 x 50,5 cm.
Found near the old nucleus of the Vila de Limia
(Ourense)

PROVINCIAL MUSEUM OF ARCHEOLOGY
OF OURENSE

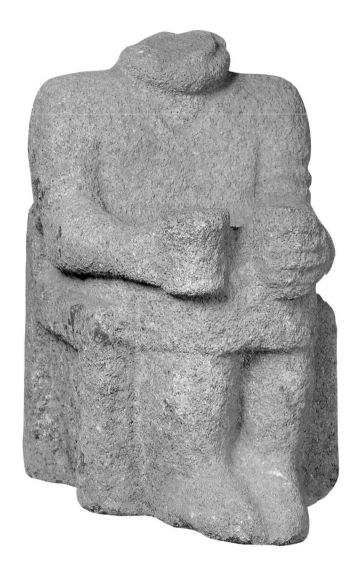

It represents a figure missing the head, with a torque in the opening of the back part of the neck. It is seated in a board chair, with legs and back well represented and finished in two cone-shaped trunks with rounded peaks. The dress and viriae of the arms are identical to those of the Galician warriors, and in its hands it holds two glasses in the position of offering. Beside this piece another very similar one was found, although more poorly preserved, which differs from this one because instead of glasses it appears to hold a patera or maybe a cartouche. In the Northwest there is a third piece from the castro of Lanhoso (Portugal), with similar characteristics but much smaller and with much less detailed design. This last piece has a hole dug in the lower part of the chair.

In spite of the fact that the piece from Lanhoso has been known since 1940 and those from Xinzo de Limia since 1972, they have inspired little bibliography. The most that was said of them is that they must be divinities or characters which honor an indigenous or Roman deity. We ourselves (in collaboration) proposed a funeral character in relation to Hispano-Roman funeral steles and with influence from the South, of the type of the Lady of Baza, but we especially insist on the idea that it was a representation of Matres. Acuña sees similarities with works of Magna Grecia and the Iberian world, and Rodríguez Colmenero thinks that the one discussed here is masculine and the other one from Xinzo feminine and compares them with the 'mother-goddeses', although he does not discard the fact that they may be offerers related to the seated Iberian figures. Silva believes there is a relationship of the funeral cult to that of the 'mother-earth' and Tranoy, without rejecting the funereal or offering character, believes that they would indicate a sanctuary. For Rodríguez Colmenero and Tranoy one of the pieces from Xinzo is male and the other female, while for Silva all three are female. All the authors agree that, in view of the material associated with those of Xinzo, they are works with Roman chronology.

For us, because of the definitory absence of anatomical features and because of the clothing and adornments—armlets, torques—contrasted in the Galician warriors, there is no doubt that these are male representations. The theme is Mediterranean; all three are from the Roman period (in principle I-IV century A.D.); the hole in the base from those of Lanhoso makes us think that it had the function of a funeral urn, and if we consider that after the beginning of the second century A.D. burial begins to be used and that the clothing of the figures from Xinzo, identical to that of the warriors, is typical of the first century A.D., we do not hesitate to say these are three works with funeral function done in the first century A.D. under Roman dominion.

(F.C.L.)

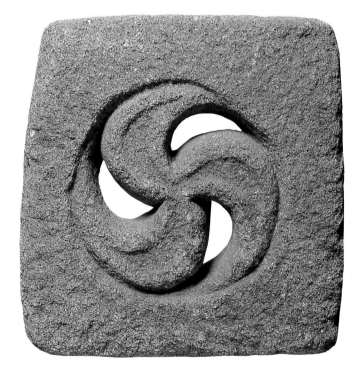

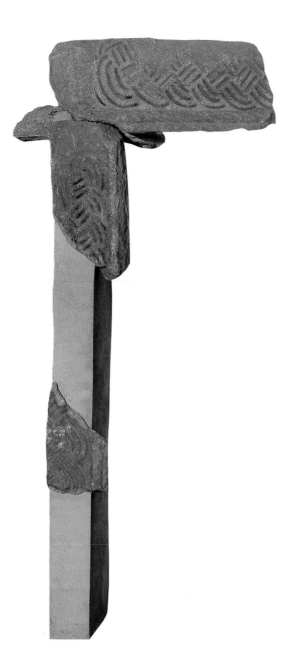

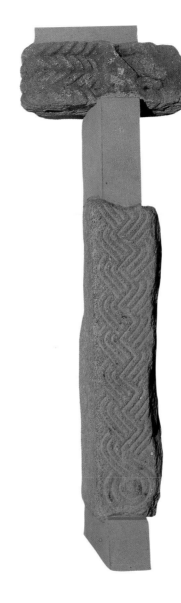

This type of decoration was interpreted as the solar or heavenly movement, and it has even been said that it is the representation of day and night, according to whether the rays swirled to the right or to the left. We are not concerned with this at this time, since our opinion is that when the castro stone-cutters decorated their houses in this way, they used various symbols, but already with no other value than the purely ornamental. We justify our theory in that these pieces were made in the Julius-Claudius period and then appeared reused as building material, even in roads and with the decoration indistinctively on the outside or inside, already in the same first century A.D., in the period of the Flavii. If they had a religious-symbolic importance, the castro inhabitants would not destroy them a few years after they were made.

As parallels to the Castromao piece we may cite two in Santa Trega, two in Briteiros, two in Santa Luzia and very possibly one in Armeá.

(F.C.L.)

BIBLIOGRAPHY
García Rollán, M. (1966) (1971).

15
Architectural decoration from Santa Trega
Ist century A.D.

Granite
Jambs: 105 x 44 cm.;
Threshold: 76 x 32 x 40 cm.
Castro of Santa Trega. A Guarda (Pontevedra)

MUSEUM OF THE CASTRO OF SANTA TREGA

Both stones, together with two smaller ones and two hinges, were mounted in the Museum of the castro in an attempt to give the idea of a door. The reconstruction was frankly unfortunate, both because of its different carving techniques and because of its placement. What is of interest are the pieces themselves, independently of the present placement. The first offers us a basketwork or interwoven motif in zig-zag which grows out from a circle surrounded by two plain parallel semicircular moulding that harmoniously develop into three and cover the surface of the piece forming the theme. The second, also decorated with basketwork motif, is framed on one side by a torsade and plain rebate moulding. The stone was cut longitudinally, with part of the carving disappearing.

In the Galician castros of the convent of Braga there is a decoration as rich and varied as in the neighboring ones of Portugal, but we did not have the good fortune to find remains of decorated doors as well preserved as those which can be seen in the Martins Sarmento Museum of Guimarães, which come from Briteiros and Ancora. We must note that these doors are to a large extent reconstructed in

BIBLIOGRAPHY
Fariña Busto, F.;Calo Lourido, F., Acuña Fernández, P. (s.d.) (G.E.G.); Ferro Couselo, J. (1972); Rodríguez Colmenero, A. (1977).

14
Open-work triskel from Castromao
Ist century A.D.

Granite
45 x 46 x 11 cm.
Castro from Castromao. Celanova (Ourense).
1966 excavation

PROVINCIAL MUSEUM OF ARCHEOLOGY OF OURENSE

One of the most common elements in the architectural decoration of the castros is the swastika of three, four, six or more radii. On the other hand, it is not so common for these pieces to have open-work, and there is precisely the interest of this piece.

It is an open-work triskel with rays turning toward the right done in a nearly square squared stone. Each one of the rays has inside another slightly deepened one. From the perspective of the manufacture, without being a work of low quality, there are in the same Museum of Ourense very superior pieces, such as the triskel from San Cibrao de Lás, but that fact that this one has open-work gives it special value because, beside the obviously decorative function, it had another one, as opening or space for a house, specifically in a square house identified with the number III by the excavator.

cement, but so well that at times they appear published as original. In the pieces discussed here we see two of the most repeated motifs of the plastic creation of the castros, that is, the torsade and basketwork, in which there was an attempt to see a continuity in stone from the previous wooden cabins. The first motif mentioned will be a recurrent theme until the popular art of our days, passing through the Asturian, Manueline and stone crosses, alms-boxes and covers from our Baroque period.

All the architectural decoration of the castros revolves around a very few themes, but their combination generated great variety. If we add to this the enormous quantity of unearthed pieces (in Santa Trega alone, between pieces and fragments, without counting the sculptures, 110 items have been inventoried), we must think that the image of the Braga castro in the first half of the first century A.D. must have had an impressive appearance. Anf if we accept that the carvings were painted, as some information reveals, this effect is multiplied.

(F.C.L.)

BIBLIOGRAPHY
Martínez Tamuxe, X. (1983); Mergelina Luna, C. (1943-44).

16
Stele from Muiño de San Pedro
End of the Ist century A.D. - beginning of IInd century A.D.

Granite
160 x 84 cm.
Muiño of San Pedro, O Rosal, Oímbra (Ourense)

PRIVATE COLLECTION

Anthropomorphic and phallic stele, carved as a separate piece. On the front part is a simple representation of the face and the inscription LATRONI/VS CELT/ IATI. F/H.S.E., that is: Latrono, son of Celtiatus, is buried here. The inscription allows us to attribute it to the Roman period, specifically the end of the first century A.D.

The head of the figure stands out for its treatment, with that long ribbon that also runs across the back, reinforcing the phallic character of the whole, in line with the tradition of the menhir steles. The representation of the physionmic features is simple, limited to incisions, in marked contrast with the overall force of the forms. This is a clear example of the art of the gentes e incolae, far from the Mediterranean artistic formulas.

(F.F.B.)

BIBLIOGRAPHY
Taboada Cid, M. (1988-89).

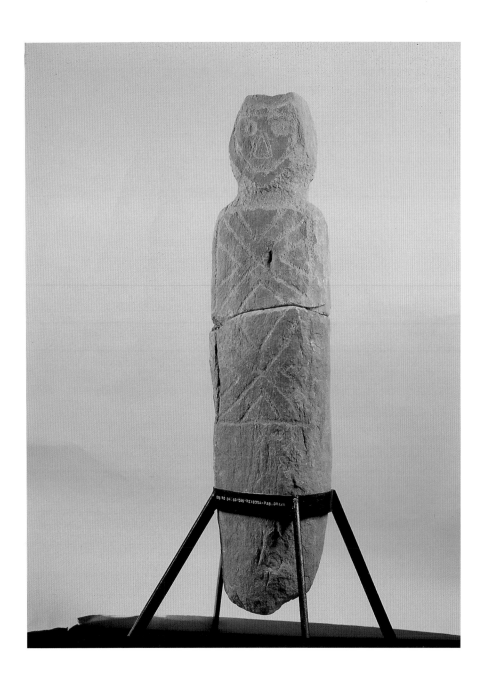

The well-made incisions are completed and widened with a stippled by abrasion. Given the great hardness of the stone, the work of cutting, preparing and decorating it must have been exceptional. The general appearance of the figure is one of great expressiveness, for the clarity of the features and its own anthropomorphic shape.

This anthropoidal slab must be considered a funeral stele, prepared to be seen inserted into the ground and on only one side.

The facial features may be classified within the known Galician statue work of the castros (large eyes, triangular nose, indefinite mouth), while the drawing of the body, besides being decorative, probably serves to indicate a sort of crossed garment, perhaps like a funeral shroud, which appears on other similar Galician-Roman steles as well. The parallels with the stele of As Coroas de Reigosa are in those of Troitosende, Paradela, Ouzande, and to a lesser extent, in those of Bermés and Muíño de San Pedro, or even in the already Christian one of Tins. In any event, the similarities are not absolute, because of the difference in material (always granite except in the case from Lugo, which marks the type of engraving) and size, as well as for the presence of epigraphs on some of them (Ouzande, Paradela, Muíño de San Pedro).

The place and archeological context of the Reigosa find (with materials which do not well indicate the date because of their common nature, but feasibly after the change in Era), allow us to consider that Galician-Roman chronology (specifically, ist - IIIrd century A.D.?), in addition to the formal parallels of the other steles cited, which the majority of specialists have dated around the IIIrd century and even later.

Because it is an anthropomorphic and anepigraphic funeral stele, its clearly indigenous aspect does not contradict the idea of this date, and rather the opposite, it can reinforce the idea of the existence of a third group of sculpture in the Northwest, the castro Galician, different of course from cultured Roman art, but also, because of its own features and the nature of both the expression and the supposed clientele, of the plebeian art defined by Bianchi-Bandinelli y Balil.

In the stele of As Coroas, the material and formal appearance and the technique are of purely indigenous tradition (from the castros, like the site of the discovery) and as far as its Roman aspect (besides the context, although not very well defined) it only has the notion of funeral stele with a 'portrait' of the deceased, as in other areas of the Empire.

(F.A.V.)

BIBLIOGRAPHY

Arias Vilas, F. (1981); Vilaseca, R. (1974).

17
Anthropomorphe stele
Ist - IIIrd century A.D.

Limestone
102 x 21.5 x 4/5 cm.
Castro de As Coroas. Santiago de Reigosa,
A Pastoriza (Lugo). Found in 1973

PROVINCIAL MUSEUM OF LUGO

Block of very hard stone, of schematic and stylized anthropomorphic form. The head stands out from the body in the form of a truncated oval, and the neck, totally redone, clearly marks the separation between the head and the rest of the body. The body is decorated with a series of straight lines forming two superimposed and joined arms, in triple parallel design, all framed in a rectangle which is molded to the shape of the stone.

18
Relief of Vestio Alonieco
Ist - IIIrd centuries A.D.

Granite
67 x 46 x 16 cm.
Found in 1944 in the wall of the farm that
belonged to Eugenio Montero Ríos. Lourizán
(Pontevedra)

PROVINCIAL MUSEUM OF PONTEVEDRA

This is a curious piece found out of context and without clear parallels in the Peninsula. It has a figure with a large head and two horns, its hair or perhaps a horned helmet over the forehead, done in bas relief. The face is very long and has prominent cheekbones, the bridge of the nose, an incision for a mouth and eyes which must have been round. Out of the chin come two enormous hands with open fingers and the thumbs pointing downward; the image ends in the sketch of a torso. Very near the site of this we find a piece of anepigraphic altar and two dedicated to VESTIO ALONIECO were found; one is incomplete, with the following text: DEO/VESTI/LONI/CO.A. (IRG, III, 26). The other, well preserved, has this inscription: DEOV/ESTIO/ALONI/ECO AR/AM/PSEV/ERA (IRG, III, 27). Already from the first moments of the discovery, the relief was associated with the god to which the altars refer, an aspect in which all the authors who studied the sculpture agreed upon. We should add that near the pieces are the remains of a castro, a miliarius of Adrian (today in the Museum of Pontevedra), tegula burials, a stole cover, and that a small treasure of 80 Roman bronzes was found, as well as one of the only two faleras in Galicia (the other is from the castro of San Millán da Xironda, Ourense), dated in the IVth - Vth centuries A.D.

Many opinions have been expressed about this piece, always called VESTIO ALONIECO with no other base than the name of the altars. The relief was assimilated to Ares, the Gaullic Mars, to Cenunnus and the Cretan Minotaur. It was said that perhaps those were not horns, but rather the representation of a floral crown or 'leaf crown', following Jacobsthal's terminology. When two heads with appendices appeared in Cerro Salomón, they were accompanied by this figure. Popular wisdom, so often correct, gave this piece the name "The Devil," and Benoit, in an iconic study of Mercury, shows that beneath this figure the Christian devil often appears, and among the many examples he cites in Romanized Europe is our figure, which he compares, even to the hands, with the Era of the funeral stele of Roussas. It is very possible that "Vestio" is, therefore, an othonic, sicopompus Mercury, unique in the Northwest, but often represented in the Romanized European media and which, for its type of carving, could have been made in either the first or the third century A.D., at the same time as the altars of the area mentioned were dedicated.

(F.C.L.).

BIBLIOGRAPHY
*Blanco Freijeiro, A. (1949) (1975); Bouza Brey, F.
(1946); Calo Lourido, F. (s.d.) (G.E.G.)*

19
Woman's head from Lugo
Second half of the IInd century A.D.

Marble
26 x 17 cm.
Rúa Bispo Aguirre. (Lugo)

PROVINCIAL MUSEUM OF LUGO

Separate woman's head, done in local marble of yellowish color (perhaps from the quarries of As Sasdónigas, Mondoñedo). The very precariousness of the material (very thick, weak grained marble) and its wear barely allow us today to see the details of the work. Still, we can see a long neck, simple but decided features, visible in the straight nose, the design of the almond-shaped pupils of double furrow, while the mouth is nearly invisible. All this, and the rounded, soft line of the cheekbones and chin, give the figure a generally sweet and pleasant expression.

The hair appears to be a large mass distributed on both sides of the head, making slight waves which almost cover the ears and which are all pulled back on the neck.

Probably it appeared at the end of the XIXth century, when the Door of Bispo Aguirre was opened in the house of Magadán. This piece was first attributed to a Roman goddess (or matron) and was also identified with Diana (?). In reality it is a Praxitelian type of Aphrodite, later Venus Augusta, who because of its expression and hair design must correspond to the second half of the second century A.D., and specifically to the dynasty of the Antoninos, given its similarity with portraits of the empress Faustina Minor (161-175), Marcus Aurelius' wife.

It is clearly classifiable in cultured provincial Roman art of Gallaecia, both for its theme and the material and possible clientele. Nevertheless, Balil has noted that some of the features make it possible to consider it a piece done in a cultured way but with a non finite purpose; that is, with a consciously unfinished air. The type of carving, with small superficial gouges (if they are not flaws in the stone), would indicate a technique of wood carving more than that characteristic of marble.

(F.A.V.).

BIBLIOGRAPHY
*Acuña Castroviejo, F. (1976); Balil Illana, A.
(1978); Vázquez Seijas, M. (1939),*

20
Stele from Fisteus
III century A.D.

Granite
185 x 64 x 13 cm.
Citadel. San Vicente de Fisteus (A Coruña)

MUSEUM OF THE CATHEDRAL OF SANTIAGO
DE COMPOSTELA

This singular piece among the group of Roman stele in Galicia lacks a concrete archeological context like a good number of pieces of this type, although it is linked with the important Roman finding nearby, where musivarius and other remains initially appeared which recalled a villa but later have been identified as a military camp which is now under excavation under the direction of Professor Caamaño Gesto.

The stele offers two principal features. The first is its wide epigraphic extension, ready for a longer inscription than that actually shows and in which is read: D.M.S./IVLIO. SEVE/RIANO. ANNO/XLVII MEMO/RIAM POSVIT/CONNGI KA/RISSIMO PL/ACIDIA LVPA/DEFVUNCTO IN/VALLE MINEI, i.e.: Consecrated to the Manes. To Julio Severiano, forty seven years old, Placidia Lupa placed it as a memory dedicated to the beloved spouse, deceased in the Miño valley.

On some occasions a late chronology has been deduced from the use of the term defuncto , IV century A.D., for the stele, but neither the usage of this term, nor the formula D.M.S., or the type of letter and other details lead us to propose a date later than the IIIrd century.

The figurative theme that completes the stele has been the focus of major discussions. Father Fita considered it a reference to the deceased person's activity, a horse-soldier. Leite de Vasconcelos tries to see a heroic representation, in which the deceased rises to heaven, which he shares with others, assimilating himself with the heroes par excellence, the Dioscuri. Bouza Brey and D'Ors, taking notice of the details of the inscription, above all to the defuncto in valle Minei, consider it related to the muleteer activity of the titular. Undoubtedly, many other interpretations may be proposed, but we think that a symbolic interpretation that includes all the elements is always difficult, from the man to the horse, the vine and the central scenes, especially if, as Balil affirms, we find ourselves with a less indigenous work than might be supposed, of the representation, well studied, of the frieze of the Arco de Aorta, that is to say, the criteria of the hierarchical perspective which depicts man in accordance with his social condition or with his meaning as master of nature and, along with it, of the irrational beings.

This consideration, as well as the use of fewer lines than planned for the inscription, may lead us to suggest that the sculptural representation

ample clothing, which only leaves the hands visible. The cut of the stone keeps us from knowing if they were full figures. It is a type of representation frequent in the Roman funeral steles in multiple parts of the Empire, thus its consideration as such, which will be reinforced by the symbolic value of the figured scene on the back. However, the information about the archeological context of the find do not allow the desirable precision as to the nature of this stele, without discarding either that it could be part of a larger composition or had a different character, for example, the Christian one that its describers in the Seminar of Galician Studies attributed to it.

The reverse side appears to have a single scene, presenting a very deteriorated relief with the central representation of a nave or mast with its rigging—illustration typical of a model of a small cargo boat from the IIIrd century, according to Alonso Romero—and four figures on board. The one on the poop deck looks toward the prow, while the other three look toward the first one. Above and to the right, an eagle with spread wings as if to take flight, with the head missing, rests on an object that is interpreted as a rock or fish, even as a cloud. Underneath the ship, in the center, a cetacean identified as a dolphin in spite of a curious triple tail fin.

This scene has been considered by Castro Nunes as a representationof the myth of Ulysses, specifically the passage of the sirens, attributing it a Neoplatonic symbolic character in relation with the passing of the deceased. Balil shares Nunes' identification, but has a different evaluation, of a Neopythagoran type. Both, in any event, are far from the nature of the image of the dangers of temptation which this representation came to have for the Christians. Acuña, in a detailed study of the parallels, has sustained the attribution, for which recently Alonso Romero has noted a greater formal correlation with the representations of the passage of Scylla and Charybdis, with a similar symbolic value.

The relief which is discussed here, done on granite, traditional material of the productions of local provincial art, presents an obvious cultured aspect in its theme, charged with a very elaborate symbolism which even reaches the forms of representation in which the technique is used with a clear illusionist effect of relief completely in parallel with pieces of other environments, such as that of Narbonne, far from the forms of local expression. The treatment of the reverse side, today very worn, is barely different.

Finally, we cannot omit the existence of other pieces of similar characteristics in the surrounding geographical area (O Corgo, San Martiño de Río, Adal), perhaps all linked to the production of a certain workshop, related to the capital: Lucus Augusti.

(F.F.B.)

BIBLIOGRAPHY

Acuña Castroviejo, F. (1976) (III); Alonso Romero, F. (1981); Arias Vilas, F., Le Roux, P., Tranoy, A. (1979); Balil Illana, A. (1974); Castro Nunes, J. de (1958); Filgueira Valverde, J., D'Ors, A. (1955); Taboada Chivite, J. (1965); Vázquez Saco, F. , Vázquez Seijas, M. (1954).

was not thought out for the type of monument that finally came through. This would open a porthole to the knowledge of the mode of production of the artisan workshops in the Galicia of the Roman period.

(F.F.B.)

BIBLIOGRAPHY

Balil Illana, A. (1974) (1978); Bouza Brey, F., D'Ors, A. (1949); Fita, F. (1910); García Romero, C. (1909); Leite de Vasconcelos, J. (1913); Rodríguez Lage, S. (1974); Sández Otero, R. (1945); Taboada Chivite, J. (1965).

21
Relief from Vilar de Sarria
IIInd century A.D.

Granite. Three pieces
77 x 60 x 12 cm.
Vilar de Sarria, Sarria (Lugo)

PROVINCIAL MUSEUM OF PONTEVEDRA

This relief has great interest because of its theme and form of representation. It is a piece worked on its two surfaces, which is interpreted as a funeral stele without epigraph, judging by the human figures, a man and a woman, on what is considered the main surface. Both characters are dressed in

22
Relief
IInd century A.D. and IIIrd century A.D.

Marble
26 x 25 x 25 cm.
Wall of Lugo (Station door)

PROVINCIAL MUSEUM OF LUGO

Fragments of relief with torso of a persondressed in tunic with folds. It conserves the right side, whose arm crosses in front to rest on the object which it holds with the left arm and which rests on the shoulder of the same side. The right cuff had a fringe decorated with small triangles, like a bracelet.

The fragment is very deteriorated, with ancient breaks and more recent ones, from when it appeared in the work of restoration of the wall in 1977.

Initially two possible interpretations of the person represented in this relief may be offered: a standard-bearer of the army or a lictor bearing the fascio. Both types are profusely documented in the historical reliefs so popular with the Roman taste, where they tell religious rites, state ceremonies, imperial deeds and events. The signifer, aquilifer, vexillifer, according to the type of insignia they had, and the lictor bearing the fascio appear repeatedly in arches, columns, altars, commemorative and funereal monuments.

With the scant data which the fragment conserves and as a result of the comparative analyses we have done in the study of this piece, we interpret the person to be a lictor, who is holding the fascio in the usual manner and is wearing the typical tunic.

The lictor is a subordinate who has a public duty, carrying the fascio as a symbol of the power and authority of the magistrates, priests, and military officials he served, who, according to their level had the right to a determinate number of them. Several texts, such as the Hispanic Lex Ursonensis, tell us this.

This small fragment is thus of great importance as a piece of information to add to those we know have about Lucus Augusti and the Romanization of Galicia. The studies testify to a special and growing interest of the imperial power in this area and they portray the capital of the "conventus" as an active administrative center whose functions modeled a typical Roman urban development. In this context, where we already know through epigraphic studies imperial officials such as magistrates, priests, and military personnel, this discovery of the lictor relief fits perfectly.

Reliefs with these theme are precisely related to a society of municipal magistrates and local upper class. In the small Italian cities and in the Narbonne province and Tarraco in Hispania we find parallels to this piece.

The folds seen in the fragment are very well formed. This, together with the material it is worked in, marble, and the iconographic type, indicate to us a cultured artistic language at the service of a purely Roman theme, different from the customarily found in the Galician reliefs of the Roman period.

The supposed bracelet or adornment, with its geometric decoration and chiseled line, nevertheless seems to indicate an indigenous theme. But we know that the lictores could be free men, slaves, or freed servants, so that nothing would stop a native Galician without status of Roman citizen from carrying out this charge.

For its chronology we have the façade of the wall in whose factory the fragment was produced. This, plus the stylistic and comparative analysis and what we know about the evolution of Lucus Augusti as administrative capital, suggest the date of IInd century A.D. or the beginning of the IIIrd.

It is difficult to tell to what surrounding this fragment pertained. We have already cited the most frequent ones in which these characters appeared. In this case, the frontal position and volume appear to suggest that, more than a continuous relief, it was an individual funereal monument of the stele type.

(P.A.F.)

BIBLIOGRAPHY
Arias Vilas, F., Le Roux, P., Tranoy, A. (1979).

23
Pillar from Amiadoso
IInd and IX-Xth centuries A.D.

Marble
65 x 49 x 15 cm.
Chapel of Saint Adrian in Amiadoso., Allariz
(Ourense)

PROVINCIAL MUSEUM OF ARCHEOLOGY
OF OURENSE

Prismatic marble block bordered on its six
sides, although in different stages. The first has a
relief in vertical position with an acanthus plant
from which come vegetal designs and stems, in
what appears to be a profuse plant decoration. On
both sides of where it begins, two tiny birds
nibble at the central stem. On one of the side
surfaces an egg-and-dart kratera is carved, with
grape leaves and tendrils. On the other there are
remains of a kratera and similar decoration,
which was redone to place the piece in its later
reuse.

It is undoubtedly one of the best examples of
Galician plastic art of the Roman period,
undervalued or insufficiently valued up to now
because of the greater interest placed on the
decoration which the block received later.
Generally the reliefs are mentioned when those of

the second period are studied, with Christian
funeral connotations always attributed to the first
decorations. All the authors repeat the same
parallels, in part correct, which are very late and
stylistically distant. In comparison, the
comparative study we have done allows us to
contrast many others, with closer artistic
characters, an earlier chronology and a context
that is quite different from that cited up until now
such as the Mediterranean area and the Germanic
limes.

Vegetal designs, grapevines and acanthus, with
human or animal figures, were popular themes in
Roman decorative art. It is enough to take a
visual stroll through the repertoires of sculpture
to see them arise and develop in the
ornamentation of the best reliefs in the metropoli
and appear insistently in provincial artistic
productions.

Frequently the themes of grapevines and
craters have been associated with a Dionysian
and Christian symbolism. Although this might be
true, it is clear that the theme was banalized by
being used as a simple decorative element. It is
true that in Galicia the sculpture of Mourazos and
the stele from Vigo document a cult with their
representations of Dionysus and Ampelos.
Nevertheless, without other elements for analysis
nor a context, it does not seem correct to interpret
it as a pagan or Christian religious element.

The present deteriorated state does not stop us
from perceiving the richness of the work and the
skill in its execution, very distant from the
schematic, flat relief so frequent in Roman
Galicia. In the wide panorama of reliefs from
various provinces of the Empire, very close
parallels can hardly compete with the artistic
quality of this piece. Importantly, it is done in
marble, fitting perfectly what Balil determined
for certain Galician sculpture: within the area of
provincial production, this piece was done to suit
a cultured client's taste, using models that were a
direct result of Romanization.

With its Christian character eliminated, its
stylistic and iconographic features, as well as the
context provided by similar reliefs, a chronology
of the IInd century A.D. is appropriate.

Rivas believes the piece to come from the
nearby Roman discovery of San Martín de Pazó,
which seems sensible. As far as its use, form and
measurements, these do not stop it from being a
decorative pillar from a funeral monument, as has
been stated, but neither does this stop it from
carrying out the same function in another type of
architecture which we cannot determine at this
time.

Later, nevertheless, the marble block was
reused, with the decoration of the three surfaces
which had been smooth until then. In the main
one, now worked in a horizontal direction, the
center was carved and fit into a smooth
rectangular frame, a figured scene, difficult to
identify more for its deterioration than for its
undeniable rustic nature (it may be a
representation of the Ascent of Christ, which if
this were so, would give the work, in which only

the feet appear, extraordinary iconographical interest, as was recently noted (I.G. Bango), in turn surrounded by a decorated strip with a wavy stem from which stylized leaves grow in alternate position. The same theme was adopted for the smaller edges of the block.

The dating of this second phase in the use of the piece has been and is a cause for controversy. Its stylistic features invite us, at least in principle, to assign it a similar chronology, XIth century, to that which works such as the baptismal font of San Isidoro of León or the reliefs of San Juan de Camba (also in the Museum of Ourense) have been given, and with which it has clear analogies— silhouettes with rounded edges, etc.—although other elements from the same building in Amiadoso and also in the Museum of Ourense—two tace crosses from whose horizontal arms hang the Alpha and Omega—suggest an earlier date for that work. This date would be from the time of Alphonse III (866-910).

(P.A.F. y J.- C. V.P.).

BIBLIOGRAPHY

Acuña Fernández P., Valle Pérez, J.C. (s.d.); Bango Torviso, (1987); Lorenzo Fernández, J. (1953); Núñez Rodríguez, M. (1976) (III) (1978); Osaba y Ruiz de Erechun, B. (1946); Rivas Fernández, J.C. (1976); Valle Pérez, J.C. (1981)

24
Stele from Riós
IIIrd century A.D.

Granite
150 x 43 x 22 cm.

PARISH HOUSE OF SANTA MARIA DE RIÓS (OURENSE)

With the construction work of the parish house of Santa María de Riós this Roman funeral stele appeared, serving as the louver of an inner door to the gallery. Thus it is a decontextualized piece, although we may suspect its relationship to one of the nearby Roman discoveries. It has an obvious interest because of its decorative design, which has three registers.

It·is a stele which ends in a triangular pediment, an infrequent type in Galicia, in spite of there being other pieces of the same sort in nearby geographical regions like Sarrenas, which also have an important decorative design. The ornamentation covers the upper and lower levels, with the text of the funeral inscription interwoven, and which says: G. NIGRINI/VS. ALBINV/S.G. ALBIANO/NIGRINO AN./XVI .F.M.P./D. M.S. (Gneo Nigrinus dedicated

a monument to his son, Gneo Albiano Nigrino, age 16. Dedicated to the Manes.)

On the lower level is a cross with a simple incision, in contrast with the detail of the treatment of the upper level, enclosed in a rebate moulding, like the inscription. In this upper pediment, widened by the spolium of the triangular pediment, we can see scarfings above a crescent moon, two round arches, a six-petalled rosette inscribed in a circle and flanked by two scarfings and finally a triple archway with its sustaining structures.

Traditionally the decorations represented on the steles were linked to Neopythagoran or Neoplatonic interpretations in relation to the religious or ideological currents prominent in the empire, although on other occasions they are explained as

survivals of the local religions with symbolic values applied to each one of the representations, some of which, because of their proximity to the representations of all the mythology of the astral cult, as some scholars affirm, seem more obvious. For example, the roses or swastikas as solar representations or the crescents as moons with all their meaning (which is varied according to the specialists). In other cases it is more doubtful, such as the identification of the crosses as celestial vaults and others even converted, such as the so-called scarfings or arms on this stele. The appearance of these elements on many steles all over the empire favored these interpretations and their relationship to the singularities of some areas motivated the turn to indigenous survival, both Celtic and African, or including relationships with the areas of recruitment

25
Stele from Antes
IIIrd century A.D.

Granite
215 x 50 x 15 cm.
Parish house of San Cosme de Antes, Mazaricos
(A Coruña)

It was discovered reused as building material, acting as skylight for the shed of the rectory in San Cosme de Antes, in an enclave that can be related to any of the abundant Roman discoveries in the area.

It is a piece of local granite, broken on the lower part, which served to keep it upright, in forward position toward the road in its original site. In the upper part is a deteriorated. Simple rebate mouldings divide it into three levels, the central one with a funeral inscription, in which we read: DI.M/P.N.../NA.MA/XIMO.A/NNORV/MLIII (Dedicated to the Manes. In memory of P. Na..na Máximo, 53 years old). The upper level has a crescent moon and three arches in a frieze. In the lower one the figure of a man, naked, with his arms akimbo, hands well detailed, the right one somewhat more elevated than the left, the genitals well marked.

The symbolic evaluation of the moon in the Roman funeral monuments allows us both to link it to the local indigenous traditions (Taboada Chivite, García Bellido, Juliá), without disregarding wider and more universal referents which affect all Celtic peoples (Hatt), as well as to interpret it as a place of rest for the dead (Cumont), with a value of supernatural protection (Nock) and even as the image of hope in the beyond (Legaly). Still, it is necessary to keep in mind the problems that a figuration may suffer with the passing of time, because of the loss of its initial value or because of the acquisition of new symbolic contents. A similar case to that of architectural representation which, if it were the indicator of the monumentality of the stele (according to the Roman concept), ends up becoming a decorative figuration, forced by its very repetition, without discarding new symbolic contents like that of the passing to another life (Elorza).

The human figure should be interpreted as the idealized portrait of the deceased person, formally far from the typical strict sense which the portrait has in the Roman world (as R. Bianchi-Bandinelli defined it) to join in a provincial plastic tradition where identification is done through the epigraph with its concrete referent, while in the figure the characteristics of organicity and the singular are given up in order to represent a type in which the head and other elements of the figure (hands, sex, etc,) stand out. In other territorial regions diverse referential elements stand out (weapons for the men and combs for the women, etc.) as happens in the area of Burgos.

of troops quartered in the area of the site where the steles appeared.

Apparently these processes are far from allowing us to find an easy, concrete explanation for each case and the time period for all the cases, but they always place us before provincial type artistic productions where without renouncing refined themes, these appear to be subjugated to the technical and interpretive treatment of this group. On the other hand, in the Galician case, and even in a wider Hispanic area, we must not forget an interesting suggestion of A. Balil which shows that "the religious nature of the peoples of the Hispanic Northwest must have been complex, but did not lead to the creation of a pre-Roman iconography. Its figurative character is clear because if there had been representations in perishable materials, they would have later been used in the Roman period as happened with the non-figurative themes. Lacking a previous expressive tradition for these concepts, the elaboration of their own iconography led to representations that were clear in their time but which are not so for us. The adaptation of the schemes they supposedly used, similar to what happened in the elaboration of a Christian iconography, did not or could not take place because of a lack of knowledge and communication of these prior iconographies."

(F.F.B.)

BIBLIOGRAPHY
Rodríguez Colmenero, A. (1987); Rodríguez Colmenero A., Carreño, M. C. (1989).

In the Galician region this stele relates to a numerically fairly broad series which judging by the type of togaed person in niche is transformed in provincial Hispanic art of the genetes et incolae into these figurations where the flat relief, facial features of the figure, hands and sexual organs form the expressive mode of a workshop with creations that can be followed in all the coastal strip in the last years of the IIIrd century A.D.

(F.F.B.)

BIBLIOGRAPHY
Acuña Castroviejo, F.; Casal García, R. (1981).

26
Dionysus and Ampelos. Mourazos
IIIrd century A.D.

Marble
93 x 62 x 41 cm.
A Muradela, Mourazos (Ourense)

PROVINCIAL MUSEUM OF ARCHEOLOGY OF
OURENSE

Two male figures, one leaning on the other, form the group. The second one is sitting astride a tree trunk. The material is marble which today is granular and very degraded by the erosive action of the extremely acidic medium. The larger figure is missing the head and right arm; it is standing, in a resting pose, supported on his left leg and marking a slight S rhythm, derived from the Praxitelian creations. With his left arm he embraces the neck of the second, smaller figure, who in turn opens his arm over the back of the first, his hand extended.

This sculpture has been interpreted as the representation of a scene from Dionysus and Ampelos, the god missing the bunch of grapes he held in his right hand, a mythological theme with very deep Mediterranean roots and which has been the object of many representations.

Regarding this one, García Bellido affirms that it is an interpretation based on a model in bronze because of the presence of the tree trunk, which affects the position of the satyr, seating on the trunk when he should be standing and holding Bacchus. Even more, the formal manner of resolving the back part and its treatment even lead to the suggestion that the artist or artisan who created it was inspired more by a painting or relief than on a separate group.

These features are precisely those which lead Balil to state that this is not a work of cultured art, but rather a provincial Hispanic artistic creation, cultured in its materials and theme, which would travel to Galicia from a possible Aquitanian or Italic

27
Stele from Vigo
IIIrd century A.D.

Granite
136 x 60 x 23 cm. Incomplete
Pavement of the Rua do Arenal of Vigo
(Pontevedra)

QUIÑONES DE LEÓN MUNICIPAL MUSEUM.
CASTRELOS-VIGO (PONTEVEDRA)

It appeared forming part of a numerous group in which differences in workshop or model may be pointed out in spite of the homogeneous nature of the group, all of it reused as part of the flagstone paving of the Rua do Arenal in Vigo, in the area where according to the scholars the Roman way went, testifying by its proximity to the use of steles as commemorative monuments along the paved road near the centers of population.

The upper part of this stele is rounded, with lateral acroters and the front is divided in several levels, the upper two decorated and the third holding the funeral inscription, which is: 'Consecrated to the Manes, Usa Sever(ra)', probably a person who is related to the dedicator of another inscription in this same group.

On the upper level is a six-petalled rose, inscribed in a circle on a crescent moon, flanked in the lower spandrels by two large thick seven-petalled flowers. On the second, there is an architectural frame of two large arcades with decoration of characters. The frontal one, on the left, is short and on its head, as if it were a milk can, it carries a Kántaros with large handles; in its hands it holds a large bunch of grapes. The one on the right, which is taller, dedicated to its partner in the gesture of the feet and hands, which cross above the central column and rest on the companion's shoulder as if to help him stay on his feet, but with the face turned to the front. The theme represented leaves no doubt: Dionysus and Ampelos, a classical theme but very unique in its interpretation.

The material used is granite, the traditional support for all the local production of the Northwest. The treatment of the bodies, the slightly oval faces, the reverse treatment, the disproportion of the figurative elements, the resolution of the problem of the relationship to the figures in the group, is all imbued with the style of provincial Hispanic art which Balil very correctly has defined as the work of gentes e incolae, but in this case starting with a very Mediterranean theme. In fact, starting with a cultured type of iconography by given an interpretation of its own and expressing it in the styles of artistic language associated with this group, with flat relief in which the silhouette is seen as a compact mass in which only the face and secondary attributes stand out. Without the criterion of organicity peculiar to the Roman-Hellenistic world, in this version we find its replica in the marble of Mourazos as an artistic work of a very different purpose.

Again following Balil, we find a craftsman who translated onto a pre-prepared stele, as in the case of Fisteus, the theme of 'Dionysus bebens'. It is not an

production center, to the point where we cannot call it Galician, and rather art existing in Galicia, suggesting an entire imported sculpture.

The site of the accidental discovery, once explored. permitted the documentation of the archeological context of a large villa in one of whose rooms this sculpture must have served as a decorative element. Other sculptural groups, also in marble, more fragmented and in worse state of preservation, would form part of the decoration.

Although the alteration of the carving surfaces is very great, it is still preserved at some points, but in conditions that are insufficient to be able to appreciate its detail, which could help be more precise in placing its chronology between the Iind-IIIrd centuries A.D., although the archeological context of the discovery may suggest the third century more than the second.

(F.F.B.)

BIBLIOGRAPHY
Balil Illana, A. (1974); Fariña Busto, F.; Calo Lourido, F.; Acuña Fernández, P. (s.d.) (G.E.G.); García Bellido, A. (1969); Taboada Chivite, J. (1964) (1965).

assignment, but rather is previously done and a funeral inscription is applied to it, which makes it difficult for us to clearly understand the symbolic value of the use of a cultured theme done in this artistic language on a funeral stele.

Finally, and along the line of this popular identification, there is a detail of formal interest: those who recall the peasant women with the milk cans on their heads returning from the fountain will transpose it to the figure of Dionysus, to the point where occasionally a scholar has been deceived into attributing a female identity to this character.

(F.F.B.).

BIBLIOGRAPHY
Acuña Castroviejo, F. (1974); Alvarez Blázquez, J.M. (1953); Alvarez Blázquez, J.M.; Bouza Brey, F. (1961); Balil Illana, A. (1960) (1975) (1979); García Bellido, A. (1967); Juliá, D. (1971); Rodríguez Lage, S. (1974).

28
Funeral stele
III - IV centuries A.D.

Granite
110 x 60 x 28.5 cm. (complete figure: 90 x 27.5 cm.)
.../FELICEM/PARENTEM/...IVLET/...FILIO
San Martiño de Río, Láncara (Lugo)

VESTRY OF THE PARISH CHURCH OF SAN MARTIÑO DE RIO (LÁNCARA, LUGO)

Block of very fine grained granite which represents two figures, one very incomplete because of the break in the stone and the other with its face almost completely unintelligible.

The characters, separated and sitting on a type of bench, have a tilted band or cartouche on their laps and knees. It has an inscription, today nearly all disappeared and of doubtful interpretation, although the unpublished notes of the report of the IRG (published in 1954) made the reading given in IRPL (Arias and others) possible twenty five years later. They are dressed with a long pleated cloak, like a toga, which leaves the right shoulder uncovered on the figure that is preserved.

In spite of the precarious and incomplete state of preservation of the piece, it is possible to relate it to other funeral steles and reliefs, presumibly contemporary (IIIrd - IVth century A.D.): that of Vilar de Sarria (10 km. from Río), the fragment of the one from Ponte Neira (Cela, O Corgo, 16 km. away), the relief of Adal (35 km. away), etc.

As in these cases, the theme of the "togaed" deceased is interpreted with native techniques that come from wood carving, with a predomination of paralle incision, very flat relief, heads in geometric form, etc., all joined here to the presence of an inscription that is not common in Galician-Roman epigraphs (with the mention of parentem). In Río there is another funeral epigraph in the form of a plaque, with Latin names and the usual formulas.

The parallels previously mentioned, because of their relative proximity and formal and material similarity, allow us to think of the possible existence of a sculpting workshop functioning in the central region of Lugo in the Late Roman period. We do not know if it would have been linked to the capital of the conventus, Lucus Augusti, or not, but in any event it had enough work in a region which has shown various signs of Romanization, both in castro settlements and in villas, and even in roadway elements (bridges, etc.), almost always with medieval or modern restorations). The characters of the stele would have belonged to one of those places; this piece has a semicultured air because of the presence of what would seem to be

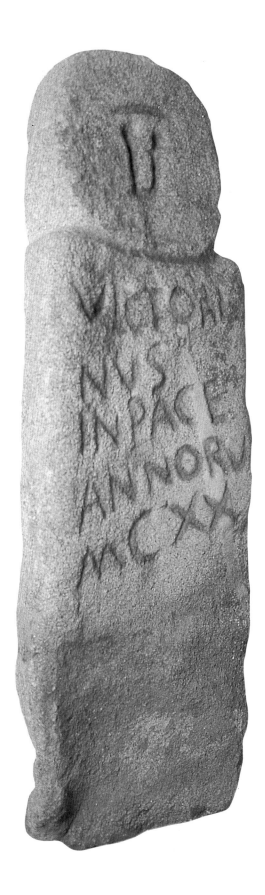

'togas' and the uncommon cartouche with inscription.

<div align="right">(F.A.V.).</div>

BIBLIOGRAPHY
Arias Vilas, F.; Le Roux, P.; Tranoy, A. (1979); Balil Illana, A. (1983); Vázquez Saco, F.; y Vázquez Seijas, M. (1954).

29
Stele from Tins
Second half of IVth century A.D.

Granite
147 x 42 x 10 cm.
Santa Eulalia de Tins, Vimianzo (A Coruña)

ARCHEOLOGICAL AND HISTORICAL MUSEUM. A CORUÑA

This anthropomorphic funeral stele is considered to be one of the first Christian indications of Galicia. It appeared in an archeological context that is very common in Galicia, that is, a necropolis of open sepulchers in large granite blocks covered with stole lauds and other simpler ones. These sepulchers are made of small slabs and even tegulae which especially cover living areas of a previous Roman villa, as Chamoso Lamas has documented.

Monteagudo believes that it is a piece from the second half of the IVth century (ca. 370), as does Díaz y Díaz, which because of its formula IN PACE is linked to the Christian movements in Gallaecia, which at that time had a somewhat different organization than that of other territories.

The inscription VICTORI/NUS/IN PACE/ANNORU/M CXX contains the basic information of a funeral inscription, that is, the name, age and ritual forma, which in this case does not follow the traditional ones in the pagan Roman world, present in other steles, giving way to the Christian one of IN PACE.

The general formula of the stele, with its simple anthropomorphic design done by a superficial treatment of physical features, is in line with an entire local tradition, a vigorous one, judging by the number of examples in the peninsular Northwest, both in Galicia and Asturias (Forniellu, Selorio, Molleda), in which the external form receives a text which shows new beliefs in a very singular expressive syncretism.

Perhaps we might point out that the fact that it is made of granite brings it formally closer to pieces such as those of Troitosende, Ouzande and, in part, Bermés, in contrast with those of schist, like that of Paradela, closer to the Asturian examples already mentioned. In any case, they all appear to coincide as well with the late chronology attributed to them: the IVth century A.D.

<div align="right">(F.F.B.)</div>

BIBLIOGRAPHY
Chamoso Lamas, M (1955) (II); Díaz y Díaz M.C. (1976); Lema Suárez, J.M. (s.d.) (G.E.G.); Rodríguez Alvarez, M.P. (1981); Vázquez Varela J.M. (1980) (II).

30
Sepulcher cover
312 - 325 A.D.

White marble
25 x 214 x 10/12 cm.
Temes, Carballedo (Lugo). Appeared April 20, 1974

PARISH CHURCH OF SANTA MARÍA
DE TEMES—OVER THE TRIUMPHAL ARCH—.
CARBALLEDO, (LUGO)

This is a rectangular piece in the form of a plate, made of Attic marble from the Pentelicon, divided in three compartments by vertical stripes. In the center is a plain plaque or board intended for an inscription which today does not exist and perhaps never did.

To the right of that cartouche is a scene of the Adoration of the Magi, together with the group of Adam and Eve, and on the left, the history of the prophet Jonah.

In the first level, the Virgin, with the Christ Child on her lap and tunic and palium, receives the Three Magi, with mantle and trousers, on their heads the characteristic pointed phrygian cap and followed by their camels.

In the second level the center is the trunk of a tree flanked by Adam and Eve. The latter, much better preserved, holds out her hand toward the tree where the serpent is coiled.

On the other side of the cartouche, a large cetacean swallows Jonah in front of three youths. Then, while the huge fish slips through the water, the scene is closed by the repose of the prophet beneath a calabash.

On the parts that have not been mutilated or rechiseled there is great expressive force, showing the sculptor's good technique.

This tomb cover, the only whole one in all of Spain, has been compared with others which have appeared in Rome (the cemetery of Saint Sebastian, Nazionale and Pio Cristiano Museums, etc.) and also in the Iberian Peninsula (Barcelona, for example). Because of its good style and its soteriological content, it is considered of proto-Constantinian affiliation (for Delgado, not posterior to Constantine nor before the end of the Tetrarchan era, ca. 312-325). Schlunk prefers the period 320-330.

For the first time in Hispania, it offers the theme of Adam and Eve in Paradise, and a good story from the cycle of Jonah with all its scenes, which makes it virtually unique.

Of undoubtedly Roman manufacture, it would reach Temes either up the Miño (a navigable river as far as the Peares, according to Schlunk), or down the Sil from the northern plateau. The hypothetical possibility that it was brought after the IXth century when the first church of Temes is consecrated is not to be entirely discarded.

Nevertheless, the fact that in this place Late Roman and Paleo-Christian pieces have appeared, such as several capitals of the Corinthian type, a bas-relief with a dove on a squared stone of the outer wall of the present church, columns reused and even an altar to the Lares of the ways, leads us to think that in Temes there was an important Paleo-Christian monument, perhaps a mausoleum or funeral chapel of a powerful, cultured Christian, one of those who appear in the area of the mid- and end valley of the Sil River (cfr. the Christ monogram of Quiroga), associated with the late villas and castros documented by archeology. The ridge itself in the hillside where the church of Temes is located must have been a castro later reconverted to a small villa, with a privileged situation above the crossroads and river junctions of Os Peares.

(F.A.V.)

BIBLIOGRAPHY
Balil Illana, A. (1976) (II); Delgado Gómez, J. (1976); (1979); Rielo Carballo, N. (1975); (s.d.) (G.E.G.); Schlunk, H. (1977).

31
Relief from Adai
IV - Vth centuries A.D.

Sandy granite
92 x 57 x 13.5 cm.; front 71 x 9.5; back 66 x 2 cm.
Vilamaior, Santa María Magdalena de Adai (Lugo). Appeared in 1977

PROVINCIAL MUSEUM OF LUGO

Parallelepipedic block sculpted on both surfaces. On the back are two seated human figures. One of them, missing the face, is wearing a mantle of which we can only see well the folds in semicircle which cover the legs, while the right hand is on the chest. The other figure is a woman, because the clothing is longer and there are adornments on the head. It is coifed with a pearled ribbon that pulls the hair back and earrings appear to be visible in the ears. The dress has a type of shawl, caught at the chest with a brooch, under which large hands with bracelets appear, resting on the lap. The mantle falls in vertical folds covering part of the feet. The face is very expressive, with large eyes and enormous pupils sculpted in white.

On the back are two superimposed scenes: the upper one has a bear facing a human figure, today incomplete, which leans backward and has what seems to be a trident in the left hand. In the lower part, an owl or similar bird is standing across from two smaller ones, also standing and of different size, which possibly are doves.

This funeral relief is an example of a piece which unites elements of a cultured nature (figures in toga, circus scenes?), with a formal representation that has indigenous roots (incision decorative technique, relatively flat relief and a certain anorganicism in the scenes) which even recall popular stone-cutting.

The figures of the front (the pair of deceased persons) allow us to think of a portrait of the post-Constantinian era, more specifically Theodosian, unique in the type of headwear and the treatment of the eyes. Precisely between the end of the IVth century and beginning of the Vth the figures tend to have a frontal view in the aulic tradition, which here would blend with the flat stiffness of the castro affiliation.

The back has a venatio or hunting scene, or perhaps better a reference to the circus games (a bestiarium?), judging by the strange position of the trident. With this interpretation, which is still open, we would have an imitation or a totally inorganic transposition of the ivory diptychs of the same period, used only by the privileged. But the one here is a funeral relief, clearly marked, in any event, by the representation of the deceased and the lower scene on the back: a sicopompo bird (soul guide) such as the owl (which sees in the dark) seems to await the two souls in the form of doves.

On the other hand, the piece from Vilamaior de Adal has visible parallels with other reliefs from Gallaecia, both in the formal disposition and the funeral sense, as in the case of the stele from Vilar de Sarria (also an example of the blending of cultured themes, popular art and autochthonous technique and material), that from San Martiño de Río (without back), that of Ponte Neira (probably from the same workshop as the others, given its relative proximity and coetaneousness) and still more.

In the case of Adal, we would also have to take into account its proximity (5-6 kms.) to Lucus Augusti, where the programs and themes of the cultured or semi-cultured sort could easily reach through the administrative and military apparatus, in reality completely Roman, to later mix with the

ideological and artistic traditions of the native currents. Possibly both clients and artist lived in the rural area of the castro (the location of the find was called 'Cortiña do Castro'), but in some way linked to the environment that was already—in the IV-Vth century—fully Romanized.

(F.A.V.).

BIBLIOGRAPHY
Arias Vilas, F. (1977-78).

32
Monogram of Christ from Quiroga
Vth century A.D.

Greyish white marble with veins
94.5 cm. diameter x 6 cm. thick (average height of letters 4/5 cm.)
AVRUM VILE TIBI EST ARCENTI
PONDERA CEDANT (inherits) PLVS EST
QUOD PROPIA FELICITATE NITES
Parish church of Santa María da Ermida, Quiroga (Lugo)

DIOCESAN MUSEUM OF LUGO

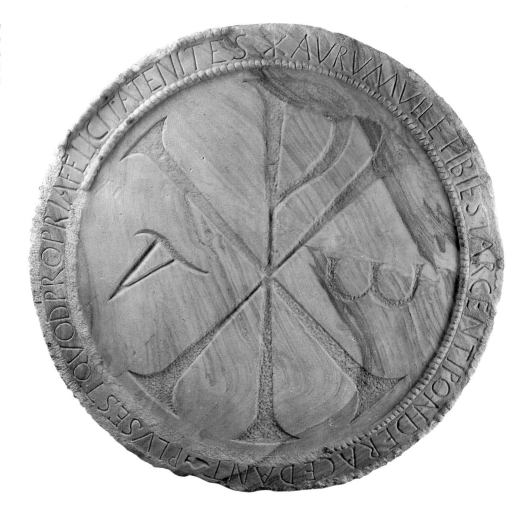

Circular marble plate (maybe from the quarries of O Incio, situated nearby), occupied in the center with a large monogram of Christ among the Greek letters alpha and omega. On the edge, between two parallel lines of spheres or pearls (those of the outside are a bit larger), it has an inscription which goes around the disk and also begins with a tiny monogram. The letters are Roman capitals, very carefully done.

The back side is plain but with signs of stippling, possibly to fix it on a metal support. The inner part of the large monogram and the central letters is also chiselled, perhaps in order to be covered or filled with metal plates, perhaps bronze.

Together, it is a piece of great perfection and careful style, in tone with the good texture under its marble material support.

Perhaps taking as an iconographic model metal pieces that later became widespread, like the patens, the disk from Quiroga was done probably to serve as an offering table (later, an altar) in horizontal position (Schlunk and Arias), and not to be set into a wall or vertical façade (Castillo, Vives and Palol), judging above all by the distribution of the outer pearls.

The decoration of the row of pearls, the design of the monogram and the drawing of the alpha, with two sides in S form, as well as the theme of the text, situate this monumental piece in the first decades of the Vth century (between 410 and 425).

According to Fontaine, the text in hexameters is centered on an exhortation to reject material wealth (gold and silver), to which the moral values of Christian happiness are opposed. The origin of this disk is in the texts of the Old and New Testament, in some authors of the first century B.C. and especially in the writings of the Fathers of the Church, such as Saint Jerome. The appearance of this theme in the text of the disk from A Ermida, with its moral and religious meaning, shows the presence of cultured Christian elements in the region of Quiroga. Note that the invitation not to consider material riches important is made precisely in an area situated between the gold mining operations of O Courel and those of the Sil River (Montepelado and As Médulas).

Also in the same church of A Ermida other pieces of white marble like two bases, a plate and two capitals of Corinthina style, have appeared and are still in that site. They are all datable in the first half of the Vth century, which allows us to think that there was an important Paleo-Christian nucleus or church in this place (whose original typology was possibly a castro), and linked to the Late Roman settlements (castle/villa type) of the region of the Sil (Penadominga, A Cigarrosa...) and, in any event unique because of its exceptionally cultured and delicate character.

(F.A.V.).

BIBLIOGRAPHY
Arias Vilas, F.; Le Roux, P.; Tranoy, A. (1979); Castillo, A. del (1925); Fontaine, J. (1972-74); Palol, P. de (1967); Schlunk, H. (1970) (1977); Vázquez Saco, F.; Vázquez Seijas, M. (1954); Vives, J. (1969).

33
Capital from Setecoros
End of V- Beginning of VI Century

Marble
45 x 57 x 55 cm.
San Salvador de Setecoros (Pontevedra)

PROVINCIAL MUSEUM OF PONTEVEDRA

Compound capital of alabastrine marble and proportions similar to those of the Vitruvian canon; formed by a double row of thistle leaves, stiffly set at intervals, with a wide surface that is very close to the block and a triple central nerve. The cornucopia emerges from among the leaves of the second row, creating an unusual decoration similiar to a plant membrane among the capital's ornaments.

The piece must have been paired with another capital kept in the cathedral at Santiago, also from the Setecoros church, and among whose remains we find a combination of elements from the late Roman period, represented by these capitals, together with others remaining in situ which, assimilating the classical tradition, begin a new period, although with simple forms lacking in innovativeness.

Compared with these later forms, which are already Visigothic, and in a context in which the compound capitals are generally infrequent within the panorama of the Galician pre-Romanesque, the structural quality of the capitals of Setecoros in their oldest expression, and above all, their carefully and originally cut ornamental forms, these capitals are unique and rare in Galicia. As explanation for their presence in this area, it has been suggested that they were imported or that they were made by a traveling foreign workshop whose stylistic tendency was toward late Roman.

(Y.B.L.).

BIBLIOGRAPHY
Nuñez Rodríguez, M. (1976) (II) (1978); Schlunk, H. (1947).

34
Sepulcher of the Holy Earl
End of Vth century - beginning VIth century A.D.

Grey marble wirh bluish veins
213 x 82 x 80 cm. (top of the slope, 140; 56 cm. high, 80 cm. wide; length of base 200 cm.
Vilanova de Lourenzá (Lugo). From Aquitaine (France) ?

MUSEUM OF SACRED ART
OF THE MONASTERY OF SANTA MARIA
DE LOURENZA (CHAPEL OF VALDEFLORES)

A piece of over 2,000 kilos in weight, with all sides worked except the bottom and the back part. The front is full of vertical swirls in the form of a

yoke, which have a monogram of Christ among four laurels of fine cord-trim on this surface. The head and feet also have swirls which converge toward the center, where a six-petalled schematic flower was sculpted inside a circle on the head and two superimposed on the feet of the sarcophagus.

The cover is very original and its carving perfect: the fours slopes, separated by a cord-trim at their peaks, are covered with scales like the slabs of a roof. On the smaller sides of the cover there are other circles with a simple six-leaved design on the head and a double one, more decorated, on the feet. This placement of the decoration leads us to think that the sepulcher was first conceived to be seen mainly from the feet.

The vertical angels of the box occupy four small columns with emphasis, capitals and Corinthian bases, very stylized and with a degenerated module. In the base of the sarcophagus a hole was made to be able to touch the wood box inside, with cultural intentions related to the devotion to its second user, the so-called Holy Count.

This sepulcher was brought by Count Osorio Gutiérrez, founder of the monastery of Santa María de Lourenzá, who died in the last third of the Xth century. In spite of the fact that the legend says it is from the Holy Land (where the Count had made a pilgrimage), the archeological facts clearly lead us to think the sarcophagus is of Aquitanian origin (southwestern France), where he would bring it from on his way back from the Middle East.

Thus, since it is a work imported much later that its manufacture outside Galicia, it barely provides facts about the historical and artistic context of the Northwest at the end of the Vth and first half of the VIth century, which is the period when it can be dated. The decoration with swirls and monogram of Christ is frequent in Christian sarcophagi after the IVth century and here it is shaped with extraordinary care and perfection, favored moreover by the good quality of the marble support, which all results in a work of high quality and interest. The sculpture workshops of Aquitaine must have worked continuously in that era judging from the examples left in several places in the West.

Still, one author (Chamoso) sees in the beveled carving of the roses on the Lourenzá sepulcher a certain relationship to the first Visigothic works documented in Mérida, Toledo, Tarragona or even As Saamasas of Lugo.

(F.A.V.)

BIBLIOGRAPHY
Chamoso Lamas, M. (1968) (1969); Fontaine, J. (1977); Palol, P. de (1967).

35
Altar from San Pedro de Rocas
Ca. 573 A.D.

Granite
77 x 43 x 41 cm.
San Pedro de Rocas, Esgos (Ourense)

PROVINCIAL MUSEUM OF ARCHEOLOGY
OF OURENSE

This probably constitutes the most ancient form of the Christian altar, with a prismatic block that has a loculus on the upper side, hollowed out in the form of a rectangular cavity with shaping for the fit of the cover, intended to hold the relics of the consecration of the era. The altar appears to be decorated on all four sides with a double horseshoe arch on corded-trimmed columns. On one of its sides it conserves the chiseled epigraphic nexus.

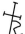

The close structural relationship of this type of altar with the Roman altars has already been noted more than once, and for Palol is testimony of the survival of forms of the Roman and Paleo-Christian world in its most archaic sense, compared with other types spreading from the official Hispano-Visigothic centers of Mérida and Toledo, consisting of altars supported by a richly decorated column.

Regarding its ornamentation, this has been classified as Mozarab, related to one of the most defining elements of the repopulation architecture of the Ourense area, the horseshoe arch, seen in a good number of geminated windows from buildings now restored. Nevertheless, the relationship of the ornamentation of horseshoe arches and cord trim of numerous Roman steles from northwestern areas, and its relationship to the decoration of the funeral slab of the monastery from 573, lead us to consider both pieces as coetaneous.

As such, the altar would correspond to the most ancient forms of the monastery of San Pedro de Rocas, clear exponent of the organization of Christian life in the VIth century, with the appearance of rustic temples in rural areas, associated with the figure of Saint Martin of Braga. In addition to this altar and the above tombstone, the crypts carved in the rock remain as testimony.

After a long period of abandonment, the posterior implantation of monastical life in this enclave, due to the active repopulation policy of Alfonso III, there is a renovation of its architectural structure—as recent archeological studies done in the monastery have shown—, mentioning the abbot Gemondus as the promoter of the restoration of religious life in Rocas. At this time other authors create the altar or at least make small changes in its ornamentation.

The monastery, which will come to depend on that of Celanova, will pass through other periods which leave their mark on this ancient rustic temple.

<div align="right">(Y.B.L.).</div>

BIBLIOGRAPHY
Duro Peña, E. (1972); Fontaine, J. (1977); Núñez Rodríguez, M. (1977) (I) (1978); Rivas Fernández, J.C. (1971).

36
Doorplates
End VIth century - beginning VIIth century A.D.

Marble with different veins
Figured: 98 x 60 cm. Others: 52 x 38 (2), 20 x 38,46 x 38, 43 x 63, 27 x 50 cm.
... FECIT S API ENTER/...H...EMENTE
As Saamasas (Lugo). One appeared at the end of the XIXth century and others in 1967

CHURCH OF SANTIAGO DE SAAMASAS (4)
AND DIOCESAN MUSEUM OF LUGO (3)

In all there are seven rectangular flat plates of which only one has a figured theme. The other six may be grouped in two blocks according to their decoration; the first block is comprised of the pieces decorated with long palmettes which grow out of a fleur-de-lis and sometimes have a deteriorated eight-pointed star above them (in reality they are two four-leaved flowers set one over the other); all this is between a row of heart-shaped petals or a curved stem with three-pointed leaves on both sides. The second block of plant decoration is found in other plates, with large roses and many crosses with fleur-de-lis at the angles. The frame is also of heart-shaped petals and trifoliate forms around a curving stem. The work of all these pieces is carved but fairly open.

The piece which has figurative decoration repeats the framing motifs above and below, which there are eight-pointed stars on the sides (vid. supra) in the upper portion and double Swirls on the lower part. In the center of these sections, and with the technique of flat relief, are two animals, one on each: above is a flat-footed animal (bear) and below a cow or bull, in the first case with the head practically lost through the wearing of the stone and in the second turning the head backward. In both cases a certain sense of volume still remains.

The edges of the plates seem to show signs of assembling and fitting together and on the ground by grooves, tabs and pegs.

The importance of these reliefs comes both from their artistic quality (in spite of their mediocre state of preservation) as well as for the interest of their nature and function, plus their interpretation, including the epigraph.

Apparently these are doorplates from the Visigothic period (end of VIth century or beginning

of the VIIth), corresponding to a primitive church in the area of As Saamasas in the region of Lugo, where already in the Xth century a monastery of 'Sanctas Masas' is cited. It is possibly related to the cults of martyrs. The doorway separated the sacred part of the altar from that dedicated to the rest of the people.

For some authors (Núñez), the plates with geometric-plant decoration would belong to a master who worked with a chisel in a manner similar to work in wood (as in the Roamn-Galician reliefs, we might add), while the piece with animal forms would be by someone else, perhaps not as skilled (?), who overdoes the flat but naturalistic relief, and to whom the most distinctive and significant plate of the possible doorway belongs.

Both the themes and the decorative motifs have been related on the one hand to Italian works from Ravenna, for example, the reading pulpit of bishop Agnelius, 556-570, and on the other, to news of Jewish/Palestinian creations which would reach the Northwest by commercial routes and the travel of Galician writers and pilgrims to the Holy Land in this period. In any event, similar pieces with geometric-plant decoration exist in the area of Mérida (pillar of El Almendral and door jamb of Puebla de la Reina), a Visigothic center of great importance, linked to the Northwest by the so-called Silver Way even in the post-Roman period. Other pieces with Visigothic architectural decoration come from Carcacia (Padrón) and Ferreira de Pallares (Guntín), although with different motifs and work.

As for the interpretation of the figurative reliefs, the similarity to the Agnelius pulpit mentioned above has been deduced (e.g., by Schlunk), but while the animals represented in the latter are 'peaceful', in As Saamasas the identification as bear seems certain. For other authors the bear and cow would be a reminder of Iberian divinities, an explanation that is hardly plausible, and the opinion still exists that they could be two animals from the Tetramorphs (the lion of San Marcos and the bull from San Lucas). According to Guerra, Núñez and others we have to consider it a reference to a text by the prophet Isaiah (11.7), which refers to the way wild animals (the bear) and the domestic ones (the cow) lived together. Unfortunately, the poor condition and fragmentation of the inscription does not help at all in defining any of the hypotheses expressed to date.

The dispersion of the already fragmented and incomplete plates in different places does not help reconstruction of this liturgical element from the Germanic era, although Guerra tried to rebuild the doorway with the pieces preserved today, to which we must add two small column shafts and a capital from he same site of As Saamasas. This reconstruction (a doorway 2.7 m. long and 1 m. high), Schlunk thinks it improbable, while he does not give the reasons for this opinion.

(F.A.V.)

BIBLIOGRAPHY

Castillo, A. de (1928); Guerra Mosquera, J. (1967-68); Núñez Rodríguez, M. (1976) (III) (1978); Schlunk, H. (1945) (1964) Schlunk, H.; Hauschild, TH. (1978).

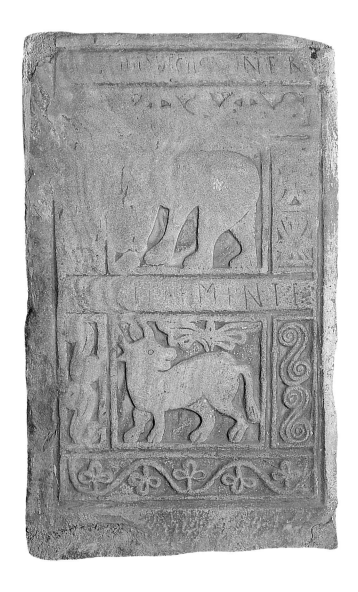

37

Sepulcher cover from Ouvigo

End of VIth century - beginning of IXth
century A.D.

Granite
64 x 51 x 10 cm.
Ouvigo, Blancos (Ourense)

PROVINCIAL MUSEUM OF ARCHEOLOGY
OF OURENSE

Fragment of an inscribed sepulchral tombstone,
with tendency to double slope and probably
subrectangular shape, which is of great interest
because of its rich iconographic repertoire in low
relief. What has been preserved belongs to the upper
extreme and has decoration in the form of a narrow
straight band, placed longitudinally and with a
widened end, crossed by a similarly made and shaped
decoration in U form. This main motif, which may be
interpreted as a very simple anthropomorphic
representation, is accompanied by other figures that
are more difficult to define, on both sides of the
previous one. They may be similar anthropomorphs
but much smaller in size, perhaps forming scenes and
possibly motifs of symbolic nature.

Apparently it was found being reused as part of
the cover of a tomb of vertical slabs in the Ouvigo
necropolis. This cemetery is one of the main
components of that complex archeological site,
structurally centered by a building thought to be
culturally conceived according to a rich and varied
ergology, which goes from the late Roman period to
the low Middle Ages. The lack of a stratigraphy that
would allow an evolutionary reading of that broad
historico-cultural framework, together with its
having been moved from the original site, make
cultural identification and dating difficult.
Nevertheless, the features of the necropolis point
toward the IX-XIth centuries, which would be
supported by the only inscription associated with it:
"tombstone of Begica," from the beginning of the
Xth century. Also the fact that the majority of the
ceramics from Ouvigo belong to periods posterior to
the XIth century, indicates that the necropolis was
abandoned at the end of that century or around then.

The temporal reading for this context leads us to
think that the Ouvigo cover is from the IXth or
perhaps the VIIIth century, fitting with the
beginning of the necropolis, as its reuse within the
same area seems to indicate. This last consideration
nevertheless forces us to suggest another possibility,
which would relate the sepulcher cover to more
ancient funeral expressions, either in a necropolis
or, in the case that there were no solution of
continuity, to a more remote origin. Regarding dates
and parting from the little information in the
archeological registry, we would situate it between
the end of the IVth or the beginning of the
following century and the VIIIth century. If this
ancient chronology is correct, and what's more if
there were a solution of continuity between both
funeral groups, the fragmentation and reuse of the
piece must be interpreted as the expression of a
possible break in concepts throughout this period,
from the Vth to the IXth century, which previous
considerations left for the dating of this piece.

The intrinsic characteristics of the tomb cover
from Ouvigo include it in the broad series of
decorated sepulcher covers which spread
throughout the Late Roman and High Middle Age
periods. From that wide time span come
complications in the iconographic definitions,
accentuated by the figurative simplicity and the
omnipresence of the theme of the stole. This
presence will galvanize the entire repertoire and
localize the research concerning it, forming logical
confusions with other themes, such as that of the
praying figure, all present on these covers. The
piece discussed here belongs to the latter, as it has
the characteristic formal simplification of the
anthropomorph, not lacking in figurative proximity
to the stole. As we already noted, this proximity
sometimes expresses a symbiosis of both themes,
sometimes it reflects a simplification that confuses
them, making the iconographic reading difficult.

The theme of the 'orans figure', in spite of the
formal confusions mentioned, has its own
iconological identity, which comes from the Paleo-
Christian ideological world, as well as a specific
iconographical definition which derives from the
representation of the dead person and evolves
formally to the loss of characterization in a very
accentuated schematism. In regard to the
chronology, this represents a temporal lapse which
goes from the Vth century to the IXth. The
sepulcher cover from Ouvigo has two
characteristics which we must keep in mind as far
as its comprehension within the evolution of the
theme. One is its schematism, which could lead us to
an advanced period of the stylistic evolution
mentioned above. The other is the presence of an
enriched iconic repertoire with themes and symbols
added to the orans figure. This would place the
piece in a subgroup of covers with this figurative
complexity. The fact that we only have one other

cover, from Santa Mariña de Augas Santas, to aid in the configuration of that taxonomic variation, keeps us from proposing a temporal estimate for it. Perhaps the presence of symbols which will be common in the covers of the IXth and Xth centuries will indicate the late position of the Ouvigo-Santa Mariña de Augas Santas group.

In conclusion, the piece from Ouvigo belongs to a subgroup of tomb covers with representations of the praying figure, characterized by iconographic enrichment. Regarding its chronology, both the characteristics of the piece itself and the archeological register to which it belongs offer few possibilities for precise and certain dating, only hypothetical and fairly lax, we propose a date between the end of the VIth century and the beginning of the IXth.

(J.S.O.)

BIBLIOGRAPHY
Rodríguez Colmenero, A. (1985).

38
Ornamental disc from Sabante
IXth century A.D.

Granite
44 x 15 cm.
Sabante, Crecente (Pontevedra)

PROVINCIAL MUSEUM OF PONTEVEDRA

Granite disc carved in the back side of a handmill. It is decorated with a rosette in the centre, which is surrounded by an interwoven crown, between two circular rims.

It is a piece with an exclusively ornamental function, intended to decorate the wall of a building, at the point of convergence of two arches. Although it is the first known case which has appeared in Galicia, in fact it follows a typical form of the Asturian constructions of Ramiro I's period (842-850). In Santa María del Naranco there are 32 medallions of this type decorating the main floor of the palace, internally as well as externally. Some discs are shallow, simply carved in the wall, but there are others engraved in cylindrical bases, which go from one side to the other of the wall, in such a manner that it is decorated on both surfaces. The samples of Naranco differ by offering representations of the bestiary, of oriental inspiration, in the interior disc. A similar composition can be seen on the lateral arches of the nave of Santa Cristina de Lena, built in the same period. Nevertheless, some defend a slightly earlier chronology, coinciding with Ordoño I's reign (850-856); he had his country palace there. The church of San Miguel de Lillo has the same decorative solution in the upper part of the tribune though the disc is smaller, due to the absence of the external crown. The simple rosettes appeared also in high medieval churches in Portuguese territory, as San Pedro de Balsemao proves.

The origins of this ornamental type caused a diversity of theories. For H. Schlunk there are no reasons to defend the influence of the Viking bracteates (as Haupt and Pijoan did) or the influence of the Greek and Roman war shields (as Puig and Cadafalch do). In his opinion the origin is oriental. There are archetypes in the palace architecture of Byzantium and, besides, the animal motifs themselves from Naranco support such influences.

The orientalist thesis seems convincing but it is also possible to note other models that help better identify the origin of this architectonic formula. Although carved in rectangular blocks, discs with ornamentation already exist to decorate the spaces between the arches in the Leptis Magna forum (IIIrd century A.D.). Their Roman and oriental origin also helps to explain the presence of this ornament inside Carolingian and Lombard architecture.

We can cite examples of the Asturian discs in the Palatine chapel in Aken and in the Italianate church of S. Salvador of Brescia. The close relationship between these and the Oviedo decorations are clearly shown in San Xulián de Prados, of Alphonse III the Chaste's times. Here, like in Brescia, the discs are painted in the sculpture. The stone discs of Ramiro I's epoch may be related to an intensification of the contacts with the Orient, which also manifests itself in other architectonic elements, such as capitals, tympanums, bases and even in some windows.

(M.R.).

BIBLIOGRAPHY
Bonet Correa, A. (1967); Crema, L. (1959); Fontaine, J. (1977); Manzanares Rodríguez, J. (1964); Donofrio, M. (1983); Peroni, A. (1976); Schlunk, H. (1948).

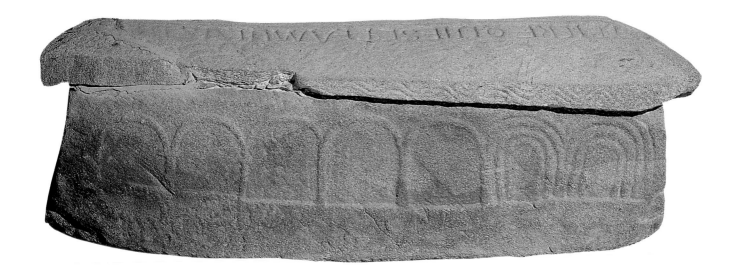

39
Sarcophagus of Saint Wintila
890 A.D.

Granite
63 x 225 x 75-51 cm.

SANTA MARÍA DE PUNXÍN (OURENSE)

Free-standing sarcophagus, formed by a trapezoidal box and covered with a stole, larger in size than the burial box.

The burial box is decorated in the front with irregularly sized arches, with a single arc, except for the first two, which are quadruple. This recalls the decoration of the sarcophagi made of lead or molded plaster. At the foot of the box the arch motif is repeated.

The stole motif appears on the lid, with a triple central rebate moulding which in the bifurcations of each end holds an Asturian cross (at the head) and a fragmented schematic anthropomorphic representation (at the foot). The presence of the decorative element of the stole shows the long survival in the Northwest of this motif for the decoration of sarcophagi, since although the dating of one from the sixth century seems correct, other pieces are clearly from the ninth and tenth centuries. In these postulations the opinions of Chamoso Lamas and Schlunk are representative.

On one of the sides of the cover there is a rich plant decoration, in spite of the wearing away of the sculpted surface, and on the side of its base there is a curving stem motif. Completing this side is an engraved inscription of which a portion is missing, with the epitaph of the familiar, widely used formula:

HIC REQUIESC(I)T FAMULUS DE(I)

On the opposite side it is completed by an inscription from a much later date painted in black characters which except for the last psalm is considered to be the transcription of the primitive text:

HIC REQUIESCIT SERVUS DEI WINTILA QUI OBIT DIE 23

DECEMBRS ANNO 890. Pretiosa in conspectu Domini mors Sanctorum

The sepulcher is attributed to Saint Witila, a hermit who sought refuge in the area of Punxín, and whose hermitage, built next to the present day church, would be one of the numerous hermitages which lined the Miño River and its tributaries, later coming to depend upon the monastery of Santa María de Barra (Coles).

Nevertheless, there is still some doubt concerning the loss of the epigraph or its incomplete nature. Ambrosio de Morales published it in its entirety, according to information received by the bishop of Ourense, Juan de San Clemente, and this would be

135

followed by later authors, who introduced slight variations in the text.

The sepulcher must be placed in relationship to the high medieval burials in the cathedral of Santiago (IX-X), but above all with the sarcophagi of San Salvador das Rozas, Mandrás and the nearby San Pedro de Viñao. As in these examples, there is already a sense of individualization, marked by the engraved epigraphs and the ornamentation, which is also the stole motif, already in regression. It shows a certain decorative showiness intended to cover the visible surfaces of the sarcophagus, not just the cover.

(Y.B.L.)

BIBLIOGRAPHY

Castillo, A del (1931); Fariña Busto, F.; Suárez Otero, J. (1988); Núñez Rodríguez, M. (1977) (I); (1977) (II); Rivas Fernández, J.C. (1981); Pérez Outeiriño, B. (s.d.) (G.E.G.).

40
Diadem from Vilavella
2000-1800 B.C.

Gold
345 mm. long
Veiga de Vilavella, As Pontes (A Coruña)

UNIVERSITY OF SANTIAGO DE COMPOSTELA

This piece reflects the formal, technical simplicity of the most primitive jewelry in gold. It consists in a rectangular plate made by the procedure of battering the gold when cold. Such a simple manufacture and the weakness of the piece makes its interpretation as a diadem very doubtful, since it seems to be an ornament component rather than an actual jewel. Now, as such a component it can be considered part of a diadem, with the strengthening of a leather strap, as happens with the Breton example of Kerouaren (Piouhinec, Morbihan).

It appeared in a Post-Megalithic tumular context. The fact of being associated with copper arrow-points of the Palmela type in a burial that lacks architectonic structure, indicates a transitional period between the Calcolithic, to which the apogee of the Megalithic is linked, and Early Bronze. This moment is located chronologically around 2000-1800 B.C., and culturally should correspond to the momentum of expansion and development of the bell-shaped ceramics and to the similar formation of the items and patterns of the Bronze Age culture or cultures.

The fact that the golden ribbons and bell-shaped ceramics belong to the same cultural context is proven by the union of both in the dolmen of Entretérminos (Madrid) or in the pit burial of Fuente Olmedo (Valladolid). If that union does not appear de facto in Galicia, we can presuppose it to the extent that both elements are in the same type of

funeral structures and there is a scarcity of contextual data that could validate or deny the present disassociation. We are thus opposed to the elaboration of pauses in the cultural evolution that affects both types of pieces, just as is expressed in the so-called Montelavar Horizon. This defines a phase characterized by a metallurgy related to the bell-shaped world, as the one found in Vilavella, but without the ceramics typical of this world. The weakness of this formula is due to a negative argumentation: lack of discoveries which associate the bell-shaped ceramics and the metallurgy that, judging from other areas, is characteristic of them; reasoning that fuses the scarcity of data previously mentioned. And also the fact, verified recently, of

the abundance and variety, at the same time as it indicates a strong link with the first moments of the Bronze Age.

Summarizing, this jewel or ornamental component is related to the cultural phenomenon characterized by the bell-shaped ceramics and the metallurgy present in the burial of Vilavella. Chronologically, it shows the evolution of these ceramics: ca. 1900-1800 B.C. or 1800-1700 B.C.

(J.S.O.).

BIBLIOGRAPHY

Harrison, R. (1974); Hernando, A. (1989); Monteagudo García, L. (1953); Ruiz-Gálvez Priego, M. (1979).

41
Chokers from Monte dos Mouros
Early Bronze Age.1800-1600 B.C.

Gold
1st: 50 x 100 mm.; 2nd: 40 x 300 mm.
Monte dos Mouros., San Martiño de Oleiros
(A Coruña)

PROVINCIAL MUSEUM OF LUGO. PRIVATE
COLLECTION OF MR. ÁLVARO GIL VARELA

These pieces belong to a gold set found in Monte dos Mouros in 1887, in unknown condition, of which gold strips, today disappeared, and a bracelet were also a part.

Both chokers have the common characteristic of a central decoration of half shanks done by breaking the leaf and the later embossing of the strips obtained, as well as a rectangular form which narrows at the ends.

The larger one has fourteen embossed strips and a decoration of vertical lines done with narrow lace edging on the inside, between the strips and the ends. The leaf ends in vertical turns for the clasp of the jewel.

The smaller one has only seven strips, the ends of the leaf are convex and have holes to close it. Its decoration is completed by three horizontal embossed lines and stippled vertical lines in the space between the scratched area and the ends of the leaf.

The nearest piece typologically is the also Galician one of Goiás (road from Lalín to A Golada). Also similar are the four examples with strips from Sâo Bento de Belugâes and the diadem from Cícere (A Coruña) which for their context of burial in a cist in the first case, in a tumulus in the second, and for the other components of the jewelry, plain diadems from Cícere and arrow heads of the palmette type in Belugâes, indicate to us a clear classification in the Early Bronze Age and even its first period: XIX-XVIII B.C. In that chronology the heavy armlets of cylindrical section which accompany the piece from Goiás are redundant.

Other parallels, which because of their similarity offer no doubt, are found on the French Atlantic coast, especially in Brittany and Vendée. The cases known here, the northern dolmen of Rondossee, in Plouharnec (Morbihan), Saint-Laurs, Deux Sévres and Saint-Pére in Retz, show a chronology from the beginning of the Early Bronze Age, similar to that for the Hispanic Northwest.

The lack of examples in other areas reduces the expansion of this type of jewel to the continental Atlantic façade. It thus corresponds to a form original to that area (there are not sufficient arguments to decide whether it was born in the North or the South of that geography, although the authors opt for the Iberian precedent) and is developed in the first half of the Early Bronze Age: XIX - XVIIIth centuries B.C.

(J.S.O.)

BIBLIOGRAPHY
Briard, J. (1965); López Cuevillas, F. (1933) (I); López Cuevillas, F., Bouza Brey, F. (1929); Monteagudo García, L. (1953); Ruiz-Gálvez Priego, M. (1978).

42

Torques from the Treasure of Caldas
Early Bronze Age: 1800-1600 B.C.

Gold
Diameter 226 mm.; large 10 mm.; weight 870 gr.
As Silgadas, Caldas de Reis (Pontevedra)

PROVINCIAL MUSEUM OF PONTEVEDRA

It is an adornment of simple creation, done by a gold bar of circular section with the ends flattened (the form of the ends motivates the decoration). For its characteristics and dimensions it has functionally been considered a torques.

It is one of the three examples we have of this type in the Iberian Peninsula. The other two are in El Viso (Córdoba), without context, and in the dolmen of La Veguilla (Salamanca), which must be associated with the important group of camapniform (bell-shaped) ceramics in that burial site. Only the latter offers us any information regarding chronology or cultures, in relation to cultures that are definable by the presence of bell-shaped ceramics, in this case the incised type of the Northern Plateau (Ciempozuelos), with chronologies between 1900 and 1600 B.C., approximately.

Nevertheless, its is a fairly common form throughout the entire Atlantic façade of Europe, from the Nordic world to Brittany and the British Isles. Its association with contexts of the La Vaquilla type, with the Veluwe wrapped bell-shaped type in Holland, or with jewels which like the lunulas, have a clear classification in the Early Bronze Age, leads us to propose a chronology of 1800-1600, that is, its correspondence to the early and full moments of that era.

Some chronologies can be used to identify the collection of Caldas, as is seen in other pieces in this exposition. Although we speak of a final stage of the Early Bronze Age for this treasure, it does not necessarily mean that all its components have an identical date, since we lack information as to the formation and significance of the collection.

(J.S.O.).

BIBLIOGRAPHY
Hernando, A. (1989); Ruiz-Gálvez Priego, M. (1978) (1979).

43

Glass from the Treasure of Caldas
Early Bronze Age. Ca. XVIth century B.C.

Gold
87 x 87 cm. Weight: 640 gr.
As Silgadas, Caldas de Reis (Pontevedra)

PROVINCIAL MUSEUM OF PONTEVEDRA

This piece, called a glass, although perhaps the term cup is better, has a globular, hemispheric appearance. Nevertheless, it has a tendency to straight line in sections of that globally curved evolution which we attribute to its body, and its formal interpretation becomes complex, based on biconical dimensions. This reading is emphasized by the irregularities in the mounting of the ribbon handle onto the glass and by the presence of a small flat background. It is thus a bit difficult to define the formal model which was applied here. Also definitory is an incised decoration of friezes covered with vertical lines alternating with other plain ones, creating a decorative field which completes and outlines a strip of triangles, also filled with an oblique design. This syntax fits the characteristics of the different parts of the receptacle where it is applied: upper part of the body, bottom and handle.

Along with this glass two other receptacles from the same treasure must be mentioned. One has a similar morphology but no decoration, and the other in the form of a pitcher with decoration of identical motifs and syntax. The three are unique and increase the value of a group which is already exceptional for the number of components and the quantity of gold they contain.

The first step toward situating this cultural form is directed toward putting it in relationship to similar expressions in the western European context, where we find a series of gold or silver recipients: Fritzdorf, in the German Rhine; Eschenz, in the western part of modern Switzerland; Saint-Adrien, in French Brittany; and Rillaton, in the British Isles. All of these have a similar form of the pitcher type, and also the same decorative formulas based on the embossing or narrow laced edging, both characteristics which make them parallel to ceramic forms of the Early Bronze Age with strong survival of the campaniform type, but which clearly differentiates them from the pieces of Caldas, in which only the small pitcher has a very generic similarity.

Nevertheless, there are facts which would give the pieces from Caldas a chronology and a cultural context not very distant from that of the European pieces. This is their morphogenesis in a type or types of cermaics from the Northwest which arise in campaniform environments with solid European connections: bell-shaped jars with decoration reaching the ribbon handle that typifies them, at times with motifs which imitate cording or in discoveries in which this ornamental formula is present. The repercussion of this ceramic type is seen in findings of the high Early Bronze Age, generally in recipients without decoration but also

with it as those of the piece analyzed here. In chronological terms 1900-1800 B.C. can be suggested, if not earlier, for the beginning of this type, and around 1700 for its expression in the Early Bronze Age.

One last argument to keep in mind for the explanation and interpretation of this piece is its relationship to ceramic forms outside the Hispanic Northwest. These forms are found in the same environments as the other western European metal pieces, such as some of the group from the Early Bronze Age in the Rhine area of Adlerberg, where the best parallels are found. The same occurs in forms of the British campaniform (bell-shaped) evolution, with an unquestionable Central European inspiration and datable in the beginning of the Early Bronze. Finally, the similarities already noted by a researcher with cups from the American tumuli, whose chronology is somewhat later (Middle Bronze Age), but which are inspired in models of the Rhine area (those of Adlerberg discussed earlier).

As a corollary, we believe that this piece belongs to a western European context based on common morphogenetic factors and a similar evolution, in relation to the first cultures of the Bronze Age, in whose high period (1700-1600 B.C.) the glass from Caldas may be situated.

(J.S.O.)

BIBLIOGRAPHY

Bouza Brey, F. (1941); Monteagudo García, L. (1953); Pingel, O. (1985); Ruiz-Gálvez Priego, M. (1978).

44

Comb from the Treasure of Caldas
Early Bronze Age. 1800-1500 B.C.

Gold
63 x 85 mm. Weight: 200 gr.
As Silgadas, Caldas de Reis (Pontevedra)

PROVINCIAL MUSEUM OF PONTEVEDRA

The so-called 'Comb of the Treasure of Caldas' shows an upper part constituted by three semicircles decorated by strips filled with dots alternating with other plain ones, a central part in the form of a wide flat plain moulding, with twenty-five straight lines in the middle, curved at the ends, which define it as an object.

Although it is one of the most attractive pieces of the gold group from Caldas, it is also one of the most problematic when interpreting it. Regarding its functionality, because of the presumable adaptation to its usage, impossible as a comb, difficult as a shell comb in any event as an object of adornment, not for use. Regarding the cultural, because it lacks parallel in the area of combs or similar items on the Iberian Peninsula.

Nevertheless, this last aspect places us in relationship with the hypothetical sources of inspiration of this treasure, reaffirming morphogenetic relationships with certain European areas. We are referring to the fact that its only possible parallels as far as the form were found in the Upper Rhine, and this form's origin is in a type of comb, which the one from Caldas reproduces faithfully, created by the interweaving of rods of plant nature. This type is abundant in the High Calcolithic—cultural groups of Horgen and Lüscherz—and the Late period—the group of 'cord ceramics' from the North and West of present-day Switzerland, where it possibly existed in the beginning period of the Bronze Age.

It would thus be a scheomorph whose form has wide roots in the Upper Rhine. Here it appears imitated in other materials from early times, prolonged in time by the continuism and convergence of the different cultural groups and facies. This would explain its presence in a group from the Early Bronze Age. This cultural convergence between Galicia and that area is also found in the glasses from this treasure, and a more generic relationship with the Central European world is shown by some other components (heavy armrings and torques with buffer terminals).

Although the comb is not very useful in chronologically defining the group, it is useful as far as its cultural interpretation. Not only because it resembles a specific cultural area (the Upper Rhine) as a source of the forms included in the treasure, but also because of its specificity, which helps to understand a collection, abundant in quantity and rich in variety. This points both to the storing of gold and the treasuring of forms which in themselves have a special value.

(J.S.O.)

BIBLIOGRAPHY

Bouza Brey, F. (1942); Monteagudo García, L. (1953); Ruiz-Gálvez Priego, M. (1978); Gerloff, S. (1975).

45
Armlet from Urdiñeira
Early Bronze Age. Ca. 1600-1500 B.C.

Gold
42 mm. height
Treasure of Urdiñeira. Parada da Serra, A Gudiña (Ourense)

PROVINCIAL MUSEUM OF LUGO. PRIVATE COLLECTION OF MR. ÁLVARO GIL VARELA

Open cylindrical armlet, formed from a narrow rectangular plate of gold and with holes on each end for the closing. It has a geometrical decoration of lines and zig-zags, done with a series of punch-dots and its syntax is adapted to the shape of the piece.

It was found together with a cylindrical bracelet, also gold, and a circular bronze plaque (both pieces

also included in this Catalogue), when a ditch was opened at the foot of Mount Urdiñeira. This find occurs at the beginning of the twenties, and no more information is available concerning the supposed great profundity of the hole where this occurred. The later history of the pieces of this group includes their separation. The armlets were in private collections, first in that of Blanco-Cicerón and later in that of Gil-Varela, until they ended up in the Museum of Lugo, while the bronze disk was donated to the Museum of Ourense. That evolution resulted in the lack of knowledge and confusion concerning the pieces of the Treasure of Urdiñeira.

If we add the uniqueness of the piece within the metal work of the Northwest to the contingencies already mentioned, we can understand why it was almost unnoticed by the bibliography on both Galician and peninsular metal work of the prehistorica era. Only Cuevillas paid attention to it, placing it in the later Bronze Age and presenting some of the most relevant confusions in the comprehension of the group to which the armlet belongs (a problem taken up again in the commentary on the bronze disk).

In spite of its uniqueness, which makes it difficult to classify among the types known today, this armlet has a series of features typical in the metal work of the Early Bronze Age. Its decoration, narrow lace edgings is very simple and very abundant in the most ancient jewelry, its morphology also common to the Ancient Bronze Age, as seen by its appearance in the diadem of hanging strips from Cícere (A Coruña) or the glasses from the Treasure of Caldas.

At the same time, its form may be related to the cylindrical bracelets, which like the one also in Urdiñeira, allow that temporal and cultural attribution.

Taking into account the evaluation of those fundamental attributes of the armlet of Urdiñeira, we consider it to be probably related to the first period of the Bronze Age, with a later date neither necessary nor arguable, although not impossible.

The distant parallels would point geographically but not formally in this direction, for it is possible to find in contexts of the Early Bronze Age in other European areas. Since they can be armlets and wristlets of the Central European culture of Aunjetitz, where the examples of Peigarten in Lower Austria, or Borotice in present-day Czechoslovakia, express the same formal conception and a similar if not identical decoration. Or also the cylindrical bronze British armlets from Knipton or Normaton, and the gold bands of that same source, like that of the rich burial site of Upton Lowell, with a chronology of the beginning and end, respectively, of the Early Bronze Age, and in relation to the culture of Wessex. This casuistry, which has been related (the British authors look toward Central Europe when explaining the morphogenesis of the examples cited), repeats the relationship on three fronts, Central Europe, the Atlantic area and the Iberian Peninsula, which become obvious when there is an attempt to understand a good part of the metal work of the Early Bronze Age, as well as many other aspects of the cultural reality or realities of that time in the Bronze Age. The geographic distance is countered by a cultural frame with similar characteristics and evolution as well as a strong interrelationship of its components, cause and efect of that similarity.

In summary, we propose a chronology of the Early Bronze Age for the Urdiñeira armlet, probably from a later date, around 1600-1500 B.C.; but we cannot discard its inclusion in the following

period, the High Bronze Age (1500-1200 B.C.), which are chronologies, but not necessarily cultural ones. A cultural classification framed in formal and conceptual parameters of the Atlantic region and Central European tradition.

<div align="right">(J.S.O.).</div>

BIBLIOGRAPHY
López Cuevillas, F.; Bouza Brey, F. (1929); Macías, M. (1921).

46
Bracelet from Urdiñeira
Early Bronze Age. ca. 1700-1500 B.C.

Gold
53 x 73 mm.
Treasure of Urdiñeira. Parada da Serra, A Gudiña (Ourense)

PROVINCIAL MUSEUM OF LUGO. PRIVATE COLLECTION OF MR. ÁLVARO GIL VARELA

Cylindrical bracelet with convex moulding decoration. Series of ten hoops of identical characteristics and dimensions, which determine the form and decoration of the piece. The bracelet has arms which open outward and its ornamentation is finished off with a series of small incised vertical lines, set in a strip along the edges and in sections of the concave spaces between the moulding

Because of its regular, closed cylindrical form, as well as the edges, we think that it should be functionally interpreted as a barcelet. That attribution shows the functional complementarity of the jewelry in Urdiñeira: bracelet, armlet and button. This complementary nature is also perhaps symbolic, differentiating this set from others of the Northwest, since it does not appear to express an accumulation of gold and/or objects of value and special meaning, as could be the case of the Treasure of Caldas, but rather the characterizing attributes of a status exclusive to an individual or individuals within a social group. This position is not reflected as much or only in the possession as in the exhibition. The group of Urdiñeira, following the previous characterization, resembles a burial site more than a treasure.

Regarding its precise cultural and temporal classification, we lack references in the area of the Hispanic Northwest. The related jewely, unique in the Iberian Peninsula to the geographic region in question, are reduced to an armlet from Monte dos Mouros and two others from the Portuguese treasure of Arnozella. None of the cases offers more information than Urdiñeira itself, the first because it appeared in isolation and without context and the second because it was accompanied by pieces that were not very indicative. The only alternative, and as such it was followed by the majority of the researchers, is to relate them to other jewelry which uses the convex moulding as a decorative formula: chokers and garters with attached strips from Monte dos Mouros, A Golada and Cícere, datable in the Early Bronze Age, or the armlets of Moimenta, whose chronology is difficult to determine. Nevertheless, we cannot forget that these are different types and forms of creation as far as decoration goes, also differentiated with respect to the piece which interests us here, for which that relationship is not very informative. This situation is aggravated if we consider the survival of that decorative formula throughout the whole Bronze Age, even reaching the world of the castros, which causes the chronological proposals of the several authors who studied Urdiñeira to be varied and at times old: the Early Bronze Age, the Late Bronze Age or simply the Bronze Age.

The continuation of the convex moulding does not necessarily imply that the different ways of obtaining it are the expression of an evolution in its long life as an ornamental form, each one corresponding to different moments of that transformation. It is necessary to take into account what types of jewelry can require or suggest ways of production adapted to their functional and/or morphogenetic specificity. Let us remember for this last conditioning factor the relationship that seems to exist between the cylindrical bracelets with convex moulding and the bracelets of rolled threads. Thus the distance noted between the bracelet of Urdiñeira and the garters or chokers of the Early Bronze Age do not exclude the former from belonging to the first phase of the Bronze Age. This seems to indicate, on the other hand, the European parallels for this piece: Aunjetitz culture in Central Europe, Bronze I in the Nordic world and Wessex culture in Great Britain, all of these from the Early Bronze Age (1800-1500 B.C.)

In conclusion, and in spite of all the problems expressed, we believe that this piece of jewelry is easily assigned to the stage of prehistoric metal work that seems to be centered on advanced periods of the Early Bronze Age (1700-1500 B.C.), where the others of the group also seem to be situated. For greater precision, within a purely hypothetical framework, we postulate a final period of that phase: ca. 1600-1500 B.C.

<div align="right">(J.S.O.)</div>

BIBLIOGRAPHY
López Cuevillas, F., Bouza Brey, F. (1929); Macías, M. (1921).

47
Button from Urdiñeira
Early Bronze Age. Ca. XVIth century B.C.

Bronze
45 mm. diameter
Treasure of Urdiñeira. Parada da Serra, A Gudiña
(Ourense)

PROVINCIAL MUSEUM OF ARCHEOLOGY
OF OURENSE

Circular bronze plate with flat section, concave interior part and convex exterior. An incised decoration articulated in quadrants, defined by successive angles up to the center covers the entire surface. The center is occupied by a cut out in the form of a cross which functions as axis of the entire decoration, which can be defined by a large central cruciform, with the cut out inside and decoration with angular designs (Monteagudo).

The button is the piece which best reflects the problematic of the knowledge of this group, since it only appears in reference to it at a very late date, while in the beginning there was mention of a piece of the same characteristics but made from a supposedly stone or citreous material (Cuevillas). The origin of this confusion, still not entirely resolved (Is there another piece?), comes from the avatars the treasure has suffered since its discovery, among them, the separation of this piece from the other two gold ones of the group, which explains the present location in different collections.

This situation led it to be less studied in the course of Galician prehistoric research. References are scarce and, as we already indicated, confusing. Its study is not helped much by the fact that is a unique piece both in the Northwest and the rest of the Iberian Peninsula, which is thus added to the lack of contextual features of an accidental discovery, of which we only know that it was fairly deep and the pieces it included were two armlets and a bronze disk.

Its morphology seems to correspond to the idea of a "button," and in that sense it has parallels in the British isles: the jet buttons, also with a cruciform decoration, from Hareope and Peeblesshire in Scotland, and the smooth jet and bronze buttons of the also Scottish deposit of Migdale, where they appear with egg-and-dart armlets, as in Urdiñeira. Both finds can be situated in an initial phase of the Late Bronze Age (XVIIIth century B.C.)

Concentrating on the decoration, it is also in the British Isles where the best parallels appear, since if the Irish gold disks of the Early Bronze Age already are a model for the decoration of the disk of Urdiñeira, the basis for a conical gold button from the rich tomb of Upton Towell (southern England) will have an identical decoration. Its chronology would be an advanced period of the Late Bronze Age (XVIIth century B.C.).

We believe that with these parallels we can

define the functional and cultural parameters in which the disk from Urdiñeira belongs. A button with careful elaboration and rich ornamentation which recallls an emblem of prestige, and thus it is reasonable to associate it with two jewels which like it, indicate the accumulation of real and/or symbolic wealth and the social hierarchization reached in the late stages of the Early Bronze Age (ca. XVIth century B.C.).

(J.S.O.)

BIBLIOGRAPHY
López Cuevillas, F., Bouza Brey, F. (1929); Macías, M. (1921); Monteagudo García, L. (1981).

48
Armlets from Moimenta
Bronze Age: 1600-1000 B.C.

Gold
36 x 170 mm.
Moimenta, Arnois, A Estrada (Pontevedra)

PROVINCIAL MUSEUM OF LUGO

Cylindrical open armlets, with an egg-and-dart decoration done with embossing and shaped by seven parallel horizontal mouldings. An attractive detail is the manner of resolving the meeting of this

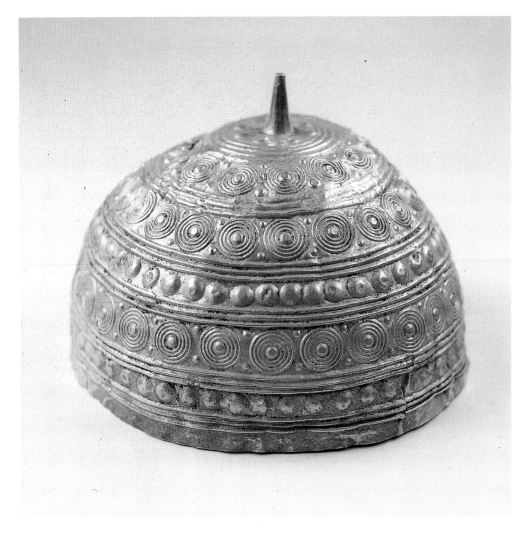

In our opinion, no definitive solution can be given now; we can only include them in the metal work tradition of the Northwest which begins in the Early Bronze Age and seems to show strong development, lasting throughout the Bronze Age. It is not possible today to locate technical or morphological changes such as those of the armlets of Moimenta.

(J.S.O.).

BIBLIOGRAPHY
Hernando, A. (1989); López Cuevillas, F. (1951) (I); Ruiz-Gálvez Priego, M. (1979) (1984).

49
Armlet from Toén
Late Bronze Age: VII-VIth centuries B.C.

Gold
20 mm. heigh; diameter: 74 mm.
Santa María de Toén (Ourense)

PROVINCIAL MUSEUM OF LUGO. PRIVATE COLLECTION OF MR. ALVARO GIL VARELA

This piece was found, together with some other elements, accidentally at the limit of the parish of Santa María de Toén when works were being done. Its decoration consists of a double row of spheres which outline an open-work area, whose technical and formal bases are found in the pieces of the Late Bronze Age of the Estremoz type. This influence eloquently reveals the function of the Atlantic routes of communication and the relations between the region of the peninsular Southwest of a Galicia also open to the influences of North and Central Europe.

(F.F.B.)

BIBLIOGRAPHY
Blanco Freijeiro, A. (1957); Bouza Brey, F. (1934); López Cuevillas, F. (1951); Ruiz-Gálvez Priego, M. (1984)

decoration with the end of the plate from which the piece is formed. The solution consists of parallel vertical mouldings at the ends of the armlet which join the horizontal rows two at a time. In this way it becomes a decoration of concentric rectangles adapted to the overall shape of the work. This ornamentation is completed by a band similar in size to the mouldings, integrated by four fillets, which runs parallel to the former occupying the edges of the piece.

The lack of context and formal specificity of the armlets makes their classification in a particular moment of our prehistory difficult. The fact that they are egg-and-dart led most all the authors to relate them pieces with the same decoratio, as in the case of some chokers or garters with strips, like those of Monte dos Mouros or A Golada, or armlets like those of Melide and Arnozela. This jewelry presents or sustains a chronology more or less ancient within the Early Bronze Age (1800-1500 B.C.), which led some researchers to assign them an identical or similar cultural identity. Thus, M. Ruiz Gálvez situates them in the final stages of this period, with a prolongation into the Middle Bronze Age.

Nevertheless, this particular decorative solution indices other authors to speak of a more advanced technique corresponding to later jewelry. This is the case of Cuevillas, who situates them in the context of the castros.

50
Helmet from Leiro
VIth century B.C.

Gold
Max. diam. 195 mm.; height to appendix, 150 mm.; length of appendix, 23 mm.; weight 270 gr.
Parish of Leiro, Rianxo (A Coruña)

ARCHEOLOGICAL AND HISTORICAL MUSEUM. A CORUÑA

This gold piece, unique in Galicia, was found by accident when a shed was being built to hold the farming implements. It was inside a ceramic glass destroyed by the discoverer's tools, which also perforated the fine metal plate. In spite of appearing in the decade of the 70s, it still has not been sufficiently published. We presented it as a helmet or cup, but in later citations is appeared definitely as a helmet.

It has a semispherical form with a cone-shaped appendix on the upper part. The entire surface of the piece is decorated with hammer embossing from the inside, with dies and punches. The decorative motifs are placed in horizontal bands framed by a series of three parallel rebate or boltel mouldings, except for those of the upper part, which end in the appendix. From top to bottom there is an alternating succession of chains of umbos or raisings and concentric circles with a small central umbo and four similar ones framing each outer circle until a total of six strips are completed.

The closest parallels are in the cups from Axtroki (Eraña, Bolibar, Guipúzcoa), also found accidentally in a landslide and which were related to Hallstatt pieces from Central Europe, especially Germany, and even with others from Denmark. The chronology we may assign to our helmet, in view of the parallels mentioned, would take us to Hallstatt B and C, approximately around 800 B.C., although this date may perhaps be closer to the sixth century B.C., when these pieces, which the oldest levels of other castros are providing, allow us to structure the Halstattization process of the Northwest.

(F.C.L.)

BIBLIOGRAPHY
Vázquez Varela, J.M. (1982).

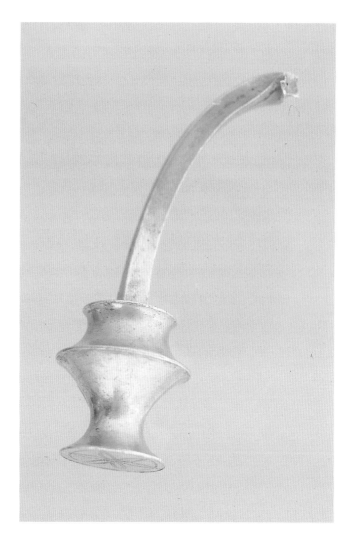

51
Torques from the Province of Lugo
Castro culture. IVth century B.C.

Gold
9 cm. long: end, 3 cm.: Weight: 50 gr.
Uncertain origin, some sources believe it is from a castro of the province of Lugo

PROVINCIAL MUSEUM OF LUGO. PRIVATE COLLECTION OF MR. ÁLVARO GIL VARELA

The fragment is constituted by a bar of rhomboidal section and a end of double scotia. The engraving of the external disc of the end shows a six-petalled rosette inserted in a circle. There is a series of torques of a very similar typology to this one from Portugal (Lebuçâo, Chaves and Paradela do Río) and from the province of Ourense (two torques kept in the British Museum). The only decoration is in all of them the six-part rosette of the terminal discs.

The rosette, traditionally considered a solar symbol, is not only a recurring motif in this category of objects, but is also one of the favourite themes for the ornamentation of a circular and flat form which, definitely imposes a rotatory pattern with a marked central point and, at times, radii pointing towards the edge. All seems to indicate that the first examples of this class of ornaments are documented in the Orient, particularly, it was widespread in western Asia and in the Minoich and Mycenaean metalwork. The momentum of the rosettas in Greece took place in the second half of the VIIth century B.C.; many examples are known from the workshops of Rodas and Melos. Towards the VIth century B.C. the Greeks developed the technique of enamel in filigree, which had its more characteristic expression in the rosettas during the IVth century B.C. In the metalwork from the Southern Iberian Peninsula, for example, in Cádiz, we see rosettas with enamelled petals that have been interpreted as derived from the Greek influence of the IVth century B.C. Nevertheless, older jewels are known from the South of the Peninsula with rosetta motifs, like the diadem from Aliseda, dated around the VIIth century B.C., or the floral compositions on the oval plates of the seals of the necklace from the Carambolo, whose principal motif is a four petal rosetta flanked by flowers or buds. From the necropolis of Dulmes (Carthage) is a circular mould of fired clay dated in the VIIth-VIth centuries B.C. This mould, 13 cm. in diameter, has a very similar decoration to some of the castro torques: a rosette, in this case with

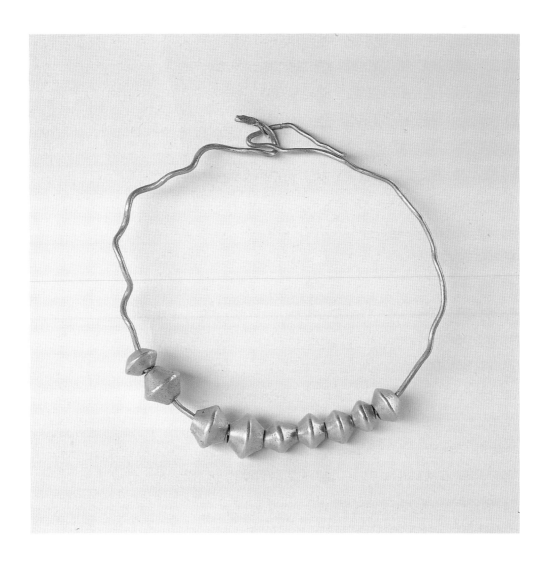

twelve petals, and a surrounding motif of intertwined Ses, a decorative pattern practically identical to the end of a torque from Lebuçâo, for example. Undoubtedly the rosettes of the castro torques are a Mediterranean motif.

Although this torque has been hypothetically dated in the IVth century B.C. because of its technique, due to the lack of a known archeological context, it is not possible to determine its chronology, although it seems clear that belongs to the Castreña Culture.

(L.C.)

BIBLIOGRAPHY

López Cuevillas, F. (1951) (I); Peinado Gómez, N. (1975); Perea Caveda, A. (1986)

52

Necklace from Chaos de Barbanza
IIIrd. century B.C.

Gold.
12 cm. in diameter and 40 cm. in perimeter; weight: 135 gr.
Chaos de Barbanza, Boiro (A Coruña)

PROVINCIAL MUSEUM OF LUGO. PRIVATE COLLECTION OF MR. ÁLVARO GIL VARELA

Gold necklace found together with a series of bronze objects of which no description remains. It is composed of gold wire, hammered, with hooks on the ends to close it, and nine biconical strung beads, also of gold. For lack of other similar objects, the necklace of Chaos de Barbanza has come to be compared with that of Estela (Minho, Portugal), but this one is much more complex and varied in its elements. The only analogy is in that the jointed necklace of Estela there are also biconical beads, eight in number. In the case of Estela we may imagine that it belongs to the Castro Culture if we take into account the context and the technique, while in the case of Chaos the simplicity of the piece does not make it easy to assign a firm chronology: some situate it in the Late Bronze Age, or even earlier, and others in the Castro Culture. Still more hypothetical is the comparison between the necklace of Chaos and that of Elviña (A Coruña). In view of jewelry like that we are discussing here, we must remember the theory of the tendency toward the archaic in which

supposedly the chronogically later pieces would keep alive some types, techniques, and motifs inherited from much earlier.

(L.C.).

BIBLIOGRAPHY

Fortes, J. (1905-1908); López Cuevillas, F. (1951) (I) (1953); Peinado Gómez, N. (1975).

53
Treasure of Elviña
Castro culture IIIrd - Ist century B.C.

Gold
Diadem: 390 x 31 mm.; choker: 320 x 10 mm.; necklace. Different pieces. Weight: 17 gr.
Castro de Elviña (A Coruña)

ARCHEOLOGICAL AND HISTORICAL MUSEUM. A CORUÑA

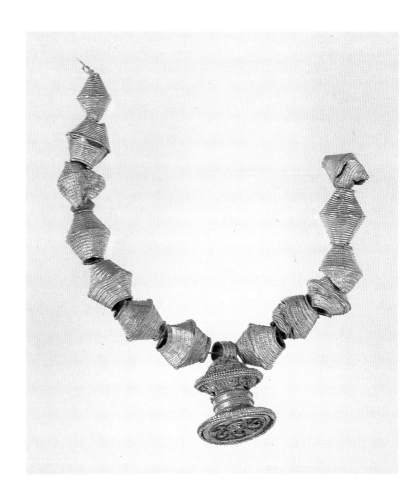

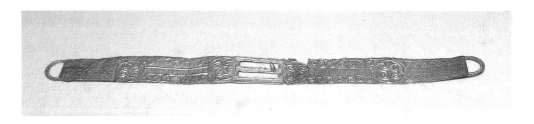

The original discovery of this treasure is very close to the city of A Coruña and the term has always been better known for a singular fact of arms in the war of independence against the troops of Napoleon, the battle of Elviña, which because of the discovery of the castro which throughout numerous excavation campaigns from 1947 until a couple of years ago, has provided abundant materials of great interest, among them several samples of gold jewelry, more particularly the group known as the Treasure of Elviña.

The castro, in spite of the excavation and consolidation campaigns, has been studied in but a small part and is not in the best condition. What has been excavated allows us to see the existence of a wide defense system with several walls articulated among each other with strong expanses and even towers like those which flank one of the accesses, while the other shows some odd stairs. The best known area of settlement is at the foot of the acropolis wall and includes contractions of circular, oval and rectangular design of which two stand out for their singularity: one is oval but with a complex floor pattern, with a bench set up against the wall, from which a block juts out and in whose front is a large phallus; the other is rectangular, with wide stairs which descend toward a cistern fountain which served the population.

It was found in one of the constructions of this sector near the fountain, in the campaign of 1953, and in a hole next to the home was a lot of gold jewelry which constitutes the Treasure and which must have been hidden about the time of the change in era or the early years of the first century B.C., judging by the archeological circumstances of the surrounding area. However, if this is the date in which it was hidden, that of its fabrication is necessarily earlier and could even go back to the third century B.C., as its discoverer thinks, whose opinion we do not share.

The Treasure is comprised of three pieces, although when they were found, and because one of them appeared independently in two fragments, it is thought that there could be four different elements. They are a diadem, a choker and several parts of an incomplete necklace.

The diadem, also initially interpreted as an armlet because of its placement as closed over itself and because of the lack of a fragment, is a unique piece in spite of its link to the diadems which we have traditionally known in the area of the castro cultures of the peninsular Northwest whose geographic distribution extends along the northern coastal fringe: Cangas de Onís, that of Ribadeo or those of the Treasure of Bedoia. It measures 39 cm. in length (with its two parts assembled) and its width oscillates between 28 and 31 mm. It is a beaten plate, with the strip divided in three longitudinal strips completely filled with decorative geometric motifs done by a not very skilled hand. Four inscribed Tetraskeles parcel off the plate in five sectors. The center one, cut out like a buckle, is decorated with filigree and at one time various ornitomorphs in high relief must have been soldered, of which one plus the beginning of another are preserved. At either end there is a ring to attach it.

The choker is a narrow ribbon of 38 x 1 cm., formed by four soldered strips of gold with rounded ends and perforated with burr marks. It is decorated with rows of dots and groups of vertical rays, done by embossing.

The necklace appeared incomplete and has thirteen gold beads, one glass and the pendant with a total weight of 17 gr. The beads are bitroncoconical and get progressively smaller. The pendant with the glass beads interset to facilitate their articulation. The extremely varied decoration

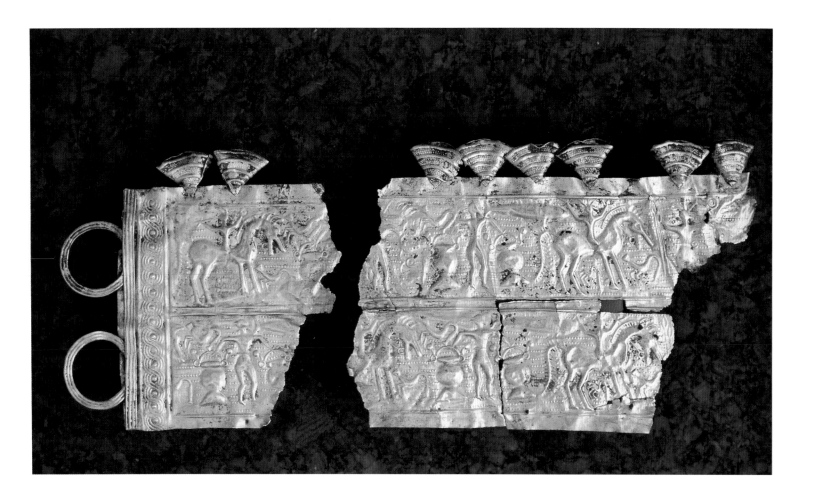

is done with embossing and filigree techniques, with torsage, dots, lines of dots and parallel lines. The pendant is an exceptional piece because of the perfection of its decorative richness and crafting, attaching to the necklace with a ring.

In all it is a quite homogeneous grouping, and especially the necklace shows influence from the Southwest of the peninsula, although the examples which could be related to it offer an earlier chronology than that of the necklace from the Chaos of Barbanza, which is also jointed.

(F.F.B.)

BIBLIOGRAPHY

Blanco Freijeiro, A. (1975); Luengo Martínez, J.M. (1954-56) (1979); Monteagudo García, L. (1954); Pérez Outeiriño, B. (1980) (1989).

54

Diadem from Ribadeo
Castro Culture. Ca. III century B.C.

Gold
42 x 65 cm. long; apendix: 2,3 cm.
Indefinite place of the present province of Oviedo

NATIONAL ARCHEOLOGICAL MUSEUM.
MADRID

These fragments, besides others assigned to the same piece, have been thought traditionally, and during a long time, to have appeared in Ribadeo or on the outskirts. At the present time its original localization in the neighboring Princedom of Asturias, seems well documented, although close to the border and always inside the geographical space of the castro culture, either in the Oscos, as Manzanares suggested, and López Monteagudo follows, or in a place still indefinite, as Maya believes, but near Ribadeo or Vegadeo, where it might have been initially on sale, hence its traditional name. On the other hand the sellers would wish to hide the real circumstances of a finding whose later avatars were also contradictory till the kept fragments are now scattered, some in the Musee des Antiquités Nationales de Saint-Germain-en-Laie, some at the Museum of the Valencia de don Juan Institute (Madrid) and others at the National Museum of Archeology.

The complete piece must have had an approximate length of 40 cm., which fits with other known pieces, whose decoration is more simple, like those from Elviña, Bedoia, Vegadeo, etc. The piece ended in a sort of funicular rings that were used to hold it. The body of the strip, divided in two

friezes, is decorated with motifs which are repeated sequentially and which represent a set of warriors on horseback and on foot, with different weapons, accompanied by or accompanying other characters bearing two big cauldrons with handles. The framework where the scene takes place must be a river bank, undoubtedly suggested by the series of parallel lines of dots, as well as the presence of fishes, batrachians and sea-birds.

The decoration technique has been evaluated in different ways, but we think it is a stamping. Maya has identified up to a total of thirteen motifs which are repeated sustematically in the piece.

The authors do not agree that all the known fragments are parts of only one piece, although they can be fit together in a reconstruction. Some suggest the existence of two pieces and even fragments of three pieces.

The chronology, always difficult in the case of metalwork pieces, is fixed in the IIId century B.C.. This is the most accepted date, although García Bellido as well as Jordá, according to the analysis of some of the depicted elements, are more inclined to consider it older (prior to the VIth century B.C.), while other authors extend its chronology up to the first century B.C., following the dates of the better documented pieces.

(F.F.B.)

BIBLIOGRAPHY

Blanco Freijeiro, A. (1957); Cartailhac, E. (1986); García Bellido, A. (1940-41) (1943); Jordá Cerdá, F. (1977); López Cuevillas, F. (1951) (I); López Monteagudo, L. (s.d.); Maya González, X.-J. (1987-88).

55
Fibula from Rodeiro
Castro culture, III - II centuries B.C.

Bronze with silver thread
70 x 95 mm.
Coto dos Castros. Aboldróns, Rodeiro
(Pontevedra)

PROVINCIAL MUSEUM OF PONTEVEDRA

The fibula comes from Coto dos Castros, from an accidental discovery and thus without concrete archeological context. The piece from the Castro de Borneiro has this context and it is an exact one, thus complementing each other in the opportunity to present, alongside the great metalwork of the castro period, the ornamental aspect of the small pieces of everyday use, signifying in the North the same as the fibula from Briteiros in the South.

It is a type of fibula very characteristic of the castro culture of the peninsular Northwest, although we know of other pieces of different areas, such as one from the necropolis of Miraveche in Burgos and other similar ones in Plymouth (Great Britain) which correspond to type H of the Hull-Hawkes classification. A Galician origin is attributed to these pieces, although their chronology is slightly older than those usually assigned to the castros which are considered to belong to the period of the third and second centuries B.C. These dates confirm the recent dating of Borneiro, according to verbal indication, for which we thank Ana Romero Masía.

The greatest interest these pieces have is in the use of a decorative technique such as niello, that is, the application of silver thread onto another metal, as a decorative element forming various motifs. But the technique used is odd and very scarce in Galicia, in spite of the frequent usage in the plateau. Still stranger is the theme of the decoration: a Mediterranean style fret, when the most common in the world of the castros are curvilinear themes. The decorative themes coincide in the known pieces and with other exceptional decoration in stone from the Cibdá de Armea, which has the same theme.

Because of their form and dimensions, as well as the decoration they show, we believe these pieces formed part of the exterior elements for tying a garment.

(F.F.B.).

BIBLIOGRAPHY
Fariña Busto, F. (1979); Museo de Pontevedra (1976).

56
Fibula from Borneiro
Castro culture, IIIrd century B.C.

Fragment of bronze fibula with remains of silver thread
80 x 55 mm.
Castro de Borneiro. Cabanas (A Coruña)

ARCHEOLOGICAL AND HISTORICAL MUSEUM. A CORUÑA

BIBLIOGRAPHY
Romero Masiá, A.- M. (1987)

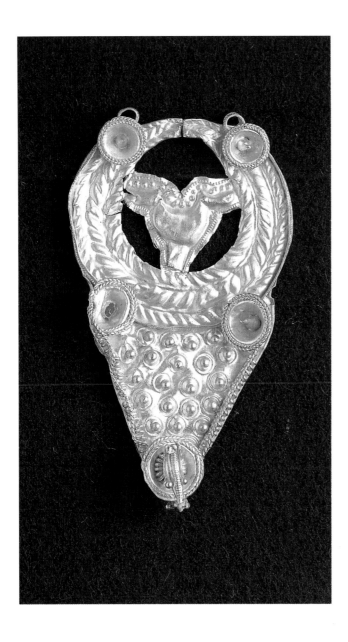

57
Earring from Vilar dos Santos
Castro culture. III-II centuries B.C.

Gold
84 x 49.5 mm.
Place called "Albariño" .Vilar dos Santos (Ourense)

PROVINCIAL MUSEUM OF ARCHEOLOGY OF OURENSE

Contrary to what happens to other prehistoric peninsular peoples, the castro metalwork is done almost exclusively in gold due to the abundance of this metal in the country. The castro goldsmiths elaborate almost exclusively objects for personal adornment in which Europeans and Mediterranean influences are noticeable along with others of clear autochthonous tradition.

The castro earrings from the NW, possibly a feminine ornament, show evident differences if they are compared with the rest of the peninsula, although some examples, among which this piece is included, have obvious precedents in southern models, mainly from Andalusia and Extremadura.

The earring from Vilar de Santos is essentially constituted by a penannular or crescent part and another triangular one, both formed after a trimmed thin plate of gold. It forms part of Pérez Outeiriño's Morphotype IIB.

A twin system of suspension assured the placement. A lost chain or lace, that started from the hoops of the upper part, provided with a suprauricular suspension which would be completed by clipping the ends of the crescent part onto the lower lobe of the ear.

The crescent part and the triangular appendix are decorated in a intrinsic manner (repoussé, high relief, dotted, burin engraving...) or by the application of decorative elements through welding

(plates, granules, filaments in spyro, funiculars, etc.) with the use of conical-trunked bell-flowers with wide horizontal edge predominating, in a similar way to what happens to pieces of Miño River origin: Estela (earring and necklace), Afife/Carreço and Laúndos fundamentally.

As to the decorative motifs, we must point out two figurative representations of aquatic birds. In the T shaped cross-piece are two opposite and joined protomos of web-footed birds while in the bell-flower of the inferior vertex of the triangle is a figure of a web-footed bird in high relief, decorated with thin granulation, holds a triangle of 11 granules welded to each other in its beak.

The scarcity of figurative representations in the castro metalwork is a constant. The two examples documented in this piece would enter the area of the mythological representations related to the solar cult, spread during the Bronze Age and the Iron Age across Northern and Central Europe. Images of web-footed birds, more or less schematized, appear in pieces such as the Diadem from Ribadeo (San Martín de Oscos), the diadem from Elviña, diadem of Bedoia Treasure, a torque from the province of Lugo, etc., with the predominance of the two in the Tramontane torques from Vilas Boas, the closest parallel of the bell-shape with web-footed bird of the earring from Vilar dos Santos.

Decorative and constructive technique, elements and motifs documented in this earring enter fully the repertory of the castro metalwork from a later period.

(B.P.O.).

BIBLIOGRAPHY

Blanco Freijeiro, A. (1957); López Cuevillas, F. (1939) (1951) (I); Pérez Outeirño, B. (1980) (1982).

58
Torques from Mondoñedo
Castro culture: IIIrd - Ist centuries B.C.

Silver
14.5 cm. in diameter; Weight: 170 gr.
Coto de Recadeira. Mondoñedo (Lugo)

PROVINCIAL MUSEUM OF LUGO. PRIVATE COLLECTION OF MR. ÁLVARO GIL VARELA

Of the eight silver torques found in the area of the castro culture, that from Mondoñedo is the only one found within the present territory of Galicia; the rest were found in the North of Portugal (Cortinhas and Bagunte), except one whose origin is uncertain. The torque of Mondoñedo is a funicular type, with triple decoration of 8 expansions and ends in the form of hooks that are slightly retouched with a globular widening in the center and a cone on the end, in place of the characteristic voluminous ends typical of the majority of the castro torques.

The arch of the torque, somewhat wider in the middle, is constructed by two thick threads of silver and two others, finer, twisted and cast on the ends on a decorated circular wand, near the beginning of the cording trim, with incised lines, dots and circles with a central point. The thicker threads expand sideways forming three loops and eights which represent the triple ornamentation.

The silver torques, normally done with braided wires, are a category apart and exceptional within the set of castro torques. To be more precise, we must consider the torques braided from silver located in the Iberian Peninsula as characteristic of the Iberian and Celtiberian cultures. The same braiding technique can be observed in a torque of the Iberian population of Castellet de Banyolas (Tivissa, Baixo Ebro), dated at the end of the IIIrd century B.C., but even more analogies are found between that of Mondoñedo and some torques from the castro of Arrabalde (Zamora) with hook closings, one with a loop in the center of the arch in a style very similar to that of the torque from Lugo. We also must note a torque that today is lost, from Cruceiro da Cruña (Santiago de Compostela); the description preserved insists that it was a funicular gold torque with side expansion in S form.

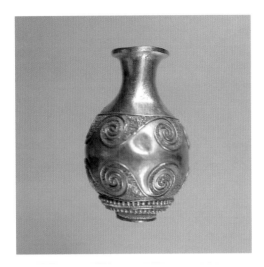

The dates of the Iberian and Celtiberian torques are usually based on the Roman coins that frequently accompany them. The silver torques from Cortinhas appeared together with a denarius of Tiberius from the year 15. Nevertheless, the date they bear is that of the hiding and not that of fabrication. Still, this class of silver braided torques tends to be situated between the third and the first centuries B.C.

(L.C.)

BIBLIOGRAPHY

López Cuevillas, F. (1951) (I); Pérez Outeiriño, B. (s.d.) (G.E.G.); Raddatz, K. (1969).

59
Torques terminals of Santa Trega
Castro culture. IIIrd. B.C. and Ist. A.D.

Gold.
Weight: 3,97 gr.
Castro of Santa Trega. A Guardia (Pontevedra).

MUSEUM OF THE CASTRO OF SANTA TREGA
(A GUARDIA, PONTEVEDRA)

Gold torque terminal, in bell flower or jug form. The belly of the endpiece has two series of scrolls bordered with filigree applied and filled with a very fine granulation. On the side where it joins the bar there are three circles of pearled cords and two vertical lines, while the outer disk of the end has a triskel done with the same technique as the scrolls, with six small balls on the ends and another in the center. The triskel is inscribed in a circumference, defined by a pearled circle, where previously a hexagon with its diagonals and a segment of the circumference on each radius were drawn.

On other torque ends from castros of the same campanula or jug form, such as that of Tourém (Montealegre, Portugal), we find a triskel made with a thread of soldered gold that is less rigorous in its geometry. This does not have the geometrical rigidity of that from Santa Trega and, in fact, is simply a series of three joined scrolls. A torque end from Estela (Minho, Portugal), in double scotia form, has on its outer plate a triskel full of stamped designs made with a very fine matrix. It would be necessary to emphasize the quatriskel of a torque from Xanceda (A Coruña), although in this case it decorates the bar and not the endpiece. Besides, we should establish a certain relationship between the style and technique of the end with triskel of Santa Trega and the gold pendent of the jointed necklace of Elviña (A Coruña), analogy which is verified in the decoration of the scrolls, although the base of the piece from Elviña does have a triskel but rather a rosette of six sinuous or curved arms, that is, a motif familiar to the orientalist tradition to which it is closer that to this endpiece of Santa Trega.

Apparently, the triskel is a motif, like the swastika, of oriental origin which in a remote period extended throughout Europe, possibly impregnated with a strong symbolic content. Its introduction in the Iberian Peninsula is attributed to the Celts and it was enormously successful in certain castros. From the beginnings of the period of La Tène it was one of the favorite motifs in continental Europe. In the British Isles, the gold torque of Clevedon (Somerset) has an end with triskel on its flat side, triskel which, even though of a different sort than that of those of the castros we know, is in itself a notable coincidence. This piece was attributed to a possible western British school, integrated in the traditition of La Tene B and introduced from the continent in a period prior to the end of the third century B.C.

The ends in campanula or jug form are characteristic of those which Cardozo called Flavian school, which includes the southwest of Galicia and the north of Portugal. Concretely, we know of ends of this type, besides the one analyzed here, in three torques of Lanhoso, one of Tourem and another from Sanfins, as well as two fragments of bracelets from Lebuçâo. They are pieces made with fine and probably late techniques, for which reason, for lack of clear archeological contexts, they are dated globally between the third century B.C. and the first century A.D.

(L.C.)

BIBLIOGRAPHY

Bandera Romero, M.L. de la (1986); López Cuevillas, F. (1951) (I); Pérez Outeiriño, B. (s.d.) (G.E.G.).

BIBLIOGRAPHY
*Chamoso Lamas, M. (1977); López Cuevillas, F.
(1951); Peinado Gómez, N. (1975).*

62
Earrings from the Treasure of Bedoia
Castro culture, IInd-Ist century B.C.

Gold
"Labyrinth-shaped" pair: 36 x 35 x 10 mm.;
"Boat-shaped" pair: 36 x 33.5 x 11 mm.
A Graña. Ferrol (A Coruña)

PROVINCIAL MUSEUM OF PONTEVEDRA

The Treasure of Bedoia, comprised of a bronze cauldron with its lid, two pairs of gold earrings, a diadem also of gold, two golden rings with stones (one engraved), 27 denarii (63 B.C. - 91 A.D.) and two gold ones (one of Nero and the other of Domitian), is considered an unusual grouping in Galicia, in which Roman jewels and those from the castros are mixed and in which the coins give an approximate date for the hiding of the collection with heterogeneous pieces, some possibly residual. This type of collections always seems to correspond to burials done by individuals or collectives of economically valuable goods in times of insecurity with the intention of recovering them once the situation has normalized.

The labyrinthine pair, with walls on both sides, is decorated with crowned funicular leaves on all the plates and twisted laminary leaves applied on the outer side. It forms part of the IB Morphotype of Pérez Outeiriño together with pieces such as that of Burela or Baroña.

The boat-shaped pair, with an open tubular, sausage-like structure, has a considerably more complex decoration from which the eight pairs of flies (not bees) stand out on each, decorated with triangular wings, triangular scapulary and head with corresponding eyes. The entire surface is covered with a Baroque succession of elements in rich filigree, set following the sausage form and in which twisted funicular threads, little barbed plates, groups of four pyramid shapes and loose microscopic granules in harmonious, studied composition. It forms part of the ID Morphotype of Pérez Outeiriño.

The suspension is double in both pairs, combining the suprauricular by means of a cord or tiny chain, disappeared with the clasp in the labyrinth-shaped pair, or with necessary perforation by means of a needle with catchplate in the boat-shaped pair.

The European influences of the already advanced period of the Iron Age (La Téne) are visible, especially in the form of the earrings, but the decorative techniques appear to insure an influence from southern forms, as well as the decorative motif of fly-like insects, unknown in any other sample of castro metal work, but which is not outside the figurative representations of the Mediterranean world.

(B.P.O.).

BIBLIOGRAPHY
*Blanco Freijeiro, A. (1957); Filgueira Valverde, J.,
Blanco Freijeiro. A. (1954); Pérez Outeiriño, B.
(1982).*

63
Ring from the Cíes Islands
IInd century A.D.

Solid gold
Ring diameter 1,4 x 1 cm.; intaglio 1 x 0,8 cm.
Cíes Islands (Pontevedra)

PROVINCIAL MUSEUM OF PONTEVEDRA

Piece with continuous external contour and very ellipsoidal interior, flat-convex section, flat oval front, oval incrustation and oblique contour. The ring widens progressively, becoming thicker and forming protruding shoulders.

This is a ring of solid gold, with a typology of the most common for the IInd century A.D. (Marshall (1907), 484-636; Henig (1974), 46). The intaglio is niciolo—agate of two layers, one dark blue, chestnut or black, and the other bluish white—which is equally cut to make the qualities of the stone stand out. The flat surfaces and the sides are cut in an outward direction, so that the second, darker layer frames the clearer surface where the engraving is, making it stand out. The stone has a small broken place on the upper edge.

The theme engraved is a male boar looking to the left, on a base line, in a tense pose as if ready to attack. Above the animal, in negative, is the

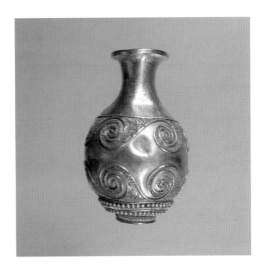

The dates of the Iberian and Celtiberian torques are usually based on the Roman coins that frequently accompany them. The silver torques from Cortinhas appeared together with a denarius of Tiberius from the year 15. Nevertheless, the date they bear is that of the hiding and not that of fabrication. Still, this class of silver braided torques tends to be situated between the third and the first centuries B.C.

(L.C.)

BIBLIOGRAPHY

López Cuevillas, F. (1951) (I); Pérez Outeiriño, B. (s.d.) (G.E.G.); Raddatz, K. (1969).

59
Torques terminals of Santa Trega
Castro culture. IIIrd. B.C. and Ist. A.D.

Gold.
Weight: 3,97 gr.
Castro of Santa Trega. A Guardia (Pontevedra).

MUSEUM OF THE CASTRO OF SANTA TREGA
(A GUARDIA, PONTEVEDRA)

Gold torque terminal, in bell flower or jug form. The belly of the endpiece has two series of scrolls bordered with filigree applied and filled with a very fine granulation. On the side where it joins the bar there are three circles of pearled cords and two vertical lines, while the outer disk of the end has a triskel done with the same technique as the scrolls, with six small balls on the ends and another in the center. The triskel is inscribed in a circumference, defined by a pearled circle, where previously a hexagon with its diagonals and a segment of the circumference on each radius were drawn.

On other torque ends from castros of the same campanula or jug form, such as that of Tourém (Montealegre, Portugal), we find a triskel made with a thread of soldered gold that is less rigorous in its geometry. This does not have the geometrical rigidity of that from Santa Trega and, in fact, is simply a series of three joined scrolls. A torque end from Estela (Minho, Portugal), in double scotia form, has on its outer plate a triskel full of stamped designs made with a very fine matrix. It would be necessary to emphasize the quatriskel of a torque from Xanceda (A Coruña), although in this case it decorates the bar and not the endpiece. Besides, we should establish a certain relationship between the style and technique of the end with triskel of Santa Trega and the gold pendent of the jointed necklace of Elviña (A Coruña), analogy which is verified in the decoration of the scrolls, although the base of the piece from Elviña does have a triskel but rather a rosette of six sinuous or curved arms, that is, a motif familiar to the orientalist tradition to which it is closer that to this endpiece of Santa Trega.

Apparently, the triskel is a motif, like the swastika, of oriental origin which in a remote period extended throughout Europe, possibly impregnated with a strong symbolic content. Its introduction in the Iberian Peninsula is attributed to the Celts and it was enormously successful in certain castros. From the beginnings of the period of La Tène it was one of the favorite motifs in continental Europe. In the British Isles, the gold torque of Clevedon (Somerset) has an end with triskel on its flat side, triskel which, even though of a different sort than that of those of the castros we know, is in itself a notable coincidence. This piece was attributed to a possible western British school, integrated in the traditition of La Tene B and introduced from the continent in a period prior to the end of the third century B.C.

The ends in campanula or jug form are characteristic of those which Cardozo called Flavian school, which includes the southwest of Galicia and the north of Portugal. Concretely, we know of ends of this type, besides the one analyzed here, in three torques of Lanhoso, one of Tourem and another from Sanfins, as well as two fragments of bracelets from Lebuçâo. They are pieces made with fine and probably late techniques, for which reason, for lack of clear archeological contexts, they are dated globally between the third century B.C. and the first century A.D.

(L.C.)

BIBLIOGRAPHY

Bandera Romero, M.L. de la (1986); López Cuevillas, F. (1951) (I); Pérez Outeiriño, B. (s.d.) (G.E.G.).

60
Torques from Burela
Castro culture. IInd. B.C.-I A.D.

Gold
Diameter of the bar, 21,15 cm.; length of ends,
6,5 cm.
Chao de Castro. Parish of Burela. Cervo (Lugo)

PROVINCIAL MUSEUM OF LUGO. PRIVATE
COLLECTION OF MR. ÁLVARO GIL VARELA

The bar of this torques, of very pure gold, has
a circular section in the center part and a
heptagonal one on the side thirds, the latter being
covered with rolled wires, convex on the outside
and flat on the inner surface, which as they are
entended form 24 spirals in one third and 22 in
the other. The center third shows fine applied
filigree work which includes 7 threads soldered to
the bar, marking off 6 parallel bands decorated
with braided threads.

The terminals have a conic trunk and a scotia,
combination which lessens the impression of
heaviness and volume typical of the ends of
double cone trunk.

In the torques of this type the terminals lack
decoration, which only appears in the middle
section of the bar (except in the torque of
Recadeira). On the upper side of the terminals of
the Burela torque there are two quadriangular
perforations of unknown purpose.

The torque of Burela belongs to the
'Asturnorgalaico' group, or what has been
called the Lugo school, located in the coastal
area between the Eo and Cape Ortegal and
extending inward to the Land of Melide. This
group is characterized by the rolled wires
around the side thirds of the bar and by the
double-coned trunk terminals or with a cone
trunk and a scotia.

Hartmann, after analyzing the torques from
castros, established two large categories,
according to the greater or lesser purity of the
gold, and included the Burela torque among the
pieces of purest gold. This group (N/NC) includes
torques of gold with little or no silver (less than
20 or 25%), less copper (less than 5 or 10%) and
minimal quantities of tin.

(L.C.).

BIBLIOGRAPHY
*Hartmann, A. (1982); Monteagudo García, L.
(1952); Peinado Gómez, N. (1975); Vázquez
Varela, J.-M. (1982).*

61
Torques from Viladonga
Castro culture, II - I centuries B.C.

Bronze wand covered with gold layer and
threads
Total width: 13,3 cm.; width of mouth between
ends: 6,1; diameter of wand, 0,81; total
perimeter: 3,7 cm.; weight: 129,9 gr.
Castro de Viladonga. Castro de Rei (Lugo).
Appeared in the excavation campaigns of 1974

MUSEUM OF THE CASTRO DE VILADONGA

Torque of bronze core covered with a layer of
wire of low-grade gold (less than 20 carats), and
possibly alloyed with silver, which is even seen in
its external color and appearance.

It has an almost perfect development of three
quarters in circumference. The terminals, pyriform
and solid, have a hole to fit and solder in them the
ends of the wand. The latter has a flat, circular

section in its central third, marked on each side and
on the two surfaces by swirls or nail heads
composed of small golden threads rolled into a
spiral (15 times) around a small central button.
From this adornment comes a thicker thread, flat,
which covers the wand rolling around it on two
lateral thirds of the torque.

This piece appeared in a dwelling of
quadrangular shape situated in the central part of the
castro's crown, and is a twin to that which appeared
in 1911 in the same site (antecastro on the eastern
side), although the latter has gold of higher carats
and weighs 215 grams. Today it is in the Gil Varela
collection, deposited in the Provincial Museum of
Lugo.

The torque from Viladonga corresponds to a
widespread model in the Northwest, both for the
decoration of the wand and for the use of gold
thread, and of course for the type of pear-shaped
terminals. Besides the two from Viladonga, others
appeared which are practically the same in the small
castro of Centroña (Pontedeume, A Coruña) and in

an unknown place, cited by Cuevillas in 1951, when
they belonged to the Blanco-Cicerón collection. In
the same author we find concrete parallels
according to the different elements of the torques:
decorated wand (Foxadas, Cangas de Onís,
Centroña...), pear-shaped ends (Melide, Curtis, etc.

The fact that two torques of the purest castro
tradition appeared in a later archeological context and
in the company of materials of clearly Roman and
even Late Roman chronology, in a quadrangular
dwelling, leads us to think there was a continuous
usage of this element of metal work, independent of
the existence or not of its symbolism and meaning of
hierarchy and wealth. If they were not made in the
high Galician-Roman period, they would have to be
considered residual materials, perhaps with a certain
votive nature (?), since in the region where one was
discovered (the one from 1974) there is no pre-Roman
level, and in the region where the other appeared (the
one from 1911) there is also notice of the accidental
discovery of circular mills, tegulae, etc.

(F.A.V.).

BIBLIOGRAPHY
*Chamoso Lamas, M. (1977); López Cuevillas, F.
(1951); Peinado Gómez, N. (1975).*

62
Earrings from the Treasure of Bedoia
Castro culture, IInd-Ist century B.C.

Gold
"Labyrinth-shaped" pair: 36 x 35 x 10 mm.;
"Boat-shaped" pair: 36 x 33.5 x 11 mm.
A Graña. Ferrol (A Coruña)

PROVINCIAL MUSEUM OF PONTEVEDRA

The Treasure of Bedoia, comprised of a bronze cauldron with its lid, two pairs of gold earrings, a diadem also of gold, two golden rings with stones (one engraved), 27 denarii (63 B.C. - 91 A.D.) and two gold ones (one of Nero and the other of Domitian), is considered an unusual grouping in Galicia, in which Roman jewels and those from the castros are mixed and in which the coins give an approximate date for the hiding of the collection with heterogeneous pieces, some possibly residual. This type of collections always seems to correspond to burials done by individuals or collectives of economically valuable goods in times of insecurity with the intention of recovering them once the situation has normalized.

The labyrinthine pair, with walls on both sides, is decorated with crowned funicular leaves on all the plates and twisted laminary leaves applied on the outer side. It forms part of the IB Morphotype of Pérez Outeirño together with pieces such as that of Burela or Baroña.

The boat-shaped pair, with an open tubular, sausage-like structure, has a considerably more complex decoration from which the eight pairs of flies (not bees) stand out on each, decorated with triangular wings, triangular scapulary and head with corresponding eyes. The entire surface is covered with a Baroque succession of elements in rich filigree, set following the sausage form and in which twisted funicular threads, little barbed plates, groups of four pyramid shapes and loose microscopic granules in harmonious, studied composition. It forms part of the ID Morphotype of Pérez Outeiriño.

The suspension is double in both pairs, combining the suprauricular by means of a cord or tiny chain, disappeared with the clasp in the labyrinth-shaped pair, or with necessary perforation by means of a needle with catchplate in the boat-shaped pair.

The European influences of the already advanced period of the Iron Age (La Téne) are visible, especially in the form of the earrings, but the decorative techniques appear to insure an influence from southern forms, as well as the decorative motif of fly-like insects, unknown in any other sample of castro metal work, but which is not outside the figurative representations of the Mediterranean world.

(B.P.O.).

BIBLIOGRAPHY
*Blanco Freijeiro, A. (1957); Filgueira Valverde, J.,
Blanco Freijeiro. A. (1954); Pérez Outeiriño, B.
(1982).*

63
Ring from the Cíes Islands
IInd century A.D.

Solid gold
Ring diameter 1,4 x 1 cm.; intaglio 1 x 0,8 cm.
Cíes Islands (Pontevedra)

PROVINCIAL MUSEUM OF PONTEVEDRA

Piece with continuous external contour and very ellipsoidal interior, flat-convex section, flat oval front, oval incrustation and oblique contour. The ring widens progressively, becoming thicker and forming protruding shoulders.

This is a ring of solid gold, with a typology of the most common for the IInd century A.D. (Marshall (1907), 484-636; Henig (1974), 46). The intaglio is niciolo—agate of two layers, one dark blue, chestnut or black, and the other bluish white—which is equally cut to make the qualities of the stone stand out. The flat surfaces and the sides are cut in an outward direction, so that the second, darker layer frames the clearer surface where the engraving is, making it stand out. The stone has a small broken place on the upper edge.

The theme engraved is a male boar looking to the left, on a base line, in a tense pose as if ready to attack. Above the animal, in negative, is the

the Phoenician influence from those who spread it. Through Greek culture, with Etruscan antecedents, they will spread to the Roman world, where their usage reached truly unexpected levels. (Zazoff 1983).

(R.C.G.)

BIBLIOGRAPHY
Casal García, R. (1980); Henig, M. (1974); Toymbee, J. (1973); Vives, J. (1971); Zazoff, P. (1983).

64
Gold ring from the Sil river
IIIrd century A.D.

Solid gold
Diameter of the ring 1,2 x 1,4 cm., width 0,3 to 0,6 cm.; setting 0,7 x 0,8 cm.; thickness 0,2 cm; small pedestal 0,2 x 0,25 cm.
Area of the Sil

ARCHEOLOGICAL PROVINCIAL MUSEUM
OF OURENSE

Typologically, the ring has a discontinuous outer area and and ellipsoidal inner area. Flat section. Narrow ring that widens progressively toward the front. Circular gold setting. Contour of oblique lines crowned by the setting.

It is a ring of solid gold. The shoulders are decorated with deep grooves in the form of double V. On one side, and as a prologation of the vertex of the V, there is a heart shaped form cut in, which is missing on the other side. On the front it has a circular piece, in the manner of setting, which does not protrude from the width of the ring, to which it is joined by a small pedestal which holds it separate. There are the incised letters PIAC, separated by a horizontal line, placed to form a triangle.

The inscription may be interpreted as the initials of a person who had the tria nomina or as the abbreviation of the name PAC(cius) of which we have other examples in Hispanic epigraphy (CIL.II. 4976, 4; 5696). The rings of the Roman period, especially after the IInd century A.D., usually have the owner's name or phrases of greeting and good hope engraved on them. (Casal (1983), 69.)

In this piece, besides its well-conserved state, the visibility of the traces of the instruments, hammer and chisel, are noteworthy. It was shaped with these, and we can even see how, when the piece of adornment was soldered on, the metalsmith, who must not have been very expert, pressed unequally, so that he deformed the bar of the ring on one side.

The ring of the Museum of Ourense has characteristics common to the rings of the IIIrd century D.C., systematized by the now-classical Henkel and Marshall, in which these rings are decorated on the shoulders to make them stand out and above all the setting is separate from the rest. The careless type of letter of the inscription, points also toward a late date, as well as the fact that the inscription was not made as a seal, in which case it would be in negative, but rather to be read directly.

The small diameter of the ring does not necessarily indicate its belonging to a child, since

inscription HEAPRV, with a link between the H and the E; the A does not have a horizontal bar. It could be transcribed as He (lvius-a) or He (renius-a) Apru(nculus-a). (Vives (1971), 3280, 6502, 6360, 5637, etc.) which would correspond to the name of the ring's owner; the family cognomen Aper agrees with the engraved theme, which confirms that many animal motifs used profusely as adornment in the Roman intaglios often correspond to verbal symbols that identified the owner of the jewel. The boar is also very frequent in representation of hunting scenes, attacked by dogs or horsemen (Toymbee (1973), 131).

The engraving is well done and belongs to the imperial-classicist style (Maaskant (1978), 196), defined by a technique very frequent in the first and second centuries A.D.—which above all marks the volumes. The work is done carefully with different drills. The anatomy of the figures stands out with a flexible shaping, the muscles are detailed with care.

The proportions are balanced and the figure always is well framed. The details, as can be observed in the curly hair of the boar of this tiny piece, are done with short, close, regular grooves without mechanical symmetry.

The use of engraved hard stones as a seal already appears in the cultures of the eastern Mediterranean in the third milennium B.C. The oldest samples set in an open arc—ring or pendant—are from an Egyptian find from around the XIIth Dynasty. Toward the XVIIth dynasty rings with a metal setting begin to be popular, and their carved decoration is similar to that done in stone. In the Cretomycene cultures, especially in continental Greece, the rings reach their maximum development both with metal settings and with gems. And we see them reappear with force in the orientalizing period when it spreads through the Western Mediterranean—especially in the Etruscan world—with a marked Egyptianizing taste through

we know by the written sources that, not each finger, but each phalange had a specific ring (Seneca, Nat. Quaest., VII). This custom of wearing rings on the first phalanges of the fingers seems to have been motivated by the desire to make them more visible (Quintiliano, Poet. III, 2). This custom is confirmed for us as well by the statuary (Daremberg-Saglin, 1873-1919, 296).

In the first years of Rome, the gold ring,—anulus aureus—was reserved for a few privileged persons (high magistrates, envoys of the senate—legati—or heads of the army), to whom was conceded that honor as symbol of their power. With time its use spread, and came to be a sign of the persons belonging to the senatorial and equestrian order. In the imperial period, it became a sort of public condecoration, reglamented in the ius anuli aurei, which at times implied the public recognition of the citizenship of a freedman or even a foreigner (Suetonius, Augusto, 27; CIL, VI, 1847). The concession of this right was gradually extended, coming to be given to nearly all the veterans from the time of the Severos onward and in general to all the citizens who had enough means to acquire them.

<div align="right">(R.C.G.)</div>

BIBLIOGRAPHY
Casal García, R. (1983); Daremberg, Ch.; Saglio, E. (1873-1919).

65
Ring from A Lanzada
End of IIIrd century-IVth century A.D.

Ring: bronze; intaglio: carnelian
Diameter: 2,1 cm.; loop: 0,35 x 0,15 cm.;
intaglio: 1 x 0,8 cm.
A Lanzada (Pontevedra)

PROVINCIAL MUSEUM OF PONTEVEDRA

A piece of discontinuous outer shape and probably circular inner portion, since the loop has undulations and has not been restored. Flat section. Narrow loop with equal dimensions. Oval setting, whose base protrudes to form a moulding around the capsule, which contains the intaglio. Profile of vertical lines crowned by a small stepped pyramid which constitute the three components of the setting.

Among the most frequent rings of the IIIthe and IVth centuries are those of narrow loops and raised bronze setting. Among the materials of which the Roman rings were made—gold, silver, bronze, iron, lead, zinc, ambar, ivory, glass paste and terra-cotta, etc.—, the most frequent in the collections of the museums are those of gold, followed by those of bronze; few silver ones have reached us, and very few of other materials, presumably for its fragility. Bronze is a material that is documented from the most ancient times in forms of very simple rings. But it is especially in the Low Empire when its use is extended extraordinarily, perhaps due also to the fact that at that time the use of rings becomes enormously popular, which no longer retain their initial usage as seals, but rather have become objects of adornment or protection and prophylaxis within the currents of magico-realist syncretism which are imposed in the last two centuries of the Empire (Casal).

The intaglio is an orange carnelian of cone-trunked form, the technique used in gems so that they will stand out from the box of the setting, which has a engraved bird—crow or parrot—looking to the left on a base line. In front of it is a tree branch. The style of the engraving is clearly framed in the incoherent current, which produces schematic and rigid figures by means of a very few grooves, without details. It is a rapid, simplified manner of working (Maaskant).

In the broad iconographic repertoire which has reached us through the Roman intaglios, the animal motifs are very frequent. In the case of the birds, the eagle is the one which occupies the first place, followed by crows, parrots, and roosters (Imhoof-Blumer-Keller). Many times they form part of clearly symbolic combinations, accompanied by glasses, palms, laurel crowns or other objects which identify them with a deity. When they appear by themselves, they have been interpreted as symbols of prosperity and good hope.

<div align="right">(R.C.G.)</div>

BIBLIOGRAPHY
Casal García, R. (1984); Fariña Busto, F., Filgueira Valverde, J. (1973); Imhoof-Blumer-Keller (1972).

66
Ring from Saint Rosendo's Treasure
Ring: V-IX centuries A.D.;
intaglio: II-III centuries A.D.

Ring: gold; intaglio: carnelian
Diameter: 3,5 cm.
Monastery of Celanova (Ourense)

CATHEDRAL MUSEUM OF OURENSE

Ring of continuous exterior contour and ellipsoidal interior, flat-convex section, slightly widened shoulders and flat oval upper part, almost totally occupied by the incrustation, and oblique contour. It formed part of a group of objects found in the Monastery of Celanova, which belonged to Saint Rosendo.

The hoop of the ring is formed by two golden plates; the inner one is flat and the outer one, convex, and they join on both sides of the ring's circumference, over which they have a tiny cord of gold thread as trim. The entire outer body of the loop is decorated with interlacings of filigree and a central small cord that divides it. The upper half of the loop has golden spheres of unequal size soldered to it. The shoulders are outlined with golden thread in spiral form which

traces a V and they are filled with beads of diverse sizes. The place of incrustation os formed by thirteen clusters of granules, one lost, surrounded on the base by a filigree cord.

The stone, set in the ring, is carnelian in which a Zeus-Jupiter sitting on a high-backed throne is engraved. He is three-quarters visible and looking toward the left. The naked torso has a mantle over the shoulders; this is held wrapped around his legs. He holds the scepter with the raised right hand and in the left he carries a patera or a bundle of beams. At his feet is an eagle facing backward (R.Casal, (1979), 1. 111). The type is inspired in the Olympic Zeus of Fidias but probably remembered as the Capitoline Jupiter. The style of engraving belongs to that called "incoherent" (Maaskant (1978), 326), used especially in the II-III centuries A.D., in which the grooves that form the figure are juxtaposed and placed without taking into account anatomical reality. The face is represented by two or three lines and the hands and feet are not even indicated. There are no details marking depth or volume. It is a style determined by the simplification and, at times, the disintegration of the figures.

Rings similar to the one analyzed here are found in European collections of Roman jewels (Marshall (1907), 156, ill. XV, 971, 972; Henkel (1913), 30, 42, 113, ills. X-XV-XLVIII, 204, 285, 1239). They are almost always from Southern Russia and are dated because of their Baroque nature in the IVth century (Andrejova (1975), 71, 45). We believe that this type of jewel, in which techniques of ornamentation so ancient and unused in the Roman world—like filigree and beading—, are already a product of the new cultures—generally "barbarian"—which form with the fall of the Roman Empire. The Germanic peoples bring to the West the techniques of the Eastern world which become popular, especially in Byzantium. The use of intaglios and Roman cameos in the decoration of Gothic art is not strange, and there are numerous examples in other types of metalwork.

(R.C.G.)

BIBLIOGRAPHY
Andrejova, I. (1975); Casal García, R. (1979); Henkel, F. (1913); Maaskant-Kleibrink, M. (1978); Marshall, F.H. (1907).

67
Earring
Second half of the VIth century

Gold
12 x 4 cm.

PROVINCIAL MUSEUM OF LUGO

The earring appears formed by six capsules, circular on the ends and the rest oval, united by soldering in the form of inverted grape cluster, intended for the incrusting of precious stones or colored glass. Three small pieces ending in filaments to which other stones, usually pearls, would be attached, hang from the lower row. For this there is a circular ring which widens on one of the ends.

The discs of the capsules are decorated on the back with engraving by punches using plant ornamentation: fleur-de-lis and four-leaved rosettes on a reticulated background, framed by slender mouldings. The stones that adorned these mountings on the front side of the piece are missing.

A Byzantine influence has been noted in the system for fixing the stones, closely following the scheme of the brooch, used as a cross for the trim of the crown of Recceswinth, from the treasure of Guarrazar, although in the piece from Lugo there is a certain "provincial" flavour.

The typology of the jewel is not very common. A similar model is seen in the pair of earrings from Extremadura which figured in the Exposition of Paleo-Christian and Biyantine Art celebrated in 1947 in the Baltimore Museum of Art. These earrings are classified as Visigothic, from the VIIIth century, a date considered too late. For the earring from Lugo the date assigned is the second half of the VIth century, when the Ravenna influence becomes noticeable in some works of art in Galicia.

The place and circumstances of its discovery are uncertain.

(Y.B.L.)

BIBLIOGRAPHY
Nuñez Rodríguez, M. (1976) (I); Schlunk, H. (1981); Vázquez Seijas, M. (1947-48).

68
Belt Clasp from Baamorto
VIth century - First half of VIIth century A.D.

Bronze plated in gold, with inlays of vitreous paste
Dia. max.: 10,7 x 6,4 cm. (dia. max. plaque 6,5; long. tongue 4,2; max. diam. inlays O,18 x O,15 and 0,45 cm.)
Pol. Baamorto, Monforte de Lemos (Lugo).
Found in the twenties while ploughing a property

PROVINCIAL MUSEUM OF LUGO

Oval (almost circular) plaque of rectangular section and with a thick needle of rectangular base that ends in a zoomorphic motif, probably in the form of an eagle (or of a dog?). The buckle (of

ultrasemicircular form) and the needle are decorated with slightly cut little circles and grooves, which also expand on the part of the plate situated between the inlays. These are sheltered in independent capsules grouped in five big ovals in very dark red color which form a cross, and two groups of three little orange ovals forming a bow and following the direction of the needle. It must have had another double set of inlays, which would form a triangular design, on the sides of the plaque, but they have disappeared today.

This clasp from a Visigothic belt (VI century - first half of the VIIth century) is different both from the repoussé and open-worked plaques (Moraime, Penadominga, of late Roman origin) as well as the eagle-shaped fibulas from the Central Plateau and in this sense it is a unique model. Nevertheless, it is conclusive the use of the incised plate, of two inlays and the zoomorphic tongue.

For some authors (Núñez) this type of pieces, of great perfection, could have been made in German workshops but with certain Lombard influences.

Schlunk and Hauschild also consider it imported and from the first half of the VIth century, without ruling out the possibility of its Swabian filiation.

In any case, metalwork of the Visigothic period had a great apogee in the Hispanic Northwest and is related to productions of the Duero River valley, particularly for this clasp, with pieces from the necropolis of Deza (Soria), Herrera de Pisuerga (Palencia) and Castiltierra (Segovia).

As in other pieces of this type there is no concrete or reliable archeological context that allows us to provide an accurate localization and affiliation, since we only have its discovery in a property for cultivation, without further data as to possible dwelling or funeral structures, accompanying material, etc.

(F.A.V.)

BIBLIOGRAPHY
Núñez Rodríguez, M. (1976) (I); Schlunk, H., Hauschild, Th. (1978); Vázquez Seijas, M. (1956-57).

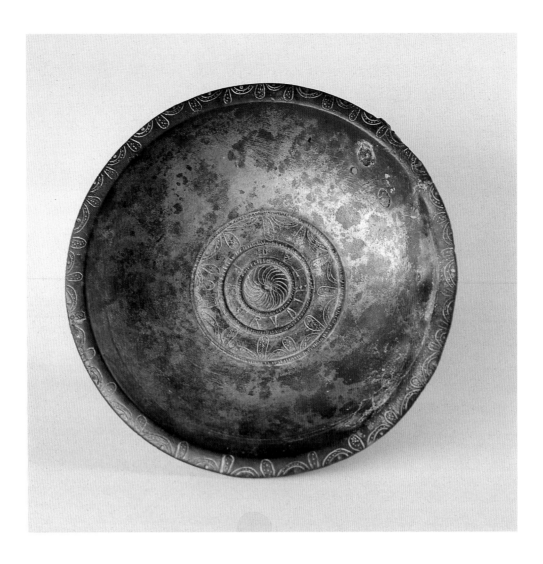

69
Paten
Second half of the VIIth century A.D.

Bronze
Diam., 19 cm.; 3 cm. deep. (max. dia. rings of
the background, 7,5 cm.; central umbo, 2,5 cm.)
A TT F ANTRVDIE (on the cross)
Comar de Sarria (Lugo). Found ca. 1955 (?)

PROVINCIAL MUSEUM OF LUGO

Circular paten like a deep plate, with the edge
folded outward and little base, it has the
beginning of a handle, possibly straight and of
iron, fixed to the edge with bronze nails. The
edge is decorated with a border of dots and
incised rays. This motif is repeated, on a larger
scale, in one of the circles of the interior of the
piece. It has five concentric circles here around a
central umbo decorated with helicoidal lines in a
left-twisting direction. The inscription is in the
fourth circle, in an alphabet with letters around 7
mm. average high.

The piece must have been cast in a wooden
mould, since the reverse lacks polish and shows the
lines of the light shaping of the original mould.

This paten is placed within a wide ensemble of
pieces which includes bronze jars, used for
ceremonies of baptism, communion and clerical
ordination in the Visigothic period.

Most patens from the Iberian Peninsula are very
similar, is why it was thought (Núñez) that they all
came from the same workshop, situated in the
Leonese region in the second half of the VIIth
century, but with later activity.

Besides its simple and careful decoration, the
piece stands out for the inscription at the bottom,
which begins with a cross and says (according to
Ares): a "testamento f(acto) Antrvdie" (made
according to Antrudia's last will). This compound
name has a second element frequent in other
Hispanic-Visigothic feminine names. Other authors,
in contrast, have the opinion that is some sort of
eucharistical formula joined to a proper name
(ENTRVDIETA), at times cryptographic (XP A TE
DIV(enit) TR(iv)NF(us). Nevertheless, it seems
obvious that it is a donation for the liturgic
ceremonies, as has been said.

Unfortunately we do not accurately know the
actual context of appearance of this paten which
could throw more light on it, since it was sold as
junk to a tradesman from Lugo as coming from a
parish in the Sarria region. (Remains from the
Visigothic period have appeared in this zone and
particularly in the parishes of Calvor and
Seteventos. Vestiges perhaps descendent from the
same whole).

(F.A.V.)

BIBLIOGRAPHY
Ares Vázquez, N. (1983); Exposición (1990); Núñez
 Rodríguez, M. (1976) (I); Peinado Gómez, N.
 (1960-61); Trapero Pardo, J. (1958-59).

THE WAY

HISTORICAL APPROACH:
GALICIA AND THE MIDDLE AGES

F. López Alsina

Each one of the great historical periods in which Western history is usually divided academically has left its imprint on the reality we call today Galicia. Many of its present features are the distant result of the changes and historical processes occurring in the more than a thousand years of the long medieval period. I do not intend to present here an exhaustive picture of these characteristics to support this affirmation, an impossible goal for so short a space. I will only underline those which seem most signifcant to me. The medieval period left Galicia its present territorial area, the definitory characteristics of its Romance language, the historical experience of a politically differentiated community—regnum—and, even, I would dare say the very name that identifies it. Perhaps the latter needs to be explained in detail. The term Gallaecia was certainly coined before the beginning of the Middle Ages and crystalized in the Low Empire as the name of one of the five peninsular provinces of the Roman diocese of Hispania, along with the Betica, Lusitania, Tarraconense and Cartaginense. At the beginning of the Modern Period, when the Catholic Kings give their diplomas, they are called the kings of Castile, León, Aragón, Sicily, Toledo, Valencia, Galicia, Mayorca, Seville, Sardinia, Córdoba, Corsica, Murcia, Jaén, Algarve, Algeciras, and Gibraltar; counts of Barcelona, lords of Biscay and Molina, dukes of Athens and Neopatria, counts of Rosellón and Cerdaña, marquees of Oristan and Gociano. Galicia is the only one of the large territorial groups of the late empire that has resisted the passage of the centuries until the end of the XVth century, although with a considerably smaller geographical base that nevertheless is quite similar to the present-day one.

Thus it can be stated that the Middle Ages left Galicia its very name, in that it prevented it from disappearing. This singular survival allows us to understand one of the explanatory keys of the Galician medieval period: the basic continuity through the diverse and profound historical avatars, which made one of the groups installed in the north west of the peninsula be perceived as Galician by the different peoples which they were associated in the medieval centuries. In this sense, the installation of the Suevi in the Roman Gallaecia at the beginning of the Vth century was decisive. In the first place, the presence of a Germanic people permitted the formation of a kingdom from an early time, its political entity similar to that of other contemporary monarchies: Vandals, Franks, Visigoths, Ostrogoths, etc. In the second place, the enormous numerical inferiority of the invaders—not more than 25,000—in relation to the large majority of Galaico-Roman population, guaranteed the survival of the term Gallaecia. We must remember that the emigration of Bretons toward the continental coasts of Europe led to the appearance of the term Britain, applied to the peninsula of Armórica. If a Suevian immigration has taken place with such intensity in the peninsular northwest, it could have caused the name of the kingdom to be changed to Suevia. But this did not happen, and in the VIth century the Suevian kingdom seen by Gregory of Tours from Merovingian France was already the kingdom of Galicia.

The Germanic period inaugurates the medieval stage of Galicia, as its initial phase, in which the interaction among Romanity, Christianity and Germanism begins. The vision of

the events of two Galician clergymen of the Vth century, such as Hidacio or Paulo Orosio, appears to obey their personal expectations. In comparison with Paulo Orosio's optimism, as he imagined that the Suevi would easily change their swords for plows, Hidacio of Chaves does not hide the pessimism in which he could not find in the events prior to 469 good omens for reaching a peaceful synthesis, with the integration of the three elements in question. As bishop of Chaves he intervened without success before the imperial authorities, in the name of the Galaico-Roman provinces, to try to find a solution to so many conflicts, sackings, and slaughters. The very instability of the Suevi was opposed to the possibility of internal unification. Since the passing through of the Vandals in the north of Africa, the Suevi, then mostly settled around the area of Braga, tried to extende their dominion and influence to other peninsular provinces. Finally, when the Suevi intervened in the Tarragonian province, Rome reacted. The Visigoths of Tolosa kept their military obligation to the empire, penetrating in Hispania to defeat the Suevi in the battle of Orbigo (456). The latter had to retreat to Gallaecia. Hidacio's chronicle stops in 469. Almost a hundred years passed before we have more news of the Suevian kingdom. This long silence, which begins in 469, makes it difficult to correctly comprehend the latest tendencies of Suevian Galicia's historical evolution. Nevertheless, it seems certain that one of the major obstacles to lasting consolidation during the reign of the Suevi was the difference in religious beliefs. Christianization, in its most external and institutional sense, had advanced significantly. It is impossible to quantify the percentage of Christian population, but at least its marked rural nature can be affirmed. The entire peninsular Northwest was characterized by a degree of urbanization notably below that of the rest of the peninsular provinces. The ruralism in the episcopal sees of the ecclesiastic province of Braga favored the reception and rooting of Priscilianism. The installation of the Suevi ended up complicating the religious panorama: resurgence of pre-Roman beliefs, Catholicism, Priscilianism, Germanic practices and cults... The Germanic monarchs tried to find prudent solutions. Catholicism was "definitely" the major religion. Requiario (448-456) was the first monarch of the entire German West who converted to Catholicism, but without trying to drag his people with him. Requiario's personal experiment was frustrated by his execution after the battle of Orbigo (456). But the problem continued. A brusque, direct confessional change, such as that which Requiario had attempted, held the danger of the loss of identity of the Germanic group and the easy absorption afterward by the Galaico-Roman population. King Remismund thought of a middle road: bringer them closer through Arrianism. In 456 the missionary Ayax arrived from the Visigothic kingdom of Toulouse with the mission of spreading the Arrian creed among the Suevi. Christianity was accepted, but maintaining the differences with the majority Nicean creed.

The method defended by Remismund allowed the confessional positions between the Suevian gens and the Galaico-Romans to be brought closer. The decree of Pope Vigil sent in 538 to the metropolitan of Braga, Profuturo, gives two important facts. First, the Catholic church enjoyed considerable freedom. Second, the Germanic population had accepted Arrianism, formula coined in the Visigothic kingdom of Tolosa, which had shown to be efficient in the promoting of understanding and cooperation between the German and Roman aristocracies.

In the mid-VIth century the peaceful understanding of the past decades had prepared the way for the defintive unification in Catholicism, which since Clovis had the precedent of the Catholic Frankish kingdom, defeater moreover of the Visigoth-Arrians in Mouillé (507). The agent of the conversion, Martin of Dumio, arrived in Galicia around 550, two years before the disembarking in the peninsula of Justinian's Byzantine armies, which was surely not separate from Martin's mission.

Two contradictory historiographic traditions have been preserved as to the decisive event of the definitive conversion. Gregory of Tours attributes the decision to a king called Carriaric, otherwise unknown, and situates it around 550. In the midst of the historically trusting contacts between Suevi and Franks, he tries to assign a deciding role to the cult of Saint Martin of Tours and the Merovingian influence. Isidore of Seville, on the contrary, attributes the conversion to king Ariamire (559-570), later rebaptized as Theodomire.

Whether it was one monarch or another, his conversion is better understood if it is framed within that slow advance along the road to prudent approximation between Galaico-

Romans and Germans, based on the achievement of religious solidarity. The last twenty five years of the history of the Catholic Suevian kingdom offer several examples of that search, both among the Suevian element and in the Galaico-Roman. The new circumstances made it possible for King Ariamire to convoke a Catholic concilium in 561. In the First Council of Braga, contrary to what might be expected, there is not an explicit condemnation of Arrianism, nor the personal abjuration of the Arrian episcopate, as would occur in the Third Council of Toledo (589). Everything seems to indicate that Ariamire refused to impose a personal decision on his German subjects, which thus allowed for the survival of the Arrian Suevi church. The last survivers of this national church would be the four Arrian bishops Sunnila of Viseo, Gardingo of Tui, Bechila of Lugo, and Arvito of Oporto, who profess Catholicism in 589. On the contrary, the eight Catholic bishops of the Suevian kingdom who meet in Braga in 561, place special emphasis on the condemnation of seventeen articles of Priscilianist inspiration. Also from the Galaico-Roman sector religious unification in Catholicism was sought, which demanded the previous and definitive overcoming of the last significant Priscilianist embers.

The last inspirer of this broad operation of renovation was Martín of Dumio. Under his leadership there was a profound territorial restructuring of the Catholic church of the kingdom, which ended up as the Suevian Parish. Two provinces were distinguished, subdivided in thirteen episcopal sees, one new: that of Braga, which included Braga, Oporto, Lamego, Coimbra, Viseo, Dumio and Idanha, and that of Lugo, with Lugo, Ourense, Astorga, Iria, Tui and Bretonia. To each one of the sees the Parish nominally assigns its parishes, which reach a total of some one hundred thirty two, proof of the profound penetration of Christianity in the Galician fields. Martín, now as Metropolitan of Braga, presides the second council of Braga (572), which reminds the bishops of the obligation to visit the parishes and tries to control the abuses and greediness of the clergy, but no longer registers any type of dogmatic concern. The long search of one hundred seventy seven years to find in Gallaecia its own road toward the synthesis of Romanity, Catholicism and Germanism finally ended with the conquest of the Suevian kingdom by the Visigoth Leovigildo (585). Isidoro of Seville notes in his History of the Suevi: "After the Suevia kingdom was destroyed it is transferred to the Goths." But the growing religious unity, painstakingly achieved in Suevian Galicia, will extend triumphantly to the rest of the peninsula in spite of the political defeat. The Suevian example will be imitated only four years later by Recaredo in the Third Council of Toledo (589).

For Galician history, the Suevian period marks the beginning of the territoial configuration of present-day Galicia. In spite of the fact that the limits of the convents of Braga, Lugo and Asturias, in which Roman Gallaecia was divided, are not known exactly, it can be affirmed that the only convent which was maintained integrally in the heart of the Suevian kingdom was that of Lugo. Only the progressive disarticulation of the spatial base of the Asturian and Bragan convents of the low empire satisfactorily explains the solutions proposed in the Suevian Parish: the ecclesiastical definition of a northern province, with its center in Lugo, to which the parishes set in what remained of the ancient Asturian convent were incorporated; and a southern province, with Braga as capital. At the time of the incorporation of the Suevian kingdom into the Visigothic, these two realities had crystallized. The Galicia of the north would maintain as a nearly permanent characteristic during the rest of the Middle Ages its integration in broader political entities, while the Galicia of the south or Braga would end up assuming full sovereignty as Portuguese nation.

The Visigothic conquest, although it may seem paradoxical, reinforces the continuity of the social and political evolution of Galicia. The figure of the Catholic German monarch, which Saint Isidoro adapts for the Visigothic kingdom, had also been profiled by Martín of Dumio for the last Suevian kings, who as defense ministers of the church with an authority delegated by God, had the faculty to convoke the councils of Braga. The final triumph of the integration into Catholicism also implied the achievement of social fusion among Romans and Germans, which also supposes the triple fusion of the Suevian, Roamn, and Visigothic aristocracies. The strengthening of the new aristocracy, characteristic of peninsular political history until 711, would be more manifest in the northwest, which was so distant from the capital Toledo.

The Galician potentes, among whom we must include the bishops, for their territorial

fortunes in the sees they administered and for their political functions exercised through the conciliar assembly of Toledo, affirm their social position over the rest of an absolutely ruralized Galician society. In the heart of the Galician people the ties of servitude extend widely among those who work the lands of the aristocracy. The factor that most decisively consolidated the position of the Galician potentes was the exercise of power, theoretically delegated by the king in the government of the small territorial districts. The constant degradation of the concept of authority during the late Antiquity led, on the one hand, to the tendency of the large territorial authorities to exercise public duties over the persons installed on their lands and, on the other hand, to the tendency of the governors of the kingdom's territorial districts, normally the large landowners residing in different territories, to consider themselves the owners of public powers, which they exercised over the free population, installed on the public lands of the rural districts, and to aspire to transmit those same powers by inheritance, as if it were patrimony. Only an energetic monarch could stand up to these tendencies toward autonomy of the territorial aristocracies, but during the VIIth century the Visigothic kings did not manage to interrupt this process of protofeudalization.

The Muslim invasion of the peninsula in 711 and the rapid conquest of the Visigothic kingdom deeply altered the course of historical evolution. The behavior of the different aristocracies was quite varied. Teodomiro of Orihuela made a pact with the Muslims. But in the northwestern quadrant, occupied by encampments of Berbers from northern Africa, the family of Duke Peter of Cantabria, ally of Pelayo after the battle of Covadonga, faced them, shielding itself in the most mountainous strip of its territories. Alphonse, son of Duke Peter, assumes the political leadership and deliberately traces a first frontier. According to the first Asturian chronicles, this primitive territory, in addition to a good part of the Cantabrian cornice which extends to the East of the Sella River, included to its West the pars maritima Gallecie, expression which nearly certainly must be understood as a minimum the space occupied now by the dioceses of Monoñedo, Lugo, Santiago, and Tui and the westernmost portion of that of Oviedo. That is, a good part of what we have earlier classified as the Galicia of the north or Lugo, thereby integrated in the Astur kingdom more than a hundred years before the Galicia of the south or Braga. The reality of the Galicia of late Antiquity, more extensive territorially than the present one, explains how the kingdom, that because of the residence of its princes could be called Astur, could in the eyes of its contetmporaries, Muslims or Carlingians, be the kingdom of Galicia. Even around 900 this territorially broad image of Galicia remains alive, when we consider that the area of Oporto or Sahagún still form part of it.

But, beneath the memories, the reign of Alphonse I marked the beginning of the definitive territorial breakup of the ancient Gallaecia. After 850, the nucleus of Astur resistance begins its primitive territorial expansion. The Christian frontier is moved to the Duero River. The incorporation of Astorga, León and Oporto accentuates the contrasts between what will end up being modern-day Galicia and the new frontier spaces, forced to resolve specific problems. The first scision occurs in 910. After the death of Alphonse III, three different kingdoms are outlined: León, Asturias, and Galicia, governed by García, Fruela, and Ordoño, respectively. This first solution undoubtedly also had linguistic reasons.

This regnum of Galicia extends to the Duero and is pollitically linked to the Leonese monarchy, except in the short periods of Ordoño (910-914), Sancho Ordóñez (926-929), and García (1065-1070). Although they are unified, modern-day Galicia and the Portuguese earldom advance along different paths. The frontier lands live the proximity of Islam and since the conquests of Coimbra and Viseo devote themselves to southward expansion. The lands of the North, today's Galicia, barely affected by the Muslim invasion, orient their historical trajectory toward more continuing solutions. The struggle between the aristocracies of both territorial wholes for control of the politics of this regnum of Galicia enters a critical point when, in the reign of Alphonse IV the restoration of the ancient Visigothic metropolis begins. After Toledo (1088), Braga should have followed, restored as a see in 1070, but how can we ignore the exceptional historical circumstances which in the last centuries had made Santiago the apostolic see of the peninsular northwest? Paradoxically, the solution of the Suevian Parish would again be fitting and Alphonse IV leaned toward the recognition of the two different realities. After Raymund of Burgundy and Henry of Lorrain the term Galicia already definitely excluded what would end up being Portugal.

At the same time as the three feudal monarchies of the XIIIth century were forming, each one with a bishopric with an eccliastical capital—Portugal-Braga, León-Santiago, Castilla-Toledo—, the definitive configuration of present-day Galicia had been completed. One of the factors which contributed the most to the gestation of this process, as well the link of medieval Galicia with western Christianity, was the organization of the sepulchral cult to Santiago in Compostela and its internalization through pilgrimage.

Within the current of growing veneration of the Apostles, the Breviarium Apostolorum introduces the novelty of assigning Santiago the Greater to Hispania and Philip to Gaul, as their respective fields of predication, around 600. At the same time it locates the place of burial of Santiago in Aca Marmarica. It was the ancient belief that the Apostles rested where they had predicated, so that theoretically the thesis of the Breviarium gave the impression that Aca Marmarica could be a place in the Iberian Peninsula. This current of opinion circulated throughout Catholic Hispania after the III Council of Toledo, to whose Christianity a direct apostolic origin was thus attributed. It is debated as to whether Isidoro of Seville adhered to this thesis or not in De ortu et obitu patrum, whose manuscript tradition reflects the novelty of the prediction of Santiago in Spain. The belief in this predication had extended widely in the last years of the Visigothic kingdom. The new circumstances, born from the Muslim invasion, were to give extraordinary strength to the cult of Santiago.

It is not surprising that the first chronicles of the Astur kingdom omit everything that refers to the origins of the Jacobean cult, if we think that the authors' goal was to establish the idea that the entire force of the resistance to the westernmost nucleus of the Peninsula was intimately linked to Oviedo, the place of residence of its last kings, especially threatened as a regal seat from the time of first Astur territorial expansion. From other sources we know that the figure of the Apostle Santiago was especially invoked in the land of Astur in the VIIIth century, before the organization of the sepulchral cult in Compostela.

The liturgical hymn O Dei Verbum invokes Santiago as the head of gleaming gold of Spain, patron and special protector. It was composed in the Astur kingdom, in the time of king Mauregato (783-788). Around the same time, Beato de Liébana included the belief in Santiago's Spanish predication in his Apocalypse Commentaries, and shapes it into the mapamundi that accompanied his commentaries. The maps that are conserved in the different copies of the commentaries record innumerable variants and, nevertheless, all coincide in reproducing the same toponym: Gallaecia. The geographical chart of Beato of Burgo de Osma, considered to be the one which most faithfully reproduces that of the lost archetype, represents the fields of predication of each Apostle with human heads. Everything seems to indicate that the map of the VIIIth century, in which Beato tried to represent graphically the new geography of the sortes apostolicas, drew Santiago's head over the extensive Gallaecia of the VIIIth century, from which the author wrote. Beato turned to the cult of Santiago, to the same apostolic roots, to face the chief theological danger that affected the Carolingian church: adoptionism.

Islam's consolidation in the peninsula led to the birth of two postures in the heart of the Hispanic church, as generally occurred in society itself. The spark that openly set off the polemic was the adoptionist quarrel. The metropolitan Elipando of Toledo, bishop of the capital of the former Visigothic kingdom and as such hierarchical head of Hispanic Christianity, in his desire to make the trinitarian theology more understandable, incurred in the error of considering Christ to be the adopted son of the Father. Félix of Urgel seconded him. Adoptionism was condemned in three successive councils. Latin Christianity, politically unified by Charlemagne, strengthened its theological unity in the face of Islam. It is not strange that, after three centuries, the Pseudo-Turpín would end up associating the emperor Charlemagne with the cult of Santiago, a young cult that had extended through all of Latin Christianity.

The condemnation of adoptionism facilitated the disintegration of the Visigothic church. The easternmost nuclei of resistance, separated from their dependence with respect to Toledo, entered the Carolingian orbit. The Astur nucleus, under Alphonse II, emphasized its independence by converting Oviedo in the new Toledo. It is in this wider context that we must situate the organization of the sepulchral cult to the Apostle in Compostela. Its historical origins have reached us cloaked in the miraculous garb characteristic of the hagiographic genre and impregnated with the sensitivity typical of the relic cult. The

complacency of the martyr with the cult which provides him with a community and his predisposition to intercede for it are always manifested in a prodigious manner. It is completely coherent that the miraculous revelation of the specific place where the martyr rests would situate it in the Astur kingdom and, even more concretely, in Iria, the only see of the kingdom whose episcopal succession had not been interrupted by the Muslim presence.

The news of the discovery of the sepulcher of Santiago Apostle in the westsern region of the known world, extended rapidly throughout Latin Christianity. More than the historical bases, what mattered was the potential of the new cult to contain the Muslim expansion and fortify western Christianity. From the early moments of the IXth century the events were presented as the restoration of the martyr's cult and of an ancient pilgrimage of the peoples of the Germanic West. Bishop Sisnando, fourth of Iria-Compostela, organized his apostolic seat at the end of the IXth century, using as intentional reference the parallelism of Lateran. The patronage of Santiago Apostle over the king and the kingdom attracted donations to his sanctuary which increased his control.

The rapid spread of the new cult and the consequent consolidation of the Compostelan sanctuary added to the facilitation of the intense relationships of Galicia with the rest of western Christianity through the Way of Saint James. This route was geographically fixed since the time of Ordoño II of León and Sancho García I of Navarre. We find Gotescalco de le Puy on it in 950, first pilgrim from beyond the Pyrenees whose name is known. Early contacts with Tours and Limoges, together with this one of le Puy, show a stable pilgrimage, although mostly anonymous, during the Xth century. After the year 1000, the frequent passage of pilgrims toward Compostela leads to the psychological establishment of this route as the Camino de Santiago (Saint James Way).

In the XIth century, Galicia is incorporated into the general awakening of western Christianity. The fall of the Califate of Córdoba and the very intense affluence of Muslim gold through the regimen of pariahs, attract contingents of "Franks" to the nuclei of the Camino de Santiago, then in the process of full urbanization. As fruit of the intensification of these relationships the first pontifical legacies, Benedictinization, the late presence of Cluny, the change in liturgy, the early implantation of the Cister arrive in Galicia. Saint James' Way, material route and expression of these intense changes, becomes the chief axis of communication of the northern peninsula. The transformative effects are accumulated at the end of the Way in the city of Santiago during the period of its first archbishop, Diego Xelmírez: the Romanesque Cathedral, the Tumbo A, the Historia Compostellana, the Liber Sancti Jacobi.

Together with the cult of Santiago there are other factors working to explain these deep changes: the increase in population, the agrarian expansion, the coining of money in Santiago and Lugo, the appearance of the first generations of professional merchants, urbanization, the intensification of maritime communications, the consolidation of the first bourgeois sectors which respond to the feudal powers of the ecclesiastical lords. All these agents of change act upon a Galicia that had been definitively shaped toward integration into the Leonese crown.

The separate crystallization of the three kingdoms of Portugal, León and Castile, following the death of Alphonse VII (1157), increased the role of Galicia within the kingdom of León, of Ferdinand II and Alphonse IX. The Galician coast constituted more than three-fourths of the Leonese maritime façade. The Leonese kings begin to become interested in the new modes of wealth that maritime trade generated and they multiplied their concessions of local judicious ordenances to sea-faring villages from Ribadeo to A Garda.

The definitive union of the crowns of Castile and León (1230) marks the beginning of the passage of Galicia toward the low medieval depression. The interests of Ferdinand III leaned toward the culmination of the task of reconquest in the southern part of the peninsula. The Way of Saint James stopped being the principle artery of the kingdom. Galicia reached the ceiling of expansion in the XIIIth century, but its position within the Crown of Castile had become more peripheral than ever. the demographic, social, and political consequences of the crisis of the XIVth century incited the feudal nobility to multiply pressure for control anarchically. Violence caused popular explosions and the formation of brotherhoods for self defense. The movement of 1469 attacked the nobility in its symbols of power with the

overthrow of the fortresses. Left to their fate by the kings, beneath the greed of the nobles and isolated during many decades from the royal itineraries, the trip of the Catholic Kings to Galicia in 1486 reinforced an automatic identification between justice, as an intrinsical attribute of the medieval monarch, and the end of feudal violence. Galicia had begun the road to the Modern Age.

ON ARTISTIC ACTIVITY:
MEDIEVAL SCULPTURE

J. Yarza Luaces

As it had to occur, the greater or lesser development of Galician sculpture throughout the long Middle Ages is closely linked to that great international sanctuary that Santiago de Compostela came to be. While it was in contact with Europe and equally related to the rest of the Iberian Peninsula, through different religious, cultural or artistic currents, it was established and maintained as the center and place of residence of sculptors, architects and miniaturists, capable of irradiating its influence to the Galician periphery. This is especially clear after the end of the XIth century and during a hundred and fifty years. When diverse circumstances begin to situate it in the "Land's End" which it was geographically, the brilliance of the works which are done there and their subsequent diffusion will be extinguished.

Parallelly, while the Leonese monarchy leads the western kingdoms, or in any case, maintains independence with respect to Castile, the kings will be notable promotors or collaborators in great artistic enterprises, which include sculpture. When all these kingdoms are definitively joined in the person of Ferdinand III the Holy, that patronage completely ceases, at least until the time of the Catholic King and Queen. In one period or another it is generally the bishops who are continuously behind the most interesting projects of the figurative arts. Although those of Santiago have, as is natural, a greater protagonism, by no means are they the only ones. Among them we would have to point out those who rule the see of Ourense above the rest. Much less need be said about the great abbeys, when speaking of projects other than the architectural. The Galician nobility, powerful, independent and little refined, has a role that is not very lucid. If we had to make an exception of an area in which they intervened, it would be sculpture. But we should not think that they were sensitive to it. It is simply the desire to perpetuate themselves and to perpetuate their memory which will lead them, at least from the end of the thirteenth century, to commission monumental sepulchers usually done in stone. The rest of the estates are of much lesser importance.

Since all medieval Hispanic art is continuously indebted to the French, Italian, etc..., it could not happen otherwise in the Galicia of the most splendorous times. But, even when it became the periphery of the periphery, during the major part of the Gothic centuries, one normally sees the influences or importations from the Leonese or Castilian, amd probably the Portuguese as well.

All the artistic forms and techniques must have been practiced then. We know of the wealth of the Cathedral treasure, sign of the presence of numerous metalworkers and silversmiths, but nearly all of it has disappeared. There were important illuminated books, although they have been lost or sold almost in their entirety. We must suppose, also, that the walls of its churches were covered with certain frequency with great painted cycles, although very few signs survive to confirm this. In this way, today we can believe that architecture and sculpture were the most frequently practiced arts. But, was it this way?

The only thing certain is that sculpture is the best known figurative art of our Middle Ages. But of all the possibilities the one that stands out is that which links it closely with architecture, of which it forms part in the most important cases. It thus a monumental sculpture, that is, stone is the material used with greatest frequency, while wood is little used in spite of its abundance, contrary to what happens in Castile and León. There are many types of stone which serve as a support for sculpture. Given its broad diffusion and the presence of quarries in all areas, in Galicia granite was preferred, without excluding the occasional use of marble and others. This determines, more than might be supposed on first impression, the results that are achieved, because with its hardness and composition those refinements of detail in the work which other more malleable variants offer, are difficult to obtain. This, which in a given period, almost exclusively in the present century, provokes in some artists an aesthetic acceptance in an attempt to fit the results to the particularities of the material, is seen as a hard slavery in the medieval centuries.

The High Middle Ages of Galicia suffered the same limitations as other places in reference to sculpture. Capitals of more or less stylized leaves were sculpted and efforts were made to produce characteristic figured reliefs on a very few occasions. The two famous reliefs of San Xes de Francelos are representative of what was being done in the ninth or tenth centuries. They flank the doorway of the church. Although at least one of the two appears to represent the entry of Jesus in Jerusalem, the other perhaps repeats the same thing (Núñez). In San Xoán de Camba, probably in the eleventh century, an Epiphany is done with a light modelling of the profiles of the figures, similar to that of English, Irish and even Hispanic examples, prior to the full Romanesque that will arrive immediately afterward.

It is difficult to determine when this occurs, but everything points to two centers of unequal importance: Santiago de Compostela and San Martiño of Mondoñedo. Everything leads us to think that it was during the bishopric of Gonzalo (1077-1112) when the reconstruction here of a previous high medieval building was begun, already within the directrices of Romanesque. And possibly it was then endowed with an important sculptural complement. It includes various capitals, among them those known as the banquet of the wealthy Epulon and the scorn of Lazarus and the other banquet of Herod with the decapitation of the Baptist; likewise, the significant antipendium of difficult cultural and iconographical meaning. These works are not from the workshops which begin in 1077, the year in which Gonzalo occupies the see, but I do not think either that they may be considered much later than 1088, after the moment in which the sculptors active in Compostela must abandon the quarry that was halted, at the time of the expulsion of Diego Peláez. I feel that at that time there is a situation which would force many to seek work wherever it was. The artists of San Martiño do not seem to know anything of these workshops. Nevertheless, their mark already persists at the beginning of the twelfth century in some capitals of San Bartolomé de Rebordáns (Tui), somewhat rougher. This is a sculpture of limited resources, although of great interest, not too distant from that which shortly before had been done in the Asturian church of San Pedro de Teverga (Bango).

Perhaps the great wall of the Cathedral of Santiago de Compostela was somewhat earlier. It is impossible to discuss in the limited space of these pages, even briefly, the sculptural projects which will be completed during more than a hundred years around the supposed tomb of the Apostle, undoubtedly without affecting the mere reference to other interesting works, but lesser in respect to them. I will pass over all of this, simply recalling that then, and never again in the history of Galicia, Santiago de Compostela was one of the most important artistic centers in the world. Architects from France coincided with sculptors of the same origin, native miniaturists and others of English origin, metalworkers and, certainly, painters. Their activity was centered on the great Cathedral, but many would collaborate in the works of the monasteries of Sampaio de Antealtares and San Martiño Pinario and in the churches of Santa Susana and Santa María de Sar, as well as in the episcopal palaces. Still today it is possible to contemplate part of what was done, especially in respect to sculpture.

In 1075 the Cathedral work begins and soon a group of artists must have started to sculpt the capitals of the retro-choir or apse-aisle. The stopping of the work because of the disposition of bishop Diego Peláez must have lasted for a short time. It is quite likely that

master Esteban, called many years later to Pamplona, was involved in this campaign, although we do not know what works correspond to him. Diego Xelmírez, the most astute, best politican, the most Galician and most universal of the bishops of Compostela, was the major promoter of the renewed works. Sculpturally, in addition to the important group of capitals of the church transept, with examples similar to those of San Isidro in León, other significant ones such as that of the punished greedy man, in the first campaign the organization of the two gable walls with their doorways at the extremes of the transept stands out. Although they are anteceded by those of Saint Sernin of Toulouse and serve as a model, with their characteristic double door, there is an improvement that is the result of the experiences which then inspire the great walls of western Europe. The tympanum appears. The ones on the northern side having been destroyed, those which correspond to the Platerías have the feature of a new trial which its date signifies. Before it there are some Aragonese tympana (Jaca, Santa Cruz de la Serós), but they are older than that of the Miégeville of Toulouse doorway. The incongruencies and defective results when assembling a group of reliefs done independently so that they form a semicircular group are visible. In the tympanum of the Epiphany and Passion, the lower part is done as a frieze, while in the upper part the clumsiness is noticeable. On the other, the proud image of a semi-naked woman with a skull in her hands has always attracted attention. It was necessary to cut off a part of the head so that it would fit in the curve of the tympanum. But in the same manner the relief of the man who is riding a lion and touches a horn as if it were to be seen from a position resting on the ground was conceived, and made to turn ninety degrees to produce the impression that he is flying. In spite of these deficiencies they are extraordinarily important works. Different sculptors were employed to do them. Some of them probably come from another great sanctuary of the Way: Sainte Foy de Conques (especially scenes of the Passion). The most important is the one who sculpts the image of the woman. With him we are at the central point of the Languedocian and Hispanic Romanesque. Before, and at the same time, sculptors such as the master of the Maiestas which today has been set in the wall perpendicular to the façade on the west side had worked in the Azabachería. On both parts marble was used in an extraordinary group of column shafts. In the Azabachería they were torsos of classical tradition, sculpted with exquisite delicacy (M. Catedral). In Platerías, they are divided in levels each one of which is occupied by figures beneath groups of arches. Nothing similar was done in the great twin church of France, Saint Sernin de Toulouse.

The Azabachería is not as confusing as it appears to our eyes today, but it was thought that the sculpture overflowed the framework of tympanums, jambs and columns and had spread toward the cornice that the modillions support. We can get an idea of what the Azabachería was like before the reforms (Moralejo). In part, something similar occurs in the Platerías. One of the basic ideas, iconographically, is marked in the middle axis of separation between both doors. Below, the lions in front of the monogram of Christ. Above, the diabolical head and the proud piece of Abraham in marble, witness to the superior Transfiguration. The Savior is later, but the Santiago among cypresses, another Romanesque masterpiece, is original. The David of the Azabachería, very popular, deserves this denomination, and is also used again in the façade that is preserved.

Complex façades with an extraordinary thematic and sculptural wealth, were done in several years. It is possible that the disputed date of 1103 over the left jamb of the right door of the Platerías is indicative of the beginning. Perhaps everything was finished some twenty years later. The program of Platerías, in what refers to its doorways, has been analyzed enphasizing that the sculptural quality was equal to that of the ideological selection of themes (Azcárate). The theory of a demonstration of the double nature of Christ by selecting those which in an immediate or allegorical manner prove it, show the didactic character of the program, but with a complexity that would require without a doubt a complementary oral explanation in order to be understood. The upsetting presence of the woman with the skull places us before the ambiguity of possible meanings, used by the mentors of the program, which both wished to represent Eve as the main cause of the presence of spiritual death in the world, in a characteristically misogynous vision, and make the spectators accomplices reminding them of a truculent story whose equally negative protagonist is this dishonest girl.

Of all that might have been done in the first half of the XIIth century in Santiago, besides the Cathedral, little remains, but it is very important. The columns of San Paio de Antealtares (National Archeological Museum of Madrid; Fogg Art Museum of Cambridge, Mass.) recall the column shafts of the Platerías, but they are more advanced in time and in their plastic conception. They announce the statue-columns that will have such an outstanding life immediately afterward. It has been suggested that they were the column shafts of a disappeared cloister, or more probably, that they supported an altar dais, when they were four and on each one were three apostles. The important similarity of the Savior which is said to be from the church of Santiago of Vigo (Archeological Museum, Madrid), somewhat posterior, but perhaps retouched in the face, is nothing more than an indication of the existence of other important works, already from the second half of the XIIth century, of Compostelan origin.

In 1129 master Raimundo begins the Cathedral of Lugo. Four years earlier the same thing must have happened with that of Tui (Bango). Since the main wall without retro-choir of Lugo disappeared a long time ago, we do not know what sculptural complement it had. Used as a water basin in the sacristy, there is an excellent capital of unknown origin. Did it come from that main wall? If so, this would be a work of strong influence between Compostelan and Tuscan, which is the same thing. In Tui, the first building stage included a good number of figurative capitals of high quality, where the memory of Compostelan work is still visible, although reinterpreted (Bango).

The sepulcher of "Santa Froila" in the same Cathedral of Lugo must have an even more advanced date. There has been mention of contacts with Burgundy (Moralejo). It is an important work for its funeral function, with a theme that partially recalls the previous sepulcher of Ansúrez, but which is more common, except in the character on the left, which is seated, without parallel in our twelfth century. Also from outside Compostela would be the western portal, now somewhat aged as far as the date of production (Vila da Vila), of Santa María de Cambre.

When in 1168 king Ferdinand II concedes a fixed pension to master Mateo for the rest of his life so that he can devote himelf to the work of the Cathedral in Santiago, we are in a time in which the first experiences of what will be French Gothic of the XIIIth century have begun. The great church had not yet been finished at the lower section. Probably a team of Burgundian origin had worked on it. Mateo will be the directing architect until, at least in 1188, when the lintels of the tympanum of the Pórtico da Gloria are placed. In the area of the crypt an important sculptor associated with Saint Vincent of Avila collaborated with him, and was also author of a sculpture that is not too well preserved in the Cathedral (Moralejo).

Although there is no doubt that Mateo is the major person responsible for the architectural whole, not everyone believes him to be the direct author of the sculpture. Two different hands have come to be distinguished as responsible, respectively, for the apostles of the right jambs and the prophets of the left (Otero). In my opinion, in spite of admitting the collaboration in the beginning of different artists, I think that when the sculpture of the crypt is finished, the rest has an artistic unity, even with differences in quality, which is only possible when the architect and the main sculptor are the same person. No matter how it is considered, Mateo was an extraordinary artist of uncertain origin, which does not exclude the possibility that he was born in Galicia, who had ample knowledge of what was being done in Europe, especially in Saint Denis (Pita, Gaillard). He was able to create a setting of profound originality, which incorporates all the novelties of the time, in the service of a mentor who gave him a very complex thematic program.

In the liberation of the architectural frame which supposes the evolution of the perhaps misnamed statue-column, which is born first as a sort of excrescence of the column shaft until it separates from it, Mateo went further than his contemporaries, giving an unequaled corporality to his apostles and prophets. He filled the archivolts of the arches with figures set radially (elder ones in the center, on the left side) or following the arch (right side), as it fit his program. He knew how to break the solemn frontal dispositon of apostles, prophets and elderly figures of the apocalypse, intertwining them in slow conversations, while in a show of modernity he endowed some with individual features, when the common thing in France was idealization, obtaining faces so different as that of the ephebic Daniel, the one with refined features of Santiago, the vigorous one of Peter or the dramatic one of Isaiah.

Sculptor and architect, he found the way in which, with glances or repetition of themes, reading and optical suggestions force a spectator to turn his/her glance from the front toward the back, seeing that there are also sculptures there, so that one feels not so much before the Pórtico as inside it, wrapped by the prodigious world of forms created for that purpose.

The Pórtico must have caused an extraordinary impression in Galicia. Perhaps the master was already dead when his collaborators were able to begin another exceptional project: the stone choir, although the general scheme might have been his. After 1200, and even before, in all of Galicia first, and later in other area a certain Matean "style" spreads; small details or large ones are copied from the model, a decorative language is adopted which had acquired a great development there. The small sculptures set in the high areas of Platerías, the tympanum of the Corticela in Compostela, a saint preserved in the museum, maybe the later Romanesque cloister destroyed and only partially recovered, depend more or less closely on Mateo. Only the Savior, situated next to Santiago in the Transfiguration of Platería, belongs to a different world, although there are no parallels in Compostela.

Meanwhile, many other edifications are in progress all over Galicia. It is the period of the government of Ferdinand II and Alphonse IX, kings of León, but always interested in matters of Galicia, where they would be buried. The work of the Cathedral of Ourense advances (Pita). The north entry, modified due to various disruptions, shows the mark of artists who know the Compostelan work. But the south door is more important, with a complex iconographic plan (Moralejo), served by a sculptor of high quality. In San Estebo de Ribas de Miño the doorway is adorned with an archivolt where the placement of the figures is taken from the old men of Mateo. In Carboeiro and San Xoán de Portomarín the memory is still perceptible, although the technical realization is far from the models.

Probably the sculpture of the north door of the Cathedral of Lugo, strictly contemporaneous with the Pórtico, is the important work which is most distant from that generalized enthusiasm. Both the Maiestas and the capital of the Last Supper, are two masterful works tha are considerably damaged. The first is in the line of the great frieze of Santiago in Carrión de los Condes (Palencia). In the monastery of San Estebo de Ribas do Sil there is a significant piece with Christ and the Apostles on the front, but also carved in the back part. Conceived as a frieze with two slopes, once more the model is in Santiago, although now it is the silverwork altar from the years of Diego Xelmírez.

A less known chapter, more difficult to analyze with the scarcity of information, is that of the freestanding images in polychromed wood. In Galicia the majority of the Virgins with Child that are classified as Romanesque are either considerably posterior and very popular, or are of low quality. The situatiob of the Crucified Christs and the Crucifixions is different. Especially outstanding is the stern crowned Christ of the Cathedral of Ourense. It may have been the first of the cathedral, substituted by the Gothic one. It must have caused a great impression, because all the pieces of the diocese take it as a model. The first and most important is that of Vilanova das Infantas. That of Salvador de Penedos, very retouched, has great dignity. That of San Estebo de Ambía, near Baños de Molgas, is clumsier in its execution. The great Crucifix of San Antoliño de Toques presents another tradition and can be considered from the XIIIth century.

It is difficult to classify Mateo among the masters of Romanesque. He is familiar with the experiences of the French prototype, interprets them and announces new paths. But this does not mean that he finds successors who pursue that route and reach Gothic. On the contrary, they become lost in a repetitive language, much less bold than that of the master. Through the first half of the thirteenth century forms are repeated, including in some of the cases mentioned above, while in the more rural areas the little dexterity of the sculptors leads to almost popular forms, although this term must always be used carefully. At times there are works which are of interest more because of their strange iconographic disposition than for the degradation of the forms, as happens with the tympanum of San Miguel do Monte (Lugo). Attributed to the very modest Pelagio (Yzquierdo) already around 1200, it is occupied by two musicians and a contortionist dancer, following an iconographic scheme that is very old, but more typical of the capitals.

Nevertheless, certain noteworthy works, some from Compostela, are a sign that we are in a brilliant period that survives Mateo and corresponds, especially, to the years of the government of Alphonse IX, last monarch of León. Compostela is still the great artistic

capital of the era of Xelmírez. In addition to Mateo, the two important miniaturists that do the significant altar pieces of Ferdinand II and Alphonse IX in the Tumbo A (Cathedral of Compostela) work there. The relationship of Ferdinand II and his successor to the city of the apostle becomes evident in the selection of the tomb. The Cathedral becomes the royal pantheon and there the first laic recumbent statues of the peninsula are produced. That of Ferdinand II is quite delicate, but that of his son and successor is also of interest. The dynastic change prevented the consolidation of the pantheon, begun with such good auspices.

The large brackets of the main room of the palace of the archbishops are the last great Compostelan works. It is clear that, brought up to date, the influence of Mateo is still here. On the other hand, from now on it will be obvious that the capitals (here brackets but conceived in the same manner) of the Galician area in the centuries of the Gothic will continue to be support for the figurative sculpture. Apparently, together with this there are works of importance from an iconographic perspective, but less important as far as their forms, such as the tympanum of the knight Santiago of the Cathedral (Sicart).

In Tui, around 1120-1235, the façade of the base is raised, with compositional similarity to León, images outside the Matean styles, probably sculpted by some French artist who had to fit his technique to the difficult granite. Not only is the modernity of his style interesting, but there are also certain noteworthy iconographic peculiarities (Moralejo).

In a sense all this contrastes with an ambitious and well known doorway: that of the Paradise of the Cathedral of Ourense, from the second quarter of this century. It is a compositional imitation, a copy undoubtedly, of the Pórtico da Gloria. Its sculptors were less bold and were far from the technique of their models, but they had seen Gothic works and reflect this, were there other groups in this progressive line, reflection of French style and with a greater or lesser use of the heritage of Mateo? Perhaps somewhat more than we suppose. The existence in San Estebo de Ribas de Miño of the splendid relief of a kneeling king, which must have formed part of an Epiphany, forces us to be moderately optimistic. It is a significant sculpture, where the form and garments of the monarch indicate late dates in the XIIIth century. Did it form part of a tympanum that has disappeared?

Throughout the second third of the thirteenth century averything was integrated into the Crown of castile, while in Burgos and Toledo the bishops introduce the high Gothic of the north of France into the new cathedrals which are beginning to be built. Soon the existence of a new political situation begins to be felt, which together with the formal foreign changes, will have a large influence on the arts in general and on sculpture in particular. The political center is moved toward the East. The North-South axis passes more and more through Burgos and Toledo and reaches the ports of Cantabria, taking the place of the ancient East-West axis, the Way of Saint James itself. This loses international importance. In the new Crown, the hegemonic role of Castile is a fact and Galicia is far from that center. The passage of time only reinforces this situation. In Galicia the nobility reaches great power. But it is not precisely cultured nor refined. Nor does it mantain frequent contacts with areas outside, for which reason it does not usually know what those of its class do in Castile or in the crown of Aragón. The kings are little interested in these lands. It is significant that the Gothic cathedral of León and that of Santiago are begun at almost the same time, but many years after Burgos and Toledo and only the first of these is finished, while the second remains as a large project and as little more than the foundations of an impressive head wall (Puente).

In the terrain of the figurative arts there is nothing of international value, not even in the sculpture which with a difference is the most outstanding. The works done are numerous, and in one way or another show a certain knowledge, almost always out of date, of what is changing in Europe, but they do not go beyond reflecting it through distant provincial features. Not even Santiago is free of this. Perhaps at a certan point Ourense becomes more significant, maybe because of its greater proximity to León.

Throughout the last two thirds of the thirteenth century, the inertia of the past takes precedence over the acceptance or knowledge of what is being done outside, except in the failed project of the Cathedral of Santiago. Around 1300 only two possibilities are seen: either a provincial school is created, rough but personal, like that called Ourensan because it had its center there would be (Moralejo), or works are imported from outside. In Campos,

near the division of Ourense and Lugo, there is an image of the Virgin on a throne with the Child, from the hermitage of San Román, which is of the type created in Burgos and León and spread as far as Alava and La Rioja. It is not of great quality, but is of certain interest. Was it sculpted in Ourense or nearby, using Leonese models or ones imported directly from León? The second possibility is the most likely. It would be one case, but it is difficult to think that it was the only one.

On the other hand, the sculpture of the Claustra Nova of Ourense at the end of the XIIIth century and the ambitious sepulcher of an unknown bishop, somewhat later, of the prebyterium of the Cathedral of Ourense are both the most significant examples of the "Ourensan style" (Moralejo).

In these centuries, besides the episcopal sees, certain seafaring towns stand out, and maintain a more or less important trade with ports of the Crown of Aragón, as with the north of Europe, especially with England. They are, above all, Pontevedra, Noia, Muros, Betanzos and A Coruña. Different buildings are constructed in them which are finished off with important doorways (San Francisco, Santa María and Santiago in Betanzos; San Martiño in Noia), at the same time as they become pantheons of the nobility or major families involved in seafaring and trade, especially the churches of the mendicant orders (San Francisco and Santo Domingo of Pontevedra; San Francisco of Betanzos).

From what has been said we must also deduce that these mendicant orders born in the thirteenth century come to have an important role in all the Galician cities, both on the coast and in the interior. Since the monks are considered especially able to help at the hour of death, their churches are frequent pantheons in all areas (Santo Domingo in Santiago; Rivadavia; San Francisco of Lugo).

Thus there is an important amount of sculpture centered on monuments and sepulchers. Its quality is uneven and never, in any case, reaches high levels. A period which can be classified as relatively brilliant is that of the last years of the XIVth century and the first half of the following. In it a noble family, the Andrades, stands out. The tomb of Fernán Pérez de Andrade o Bo ('the Good'), in San Francisco, represents the most complex iconographic level in the entire Galician world of death, transforming the head wall of the church into a funerary chapel laden with allusive iconic signs. In San Martiño of Noia we find a "revival" of Mateo which has already extended to other parts of Galicia. The monumental doorway of the beginning of the XVth century shows continuous references of all sorts to the Pórtico da Gloria, although this does not mean that it is not imbued with great dignity (Caamaño).

There was an immense number of sepulchers of which many have disappeared. In Vilar das Donas, which from 1184 belonged to the Military Order of Santiago, up to twenty sepulchers are mentioned in the cloister in 1494 (Chamoso). Today only two remain, along with some sepulchral lauds. That of Santiago Pérez de Ulloa shows the knight dressed in armor and holding a sword, in high relief modelled with certain care around 1410. It belongs to a very common type among the Galician nobility of the Gothic period. Except for the sepulcher of Fernán Pérez de Andrade and a few more, the majority of the nobles only included their reclined figure, epitaphs and representation of their arms. Thus, in them predominates the desire to await the judgement hour in a suitable place and the perpetuation of their fame or that of their lineage (Núñez). There has been an attempt to see who the authors of these works are. There is no documentation available at all, so that any observations are limited to hypotheses. It is suggested that there must have been itinerant workshops, although their usual place of residence would have been some important city, such as Santiago, which would go to the places where they were needed, repeating similar types with an average quality that nevertheless does not satisfy the client (Moralejo, Sánchez Ameijeiras).

Several works, and particularly three, all of bishops, stand out over the rest and are a product of the will and power of those who commission them. The bishop Vasco Pérez Mariño dies in 1343 and is buried in a proud sarcophagus in the Cathedral of Ourense. Although he is always presented in relation to Fisterra (Land's End), it is clear that he must have had important contacts with the Castile-León area, because the work commissioned is different from the already dead "Ourensen school" and to all that was being done in Galicia at the time. With the disappearance of the tomb of Lope de Mendoza and leaving aside the royal pantheon of Santiago, it is the most important funeral monument in Galicia.

Lope de Mendoza, after abandoning the idea of reaching the see of Toledo, decided to be buried in the Cathedral of Santiago (1442-1451). His funeral chapel must have been very important judging by the references which we have. Later destroyed, we can only guess at what it was like by the enthusiasm it caused and by the image of the Virgin and Child, with the prelate praying before them, that is still preserved. While the previous tomb is in the tradition of 1300 of Castile-León, this tradition reflects the novelties of international Gothic and it has been thought that there are parallels in the Salamancan tomb of Diego de Anaya (Caamaño). It is clear that, including the material used, it had little to do with what was being done in Santiago. Unfortunately, both of these are individual projects of two different bishops, which had no echo in the surrounding area. To these works, different from the norm, we would have to add the sepulcher of bishop Alonso López of Valladolid, from the end of the XVth century and also in the Cathedral of Compostela.

As far as the freestanding sculpture of the XIIIth and XIVth centuries and first half of the XVth, it has the quality of an art object, able to be transported from one place to another and for this reason to be brought from far-off centers. Nothing is more indicative of this state of things than the trading of small English pieces of alabaster, between the end of the fourteenth century and the beginning of the sixteenth. The coastal cities or those near the coast, as well as the places where there is no important sculptural tradition, are those which acquire the most pieces of this sort. In all Cantabria there are still pieces of this type preserved today (especially in the Basque Country). Galicia must have been in a similar situation. Aside from the gift of the altar piece of Santiago delivered directly to the Cathedral of the city, an altar piece with these reliefs was also done for the Cathedral of Mondoñedo. Remains of figures of saints in the Museum of Lugo and other pieces in private collections and museums indicate to what extent they fulfilled an important role.

Among the images of devotion the Christ of Ourense and the Virgin of the Big Eyes in Lugo stand out. They are objects of constant veneration, poorly studied because of this. The donation of the Christ to the Cathedral of Ourense is attributed to Vasco Pérez Mariño. It belongs to this very special world which he shares with other devotional works such as the Christ of Burgos or the reclining one of the Clarisas of Palencia (although it is doubtful that the latter is medieval). The great image of Our Lady of the Big Eyes, which does not appear to receive this name until well into the XIVth century, is a statue which has caused few commentaries and these not in agreement. A date within the first half of the XIVth century has been indicated, but later and earlier ones have also been given. Apparently it is inspired in an ancient model, but I do not think that it was done before the second half of the XVth century. There are other cases of various important sculptures conserved in Santiago. Was it an image of the doorway of the Virgin in the convent of Belvís, probably from the XIVth century, as its very name indicates? The group of the Crucifixion is very noteworthy; it crowned the retro-choir of the Cathedral of Santiago and today is in the chapel of Sancti Spiritus. It is not easy to distinguish, because of its place, but it depends on models of the XIVth century, very frequent in Castile. Nevertheless, the careful shaping of the body of Christ seems to indicate much later dates.

All of these are exceptional pieces. The usual thing was rougher and must have been abundant. Compare the Virgin of Carboeiro (church of San Xoán de Saídres), very popular in spite of coming from such a prominent monastery (Bango).

At the end of the Middle Ages, between the last quarter of the XVth century and the surviving elements at the beginning of the XVIth, numerous works appear in Galicia, some of great quality. The watch tower of Compostela has a group of apostles of great plastic force and clearly northern features set in its walls. The northern gable-wall of the Cathedral of Ourense is fixed and Diego de Fonseca (1471-1484) must order the placement of a tympanum filled with images centered by a large Pietá and a Cross, where a strong Flemish influence is obvious.

This Pietá places us in contact with some of the great themes omnipresent in the Hispanic and European low Medieval society. It is repeated in late pieces (main altar piece of the Cathedral of Ourense) and in separate pieces (San Antonio de Padua, Monforte). The same thing occurs with Saint Anne, with different iconic models, especially the well-known one with the Virgin and Child, of smaller size. An excellent one, of strong northern influence, is preserved in the museum of the Cathedral of Santiago, but also very noteworthy

are those of San Vicente del Pino (Monforte) or that included in the Plateresque altar piece of the Cathedral of Mondoñedo. Some emblematic images are copied over and over, like the Virgin of Trápani (Cathedral of Ourense).

There are wooden altar pieces. Robbed and nearly totally recovered, of the altar piece formed by small pieces of Santa María de Azougue (Betanzos) it has been said that this is very normal at the end of the XVth century. We cannot be certain that this is what happened with the important Brigantine sculptures. For various reasons the Renaissance will be taken into account, but structurally it responds to the late Gothic type that was so abundant in the Iberian Peninsula. Although Cornielles of Holland works there and was later active in Santiago in works which are clearly renaissance, I suspect the major part of the scenes could have been done before his arrival by local sculptors or those from northern Portugal. Around 1520 he joins the work. He is the author, not only, as has been said (Chamoso) of the small statues of male and female saints in the space between two mouldings, but also of the excellent group of the Pietá. Its very Flemish aesthetic has the ambiguity of this late medieval tradition, only partially renewed with the knowledge of the Italian.

Much the same would have to be said of the sculpture of the chapel of the hospital of the Catholic King and Queen, built by outsiders, some of French origin (Nicolas Chanterenne). But contemporaneously great sculpted portals, archaic, with a rich iconographic content are still being made, like that of Saint Jerome, from the former Hospital of the Azabachería, in Santiago (Caamaño, Otero).

The great renovation of Galician sculpture comes much later and will be very brilliant. The medieval influence continues in the XIVth century in mostly rural examples. The Gothic had been an attractive period, interesting, uneven, where it is difficult to draw evolutionary lines of long duration. It was undoubtedly the reflection of the situation in Galicia, with its achievements and localism, only maintained by bishops of broader perspective than those of the rest of their contemporaries.

70
Relief from Pazó
X Century (Circa 920-940)

Granite.
22 x 37 x 17 cm.
San Martiño de Pazó, Allariz (Ourense)

PROVINCIAL MUSEUM OF ARCHEOLOGY
OF OURENSE

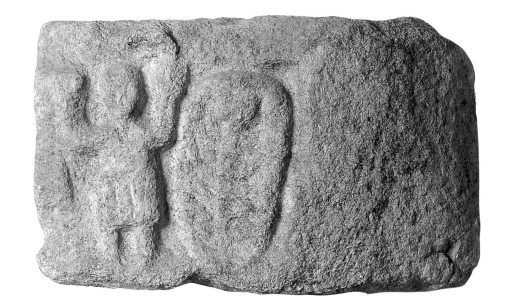

The renaissance in construction which takes place in Galicia throughout the ninth and tenth centuries, due to the impulse and protection its nobility gave to monastic foundations and restoration, including the reshaping of older buildings, is reflected in San Martiño de Pazó (Alariz), the former monastery of Palatiolo, whose forms are considered more ancient.

The building, of which important remains of the present day church are preserved, appears to have been restored between the years 920-940 by the ancestors of Guntroda Gutiérrez, linked to the figure of Saint Rosendo and also Benefactors of the monastery at Celanova, on which it would soon come to depend.

This relief comes from that building, and probably was intended to fit into the wall like a capital impost. Two of its sides contain a hollowed out space inside checkered frames. On the main side is a male figure dressed in a short tunic caught at the waist, arms raised upward and hands open in a praying position, together with a leaf with deep veins, interpreted as the Tree of Life. In the side compartment the plant theme is continued with the overlay in two groups of four acanthus leaves.

In spite of the roughness and coarseness of the plasticity, which is increased by the erosion of the sculptured surface, characterizing the forms of this relief, it is related to traditional sculptural forms and a carving style which tends to round out the forms and shows knowledge of modeling. We are led to date it in the eleventh century by the abandoning of chiselled cutting in favor of a greater volume for the relief in the background and its parallelism with the reliefs of Camba, but especially with that of Amiadoso.

The theme of the 'prayer', seen in the decoration of this relief, is already present in Paleo-Christian iconography as the representation of the deceased person's soul, associated as well with the decoration of sarcophagi with the scene of Daniel in the lions' den, which will last for a long period. It has even been pointed out by other authors, although with reservation, that the stole decoration on the covers of the sarcophagi during the high medieval period of the northwest is simply a schematized representation of the 'prayer'. Occasionally, such as in the necropolis of Ouvigo (Blancos), both themes appear together. But it is here in this small relief where for the first time in this area we see it transferred to an architectural element. The theme has certain analogies with a Capital of Vila Mou (Viana do Castelo), and will reach its greatest expression in San Pedro de la Nave (Zamora).

(Y.B.L.).

BIBLIOGRAPHY
Fariña Busto, F., Suárez Otero, J (1988); Rivas Fernández, J.C. (1976); Valle Pérez, J.C. (1981).

71
Modillion and capital.
Vilanova das Infantas
Second third of Xth century

Granite
85 x 32,5 x 10,5 cm.; 33 x 26 x 26 cm.
Vilanova das Infantas, Celanova (Ourense)

PROVINCIAL MUSEUM OF ARCHEOLOGY
OF OURENSE

The program of monastical reform carried out by Saint Rosendo would allow a new orientation and give stimulus to monastical life, but it would also initiate a new stage in Galician architecture of the tenth century, which would receive new artistic experiences consolidated from other geographical areas, with a clear vocabulary from the architecture of repopulation.

This is the context of the monastery of Vilanova das Infantas, founded by Ildaura, mother of Saint Rosendo, around the years 930-940, which judging from the remains and from the information by authors who saw parts of the building before its destruction, was very similar to that of Santiago de Peñalba.

These architectural elements, remains of the monastery's now disappeared factory, provide an idea of the construction's transcendence.

The modillion, quite full, appears to be formed in the same way at that of San Miguel de Celanova, with eight lobes set at intervals, the upper one larger than the rest, which form a scotia profile, meant to support the eave of the covert. Inheritor in the form of the Cordoban tradition, it shows a decorative continuism that is joined with Hispano-Visigothic formulas in the ornamentation of the sides, chiselled in spiral rings and six-petalled rosettes, strictly alternating.

In the capital, apparently from the arch of the apse, there are also clear parallelisms with Leonese architecture. Its structure, with a double row of leaves, imitates the elements of the Corinthian capital, although its concept of stone block and rounded outlines distance it from the classical capital. The decoration, which imitates chiselled work and is emphasized by small trepanning-like incisions, tends toward abstraction. In the stringing together of the designs and on the base of the capital, decorated with a plant motif of undulated stem, one sees the weight of the tradition.

(Y.B.L.)

BIBLIOGRAPHY
Núñez Rodríguez, M. (1978); Osaba y Ruiz de Erenchun, B. (1946).

72
Stele from Manín
Xth - XIth centuries

Local granite
62 x 37 x 11 cm.
Along the old road from Riocaldo to Aceredo

CHAPEL OF SANTA EUFEMIA DE MANÍN,
LOBIOS (OURENSE)

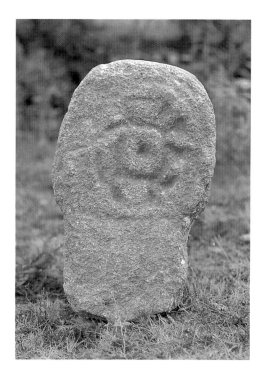

The piece was buried in a wall of the path next to the atrium of the Chapel of Santa Eufemia de Manín (County of Lobios) and was discovered during some systematic surveys carried out in that area. Later, in June 1990, in the field above the chapel an interesting high Middle-Ages necropolis (Necropolis of Campelo) was found with inhumations done in rectangular shaped tombs, oriented toward the West and made with few stones, set in the ground, tending toward the form known as a platense arch with the same type of stones for the cover.

The disc is decorated with the same motifs on both surfaces, but different in number and treatment. A series of triangles in radial disposition are organized around a circle and at the same time they are enclosed in another circle. On the lateral edge there is a channel that covers its entire length.

On the symbolical level, the circle is the solar allegory or representation of eternity and perfection; in this case we think that the solar image is more evident because of the presence of the triangles that surround the circle in the form of rays. In other Galician cases, such as that of Castillós (Ferreira de Pantón) the decorative motif is a rounded cross, while these pieces are very representative of the high Middle-Ages necropolis of the Soria region.

The existence of the discoid steles is relatively frequent near roads and in places where there are medieval dwellings, like Manín, which already is cited in documents of the year 1065. The chronology of the piece must be slightly earlier, although we think that it should be located between the Xth and XIth centuries and we must undersit tand that pertains to the nearby necropolis of Campelo.

<div align="right">(M.X.R.)</div>

BIBLIOGRAPHY
Eguileta Franco, J.M.; Rodríguez Cao, C., Xusto Rodríguez, M. (1988) (1989).

73
Reliefs from Camba
XIth century.

Granite.
58 x 53 x 25 cm.; 52 x 56 x 30 cm.
San Xoán de Camba, Castro Caldelas (Ourense)

Both reliefs, together with the twin horseshoe arches, come from the factory, now disappeared, of the monastery of San Xoán de Camba in Castro Caldelas. Historical sources testify to the existence of this monastery in the year 963, the date when its founder, bishop Diego, gives it with its possessions to the diocesan church of Astorga. In the document cited, it is indicated that the monastery was duplex and its confirmation by Sancho I, who checked and terminated the monastical institution. In 1085 Alfonso VI restored together with other cenobies and villas, to the Astorgan see. It is documented as being in existence a number of years prior to this.

One of the reliefs represents the scene of the Adoration of the Magi. The theme includes the habitual Paleo-Christian design and has as precedent one of the most ancient artistic testimonies of Galician Christianity, the Epiphany of the cover from the sarcophagus of Temes. The composition, in a line, is reduced to the figures essential to the Virgin, who is enthroned, resting her feet on a footstool, with the Child Jesus seated on her knees and the three Magi offering their gifts. As a novelty for the iconographic development of the theme we should point out the kneeling position of one of the Kings; it is thus that they reappear in the doorway of the Platerías of the Cathedral at Santiago, with the importation of new elements to the scene which will became common in the decoration of Gothic tympana.

The second relief shows a scene of disputed theme, interpreted as Jesus tied to the pillar, Baptism of Christ, or Sacrifice of Abraham. Delgado, after a comparison of the relief with a Romanesque capital from Valboa, interprets it as the Resurrection of Christ, which represents in brief synthesis verses 35-55 of the Apocryphal Evangel of Saint Peter. As such, in the center of the figure of Christ arisen, with a cross-shaped halo, flanked by two males who, having descended from heaven, hold him by the arms, in the upper corner the scene is completed by an angel carrying a tray possibly with grains of incense to anoint Christ.

Gómez Moreno pointed out the relationship between these reliefs and that of the baptismal font of thee collegiate church of Saint Isidore in León. In all of them, in spite of the survival of the frames and the plastic rusticity of the figures, which in Camba accentuate its roughness, reducing the facial features to simple incisions, without individual distinctive characteristics and with simple garments of straight folds, one can observe an evolution in the plastic conception of these clothes thanks to the volume, clearly made to stand out from the background plane, and their shape, which shows the complete

overcoming of the bevel edged figure of earlier sculpture, evolution already announced in the Ourensan reliefs of Amiadoso and Pazó.

(Y.B.L.)

BIBLIOGRAPHY

Bango Torviso, I. (1989); Delgado Gómez, J. (1982); Osaba e Ruiz de Erenchun, B. (1947); Quintana Prieto, A. (1968); Valle Pérez, J.C. (s.d.) (G.E.G.); Vázquez Pardo, E. (1927).

74
Frontal of San Martiño of Mondoñedo
End of the XIth century

Granite
115 x 32 cm.

CHURCH OF SAN MARTIÑO OF MONDOÑEDO (LUGO)

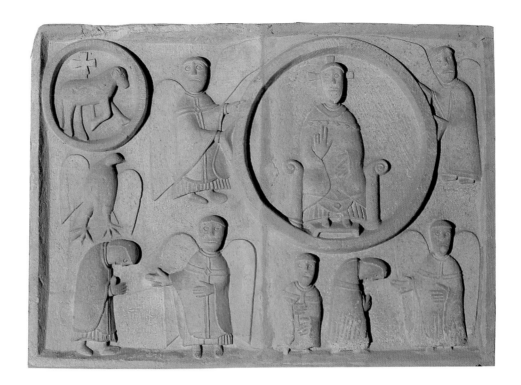

Relief composed of two pieces of very similar dimensions, which must have been sculpted separately following a previous drawing, and then have been made to fit perfectly. Nevertheless, because of the lack of organization of the images, it has repeatedly been indicated that another piece was missing (Chamoso). If we observe the work as it is preserved, looking at the projections of the framing and the precise fusion of the line of the mandorla of God divided between both pieces, there is no choice but to accept that it was originally planned as we see it today (Peinado). The sculptor has traced figures and signs, and then has engraved the background, which makes both frame and characters stand out. In the upper right area we see a Maiestas of cruciform halo, apparently beardless, blessing with one hand, enthroned and wrapped in a very thick circular mandorla, held by two winged angels with long garments. The deficient technique leads the artist to place the one on the right a bit higher. On the opposite side, another smaller mandorla, but again circular and thick, surrounds the Lamb who holds the cross in a characteristic manner. Below, a bird, most probably an eagle, with unfolded wings. Even lower, a character dressed with priest's robe leans before another angel with features similar to those cited above, who appears to speak to him. Below, but to the right, the same scene is repeated. In the middle, although displaced slightly to the right, in order not to be split in two halves, another male figure, also dressed with priest's garments. The simplicity of the carving does not allow greater precision in certain descriptions, for example, because we can barely affirm that the image of God is beardless and in no case is there tonsure, because the hair is shaped in an extremely sketchy manner. Each figure and sign has been made to stand out from the background with a fairly deep relief, but done with a very elementary sense of shape. The same clumsiness is reflected in the features, almost always the same, of the various characters. A first analysis allows us to affirm that the author is the same one who did several capitals of the transept, especially those of the banquet of Epulón and that of Herod and Salomé (Villaamil y Castro, Chamoso, Bango, etc.). On the other hand, already since the past century it was seen that these capitals are later copied in Saint Bartholomew of Rebordáns—Tui (Villaamil y Castro, Bango). Nevertheless, noteworthy parallels outside the area of Galicia have not been found, perhaps a result of the author's technical limitations, who must only have weakly reproduced the features of the master of the workshop where he was formed. There are two main motives for the interest of this exceptional work. First, it is the most outstanding of a school or workshop established in Galicia and the border of the quarry of the Cathedral of Santiago which then begins. Second, in spite if the fact that we have very noteworthy works, changing frontals, antipendia, in stone, painted or in metal work, none is equal to this one. Regarding the first we must remember that the bishop's see, later transferred to Mondoñedo was occupied from 1077 to 1112 by the important bishop Gonzalo. It is then when the second phase of the works in the church was begun, specifically on the headwall. It is not known exactly at what point it was sculpted, although it would be some time after the initial work of the architects. In any event, these works are completely apart from the Cathedral of Santiago in 1075. In 1088 Diego Peláez is deposed in Compostela and shortly after the works must have stopped. It is easy to imagine that the sculptors and architects sought new places of work. The case of Master Esteban could be

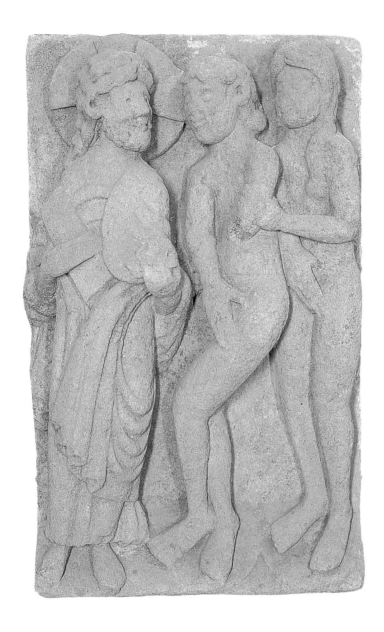

suggest that the main content of the relief has this sacrificial character, in addition to the theophanous, as befits an altar. The figure of the lower area in the center, could be a saint, perhaps San Martiño. But we must insist more on the overall meaning, which perhaps is not so precise, but rather somewhat ambiguous, since the limited artist did not have an exact model for the resolution of the problem he faced.

(J.Y.L.)

BIBLIOGRAPHY
Bango Torviso, I.G. (1987); Chamoso Lamas, M. (1973) (I); López Valcárcel, A. (1963); Peinado Gómez, N. (1972); Regal, B. (1973); Villaamil y Castro, J. (1904).

75
Reprobation of Adam and Eve
Beginning of the XIIth century

Granite
110 x 66 x 25,5 cm.
Cathedral of Santiago de Compostela

MUSEUM OF THE CATHEDRAL OF SANTIAGO DE COMPOSTELA

Even in 1900 López Ferreiro describes this work as 'set over the door of a garden in the neighborhood of 'Pitelos', and he considers it to have come from the Azabachería façade. It joined the Blanco Cicerón collection and was later ceded in deposit to the Museum of the Compostelan Cathedral. Very damaged and worn, in the old photographs we can still see Adam's left arm, missing today. It was in the Romanesque exposition of 1961 sponsored by the European Council. It formed part of a cycle dedicated to the reprobation and expulsion of Adam and Eve described in the Códex Calixtinus and situated in the doorway of the Azabachería. The other relief, it has been said, is presently fit into the left part of the Platerías. The similarity between the two visions of God leads us to believe that both pieces were done by the same artist (Naesgaard, Moralejo). Porter called this sculptor a "master of deceipt" after the Taking of Christ of the right tympanum of the Platerías, linking it to Conques, although this relationship has been rejected or at least placed in doubt. Knowlton attributes the doorway of the Lamb of the collegiate church of Saint Isidoro of León to him; this opinion is accepted by other authors, such as Pita and Moralejo. In spite of certain similarities, I do not think that it is the same artist. The main problem posed by both reliefs as far as similarities is the different manner of representing Adam and Eve. It has been indicated that in our relief Adam is

the last of these in 1101. Moreover, there are certain similarities between this sculpture and that of San Pedro de Teverga, at least as an idea (Bango). For these reasons we must assign the altar piece dates between 1077 and 1100, approximately. The theme has been described identifying each character, but a result accepted by everyone has not been reached. A reference to the sacrament of the priestly order has been suggested (Peinado), to an episcopal congregation (Chamoso), or to an apocalyptic allusion in relation to the seven churches of Asia (B. Regal). From the formal point of view I believe there are similarities with scenes from the Beati. The relationship established with Saint John and the angels, both in the message of the churches and in the occasions when the spirit will see the glory of God, are presented in a similar manner as in Mondoñedo. On the other hand, when the angel plays the fourth

trumpet (Apoc. 8, 12-13) a flying eagle is seen, not very different from that which unfolds its wings here. Likewise similar is the way of seeing the Lamb carrying the cross in its hoof and the Maiestas of the mandorla is generic. Therefore it is likely that the sculptor turned to a lost Galician Beatus to shape his reliefs. But it is not necessary for the thematic content to be repeated. In other altars, such as the Ottoman one of Santa Cruz (Munich, residenz, Treasure, ca. 1015-1020), the figure of the Lamb is also seen above, in the mandorla which the angels carry, and other figures in the lower part. In reality, the double vision of the Maiestas and the lamb alludes to that double theme frequent in missals and previous sacraments, where in relation to eucharistical texts the Crucifix and the Maiestas are contrasted. In the Hispanic case, the expression of the sacrifice on the cross through the Lamb is common. For this reason, I

beardless and Eve has straight hair, while their eyes show no signs of having been dug out, contrary to in the Platerías relief (Moralejo). We would have to add that certain floral motifs present in the latter and in the Museum's Maiestas, which also seems to come from the Azabachería, are missing there. Nevertheless, the dimensions must be similar; God is done by the same sculptor in both cases. I think that it cannot be affirmed that Adam is beardless. The figure of the fathers gives the impression not only of being eroded but also of not having been originally finished. The way of resolving the theme corresponds to a tradition from the primitive Christian era. In the mosaics of Saint Mark of Venice, whose model is related to the nearly lost Cotton Genesis, two scenes are given to the dialogue between God, Adam and Eve. The manner of seeing the second is not distant from our relief, although there God appears on a throne, while everything has another solution in the Carolingian tradition of the Bibles from Tours.

(J.Y.L.)

BIBLIOGRAPHY
Chamoso Lamas, M. (1973); Knowlton, J.H.B. (1950); López Ferreiro, A. (1898-1911); Moralejo Alvárez, S.(1969); Naesgaard, O. (1962); Porter, A.K. (1923).

76
The month of February
Beginning of the XIIth century

Granite
47 x 27 x 8 cm.
Cathedral of Santiago de Compostela

MUSEUM OF THE CATHEDRAL OF SANTIAGO DE COMPOSTELA

Fragment of a very eroded relief, which lacks a good part of its right side. A man seated on a simple chair is covered with a long tunic which nevertheless allows his two naked legs to be visible as far as the knee. Over the tunic, a mantle with hood which covers the head and only allows us to distinguish the face in profile. In front, waves of very flat relief in all certainty must indicate lines of fire. It is a man warming himself by a fire, as the month of February is usually represented in the Romanesque mensarii (M. Gil). Although it was said that it could come from the doorway of the Platerías, it is more accurate to suppose that its origin was in the North Door or theat of the Azabacheríq of the Cathedral of Santiago

(Moralejo). The Codex Calixtinus describes, in the left area, above the doors, the months of the year in relief. This would be one of them. In spite of the fact that the mensarii have variations, it could be affirmed that the reference to the man warming himself with a part of his body uncovered is more common in the French region than in the Italian, according to the two great families of representations, which are not always clear. This vision is also more frequent in the Hispanic version, at least in the Romanesque centuries, both in sculpture (San Claudio de Olivares-Zamora, although here there is a second figure) and in painting (San Isidoro of León, almost contemporary with the relief of the Azabachería),

surviving in Gothic (roof of the Cathedral of Teruel). Given its deterioration, it is difficult to approximate the work stylistically to any of the Compostelan workshops. With reservation it has been suggested that it could be the work of the sometimes called 'master of the Platerías' (Moralejo), in all probability poorly identified with the doubtful master Esteban who was called to Pamplona in 1101.

(J.Y.L.)

BIBLIOGRAPHY
Gil, M. (1961) (II); Moralejo Álvarez, S. (1969)

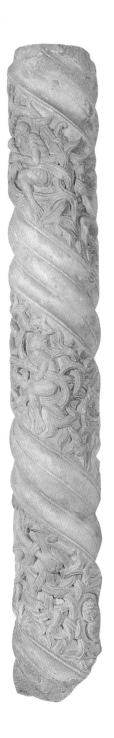

77
Engaged columns from the Azabachería
Beginning of XIIth century

Marble
185 x 25 cm.
Cathedral of Santiago de Compostela

MUSEUM OF THE CATHEDRAL OF SANTIAGO
DE COMPOSTELA

A. López Ferreiro managed to ascribe this group to the portal of the Azabachería, analizing as well the formal similarity of elements from the Platerías. Nevertheless, later critics have claimed, even emphatically (Gaillard says: "sans doute de la façade occidental détruite", despite finding similarity with works from Platerías), that its origin was in the hypothetical occidental façade, barely but enthusiastically described in the Codex Calixtinus (Vidal y Castillo). There is little doubt that these magnificent pieces must come from the North portal or that of Paradise (Otero, Bouza Brey, Moralejo, Chamoso).

It seems that previously some of these columns were reused to form the base of a low quality pediment.

From the formal point of view they have been attributed to the Master of Platerías (Otero, Moralejo), mistakingly identified with master Esteban, artist who might have worked, according to Yarza, in the first campaign, initiated by Diego Peláez, who later calls him to Pamplona. The ornamental and thematic richness has always aroused the attention of the critics, though some consider everything only simple ornamental caprice (Gómez Moreno). It is obvious that some of the scenes with boys among branches and grape-vines come from Classical Antiquity. Also similarities with Paleo-Christian sarcophagi have been pointed out, with a fragment of a pilar from the Squilinus in Rome (Moralejo). But other scenes are extremely attractive and have been related to the epic world, present often in the sacred sphere. The chanson de geste of Roland, which has been studied almost exhaustively (Stiennon, Lejeune), can be included according to the religious value that it presents on various occasions, the same as the more directly related with the same Charlemagne, liberator of the sepulcher of Santiago, following late traditions. That is why the relationship with some of these productions has been suggested to explain the shaft where some war scenes, dead horses, etc., are found (Bouza Brey). On the other hand, a thematic contrast has been sought between some of the shafts, with a redemptive symbolic weight (Moralejo). It is still difficult to come to a conclusion with all that has been said about these exceptional works and a more detailed, deep study is necessary, but everything points to an iconographic reason, beyond the neat brilliant decorativism.

(J.Y.L.)

BIBLIOGRAPHY

Bouza Brey, F. (1982); Castillo, A. del (1949); Chamoso Lamas, M. (1973); Gaillard, G. (1938); Gómez Moreno, M. (1934); López Ferreiro, A. (1898-1911); (1905); Moralejo Álvarez, S. (1969); (1977); Otero Túñez, R. (1965); Vidal, M. (1926); Villaamil y Castro, J. (1866); Yarza Luaces, J. (1980)

78
Relief with female figures
Second quarter of the XIIth century

Stone
75 x 39 x 11 cm.
Cathedral of Santiago de Compostela

MUSEUM OF THE CATHEDRAL OF SANTIAGO
DE COMPOSTELA

Little is known of this singular relief which was seen by Carro García in an aisle of the Compostelan monastery of Sampaio de AnteAltares, where it was deposited by a person who told him it came from a farm 'set in the site of Bar, parish of Saint Fructuoso, the Black Forest, southern slope of Mount Pedroso, on the road leading to Santa María de Figueiras'. There were other pieces on the farm, different from and later than this piece, which were said to have come from a demolished chapel dedicated to the Virgin of Carmen.

The relief was acquired before 1944 by the State. Nothing more is known of it until its exhibition in 1961 in the exposition which was dedicated to Romanesque art. In the catalogue it figures as a "fragment of a door jamb," and is located in the Museum of the Cathedral of Santiago. It also figured in the exposition celebrated in 1988 for the VIIIth centennial of the placement of the lintels of the Pórtico da Gloria.

If the origin of the slab is enigmatic, its purpose is also problematic. The author mentioned doubted whether it could have belonged to a façade, a jamb, frontal or even a balcony. Perhaps it was a jamb, like he said and as it figures in the 1961 catalogue, but it would also be possible to make the conjecture that it had been placed in the corner of some cloister, although the lack of information does not permit greater detail.

The rectangular piece has a beveled left side, decorated with a wavy stem with leaves, repeated on the right edge and on the thickness of the slab; on the right edge an interlacing is visible. The upper part has two schematic quatrefoils.

The front has two squares that are superimposed and framed by small columns which support round arches. Only the upper one remains, since the lower one has little more of the arch. Toward the left, between the columns and the plant ornamentation, a row of small spheres or pearls, rhythmically distributed, has been engraved.

The left column of the upper group has a decorated shaft, perhaps adjoining or with a coiled stem—its state does not allow for a more careful examination—. The capitals they end in are ornamented with different motifs, in spite of their tiny size. The arch, which is smooth and has a sharp edge, has an inscription on its coil, according to Carro. On the upper part he says he has read 'SANT...', while on the other he could not make it out. Today absolutely nothing is readable. Various small plant leaves have been worked on the small spandrels.

There were two female figures under the arches, of which only the one in the upper square is complete. It is wearing floor-length clothing, fine, with small concentric folds that are barely indicated, which allow a good portion of the anatomy to show through. The right hand is raised, showing the palm extended over the chest, while the other remains on the thigh at her side. The head is covered by a coif, encircled by a crown, facing toward the front. The most salient feature of the face are the pupils of the eyes, deeply dug out.

Only the head of the lower figure remains. It is slightly tilted to the side, wearing a coif, and the features are similar to those of the other one, including the cut of the eyes.

79
Punishment of the Lascivious
Second third of the XIIth century

Granite
60 x 14 x 24 cm.
Cathedral of Santiago de Compostela

MUSEUM OF THE CATHEDRAL OF SANTIAGO
DE COMPOSTELA

This piece is comprised of two archivolts which must have belonged to the same arch, considering the similarity on their measurements, the artistic resemblance and the thematic complementarity, although the masculine one would be situated on the left side and the female on the right. Apparently there is no information as to its origin, for which two possibilities have been suggested: the disappeared western doorway before the Pórtico da Gloria (A. del Castillo, M. Gil) and the door of the Azabachería or north door (Chamoso). We must discard the second hypothesis, since the north door, almost contemporary to the Platerías, must have been begun a bit earlier; at that point (and the one preserved shows this) archivolts with figures were not sculpted. On the other hand, in spite of the fact that much has been said about the reality of the western doorway, described with enthusiasm and imprecision in the Códice Calixtino, since Caamaño's proposal in this respect, it is suspected that it ended up as an unfulfilled project. This could eliminate as well the possibility that it came from there, although chronologically there is nothing to impede this work from being placed inside it. In any event, without rejecting the theory of the Pórtico da Gloria, it would be possible to believe that a sculpture workshop had worked on a doorway that was not finished, and it was from there that these sculptures would come. Nevertheless, with the lack of information, and given that there are other very important works in the Cathedral whose placement is very dubious, I think that for now we cannot assign any site to the archivolts of the punishments. Nevertheless, we have to note that they were made for a doorway of good size.

Both pieces are of considerable roughness. The male figure, facing the front, is completely naked, beardless and short; around its body like with the old Mithraic Zervan, a long serpent is coiled, its head biting his testicles. From below an animal difficult to identify emerges, probably a giant toad rather than a dragon. The woman is more complex and impressive. She is also naked and sees how two serpents between her legs bite her breasts. Her head is turned upward in a difficult position and from her open mouth comes an enormous tongue also being bitten by a possible dragon. It is obvious that this is the punishment of the lascivious. The woman, for the way she takes the serpents in her hands, vividly recalls the classical Earth, as it could be represented earlier, and is in the origin of the lascivious Romanesque woman who is punished. The bitten tongue does not normally allude to the same sin, but

The relationship of the piece to the columns with figures of the façade of the Platerías seems evident, both for the architectural framing and for the rest of the ornamental motifs and even for the treatment and disposition of the images. Even the material is the same: local marble. The digging out of the pupils, probably done to set lead or jet in them, evokes formulas used by the Master of Treason or Pardon, the only one of the great sculptors of the façade of the Platerías who used this technique, later repeated on the columns from Anteltares which guard the National Archeological Museum and the Fogg Museum of the University of Harvard.

In the same workshop where these important works were created this relief must also have been done, as Moralejo wrote. As a result, with this identification the piece exhibited here must date from the second quarter of the XIIth century, period in which the spread of the Romanesque style began throughout numerous places in Galicia.

(R.Y.P.)

BIBLIOGRAPHY
Carro García, J. (1944); Gil, M. (1961) (III); Moralejo Álvarez, S. (1988)

rather to the evil-tongued or blasphemers. Since a clear context is lacking it is difficult to analyze this second meaning. Master Mateo, who in such a strong manner was inspired by previous works in Compostela itself, in the Pórtico da Gloria, also took these archivolts into account for the external architecture of the south door, right side, of that Pórtico. Normally the lascivious woman is the one punished, but there are other examples in which a man and a woman appear. The closest one I know of in the Peninsula is on the south side of the cloister of Cathedral of Gerona, where the similarity also extends to the manner of punishing the male figure. The date of the Compostelan work in our opinion must be around the middle years of the XIIth century.

(J.Y.L.).

BIBLIOGRAPHY

Caamaño Martínez, J.M. (1962); Castillo, A. del (1949); Chamoso Lamas, M. (1973); Gil, M. (1961) (I)

80
Fragment of Archivolt
Ca. 1120-1130 ?

Granite.
40 x 51 x 40 cm.
Cathedral of Tui (Pontevedra)

MUSEUM. CHAPTER-HOUSE. CATHEDRAL OF TUI (PONTEVEDRA)

Piece of pentagonal shape on one side by a fragment of semicircular arch from the smooth prismatic section. On the opposite side are two curved springs, today separated by a concave furrow—it is not certain that it was like this initially—which correspond to the two arches of different unfolding. On the sides, one has a straight cut with a very deteriorated frontspiece, which explains the irregular outline it now has. In the space limited by the segments of arches mentioned, a male figure brusquely settles himself. He appears to be in the position of offerer and adoration, covering his hands with a cloth. Next to his face is a silhouette which may belong to the lower part of another figure that in this case would have been kneeling.

According to information provided by those in charge of the Cathedral Museum at Tui, the piece, together with those of the next two notes, was used as fill in material and appeared during the 1950s. At that time a wall fell which had been ordered built by Bishop Don Diego de Torquemada (1564-1582) and was located between the chapel of Saint Telmo, which was threatening to fall, and the chapter-house.

That the fragment comes from the cathedral factory appears certain. This is not so much because of the place in which it appeared as, fundamentally, because of the style of the human figure, which matches that of some found in capitals of the building's Romanesque campaign.

It is not easy to specify where the piece comes from, although because of its characteristics we might consider it a fragment of the archivault of a window or door, an opening which would in any event have a lobed closing.

The decorative fragment presented here has great interest for the history of the Roamnesque temple at Tui. It is therefore surprising that no one has noticed it. In fact, because of its style—fat-cheeked facial type; hair set in thick parallel locks, closely resting on the head so that they emphasize its roundness; the treatment of garment folds, etc.—the figure reveals a considerable proximity to works belonging to the second building campaign of the Cathedral of Santiago, which leads us to date it around the time of these works. This circumstance, taking into account the chronology assigned today to the most outstanding elements of that Compostelan period, allows us to set the beginning—frequently a controversial matter—of the works of the Romanesque Cathedral in Tui around the year 1120. This year was, in fact, cited in the last century, although we do not know what was the basis of his information, by the canon of Tui, R. Rodríguez Blanco, as that of the placing of the cornerstone of the temple by Bishop D. Alfonso.

(J.- C.V.P.)

BIBLIOGRAPHY

Bango Torviso, I. (1979); (1987); Chamoso Lamas, M. (1981); Rodríguez Blanco, R. (1879); Valle Pérez, J.C. (s.d.)

81
Fragment of wreathed column
Ca. 1120-1130 ?

Granite.
60 x 24 cm.
Cathedral of Tui (Pontevedra)

MUSEUM. CHAPTER-HOUSE. CATHEDRAL
OF TUI (PONTEVEDRA)

Fragment of a column shaft with spiral striations.
The widest, with concave profile, have small balls
set in places; the others, which are finer, are convez
and smooth.

Typologically, the column has immediate
antecedents in the second constructive campaign of
the Cathedral of Santiago (the closing off of the
main chapel and door of the Platerías, in particular).
Nevertheless, it is not as finely made as its
prototypes.

Because it appeared in the same place as the
fragment of archivolt of the previous note, and
because of its similarity and the proximity that
reveals its sources, it supports what was said about
its dating at the beginning of the construction of the
Cathedral of Tui

(J.- C. V.P.)

BIBLIOGRAPHY
*Bango Torviso, I. (1979); (1987); Chamoso Lamas,
M. (1981); Rodríguez Blanco, R. (1879); Valle
Pérez, J.C. (s.d.)*

82
Engaged capital
Ca. 1120-1130 ?

Granite
27 x 31 x 30 cm.
Cathedral of Tui (Pontevedra)

MUSEUM. CHAPTER-HOUSE. CATHEDRAL
OF TUI (PONTEVEDRA)

Engaged capital, forming a corner, decorated on
the edges with long leaves of deeply sunken centers
that are swirled in the form of a spiral at the ends.
At the free angle is a masculine figure with bent
legs who rests his feet on the astragal. He is wearing
a tunic and is grabbing his neck with both hands.
His head, with rectangular shape and stern features,
is covered with large locks of hair that are tight and
rounded.

Both the type of leaves as well as the human figure that accompanies them follow models existing during the first building campaign of the Cathedral, which allows us to believe that the capital is from there. (That it appeared in the same place as two earlier pieces not only supports this attribution but also its probable first location in the same area of the building, a fact that also confirms the coetaneous nature of the three.) Regarding its original site, given its characteristics—it is engaged and in a corner position—it is likely to have belonged to either a window or a doorway, in all probability located in the Southwestern corner of the transept, area where there are various works commissioned by Bishop Torquemada, the prelate who built the wall in which this piece was used as a fill-in element, as were the previous ones.

(J.- C. V.P.)

BIBLIOGRAPHY

Bango Torviso, I. (1979); (1987); Chamoso Lamas, M. (1981); Rodríguez Blanco, R. (1879); Valle Pérez, J.C. (s.d.)

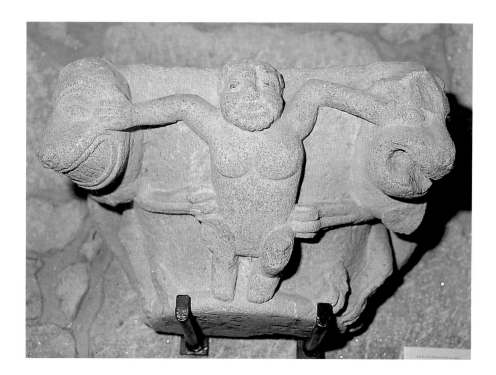

83
Capital
Middle of the XIIth cenntury

Granite
34 x 57 x 40 cm.
Church of Santa María de Bermés, Lalín
(Pontevedra)

PROVINCIAL MUSEUM OF PONTEVEDRA

Ornate capital, in the center of the main side, with a robust human figure, bearded, totally naked, with bent legs and open arms, trying to push aside the voluminous heads of two threatening quadrupeds (lions) situated at the corners of the basket. The animals are resting a front paw on the astragal, clutching in the other the figure, whose feet rest on the same moulding as the animals.

The capital shows one of the most frequent themes in Galician Romanesque; Daniel in the lions' den, especially appropriate theme because of its symbolical implications- Daniel saved from the lions, as L. Reán indicates, is the image of the soul saved from evil and at the same time prefiguration of Christ resurrected coming out of the tomb—, for inclusion in an apse (R. Yzquierdo has convincingly suggested that this work served as a support for the triumphal arch of the church).

In the stylistic aspect, what stands out is the marked volume of the figures, feature which, along with the detail used on some of its parts, allows us to set the capital—without taking into account some of its errors in composition—in an area still close to the Santiago nucleus which nourished the large majority of masters who expanded the Romanesque formulas throughout the rural Galician region.

(M. L.M.-S. L. y J.C.V.P.)

BIBLIOGRAPHY
Bango Torviso, I. (1979); Yzquierdo Perrín, R. (1978)

84
Mutilated masculine figure
1170-1175

Stone
137 x 47 x 33 cm
Cathedral of Santiago de Compostela

MUSEUM OF THE CATHEDRAL OF SANTIAGO
DE COMPOSTELA

The Codex Calixtinus, in Book V, says that the west façade of the cathedral of Santiago "is decorated... with different representations and with diverse styles: men, women... The motifs are so many... that it is impossible for me to describe them." Such imprecision, in contrast with the detailed account of the frontispieces of the crossing, has caused different figures to be attributed such an enigmatic and doubtful work, among them this one, mutilated and formed by two fragments. According to Chamoso the lower part was in the Museum of the Cathedral, and he found the upper part in 1959. At the time it was thought that it was part of the same group of sculptures attributed to the "disappeared western façade." For Gómez Moreno, nevertheless, they came "from the entrance of the Old Cathedral, today destroyed, and not from the primitive occidental façade of the basilica." It is a masculine sculpture, smooth on the back, which is why it was lean. It is headless and also lacks part of the chest and arms. The latter are bent, the hands hidden by the mantle, holding an open book in which part of some letters are seen. His legs are a little separated, the left slightly bent, position that stiffens the garments and reveals the anatomy, while it allows the creation of abundant drapery, causing sharp light contrasts that tend to unfold in fan shape. The technique of wet folds that its author has used, has been cited by those who have studied this magnificent sculpture. The upper edge of the tunic, as well as those of the mantle are delicately adorned. For Chamorro the statue could be the figure of Jesus of the Transfiguration which, according to the Calixtinus, would have been in the main façade.

In opinion of Gómez Moreno the sculpture is "so much of Avila type that it looks like it was taken fron San Vicente... it must have been the first thing that Mateo sculpted around 1168, before his mastery of complete naturalism was known." The attribution to a young Master Mateo runs up against serious difficulties, which led Professor Moralejo to talk of a master of wet folds, whose style can be traced in other pieces, for example, in the keystone of the angel with a crescent moon in his hands, also hidden, which is in one of the vaults of the crypt of the Pórtico da Gloria. This superb sculpture perhaps belonged to the decoration of the Pórtico, piece whose chronology could be set around 1170-1175. It would thus be contemporary to, but different than, the activity of the Maestro Mateo and his workshop.

(R.Y.P.)

BIBLIOGRAPHY
*Chamoso Lamas, M. (1973); (1976); Gómez
Moreno, M. (1961); Moralejo Álvarez, S. (1973)*

85
Stone choir of the Cathedral
of Santiago
MASTER MATEO
1211

Granite
Cathedral of Santiago de Compostela

MUSEUM OF THE CATHEDRAL OF SANTIAGO
DE COMPOSTELA

In the first three sections of the main nave of the Cathedral of Santiago—counted from the center of the transept—the seats of this former choir were placed. The following intercolumnar, the fourth, was occupied by what the documents and texts call the leedoiro and which would be like the jubé of other European cities.

This great choir, built and carved by Master Mateo, would be finished for the solemn consecration of the temple which, with the help of King Alphonse IX, his court and a good number of ecclesiastical dignitaries, took place April 3, 1211. From that time on, and until the first years of the XVIIth century, it carried out its function. It was the stage for multiple events, and its leedoiro served as a frame for very different religious and capitular functions. Then archbishop Juan de Sanclemente, wishing his prelate's chair to be placed in the center of the choir, has the church chapter, after overcoming certain resistance, tear down the structure. The work was begun in the first years of 1600, forcing the prelate to build another choir which would completely satisfactory to the chapter. The assessment of this destruction by some contemporaries is seen in the phrases which Castellá Ferrer devoted to it in his *History of Santiago Apostle:* "The most beautiful old choir that existed in Spain has been destroyed."

The placement of the choir in such a privileged place made it have not only a splendid set of seats, but also façades which separate it from the side naves, except in the leedoiro, whose lower part was open both toward these and the central one. This independent area within the Cathedral itself had a symbolic nature: it was the celestial Jerusalem, the holy city which was surrounded by a high barrier represented by strong towers alternating with the prophets and apostles, the twelve "stones" which serve as its base, according to the sacred text. For its part the façade of the retrochoir has as central motif an Adoration of the Magi, almost entirely

disappeared, but whose existence is not to be questioned, given the repeated documentation and the few remains that are known, particularly the three small horses that emerge from a tower and are seen there.

The crowning of the choral seats was formed by a magnificent heraldry in which there was also alternation of canopies with architectural elements and animals, preferably fabulous, in its lower part, and sculptures of young cantors. These mythological beings: mermaids, dragons, griffins, basilisks, etc. naturally have a clearly negative nature, and represents the worldly and sensual song which leads men from the song of praise to the Creator which the child canters sang.

The seats were planned to comfortably hold the numerous cannons who then comprised the church chapter of Santiago, seventy two from the times of archbishop Diego Xelmírez. Half of them had a seat

in the stalls of the upper part and the rest, in the lower one. This would have been reduced to a bench with its corresponding back. The accommodation in one place or another led to more than a few battles and disputes which the different choral constitutions tried to avoid, and which was not always possible.

When such a singular setting was destroyed, some of its fragments were not long in being reused with dignity, for example those which still adorn the Holy Door of the Cathedral; others were also used in various works, but outside the church of Santiago, like the two figures of the fountain of San Pedro de Vilanova (Vedra, A Coruña); some must have been lost by the warehouses of the Cathedral, which allowed them to be used quite a bit later, like the six children that López Ferreiro inserted in a frieze of the Platerías façade at the end of the XIXth century; but undoubtedly the greatest number of pieces served as building material for works which

to that done so far led the executive board of "Europalia 85" to ask us to reconstruct three seats in order to exhibit them in the exposition "Santiago de Compostela. A thousand years of European pilgrimage."

In the seats we proposed the existence of a stone bench, decorated with blind arches, and which alternated with brackets with plant ornamentation. The columns that held the flowers and cresting were supported by them. The canopies of the latter have architectural elements that in the lower half hold animals, mostly fabulous, although the real ones are not lacking. Alternating with these pieces are figures of children, with cartouches and placed on the axis of the columns. The whole was crowned by an original cornice that was carefully decorated. Each seat was finished with armrests, formed by arches like those of the bench, but with open-work, plus other elements: back rest, wooden seat and cushions that made the stay of the cannons more comfortable.

The studies we did have allowed us to do a total reconstruction of the choir. Thus we know that in the center of the upper part of the seats a door opened beneath a trefoil arch, which led to the lower part of the leedoiro, place where chapels were founded and burials done. On the north and south sides the organization of the arches was as in the corresponding sections of the capitular seats, but with the variation that here they were impractical. The same thing happened in the retrochoir. presided by an arch with an Epiphany.

Only four pieces are exhibited from such an exceptional work: one from the seats, one from the back choir and the other two from the lateral façades.

The first mentioned is a canopy which belonged to one of the seats. It has the usual architectural organization: fine small lateral columns ending in castles that imitate a trefoil arch. This holds a bird mermaid, lying down, its beautiful head raised toward a strawberry that frames the central lobe. As is customary in the choir mermaids, and in general in all of those of Master Mateo and his workshop, it has quadruped legs; the wings, carefully worked, rest on the body; and the head has exquisitely carved human features, just as its long hair. Around it a rich plant decoration appears.

Above the trefoil arch three windows opened on each side of the central tower; today they are broken and constitute the greatest deterioration undergone. A small roof with "Scales", and open-work circles, like tiny eyes, complete the canopy. Such an extraordinary piece has reached us with important remains if the polychromy in which red, blue and black predominate, emphasizing its quality.

The second of the pieces displayed belonged to the back choir. It consists of a rectangular tower and with small blind arches on its different "sections and façades." It ends with a pyramid-shaped roof with the same technique as that seen previously. From this tower three horses emerge, only two of which have the necks and heads carved, and also the front legs of the first. The work is skilled and careful, so that the different inclinations of the

then and later even were carried out in the Compostelan basilica, which since the times of the cannon López Ferreiro has resulted in the finding of an important number when reforms and archeological excavations were done, especially relevant being those done by Chamoso Lamas. The last discoveries occurred in 1989, and other elements could be recovered immediately if we knew their exact location.

As the number of pieces and fragment increased so did the knowledge and evaluation of the choir, which led to the idea of the possible reconstruction of some of the seats. When Filgueira Valverde and Ramón Fernández Oxea studies the Galician canopies they realized the relationship between the sepulcher of the church of the Magdalena in Zamora and some Compostelan elements from Mateo's choir. Nevertheless, it was professor Pita Andrade who in an article published in 1953 proposed a hypothetical reconstruction of a seats, taking as

reference point the Zamoran sepulcher. Some years would pass, until 1961, when with the motive of the exposition dedicated to Romanesque art in Barcelona and Santiago Dr. Chamoso, with the support of Prof. Pita, reconstructed a seat from the choir. Both continued to be interested in the theme, new pieces were found and, upon celebrating an exposition in New York in 1970 dedicated to the year 1200, a reconstruction of two seats of honor was done, with some differences in comparison to the first.

The recovery of elements from the choir in the first months of 1978, when work was being done on the stairway and elevated atrium of the Obradoiro façade, made possible a new and substantial advance in the knowledge of the work, both from a formal point of view and an iconographic one, a task undertaken by Profs. Otero Túñez and Yzquierdo Perrín. The importance of our work and the novelty it meant with respect

heads allows the viewing of the individualized carving of each one. We also must point out the remains of polychromy, especially in red, black and white.

The transcendence of this fragment for the knowledge of the theme developed in the tympanum of the back choir is great, while it confirms as well the documentary references. Thus there is no doubt that it represented an Adoration of the Magi. The treatment it was given in European works must have been similar to that in Compostela, and a fragment of the old jubé of Chartres is especially significant, as it is very similar to the one from Santiago, although there is also a groom. This, without the tower, but with the horses, is repeated in one of the vignettes of the first Cantiga of Alphonse X, in the Door of the Clock of the Cathedral of Toledo and in other cases. For Galicia it was particularly important since it had a clear influence on a good number of Gothic tympana. As example, that of the main door of Santa María do Campo in A Coruña, or those of the doorway of Santa María and Saint Francis of Betanzos; we also see it in the tympanum from Santa María of Vigo, which is in the Museum of Pontevedra. In all the Galician examples the servant is missing, and except in that from A Coruña, the tower also.

Finally, the other two pieces exhibited belong to one of the lateral façades of the choir where, as I have already said, they formed a barrier with other slabs decorated with towers. These completed and gave meaning to the fragments of arch that are seen behind the heads. According to the studies which professors Otero Túñez and Yzquierdo Perrín have done , they possibly represent the apostles Peter and Paul. in spite of the epigraph "DANIEL" which is read in the cartouche of the latter and which seems to have been done after the destruction of the choir, which explains, among other reasons, that it is the only figure which represents him. As in all the others of the series they are seated.

The figure identified as Saint Peter rests the right hand on the right knee, and with the other, veiled by the clothing, grasps a book that is closed and tied with a strap. His face, with its sweet expression, looks to one side to pair up, certainly, with the other figure. The beard and hair are curly.

Saint Paul, for his part, has a broad, high forehead, increased by the usual baldness. He looks to the right, seeking dialogue with saint Peter. The hand on this side is placed on the chest, and with the other he holds a cartouche in which the mentioned epigraph may be read. He crosses his legs and wears shoes. The anonymous author did other figures for this choir, collaborated in the Pórtico da Gloria and was, like the sculptor of Saint Peter, a member of Master Mateo's workshop.

After the tearing down of the choir both figures left the Cathedral under unknown circumstances and at an unknown time. In the exposition

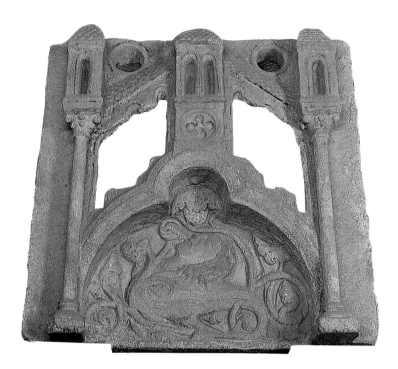

dedicated to Romanesque art in 1961 they figured as belonging to the Blanco Cicerón collection. Today they are in the Museum of the Cathedral, which, together with their possible original pairing, allowed them to be used by us in the reconstruction of 1985.

(R.Y.P.)

BIBLIOGRAPHY
Chamoso Lamas, M. (1950); Otero Túñez, R. Yzquierdo Perrín, R. (1985); (1990)

86
Altar support
Ca. 1188

Granite
103 x 26 x 28 cm.
Cathedral of Ourense

MUSEUM OF THE CATHEDRAL OF OURENSE

Monolithic column, with attic base and wide lower torus, set on a low plinth; smooth column and capital adorned with angular spirals bearing a simple floral decoration. On the upper part of the capital a hole was made to hold relics.

On the same stone block as the column a male figure was sculpted. Of very stylized canon, he wears a tunic that clings to the body and shows his anatomical forms. Like Atlas, he raises both arms in the appearance of holding up the altar table which received support in the base. The figure's feet, without shoes, rest on the upper torus of the base, suspended afterward to touch the end of an acanthus leaf which rises up from the plinth like a claw.

The stand has enormous interest not only because of its uncuestionable artistic quality, but, and above all, for the assistance it provides for the study of the building to which it belonged. In effect, both the features of the elements which comprise the column itself—the type of base and the capital, specifically—as well as the features of the figure which compliments it, are repeatedly found in works or parcels belonging to the main area, transept and easternmost sections of the Cathedral's naves (simply as a sample, compare the details of the Atlas—model, face, treatment of the hair, canon, folds, anatomy, placement of the feet, relationship to the column, etc.—with that of the deteriorated column-statues that are set in the northern doorway of the transept, sculptures, in fact, whose relationship with the nucleus at Avila,

also valid for our stand, has been commented on occasion). Such evidence, given the chronology of the artistic centers which favored the cathedral factory in Ourense in its beginnings—the Compostelan circle of Master Mateo, in addition to the Avilan already mentioned—allow us to think that this is a stand which belonged to the altar consecrated by bishop Alfonso I on July 4, 1186, proof which in turn provides a valuable point of reference for the dating of the temple.

(J.-C. V.P.).

BIBLIOGRAPHY
Chamoso Lamas, M. (1979); Leiros Fernández, E. (1936-38); Pita Andrade, J.M. (1954); (1988); Valle Pérez, J.C. (1984)

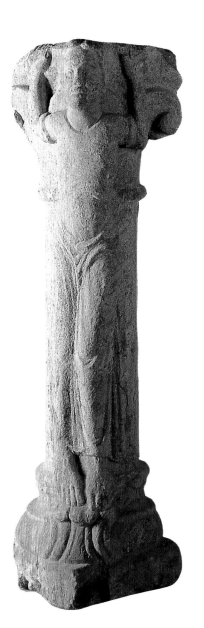

87
Savior
Last years of XIIth century

Granite
87,5 x 41 x 39 cm.
Parish of San Pedro Félix or San Fiz de Muxa (Lugo)

PROVINCIAL MUSEUM OF LUGO

Seated figure on a tiny folding chair. With the left hand it holds a closed book which is resting on its chest; the right hand, now mutilated, was probably in benediction. Its legs are incomplete, sculpted only to the knees. The head, with long hair parted in the middle, shows a bearded face dominated by two large almond-shaped eyes. In the back of the sculpture, carved on the same black, are two columns, one wreathed, which probably served as support for the canopy that must have covered it.

The image, obviously rustic—notice the disproportion between the different parts, the clumsy, simple, monotonous treatment of the garment folds or their stiffness—, has not always been awarded its true value. In even recent times, nevertheless, it has been correctly related (E. Varela), given its facial type, with the stele of a workshop with Burgundian affiliation, in turn related to the nucleus of Aguilar de Campo (Palencia), which produced several works of the Cathedral in Lugo, among them the North door of the transept.

(M.ª L.M.-S.LL. y J.- C. V.P.)

BIBLIOGRAPHY
Carballo-Calero Ramos, M.V. (1976); Gaya Nuño, J.A. (1968); Trapero Pardo, J. (1960); Varela Arias, E. (1983); Vázquez Seijas, M. (1932-34)

88
Two reliefs from a tympanun
CONTINUER OF MAESTRO MATEO
Ca. 1200

Granite
80,5 x 30 x 18,5 cm.
Tympanum of the western portal of the
monastery church of San Lorenzo de Carboeiro
(Pontevedra)

MARÉS MUSEUM OF ART (BARCELONA)

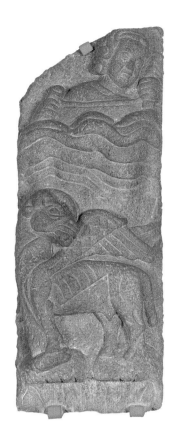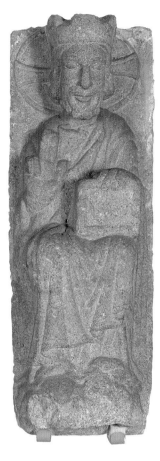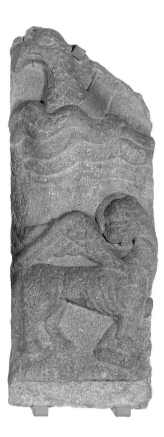

This sculptural group represents a Maiestàs and
tetramorfo.

The right relief, the symbols of Saint Matthew
and Saint Mark, is a modern replica of the original
which, very deteriorated, still is in situ. The central
relief represents the Lord sitting, holding a book
with his left hand resting on the knee, while he
raises the right to give a blessing. He wears a crown
and a cruciferous halo.

In the third relief the emblematic animals of the
Evangelists John and Luke are represented: above,
an eagle head comes out of the clouds; below, the
winged ox.

These pieces were part of the authentic
tympanum which served then as a support,
following a very well known model in the Galician
Romanesque.

San Lorenzo de Carboeiro was a Benedictine
monastery whose origin goes back to the Xth
century. During Fernando's abbotship (ca. 1162-
1192) a certain economic splendor permits the
construction of a big late-Romanesque church.
This temple constitutes one of the most
paradigmatic executions of the progress and
transformation of Galician architecture as well as
of all the peninsular kingdoms during the last third
of the XIIth century.

The western door was formed by four
archivolts based upon other pairs of columns.
Except the second from the exterior, which
depicts the wise men of the Apocalypse, its
decoration is made of big fleshy leaves. The wise
men—only twenty three are reproduced—appear
wearing a crown and holding diverse musical
instruments and vials in their hands. From the
iconographical point of view there is no doubt that
we find here an evident theophany of
apocalyptical character, confusedly inspired in
certain parts of the very famous Compostelan
model of the Pórtico da Gloria.

It is the work of a sculptor with a certain skill in
granite work, although this type of material always
gives the creation an evident roughness. Our artist's
activity and that of his workshop would develop
toward 1200, leaving his mark in the decoration of
another door in the southern façade of the same
church.

(I.-G.B.T.)

BIBLIOGRAPHY
*Bango Torviso, I. (1979); (1987); Carro García, J.
(1941); Castillo, A del (1972); Chamoso Lamas,
M. et alii (1973); Filgueira Valverde, J. ,
González, S. (1940); Gudiol Ricart, J.e Gaya
Nuño, J.A. (1948); Lambert, E. (1925); López
Ferreiro, A. (1905); Lucas Álvarez, M. (1957);
Valle Pérez, J.C. (1988) (II); Villaamil y Castro,
J. (1904)*

89
Saint Peter
FOLLOWER OF MASTER MATEO
Ca. 1220-1230

Granite.
135 x 46 x 21 cm.
Church of Santiago de Gres, As Cruces
(Pontevedra)

PROVINCIAL MUSEUM OF PONTEVEDRA

Upright image, in pontifical dress. The feet, clad
in pointed buskins, rest on a slightly convex
pedestal. He is blessing with the right hand, and in
the left, covered by the chasuble, is holding three
keys, two raised and the other hanging. The head,
with an expressionless face, has a beard and hair
distributed in locks which end in coiled curls.
Remains of polychromy are preserved.

The figure depends rigorously—it is a true 'copy',
taking the term in its Medieval sense—on one of the
same name set beneath the rebate in the door frame
on which the tympanum rests, in the right wing of
the central opening of the Pórtico da Gloria.
Nevertheless, it differs in its lesser expressiveness,
its marked hieratism, its strong frontal appearance,
reinforced by the symmetry with which the garments
are arranged, and also by its flatness, with its less
protruding form, features which coincide with the
evolution that has been noted in the premises
inspired by the art of Master Mateo. All of this
suggests that the production of the work from
Pontevedra occurred a certain time after the period
when those formulas were in full vigor.

The smoothness of the posterior parte of the
sculpture leads us to think that it was conceived of
to be connected to the wall. The trimmings and
damages of the sides are the result of later
interventions, done to facilitate its incrustation into
a wall, where it was when bought.

(J.-C.V.P.)

BIBLIOGRAPHY
*Catálogo (1988); Moralejo Álvarez, S. (1975);
Otero Túñez, R. (1965)*

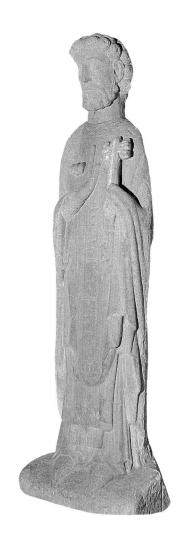

90
Sitting Santiago
Middle of XIIIth century

Granite
120 x 55 x 50m cm.

PARISH CHURCH OF SANTIAGO DE GUSTEI
(OURENSE)

Seated figure on a low chair with a small human (?) head on each of its sides. Dressed in tunic and mantle. With the right hand he is clasping a short staff with a scallop shell at the end. With the left he holds an open book, resting on a leg, on whose pages we can read SANCTE JACOBE / ORA PRO NOBIS. The head, of marked frontality, has a beard divided in curled locks, like the ends of the locks of hair.

The sculpture is polychromed. Nevertheless, the paint it has today is modern.

The image, although its general arrangement and some details could lead us to think it linked to Compostelan models (Sitting Santiagos of the mullion of the Pórtico da Gloria and the main chapel), does not depend directly on them. There are many characteristics—stylistic and iconographic—which separate them. Its inequivocal point of reference is located elsewhere: in the sculpture of Santiago adjoined presently to the mullion of the Pórtico do Paraíso of the Cathedral in Ourense. In truth, both the facial type as well as the arrangement of beard and hair, the treatment of the drapery or the manner of showing the book toward the observer coincide completely with the Ourensan prototype, which confirms their relationship. The fact that the impact of the Ourensan Pórtico is also seen in other points of the church at Gustei—especially the main façade—suggests that the image of Santiago discussed here, with identical chronology and affiliation, is the same one that presided the temple from the time it was constructed.

(J.-C. V. P.)

BIBLIOGRAPHY
Chamoso Lamas, M.(1980); Moralejo Alvarez, S.(1975); Pita Andrade, J. M. (1954); (1985); Vázquez Núñez, A. (1902-1905).

91
Decorated keystone
Middle of the XIIIth century

Stone
32 x 44 x 45 cm.
Medieval cloister of the Cathedral of Santiago
de Compostela

NATIONAL MUSEUM OF PILGRIMAGES.
SANTIAGO DE COMPOSTELA

According to the Historia Compostelana, 'Forty six years had passed since the beginning of the new church of Santiago... and.. it still did not have a cloister'. Archbishop Xelmírez tries to begin it, offering an important donation, and the same is done by Alfonso VII. In spite of everything nothing must have been done, and the cloister of the nearby Canonical church must have carried out this function.

In the middle of the XIIIth century, during the episcopate of Juan Arias, the project was carried out. In 1250 the first of the many funeral chapels that would be constituted in it is founded. With this chronology its style is related to that generated by Master Mateo and his workshop. López Ferreiro called it the "Compostelan style" and it would be defined precisely in this cloister.

Throughout the XIVth century there would be a lot of works done on the cloister, perhaps the most notable being a great tower adjoined to the arches of the northern gallery.

The disorder which characterizes the city from the middle of the XVth century seriously affect the cloister, which has to be partially redone. The ruinous state it is in leads archbishop Fonseca in 1505 to assign a million maravedis to begin the construction of another; Juan de Alava would draw up the plans and begin the work.

Although knowledge of the medieval cloister is still incomplete, its floorplan and walls can be reconstructed in general terms. It was at a lower level than the present one, and was smaller than this one. The length of its galleries was not less than some twenty seven meters, which allowed for five sections in each one. Between these sections were small pillars, necessary for the interior structure, which had buttresses toward the patio part. In each one of these sections a pointed arch held a pair of round arches with some two meters of light. The width of the galleries was approximately five meters and they were covered with arches of four-part intersecting ribs, as the remains of the pillars, and particularly the keystones, show.

The keystone of the exhibit was found during the work and excavation done in the Renaissance cloister between 1963 and 1964 by Chamoso Lamas. The keystones that have been recovered are few and all of them, except this one, have a floral decoration in the center, here substituted by a beardless bust with curly hair which holds a partially unrolled cartouche in its hands. A type of swirl has been worked around the figure.

Underneath the effigy and to its right, two long necks with carefully combed manes are crossed. Their heads appear to bite the nerves of the vault. On the other side, beneath the bracket, a quadruped is coiled and sleeping; it appears to be a dog. In one of the upper corners a human figure stands out, with long hair, probably bearded, and dressed with a tunic reaching the feet and tied at the waist. The long arms end in strong hands with which it holds two spherical forms that could be heads. The strong abrasion it has suffered make a more detailed analysis impossible.

The preponderance of figured decoration, unusual in pieces of this type in Galicia, gives it special value. Its author, as the rest of the cloister, shows that he knows some recipes of Matean origin which are shown in the major Compostelan works of this period.

(R.Y.P.)

BIBLIOGRAPHY
Yzquierdo Perrín, R. (1989); "O Pórtico da Gloria e o seu tempo" (1989)

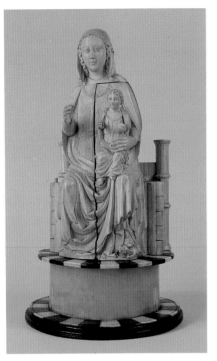
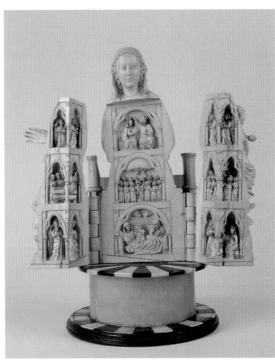

Opening Virgin
End of XIIIth century

Ivory (with remains of polychromy) and ebony
32 cm. (without base)

CONVENT OF SANTA CLARA DE ALLARIZ
(OURENSE)

Seated figure on a simple throne or chair. It is
wearing a tunic bound with a belt and a mantle
held at the neck with a cord, forming beautiful
rounded folds between the legs. The head has an
oval face of soft, careful shaping, framed by
waves of the hair, only visible in this part, since
the image is covered with a veil. The Virgin
extends her right arm, holding the Christ Child
with the left. The latter, with curly hair and also
dressed in tunic and mantle, is seated on his
Mother's left leg, from under which a demon-like
figure emerges. The Child, likewise facing the
front, has a sphere in his left hand, and the other
is in the blessing position.

When it is opened—and this occurs from the
neck down—the sculpture becomes an altar piece
meant to praise the Virgin's joys (M. Trens). In
the middle panel, beneath trefoil arches, are three
scenes in relief. Beginning from below they are:
the Birth, the Ascent and the Coronation of Mary.
On the right side, also framed by trefoil arches,
but now pointed, not rounded—the need to adapt
to an angular space, not entirely frontal, likewise
gives them a scenographic aspect—, there appear
from bottom to top: the Adoration of the Magi,
Pentecost and two angels with candles who
accompany the Virgin in her Coronation. An
analogous scene appears in the upper section of
the opposite side, and beneath it the Maries
before the sepulcher and the Annunciation, all
three with an identical frame to that mentioned
for the right door.

The work, unanimously valued for its artistic
quality, corresponds to a model that was very
successful in the Late Middle Ages.
Nevertheless, there not many certain
testimonies have reached us. The oldest, in any
event, are French. Our Virgin, whose origin
continues to raise questions, has repeatedly
been related to them, and particularly to pieces
of Parisian affiliation. Its stylistic features, in
which there is still a relationship to formulas of
the past—there is especially an insistence on
the great frontal character of Mother and
Son—lead us to think, nevertheless, that it is a
Spanish work, from foreign prototypes,
although the precise place it was done cannot be
determined. Its undoubted category and date,
deducible both for the style and the hints
provided by models and parallels, suggest that
the Virgin could have belonged to the founder
of the Convent in which it is located, the queen
Dona Violante, wife of Alphonse X, who died in
the year 1300. Violante would have donated it

to the nuns, as it seems from the content of her will, written in 1292.

(J.-C.V.P.)

BIBLIOGRAPHY
Estela Marcos, C.M. (1984); Gaborit Chopin, D. (1978); Santa Clara de Allariz, (1986); Trens, M. (1946); Yarza Luaces, J. (1980)

93
Calvary
Beginning of the XIVth century

Polychromed wood
Christ: 210 x 159 x 28 cm.; Virgin and Saint
John: 59 x 16 x 16 cm.

PARISH CHURCH OF SAN FIZ DE CANGAS,
PANTÓN (LUGO)

The parish of San Fiz de Cangas is an ancient monastery of Benedictine nuns which in 1515 was annexed to that of Sampaio de Antealtares in Santiago. The church is a very interesting example of the Romanesque in Galicia, and this exceptional Calvary pertains to it. It is 'from a small chapel or roadside shrine which was on the royal highway, not far from the church," according to Rielo, who also transcribes an inscription from the end of the XVIth century. Moved from here to the parish church, it was placed on the southern wall of the nave, and some years ago was placed in an official dependency for greater security.

Its figures are almost life size. It is carved in polychromed wood, although almost all the color is gone.

Christ is crucified on a cross, nailed to it by three nails, which is new and affects the position of the legs. The nails of the hand pierce the palms and the fingers are together. The right arm of the image is disjointed. The head has inclined toward this side, with its royal crown, probably one of the last representations of this type, since from the middle of the XIIIth century it was substituted by the crown of thorns, generalized after the XIVth century although in some cases, like this one, the artist prefers to continue with the royal one. His face, with a short beard, shows a deep serenity, his suffering is not visible, and even a soft smile on his lips, has traits that tend to continue until the middle of the XIVth century.

The torso has a special tretament, especially in the ribs which clearly mark amd outline the abdomen. The loin cloth is tied at the waist by a strong rope, probably formed by the twisting of

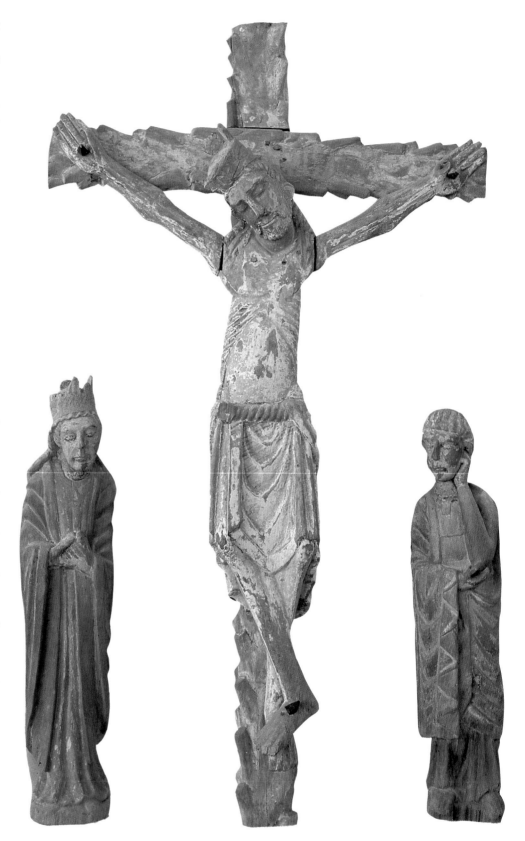

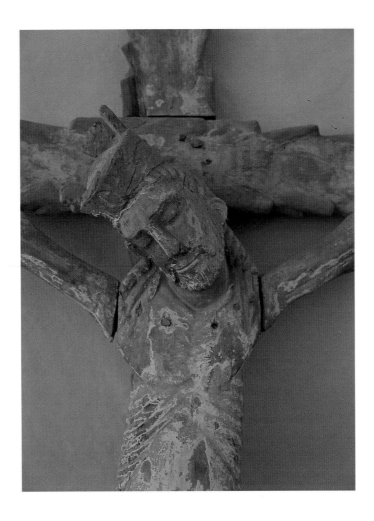

the fabric itself, and falls to the knees. It shows geometric folds on an angle, especially between the legs, which are crossed, with one foot over the other, and pierced by a third nail.

The figures of Mary and Saint John show the same concept of delicacy and moderation, while they include some traditions that are already familiar. Mary is wearing a tunic and mantle which reach her feet, preventing any anatomical reference. The geometric folds of her clothing stand out, forming angles from the shoulders to the elbows, and falling vertically from there to the ground. The head with a crown similar to her Son's, is slightly tilted, and her face shows the same serenity mentioned above. Using previous formulas, the hands are crossed over the chest.

Saint John also wears a tunic and mantle, from under which the tips of the feet are visible, and appear to be shod. He also has a traditional posture: his right arm is crossed in front of the body, he holds a closed book against his chest,

and his hand is beneath his left elbow, with the left hand on his cheek, which makes the head turn slightly. The hair curls over the forehead and the face is beardless. Perhaps the most outstanding feature is the proliferation of angular, geometric folds which are formed in the tunic.

The absence of other similar works and the lack of documentation makes it risky and difficult to determine the chronology and possible stylistic affiliation of this work, in which the folds of the clothing are its most constant characteristic. The geographical and in a sense stylistic proximity of Ourense may be a path for research. The Crucified Christ is definitely more advanced than those of Vilanova dos Infantes, the Cathedral of Ourense and San Salvador dos Penedos, among others, but it has some of their characteristics: the placement of head and feet, which causes the artist to abandon the four nails, adopting the three seen, and of

course, the treatment of the anatomy and the loin cloths. These recall those seen on various reclining figures of bishops of the Cathedral of Ourense itself, although logically there are differences. Moreover, it is known that the workshop of Ourense reached important diffusion throughout Galicia.

As a consequence, the chronology of the Calvary from San Fiz de Cangas can be set in the first years of the XIVth century, date in which this composition in general, and the Crucified Christ in particular may be found both in other places on the Peninsula as well as in western Europe, where the oldest examples are dated from the middle of the XIIIth century to the beginning of the XIVth.

(R.Y.P.)

BIBLIOGRAPHY
Rielo Carballo, N. (1975); Vázquez Saco, F. (1950).

94
Capital
Ca. 1310-1320

Granite
40 x 39 x 35,5 cm.
Cathedral of Ourense

PROVINCIAL MUSEUM OF ARCHEOLOGY OF
OURENSE

Free capital, with conical trunk and polished surface, whose basket shows a washstand and the twelve Apostles.

In this piece we must point out the talent with which the placement of the numerous figures it contains is resolved; the only data concerning it in the Museum where it is exhibited today indicates that it is from the Cathedral of Ourense. Various arguments, however, suggest it should be initially related to the scarcely begun Claustra Nova of the Cathedral. On one side, its structure and finish, the latter being conical on one side and on the others, spreading onto all of them underneath the abacus angles, a very naturalistic open leaf, which serves to make the transition between the squared surface of the abacus and the circular one of the basket. On another side, by the style of the figures: the manner in which they are placed, their facial types, the treatment of their garments, etc., are similar in the one discussed here and in those still in the Cathedral. In all of these there is a marked tendency toward geometrizing of the forms.

Nevertheless, it does not seem probable that the capital of the Museum had been destined for the Cathedral dependency mentioned. Its dimensions, somewhat larger than those of the works preserved in the cloister, and its very separate character, incompatible with what may be deduced was the rest of the structure, strongly negate this. This same rejection is supported by the different profile of the abacus. This last fact leads us to consider the capital to be slightly posterior to those of the Claustra Nova, the moving back in date also proposed by S. Moralejo, who considers this dependency of the Cathedral to be prior to 1306, given its stylistic features.

(J.- C. V.P.).

BIBLIOGRAPHY
Chamoso Lamas, M. (1980); Fariña Busto, F. (1978); Moralejo Álvarez, S. (1975); Pita Andrade, J.M. (1954)

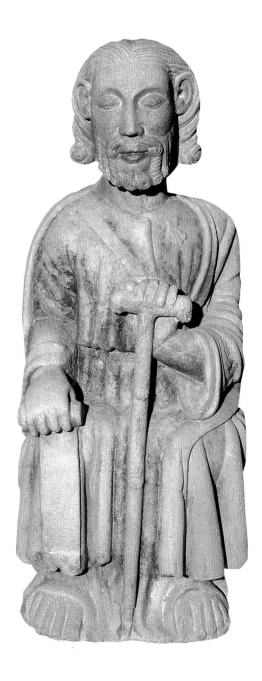

95
Seated Santiago
Ca. 1330-1340

Granite with remains of polychromy
125 x 50 cm.
Chapel of Santiago of O Burgo (Pontevedra)

MUSEUM OF ART OF CATALUNYA
(BARCELONA)

Seated image, with bare feet, dressed with tunic bound with cord at the waist, decorated with scallop shells and mantle. On the first article of clothing is a belt over one shoulder which would serve to hold an invisible pouch. The left hand rests on a staff in form of tau, also decorated with two small scallop shells, holding a phylactery with the right hand, partly rolled and today without epigraph, which runs parallel to the leg. His face, with great serenity, is full of an abundant beard. The latter, like the hair, long and parted in the middle, has multiple coiled curls.

Typologically and iconographically, the figure, rigorously facing the front, circumstance which does not less his clear monumental appearance, must be considered a derivation of Compostelan prototypes, specifically the homonymous sculptures set in the skylight of the Pórtico da Gloria and the main altar of the Cathedral (the latter greatly modified at the end of the XVIIth century).

This relationship and the remembrance of formulas and recipes linked to Master Mateo's sphere—notice particularly the beard and hair—, which has caused the image repeatedly and almost systematically to be related to the followers of the Compostela craftsman and to date it toward the end of the twelfth century. A careful analysis of the sculpture, nevertheless, makes both this affiliation and the chronology inviable. In effect, the general nature of the figure and in particular the treatment the clothing receives, with rounded, tubular folds, very vertical, lead us to delay its execution considerably, and it should be dated, judging from the parallels which must be mentioned as reference (compare, among other things, with works such as the tympanum of the Door of the Holy Man in Santo Domingo de Bonaval of Santiago, or the western tympanum of the abbatial church of A Franqueira, both dated by inscription, the first in 1330, the second in 1343), in the second quarter of the XIVth century (ca. 1330-1340). It can be perfectly related to the creations of the so-called "Ourensan style" (Moralejo) in its phase of dissolution, during which its premises are spread throughout Galicia.

(J.-C.V.P.)

BIBLIOGRAPHY
Caamaño Martínez, J.M. (1962); Filgueira Valverde, J. (1942) (II); Moralejo Alvarez, S. (1975); Sá Bravo, H. de (1972); Valle Pérez, J.C. (1985).

96
Tympanum
Second quarter of the XIVth century

Polychromed stone
92 x 130 x 39 cm.
Cathedral of Santiago de Compostela
Chapel of Dona Leonor.

MUSEUM OF THE CATHEDRAL OF SANTIAGO
DE COMPOSTELA

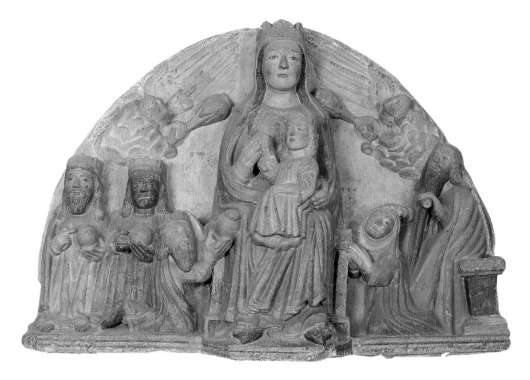

In the first half the chapel of Dona Leonor or Rodrigo y Payo Soga was built in the Cathedral of Santiago. It was next to the western doorway, at the foot of the bell tower, 'on the balcony of the Holy Church which falls toward the square of the Hospital', in the words of Cardinal Hoyo. Archbishop Berenguel de Landoria, indebted to the Soga family, to which the second husband of Dona Leonor belonged, had already conceded it. The chapel existed until the XVIth century, when the chapel of the Deacon must have taken its place, and in turn would be reformed in the XVIIIth century.

The tympanum was in the chapel door, which made it possible to see the plant decoration of the lintel and the reading of its epigraph: :CAPELLA:DONA:LEONOR:

According to Professor Caamaño, there is another inscription in the dorsum of the tympanum, which reads: CAPILLA DE DONA LIONOR RESTAURADA EN EL 1768 (Chapel of Dona Leonor restored in 1768).

The theme developed, the Adoration of the Magi, is one of the most frequent in the Galician tympana of the end of the Middle Ages, particularly those of the XIVth century, and especially in those of Santiago. Undoubtedly the point of departure was the Epiphany which was on the door of the back choir constructed by Master Mateo and his workshop in the Cathedral of Santiago. The oldest of those of the XIVth century is that of San Fiz de Solovio, dated 1316. In it is the figure of the donor which necessarily is seated to the left of the Virgin, seeking perfect symmetry with the king kneeling on the other side.

In the chapel of Dona Leonor, Mary is seated on a backless chair, is crowned and faces the front. With her right hand she holds a piece of fruit and with the left the Christ Child, seated on her lap, barefoot (his Mother is shod), and turned toward the offerent, whom he blesses with his right hand, while the other is extended over his thigh.

The first of the kings, kneeling, offers his gift, in form of a container, to the Child, with his right hand, at the same time as he moves his left hand toward his crown to remove it. This is the cliché used in the tympanum of the Corticela, and in the one which was in San Estebo de Ribas de Miño (Saviñao, Lugo) or that of Santa María do Camiño de Santiago; the only difference is that in those of Corticela and Ribas de Miño the character only has bent knees, while in the other two he is kneeling.

On the other side of the throne is Dona Leonor, also kneeling and with hands pressed together. Her head is covered with a coif and Saint Joseph, seated on a stool to the extreme right of the tympanum, rests his hand on her head. He is shown in profile, with his left hand on a tau-shaped staff. He has a beard and long hair, and like the rest of the characters except for the Child, is wearing a mantle and tunic.

On the other side of the tympanum are two other Magi, standing, with their gifts in their hands, and crowned. The second is beardless. Taking advantage of the space above the heads and at Mary's sides, two thurifer angels have been carved, arising from clouds. These are repeated in the rest of the Compostelan tympana with this theme, except for that of the Corticela and San Fiz de Solovio.

The carving is overall carefully done. There are somewhat geometrical folds, quite deep at times.

There is attention to small details in the seats, the clothing of the Virgin and the Child, with adornments of stars on the neckline, and on the angels' wings. Its chronology, as Professor Caamaño has already described, is situated in the second quarter of the XIVth century.

(R.Y.P.)

BIBLIOGRAPHY
Caamaño Martínez, J. (1958); Carro García, J. (1930)

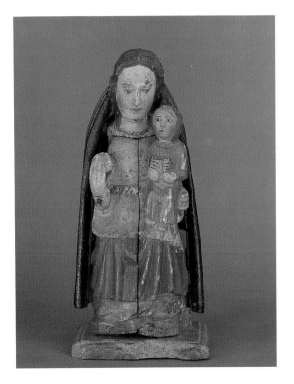

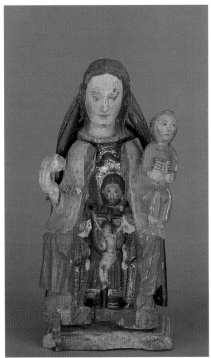

Her head, slightly bent backward, is oval, with small closed mouth, straight nose, round open eyes, wide forehead, with no crown or diadem, although she may have had one and it was eliminated when the hair was recarved, falling over the shoulders. The Child's head may also have been modified or even redone.

Up to here the Virgin of Toldaos is no different from many others in the churches of Galicia, and the most outstanding is its small size.

The open image. The ability to open the image is a singular feature. From the lower part of the neck of Mary two small doors—27 cms. high—open, showing a representation inside of the the Most Holy Trinity of the throne of grace type.

The Eternal Father is seated on a throne. He is wearings a tunic that reaches his bare feet, and from his knees down there are vertical folds. Over his chest and lap he is wearing a chasuble with a rounded edge. He holds the cross on which his Son is nailed before him, and behind the right hand is the symbolic disk that usually appears in these images of the Trinity.

Christ, crucified with three nails, is dead. His head is bent to his right, which together with the twisting of his body gives him a line similar to an inverted S. Arched arms, bended knees, bearded face, hair falling to the back and slightly represented anatomy. The loincloth, tied on one side of the hips, reaches his knees and in the center forms angular parallel folds. The painted accents, with abundant blood, stress the pathos of the suffering.

Over the right shoulder of the Eternal Father is a dove with folded wings which turns its head toward that of Christ, although without touching it. This placement is neither frequent nor correct, according to the Second Council of Lyon, in which it was determined that the dove which represents the Holy Spirit had to touch the other two persons of the Holy Trinity on their mouths, known as the ab utroque procession.

Thus the Virgin of Toldaos is an opening virgin of the Trinity which the typical scheme adds having two carved figures inside the small doors. The right one, beardless and with short hair, has a bonnet and is wearing a tunic that reaches his shod feet. In front of him he holds an open book in his hands. The figure on the other side repeats these characteristics, although with the right hand he grasps what seem to be some pebbles, and with the left a long cartouche. It is difficult to identify them. The first could be Saint John and the second, perhaps Saint Stephen, although other interpretations are possible. The greatest difficulty lies in their presence in this image.

The opening images of the Trinity, according to Trens, are based on different Biblical texts and on religious literature of the medieval period. Perhaps the most significant is that of Adam of San Víctor, who in a hymn calls the Mother of God "Totius Trinitatis nobile triclinium." Nevertheless, this type of figures was not long in being considered contrary to Catholic dogma, since it could be thought that the three persons of the Trinity had been incarnated in Mary. Thus they began to be destroyed at the end of the medieval period and continuing into later centuries. The hidden character of the parish of Toldaos favored the conservation of this exceptional piece, unique in Galicia and probably in the entire Peninsula.

97
Opening Virgin
Third quarter of the XIVth century

Wood
30 cm.

CHURCH OF SAN SALVADOR OF TOLDAOS, TRIACASTELA (LUGO)

The church of San Salvador of Toldaos, founded by the monks of Samos before 1159, has preserved this image of the Virgin, worked in wood, its most outstanding peculiarity not affected by reforms: it opens to show a representation of the Trinity in its interior.

The closed image. Mary sits on a bench that is barely visible. She faces the front, and with the right hand grasps an apple, while in her left arm she holds her Son, who rests his feet on her knee. Over his chest is an open book which he holds with both hands. He is wearing a tunic that reaches his bare feet.

His mother also wears a floor-length tunic, with pointed shoes. Over her clothing she wears a fur cloak or overgarment pulled in by a belt. The garments of the two characters form angular folds, especially from the knees down and between the legs, as well as on both sides of Mary.

It is a Gothic work whose date is not easy to determine. because of its similarities with other seated Virgins with the Christ Child and because of the crucified figure in its interior, we might think that it is from the third quarter of the XIVth century.

(R.Y.P.)

BIBLIOGRAPHY
Yzquierdo Perrín, R. (1988-1989)

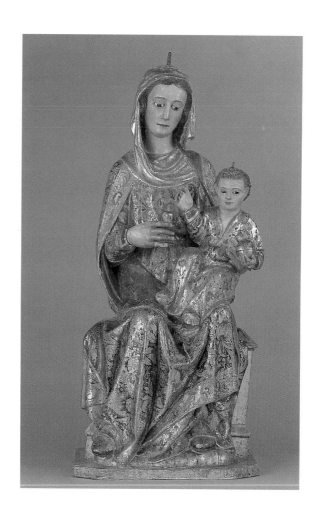

98
Seated Virgin
End of the XIVth century - beginning XVth

Polychromed wood
102 x 40 x 33 cm.

CATHEDRAL OF TUI (PONTEVEDRA)

Enthroned image of the Virgin with the Christ Child, polychromed, certainly later than its carving. The slenderness indicates a long canon. She is wearing a long tunic whose neckline cannot be seen because it is covered with a cloth that apparently forms part of the veil or headpiece. The fold which forms over the right knee in a diagonal direction is very frequent in works from the XIVth century. The manner of placing the mantle which is bound to the left arm at the level of the forearm is very normal in the type of Virgin which arises in Burgos-León toward the ends and extends especially in the Basque Country, Rioja and Navarre throughout all the XIVth century. The headpiece of the Virgin, although in principle it is very common in this type of images, becomes unusual because of the way in which it invades the area of the chest so that its reading is not very clear. In general it is more frequent that Mary's hand hold something and be placed toward the upper area, but neither is the posture here a strange one. The very wavy hair which comes out from the headpiece is again common in the XIVth century, The displacement of the Child to one side is usual, although the tunic is not generally worn so open. Perhaps the features of the heads of the Virgin and Child have been modified, either because of the polychromy or some previous restoration, for which later dates are suggested than those corresponding to their possible execution. The Virgin is holding a pear in her hand. It has been said that it is a sign of fecundity (Trens,María, Iconography of the Virgin in Spanish Art, Madrid, 1947, p. 566). There are no exact parallels in the broadest Hispanic repertoires (Trens, Bernís, Ara Gil, Fernández-Ladreda, etc.), but it seems evident that the Burgos type is distantly reflected, and at times it is mistakenly, because it is very frequent there, called Riojan, Basque or Navarran. All the characteristic point to the second half of the XIVth century, although certain details could lead the piece to be dated in the beginning of the following century. It is here where it has been classified without great precision on occasions (Durán Sanpere, Alnaud, Gothic Sculpture (Ars Hispaniae XIII), Madrid, 1956, p. 84). In spite of its undoubted quality, it has not been mentioned in the general works on Galician art.

(J.Y.L.)

RESTORATION NOTE:

State of preservation:
• Support with unglued assembly, broken finger on the Virgin and loss of part of four fingers of the Child.
• Layer of traditional preparation (compound and animal glue) with red bole which breathes, with good internal cohesion.
• Bad adherence to the support in the areas with cracks and on the edges of the small bare areas.
• Paint layer with good cohesion and adhesion, small bare spots coinciding with the layer of preparation and erosions.
• Protective layer of varnishes and lacquers.
• Wax deposits.

Treatment done:
• Mechanical cleaning of dust and biological deposits.
• Disinfection with methyl bromide.
• Fixing of the preparation layer to the support.
• Cleaning of wax drippings with Leister.

• Chemical cleaning of the greasy surface dirt.
• System of presentation: Neutral watercolor ink on the blank areas where there are losses of the painted layer.

Additional treatment:
• Physical-chemical and photographic analysis.
• Gluing of parts.
• Elimination of deteriorated varnishes and lacquers.
• Renewal of the protective layer.
• Following of the state of preservation through control of environmental and conservation conditions.

BIBLIOGRAPHY
Otero Túñez, R. (1965); Pita Andrade, J.M. (1952); (1954); Sánchez Ameijeiras, R. (1989); Vila da Vila, M. (1986); Yarza Luaces, J. (1984); (1989); Yzquierdo Perrín, R. (1983)

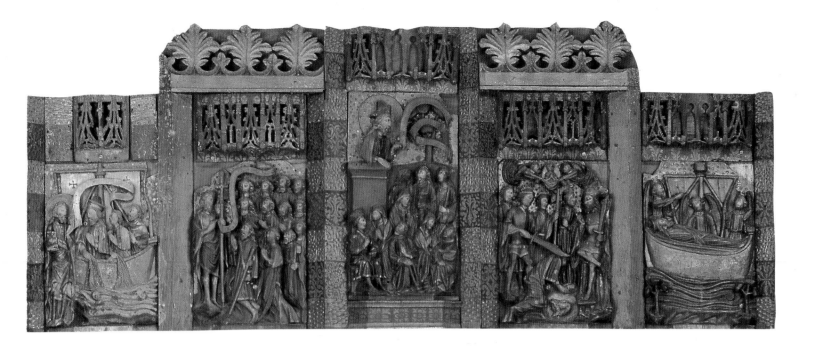

99
**Little english altar-piece
of John Goodyear**
1420-1460

Alabaster and polychromed wood
186 x 90 x 6,8 cm.
England

CHAPEL OF THE RELICS. CATHEDRAL
OF SANTIAGO DE COMPOSTELA

This little English altar-piece is a pilgrim's
offering, done by John Goodyear, parson of Chal, on

the isle of Wight, diocesis of Winchester (England),
in the jubilee year of 1456. Thus is documented in
the Tumbo F of the Compostelan Cathedral:

"Sabedue de que o seu corpo era ena dita santa
iglesia... dou logo en pura et libre deçon a dita
iglesia compostelana un retablo de madera, las
figuras de alabastro, pintado en ouro et azur, en que
se contía et conten pintado et fegugo presento et
ofereseeu eno dito altar mayor dela..."

The valuable little altar-piece is formed by five
alabaster panels which tell the life of Saint James
the Greater, grouped in a wooden frame. Each relief
ends in an open work cresting. The central relief
stands out, as do the side reliefs with palmette ends,
creating ascending levels. The altar-piece is set on a

flat board, like a predella, which continues in some
little boards joined by hinges, which indicate a
possible closing door, as is characteristic of this
type of furniture of private devotion. A latin
inscription in big Gothic letters refers to the
corresponding Jacobean passages: Vocatio Iacobi ad
Apostulatum; Missio Iacobi ad predicandam fidem;
Predicatio Sancti Iacobi; Martirium Sancti Iacobi;
Traslatio Sancti Iacobi ad Compostele.

The reliefs have a symmetrical disposition,
centred on the Jacobean Preaching. An interior
symmetrical composition in every scene is due also
to this Preaching, and is even antithetical. The
vertical and horizontal position of the characters
also takes part in the internal dynamics of every

relief, in perfect antagonistic opposition: Life-Death; Good-Evil. So, the reliefs situated at the extremes, Vocation of Saint James and John and Taking Saint James's body to Compostela, are scenes in which the boats are present. Jesus-Life is differentiated by his verticality, confronted to the recumbent position of the Apostle. The reliefs Evangelical mission and The martyrdom of Saint James have an opposing composition: Resuscitated-Christ, on the left of the scene, accompanied by the disciples in horizontal rows, in which Saint James is kneeling before the Lord; in the other relief, Herod appears on the right of the passage. The disciples approach him asking for the beheaded body, situated in front of the Tetrarch, in perfect antithesis. In the central panel Saint James preaches the multitude, who gesticulate in groups. In this way the dramatic tension among the different characters, and among the opposite reliefs, is emphasized as part of these artistic productions.

They are beautiful compositions of realist-narrative nature, with well proportioned and slender figures, of neatly done draperies, with rounded folds. They stand out with their wide faces, pop-eyes, hair and beard with big curls and with a dreaming and aristocratic look. The polychromy, of intense colouring, in red, blue and gold gives them a luxurious and rich appearence.

They are simple handicraft pieces, from the traditional English workshops, exported to Europe, produced in series, with lasting forms and without great originality. Therefore, this piece is situated in one of the aspects of Medieval art: the specialized industrialization, which is not artistical mediocrity.

The little altar-piece of Saint James belongs to the period of these popular alabasters, dated between 1420 and 1460.

<div style="text-align:right">(A.B.B.)</div>

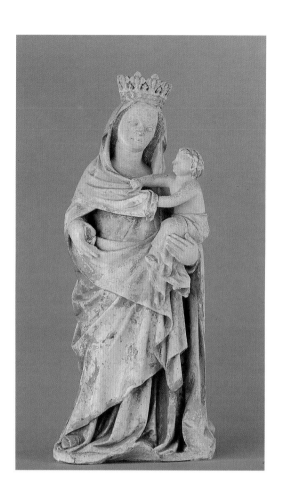

BIBLIOGRAPHY

Alcolea Gil, S. (1971); Carro García, J. (1947); Chamoso Lamas, M. (1961); Filgueira Valverde, J. (1959); Hildburgh, W.L. (1926); Muñoz Párraga, M.C. (1987)

100
Virgin with Christ child
SCHOOL OF COIMBRA
Ca. 1440-1460

Limestone, with vestiges of polychromy
72 x 34 x 21 cm.

PARISH CHURCH OF SAN ANDRÉS DE VEA, A ESTRADA (PONTEVEDRA)

Standing Virgin, with a soft S line. Her crowned head is covered with a veil. Her face, with rounded line and soft features, is framed by her hair, which is only visible in this front area, leaving her forhead free also. She is wearing a long tunic which falls in thick, contrasting vertical folds which break below, leaving only the tip of the shoe visible. The mantle crosses the figure from one side to the other, also serving to cover the lower part of the Child. Naked, smiling and with robust anatomy, he is seated on his Mother's left arm. He looks at Her while grabbing the veil with his left hand, which he brings near or pulls on as if to hide what he is doing with his left, placed beneath the veil.

Typologically, the Virgin with Child of San Andrés de Vea, unpublished up to now, corresponds to a model which was widespread in the Gothic centuries. The affective relationship which is established between Mother and Son—crossed glances, as if responding to a mischievous game which He is playing—and the purely formal features of the figures, particularly the Virgin—little emphasized curving silhouette; treatment of the folds of the clothing, reinforcing with them the corporeity and volume of the image, to which they give an undeniable monumentality—lead us to think of the middle years of the XVth century as an appropriate frame for its execution (compare, for example, the Virgin of Forgiveness, from the funeral chapel of the Compostelan Archbishop Lope de Mendoza, datable a little before 1451).

Regarding its affiliation, both the Virgin's physiognomy and the material in which the group is sculpted suggest that it is a foreign piece. In this sense, the first information considered seems to point to Burgundy or some nearby region as its place of execution. The errors which are detected when the two figures are carefully analyzed—notice, as an example, the way of placing the arms of the Christ Child or the two hands of the Virgin—make it difficult to accept this suggestion, and on the contrary, make us believe that it is a work derived from or inspired by prototypes of that origin. This fact and the use of limestone in its fabrication point to the nucleus of Coimbra, where there are numerous parallels in the dates indicated—compare in particular with works by Master Joâo Afonso and his circle—, as a possible place for the production of the group. It would thus be one more piece to add to the already significant list which certifies the existence of an important art trade between the Portuguese city and Galicia in the final period of the Middle Ages.

<div style="text-align:right">(J.-C.V.P.)</div>

BIBLIOGRAPHY

Caamaño Martínez, J.M. (1960); (1962); (1977); Días, P. (1986); Santos, R. dos (1948)

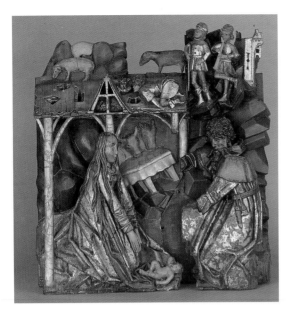

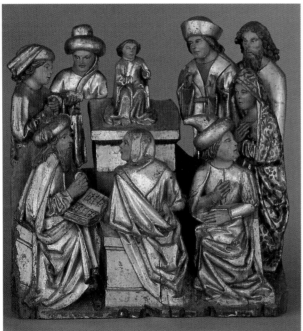

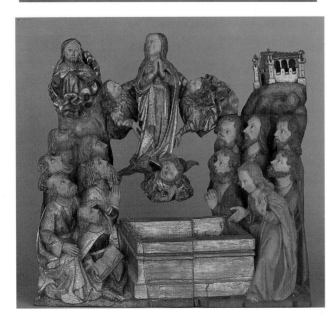

101
Main Altar Piece of Santa Maria de Azogue
FLEMISH WORKSHOP
XVth century

Polychromed wood
50 x 60 cm.

CHURCH OF SANTA MARIA DE AZOGUE.
BETANZOS (A CORUÑA)

The fourteen panels which represent the mysteries of the Rosary, are inserted in a Baroque altar piece, done in 1743 by the sculptor from A Coruña, Ignacio Francisco Gómez Soneira. In the contract it is agreed that the fifteen mysteries of the primitive Gothic altar piece will be preserved.

Of the Joy mysteries, that of the Annunciation has not been able to be recovered after the robbery of the church on October 1, 1961, and presently in its place is board number fifteen, which represents Saint Joaquín and Saint Ann, found in 1951 behind the main altar.

The work, which may be classified in Hispano-Flemish Gothic, is imported, possibly acquired in the fair of Medina del Campo by Fernán Pérez "the Younger", sixth lord of Andrade, under whose patronage the church is completed.

The scene of the Birth is treated with much naturalism and many iconographic details. It is developed beneath a very small doorway in which the three central figures adopt a closed position, related to one another by their glances and th emovements of their arms. The Christ Child, naked and with a finger in his mouth, rests on the ground, partially protected by the Virgin's mantle. Saint Joseph, with curly hair and beard, is wearing a Flemish tunic decorated with rich painting on gilt ground. The expression is centered on his face and the rest of the figure is transmitted to the garment which with rigid parallel folds disguises the body structure. The theme is completed with a landscape of great rocky masses, in contrast with the golds of the building; in it two shepherds tend their flocks, each one playing a musical instrument, while a third spies on the scene from a hole in the roof. There is a concern for representing the landscape and the consequent abandonment of golden backgrounds.

In the mystery of Jesus Lost in the Temple there is no reference to the architecture, but the accessories and garments are treated with great detail. The doctors in positions of dialogue relate to each other making the composition dynamic. The Christ Child is in the middle, on the table planned to be seen from above. The panel does not have the original painting on gilt ground.

In the Ascent of Mary the treatment of the theme corresponds to medieval iconography. The Virgin, in the middle, in praying position with her hands together, is lifted to heaven by three angels, which are her only point of support. In her ascent she makes an S design. She follows northern models: long blond hair falling freely to her shoulders, wide forhead, small eyes and a youthful expression. The Apostles are organized in two groups, on both sides of the empty

sepulcher, showing the surprise of the discovery on their faces. In the background, on a rocky hillock, a building with Gothic traits situates the scene outside.

(A.C.F.)

BIBLIOGRAPHY
García Iglesias, J.M. (1982); Vales Villamarín, F. (1951).

102
The Virgin of Forgiveness
Middle of the XVth century

Alabaster
96 x 35 x 33 cm.
Chapel of Don Lope. Cathedral of Santiago de Compostela

NARTHEX OF THE CHAPEL OF THE COMMUNION. CATHEDRAL OF SANTIAGO DE COMPOSTELA

The Compostelan archbishop Lope de Mendoza died in 1445 without seeing the completion of the funeral chapel which he had ordered constructed adjoining the northern wall of the Cathedral, between the latter and the Archbishop's Palace. The work was finished in 1451, as registered on a stone slab. It has a rectangular base and in the center the magnificent sepulcher of the founder, "very large tumulus of alabaster and very well carved," according to that written by Cardinal Jerónimo del Hoyo after visiting the chapel in 1605. Its conception is of a funeral type, which had left such important examples in other Cathedrals. It belonged to the University of Santiago, since "the major grandees, because of style and ancient custom, and according to the norm, were found in the Chapel of Don Lope... "

Hardly anything is preserved of this beautiful grouping, destroyed around 1770 to build the Chapel of the Communion, under the patronage of Archbishop Raxoi; the most valuable piece is the image of the Virgin of Forgiveness, made of alabaster—unusual material for Galicia—but also used in the sepulcher discussed here. There is stucco on the main altar, with a glass window behind.

The lower part of the base, a few centimeters high, is decorated with plant motifs of the typical technique of the Xvth century. There, on the left, the archbishop Don Lope himself is kneeling, his hands together, whence emerges a phylactery that reads: "MEME(N)TO MEY." The head is thrown back, covered by the miter, to look at Mary. Both this headwear and the upper part of the wide cape he is wearing, are richly and carefully decorated. In front of the praying figure, almost in the center of the base, is the tau-shaped staff with animal heads on the ends, which recalls those of the Santiago of the mullioned window of the Pórtico da Gloria. A panisellus covers the upper part of the shaft. Toward the right is a circle with an inscribed equilateral triangle and its bisectrices, all done with a chain. Its meaning is unknown, being interpreted as a magic emblem or simple decoration. On the corner of this side is the coat of arms of the prelate. On the extremes are thistle-shaped leaves.

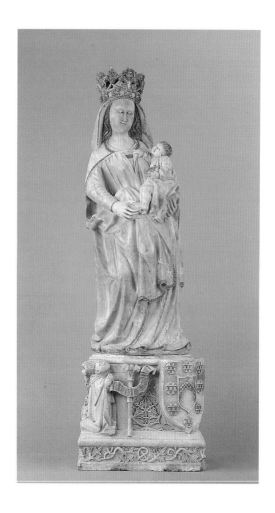

The Virgin is standing and is wearing a crown that could have been reformed on her head. She is carrying the Christ Child over her left arm and her right leg is bent, which gives her an elegant S line, accentuated by the folds in her clothing, particularly the tunic, which fall to the ground and cover her feet. With her index finger and thumb of the right hand Mary delicately grasps one of her Son's feet, bare and turned toward her. He rests his right hand on the edge of Mary's neckline, over her chest. For Trens, "this gesture... is a bashful formula of the representation of the Virgin of Milk." With the other hand the Child holds a little bird, carefully done, and whose meaning is varied, since it is "one of the most ancient attributes and one of the most difficult to interpret," according to the author cited. Mother and Son look at each other with immense love, which gives Mary's face a special sweetness and naturalism, including a slight smile.

The image has great elegance and quality, which is added to by the fine grain of the material and the polishing it has received. Such an exceptional piece follows a Burgundian style with features that "in a special way bring it close to the sculptural work of the

Master of Archbishop Anaya, in Salamanca," in the opinion of Professor Caamaño. It is a pity that such an exceptional sculpture, contemporaneous with the construction of the chapel, which preserved vestiges of its original polychromy, has suffered a recent touch up.

(R.Y.P.)

BIBLIOGRAPHY
Caamaño Martínez, J.M. (1960) (1962) (1976).

103
Reliefs from an altar piece
WORKSHOP FROM NOTTINGHAM
Ca. 1462

Alabaster, with remains of gilding and polychromy
1st: 40 x 27 cm.; 2nd: 39,5 x 27 cm.; 3rd: 35 x 28 cm.
Cathedral of Mondoñedo (Lugo)

CATHEDRAL AND DIOCESAN MUSEUM OF MONDOÑEDO (LUGO)

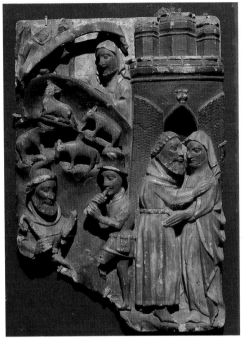 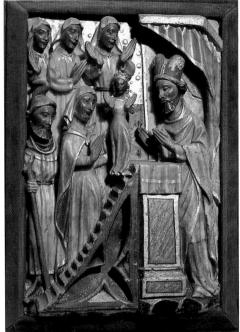 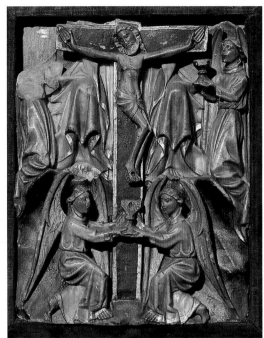

Set of three reliefs of the same series. In one of them, which is chronologically first given the theme to which they are related, three episodes are represented: the Annunciation of the Angel to Saint Anne and Saint Joachim among the shepherds, both on the left side (the first above and the second below) and, on the right side, the Embrace of the Spouses before the Golden Door. In the second panel is the Presentation of the Virgin in the Temple. In the third, apparently, only the Crucifixion of Christ is carved. A simple inspection of the piece, however, reveals that it is incomplete, with the upper part of the figure missing, the legs nearly completely hidden by the clothing. Judging by the known parallels, it would be God the Father, seated and perhaps with raised arms, holding Christ Crucified between his knees. The absence of vestiges does not allow us to define with certainty the organization of the rest of the upper part of the plaque, which must not have differed much, in any event, from that of the panels with identical themes which are invoked below.

The three reliefs, whose stylistic similarities are unquestionable (cf. the physiognomies and dress of the figures, the type of folds and the manner of carving them, the polychromy and the gilding, etc.), must have formed part of an altar piece dedicated to the Virgin. Two other panels would belong to it as well: one with the narration of her Birth (now in an unknown place) and the other with the scene of her Purification (a fragment of this is preserved in the Museum of Mondoñedo).

From the dimensions of the reliefs, deducible in spite of the mutilations they suffered, and from what the numerous parallels suggest, it is not risky to suppose that the last two plates mentioned, as well as the first two described, would have occupied the side parts of the altar piece (relief with the Embrace and Birth on the left; Presentation and Purification on the right), placing the panel with God the Father and Christ Crucified (perhaps also with the Holy Spirit) in the center, which would be higher than the others. Thus it would be ordered in the usual manner of the alabaster altar pieces that have reached us, which implies that all the reliefs lost the open-work crestings (and the frames) that must have crowned them.

Regarding the origin of the reliefs, both the material in which they are created, alabaster, and the details of their style, on which so many authors have insisted, confirm that they are works imported from England, in all probability done in one of the many workshops active in Nottingham at the end of the Middle Ages.

We can point out parallels for the dating of these plates—compare, for example, with the pieces which are inserted in pages 70, 302, 304, etc. of the Catalogue by F. Cheetham—suggesting, as has repeatedly been done, that they could belong to the main altar piece of the Cathedral of Mondoñedo, consecrated August 22, 1462 by bishop Fadrique de Guzmán. Thus they would correspond, because of what we presently know of the evolution in the production of these workshops, to a phase in which the work was already done in series, systematically repeating the same themes and models. This circumstance explains perfectly also the deficient artistic quality of the panels in the Museum of Mondoñedo.

(J.-C.V.P.)

BIBLIOGRAPHY

Alcolea Gil, S. (1971); Cheetham, S. (1984); Hildburg, L. (1944); López Ferreiro, A. (1883); Mayán Fernández, F. (1958-59); San Cristóbal Sebastián, S. (1980); Villaamil y Castro, J. (1865)

104
Annunciation
Second half or end of XVth century

Polychromed limestone
Saint Gabriel: 164 x 44 x 32 cm.; Virgin of Good
Hope: 160 x 44 x 38 cm.
Central nave of the Cathedral of Santiago
de Compostela

MUSEUM OF THE CATHEDRAL OF SANTIAGO
DE COMPOSTELA

Among the altars and chapels that were in the space behind the choir of the Cathedral of Santiago were those of Saint Gabriel Archangel and Our Lady of Good Hope, also called of the O. The sculptures of this Annunciation come from both of these.

According to Cardinal Hoyo, the chapel of Saint Gabriel 'is in the front pillar of Our Lady of Good Hope. It had been founded by the clergyman Pedro Martínez de Mar the fourteenth of August 1491, endowing it with enough income to have a chaplain and masses. The point indicated corresponded to the southern pillar of the Cathedral naves near the choir space, next to the altar of Saint Mary dos Ferros, repeatedly cited in the documentation.

Nevertheless, the chapel of the Pregnant Virgin was more important. It was situated on the northern pillar facing the Archangel and the Virgin dos Ferros. It came to have a brotherhood of choir canters, who already in 1526 sang the salve before the image. The sections of the main nave of the Cathedral between the space behind the choir and the Pórtico da Gloria were called the 'nave of Our Lady of Good Hope.

Both sculptures remained in these places until 1849, when they were moved to the chapel of Sancti Spiritus—today of Solitude. The figure of the Virgin was placed on the main altar and to the right, on top of a closet, was the archangel Gabriel. When the Cathedral choir was taken out, in the middle of this century, the altar of the disappeared back choir, and the images of the Annunciation were placed on the side walls, whence they were moved to the Cathedral Museum in the decade of the sixties. It is impossible to determine if in these successive moves there was any influence by the current which removed many of these representations of the Virgin of the O from the end of the XVIIIth century and throughout the XIXth.

Both pieces are carved in limestone, a little used material in the sculpture of Galicia, and their polychromy is posterior to their production, probably from the XVIth century, but beneath it another earlier one is visible. Mary has an elegant, slightly curved outline, accentuated by the folds of the tunic, which falls to the ground leaving the toes of her shoed feet

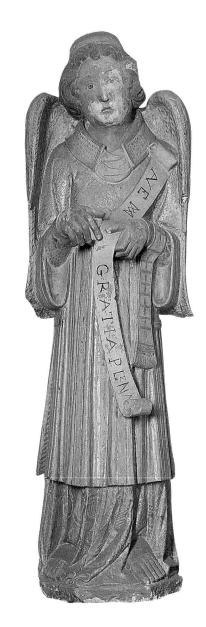

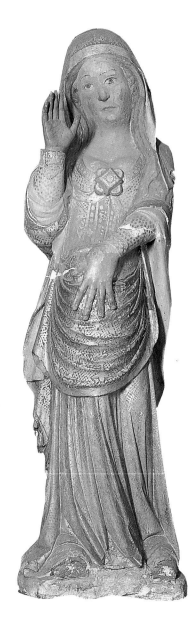

uncovered. Her head is tilted to the left. The mantle covers her hair, tied with a plain ribbon, and falls over her shoulders and arms to the rounded belly; the curved folds, somewhat concentric, increase the impression of roundness. She seems to hold the mantle with her left hand, which is open and has the separated fingers placed upon it. She has a wide neckline, with a large brooch in the middle, which shows the upper part of the breasts. Her right hand is raised in the sign of obeisance of the message transmitted by the angel. Her face has soft features and is framed by long hair which hangs to the arms. She is attentive to, absorbed in, the announcement.

Gabriel has similar features. His feet are bare and show from under the tunic, whose folds are placed in a

similar manner to those of the Virgin. He is wearing a dalmatica over this clothing. With both hands he holds before his chest a long phylactery of rolled up ends on which is written the salute to Mary: "AVE MARIA GRATIA PLENA," which dates from the time of the painting. On his right forearm he wears a maniple. Adjoined to his back are short wings, only reaching his elbows, on which the feathers have been carefully worked. His head is slightly tilted, his hair short and curly, covered with a headpiece. His face is treated like Mary's, with whom he maintains a silent but intense "dialogue.'

The life-size figures have folds which do not fall into the geometrizing of other Galician Gothic sculptures and even produce chiaroscuro in certain parts, Professor

BIBLIOGRAPHY
Caamaño Martínez, J.M. (1977); Fernández Sánchez, J.M., Freire Barreiro, F. (1882).

105
Crucifix of Ordoño II
Second half of the XIth century

Gold leaf over wood center
22 x 15 cm.
Cathedral of Santiago de Compostela

CHAPEL OF THE RELICS. CATHEDRAL
OF SANTIAGO DE COMPOSTELA

Very deteriorated crucifix, with broken inscription on the back (from XVIIIth century?): O/DI/L/S/-RH L/M/L on two lines in the crosspiece, and on the vertical arm: H C/DEI V/DE E/R NT/S O/IA O/ B/A S/LO, with a possible reading: HOC/DEI Lignum/Dederunt/Sancto Iacobo/Apostolo.

The crucifix is beaten on a very fine gold plate, which forms a deepened cross with a solid framing strip and a cartouche with the letters symbolic of Jesus: IHS (with the S inverted). It is a frontal figure, well proportioned, held with four nails; the feet are on a plain base, well made. The head in high relief is separated, the face has round cheekbones, large open eyes and long nose. The beard is short and grows at the edge of the facial oval, ending in coiled, separated points. The hair is combed with a part in the middle, with fine locks that mould to the head, ending below the neck. Behind the separate head, embossed on a plate, is the halo with Jerusalem cross, incscribed. The loin cloth is tied with a knot in the center, and the end is doubled toward the right, falling in folded fabric toward the outside, after the central fold, which slowly widens to reach below the knees in a waving border. It resembles the ivory Crucifix of Ferdinand I and Sancha (1062), given to the church of León (National Museum of Archeology).

The back side of the cross is decorated with simple incisions which frame it, forming circles of double lines, at the ends. On these backgrounds are the symbols of the Evangelists, engraved with good drawing technique. The plate has been cut to allow access to the "Lignum Crucis," probably through the widening of the central fenestela. It is thus an estauroteca given to the Holy Apostle, in the second half of the XIth century, this being the reason it has survived the vicissitudes through which metal work always passed. Due to this character as reliquary of a piece of Christ's Cross, it was adjoined to the cross of Alphonse III until the end of the XIXth century.

This Crucifix is distinguished by its originality: profound humanity and dignity insuffering, sobriety and solidity, and engraved in a good design: in the drawing and the certainty of the line incisions. Monumentality is sought through volume, by the perfect embossing technique.

The piece is situated, by its forms and spirit, in the western European current of Spain,

Caamaño has written that "they are similar to Italo-Gothic ideals from Sienna, already touched by the grace of international Gothic." Its chronology is difficult to determine, although the most logical would be to think that it was not much different than the date of the founding of the chapels, that is, from the end of the Xvth century. The most logical would be to think that the date of the founding of the chapels, that is, at the end of the Xvth century, or at least in the second half. We still do not see in them the stylistic features proper to Hispano-Flemish art, which could be justified by the lateness with which such orientations are introduced here and the weight of the traditional formulas.

The theme of the Annunciation was known to Galician sculpture from the Roman period, although it was in the XVth century when it reached a greater range, just as in other zones. The majority of the representations are in doorways: the southern door of Saint Francis of Betanzos, or in the main church of the same advocation in Ourense, in both cases with Mary set to the spectator's right, or the one that existed until the end of the XIXth century in the western door of Santa María of A Coruña. But none had this one belonging to the Compostelan Cathedral, which did occur with that of the façade of Santa María de Salomé in Santiago, since a slightly reduced replica has been made and the Virgin has even been placed on the left.

(R.Y.P.)

representative of a new art, with qualifications which are already characteristic of Romanticism: clearer silhouette, more lively interior poses, and graphism of the clothing through a geometrization of the volumes. Examples in the Peninsula are the Crucifix of León and the Arca Santa of Oviedo, both pieces related to the sculpture of southern France.

The leaving off of previous traditions leads to the consideration of what Focillon calls "the two aspects of the year 1000," and which has its beginning in the Ottoman empire, with a different accent and new concept of forms, The Crucifix of Compostela, quite rare, must be considered a work of the second half of the XIth century—closer than the cultural hinge of the year 1000—and as an important link between the evolution of forms, within the great Tréveris movement—, with whose art it must be associated in any event. The Crucifix of San Salvador de Serrano also must be assigned to the workshops of the great Compostelan nucleus.

(A.-B.B.)

BIBLIOGRAPHY

Alcolea Gil, S. (1975); Chamoso Lamas, M. (1976); Filgueira Valverde, J.(1959); Grodecki, L., et alii (1963); López Ferreiro, A. (1898-1911).

106
Portable altar
Ca. 1105

Green porphyry, gilded and niello silver
26 x 18 x 4 cm.
+OBB ONOREM: SCI SALVATORIS:
CELLENOVENSIS RUDE: SINDUS: AEPIS:
PETRUS: ABBA: MEIUSSI FIERI, on the forehead.
+ESSE DE CET CLARAM VITAM
VENIENTIS AD ARAM: OFFERAT UT
MITEM POPULI PRO CRIMINE VITE,
on the back side.
Monastery of Celanova (Ourense)

MUSEUM OF THE CATHEDRAL OF OURENSE

The portable altars were used frequently in this period because of the need to say mass in an itinerant manner. They were formed by a central plate of ornamental stone, in this case green porphyry, adorned with a more or less simple frame. This one is wood covered with plates of overgilded and niello designs. The back side shows the theme of the Ascension. Christ is standing and blessing with the right hand, with the Book of Laws in the other, framed by a border with geometric decoration, which is held by four angels placed at the corners. The inscription, which stands out against the niello background, becomes a decorative element that surrounds the scene. On the front side, the frame is decorated with a strip of spirals and birds of prey, and another one inside this with an inscription, after whose last two letters two Kufic signs are inserted which as yet have not been interpreted. With the wooden frame covering the four sides, there are

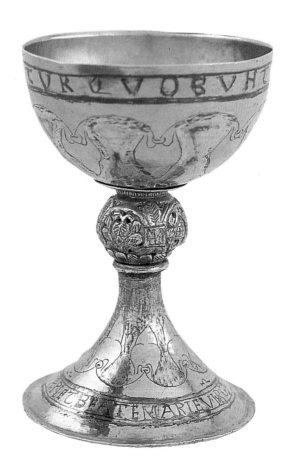

It corresponds to the typology of the Romanesque chalice of strict linear definition of forms, with fairly wide semispherical cup, on a splayed foot of circular base, not very tall, interrupted by a spherical knot.

The foot has the inscription IN NOMINE DOMINI NOSTRI IESUXPI ET BEATE MARIE, framed in lines and engraved decoration of simple plant motifs that tend toward symmetry. On the joint the decoration is much more abundant and technically complex, with round arches on four plant-adorned columns and capitals, which hold bouquets of cut out leaves. The mouth, like the foot, has engraved decoration and the inscription that surrounds it HOC SACRATUR QUO CUNTIS VITA PARAT is framed by very rough characters.

It is said that on the chalice and the paten that accompanies the miracle was verified—miracle mentioned in the Bull of Innocent VIII (in 1497), of the conversion of the Host in flesh and wine in blood, after having been blessed by a presbyter of little faith.

It also also considered related to the legend of the Holy Grail, recreated by Cabanillas in O cabaleiro do San Grial.

(M.L.L.).

BIBLIOGRAPHY
Castillo, A. del (1972); Inventario (1975-1983); Villaamil y Castro, J. (1896)

108
Paten
Second half of the XIIth century

Glossed silver
Max. diameter 9 cm.

SANCTUARY OF CEBREIRO, PEDRAFITA
(LUGO)

Belongs to the same period as the previous chalice. Also of Romanesque work, in which symmetry and simplicity of geometric forms predominate, it is circular, with six lobes constituted by a plate applied to the background and in the center an incised motif which shows the divine hand blessing in the Greek manner.

(M.L.L.)

BIBLIOGRAPHY
Castillo, A. del (1972); Inventario (1975 - 1983); Villaamil y Castro, J. (1896)

plates, also of overgilded and niello silver, with plant and geometric ornamentation of Arabian taste.

Although it is believed that it belonged to Saint Rosendo, the inscriptions which it bears allude to the dedication of the altar to the monastery to Celanova by the Abbot Peter (1090-1118). Comparisons may be established with this work and others of Compostela, specifically, those of the group of metalsmiths from various places, which Gelmírez brought together in the Cathedral during the first years of the XIIth century.

(M.L.L.)

BIBLIOGRAPHY
Marquina, E. (1910-1913); Moralejo Álvarez, S. (1980); Valle Pérez, J.C. (1985)

107
Chalice
Second half of the XIIth century

Embossed and natural silver
13 x 9 cm.
HOC SACRATUR QUO CUNTIS VITA PARABATUR on the mouth; IN NOMINE DOMINI NOSTRI IESUXPI ET BEATE MARIE VIRGINIE on the foot

SANCTUARY OF CEBREIRO, PEDRAFITA
(LUGO)

109
Parish Cross
End of the XIIth century

Gilded copper, enamel, fine stones and crystal
53,5 cm. each arm

CHURCH OF SAN MUNIO DE VEIGA. A BOLA
(OURENSE)

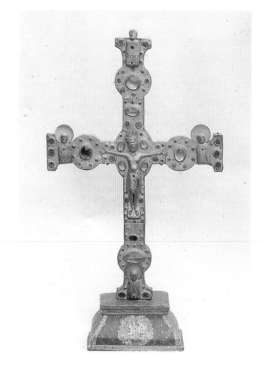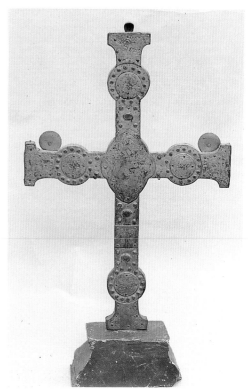

Tace Latin cross composed of thick, flat plates of gilded copper (today repainted with purpurine), applied to a wooden core, with circular expansions toward the ends of the arms.

Great importance is given to the dazzling appearance of the thick stones systematically set onto the piece. Complex techniques are not used for the chaser of the stones, which are simply inlaid. The enamel is integrated as a new decorative element. The figure of Christ is of cast copper in mid relief, with crude modelling. It has a king's crown finished in the front by a small cross. With expressive eyes, it has no beard and bends its head slightly to the right while the body remains rigid and facing frontward. The loin cloth which covers him to the knee has straight, parallel folds, almost without volume. His arms are long and disproportionately slim in comparison with the rest of the body. He is attached to the cross by four nails.

On the ends of the arms are four small figures dressed in tunics and with a prominent halo. They represent the four Evangelists although we cannot identify them individually because they lack attributes.

(M.L.L.)

BIBLIOGRAPHY
Alonso Romero, F. (1981); Villaamil y Castro, J. (1896)

110
Bishop Pelayo's Crosier
PROVENÇAL WORKSHOP
1199-1218

Gilded and enamelled copper with tourquoise
32,5 x 15 x 8 cm.
Ribadeo (Lugo)

MUSEUM OF ART OF CATALUNYA
(BARCELONA)

Bishop's crosier of circular shape finished in a flattened sphere which supports the handle in the form of a volute.

The surface of the crosier is covered with "champleve" enamel, among vermiculated foliage, characteristic of the Lemosine workshops, to which stylized lizards are applied, their tails curving to form a volute. The joint, interrumpted in the middle by a small moulding-plane, shows zoomorphic ornamention composed of a series of lizards which intertwine their tails. A sort of crown surrounds the niche of the handle—also enamelled like the shaft—which has the form of a swirl and ends in a serpent's head. Inside is a scene of the struggle of Saint Michael against the dragon. Both figures are gilded and enamelled. Saint Michael, with disproportionate head and extremities, dressed with a long tunic of detailed folds and large blue ribboned wings, adopts a severe pose when thrusting the lance he holds into the back of the dragon at his feet. The dragon has large wings enamelled in red and blue and a long tail which extends almost to the beginning of the handle, forming another volute.

It was found in the only episcopal burial of the church which, for some years was a Cathedral in Ribadeo. The sepulcher is supposedly that of the bishop of Mondoñedo Pelayo de Cebeyra, who ran the diocese between 1199 and 1218.

Iconographically, it shows the clear message of God as triumpher over Evil, in which the archangel who kills the dragon (which together with the serpent constitute the double apocalyptic representation of the devil). The presence of the lizards may refer to the duty of the faithful to seek the light of this Truth. Theme and symbolism common in the Romanesque period in which this piece is classified.

(M.L.L.)

BIBLIOGRAPHY
Villaamil y Castro, J. (1895).

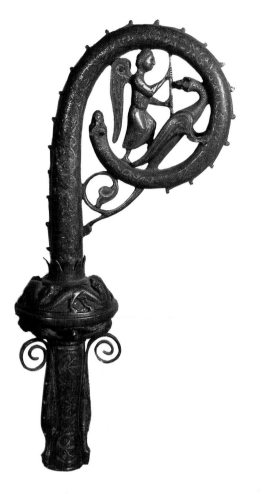

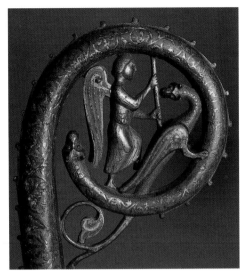

111
Cover plates for a reliquary-coffer
Beginning of XIIIth century

Gilded and enamelled copper
31 x 12 cm. each big plate
Limoges

MUSEUM OF THE CATHEDRAL OF OURENSE

Group of fifty three pieces (incomplete). Seventeen are of larger size and have cast and engraved figures in mid relief, applied with nails to the enamelled background. There are five oval plates of smaller size, six round arches and a column with base and capital, eleven spandrels similar to small towers and five small rectangular spandrels. In the middle, three form corners, a semicircular one, another almond-shaped one and four curved ones which complete the group.

The figures are of very simple modelling, with little volume, and appear in frontal, rigid positions. The heads, with Florentine halos, expressive, with rounded faces, similar to one another, straight nose, hair close to the face, round, protruding eyes with pupils of emphatic black enamel, are characteristic of Romanesque and clear Byzantine tradition. The Saints are wearing togas and the Apostles, dalmatica. The Virgin also appears carrying a scepter. The background has stylized floral decoration of oriental influence, broken by three bands. The upper one, with the character's name, and the other two with a drawing that resembles Kufic characters. A wavy indentation frames the plates. The exception is the figure of Saint Martin, who breaks the stiffness and is more dynamic: he has the expression of the Saint placing his right hand upon the head of the figure kneeling at his side.

It is considered to be an altar piece or coffer who could have contained the relics of Saint Martin of Tours. At the feet of the figure kneeling before the Saint is written: "Alphonse Areri." It is Saint Alphonse Aredio or of Yriek (locality near Limoges, where he was from), son of Saint Paconia, Bishop of Ourense in the XIIIth century and possible donor of this work. A devout follower of Saint Martin, titulary of the Cathedral of Ourense, he ordered in his will that several enamelled altar pieces be made in Limoges for churches dedicated to this saint.

(M.L.L.)

BIBLIOGRAPHY
Gallego Lorenzo, J. (1949); Martín Ansón, M.L. (1984)

112
Crystal Cross
End of XIII century (later reforms)

Embossed silver, quartz, enamel, painted
parchment
23 x 15 x 14 cm. base; 100 x 28 cm. cross
Convent of Santa Clara of Allariz (Ourense)

MUSEUM OF SACRED ART. ALLARIZ
(OURENSE)

Three kneeling angels and a stem finished in
an embossed band are set on the base of
pyramidal trunk. Above is the joint, formed by
a crystal polyhedron. From the upper part of
the base two curved stems grow, supporting
two figures, and in the inner space they form,
there are two other smaller figures. Here the
cross of Latin form and ends with fleur-de-lis is
set, its upper portion broken and the pieces
held by a silver setting. The base is decorated
with a series of painting in distemper on gilded
background, protected by crystals. Five are
placed about the sides of the pedestal, a larger
central one and four smaller ones on the sides.
The front one shows the Ascent of Christ in the
center, Saint Lucia, Saint Catherine, Saint
Simon and Saint John, Saint Jacob and Saint
Philip on the sides. On the other side, the
Transfiguration in the middle, Saint Jacob,
Saint Thomas, Saint Lucas and Saint Matthew,
Saint Peter and Saint Peter on the sides. On the
third size, Christ crucified, between the Virgin,
Saint John, the sun and the moon, and on the
sides, Saint Nicholas, Saint Basil, Saint
Thadeus and Saint Thomas, Saint Bartholomew
and Saint Andrew. The stem, adorned with
elongated arches of ogival shape, is finished off
with a band in relief that has eight small
figures of seated prophets, all bearded except
for one. On the corner plates of the base,
holding the stem, there are three kneeling
angels, of which only one has the original
wing. On the curved stems, the Virgin with a
book and Saint John. At their base is the scene
of Christ's arrest. Inside the stems, on flame-
shaped bracketts, there are small figures with a
crown which probably represent the persons
who paid for the work or perhaps the new
setting. Two tiny standing figures flank the
head of the cross, and are set over the upper
points of the plate that covers the crossing.
Christ, held by three nails, is very bent over.
His hands are exaggeratedly large and his arms
disproportionately long, with the head inclined
forward, crowned with thorns and a loin cloth
tied on the right side, covering him above the
knee.

It appears to be one of the crosses left by
Queen Violante, wife of the Wise King, in her
will, donated April 11, 1292, and which
perhaps formed part of her chapel given to the
convent. If the cross is the one mentioned in
the memorandum-book, undoubtedly its
settings and adornments were reformed a
couple of centuries later. On the other hand, the
enamels could have been done at the end of the
XIIIth century and possibly belonged to this
queen.

(M.L.L.)

BIBLIOGRAPHY
*Chauncey Ross, E. (1933); Martín Ansón, M. L.
(1984); Villaamil y Castro, J. (1907).*

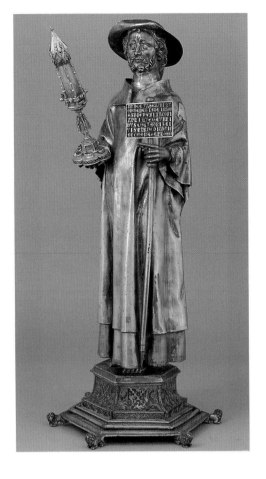

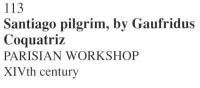

113
Santiago pilgrim, by Gaufridus Coquatriz
PARISIAN WORKSHOP
XIVth century

Glossed silver, parts in gold and enamel.
53 x 24 x 24 cm.
IN HOC VASI AURI QUOD TENET ISTE
IMAGO EST DENS B(EAT)I IACOBI
AP(OSTO)LI QUE GAUFRIDUS
CONQUATRIZ CIVIS PAR(ISIENSIS) DEDIT
HUIC ECCLESIA. ORATE PRO EO.
Cathedral of Santiago de Compostela

CHAPEL OF RELICS. CATHEDRAL OF
SANTIAGO DE COMPOSTELA

The cathedral inventory of 1527 gives a description of the precious statue: 'Image of Lord Santiago, of silver, completely gilded, which has a veryl in the right hand in which one of his teeth is set, and in the other hand a pilgrim's staff, and on the head of the staff a tablet of enamelled letters and beneath the foot of the veryl six stones of various colors are set... on the head is a hat of silver, completely gilded, and the foot is of enamelled silver'.

The modillion gives the name of the donor, a citizen of Paris, identifiable as Geoffrey Cacatrix, treasurer of Philip IV the Fair in 1301. It is a votive offering, one among many made by those who left us some pieces of singular importance. The tooth, which disappeared in 1921, was replaced by another bone relic of the Apostle.

With characteristics still representative of the iconography of an apostle (long tunic and bare feet), Santiago appears transformed in pilgrim: closed greatcoat with open sleeves and attributes such as the game-bag, staff and scallop shells engraved on the hat with spherical crown and broad brim. It is a "jacquaire." The image must have been at the head of the representations of this hybrid type, pilgrim apostle, which appears in slow evolution in the XIIIth century. It must have had the sword symbolic of martyrdom in the right part—the pendent still exists—which would complete the typology representative of the iconographic period.

It is an exceptional piece of French Gothic metalwork, with perfect technique. The hands, feet and head are cast. The beautiful face is a singular portrait, of the purest naturalistic idealization, with well drawn eyes, framed by a heavy brow and arched eyebrows; the beard sways in curly locks, widening beneath the rounded cheekbones to join the rhythmical moustache that frames fleshy lips and reaches the chin in two sections of rumpled spiral curls. A lock falls across the wide forehead, separating the curly hair with its great swirling waves, which frame the face, and is pulled back behind the strong neck. The body is perfectly revealed beneath the elegant garments, of tin molded in ample shapes, with soft folds and angles at the upper neck, lapels, and sleeves. It is an

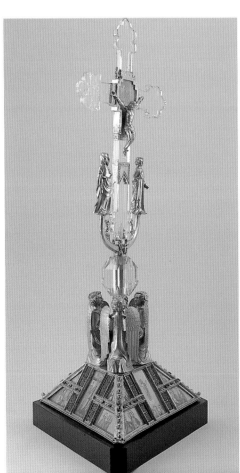

upright figure, resting, but with restrained force and expressive visage.

The "vas auri" is a reliquary in miniature (8 cm.), in the form of a small tower, with delicious thirteenth century architecture.

The hexagonal pedestal rests on lions lying at the corner plates and is decorated with sectioned plates enamelled in blacks, burgundies, and reds, in representation of the bird associated with the title of nobility.

(A.-B.B.)

BIBLIOGRAPHY
Filgueira Valverde, J. (1959); Huyghe, R. (1966-67); Steppe, J.K. (1985)

114
Bust-reliquary of Santiago Alfeo
RODRIGO EÁNS ?
1332

Glossed silver
74 x 51 x 30 cm.
SI A VOUS NE PLAYST AVOYR MESURA
CERTES IE DI QUE IE SUY SANS VENTURA
Cathedral of Santiago de Compostela

CHAPEL OF RELICS. CATHEDRAL
OF SANTIAGO DE COMPOSTELA

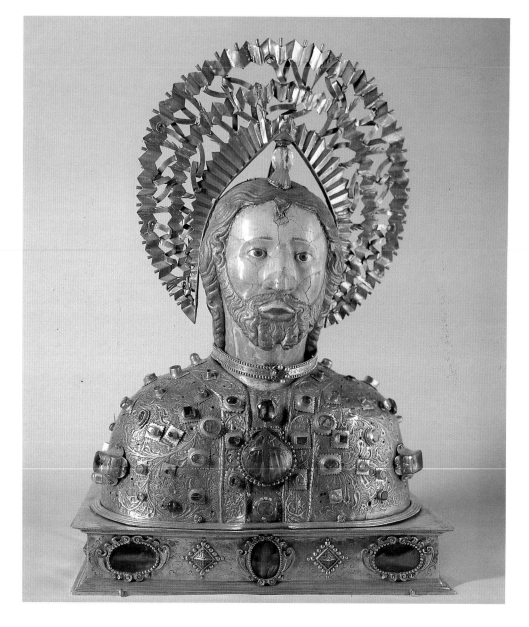

The 'caput argenteum' is the most famous of the reliquaries 'of the Composelan treasure'. It contains the head of Santiago the Younger, the Bishop-Apostle of Jerusalem, where he suffers martyrdom and whence it is brought, in 1108, by the enigmatic D. Mauricio Burdino (later Anti-Pope Gregory VIII). Doña Urraca acquires the relic and gives it to D. Diego Xelmírez, who, as object of a special cult, deposits it in a gold coffer in 1116. The Archbishop D. Berenguel de Landoire ordered the bust to be made, bearing it personally in the Christmas procession of 1322. The Compostelan reliquary does not have antecedents in Germany nor Rome. Through the centuries it gained in richness.

The bust is of engraved silver, the face and neck, enamelled with bright colors. In spite of a few flaws and its hieratism, it is a beautiful face with a frontal, fixed gaze and expresssive lips, with golden hair and beard, curly locks and rhythmic moustache, intentionally giving the impression that it is alive, inviting the trusting intercession.

The golden cape which covers it is of good technical quality, repoussé with designs of large branches and thistle-shaped leaves, in symmetrical formations of wide twisted swirls and a sharply outlined perimeter. The stylized hood hangs down the back, decorated with five elongated scallop shells.

The luxurious decoration is enriched with various gemstones and jewels through the centuries,

especially at three moments: the rich stones of Landoire; the Greco-Roman gems of the ring collection of the humanist archbishop D. Juan García Manrique, who offers them to the Apostle. It is a glyptic series identified with the account of 1388. It is comprised of two helenistic cameos and five intaglios, in addition to other stones. The sphere and the blue scallop shell on the head, and the quartz shell with the cross of Santiago on the chest (1426), are joined to the curious halo of guilded silver, formed by three folded ribbons which are joined to waiving belts, perhaps a gift of the guild "of the beltmakers". The series of rich stones, some of large size, set in decorated unpolished rubies, and the magnifying glass that hangs from the back are related to the Classicist renovation of the reliquary—passage

from the XIVth to the XVIIth century—, when the pedestal for relics is made along with the velvet canopy with alternate plates of stars and rosettes, on four columns, ending with a Baroque moor-slayer Santiago. The little street lamps of Rococo style are by Antonio Moreiras of Portugal.

On the neck we find a gold bracelet with the French legend by the famous Suero de Quiñones, who donates it to the Apostle in his pilgrimage to Compostela, after the incident of the "honorable passage" of the bridge at Orbigo. The piece with pearls of the bracelet is related to the cross with pearls in the Catedral, from Paris.

Metalwork flourishes during the century, since it has the protection of the archbishops and good group of metalcraftsmen, organised in an important guild. The work in the area of the basilica and have left us

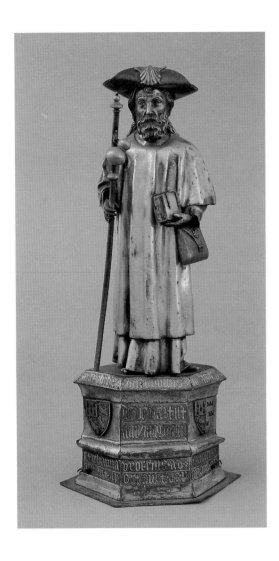

The image appears registered in an inventory of 1426: "Completely gilded, with a pilgrim's staff, and esparto-grass basket, and white hat, and and its gilded book in one hand, and it stands on a base with two escutcheons.

The monumental base, of gilt copper, is hexagonal and very simplified, divided in two parts by wide moldings which carry the noble coats of arms and the legend of the donation: 'Dederunt istam imaginem nobilis vir Dominus Johannes de Roucel miles de regno francie et Johanna uxor eius ad honorem dei et sancti Iacobi de Gallaecia et ego Johani aportauit de Parisius ex parte prefati Domini. Orate pro eis.'

Within the tradition of the Parisian workshops, and with many characteristics which lead it to resemble the Santiago of Coquatriz. It is a beautiful piece of gilded silver, with good embossing technique in which one sees the stylistic evolution of sculpture.

On the Apostle's tunic, which reaches the feet, is an over tunic, short and with loose sleeves, hanging to the elbows, both fall in wide folds of deep undulations.

The face, peaceful and dreamy, looking fixedly into the distance, is distinguished by its good modelling. It shows a large, rounded beard of loose, curly locks, and a large moustache, in rhythmical Ses, which frame a deep-set mouth. There is an intentional search for chiaroscuro. The long hair is pulled back. It is an authentic portrait, of sensitive realism, full of life and will, which represents an older, short man, in a classical moment of Realism.

The gourd is added to the already recognized symbols of the Jacobean pilgrim (wide-brimmed hat, fold in half-moon shape with the scallop shell bearing two crossed staffs, rounded shepherd's pouch with buckle and shell, book in the hand, and staff), with which the Apostle is equipped in the iconography at the end of the Middle Ages; for this purpose there is a hook to hang the gourd.

The image probably arrives in Santiago a little before 1426, and shows the characteristics typical of the stylistic moment.

The coats of arms are of the husband and wife and have a diamond shape around them (Gothic). The one on the right is divided, with the upper left quarter with ermines enamelled in black on silver fields; the other three quarters are occupied by a bird, in each one on a field of gules. The one on the left is divided, with the upper left quarter with ermines and the lower one with two birds on a field of gules. The right hand part is occupied by three crowns (?) in black on a gold field.

(A-B.B.)

BIBLIOGRAPHY
Alcolea Gil, S. (1958); Filgueira Valverde,J. (1959); Steppe, J.K. (1985).

pieces which show great technical perfection and exquisite artistic taste.

The work is considered to be from Compostela, attributed to Rodrigo Eáns, the cathedral's silversmith. The study of the hair with the lock falling over the forehead, the beard and moustache in rhythmic "S" forms, must have had in mind the Santiago pilgrim of Coquatriz, which reinforces the identification with the workshop of Eáns, which, could have seen the French work.

(A-B.B.).

BIBLIOGRAPHY
Alcolea Gil, S. (1958); Castellá Ferrer, M. (1609); Filgueira Valverde, J. (1959); Filgueira Valverde, J., Blanco Freijeiro, A. (1958); López Ferreiro, A. (1905); Villaamil y Castro, J. (1907).

115
Santiago pilgrim by Johannes de Roucel
PARISIAN SCHOOL
First quarter of XVth century

Overgilded silver
48 x 18 x 21,5 cm.
DEDERUNT ISTAM IMAGINEM NOBILIS VIR DOMINUS IOHANNES DE ROUCEL MILES DE REGNO FRANCIE ET IOHANNA UXOR EIUS AD HONOREM DEI ET SANCTI IACOBI DE GALLICI ET EGO....
Francia

CHAPEL OF RELICS. CATHEDRAL OF SANTIAGO DE COMPOSTELA

116
The founders of the Mendicant Orders
VICENTE FLAMENCO ?
XVth century

Overgilded silver
62 x 27 x 27 cm.
Santiago de Compostela

CHAPEL OF THE RELICS. CATHEDRAL
OF SANTIAGO DE COMPOSTELA

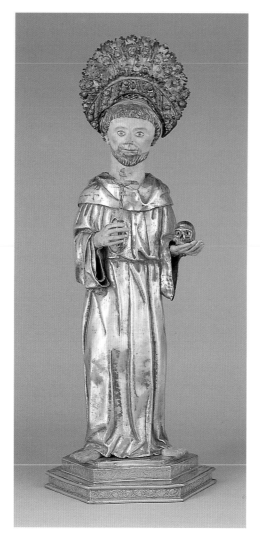
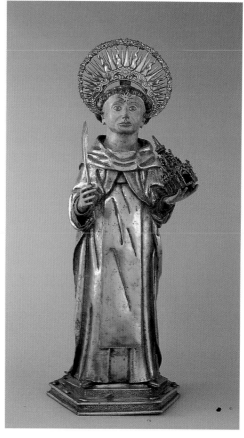

The images of Saint Domingo and Saint Francis of Assissi pertained to the series of ten small statues of the oratory of the archbishop D. Lope de Mendoza (1399-1445), of which five are preserved, to which must be added the Virgin of the Lily and the Santiago of D. Alvaro de Isorna, as well as those now disappeared of the Archbishop Luna (1451-1460), reaching thirteen, reserved "for solemnizing and adorning said church and for the main altar of said Apostle Saint", and placed on the "pyramid" of the baldachin, work of the silversmith Juan Da Viña (after 1464). They form the Compostelan series of a brilliant period of metalwork in Santiago images, with a numerous presence of Galician silversmiths, such as Diego Eáns, Pedro Martínez and Juan Da Viña, and foreigners, among which are Francisco Marin, Italian, Pedro (French), and Vicent Framengo. To those pieces must be added the donations by pilgrims, such as the Santiago of Roucel.

This is the artistic environment in which these two twin images are born, made in the same workshop. Of embossed and gilded silver, the flesh is colored with cold enamelling. The bases, hexagonal with two steps, are decorated in front with a simple engraved plant border and with rough oval rubies. The clothing, pertaining to the order, are distinguished by their elegant treatment, with wide folds which break over the base; the body is modelled under the fabric.

The heads are a spiritual study of the characters, of delicate features, with the face of Saint Francis standing out: a fixed and dreamy gaze, wide cheekbones, sparse beard and moustache, following the oval line of the face and with hair cut of straight, individualized strands.

Both founders bear their own symbols. Assissi "The Poor" has the crucifix and the skull, stigmata in hands and feet: he opens his habit to show the wound in his side and, now that the statue is missing the seraphin with light beams, it preserves the complicated aureola of the period. Saint Domingo has the features of the star on the forehead, the quill pen, and the Church in his hands; the halo is from the XVIIIth century.

The intellectual aristocratism of these figures is associated with the lack of thinness. They are short and robust: spiritual and plastic Realism, swollen with mysticism.

The architecture of the Gothic temple which Saint Domingo holds stands out; it has a tall square tower in the transept, polygonal apse and buttresses in bands, very typical of the Low Countries. These two statues could be attributed to the workshop of Vicent "Framengo", native of the country of the apogee of the great mystics, Kempis and Gerson.

(A.-B.B.)

BIBLIOGRAPHY
Alcolea Gil, S. (1975); Caamaño Martínez, J.M. (1960); Filgueira Valverde, J. (1959); Huyghe, R. (1966-67); López Ferreiro, A. (1901)

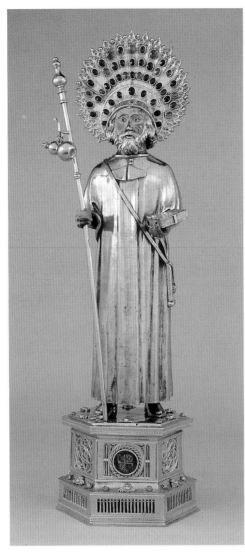

117
Santiago pilgrim of D. Alvaro de Isorna
FRANCESCO MARINO.
SCHOOL OF COMPOSTELA
XVth century.

Glossed and enamelled silver
73 x 21 x 21 cm.
"F" and "M". EN ESTE LIBRO AY DE LA
VEISTIDURA (sic) DE NRO. PATRON SANTO
Cathedral of Santiago de Compostela

CHAPEL OF RELICS. CATHEDRAL
OF SANTIAGO DE COMPOSTELA

The statue is described in the inventory of 1537:
'Of silver, totally gilded, with crown on the head, in
the right hand it holds a staff and in the left, a book;
it is on a pillar, with a small coat of arms of the
Archbishop Isorna (1445-1449).

The image corresponds stylistically to the first
half of the Xvth century. It is wearing an overtunic
of wavy parallel folds, which begin to shorten and
do not reach over the base. The neck is buttoned
and the lapels stylized, with warped rounded forms.
It opens on either side in wide folds, reaching the
elbows, and shows the tunicle of narrow sleeves
with button closing. The strap of the shepherd's
pouch crosses the chest, and hangs on the left side.
The tunic, with pleasantly rounded forms, is
bordered with spheres and graceful elongated
scallop shells at the ends. All the clothing is
decorated with floral designs of four-lobed rosettes
and with shells on the trim. It is wearing graceful
pointed sandals with scallop shell and buckle.

It is wearing the insignia of the Jacobean
iconography: staff with gourd, book (to hold the
relic), pilgrim's cloak, close-fitting cap on the head,
with shells, and a large crown of eccentric strips
with gemstones. All these pieces are from the
XVIIth century, but are probably from that period.
Thus, the cap, which extends behind, is similar to
that of the stone Santiago of the Clock tower. But
not the cloak, which it must not have had, like its
French contemporary, the Santiago by Roucel, since
like the latter, it is wearing an overtunic that is a
long pilgrim's cloak.

The face is marked by the realism of the period.
It seeks to accentuate the features, with hair, beard,
and large moustache of straight, parallel locks that
give a serious expression of an older person,
pleasant and somewhat spiritual.

The base is intended to be monumental.
Hexagonal in shape, it is composed of two sections.
In the first, of combined and dense moulding, there
is a row of spheres and a frieze of small carved out
windows in series. A bevel surrounds it and leads to
the second section, of broad frieze and with square
panels and rebate moulding and decorated with
large flame-shaped rose windows. In the front there
is an attractive coat of arms of Archbishop Isorna,
flanked by small geminated windows. Inscribed in a
double corded ring, in a circle of green background,

it has a rectangular form with round background and quartered field, with the alternation of five red bars set obliquely, piercing leaves of black niello, on a field of silver, and with five fleur-de-lis on a black field.

The enamel is translucent, with bright color, very much associated with the Italian schools. It is from Compostela, from the Italian workshop of Francesco Marino, whose initials are found on the mould, showing a certain similarity with the pieces which are assigned to him: the Virgin of the Lily, Saint Peter, Saint John the Baptist, and Saint Andrew.

(A.-B.B.)

BIBLIOGRAPHY

Filgueira Valverde, J. (1959); Huyghe, R. (1966-67); López Ferreiro, A. (1905)

118
Virgin of the Lily
FRANCISCO MARINO ?.
SCHOOL OF COMPOSTELA
XVth century.

Engraved and glossed silver
76 x 27 cm.
"Lignum Domini est intun"
Cathedral of Santiago de Compostela

CHAPEL OF RELICS. CATHEDRAL
OF SANTIAGO DE COMPOSTELA

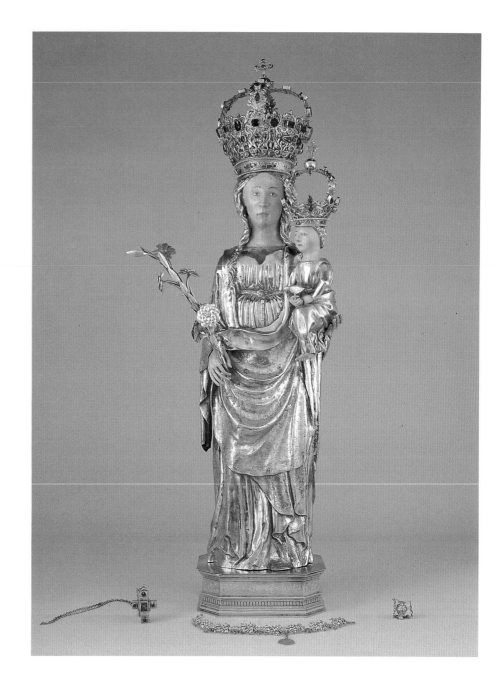

The image is listed in the inventory of the Cathedral in the XVth century, described as "an image of Saint Mary with her son and her lily in the hand and with a silver and irregular pearl crown, completely gilded." It must have acquired by the cathedral chapter to place in the main altar and to be taken out in certain mitered processions. This sculpture heads the series in the cathedral formed by a Saint Peter and a Saint John the Baptist and a Saint Andrew from the same workshop.

The base is rectangular, with beveled corners. It is formed by two strips amid groups of small mouldings of sharp profile, decorated with a row of small windows, the lower strip, with a nail head design, and the upper strip is engraved with prominent thistle-shaped leaves. Its shield is missing.

The slender carved work is wearing a smooth tunic, square-necked, with a border of multi-lobed tiny leaves and high waist, with a buckled belt. The tunic, of tiny puckers, falls in wide breaking folds over the pointed slippers. The back of the mantle reaches the base, and the front is crossed to wrap the Child, lifted above the left arm. In this manner it forms the classical Gothic composition of large waves, with silken fabric qualities falling in fan shape into multiple pointed folds. In contrast with the tunic, it is decorated with a delicate design of engraved bouquets, tendrils forming

wide circles, with schemtaic tiny leaves and grape clusters. The trim is bordered with fleur-de-lis.

The Child is wearing a tunic and a short overtunic, tied with a belt, and holds a small bird in his hands.

The Virgin's face is oval, with regular, fine features, small, profoundly expressive eyes of deep glance, although their realism is picturesque in certain details.

The present day crowns are from the XVIIth century, and the bouquet of lilies is from the XVIIIth century. A silver cross, with arms of equal size, sectioned off with crystals, is from the XVIth century.

The figure wears a modernist jewel at the neck, in which crowned "A" and a delicate bouquet of tiny flowers alternate, gift of Alphonse XIII on his trip to Santiago. A gold coin of Philip II hangs from this

piece of jewelry. Another chain bears a small jug from the XVIth century. The image of the group of Saint Peter, Saint John the Baptist and Saint Andrew shows the change in sensitivity in the cultural and aesthetic transition which is taking place at this time. It may be attributed to the Italian metalsmith Francesco Marino, who was in the service of D. Lope de Mendoza, and is in the same line as the Santiago of D. Alvaro de Isorna, piece signed by this artist.

(A.-B.B.)

BIBLIOGRAPHY

Alcolea Gil, S. (1975); Filgueira Valverde, J. (1959); López Ferreiro, A. (1905)

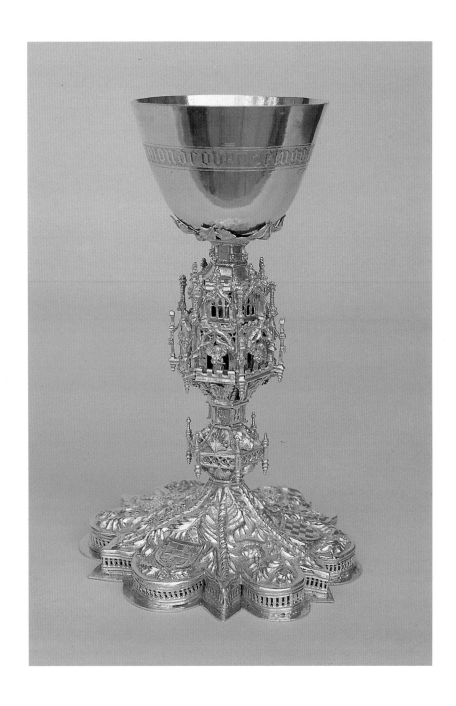

119
Chalice from Vaamonde
1462

Embossed silver
35 x 19 cm.
ESTE CALYCE DYO DON GARCIA DE
VAAMONDE OBPO DE LUGO A EST IGLIA
(On the upper half of the cup)
Valladolid

MUSEUM OF THE CATHEDRAL OF LUGO

Star-shaped foot with smooth edge and vertical border with open-work transoms, with six alternating lobes with triangular points. The stem is formed by two hexagonal knots, the main one with two bodies at intervals ending in a casquette. A scant embossed plant base holds the cup.

On the lobes of the foot, decorated with embossed thistle leaves, three shields with the chekered coats-of-arms of the doner are applied. On the border of one of these lobes is his second last name in Gothic characters. The first knot is prismatic in relief, with transoms, pinnacles, and plant decoration. The main knot of architectural structure is also relievo-work, with an arcade at each side sheltering an angel that bears an attribute of the Passion. He brings together the secondary elements, such as pinacles, flying-buttresses, etc..., in great detail but lost in the overall vision.

It was given to the Cathedral in 1462 by Bishop of Lugo Don García Martínez de Vaamonde, who governed the see between 1440 and 1475. Chamoso notes the early date of its execution in relation to the decoration used, more typical of the late Gothic architecture. Because of its style and manufacture, it must be attributed to a workshop from Valladolid (Brasas).

(M.L.L.).

BIBLIOGRAPHY
Brasas Egido, J.C. (1983); Chamoso Lamas, M. (1984); Vázquez Saco, F. (1953); Villaamil y Castro, J. (1892)

THE SPLENDOR

GALICIA IN THE XVI-XVIIIth CENTURIES:
THE HISTORICAL CONTEXT

Pegerto Saavedra Fernández

The half century between 1470/80 and 1520/30 constitutes a fundamental stage in the History of Galicia, since the political and social changes which are produced in that period are going to profoundly condition all the Modern Age, period that ultimately takes place within the frameworks then created or at least reorganized. In this respect, the changes that the Catholic King and Queen carried out in the Government of Galicia and in the balance of the different social groups can be evaluated from different viewpoints and even discovered—and in ancient and recent historiography there are indications of this—, but no one, neither in the past or the present, seems to doubt their transcendence.

The society which emerges in Galicia when the governing methods of Isabella and Ferdinand bear all their fruit—which does not really occur until the decade of 1520—is not, in comparison with the medieval society, completely new, but it contains important elements of a novel sort, whose slow development will end up giving this society some of its fundamental characteristics. Until the decade of 1470 the emergence from the low medieval crisis does not begin in Galicia. The crisis is prolonged and profound, since it lasted from the beginning of the XIVth century and was seen in the numerous social conflicts we have news of, which culminated in the great Irmandiña war of 1467-69. Although the lay and ecclesiastical aristocracy had managed to gain control over the rural and urban groups which had rebelled, the victory brought no peace. The triumphant sectors had managed to avoid immediate shipwreck—which was not a small thing, by any means—, but they couldn't overcome the great endemic difficulties that affected them. With the Irmandiños defeated, the nobles returned to their continuous and intricate conflicts, described by A. López Ferreiro, S. Portela Pazos and J. García Oro. Thus the situation of Galicia was again similar to that prior to 1467, although the lords had been warned and made to feel fear.

In this period characterized by instability and division, the Galician nobles had to face the civil war that was produced in Castile with the death of Henry IV (1474). Today it appears to have been shown—such is at least the authorized opinion of Prof. José García Oro—that the majority of the nobility, lukewarm in the beginning, soon leaned—although with different enthusiasm—toward the Isabeline side. The only exception of importance would be the famous count of Caminha, D. Pedro Alvarez de Soutomaior (married to the Portuguese Dona Tereixa de Távora) and in a later period—since in the beginning he was with the Isabel-Pedro Pardo de Cela faction. But the support for the winning side did not free the great leaders of some political methods which at first were not very pleasant for them, used as they were to acting freely, like small kings, with no other impediments than those they could pit against one another. The nobility had to go along with political submission, from then on only shaken sporadically, in moments of crisis of the monarchy. Soon the new situation of unquestionable dominion of the monarchy would begin to be accepted as inevitable, and even desirable, by part of the old aristocracy.

The politico-military control of some warring nobles living in frontier regions, used to their "broad freedom," set in rocky castles and with small armies of their own, was achieved

by the monarchs after 1480—once they were assured the throne—, by means of the implantation of the Santa Hermandad and the sending of Acuña and Chinchilla, with especial powers which did not remain as mere words on royal decrees. The repressive tactics, among which the decapitation in Mondoñedo of Pedro Pardo de Cela stands out, came one after another in the decade of 1480. The monarchs came to the Kingdom of Galicia in the fall of 1486, and this visit is linked to dispositions relative to the sanctuary of O Cebreiro and the creation of the Royal Hospital of Santiago, as well as others relative to the reform of the regular clergy and the departure of the nobility for Granada, where the Reconquest was about to end.

However that may be, the great nobility had to accept politico-military submission, which included the giving up of indiscriminately using private armies, many fortresses were torn down, if they hadn't been already by the Irmandiños, although those which were used for defense from an "external enemy" did not lose their functioning. But the nobiliary concessions had considerable counterparts. One of these is the certainty of collecting loans which the peasants had rejected with repugnance. If during the crisis of the Low Middle Ages the confrontations between lords and peasants had been violent, the first having to turn to their own armies, now the Royal Audience, collegiate tribunal which arises from the evolution of a government with repressive powers personified in Acuña and Chinchilla, takes charge of resolving the many conflicts relative to the payment of income of very diverse sorts, the majority of which are kept active. As the Kingdom is pacified, the role of the Audiencia as organ of control of the noble and local powers and also organ of arbitration in the battles between Counsillors and nobles, grows. As A. López Ferreiro said, arms give way to togas, which signifies that the role of burocracy within Galician society begins to be decisive: not only that of the burocracy tied to the Audiencia—oidores, relatores, lawyers... which will end up characterizing the city of A Coruña, to where the Royal Court is transferred at the end of the sixteenth century—, but also of the scribes and lawyers which in the middle of the XVIth century are abundant in the cities and towns of Galicia, some of which will give way to important noble houses (R. Villares). It is not an accident, therefore, that there is a concern for teaching shown already at the end of the fifteenth century by Diego de Muros III, Lope Gómez de Marzoa or Fonseca himself; in the new political situation the knowledge of canonic and civil law was fundamental.

The nobility definitely conserved its financial patrimony (except for that usurped from the ecclesiastics), whose defense corresponded to a group of petty lawyers. On the other hand, the participation in "businesses" of the monarchy allowed the bosses of the great houses to diversify their sources of income and even, to some extent, increase their influence, by their very proximity to the king. The consequences of the "Exile" of the representatives of the great houses have been underlined on numerous occasions. The old lay aristocracy would lose all ties with Galicia, and the Kingdom having lost its "natural lords," Galician society would be beheaded; much income would be invested in the Court, when if the counts had resided in their places of origin, their patronage would have been felt, particularly in palatial constructions similar to those in some Castilian cities. If there is much truth in this, it is necessary to remember that the noble unrootedness is progressive; the lay lords not only conserve their patrimony in the Kingdom (foral rents, income from tithes, faculties of provision of trades and presentation of curates), but also some counts—that of Lemos, especially; also those of Andrade and Monterrei—play an important role in Galicia after the death of the Catholic Queen at the end of the War of the Communities, and, moreover, even residing in the Court, in embassies, viceregalties or in other positions of service to the monarchy, many members of the great noble houses of Galicia did not break entirely with the numerous ties that bound them to their lands, as is seen in the facility in the various foundations, such as the College of the Jesuits in Monterrei, from the middle of the XVIth century, or the "College of the Cardinal" in Monforte, from the end of this century. Without the patronage of certain families of the old aristocracy some important artistic productions cannot then be explained. Monforte in this respect constitutes the most genuine example, owing to the visits of the counts, or to retreats which hid exiles from the Court, as happened to Pedro Fernández de Castro, secluded in the town at the end of the decade of 1610, occupied in attending different religious and theatrical play festivals and in writing El Buho Gallego con las demás aves de España haciendo Cortes (The Courtship of the Galician

Owl and the Rest of the Birds of Spain), a small work in which he defended that "Galicia, my country, is the best of Spain, because it is the end and beginning of this head" (X.R. Barreiro). Until well into the XVIIth century the patronage of old lineages was felt in some points, particularly in religious foundations, not in civil constructions. This, together with the reform of the regular clergy—and later the secular—, would decisively affect the various artistic creations that are carried out from the end of the fifteenth century.

Another measure of great transcendence, impelled by the monarchs at the end of the XVth century, was the reform of the regular clergy, whose communities were passing through a period of profound material and moral prostration. Beyond their religious range, the monastical reform appeared to the monarchs as necessary for pacifying the Kingdom. While many ecclesiastical incomes were collected by lay nobles, this was not only due to the use of violence, but also to the family links between the abbots and abbesses and the local nobility. It was therefore hard to change the economic administration and the manner of life within the temples if these continued to be governed perpetually by second born of noble lineages. The fact that the reform was so bumpy—with the use of force needed to enter the women's "bunkered" convents—this is because the small reigning nobility gave military aid to the religious men and women, from whom in exchange they demanded a change in lifestyle that was too brusque.

The monarchs resolutely supported the reform of the Benedictine order and the Cister, which in Galicia were very powerful. The numerous tiny temples spread throughout all the Kingdom and in which there were rarely more than four nuns—and at times just one—were eliminated, with the excuse that there were perpetrated and committed, in words of a zealous Castilian monk, "great and abominable sins and blasfemies of God Our Father and his blessed Mother (...), in great disdain for them and for our glorious father San Benito and for all our Holy Religion and congregation" (G. Colombás). In the midst of great difficulties, the nuns were concentrated at the end of the XVth century in San Paio, whose building, belonging to the monks of San Martiño—, was readapted and whose patrimony was much increased upon adding the incomes of various small temples which were eliminated (reduced later to the condition of "priorates" or "graineries"). Such measures in the long run meant the foundation of a new Benedictine monastery, which was to be the most powerful in Galicia amng those for women and which would hold between its walls the daughters of the most illustrious reigning nobility. In general, all the religious convents, of old or new founding, were a place of retreat of damsels of noble lineage in Galicia, to whom it was not possible or desirable to propose marriage, but no convent could compete with San Paio, neither in income nor in the noble quality of the nuns.

The incomes from other small temples were added to San Martiño, transformed in this way in to the major masculine community of the Kingdom. The Benedictine monasteries would enter the congregation of Valladolid, and those of the Cister in that of Castile. The incorporation was produced gradually: in the case of the Cister, for example, Sobrado enters in 1498, Penamaior in 1505, Melón and Monfero in 1506, Meira in 1514, Montederramo in 1518, while Oseira does so in 1549, and in the following years, Xunqueira de Espadañedo and Oia. The incorporation meant admitting the constitutions of each congregation, the agreements of the general chapters and the orders—very concrete in the Benedcitine case—of the Inspectors. The constitutions and visits meant a notable control, both in the form of exploitation and administration of the patrimony as well as that related to the major and minor works. The abbeys stopped being perpetual and monks from outside Galicia invaded the masculine monasteries of the Kingdom, keeping the local nobility from occupying them, protected in the church chapters of cathedrals and collegiate churches and in the best parishes. With the crowd of foreign friars and burocrats, Spain received a decisive push in the area of writing. the economic situation of the religious institutions improved spectacularly by the fiscalization of the superiors and Inspectors of the orders, because of the break of the family links between the abbots and the local nobility, because of the dispositions of the Crown which forced the nobles to return the goods they had in their charge to the ecclesiastics and because of the reinvestment itself in the agricultural and demographic situation.

In the reform of the regular clergy carried out at the end of the XVth century and beginning of the XVIth we find the immediate origin—the mediate one would have to be

sought in the foundations and donations themselves—of the already familiar economic and social power of the monasteries in Galicia, some of whose constructions even today, after many avatars, cause admiration. In this sense we must taken into account that the "Galician Church" was basically secular, given the number of members in the ecclesiastical estate. The regular ones were scarce in comparison with those in the crown of Castile, but this scarcity was based on the small number of mendicant foundations, very tied to the advanced phases of the Reconquest and the thrust of urban life. In contrast, the oldest orders, mostly rural, were well represented in Galicia. Thus, according to the census of 1591, in Galicia lived 10% of the population of the Castilian crown, but more than a third of the total of Benedictines and Cistercians of the Castilian crown lived in Galician houses (and in the province of Ourense alone 16% of them), thus the importance of the Cistercian monasteries of Galicia and the internal struggles of the Congregation of Castile. The regular Galician clergy is therefore numerically weak, but has a great agrarian wealth because of the strong concentration of Benedictine monasteries and the Cister, much benefitted by the reform which the Catholic King and Queen promoted.

The measures taken regarding the nobility and regular clergy in the last fourth of the XVth century reinforced the role of the Church within Galician society, and allowed the ascent and consolidation of the nobility, which will partially occupy the role of the old aristocracy and will keep close family ties with the convents of nuns and the secular clergy that was better off. But overcoming the long medieval crisis—with a new balance among social groups—was not due only to measures of the political sort. It was also possible through an agricultural and demographic recovery of which there are solid indications at least from 1480 on (P. Saavedra). Around 1460-90 in various regions, there is evidence of nearly abandoned villages, parishes with a ridiculously small number of people, uncultivated lands... The situation is not much different in the urban world, although the populations of the coast appear to have resisted the crisis of the XIVth to the XVth century well, and the mercantile trade with the North and the Mediterranean was sustained. In fact, the people of the end of the XVIth century were convinced that wealth in Galicia was located in the western area, and most particularly, in the urban centers (F. Ferreira).

The agricultural and demographic restoration made a slow humanization of the landscape and greater amounts of sociability possible, by increasing the number of parishioners in the parishes. It also made the increase of income of the privileged classes possible, as they could then begin new constructions. Until after the XVIth century, the Galician economy, rural and urban, appears in expansion and open to exchanges, benefitted by the development of Atlantic trade. Through the exportation of fish, wine and wood, and through emigration itself, close ties are established with Lisbon, Seville, and through these metropoli, with the Indies. The treasuring which at the edge of 1600 is seen in the Churches and noble houses is related to the arrival of American metal (O. Gallego). Likewise, commercial contacts are maintained with the North (France, England and the Low Countries) and although the Lutheran reform affected the pilgrimages, the trade relations with the countries infected by the "protest" were not permanently interrupted and, in the first years of the reign of Philip II the British ships, in peaceful gesture, took port in Baiona, Coruña or Vigo. When a member of the Inquisition acused the heretics, the civil authorities clamed that "Galicia cannot live without the English, who bring it all it needs." The exchanges with Castile were also intense; English products unloaded in Vigo were taken through Ourense to the fairs of Medina, where the Galicians bought colonial products and especially textiles.

From the economic point of view, the Galicia of the XVIth century is not therefore a completely rural and closed world. On the contrary, if the exchanges have a certain importance, it is due in great part to the fact that the urban population represented 10-12% of the total population of the Kingdom; in the XVIIIth century this percentage had been reduced to half that. The society of the XVIth century also shows some characteristics of fluidity: the ruling elites of the urban world have a varied composition, without the rentismo's reaching the force it will show in the XVIIth and XVIIIth centuries (J.E. Gelabert). Many nobles participate actively in the trade and there are people with an important rustic patrimony who pertain to the lower classes. Therefore we can speak of an open society, including in the cultural aspect. It is not that in Galicia there were cultural

centers with autonomy. Nothing of the sort. Galicia is a "provincial society" whose official culture is none other than that of the crown of Castile. In this sense, the links with Salamanca—reinforced by Fonseca—and with Valladolid and Alcalá, were close. Although from the end of the XVth century the press functions in some nuclei, little was edited other than instrumental books of religious nature, others probably being imported from the city of the Tormes, according to documents published at the end of the XIXth century by A. López Ferreiro. Thus the press produced nothing new in Galicia (is we do not count perhaps the Compendium of Albiteira and the Description of the Kingdom of Molina), this did not stop there being works of classical Greek and Latin authors and authors of Christian humanism, like Erasmus, from being in the libraries of the Compostelans of the XVIth century (J.E. Gelabert). Few are those who have them, but their existence shows that the new currents of thought reach the urban elites, lay and eccelesiastical. The rural world remains completely on the margin, far from ideological control, even from the church itself, since the reform of parochial clergy is much later than that of the regular.

In the last third of the XVIth century deep ideological and social transformations will begin which will affect, in the first place, the dominant groups and slowly—particularly the transformations of ideological sort—more extensive layers of the population or, what is the same thing, the peasantry. The social changes are based mainly on the consolidation of the rentistas as dominant group with the exclusion of all others—commercial, etc.—which could cast a shadow on it, that is, in the ascent of the nobility and its establishment as a sector with a certain homogeneity inasfar as the typology of its income and its mentality. This process was favored by the political changes themselves of the end of the XVth century, which allowed the small nobles, who were satellites of the large houses and were involved in pillage, to orient themselves toward carrying out posts in the local government, Church or royal service, attempting to live peacefully from their incomes. As was well shown by Professor Ramón Villares, among the founders of important noble houses there are members of secondary branches of the great lineages, "standard-bearers" and other servers of the old aristocracy, aldermen, scribes and even clergymen who accumulated copious incomes during the course of the XVIth century. In the second half of this century, with the crisis of peasant property, merchants or members of the burocracy could feather their nests and establish ties upon the ruin of the landowning peasant. It is no accident that the majority of the entails and family estates are established in the second half of the century and the first half of the XVIIth, when there is a passing from a society in some respects open and dynamic to another, closed one, in which only the rentista is rich (J.E. Gelabert).

The nobility is an unequal group if we judge by the amount of income of each family, and the palatial homes themselves show the economic differences. The most costly are located in the Rías Baixas (Low Fiords), Mariñas and wine-growing regions, that is, in regions of high demographic density—with many renters , therefore— and with an agriculture capable of producing large surpluses, although taken away by force. In the province of Lugo, with low population densities and an extensive agriculture, the palatial homes are at times no more than "big houses" which differ little from those of a wealthy peasant. But the nobles' power is born from its very number, since they are distributed throughout the Kingdom, with their control of the local government, their links to the secular clergy and their "paternal" role with respect to the peasantry. With the emigration of the old nobility, they are the patrons of chapels and tombs, the propietors of benches in important parts of the churches, the founders of many chaplaincies and pious works, and in the political area it is the urban nobles who represent the Kingdom. As the XVIIth century advances and the palatial homes with coats of arms arise or are restored, executorships are obtained and people rise in position in the local government or church, no one will remember any more that many noble homes had been founded by a scribe who was perhaps a bit greedy or by a clergyman who was avid and undisciplined; by diverse paths the nobility will try to transmit a discourse that gave it a very ancient origin, as corresponded to a special race.

Although it is best to avoid a rough economicism, it seems appropriate to relate the consolidation of the nobility to certain changes of the economic type, which affect the urban and rural world. At the end of the XVIth century certain urban economies, in particular those of the coast and the province of Ourense, show signs of crisis, which must have led

trade sectors to invest in property. From the decade of 1560 on, moreover, the pest frequently comes to the coast and some regions of the interior, causing true panic and provoking an increase in the devotion to Saint Roque, of which there are eloquent testimonies, among them the erection or remodeling of the hospitals of Saint Roque in Ourense and Santiago, or the construction of a chapel dedicated to the same patron in Celanova, in 1598, at the request of the monks themselves. After seeing the convent "closed by the work of the pestilence which God has seen fit to send universally to the world,", the Virgin is invoked and the "Blessed Saint Roque, taken as interceder, patron and advocate, whom the entire prostrated convent buries in the Church (...), together with the residents of the village, we promise to celebrate his day, and that in this house his festival will be celebrated with double ceremony. More so, we promise to build a hermitage dedicated to his holy name... "

The sources of a narrative type offer abundant information about the fear which in the last forty years of the XVIth century is caused by the proximity or presence of the plague. Its demographic effects are unknown to us, but they must have been great in some urban centers whose economy was beginning to show signs of difficulty. Pontevedra, for example, the main urban population of Galicia, with a strong guild of Sailors—O Corpo Santo (The Holy Body)—which had begun the construction of Santa María a Grande, complains at the end of the century about fiscal pressure and the high price of salt, which makes fishing activity difficult. It will begin to lose residents and turn into a property-owning and commercial nucleus, with fishing becoming a residual occupation (as seen in 1520). But the rural world seems to have resisted quite well, from the demographic point of view, the last third of the XVIth century and first third of the next. In 1590 Galicia would have 750,000 inhabitants (double those at the beginning of the century), a considerably higher figure than has been thought. From 1630-40 on the western coast and from 1660-70 on the Cantabrian, the number of residents increases greatly, thanks to the cultivation of corn and to an intense rotating process (J.M. Pérez García). It is basic to insist on this in that the XVIIth century is not a period of crisis in Galicia—that is, of depopulation, abandoning of the land...-. but rather one of strong demographic and agrarian expansion. And the development of the productive forces had great transcendence for the property owners, more and more numerous and wealthy, as the number of peasants and the volume of agrarian surplus increased. In contrast with what happens in the interior of Spain, where the incomes of many religious institutions and noble houses are destroyed, the incomes of the monasteries, church chapters, bishops, titled nobility and of Galicia are maintained or even grow in the XVIIth century (O. Rey Castelao, C. Burgo López). Otherwise it would be difficult to explain the beginning of great works by both ecclesiastical institutions and noble families. Galician Baroque definitely has as a background or support, a rural world in expansion, a peasantry increasing in numbers, payer of enormous rental fees.

But at the end of the XVIth century, not only are there social changes which culminate in the consolidation of the nobility which, together with the ecclesiastics, control a ruralized society formed by peasants and property owners, with the latter as the only dominant group. At the same time there is an increase in ideological control by the ecclesiastical hierarchy. This fact, basically a result of placing in practice the dispositions of the Council of Trent, was of enormous importance and its effects will be seen until the crisis of the Old Regime, and even go beyond it. To assess what such a religious change meant, it is necessary to take into account the predominant situation in this area in the first half of the XVIth century. Through some pastoral visits it is easy to document the existence of a rude parish clergy, violent, roundly ignorant and with a non-religious life. It is unnecessary to make much of an effort to know what was the state of the parish churches and the indoctrination of the peasants. In the diocese of Mondoñedo, at the beginning of the century, they show utter negligence and the peasants are dominated by "superstitions" and "heathen" or "diabolical" rites.

Already prior to 1550 there are certain attempts at reform and in several synods of Mondoñedo the many abuses of the clergy are stigmatized, along with the superstitious beliefs and practices of the rustics. But it would not be until the conclusion of Trent that the efforts would become systematic and tenacious. The bishops knew it was necessary to begin with the reform of the parish clergy, whose formation was scant and whose beliefs were

often far from the Trentian orthodoxy. The Jesuits justified precisely the foundation of the College of Monterrei "because the Kingdom of Galicia has such uncultured and barbarous people, with so little teaching in the law of God," there being a need above all for "clergy of honest and retiring life and who had an awareness of God's things." In the confessions which the fathers of Monterrei heard on the occasion of the jubilee years, they found "incredible and even horrendous things, that the people did not consider sins due to the priests' ignorance;" apparently the peasants of the region "did not consider as evil the terrible sins of the flesh, nor cohabitation, which was common among them (...). nor blasphemy, which was even the custom among women" (E. Rivera Vázquez). Although these testimonies have some slant, it is certain that in the last third of the XVIth century, the Inquisition tries more than a hundred clergy, the majority for affirming, privately or even from the altar, propositions in disagreement with the dogma defined in the Council (J. Contreras).

Thus it was urgent that the parish clergy be reformed, and so with the last sessions of Trent over, frequent diocesan synods were celebrated, whose constitutions were at times published so that the priests could have a copy, recommending that the clergy lead an honest life, abstaining from betting and visits to taverns and the practice of certain readings. The prelates well knew that "Christianization" of the peasantry was impossible without a previous reform of the parish clergy and in this sense it was necessary to show a certain rigor when conferring orders (especially when the right to presentation often was beyond the prelates, as Francisco Blanco indicated) and to make periodic visits to the parishes. The foundation of some seminaries (like those of Mondoñedo and Lugo, from the end of the XVIth century) and the task of the convent schools of Dominicans, Franciscans and Jesuits, undoubtedly allowed for a progressive improvement in the formation of those who aspired to the "sacred order." The fact that before 1600 some parochial temples were reconstructed, the hygiene of the temples improved and the clerical absenteeism reduced must be taken into consideration.

The reinforcement of the bishops which the Council of Trent meant had decisive consequences for parochial life. The control and direction of predication, the teaching of the doctrine and the works to carry out in the churches became increasingly evident. In this respect it is difficult to speak of a "popular art"—or a "popular religion"—located in the churches or hermitages, when we know by the chapters of the synodal constitutions and the mandates of the visits that the prelates watched over any reform in the temples, whether it affected the walls, the images or the objects of the cults themselves.

The bishops appear, above all, obsessed with the idea of the decorum of the divine cult: in Compostelan synods of the beginning of the XVIIth century, for example, allusions to the "hygiene and decency" that the priests were to observe with the sacred objects are repeated, and from the visits in the XVIIth and XVIIIth centuries to parishes of the diocese of Mondoñedo there are numerous mandates which order the maintenance in good condition of buildings and images, the care of hermitages, or if not, tearing them down, the burial of images that were the cause for "laughter and irreverence... ". The prelates' authority affected other aspects of religious life, such as those relative to the brotherhoods. Some of these associations, like that of the Most Holy sacrament, existed in all the parishes, simply by episcopal order. Nothing at all of the religious life of the parishes escaped control by the bishops, followers of the instructions of Trent. This is the reason why the typology of the images of the altar pieces is quite similar in the dioceses which remain faithful to Rome. The Christological and Marian representations and those of the saints are common all over, according to the orthodoxy affirmed in the Council. Only to God is adoration owed (but God is incarnate in Christ, present in the Most Holy Sacrament); the Virgin is the privileged intercessor, and the saints also must be invoked since they "offer their prayers for people to God." The system of images—of altar pieces, paintings—will fit this conception and set a catechismal goal, of education in the faith. Not in vain the archbishop of Compostela Friar Juan de Sanclemente, familiar with the illiteracy which affected most of the peasants, conceived of painting as a "book for rustics and the ignorant" (R.J. López). It is not our place to study in detail the reflection of the Trentian dispositions in the religious art of Santiago, but we will insist that such dispositions begin to be applied soon—already at the end of the XVIth century—and that the authority of the bishops will be felt more and more

in the parishes. Of course orthodoxy, the "officialism" of image-making or painting, did not mean that the peasants understood the meaning of the representations—neither did they manage to understand the rudiments of the faith taught by catechism—; nor should we think that many beliefs and practices of the rustics which bordered on, or were completely superstition, disappeared. But these questions constitute problems of another sort. One thing is the orthodoxy that was taught, represented and practised, another thing is the mentality of the peasantry, never completely "dominated," since even a part of the clergy, because of its rural origins, did not completely separate from the "non official" culture.

The XVIIIth century passes in general under the sign of continuity. In the economic sense it should be pointed out that demographic growth continues, although in the western regions it loses force in comparison with the previous century. Galicia had 1,1000,000 inhabitants in 1700; 1,300,000 in 1750, and 1,500,000 in 1800. The densities are very high for the period—an average of 50 inhabitants per square kilometer at the end of the century—, but it is a very ruralized population, since only 5% of the total con be considered urban. In mid-century Santiago has displaced Pontevedra from the position it occupied in the XVIth century, when it was the largest urban nucleus of the Kingdom. In 1750, Compostela has 4,5000 residents, and the town of Lérez 1,4000 (less than two hundred years before). In any case, there is no large city in XVIIIth century Galicia: Santiago has approximately 16,000 inhabitants in 1787; Coruña (expanding with force) has 14,000, Lugo 4,000 and Ourense 3,000 (A. Eiras Roel). From the end of the XVIth century the nuclei associated with fishing and wine-growing economy have lost population, and those situated in increasingly populated agrarian regions (the cases of Santiago, Lugo, Mondoñedo...), whose residents pay high rent and create a demand for artisens products.

Although in the second half of the XVIIIth century the industrial activities and exchanges show a certain increase, the bases of peasant, rent-paying Galicia are barely altered. After the middle of the century, groups of bourgeois of diverse origin (Castilians, Riojans, Asturians, Basques, Catalans) invade the cities and towns of Galicia, devoting themselves to the trading of linen, cloth, leather, iron or sardines. It is a new bourgeoisie, at first not so associated with the structures of the Ancient Regime as the traditional Galician bourgeoisie. But at the beginning of the XIXth century the integration among those land-owning groups of this new bourgeoisie will be evident.

The strength of the land-owners within XVIIIth century Galician society is questionable. The Church appears as the main recipien of the agrarian surplus, since some two thirds of the total of foros and tithes belong to it; the other third goes to the hands of the titled nobility. But the ecclesiastical estate is extremely heterogeneous, beginning with the prelates themselves. If the rental incomes of the archbishop of Compostela are eight or ten times more than those of each one of the other Galician dioceses, it is clear that the bishops of Mondoñedo, Lugo, Ourense and Tui could not compete neither in alms, nor in works, nor in palatial ostentation with the mitre of Santiago. The incomes of the Chapters were also very unequal, since a canonship of Compostela was worth double what one in Tui or Ourense was, and triple what one in Lugo or Mondoñedo was. Concerning the parochial clergy, the life that a priest who led a rich curate could live had nothing in common with that of the inheritor or chaplain who managed to support himself with indecorous jobs.

Heterogeneity was thus born out of the social origin and the value systems of the ecclesiastics. The wealthiest secular clergy is basically of noble origin, as the sociology of the cathedral chapters and collegiate churches and that of the priests who are in the best parishes reveals. If many noble families in Galicia are not worried about pursuing a career outside the Kingdom it is because they can place their sons in canonship and curates, or their daughters in famous convents. It is signficant that many of the collegiates of Fonseca end up as priests or canons. There is, therefore, a close relationship between the small local nobility and the wealthiest sector of the secular clergy. We can assume that the canons and priests continued to maintain the values of their origins and were firm defenders of their lineage. In the cities, nobles and canons constitute the social elite, both for their level of income and their way of life, as well as for the "respectability" they enjoy (A. Eiras Roel). But the canons are also very close to the institution of which they are a part, particularly those of Santiago, whom the participation in multiple combats in defense of the Apostle's Patronage, the Vow and general preeminence of this Church had endowed with a considerable

corporative sense (O. Rey Castelao). Contrary to what happens in other western kingdoms, as in France, in Galicia the cathedral chapters remain vigorous—and prestigious—institutions throughout the eighteenth century.

A major part (around two thirds) of the parochial clergy is of peasant origin (B. Barreiro). Nevertheless, this is the most poorly situated clergy and also the most poorly educated, since some of its members do not appear to have entirely renounced the "mentality" of their families of origin and will be the object of criticism by the most enlightened ecclesiastics. Still, that many clergy belonged to peasant families is a singularly important fact, since it helps explain the influence which the church had over the rural population during the times of political change at the beginning of the nineteenth century.

The income of the landowners grew at a good rate in the XVIIIth century and not so much because the quantities of grain that went to their coffers increased—which also happened—but rather because the agrarian prices increased, principally in the second half of the century. Since the foros were stipulated in fixed quantities in kind, the influence of the prices on the landowning economies was decisive. In any event, until the beginning of the XIXth century, and then in great part for reasons of political nature—a greater fiscal pressure on the eccelesiastical institutions—monasteries, church chapters, prelates and nobles went through a period of "fat years", indicated by the many constructions. In the case of the nobility, we must taken into account as well that it has a marked urbanization process (begun already in the XVIIIth century), which motivates the construction of housing in cities and towns, without overlooking the maintenance of rural mansions. The nobility of the XVIIIth century is, above all, the most powerful, urban, and "cultured." Its members devote themselves to ecclesiastical and juridical studies (and at the end of the century, to military careers), and it becomes fashionable to attend tertulias and saraos which require the mastery of social codes unknown to the rural nobility. In this context of need for a higher education the College of Teaching emerges in Santiago in 1760, at first destined to the education of the daughters of noble families.

But the continuity of the XVIIIth century is also observed in the religious area. The efforts of the bishops to improve the education and behavior of the clergy and to catechize the peasantry are pursued intensively. The visitors frequently inform the bishop of the intellectual and moral conditions of the parish priests, landholders, patrimonistas and even the students who aspire to the holy order. The vigilance is thus strict. The reform of the seminaries in the time of Charles III allowed a better preparation of the clergy, although—as we have indicated—many ecclesiastics did not abandon the peasant mentality. In this terrain, affirmations should be clarified: the priest of 1750 has little to do with that of 1550, but for the very demanding the Galician clergy of the end of the eighteenth century left much to be desired. Fernández Posse speaks in regard to the diocese of Compostela of "priests who were ignorant or servants, mercenary clergy, drunken and conjurers and an entire clergy whose wisdom was a little bad Latin and some cases of father Larraga... " A clergy typical of a country emerged in the "grossest ignorance," in the "most unabashed lasciviousness," which the ecclesiastical hierarchy, in spite of the control over parish life, had not managed to extirpate in 1800 (after some decades in which the insistence of the prelates on the need to teach the catechism to the faithful had been increased).

One thing was that the peasants understand and accept the doctrine of Trent, and another that it participate collectively in the rites and ceremonies of the Church and that its testamentary dispositions be accommodated to the strictest orthodoxy. The study of the testaments allows us to see, precisely, that the religious changes are scarce in the XVIIIth century. The pious invocations are maintained, along with the petitions of suffrage, the burials within the churches... There is great uniformity, in this respect, between the rural world and the urban, and certain practices, such as the use of a habit—the Franciscan—as a shroud become general, after having been accepted by the urban elites (D. González Lopo). Nor are there appreciable differences between the towns, cities and villages; in the rural parishes of the province of Mondoñedo, the names of Juan, Antonio, Domingo, Francisco, José and Pedro are given to 50% of the males; that of María to a third of the women, followed by Ana, Antonia, Rosa, Juana or Catalina... In the city of Santiago, in the mid-XVIIIth century, 116 are registered among the 3,150 heads of household laymen, but 60% of these are named Juan, Domingo, Francisco, José, Antonio, Pedro, Andrés or Manuel.

Among the women who are heads of household there are 85 names, with the same percentage corresponding to María as in the rural world (although in the city the name of María frequently is followed by another). Of the 418 chaplaincies of which there is testimony in the XVIIIth century in the diocese of Mondoñedo, 118 were under the advocation of Our Lady (of the Rosary, 27, of the Conception, 21, of Carmen, 18...), 55 under Saint Anthony, 22 under Saint Peter, 20 under Saint Joseph, 25 under Saint John the Baptist... Saint Francis and Saint Domingo nevertheless have a lesser importance than in the onomastics. We should note the slight role which the parish patron plays, both in the giving of names and in the wills, even that of Santiago is a name of low frequency in Compostela (there are 10 heads of household who are called thus, and some fifty whose parents opted, significantly, for the name of Jacobo).

Finally, the fact that throughout the XVIIIth century the rhythm of priest ordainments is maintained and even increased and that no longer the peasants but rather the urban sectors see in the ecclesiastical career an important way to promotion, is another proof in addition to the continuity which is registered on the social and mental level in Santiago between the century of the Baroque and that of the Enlightenment. The novelties of the XVIIIth century are very secondary beside the substantial permanences, among them the uncontested hegemony of the Church and nobility, estates which keep close family, value system, and interest ties and maintain, even at the beginning of the XIXth century, an important ideological influence over the peasantry.

RENAISSANCE AND BAROQUE: A NEW ARTISTIC ORDER

M.ª Dolores Vila Jato

The penetration of Spain by new representative styles, in the Italian manner, was late and limited to a specific reduced cultural elite, while the majority of the people continued to prefer a Gothic option of northern affiliation, which had taken root in its sensitivity and had been promoted by the Court of the Catholic King and Queen and even by that of Charles V, influenced by his Flemish formation. If this phenomenon of the survival of the northern taste or, in any event, of the reelaboration of Italian models through prints and engravings remained in force until the reign of Philip II in practically all the peninsula, in the Galician case this superficial penetration of the Renaissance made it possible, except for Compostela, to keep Gothic typologies and constructive forms in architecture or a realistic narrative feeling, expressive in its statement of the religious image, alive for many years.

The artistic context of the Galician Renaissance also lacks the components which will play a primordial role in the expansion of the style: the presence of Italian artists or those formed there or the arrival at a more or less early date of pieces from Italy, which apparently did not even interest such a profound humanist as the archbishop Fonseca, at least during his stay in Santiago.

The only artist who can be placed authentically in relationship with the Italian world, although always indirectly, is the sculptor and painter of Aragonese origin Juan Bautista Celma, author of the pulpits of the Cathedral of Santiago and who brings to Galicia a profound influence of Raphael, whom he knew through drawings and prints which he could have studied as a result of his apprenticeship in workshops of Burgos and La Rioja, linked to sculptors such as Pedro López de Gámiz or Juan de Ancheta. Through the latter he would also come to know the most refined and Italianizing tendency of the French Renaissance, that is, the School of Fontainebleau.

Except for this exceptional case which for this same reason had a relative echo in the Galician artistic context, the classical forms will reach Galicia first through Castilian artists and much later, Andalusians, who assimilated the Classicism of Burgos of Diego Siloé and, through him, all classical architecture or fundamentally through the Italian texts, Vitruvius, Serlio or Vignola, who only begin to figure in the diminished libraries of our artists after 1580-90. This is the period of greater classicist strength, visible in works such as the College of Cardinal Castro in Monforte (Lugo).

The stagnation which Galician art had reached in the last decades of the XVth century needed a revulsive, a renovating air that had to come from other regions, from very diverse places, and which would be fundamental for the formation of the generations of Galician artists who interpreted that foreign language as a symptom of modernity.

The first of these initiatives, which might seem episodic and local, is the decision of the Catholic King and Queen to found a Hospital for pilgrims in Santiago. This would lessen the chaotic situation of aiding the people who still came to Santiago from all over Europe. The Charter of Foundation is from 1492 and in 1499 the King and Queen issue a Royal

Decree which orders the Deacon of Santiago D. Diego de Muros to begin its construction, assigned to the royal architect Enrique Egas.

This intervention of the Catholic King and Queen would be somewhat episodic and superficial if in those same years the Archbishop D. Alfonso III of Fonseca had not occupied the Compostelan See. His humanistic culture and artistic concerns are widely known, and he will be the great patron of the Galician Renaissance, transforming Santiago into a center which spread the new style and to which such an important fact for the consolidation of the new culture is owed as the foundation of the University.

These great building projects of the Catholic Monarchs or Archbishop Fonseca will bring together in a single workshop, whether for the Royal Hospital or the Cathedral cloister, Gothic sculptors such as Nicolas of Chanterenne, "Isabeline" designers such as Enrique Egas, "Plateresque" Salamancans such as Juan de Alava or an endless number of stone-cutters and master-builders from the Kingdom of Portugal. This multiplicity of origins will as a consequence the fact that in one single building, an example being the Royal Hospital, the influence of Egas and his Gothic tendencies are complemented in the chapel by the new constructive typology, already Renaissance, of Juan de Alava. The Burgundian decoration on its pillars or the arch of triumph that is the entry to the hospital are related to contemporary Portuguese art, since its craftsmen, Martín de Blas and Guillén Colás, had previously worked on the Jeronymite Monastery of Belem in Lisbon under order of Juan del Castillo.

The northern influence, specifically Burgundian, dominates exclusively in the sculpture and metalwork of the time, over the multiplicity of influences in the architecture of the first decades of the century. Here sculptors such as Master Arnao and Cornielles of Holland work. The latter is a magnificent, enigmatic artist, who appears in Ourense in 1516 and who, after his establishment in Compostela in 1524, will gather the Renaissance decorativism and northern expressivism always in Galician work, in his sculptures, altar pieces and doorways. This sculptor would be assigned the altar piece of the vestry of the Royal Hospital in 1524. In the contract it was specified that the work was to be "á romana" (In Roman style), a true act of birth of the new style.

The metalwork of the period also follows the same strongly Gothic-Burgundian coordinates. These are seen in pieces like the Rich Cross of the Cathedral of Ourense, traditionally attributed to Enrique de Arfe, the pix of the count of Andrade, in the church of Pontedeume, or the pix given by the count of Benavente to the Cathedral of Ourense, with a scene of the Pietà exactly like the one in the first section of the main altar piece of the Ourensan Cathedral.

After the fourth decade of the century, this complex panorama is simplified in the sense of a progressive presence of Castilian artists, from Salamanca or Toledo, who arrive in Santiago to carry out the works begun years earlier by Archbishop Fonseca: the Cloister of the Cathedral and the building of the University, the college of Santiago Alfeo. For this the archbishop, now from his see in Toledo, apparently solicits the opinion of Alonso de Covarrubias, a transcendental fact in the development of the Galician Renaissance because it indicates the overcoming of a Plateresque decorative language by a greater classical assimilation, which triumphs on the doorway of the college.

This same classicist sense, of the triumph of proportion and rhythm over decoration, encourages Rodrigo Gil de Hontañón, Salamancan architect who takes charge of the cathedral cloister on the death of Juan de Alava. The façade of the Treasure, of clear civil and palatial aspect, expresses perfectly the assimilation of the classicist language, particularly the graded tower, set in the angle of the cloister, definitely related to Italian characeristics and with funeral symbolism linked to the projects of Bramante for Saint Peter of the Vatican and to the reconstruction by Antonio da Sangallo of the Mausoleum of Halicarnassus. Although the presence of Rodrigo Gil is episodic and limited to the periodic visits to Santiago and Ourense to supervise the works he directed, it has the enormous importance that with him comes an extensive list of architects and master-builders from the Cantabrian region of Trasmiera, who permanently settle here. They are stone-cutters who are very skilled in the stereotomy of stone, all of analogous formation and related by family

ties. In Galicia they install a plan of work based on the collaboration on a single work of various masters and the passing of works from one to another. This is seen above all in the monastical architecture, which renews its building thrust after mid-XVI century, when the monasteries have overcome the terrible period of the commendatary abbots and most of them have been incorporated into the Congregation of Valladolid. This initiates a profound transformation which in its first phase will affect the utilitarian dependencies and will culminate after the middle of the XVIIth century in the construction of the great churches of our monastical Baroque. Names such as Juan de Herrera (whom we call de Gajano so as not to confuse him with his namesake from El Escorial) and Juan Ruiz de Pamanes, who work in the Cathedral of Ourense around 1560, Juan and Pedro de la Sierra or Simón de Monasterio, all from Trasmiera, as well as Melchor de Velasco, with whom the Baroque aesthetic begins.

This situation of classical affirmation of architecture contrasts with the impoverished panorama in which Galician sculpture develops in the middle years of the century. The only outstanding figure is an enigmatic sculptor active in the region between 1545 and 1565. He must have been formed in the Leonese workshop of Juan de Juni, and is usually called the "Master of Sobrado." We owe him the first implantation of Juni's influence, which will enliven a good part of Galician sculpture of the final years of the century. In the area of painting, beyond a general artisan and behind level, we must also emphasize the enormous importance of the so-called "Painter of Banga," what he signifies by way of a conscious or unconscious shaping of a Neoplatonic philosophical program.

Both the "Master of Sobrado" and the "Painter of Banga" will work primarily in the diocese of Ourense, transformed from the middle of the sixteenth century into an important artistic nucleus which will continue to grow with time. Through it, intensely strong and frequent connections with Castilian art, to which southern Galicia is always turned, will be implanted. It is also important to underline that while in Santiago the artistic work is centered especially in architecture, renovating a city and especially a Cathedral which begins to be an urban environment, in contrast, all the efforts to endow the churches with altar pieces and sculptures, pieces of metalwork and objects of cults linked to collective devotion, will be concentrated in Ourense.

The inactivity or apparent decadence which Galicia seems to experience in the middle years of the century becomes feverish activity in the final years, preparing the way for the expansion and triumph of Galician Baroque, which will not end until the end of the XVIIIth century. While in the previous perid Santiago had been the epicenter of artistic activity, so that the Renaissance aesthetic was an episodic phenomenon in the rest of the region, linked generally to the desire of a specific client, or to the chronological dynamic of the works (I am thinking, for example, of the drawing out of the construction of Santa María in Pontevedra), after the seventh decade of the century, and although the city of the Apostle continues to be the preferred workshop of artistic activity, constructions, altar pieces or metalwork objects appear all over, speaking for themselves of a classical triumph.

As far as architecture, there will be a triumph in Galicia, as in the rest of Spain, a valuing of the building not so much for its "adornment" as for its harmony and balance of proportions, the skill in the use of order and the reflection of the great works of Italian architecture. These were known through the authors of treatises who, like Palladio or Vignola, are now cited as models to imitate.

Again Compostela will be the meeting point of all artistic efforts, centered on architecture, although now other nuclei of relevance will spring up. This occurs especially in the south, in Ourense and Monforte, where the foundation by the Cardinal Rodrigo de Castro of the College of Our Lady of the Antigua, will provide the most pristine Galician interpretation of Vignolesque architecture. For this reason the building has been nicknamed the "Galician Escorial." In the magnificent church, presided over by a complete cupola, unusual in Galician architecture and done in imitation of that of El Escorial, part of the artistic Treasure donated by the Cardinal to the foundation is preserved. From this we may emphasize a Christ of marble sculpted by Valerio Cioli, disciple of Michelangelo, and the funeral monument of Don Rodrigo in the presbyterium of the church, similar to the royal sepulchers of El Escorial, cast in bronze in Florence by Giambologna.

In Santiago, for some years the archbishops suceeded each other with unusual rapidity, which impeded the consolidation of religious patronage. After the VIIth decade of the century the continuous work of the prelates brought important building work, began by archbishop Francisco Blanco. He contributed decisively to the implantation in Santiago of a Classicist alternative, whose best example is the sepulcher of the archbishop himself, first sample of the influence of the sepulchers of El Escorial on Galician funeral sculpture. No less important for its implantation of an Italian model, is the comission of the church chapter for the pulpits of the Cathedral of Santiago, given to Juan Bautista Celma, or the continuous presence of master-builders from Trasmiera in the always open workshop of the cloister. These already bring a model of more simplified ornamentation, closely related to what was being done in Castile at that time.

Francisco Blanco was suceeded by Juan de Sanclemente, craftsman of the definitive substitution of the old stone choir by Master Mateo with wooden choir stalls. This was charged to two sculpters of obvious Castilian affiliation: Juan Dávila y Gregorio Español. They bring a new Mannerist impulse to the mediocre panorama of Compostelan sculpture of that time, with frequently intelligent touches. They are related to the workshops of Juan de Juni or Esteban Jordán in Valladolid, or with the grandiloquent Mannerism of Gaspar Becerra, of whom Gregorio Español must have been a disciple. The long artistic trajectory of this sculptor will lead him to participate in the work which in sculpture marks the beginning of a Baroque aesthetic: the altar piece of the chapel of Relics of the Cathedral of Santiago. In this the craftsman Bernardo Cabrera used for the time in Spain a type of twisted column which over time and with a decoration of bunches of grapes and leaves, will become the salomonic column.

Archbishop Sanclemente also founded the college that bears his name, financing the construction of a building which traditionally has been attributed to the Andalusian architect Ginés Martínez. He introduced a new Classicist interpretation into Compostela, closely linked to the models of Granada developed by Diego Siloé and his disciples, of Italianizing line frequently based on interpretations of engravings by Italian authors. Another facet of Ginés Martínez is the theoretical one, as he is the author of a book on Cerramentos e Trazas de Montea (Closings and working drawings) whose possible influence in Galician architecture is still unknown to us, although it is a suggestive hypothesis.

Ginés Martínez must have arrived in Santiago in 1603, forming part of the following of archbishop Maximilian of Austria, for whom he will work until 1606 on works of such importance and innovating quality as the stairway of the façade of the Obradoiro in which the memory of the ramps of the Belvedere de Bramante is closer to the Golden Stair of Diego Siloé.

Ginés Martínez also intervened in the construction of the grandiose monastery of San Martiño Pinario, the great Classicist factory of Compostela, workshop in which our most important architects were formed throughout the centuries, and whose church the Portuguese Mateo López had begun years before.

The Andalusian influence which renewed the panorama of Compostelan architecture lika a breath of fresh air, received a new impulse in the XVIIth century. In 1626 the architect from Granada Bartolomé Fernández Lechuga arrives in the city, summoned by the community of San Martiño Pinario. In his work, he combines a vocabulary inherited from Siloé or Vandelvira, with a verticalizing and unifying rythm in the different architectual elements, or a certain taste for geometric ornamentation which make it the swan's song of a Classicist style which will disappear years later, with the decisive intervention of the canon Vega y Verdugo.

Compaired with the many influences in Santiago in the last Renaissance pariod, in the rest of the Galician workshops, and especially in the one centered in the Diocese of Ourense there is complete dependency on the Castilian schools both in architecture and in sculpture and metalwork, while in painting (now with an important developpment in painted boards), the most important influence is that of Portuguese artists.

In Ourense especially workshops of sculpture are installed, integrated by artists from Castile (León or Valladolid) and in second place Portuguese, all filled with a vitalistic and

expressive sense of the image, conceived as an intermediary element between the person and the divinity. This concept ties together the ideas set forth in the Council of Trent and expressed masterfully by Juan de Juni, constant point of reference for the Galician sculpture of the period, although his paroxysm is braked, or we should say, frozen, by the Mannerist contention and coldness of Gaspar Becerra or Esteban Jordán. It is picked up again by Juan de Angés The Younger and, to a lesser degree, by Alonso Martínez, the master of Francisco de Moure, one of the maximum image-makers of Galician sculpture, key in the passage from Mannerism to Baroque. He maintains an intense activity not only in Ourense but also in Lugo, Samos and Monforte, and his masterful interpretation of the religious image is only comparable to that of Gregorio Fernández, Galician from Sarria (Lugo), who had the intelligence to renovated the plastic expression of the image.

In the field of architecture, the nucleus of Ourense is very unified and in close relation with the post-Herreran schematism set forth in Valladolid in the first years of the XVIIIth century, which is a consequence of a simple geographical proximity and of the activity of architects who have been in contact with the designers of the center in Valladolid for its intervention in the College of the Antigua of Monforte. Here men such as Juan de la Sierra or Simón de Monasterio work, authors, respectively, of the church of the Monastery of Montederramo and the retro-choir of the Cathedral of Ourense. With them a key chapter of classicist Galician architecture is closed. Until the mid years of the eighteenth century, this architecture will move in pure inertia and the repetition of models of already proven effect, which coincides with an era of relative stagnation of building activity, both of Cathedrals and churches as well as monastical architecture, which will emerge anew with force after 1660.

If Galician art throughout the Renaissance moves in an exclusively religious orbit and, except for very scattered cases, the only client is the church, secular or lay, the situation varies little during the following period, high Baroque. However, due to a series of circumstances of a socio-economic sort, the monasteries which now modify or construct their buildings acquire renewed height, in the same way as, especially in the XVIIth century, a small nobility made wealthy by the politics of the foros, builds that rural housing of palatial aspect that we call pazos or commissions some urban palaces as a result of their never forgotten city origin. But undoubtedly the great promoter of the Galician Baroque was still the religious class, whether the church chapter of the Cathedral, monastical community, or the people joined in brotherhoods, paying for works, altar pieces or objects of metalwork in the service of religion. In the case of Santiago, the task of artistic enlargement, which during this period will reach unusual heights, is favored by some archbishops who act as authentic Mycenas, such as Archbishop Friar Antonio de Monroy, or, later in the eighteenth century, D. Bartolomé de Raxoi. Also outstanding, because of his peculiar support of the arts, the schoolmaster D. Diego Juan de Ulloa.

Santiago, centered around its Cathedral and dominated by the powerful church chapter, now in a buoyant economic situation because of the income from the Vows of Clavijo and Granada, will continue to be the great workshop where all the innovations are tried out and where all the urban construction will be focussed, until the end of the eighteenth century. The activity's echo will be felt, more or less metamorphosized, in the other Galician dioceses, since the different church chapters came to Santiago when they needed architects or makers of altar pieces, preferentially contracting the master-builders of the Cathedral who in turn made the floorplans, supervised the works and placed a reliable assembler in control, as occurs repeatedly, for example, in the Cathedral of Lugo. Here, in the first years of the XVIIIth century, the construction of the cloister brings Friar Gabriel de Casas, master-builder of San Martiño Pinario, who recommends his assembler Fernando de Casas y Novoa, true craftsman of the Baroque in Lugo. There the latter would try out decorative-architectural possibilities later developed in his work in Compostela, as occurs, for example, in the beautiful Chapel of Our Lady of the Big Eyes, similar in plan to that of the Virgin of Aid in San Martiño Pinario and whose altar piece-closet, done by Miguel de Romay, is a first version, inspired by the Triumph of Ferdinand III the Holy, published by La Torre Farfán. It was later enlarged by Casas in the altar piece-iconostasis of San Martiño Pinario.

In southern Galicia the dependency regarding the art of Compostela does not appear to be so exclusive, although we still have very little information about the Baroque artistic activity in the dioceses of Ourense and Tui. Curiously, these seem to devote themselves, and especially the first, to the sculptural activity in which it had already been concentrated since the previous century and in which the Compostelan influences, through Mateo de Prado, Bernardo Cabrera, Domingo de Andrade or Pedro de Arén, appear to be combined by contacts with the exuberant decorativism of the Portuguese Baroque. The latter was already evident in the decoration of the Chapel of Christ in the Cathedral of Ourense, in which in the early years of the XVIIIth century, the architect and sculptor Francisco de Castro Canseco, worked. He was from the Compostelan artistic environment of Domingo de Andrade, but both in his altar pieces and in his works of architecture (for example the convent façade of the Monastery of Oseira), he seems to demonstrate a knowledge of art from the neighboring country.

In the Renaissance, the dependency of Galician art with respect to other peninsular points had been complete, and there are very few artists born in Galicia. During the Baroque period, on the contrary, precisely the opposite process takes place, since except for the early period, in the second half of the XVIIth century, in which artists from other regions such as Peña de Toro (Salamanca) or Melchor de Velasco (Transmiera) still work together, the craftsmen of the high point of this Baroque period are native, formed in Galicia or, although formed outside, as in the case of Mateo de Prado in Valladolid, they center their activity in Galicia.

This autochthonous character of our Baroque poses another unkown of no lesser interest. That is the attempt to see what were the suggestions, sources and models to which these artists had access. In the case of the sculpture, it is evident that the influence of Gregorio Fernández, brought directly by Mateo de Prado his disciple, is sufficiently novel so as to last throughout the XVIIth century in the entire area, although there is a slow stylization of the canon or a greater complexity and linearism in the fold, in consonance with what was happening in the Castilian school. Mateo de Prado offers a direct version of Fernández, even copying some of his most widespread iconographic types; in Pedro Taboada as well, who collaborated with Domingo de Andrade on some altar pieces, there is a peculiar vision of the Castilian image-maker through his master Mateo de Prado, whom he tried to imitate faithfully. This makes analysis of his work difficult; it is still little studied and appears to differ from that of Prado in the greater lengthening of the canon and a different conceptualization of the faces.

Works as different as the sepulcher of Archbishop Monroy in the Chapel of the Pillar of the Cathedral of Santiago, and the relief of the Descent of the altar piece in the Chapel of A Prima in the same Cathedral, are attributed to Diego de Sande, another follower of Gregorio Fernández. In A Prima, the memory of the scenic composition of the processional float of the same theme by Fernández is fused with a much more superficial and pictorial technique. Also by Sande is the pathetic Flagellated Christ of the church of San Agustín, conceived as a processional float in which the mark of the Castilian image-maker is visible.

Coinciding with the expansion of the altar piece and its exaltation as a great "machine" which covers the religious spaces, Baroque sculpture appears to enter a period of decadence, coming to be at the service of the altar piece, which acts as a pole of attraction. Makers of altar pieces such as Miguel de Romay draw the floorplans of the great architects like Fernando de Casas, completely filling the surface with decoration and leaving only the niches or attics for sculpture. The sculptor Benito Silveira worked with Miguel de Romay. With the former the Castilian influence is definitively broken; formed in Seville and familiar with the sculptors active in the Palce of La Granja, he would bring an Andalusian influence, in the line of the intimistic sculpture of Alonso Cano or Pedro de Mena, together with an effectist and pictorial concept already on the threshhold of Rococo. Finally the Italian influence will reach Galicia, as a Berninian Baroque joined with Rococo sensitivity through José Gambino, in whose workshop our best Neoclassical sculptor, José Ferreiro, is formed.

The same dependence on Castilian workshops that is seen as dominant in sculpture is also seen in the Baroque metalwork, thus continuing a current of influence that had already begun in the previous century with artists such as Juan de Nápoles or Marcelo de Montanos,

founder of a dynasty of silversmiths which will remain active in the diocese of Ourense at least until the middle of the seventeenth century. After that, the workshops of silverwork from Valladolid begin to decline and are substituted, according to the preferences of the Galician clientele, by the Salamancans, among which Juan de Figueroa Vega stands out. He was called by archbishop Monroy to do diverse ornaments for the altar of the Apostle Santiago. Already in the passage to Neoclassicism, the dynasty of the Peculs is installed in Santiago. The most famous member, Francisco Pecul Crespo, was a student of the Royal Academy of Fine Arts of San Francisco.

In sculpture it is relatively easy to establish a succession of foreign influences that determine its evolution, but the panorama of Galician architecture is much more complex. I do not know if this is because it is better known or because of the category of its craftsmen and the magnitude of their works. I have already emphasized the agglutinating role of Santiago and its character of epicenter for all the artistic experiences. That occurred after the middle of the seventeenth century, since earlier, that is, between the departure of Bartolomé Fernández Lechuga for Granada in 1638 and the naming of the canon Vega y Verdugo as Fabriquero of the Cathedral, Compostelan architecture goes through an uncertain period, including one of crisis, because the language of the local masters is worn out and there is no adequate substitute neither in the city nor in Galicia. This forces the church chapter to name the artisan Francisco de Antas Franco as master-builder of the Cathedral and, finally, to solicit in 1646 that a "master-builder for the church" be sought in Madrid "or somewhere else."

Under these circumstances, the decisive role which the canon D. José de Vega y Verdugo as renovator of the Compostelan artistic panorama is explainable. He will also contribute decisively to the formation of an entire generation of architects which are the culmination of Galician Baroque. Before his arrival in Santiago in 1649, Vega y Verdugo, count of Alta Real, usually lived in Madrid, but he had also lived for a time in Italy, in the Rome of Bernini and Borromini which in those years of Papal splendor renovated a city that was the "caput mundi" and goal of pilgrimages. That explains why on arriving in Santiago, the contrast between Rome and Compostela, the two large centers of western pilgrimage, was painful, especially the state in which he found the Cathedral. It was full of add-ons that disfigured it, and thus the decision was made to transform the Cathedral and its surroundings, now conceived as a gigantic stage, a "party space" of the purest Baroque strain and which would be represented in his lifetime by the forming of that immense scenic space that is the Quintana Square.

All the ideas were immediately well received by the church chapter of Compostela, which named him Fabriquero of the Cathedral in 1658. Vega wrote a Report on the works in the Cathedral of Santiago which, more than an analysis of all the works to be done in the building, is a Treatise of Architecture in which Vega shows his Baroque vocation. Although in his Report he speaks of the need to remodel the entire Cathedral area from the Quintana to the Obradoiro, the fact is that his efforts are concentrated in two concrete actions for which he solicits the help of the Salamancan architect José de la Peña de Toro, at the same time master-builder of the works of San Martiño Pinario. The reforms which are begun at that time are centered around the construction of a "Royal Doorway" (later redone), the reform on the Holy Door and the construction of the Door of the Abbots, as well as around the unification of the crowning of the church's headwall, not only in order to eliminate the excessive spatial fragmentation produced by the different chapels of the retro-choir, but also and especially, in order to "beautify domes and towers" according to the funeral symbolism of the overall building. In the interior of the Cathedral, Vega will form a new spatial sense from the headwall with the construction of the great dais, monumentalization of an ephemerous architecture which challenges the laws of gravity. In its plan, the recollection of the grandiose dais of Bernini in the Vatican may have been present, as well as the Baroque taste, as in the case of the levantada in the Cathedral of Seville in honor of Ferdinand III the Holy and even in the funeral catafalque known through drawings and descriptions; we should not forget that the function of the dais is to make perennial and underline a funeral site, the sepulcher of Santiago the Apostle.

Whatever may be the suggestion that influenced the designer of the dais, its importance in the context of Galician art is extraordinary. This is not only because of the imitations which were done in the Chapel of Christ in the Cathedral of Ourense or in the disappeared dais of the Monastery of Oseira, but because of what it meant in terms of innovation, of the implanting of new models in relation to what was being done in the rest of Spain and, above all, because in the workshop of the dais, among the architecture and work on altar pieces and under the guidance of the Canon Vega y Verdugo, Domingo Antonio de Andrade must have begun his artistic career. Andrade signifies the personalization of Galician Baroque with differential features, with sources of inspiration of very diverse origin and all applied in a skilful manner to material conditions and clientele like those of Galicia.

Domingo de Andrade may be considered the creator of the Galician Baroque school, member of a generation, that of Friar Tomás Alonso, Pedro Monteagudo or Diego de Romay, who set the base for an architecture which combines the perfection in the spatial concept of the building, its insertion in an urban context which now begins to emerge, together with a decorative exuberance that covers the walls and enriches the supports and whose inspiration must come from printed sources. These are seen clearly in the strings of fruits which serve as frame to the covers of the books of Serlio, although possible Spanish American influences cannot be discarded. These would have arrived through the codices and manuscripts still little known and studied today.

Another important aspect to be underlined is that now the architect becomes maker of altar pieces and the Baroque effectisim makes the architecture of the altar piece impose itself upon the sculpture, as a totalizing element that centers the visual attention of the faithful and which encircles the images, which at times are glimpsed with difficulty among the mass of leaves.

Around the same years in which the Baroque of Andrade was triumphing in Santiago, the constructive activity of the monasteries, begun a hundred years before, receives a new and decisive impulse. Its maximum examples are the construction of the new church of the Monastery of Sobrado or the works of the Monastery of San Martiño Pinario, in which at the end of the XVIIth century works of the importance of the monastical façade by Friar Gabriel de Casas are initiated. With him Fernando de Casas y Novoa will work, and will contribute decisively to the ornamentation and enlargement of San Martiño. In 1711 he was named master-builder of the Cathedral of Santiago.

I do not think it necessary to insist on the talent of master Casas nor that of his works, well known, but rather will try to clarify some possible sources of his artistic concept, so different from the decoration of Domingo de Andrade, who is undoubtedly influenced by the various printed sources he used throughout his life. We may possibly know only a small part of them: texts by Vitruvius, Serlio, Vignola, Friar Lorenzo de San Nicolás or Caramuel and, above all, the book of Fernando de la Torre Farfán on the Festivals of canonization of Ferdinand III the Holy will be constant references in Casas' work. As an example, the very conception of the façade of the Obradoiro, immense ephemerous architecture made eternal in stone, commemorative "triumph" of the Apostle and pilgrimage, inspired in the drawings of this text.

In Santiago, coexisting with this decorative and naturalistic Baroque of Fernando de Casas, after the second decade of the eighteenth century there appears a geometric and abstract tendency in the decoration. It is headed by Simón Rodríguez and in a way continued by Clemente Sarela. In both men there is a combination of the ever fashionable inheritance of Andrade in the architectural structures with a geometralizing decoration that has led this source of inspiration to be called "Plate Baroque." Its origin and source of inspiration could be identified in the engravings of Wendel Dieherlin or Jean Vredeman de Vries. In the architecture in stone this geometric concept triumphs exclusively, masterfully shaped in the façade of Santa Clara in Santiago, while in the altar piece work of Simón Rodríguez the geometrical elements coexist with a detailed naturalistic decoration, as in the case of the altar piece of the church of the University of Santiago, on which Miguel de Romay worked using plans by Simón Rodríguez,

The mark of Simón Rodríguez and Fernando de Casas is continued by Lucas Ferro

Caaveiro and Clemente Fernández Sarela, who in an agglutinating sense try to blend the two architectural concepts at first so opposed. Both repesented a project in 1762 to complete the Façade of the Azabachería. It was rejected by the church chapter, which requested a report from the Academy of Fine Arts, done by Ventura Rodríguez, who in addition sent Domingo Lois Monteagudo to take charge of the work. With this the Baroque style can be considered officially over; nevertheless, the reality of the daily assignments is quite different since this style, which had gone deep in the taste and sensitivity of the people, survived above all in the rural area until well into the XIXth century.

120
Retable
ANONYMOUS
Beginning of XVIth century

Granite
187 x 88 x 20 cm.

CHURCH OF SAN SALVADOR OF VILAR DE
DONAS, PALAS DE REIS (LUGO)

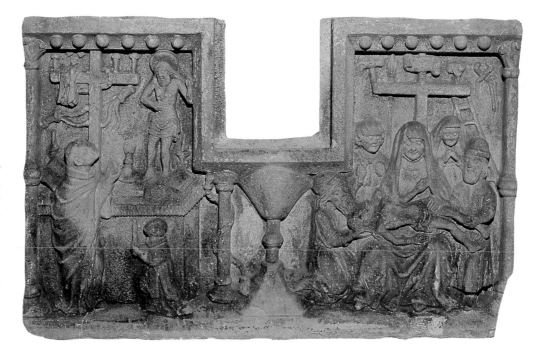

Rectangular panel framed by fine columns of
ringed shaft and plant capital. In the center of the
piece is a chalice with a hole which today has no
function. In the beginning, however, it bordered
frontally on a niche-ciborium that ended in a
rounded arch carved from a different block of stone.

On each side of the strip described a scene is
carved, both crowned by a concave molding
decorated with six thick plain spheres. On the right
side, in front of a cross, there are stairs and various
instruments of the Passion (tongs, hammer, lance and
sponge). It is a representation of a Lament for the
Dead Christ, centered by the figure of the Virgin,
who is seated, supporting Christ in her lap. On the
left side is another cross, likewise associated with
several instruments of the Passion (shroud, nails and
whip). In front of this cross is an altar table, on
whose extreme right is Christ Resurrected, naked and
crowned with thorns. In the foreground of the scene,
on the altar where there is a chalice, two candles,
there is an acolyte who holds another, lighted candle
in his hands, and a Priest, undoubtedly Saint Gregory,
who, dressed with liturgical garments and looking at
Christ, lifts the Host.

The altar piece, although not a first quality
work—the hardness of the granite did not make this
possible—is of considerable interest. The
composition is not well resolved as to all the
components—the unnatural placement, under the
mentioned hole, of a holy man who holds the head
of Christ, forces to locate the Pillory on the other
side of the chalice—, nevertheless it is a good
testimony of the use of the late Gothic premises in
the rural Galician sculpture: the features of the
figures, their garments or the treatment of the cloths,
with bent and paste board folds in some cases, refer
unequivocally, in addition to the quality of the work,
to formulas of Burgundian and Flemish origin.

The piece that we have just commented, both in
form and dimensions and for its iconography of
clear eucharistical content, was evidently conceived
as a retable for an altar. It was probably under the
baldacchino that today is in the northern arm of the
crossing of the church, although stylistically it has
nothing to do with it. It is datable between 1494
and 1496, according to the data that the books of the
priorate give, collected by Novo Cazón; the retable,
formally more advanced, must be dated in the first
years of the XVIth century.

(J.- C. V.P.)

BIBLIOGRAPHY
*Filgueira Valverde,J. , Ramón Fernández-Oxea,
J.(1987); Novo Cazón,J.L.(1986); (1988);
Vázquez Saco, F.(1947-49)*

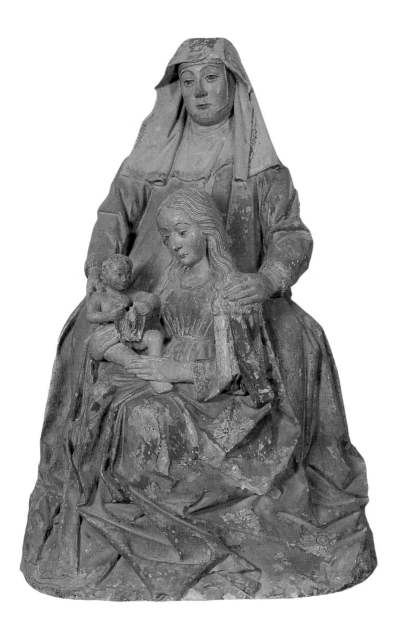

121
Group of Saint Anne with the Virgin and Child
ANONYMOUS
First years of the XVIth century

Polychromed limestone
90 x 56 x 29 cm.

MUSEUM OF THE CATHEDRAL OF SANTIAGO
DE COMPOSTELA

Practically nothing is known about this sculpture. It must proceed from archbishop don Lope's old chapel, as López Ferreiro stated. There were four chapels in the mentioned chapel, and in one of them was the Lady Sancta Ana, according to cardinal Hoyo. Once the chapel was demolished, around 1770, the image remained in the cathedral and belongs to the museum since its foundation.

It is a splendid piece, made in limestone, of the Triple St. Anne type, that is, she is with her daughter and grandchild. The composition used forms a isosceles triangle, which communicates an extraordinary elegance to the whole. St. Anne is sitting on a chair with a low back and broken ends. She is wearing an ample tunic spread on the floor which creates multiple folds of cardboard-like appearance, and with deep carving, typical of Flemish art. Her head is covered with a coif bound to her face in which the sweetness of her expression stands out. Mary is sitting at her feet, characteristic that appears in images of the late Gothic. She is wearing a tunic tied with a narrow belt, in this way few vertical folds are formed on her bust.

Her shoulders are covered with a mantle that mingles with Sta Ana's clothes, and completely hides the lower half of her body. Beneath the mantle the knees on which the Child is sitting are suggested. The Virgin has long blond hair which falls a little below her shoulders. She is absorbed looking at her son, her face like an adolescent's. She holds the Child with her arms, puts her right arm behind his body and her hand on the belly; with the other she partially covers his right leg and foot.

Jesus is naked and holds a bird, today beheaded, in his hands, by the opened wings. His grandmother sets her right hand on the child's shoulder, while resting the other on her daughter's. The representation abounds in peace, familiarity and harmony both in form and meaning. It would be called a family portrait today. The piece is polychromed and in those parts where the dominant golden colour has fallen off there is an intense red tone in the ample garments.

The quality of the work is exceptional and there is no doubt of its Flemish affiliation. These orientations were introduced in Galicia by the artists who came to work on the construction of the Royal Hospital of Santiago, and particularly, in the decoration and images of the chapel pillars. They knew the Toledo Gothic of the XVth century but undoubtedly the most outstanding sculptors were foreigners: Pedro Francés and, above all, Nicolás de

Chaterenne, to whom this Triple Saint Anne has sometimes been related. In this way its chronology is situated in the first years of the XVI century.

<div align="right">(R.Y.P.)</div>

BIBLIOGRAPHY
Azcárate, J.M. de (1955); Hoyo, J. del (1607); López Ferreiro, A. (1968)

122
Saint Mark
ANONYMOUS
End of the XVth century - beginning of XVIth

Wood
145 x 85 x 40 cm.
Parish church of San Andrés de Canle
(A Coruña)

PARISH CHURCH OF SAN MARCOS DE CORCUBION (A CORUÑA)

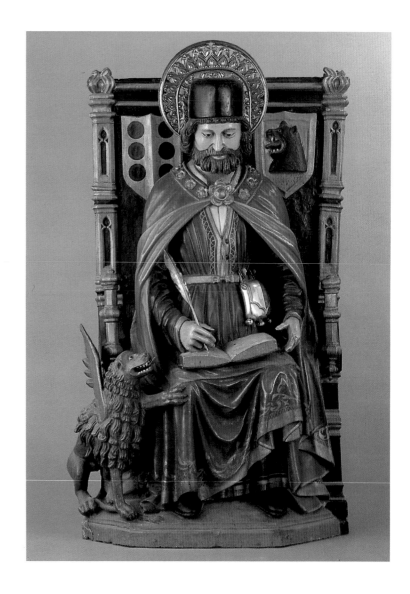

There are no concrete studies of this work, brought in a Venetian vessel and given by the Count of Altamira to the parish church of San Andrés de Canle, which motivated the change in the titularity of the parish (it became San Marcos) and the construction of a new temple (1430) next to the port.

'Chair image' that represents the enthroned Saint, carrying a feather pen and the Evangel in the manner of a 'notalo' or 'glurista'. Next to him, the Lion of Tetramorfos. He is dressed as a man of law or important Italian of the XVth century: ruffled "lucco" over the waist, mantle, and head covered with "copricapo" in the camauro style. The frontal image is typical of a niche.

Like so many "exotic" works in our region, this is a testimony of the trade, cultural and devotional relations of Galicia with the outside (the sarcophagus of the Holy Count, hidria (water jar) of Cambre, Gothic Virgin of San Martiño Pinario, alabasters of the Compostelan Cathedral, monstrance from Noia...), more intense and effective than is commonly thought.

Stylistically and culturally it must be classified in the wood sculpture of the North of Italy, phenomenon of broad area and interesting evolution, interfered with the history of statues in terracotta.

In the Sienna of the XVth and XVIth centuries, a strong tradition of sculpture in wood in all of Tuscany survives from the Duecento and Trecento, and is even cultivated by great Siennese masters and especially Florentines: Francesco de Valdambrino, Domenico de Nicoló del Cori, Antonio Federighi, Jacopo della Quercia, Bruneleschi (Crucifix of Santa María Novella), Donatello (Crucifix of Santa Croce, Magdalena del Baptisterio) and even Michelangelo (Crucifix of Santo Spirito). In Lombardy the movement includes Matteo Raverti.

As years pass, the genre is influenced by sculpture in terracotta (Vecchietta, Niccolo dell'Arca and especially Guido Mazzoni and artists of the Brunelleschian and Robbian circle (Master of Monteolivetto Maggiore...). This provokes a new morphology in sculpture in wood: corpulent figures, bourgeois balance (Nerocchio de Bartolomeo, Master of the Saint Thomas of Leipzig...) These are semicultured images, semi-devotional, to which the Saint in question belongs, marked by the cordial and plastic naturalism of Emilia-Romaña.

The iconography, which undoubtedly meant a braking of his popularity and the expansion of his cult, is the fruit of a curious evolution: until the XIth-XIIth century the Saint is represented as a classical scriptor (toga, mantle). In the XVth century the bust-portrait (one of the most beautiful products of the Tuscan Renaissance), splendid exponent of Florentine humanism, clearly influenced the iconography of the saints (Saint Lawrence of Donatello, the Quattro Santi Patroni of Fr. de Valdambrino, Santo Domingo de Niccollo dell'Arca...) to the point where many images of saints are really full-length busts (Cozzarelli, Della Robbia) done in terracotta and wood, like cultured humanists, like many saints or images of devotion at the time, Saint Mark was represented as a humanist, as a man of letters, as giurista or man of law, as if it were a bust-portrait. But such an appearance was not very eloquent to the Galicians, so that outside Corcubión, the Saint did not reach popularity nor did his iconography manage to start a local tradition.

<div align="right">(S.A.E.)</div>

BIBLIOGRAPHY
González Fernández, J.M. (1990); Mayán Fernández, F. (s.d.) (G.E.G.)

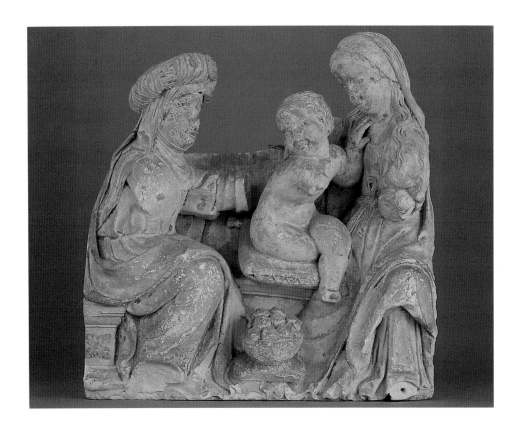

123
The Virgin with the Child and Saint Anne
ANONYMOUS
Around 1520

Limestone
59 x 56 x 24 cm.
Former main altar piece of the Cathedral of Tui
(Pontevedra)

TUI CATHEDRAL (PONTEVEDRA)

Of the three main altar pieces from the Cathedral of Tui for which we have information and which succeeded each other at intervals of a century, the first, done in the first years of the XVth century, was undoubtedly the best. Unfortunately, we can only imagine it through the proceedings of two pastoral visits by Bishop Muñoz in 1540 and 1542, and through several pieces which the Cathedral still has today. The altar piece was headed by an image of the Virgin and ended with a representation of the Holy Spirit. It also included seven stories of Our Lord and was jointed by large pillars which images of saints were placed. Done in limestone from the Portuguese region of Batalha, it was polychromed by Jácome de Blancas by express desire of Bishop Muñoz as a result of his visit in 1540.

The relief of the lament for the death of Christ belonged to this altar piece and presumably was in the center of the first section. Today it occupies the space of the old entry to the Chapel of Saint Catherine. Of the eight figures around the lifeless body of Christ, the Virgin and Saint John create an axis around which the rest of the characters are placed, with the Magdalen at the feet and Nicodemus at his head. It is the piece which presents the best state of preservation and a good exponent of that linguistic pluralism which begins to characterize Galician art of the renaissance in the first decades of the XVIth century. The insistence on some emmotional and dramatic formulas, tending to emphasize what there is of suffering in Christ's torment is an obvious feature of the anti-classical character of the scene. The importance given to the gesture—Virgin's arms crossed over her chest, which concentrate a feeling in one place which later expands to the whole, the knot formed by Christ's hands and those of one of the holy women—, the body of Christ itself which continues to bend with the hardness of a Gothic zig-zag and not with the docility of a classical wreath, the shroud which stiffens like an arch or the garments of José of Arimethea which stretches as if it were trying to mark the line of direction of the body, indicate that we are still within the affective lines of the Gothic. But together with all this, we can observe how the different components of the relief are controlled by an equilibrium of a composition based on geometrical principles and on a rigurous symmetry, reaching a certain balance between the Nordic model and the renaissance one, although in general terms this relief can be considered an example of the traditional survival of Gothic art at the beginning off the XVIth century. In general, the remains of this relief confirm how the incorporation

of Galician sculpture into the Renaissance is produced, although not exclusively, in relationship to artists of northern formation and origin who, either settled in Galicia or on their way to Portugal, contribute a style that is permeable to the Gothic vocabulary and who give our renaissance its particular vision of the classical language.

(A.- A. R.V.)

BIBLIOGRAPHY
Rosende Valdés, A.- A. (1989).

124
Our Lady of Sorrow
ANONYMOUS
Beginning of the XVIth century

Polychrome wood
70 x 46 x 17 cm.
Door of the city. Viveiro (Lugo)

CHURCH OF SANTA MARIA DO CAMPO.
VIVEIRO (LUGO)

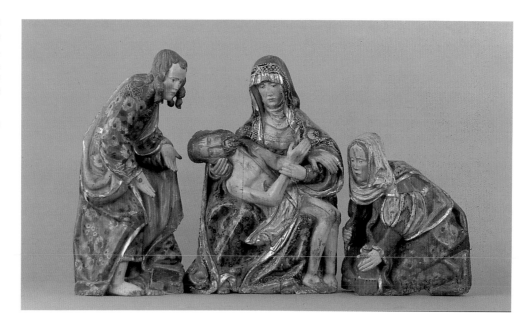

The city of Viveiro, which maintains a good part of its medieval design, was surrounded by a high thick wall in which at more or less regular spaces six doors opened to organize the main ways of access and to signal the limits of a tortuous road network formed by three streets around which the urban life was centered. The main street, Rúa Grande, crosses the city transversely and connected the Castle of the Bridge or door of the Main Bridge to the door of Vallado. The other two, which are almost parallel, crossed it longitudinally from the door of Saint Anne to that of Saint Anthony and from the door of the Villa of Christ to that of the Sorrows. For several centuries the careful attention of the village made it possible to keep walls and doors standing, but in the last third of the XVIIIth century the inclosure had almost disappeared, with only the six doors left, which in the course of the XIXth century were reduced to half that number. In this sense, the date 1861 is important, since in that year the demolition of the door of the Sorrows was requested of the Town Hall. The name, like the majority of the doors, came from the image which had been worshiped in it. The municipal organization accepted the request, but also that of the parish priest of Santa María, who claimed the sculpted group for his church, where today it can be seen.

It is a small group in polychromed wood which represents the Virgin holding the lifeless body of Christ, accompanied by Saint John, at the head, and Magdalene, at the feet. Both its dimensions and the flat back plane or its complete accommodation to a semicircular scheme shows its original placement in the tympanum of the door. Immersed in the emotional statements of Gothic art, the work announces the dramatic current which will characterize an important part of the Spanish religious imagery of the XVIth

century. The clinching fusion of the bodies of Mother and Son, the insistent presence of a lacerated image and suffering faces, attenuated in the figure of Saint John, the locks dampened by sweat or the disproportions, join with that idea of clarity and regularity in the composition and an ordering of the fold which show the modernity of the work, although the characters cannot be inhibited by that type of elaboration of the religious image that is still Gothic.

(A.-A.R.V.)

RESTORATION NOTE:

State of preservation:
• Serious damage by active xylophagus insects, placing the structure of the support in danger.
• Losses of the lower zones of the three pieces, unglued parts and cracks.
• There are two layers of preparation, the second thick and traditional (compound and animal glue), with good adhesion but lack of adherence to the support and with empty spots produced by the contraction of the wood.
• The painted layer is a repolychromization from the XVIIIth century in good condition.
• The original polychromy is only visible in a small laguna.
• The protective layer is composed of lacquer and varnishes.

Treatment applied:
• Mechanical cleaning of dust and biological deposits.
• Disinfection with methyl bromide, preventive treatment of the wood with xilamón.
• Consolidation of the support with synthetic resins.
• Fixing of the preparation and paint layer.
• Chemical cleaning of surface grease.
• Bevelling of the edges with stucco.

Additional treatment:
• Physical-chemical and photographic analyses to determine the existence and extension of the original polychromy as well as its state of preservation and its possible recuperation.
• Following of its state of preservation through control of environmental factors of preservation.

BIBLIOGRAPHY
Chao Espina, E. (1988); Donapetry Yribarnegaray, J. (1953)

125
Main Altar-piece of the Cathedral of Ourense
ATTRIBUTED TO CORNIELLES OF HOLLAND
1515-1520

Polychromed wood
70 x 25 x 19 cm.

CATHEDRAL OF OURENSE

In the year 1511, Pope Julius II appointed his treasurer, D. Orlando de la Rubiere, to the Bishopric of Ourense, and who, on not occupying the position, named as official in the diocese the precensor and prior of the Collegiate Church of Xunqueira de Ambía D. Alonso de Piña, key figure in the

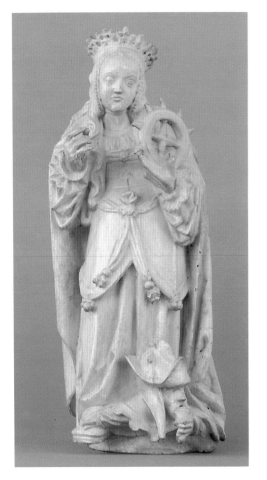
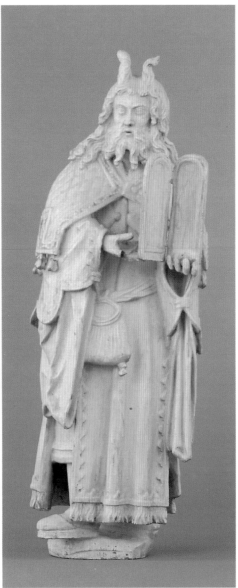
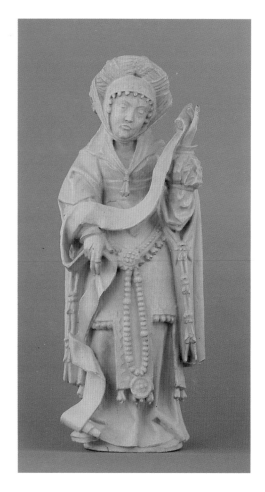

introduction of the Renaissance in Ourense and promoter of important works, among which the main reredos of the cathedral is the most prominent, of which we have very few documented facts regarding its authorship, traditionally attributed to Cornielles of Holland, nor regarding the exact dates of construction, which vary between 1515 and 1520, year in which it would have been completed.

The altar-piece was cleaned and retouched in 1718 by Pedro Carballal and the Neapolitan Joan Valentín; in 1843 it was restored and polychromed by the painter and gilder D. Manuel Valdés.

Typologically and stylistically, the retable belongs to designs spread throughout Spain in the final years of the fifteenth century and the beginning of the sixteenth, of great proportions and a strongly narrative sense, destined to cover the enormous headwalls of the Gothic temples such as

those of Seville, Toledo, Oviedo, etc., and in which the idea of the total composition, the architectonic complexity, predominates over specifically sculptural values.

From the point of view of the architectonic structure as well as the sculpture itself, the altar-piece is still entirely Gothic, and thus there are numerous borders with pinnacles, carved out swirls or the groups of small columns as a dividing element of the various sections. The sculptures, reliefs and separate small figures (the latter of very superior quality) also follow a technique used in the final phase of the style, in the type of folds, clothing or narrative reading of the different scenes.

Regarding its authorship, we must distinguish between the sculptures painted in white which are set in the sections, the majority of which are the personal work of Cornielles of Holland, and the

reliefs, very rough and plain, which must have been done by those in the studio.

The altar-piece is comprised of four bodies and five sections with narrative scenes that are episodes from the lives of Christ and the Virgin; in the central section the compartments are reduced to three with scenes of the Pietà, the Assumption and Coronation of the Virgin. The first three bodies of the retable are filled with scenes from the life of Christ: in the first body, the cycle of the Passion with the Flagellation, the Crucifixion, the Pietà in the center, the Burial of Christ and the Resurrection. In the second body scenes of the public life of Jesus are depicted: Christ among the Doctors, the Baptism, the Last Supper and the Agony in the Garden. The third body is devoted to the infancy of Christ, beginning with the Birth, the Epiphany, the Circumcision and the Death of the Virgin, who

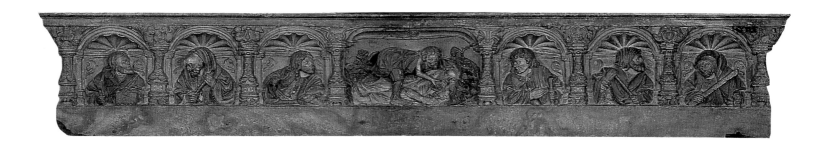

inexplicably appears here, since it is a theme which would fit better in the cycle of the Virgin, which occupies the fourth and last body, with scenes of the Birth of the Virgin, the Presentation of Mary in the Temple, the Annunciation and the Visitation.

On the groups of small columns which join the altar-piece there is a total of 36 small separate sculptures beneath ornate borders which in their majority have not been identified nor interpreted iconographically in conjunction with the altar-piece. In the second body they are placed three sculptures to a pillar, in the second there are two, and in the last body there is only one figure, all of which are of unequal technique, which leads to believe that several sculptors were involved, influenced by northern Gothicism that can be associated with the sculpture which adorns the pillars of the Royal Hospital of Santiago, for example, as far as the search for realism and expressiveness in the faces, among which some female figures stand out, such as Saint Lucia with her softness and beauty of facial form.

In the narrative reliefs the sculptor concentrated his concern for the overall effect and for the introduction of a series of narrative elements, foregoing the individual treatment of the bodily detail, proportions, or expressiveness of the figures. The only noteworthy features are the reliefs of the first body of the altar-piece, and in particular the relief of the Pietà, for its symmetrical composition and the emotional evenness in which the birth of a new sensitivity can be detected, which nevertheless is far from the expressive pathos of the Christ whose extreme stiffness recalls the Gothic portrayals of the theme.

(M.ª- D.V.J.).

RESTORATION NOTES:

Moses.

State of preservation:
• Wood support with some damage by xylophagus insects.
• Breaks of the support on fingers of the left hand.
• Due to the ceruse we cannot see the state of preservation of the original layer of preparation.
• The surface of the painted layer (white) has good adherence and underneath are remains of the original polychromy.
• On the surface is a very fine layer of deteriorated varnish and over this remains of smoke, deposits of dirt and dust.

Treatment applied:
• Mechanical cleaning of the dust and biological deposits.
• Chemical cleaning of deposits of dirt, smoke and biological deposits.
• Structural reinforcement of the support.
• Gluing the fingers of the left hand.
• Disinfection by methyl bromide vapors in gas chamber.

Additional treatment:
• Physical-chemical analysis, photographic studies to determine the state of the original polychromy and its possible recuperation.
• Control of environmental conditions (temperature, relative humidity and biological damage).

Saint Catherine.

State of preservation:
• Support with serious damage by xylophagus insects affecting the wood structurally and causing losses on sides.
• Weakened edges.
• Surface paint layer (ceruse) shows good adherence to the support.
• Remains of the original polychromy are visible.
• On the surface is a fine layer of oxidized varnish with deposits of dust, smoke and dirt.

Treatment applied:
• Disinfection and preventive treatment of the wood with xilamón, by injection.
• Mechanical cleaning of dust and biological deposits.
• Chemical cleaning of dirt, smoke and biological deposits.
• Consolidation of the support with stable synthetic resin by injection and reinforcement of weakened edges with wood paste.

• Disinfection by methyl bromide vapors in gas chamber.

Additional treatment:
• Physical-chemical analysis, photographic studies to determine the state of the original polychromy and its possible recovery.
• Control of environmental conditions (temperature = 18 degrees C, relative humidity = 66% and biological damage).

BIBLIOGRAPHY

Chamoso Lamas, M. (1973) (II) (1980); Fernández Otero, J.C. (1983); Filgueira Valverde, J. (1942) (I); Gómez Moreno, M. (1942); González García, M.A. (1989); González Paz, J., Calvo Moralejo, G. (1977); Martínez Sueiro, M. (1918-22); Muñoz De La Cueva, J. (1726); Sánchez Arteaga, M. (1916); Weiler, A. (1924).

126
Altar-piece of the vestibul of the Royal Hospital of Santiago
CORNIELLES OF HOLLAND
1524

Walnut and chestnut
245 x 40 x 12 cm.
Vestibule of the Royal Hospital of Santiago

ROYAL HOSPITAL OF THE CATHOLIC KING AND QUEEN. SANTIAGO DE COMPOSTELA

The third of July, 1524, Cornielles of Holland, sculptor, resident in Ourense, signs a contract with the administrator of the Royal Hospital in Compostela to create a reredos of walnut and chestnut woods for the altar of the main vestibule of this institution for the ill.

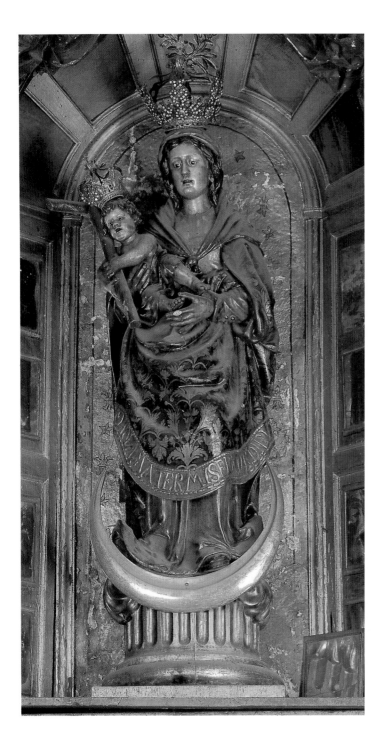

The sculptor, who until then had worked in Ourense in a style that was quite close to the patterns of late Gothic, was given the condition that the work had to be "Roman", that is, it was to fit the aesthetic preferences of the Renaissance-something which until then was unknown in Galicia and which was beginning to be introduced by John of Alava.

The reredos, of which only the predella remains, would consist of sixteen images: "Above the reredos a Crucifix and below A Veronica and on one side Saint Peter and on the other Saint Paul and below an image of Our Lady of the Rosary and on the sides Saint James and Saint John his brother and below Saint Anne and on either side Saint Bartholomew and Saint Andrew and at the very bottom six half Apostles..."

The appraisal of the altar-piece by Petijuan and Master Philip at 51,500 maravedis, was not accepted by the Hospital's administrators, at which time Juan de Alava was named new assessor and validated the previous price.

The "six half apostles", that is, their busts, are still preserved, as small figures, separated by columns that vaguely resemble those with balasters-like appearance and covered with conch shells. The technical treatment of the sculptures readily recalls those of the main retable of the Cathedral of Ourense, although the type of fold employed is much more linear and simplified.

The center of the predella contains a scene of complex symbolism, in which there is a male figure lying on the ground, in the middle of a stylized landscape, and another figure leaning over him in the gesture of assistance. Given the place where the altar-piece was to go, in the vestibule of the hospital, I believe that this relief should be interpreted in a thaumaturgical sense: the aid or curing of the invalid or ill to whom the building was dedicated. In this sense, perhaps it might not be too bold to identify the scene as a visualization of the parable of the good Samaritan (Luke 10, 30-37).

(M.ª- D.V.J.).

BIBLIOGRAPHY
Chamoso Lamas, M. (1973); Pérez Costanti, P. (1930); Rosende Valdés, A.A. (1982)

127
Virgin of a Prima
CORNIELLES OF HOLLAND
1526

Polychromed wood
185 x 78 x 50 cm.
Chapel of A Prima. Cathedral of Santiago de Compostela

CATHEDRAL OF SANTIAGO DE COMPOSTELA

The image of the Virgin with the Christ Child known by the name of the chapel where it is held, is the only piece preserved from the altar piece commissioned to Cornielles of Holland for the chapel of the Clergy of the choir or A Prima, in the

transept of the Compostelan Cathedral. In the contract the sculptor was required to do the work "a la romana", that is, following the recent Renaissance taste. In 1721 A new altar piece was done for the chapel, with designs by Simón Rodríguez, where this image was placed.

In the conception of the sculpture the new feeling is clearly revealed, which after the third decade of the XVIth century begins to be promoted in Galician sculpture, evident in the Child's anatomical forms, in the serene and idealized beauty of the Virgin and the rounding of the folds, now lacking all the Burgundian angularity.

Iconographically the Virgin of A Prima is interesting because it represents the Immaculate Virgin in the medieval manner, that is, as Apocalyptic Woman, although the devotional message is spelled out in the legend "Mater Misericordiae" which appears on the edge of the Virgin's dress: Mary as interceder for the human race, which will achieve salvation through the Pasion of Christ, already present in the child's infancy, as he embraces the Cross.

(M.- D.V.J.)

BIBLIOGRAPHY

Chamoso Lamas, M. (1973); Filgueira Valverde, J. (1942); Folgar de la Calle, M.C. (1989); González Paz, J., Calvo Moralejo, G. (1977); Martín González, J.J. (1977); Otero Túñez, R. (1956); Rosende Valdés, A.A. (1982)

128
Saint Lucia
ATTRIBUTED TO CORNIELLES OF HOLLAND
First third of the XVIth century

95 x 32 x 24 cm.
Cathedral of Ourense

MUSEUM OF THE CATHEDRAL OF OURENSE

The sculpture probably dates from around the same years as the main altar-piece of the Cathedral of Ourense, given their similarities of technique with the small figures situated on the pillars of that retable. It is dressed in the Burgundian manner, with tunic and mantle of broken folds, and wears a headpiece called "rollo", typical of the Flemish fashion.

The form of the face is soft and round, which gives the figure a sweet expressiveness and the folds of the tunic are deep and stand out, in an effort precisely to create a sharp light contrast through the creation of large empty spaces.

From an iconographic perspective, the saint is represented in a traditional manner, that is, she holds the plate with her eyes in the left hand, while in the right hand she would have carried the palm of martyrdom, which has disappeared.

The image is well preserved and its polychromy beautiful.

(M.ª- D. V.J.).

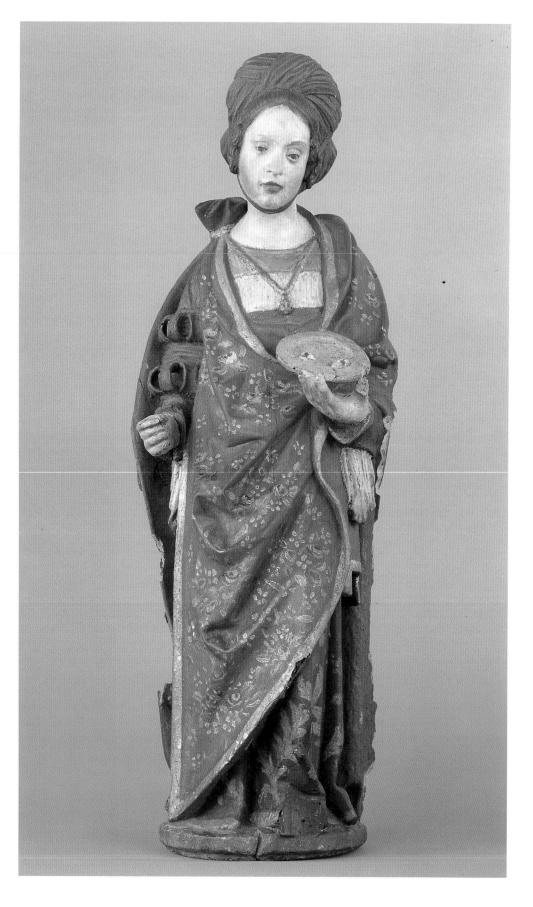

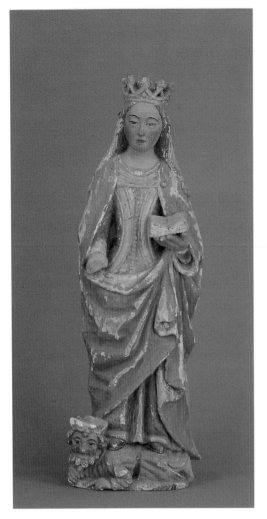

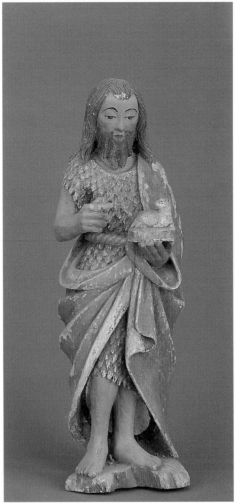

BIBLIOGRAPHY

Chamoso Lamas, M. (1973); (1980); González Paz, J., Calvo Moralejo, G. (1977)

129
Saint Martha and Saint John of San Pedro de Moreiras
CORNIELLES OF HOLLAND
First third of the XVIth century

Polychromed wood
67 x 25 x 18 cm.
Altar piece of the church of San Pedro de Moreiras (Ourense)

CHURCH OF SAN PEDRO DE MOREIRAS (OURENSE)

The reredos of the Ourensan church of Saint Peter of Moreiras was commissioned by the precentor of the Cathedral of Ourense, D. Alonso de Piña, important mycenas of the beginning of the fifteenth century, and follows typologically the patterns prevalent at the end of the sixteenth century in Castilian schools, but it differs from them in that, instead of having the various pictorial spaces occupied with scenes in relief, that is, with narrative area, separate standing figures have been used, some of which have now disappeared.

The relievo-work of the altar-piece is flamboyant Gothic, with two small carved out daises to hold the sculptures and a proliferation of pinnacles, interwoven arches, and natural motifs. The type of support used to separate the different sections are helicoidal columns, very infrequent in Galician retable pieces. As a means of separation between the columns of the different sections, small sculptures are introduced beneath vaulted niches, in a technique often used by the sculptor Cornielles of Holland.

As far as the figures, the original iconographic plan is altered by the inclusion of figures from different periods. Belonging to the original altar-piece are: a sculpture of Saint Martha, a Saint John the Baptist, and a sculpture of the Virgin in the top part, as well as the twelve small figures of Apostles which are interplaced on the column shafts. In all of these a strong Burgundian flavor is noticeable, both in the clothing and especially in the expression, the exaggerated naturalism in the faces, and an irregular placement of the fabrics, which disguise the structures of the body in their stiff folds.

(M.ª- D.V.J.)

BIBLIOGRAPHY

Chamoso Lamas, M. (1973); Fernández Otero, J.C. (1983); González Paz, J., Calvo Moralejo, G. (1977); Ramón Fernández-Oxea, J. (1969)

RESTORATION NOTE:

State of preservation:
• Serious damage by xylophagus insects (Anobium Punctatum and Ilotropus Ballolus).
• Numerous galleries, giving the wood a spongy appearance and structurally affecting the image.
• The areas of lesser thickness of wood are practically hollow, and its capacity as support is lost. These areas are held sustained by the preparation and various layers of polychromy.
• The back part, lateral folds and left hand are the areas with greatest cavities.
• The preparation layer is white and very fine (animal glue and compound) with good internal cohesion.
• The upper layer of repolychromy has a good state of preservation but is of very poor quality; it has traces of purpurin on the clothing.
• Slight wrinkling in the flesh areas due to bad technique, as well as an irregular surface patina.
• On the surface are remains of bitumen, wax and dirt deposits.

Treatment applied:
• Due to the serious damage which it had there was first a

disinfection with xilamón and the consolidation of the support with synthetic resins by injections, to reconstruct its function as support and thus manipulate the statue.
• Stuccoing and injections of compound (wood paste) in the cavities and edges of polychromy which had lost their support.
• Mechanical cleaning of surface dust.
• Cleaning of wax incrustations from candles with Leister.
• Soft chemical cleaning of flesh areas to lighten and homogenize the patina.
• The rest of the statue was very superficially cleaned to maintain an aesthetic equilibrium.
• Neutral ink on the edges and bare stuccoed spots with wood paste.
• Disinfection of the support with methyl bromide vapors in gas chamber.

Additional treatment:
• Physical-chemical analyses and photographic studies (I.R. and U.R.); according to the results of the analyses a diagnosis will be done to proceed to a restoration and possible recovery of the original polychromy.
• Control of environmental conditions (temperature, relative humidity, biological damage).

130
Christ of Humility
MASTER OF SOBRADO
Mid years of the XVIth century

Polychromed wood
106 x 46 x 35 cm.

PARISH CHURCH OF SANTA MARIA DE VELLE
(OURENSE)

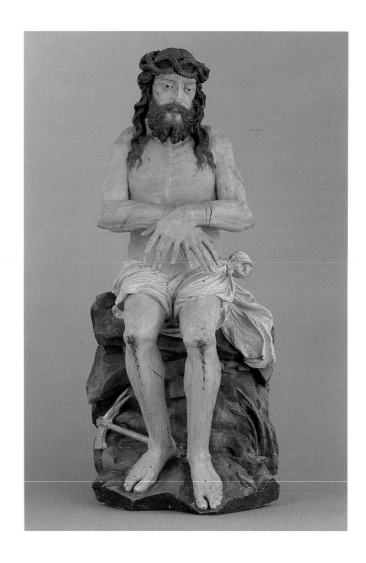

This Christ of Humility, placed in a Baroque reredos of the parish church of Velle (Ourense), must have formed part of a retable devoted to the Passion of Christ.

The theme of the Christ of Humility or Patience comes from the Ecce Homo, which it differs from by its sitting position. Christ appears without clothing, with bloody hands and feet, crowned with thorns and seated on a promontory of sharp rocks with great craggy shapes. It is the moment prior to the Crucifixion.

The body type of Christ is exactly that used by the "Master of Sobrado": corpulent anatomy, details of muscles and veins, and concern for the expressiveness of the hands.

On his head again all the defining characteristics of the Master are concentrated, such as the square face and the angular features, as well as the grimace of pain suggested by two wrinkles about the mouth.

(M.ª- D. V.J.).

RESTORATION NOTE:

State of preservation:
• Scattered damage by xylophagus insects.
• Although more serious in the lower part where there is a high degree of dampness (in reference to its placement).
• There is a crack in the back part of the body of the fitting that is unglued on the right arm.
• The preparation layer is traditional white (compound and animal glue) with good cohesion and adherence.
• The painted layer is a later re-polychromy which is in good condition with small, very scattered lacunae.
• Protective varnish layer.
• Concretions of wax and dust on the surface.

Treatment applied:
• Mechanical cleaning of surface dust layers.
• Disinfection with methyl bromide.
• Preventive of the wood with xilamón.
• Scattered consolidation of the support with synthetic resins.
• Cleaning of concretions of wax with Leister.
• Chemical cleaning of surface.

Additional treatment:
• Physical-chemical and photographic analysis to determine the state of the original polychromy and its possible recovery.
• Following of the state of preservation by control of the environmental conditions.

BIBLIOGRAPHY
Martín González, J.J., González Paz, J. (1986)

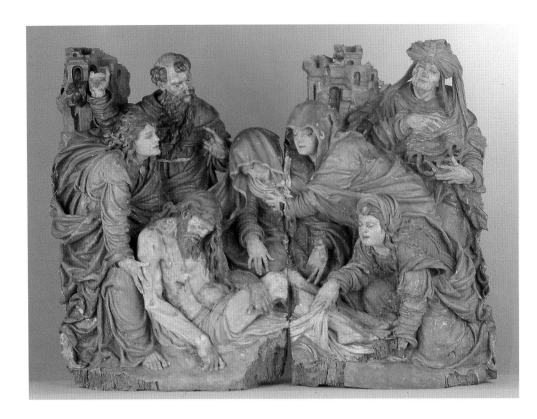

131
Holy Burial
MASTER OF SOBRADO
Mid-XVIth century

Polychromed wood
128 x 167 x 32 cm.
Monastery of Sobrado dos Monxes (A Coruña)

CHURCH OF SAINT PETER OF THE DOOR.
SOBRADO DOS MONXES (A CORUÑA)

This group of the Burial of Christ in polychromed wood, which formed part of the main altar-piece of the monastery of Sobrado dos Monxes, is located in the church of Saint Peter of the Door, near the monastery. The relief shows all the peculiarities of the "Master of Sobrado" and proceeds from the groups of the same theme executed by Juan de Juni, specifically the clay sculpture of the Cathedral of Salamanca which forms part of the sepulcher of the archdeacon Gutiérrez de Castro.

The scene is not exactly a Holy Burial, but rather the moment when, after the Descent, the cadaver of Christ is placed upon the shroud. It consists of seven figures in a very pronounced high relief which gives them the appearance of roundness.

The composition is symmetrical, with a true symbolic central point at the head of the Virgin, which serves as an axis for the grouping. Above her the sculptor left a deep hole which upsets the balance of the composition and leads the spectator instinctively toward the central part of the scene. In the foreground is the body of Christ, placed on the ground and supported on both sides by Saint John and Mary Magdalene, who covers him with the shroud. The artist reveals himself in all his capacity with the head of Christ: the resigned, serene pain, the sweetness of the acceptance of death, are reflected in the face bent over his chest and surrounded by a heavy beard.

The two male figures situated in the background again repeat Junian features. Thus, Joseph of Arimathea raises his right arm in a gesture which Juni uses in the Burials of Valladolid and Segovia, while on the other side Nicodemus, who is holding in his hands the crown of thorns, is a magnificent interpretation of the Saint Ann of Juan de Juni, preserved in the Museum of Valladolid.

(M.ª- D.V.J.)

BIBLIOGRAPHY
Castillo, A. del (1921); Martín González, J.J. (1966); Rey Escariz, A. (1922); Rosende Valdés, A.- A. (1982)

132
Birth of the Virgin
MASTER OF SOBRADO
Mid-XVIth century

Polychromed wood
130 x 100 x 30 cm.
Monastery of Sobrado dos Monxes (A Coruña)

MUSEUM OF THE GALICIAN PEOPLE.
SANTIAGO DE COMPOSTELA

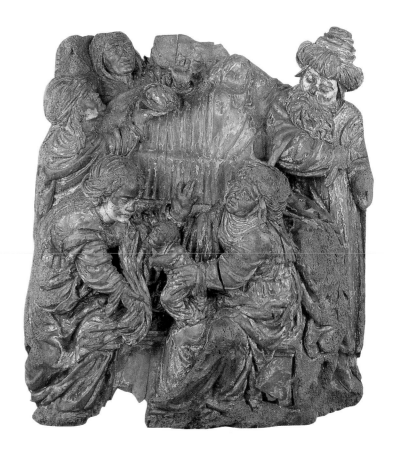

 This relief of the Birth of the Virgin must have
formed part of the main altar-piece of the monastery
at Sobrado and is undoubtedly the work of the artist
known as the Master of Sobrado, although its poor
condition makes it difficult to study the figures in
detail. Because of the loss of the architectonic frame
which must have surrounded the scene, it is now set
in an undefined space, with the result being the
difficulty in analyzing the overall composition. The
work is limited to an inverted triangle whose sides
are marked above by Saint Anne's bed and on the
lateral lines by the figures of two women who are
bathing Mary. The depth of the planes is reduced
because of the perspective deriving from Mannerist
superimposing and all effects of distance are avoided
through a rapid convergence toward the foreground.
 The sculptor differs from his Junian source in
regard to the composition, as he does not carry out a
pictorial treatment of space, but in the conception of
the figures he continues to evoke his model at all
times, in their physical features and the
expressiveness of their faces.
 The theme of the Birth of Mary, like all the scenes
related to the youth of the Virgin, is taken from the
Apocryphal Gospels and artists are inspired in
general by the Birth of Christ, introducing in addition
a series of descriptive and anecdotal elements.

<div align="right">(M.ª- D.V.J.)</div>

BIBLIOGRAPHY
*Castillo, A. del (1921); Martín González, J.J.
(1966); Martín González, J.J. , González Paz,
J. (1986); Rey Escariz, A. (1922)*

133
Adoration to the shepherds
MASTER OF SOBRADO
Mid-XVIth century

Polychromed wood
114 x 100 x 38 cm.
Monastery of Sobrado dos Monxes (A Coruña)

MUSEUM OF THE GALICIAN PEOPLE.
SANTIAGO DE COMPOSTELA

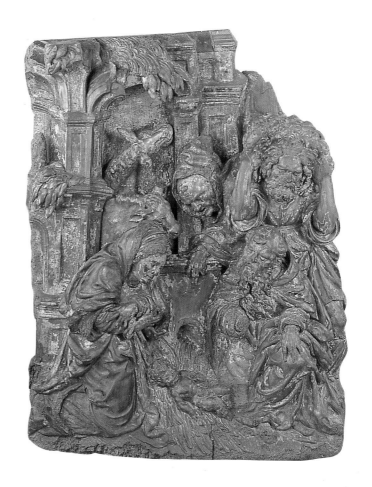

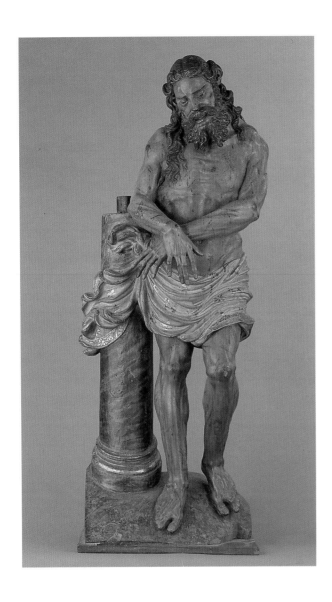

134
The flagellation
MASTER OF SOBRADO
Mid-XVIth century

Polychoromed wood
72 x 24 x 21 cm.
Cathedral of Ourense

MUSEUM OF THE CATHEDRAL OF OURENSE

Traditionally attributed to the "Master of Sobrado," the stylistic features of the figure confirm this. The sculpture shows the heaviness of forms, the stunting of the proportions, a disdain for formal beauty in favor of greater pathos. Another characteristic also typical of the artist is the effect of plenitude which rules the composition, in which all the members are distributed along a single foreground.

Christ is shown standing, flush with the whipping post, but not tied to it. This column, today broken in fragments, must have been tall and would have served more as a symbol than as an actual support for the figure of Jesus, who crosses his hands at waist level with a submissive gesture, as if he were an Ecce Homo, whose iconography he attempts to assimilate, although such differentiating elements are lacking as the crown of thorns, the purple robe, or the rod.

(M.ª- D.V.J.)

RESTORATION NOTE:

State of preservation:
• Very scattered damage by xylophagus insects.
• Losses on the upper part of the column and a small attachment of the rear part.
• There are an unglued attachment and small cracks.
• The loss of the attachment as well as a crack in the loin cloth have been filled in with wood paste in a previous intervention.
• The painted layer is coming off in small areas but in general has good cohesion and adherence.
• There are several layers of very oxidized lacquers on the surface.

Treatment applied:
• Cleaning of the dust and biological deposits.
• Disinfection with methyl bromide in gas chamber.
• Chemical cleaning of greasy deposits on surface.

Additional treatment:
• Physical-chemical and photographic analysis.
• Substitution of the wood paste due to its poor condition.
• Gluing of attachment.
• Elimination of lacquers which distort the reading of the piece.
• Following of the state of preservation of the piece by control of environmental conditions of preservation.

The scene of the Adoration of the Shepherds, also from the retable of Sobrado, still shows the remains of architecture in ruins which recalls the relief of the Birth of Christ of San Marcos in León, by Juan de Juni.

In the foreground, Mary and Joseph contemplate the Child with devotion, as he rests upon the straw. In the background there are two shepherds arriving to contemplate the Divine Child. One of them is carrying a sheep on his shoulders, which can be interpreted as a reference to primitive Christian art, in which one of the shepherds evokes in this manner the "Good Shepherd." As if overcome by the weight, the shepherd flexes his muscles and

wrinkles his face in an expression of pain which faintly recalls the group of Laocoontë. Their clothing moves wildly, swelling in cottony folds as if they were sculpted in clay, although, in comparison with other sculptures of the artist, they have lost part of their softness by becoming rigid and forming curved, concentric folds.

(M.ª- D.V.J.)

BIBLIOGRAPHY
Castillo, A. del (1921); Martín González, J.J. (1966); Martín González, J.J. , González Paz, J. (1986); Rey Escariz, A. (1922)

BIBLIOGRAPHY
Chamoso Lamas, M. (1980); Martín González, J.J. (1966); Martín González, J.J. , González Paz, J. (1986)

135
Saint Michael Arcangel
PEDRO DE ARBULO
1563

Polychromed wood
80 cm. high

PARISH CHURCH OF SAN XULIÁN. CASOIO
(OURENSE)

The precious altar piece, dedicated to Saint Michael, of the small Valdeorras town of Casoio was assigned in 1562 to Gaspar Becerra, who the year after passed it to one of his collaborators on the work of the main altar piece of the Cathedral of Astorga, Pedro de Arbulo, and to the painter Pedro de Bilbao.

The art of this period in the Ourense area of the diocese of Astorga depends on the important center which arises after the Council of Trent in the diocesan capital. The image of Saint Michael, today taken from the place that corresponds to it in the main altar piece, is a beautiful work, completely Mannerist, which from the iconographic perspective follows the usual pattern of subduing the devil, threatening from between his feet, with the sword which the Archangel carries in his right hand, lifted to gain force.

The young Archangel is wearing military garb, as suits his condition as "Prince of the celestial militia"; over his shoulders falls a cape of elegant folds.

The polychromy, together with that of the beautiful altar piece, is the work of another outstanding master of Astorgan pictoral Mannerism, but of Northern origin, as his last name indicates: Pedro de Bilbao. In the case of this work he carried out his craft with dignity, without any special subtleties.

(M.- A. G.G)

BIBLIOGRAPHY
García Iglesias, J.M. (1986); González García, M.A. (1988)

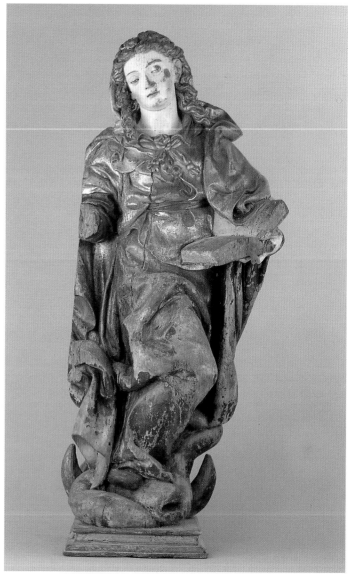

136
The Immaculate Virgin
JUAN DE JUNI
Around 1577

Polychromed wood
127 x 50 x 37 cm.
Former convent of Saint Francis of Ourense

PROVINCIAL MUSEUM OF ARCHEOLOGY OF OURENSE

This sculpture comes from the former convent of Saint Francis of Ourense and was commissioned by

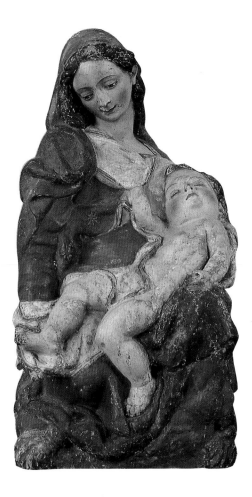

Inés Pérez de Belmonte for this city. In 1577 the sculptor still has it, judging by one of the clauses in his will. The image, which has a wide body, strong neck, rounded face and thick hair, carries an open book in the left hand and has a serpent with thick coils at its feet. Her hair is covered in back with a headpiece knotted at the chest, with one of Juni's customary jewelry pieces, and one ear is uncovered. This is the type of Immaculate Virgin made by the artist for the altar piece of the Antigua, staying within the scheme of the most Holy Virgin of the altar piece of El Salvador in Arévalo (Avila). It is seriously deteriorated, with a mutilated right hand and many nicks. The flesh is matte and the tunic and hair gilded.

The back part is not carved, but this does not stop the artist from affirming his vocation for the roundness of the sculptural form. Juni constructs his images basing his concept of volume on the fullness of strong fleshy figures, to which centripetal helicoidal movement, which concentrates the sculptural mass around its own access, undoubtedly contributes. Again there is the importance of the clothes, which he conceives as independent volumes and which greatly contributes to the movement of the figures and to the intensification of the expresiveness of the figure when combined with the gestures. The folds of the clothing show qualities inherent to clay, which he uses with a mastery transferred to wood, whence the effect of softness viscous and slippery nature. Juni likes to accumulate fabrics, and needs the cloth that is always full of life. Even in a period such as this one, which is calmer, the figure is weighed down by the mass of garments.

As we have seen, this work was in his possession when he made out his will and thus can be dated in the last years of his life. In spite of the distortions the restful air and the quietude of the folds correspond to the expressive features of his last style, which match these dates.

(A.- A. R.V.)

RESTORATION NOTE:

State of preservation:
• The wood support has serious damage by xylophagus insects, affecting its structure.
• There are two types of orifices, some older, already treated and covered with wax and others, belonging to a recent damage, still active. Both cause important losses in the support (rear part, curls of hair, knee, mantle fold).
• Other losses of the support have been produced by the ungluing of the pieces (right lateral, part of the fingers of the left hand with part of the book it holds and folds of the left sleeve).

• There are several cracks caused by the coming apart of the gluing and the natural shifting of the wood.
• The layer overall has good adherence to the support except for the areas that are most weakened which, because of their loss of preparation have raised up, forming small blisters.
• There are lacunae in the preparation where the wood has been left bare.
• The red bole has been applied over this layer over the entire carving, except for the skin areas, which are burnished oil.
• Gilding and paint on gilt ground in fine gold (garments and headpiece). The blue mantle is done in distemper and over this is a very oxidized layer of lacquer.
• Numerous lacunae of the painted layer and cracking in the skin areas.
• On the surface there is oxidized lacquer, wax and dirt concretions.

Previous interventions:
• Reintegration of the support in cracks and small areas with wood paste and araloit.
• Orifices from xylophagus insects and consolidation of the support.
• Scattered touch-ups of polychromy.
• Touch-ups on the base with purpurin.

Treatment applied:
• Disinfection and preventive treatment of the wood with xilamón and methyl bromide vapors.
• Consolidation of the support in the most affected areas with synthetic resins.
• Fixing of the painted layer in scattered points.
• Mechanical cleaning of surface dust.
• Removal of the remains of wax from candles with Leister.
• Fixing of the painted layer and preparation on edges and blisters.
• Chemical cleaning of surface and paint on gilt ground.
• Chemical cleaning of skin areas and lightening of the oxidized lacquer which covered them.

Additional treatment:
• Study of the piece for the possible removal of deteriorating touch-ups and carrying out of an adequate reintegration.
• Control of environmental conditions (relative humidity, light, temperature and biological damage).

BIBLIOGRAPHY
Martín González, J.J. (1962); (1974); Nós (1927)

137
Virgin with the Christ Child
JUNI'S WORKSHOP
1560-1577

Polychromed pine
34 x 17 x 18 cm.
San Bartolomé de Rebordáns (Pontevedra)

MUSEUM AND HISTORICAL DIOCESAN
ARCHIVE OF TUI (PONTEVEDRA)

We have just seen how Juan de Juni is one of the most important artists of the XVIth century, personalizing, along with Alonso Berruguete, the major Spanish contribution to Renaissance sculpture. His work was not limited to fertilizing the Castilian school with epicenter in Valladolid, but rather affected other areas, such as Galicia, and in this case, to the extent that from the middle years of the century, the major sculptural trend of the time

was fed by Mannerism of Junian origin, with Ourense and Compostela acting as polarizing centers of this influence. Ourense, due to the presence of works by the master himself and to the arrival of his followers, and Compostela, through the most important sculptural project of the period in that area, as was the choir of its Cathedral, where one sees uneven approximations to the master's art due to different formations of their authors. But we must add to this the fact that the Museum and Historical Diocesan Archive of Tui have among their pieces an image of the Virgin with the Christ Child, which is from the parish of San Bartolomé de Rebordáns, next to the city, and which can be related to the circle closest to the Franco-Burgundian sculptor.

It is a small group of high quality, worked in pine and disastrously polychromed. Its state of preservation is poor, with many cracks, mutilations, and peeling paint. It is not difficult to see a likeness of the work done by Juni for the Church of Santa Eugenia de Becerril (Palencia). And its aspect is so decidedly Junian, that it would have to be considered a work from his studio, executed perhaps according to the wax or clay model that the sculptor would have done for the church of Becerril. The centripetal movement of twisting, the position of the head, the natural representation of the Child, the compactness of the group or the softness of the drapery, show a perfect knowledge of the master's style, although it does not reach that naturalness which Juni has always been able to imprint upon his volumes. Nevertheless, despite its importance, the work does not appear to have had any influence in the area. We may know the cause when we ascertain whether the Church of Saint Bartholomew was its original destination and how and when it arrived here.

(A. - A. R.V.)

RESTORATION NOTE:

State of preservation:
• Wood support with scattered damage by xylophagus insects.
• Very pronounced cracks on the left portion of the figure, erosions which almost lead to the disappearance of the fingers of the Child's left hand.
• Some areas were reconstructed with stucco and cloth (cloak, base and cushion).
• The preparation is traditional, white, with animal glue and compound in the flesh areas with problems of adherence to the support.
• There is another preparation layer which covers almost the entire figure that served as a base for a new polychromy of very poor quality.
• The reading of the image is made difficult by the re-polychroming which covered wide areas of the cushion, the Virgin's veil, the ball in the Child's hand, tassels...
• There are some lacunae which allow the observation of the original polychromy (left arm of the Virgin, hair). Gold painted on gilt background and a wide area on the back (cushions) where there is no gold.
• It was later retouched with enamel and oil paint which aggravate the bad reading.
• Cracking which follows the movement of the wood in the flesh areas. Very dark, hard patina which covers the whole figure.

Treatment applied:
• Preventive disinfection with xilamón and in gas chamber with methyl bromide.

• Fixing of the preparation layer and the polychromy.
• Chemical cleaning, lifting of touch-ups and patina (in the flesh areas).
• Stucco and touch-up of some areas with neutral ink.
• Repositioning of the protective layer in the flesh areas.

Additional treatment:
• Physical-chemical analysis and very specific photographic study (infrared and x-rays) to determine the state of the original polychromy and if possible a recuperation.
• Diagnosis for a later restoration.
• Control of environmental conditions (Relative humidity, light, temperature, biological damage).

BIBLIOGRAPHY
Rosende Valdés, A.-A.(1980)

138
San Sebastián Camarasa
ANONYMOUS

Last quarter of the XVIth century
Polychromed and ornamented wood
210 x 72 x 33 cm.
Chapel of the "Villa de Guadalupe" (San Sebastian)

PRIVATE COLLECTION

This image was in the chapel of Villa de Guadalupe, in the neighborhood of Gros (San Sebastian), property of the marquises of Santa María das Penas y de Camarasa. In 1946 it was taken to the Pazo de Oca (A Estrada, Pontevedra), which today belongs to the dukes of Medinaceli and marquises of Camarasa. After the death of the marquis of Camarasa (1950), the administrator did an inventory for the widower marquee in which this piece was included as a wooden San Sebastian work of Gregorio Fernández. In 1961 it was donated to its present owner, A. Rodríguez Liste.

The author feels the material in an exemplary way: the holy martyr is really "flesh." It is not a case of a classical Apollinean hero, clearly architecturalized and contoured, but rather martyred material which is imposed upon us, overcomes us and enslaves us. It could be said that it is a pre-Baroque cultural product. Unfortunately its condition of isolated case of exotic piece has not been overcome; it did not manage to be included in the artistic trajectory of the region in spite of its very high quality and its curious but intense similarity to Galician sensitivity to the material (not the form).

Classical representation of Roman martyr, it is pierced with arrows, though with iconographic tinges that acquire a cultural and representative meaning. In contrast with the habitual martyr tied to the tree and pulling away from it (Solari in Duomo of Como, Siloé in Barbadillo de los Herreros, Berruguete in San Benito el Real...), the

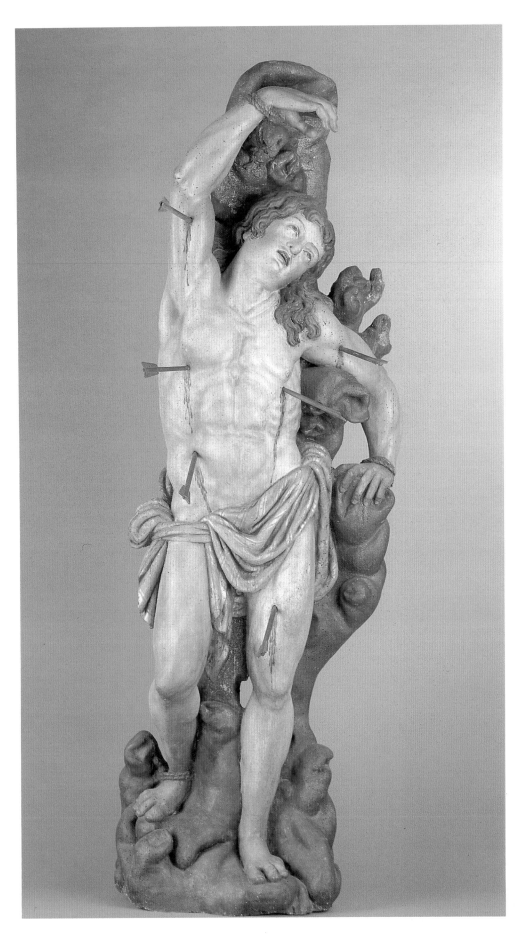

San Sebastián Camarasa tends to be devoured by the tree itself, as if it were a triumph of the sensory matter, just like Alessandro Vittoria will do a little later (Luganegheri altar in San Salvatore di Venezia, ca. 1591). It is very likely that both were inspired by Michael Angelo's Slaves or Prigioni and more specifically in the Schiavo morente of the Louvre as to the construction of the figure.

The author of the San Sebastián Camarasa enters culturally and stylistically in the artistic circle of Juan de Ancheta and other sculptors of the Trento sculpture of the Basque-Navarre-Rioja school. The parallels of this piece with Anchieta's production turn around typically Anchietan factors: at the same time fleshy and very heavy monumentality; importance of the volume and the way of connecting the volumes; dynamic of internal tensions which branches out in two opposing halves with a clear expressive intention; sensual or Semitic conception of the sculptural materia.

There is in the San Sebastián Camarasa a tendency to specify the forms, to make the sculptural material monumental, soften by a progressive sensitive subtlety that becomes a distilled condition of the textures, as well as an expressive intensity of imperceptible taste. As a result, the sculptural materia looks swallowed by the abundance of flesh.

For all this the San Sebastián Camarasa seems later than the Zapata's altar-piece of the Seo de Zaragoza , but in fact is prior to the altar-piece of Tafalla. Therefore it must be dated between 1580 and 1588.

(S.A.E.)

RESTORATION NOTE:

State of preservation:
• Support with important damage by xylophagus insects.
• Important dampness in base with weakening of the wood.
• Unglued parts with loss of fragments of fingers and pieces of the loin cloth and rear trunk.
• Traditional white preparation (animal glue and compound) with good internal cohesion and bad adhesion to the support.
• Scattered losses of paint layer leaving a previous polychromy visible.
• Important touch-ups on the areas of the face, arms, part of the abdomen and both legs.

Treatment applied:
• Mechanical cleaning of accumulated dust and biological deposits.
• Fixing of preparation layers and polychromy.
• Disinfection of the support by injection and impregnation with disinfecting products and by methyl bromide vapors.
• System of presentation: neutral watercolor ink on the bare spots where the painted layer was lost.

Additional treatment:
• Macroscopic analyses, x-ray and stratigraphy to determine the state of preservation of the underlying polychromy and its possible recovery.
• Following of the state of preservation of the piece by controlling the environmental conditions of preservation.

BIBLIOGRAPHY

Ares Espada,S. (s.d); Azcárate, J.M.de (1958); 0Beccheruci, M. (1962); Camón Aznar, J. (1943); (1961); Pope-Hennessy, J. (1966); Weisel,G.(1966)

139
Three boards from the choir of the Cathedral of Ourense
JUAN DE ANGÉS THE YOUNGER
1587-1590

Black walnut without polychrome

St. Sebastian: 136 x 56 cm.; Temptation of Adam and Eve: 190 x 64 cm.; Expulsion from Paradise: 190 x 64 cm.
Cathedral of Ourense

MUSEUM OF THE CATHEDRAL OF OURENSE

The choir, contracted in 1580, occupied the three sections which precede the transept. It was formed by two series of chairs and entablature. Diego de Solís did the design and assembled the work, examined and approved by Esteban Jordán, who came from Valladolid to do so. In 1587 the Church chapter decided to take it out: the sculptures were destined in their majority to cover the facing of the body of the nave of the Chapel of Holy Jesus. To adapt them to the area it was necessary to eliminate pieces and alter their former placement. Other pieces were installed in the chapter-house, either in the Cathedral Museum, or in other dependencies of the temple.

The high stalls have 41 seats, separated by pillars, with half-figures on the lower level and full-length ones in the upper. Among the latter the relief of Saint Sebastian, pierced by soldiers' arrows, stands out. Starting with realism, the forms are exaggerated and his musculature is emphasized with a desire for detail that contrasts with a certain abandonment of the face. The sacrificial scene serves as a pretext to the artist to show his anatomical knowledge and shape an elegant nude figure of "ideal" beauty. The Mannerist narrowness of the surrounding space gives the figure anguish, forcing his arms and legs to go beyond the frame. The lower stalls have 29 seats with busts framed by round arches on pillars.

In the entryways, which were located on the larger sides of the original choir seat, the Temptation of Adam and Eve and their Expulsion from Paradise are narrated. In the scene of the Temptation, the characters are placed against a landscape constituted only by the tree of Sin around which the serpent is coiled, which does not offer Eve the forbidden fruit, but rather both figures raise their arms at the same time to grab the apple from the tree. Naked except for their sexual organs, they are represented after the sin. Here the lack of familiarity with bodily beauty according to the classical canons becomes obvious. The artist tries to reach the evaluation of the human body not through anatomical models, but by creating a series of concave and convex rhythms in which light has the function of suggesting the forms. There is undoubtedly an inspiration in the Central European engravings, especially those of Durero and Lucas de Leyde.

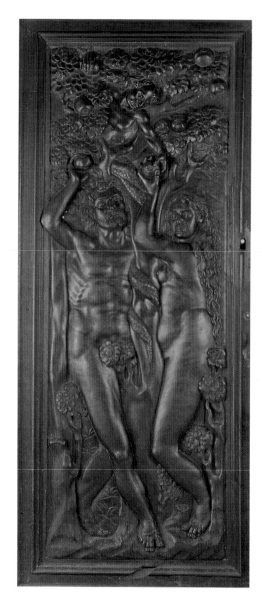

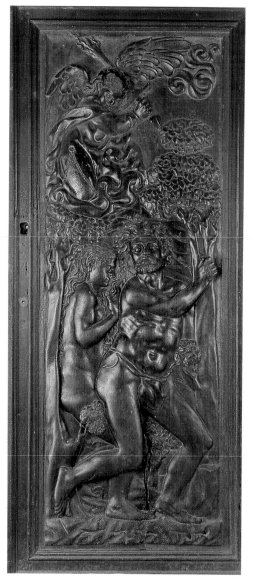

The same could be said of the Relief of the Expulsion, where the original human couple is expelled by the angel armed with a sword of fire.

(A.- A.F.R.)

RESTORATION NOTE:

Chor Door

Treatment applied:
• Overall damage by xylophagus insects.
• Loss of part of the moulding of the lower area and part of the frame on the left.
• There is a graft which corresponds to the box of a lock joined by two rusted nails to the piece.
• It has suffered a strong blow on the lower right portion (between the tree and Adam's foot), forming two cracks which separate from the piece.

• Small cracks due to the shifting of the wood caused by environmental changes.
• In the lower right area and part of Eve's arm and the adjacent portion there is a very cracked dark part.
• Several layers of wax.

Treatment applied:
• Mechanical cleaning of surface dust.
• Disinfection with methyl bromide in gas chamber.
• Chemical surface cleaning of greasy dirt.

Additional treatment:
• Gluing of cracks opened by blows that endanger a small part of the work by coming loose.
• Elimination of the rusted nails of the graft and their substitution by another joining system.
• Analysis of the dark layer which appears on the surface and its elimination.

140
Saint Benito
JUAN DE ANGÉS THE YOUNGER
1593-1594

Walnut, painted and gilded
113 x 42 cm.

MAIN ALTAR PIECE OF THE CHURCH OF THE
MONASTERY OF SAN ESTEBO DE RIBAS DE
SIL. (OURENSE)

After the choir seats in Ourense were done,
Angés the Younger is requested by the Benedictine
monks of Ribas de Sil to do four altar pieces in their
church, of which only the main one is preserved.
Abbot Víctor de Nájera hired Juan de Angés the
Younger, sculptor, and the painter Manuel de Arnao
Leitao to do the work.

This altar piece is comprised of a bench or
predella, four bodies, separated by architrave, frieze
and cornice. It has five panels limited by pillars.
San Estebo, patron of the monastery, presides the
altar piece. His technique seems different from the
hand of Angés. The work ends in a tympanum with
the figure of the Almighty, beneath which is the
image of the Annunciation surrounded by angels.

In the inner panels are different scenes in low
relief, while inthe outer ones, inserted in niches
crowned by straight and curved pediments, are the
high relief images.

The figure of Saint Benito, founder of the Order,
is placed in the outer left panel of the first section,
paired to the right with the figure of Saint Gregory
the Great. Beardless and with expressionless face,
he is presented beneath a wide cowl of full folds,
and holds the staff in his right hand, or rather, what
is left of the staff, and in the left hand is the Book of
the Law.

Angés must have devoted himself to the total
concept of the altar piece. of great architectural
value and concern for global effects, and to the
figures of the first sections, since after the third one
the collaboration of his workshop seems to increase
and thus the quality of the figures declines

(A.-A.F.R.)

RESTORATION NOTE:

State of preservation:
• Wood support seriously damaged by xylophagi.
• Some areas have loss of cohesion of structural elements of the
 wood, pronounced cracks (left hand), open parts in the left
 arm of the figure. Loss of staff.
• Layer of traditional preparation (compound and animal glue)
 with poor adhesion to the support.
• A previous restoration was done to fix areas where the
 preparation was coming off, which caused the nearly total
 loss of the painting on gilded ground of the image (water
 temper), which is still preserved in the lateral zones and the
 interior of the folds.
• The gold comes off easily due to the tensions produced by a
 very thick lacquer which at the same time created a very
 marked cracking.
• Serious oxidizing of the lacquer in some areas.
• Loss of color on the flesh areas.

Treatment applied:
• Mechanical surface cleaning of dust.

• Following of the state of preservation by control of the
 environmental conditions

Expulsion from Paradise

State of preservation:
• Serious damage by xylophagus insects, affecting the structure
 in some areas.
• Losses in the support due to the damage by xylophagus
 insects and the ungluing of pieces (angel's forehead, curls of
 hair, central part of Adam's abdomen and his right leg, etc.)
• Several cracks.
• The lacunae of the support are covered with another, lighter
 wood or with wood paste.
• There is an orifice in the door frame which corresponds to the
 lock, this part being the most eroded due to rubbing, and
 there is a graft.
• There are remains of wax on the surface as well as drippings
 of dark varnish.

Treatment applied:
• Mechanical cleaning of surface dust.
• Disinfection with methyl bromide gas and preventive
 treatment of the wood with xilamón.
• Consolidation of the most affected areas with injections of
 synthetic resins.
• Chemical cleaning of surface dirt.

Additional treatment:
• Substitution of the patches of wood with other more adequate
 ones.
• Removal of the dark varnish remains once the composition
 has been analyzed with the most appropriate means.
• Following of the state of preservation by control of the
 environmental conditions.

BIBLIOGRAPHY
Martín González, J.J.(1962); Vila Jato, M.-D.(1983)

- Fixing of the preparation and polychromy.
- Surface cleaning with chemicals, more pronounced in the deteriorated areas.
- All these operations were done with great caution and limiting the use of products due to the nature of the polychromy.
- Disinfection with methyl bromide gas.
- Preventive treatment with xilamón.
- Reinforcement of some areas of the support with synthetic resins.
- Touch-up of the paint in bare areas with neutral ink.

Additional treatment:
- Physical-chemical and photographic analysis.
- Later diagnosis and plan for restoration.
- Control of environmental conditions (temperature, R.H., biological damage).

BIBLIOGRAPHY

Duro Peña, E. (1977); Martín González, J.J. (1962); Vila Jato, M.- D. (1983).

141
Choir Seats
GREGORIO ESPAÑOL AND JUAN DÁVILA
1599-1606

Walnut
Cathedral of Santiago de Compostela

MONASTERY OF SOBRADO DOS MONXES AND CATHEDRAL OF SANTIAGO DE COMPOSTELA

The new needs which arose with the increase in the clergy of the Cathedral resulted in the decision, September 1594, to enlarge the choir of Mateo. Diego de Solís and Gregorio Español were the persons charged with doing some seats which for the moment would alleviate the problem. Two years later they were finished, but the project of archbishop Juan de Sanclemente was more ambitious. He was determined to close off the choir area in the back in order to place his archbishop's chair, which at that time was at the upper end, on the side of the precentor, in that space. For this he had to overcome the strong resistance of a church chapter which was opposed, arguing that his project would take light from the area. But the stubbornness of the prelate was rewarded, and July 20, 1599 he has continuous requests were admitted, with the archbishop promising that the new work would increase in clarity, or if not he would bear the cost of all modifications that might be necessary. For this purpose Juan Dávila is summoned from Valladolid, and in August of this same year he presents the project for new seats, at the same time as he assesses the enlargement work of Solís and Español. The next month, together with Español, he signs the corresponding agreement in the presence of the scribe Pedro das Seixas. The execution of the work was to take more than double the time established, judging by the date of 1606 which is on one of the closing panels of the seats

and which clearly alludes to the year of its termination, although certain details will push back the desired finishing date.

These seats, the most important work in sculpture of the time and one of the most relevant of the entire century in Galicia, would have a dynamic history in our century when it is decided to take it apart and take it from the central nave of the Cathedral to the high choir of the church of San Martiño Pinario, which would require the elimination of some panels and the alteration of the distribution of others. In spite of all this, the place was adequate and the best of the possibilities. Nevertheless, its stay in San Martiño Pinario would not last, since it soon was taken to the Monastery of Sobrado dos Monxes. Once there, one part would remain in the church and the rest was distributed in

different monastical dependencies. If in the first move the material damage had been slight, in the second some irreparable harm occurred.

The seats' beautiful design was the work of Dávila, who in turn took over a direct part of the execution and direction. The design is typical of the period for the clarity of its architectural lines and the control of the decoration, which is very rich but does not overwhelm the value of its structure at any point. It is comprised of two sets of seats, the first with thirty two, with half-length figures limited by pillars and the second, with ninety nine with full-length figures between adjoining columns and a grotesque lower third. It was completed by a ledge, illustrated with histories referring the collection of lives of the saints below, separated by small columns that

also had a third decorated but with straight striations.

Its iconographic program was centered on the idea of a "imago militantis Ecclesiae" and for this they used to its maximum a broad discourse from the litany presided over by the figure of the Savior, which was framed by two strips with three reliefs each with the images of Adam and Eve in the center and Prophets on the ends. On the right and left were the panels of the Virgin with the Christ Child and Santiago the Elder, who as patron displaced Saint John the Baptist, who had the main place because he was the greatest man born of woman. They are followed by Saint Michael and the Precursor, then the Apostles and Evangelists. To this point we find exhibited, then, the foundation and doctrinal base of the church, of which Christ

was the founder, the Virgin the supreme intercessor and Michael its protector. Immediately afterward came Saint Joseph, who together with the Baptist had been the greatest of the Prophets, but also the greatest of the Patriarchs, and whose figure had undergone an enormous ascent throughout the XVIth century, and protected by the religious orders as a cult will achieve his best promotion, especially in Spain, where, as E. Male pointed out, he found his best roots. Martyrs, bishops, confessors and founders finish off the iconographic exhibition of this level together with the prophets and angelic order. The fact that the former occupy such as displaced site is an argument in favor of the discourse's intimate structure. They are placed at the feet of the seats because they are also at the beginning, they are the ones who announced the

image of this church, they are, along with the apostles, its pillars. In the prelate's chair they had already been alluded to. With the reference to Adam and Eve the presence of the Son was justified in the work of the Father, which the prophets were in charge of predicting, the same as the Baptist, character in both Testaments. But what in these seats was expressed as a simple footnote, is now broadly developed. The Guardian Angel and Saint Raphael occupy the last two boards and their presence here is also justified. If Saint Michael recalled God's protection of his Church, the guardian angel and Raphael symbolize the protection God gave to each one of its members, helping them, like Tobias, to dissipate the shadows with the light of Grace.

In the lower seats, the doctors of the Latin church, accompanied by their eastern colleagues, whose presence recalled the enrichment of the doctrinal corpus, led an army of martyrs, virgins and other saints, with which this ecclesiastical building was shaped, not without previously evoking in the ledge some of the heroic gestures protagonized by its members, along which, as was typical of the period, those of martyrdom had special relevance.

If up to here we were to carefully review the lives of the saints, we would observe certain peculiarities, but among them we would particularly notice the fact that the episcopal order was so strongly emphasized, having a very high number of representatives. But once we identify them as the Apostles, or what is the same, as the disciples of Santiago, their presence in a church which holds the remains of their master and two of them is not so strange. As is usual, individual interests imposed their conditions, determining the selection of those members according to the particular symbolism that was being sought, which fit well with the dignity of the Cathedral in which it was placed.

Two different stylistic concepts predominate, but they are two types which should be understood as two poles which articulate different variations. One of them would be that represented by Juan Dávila, whose formation in Valladolid would justify a style in which the gouge happily describes the rough bodily shape of its characters, at times with such intensity that certain faces would not be a discredit to Juni himself. Dávila also works with slender, elegant sculptural types, reaching similar heights to those of El Greco. The cloth becomes a fundamental element of expression. The fabric twinkles in tunics and mantles and is bound to the body showing the anatomy, as if it were an X-ray, also preferring certain conventions of Jordán-like nature, such as the triangle with inverted vertex. The interest in expressiveness leads him to seek ever dynamic postures through twisting and the use of different planes for the feet. The mediation of Jordán and the broad, cold formalism of the second half of the century do not stop the nervousness and agitation, often of Junian and Berruguetean origin, which lies in the beings created by the artist and of which figures like those of Saint Paul, Saint Mathias, Judas Thaddeus, Saint Thomas or the saint carrying an axe in fasces would be good examples.

The other option, represented by Gregorio Español, in whom Junian art is enormously tempered by Becerra's Mannerism and the mark of Jordán, prefers more peaceful styles. The anatomical treatment, although it may seem eloquent, is more economical. And in regard to the fabric, these accumulate due especially to capes and mantles, and appear swollen, cottony, and accordingly the folds are very ample, giving more aplomb and static nature to the images. Making use of the abundance of fabric, he tends to widen the figure in the middle through the presentation of bodies inscribed between wide parentheses, especially significant in the reliefs of Saint Andrew, Santiago the Younger, Saint Isidoro, Aaron or Melquisedec, due to the amplitude of their mantles. From the beginning they prefer to shape a wide mass of cloth in one hand, hold the mantle or cape with the aid of a book surrounded by abundant fabric, or show a particular placement of the fingers, when holding an object. The better knowledge of this work allows us today to correct some of its attributes, as occurs with the panel of the Virgin with the Child which I now believe belongs to him, but also to confirm others—such as in the case of Saint Torcuato and Saint Tesifonte or Santiago the Younger, whose types appear to have been announced earlier by Español in the altar pieces of Saint Román el Antiguo (La Bañeza, León) and Saint Lawrence of Nogarejos (León) respectively—and which seem to be better distributed in the work on the ledge. The detailed analysis of the reliefs of the altar piece of San Román el Antiguo announce types which reappear later in the seats, or which reliefs of the altar piece like that of the Martyrdom of Saint Lawrence, from the altar piece of Nogarejos, of which are repeated with little variation in Santiago, allow considerable advancement in the task of assigning a stylistic mode to many panels, although it might only be in a very generic sense given that the workshop interventions increase. Still, we must be cautious when approaching those manners to which we have referred and not forget that, together with the placements and thus the most obvious cases, there are approximations. An example is the panel of Saint Bernabé, which in the human type resembles Davila, but in the shaping of the mantle and the resulting widening of the image point to Español.

But alongside these sculptors a strong workshop with no creative members is hidden, and the seats owe some of their boards of excellent execution to the work of these artisans. Reliefs such as those of Saint Anthony or Saint Peter Martyr on the one hand, or Saint Hermenigild and Saint Theodore, on the other, the first still within a Junian tradition, although very modified, and the second completely outside it, demand their own attention.

(A.- A. R.V.)

RESTORATION NOTE:

State of preservation:
• Support with serious damage by xylophagus insects.
• Losses on the most prominent parts.
• Laguna on the left corner.

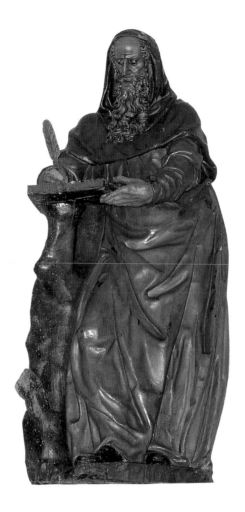

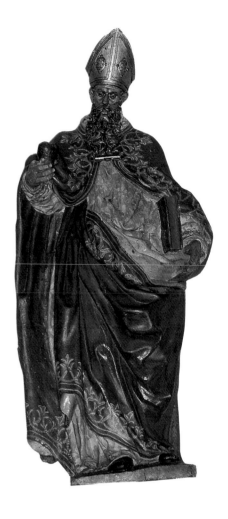

• Vertical cracks in the central area.
• On the edges of the board there are various old holes, perhaps from a different placement for the support?
• The board is framed on a canvas stretcher of tablex lined with green velvet by three metal screws.
• There is a protective layer of varnish and diverse layers of wax.

Treatment applied:
• Mechanical cleaning of dust.
• Disinfection with methyl bromide in gas chamber.
• Preventive treatment of the wood with xilamón.
• Chemical cleaning of greasy dirt on the surface.
• Provisional removal of support.

Additional treatment:
• Removal of the various layers of varnish and accumulation of waxes.
• Renewal of protective layer (waxes).
• Study of a new support.
• Following of the state of preservation by control of the environmental conditions of preservation.

BIBLIOGRAPHY
Chamoso Lamas, M. (1950); López Ferreiro, J. (1905); Martín González, J.J. (1964); Rosende Valdés, A.A. (1978)

142
Altar piece of the chapel from Fonseca
JUAN DAVILA AND GREGORIO ESPAÑOL
1603-1608

Polychromed chestnut
Chapel of Fonseca. Santiago de Compostela.

CHAPEL OF COMMUNION. CATHEDRAL OF SANTIAGO DE COMPOSTELA

While they were working on the choir seats of the Cathedral, Juan Dávila and Gregorio Español joined in a new project. The University in the meeting of March 6, 1603, decided to assign them the altar piece for its chapel. At first it was thought that the work would not exceed the 600 ducats that the cannon Suárez had left for that purpose, but it soon proved necessary to increase the budget to almost double. The agreement between the University and the sculptors was signed in the middle of October, but the work was not begun immediately as had been agreed, nor was it finished

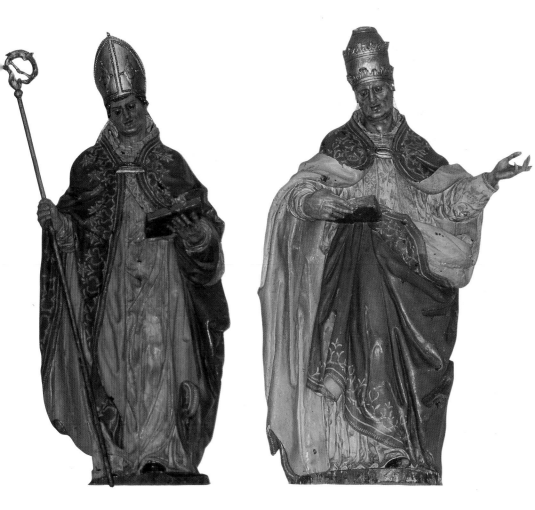

the following year as had been planned. Only four years later was the altar piece ready to be installed and some months later prepared for appraisal. And even then it was necessary to make some changes, after which on the 10th of July, 1608 it was declared finished.

It had two bodies, with three panels each and an attic. The articulation was Ionic, Corinthian and combined keeping the typical classical organization regarding height. From the central niche of the first level the image of Santiago Alfeo presided the altar piece, accompanied by Saint Gregory and Saint Jerome, who occupied the lateral niches. The second body had an image of the Virgin in the middle, flanked by Saint Ambrose and Saint Augustine and was finished off by a Calvary inside a niche. The altar piece has disappeared, but the most important images remained, although only Santiago is in the original place. The College of Saint Jerome today site of the presidency of the University of Santiago, holds the Crucifix, and the Communion Chapel of the Cathedral holds the figures of the doctors. As we may deduce from the brief description of Fernández-Freire the image and the altar piece were without polychromy at least

until the end of the XIXth century, except for the Virgin and her niche, which must have been carelessly polychromed at an unknown date. Their appearance today is therefore from recent years.

From the iconographic point of view, as is customary, there is still insistence on the idea of the Redemption, in an aspect which had previously been affirmed for the building's doorway. Thus the image of Santiago Alfeo would refer to the patronage of the establishment; the four most relevant doctors of the Latin church would refer to Christian knowledge as the main goal of the institution; the image of the Virgin, strategically placed first beneath the Calvary and later next to the Cross, would recall her important mediating role, for which reason her figure is often emphasized in the altar pieces of the time and, finally, the Calvary would clearly indicate that the main goal of the teaching in this center was salvation.

The image of Santiago Alfeo, whose state of conservation is ruinous, is the work of Gregorio Español. We know that it presided the first section of the altar piece with that arrogant tone which his appearance gives. The figure is elegant and ingenious. It is elegant in the way it grasps the

knotty cane which allows the image to project forward, although this opening movement does not distance it in the existential space of the spectator; it is ingenious in the soft helicoidal line of the body or the placement of the mantle which, in line with one of most frequent themes in Mannerist statues, uses the solution of binding the fold to the free leg, which seems to serve more as a support for fabric than as an expression of a contrapposto. On the other hand, the clothing has given up the vibrant effect of some of their panels in the Cathedral choir seats. Its cottony nature allows an easier execution of the figure. In reality what Español has done is to bring together all the themes of his style, although here quite exaggerated, since both the physiognomy of the character as well as the way of holding the book—around which the cloth accumulates and the way of folding, had been experimented with by the author or were being so in other works. Español, who appears to have had a greater intervention than his companion in the execution of the sculptures, is also responsible for the image of Saint Ambrose, which was paired with Saint Augustine in the second section of the altar piece and which had a smaller format than those of the lower level. He belongs to a family with abundant and we could even say prestigious antecedents in the list of the author, as in the case of the choir seats.

Facing these sculptures is that of Saint Jerome, done by Dávila, points in another aesthetic direction. Differing from Saint Gregory or Saint Ambrose, who appeared absorbed in their reading, or that of Saint Augustine, who is busy showing us the familiar flaming heart, Saint Jerome is shown in the act of writing, for which a fortunate tree trunk acts as desk. The lion, normal attribute of the saint, is now missing, although in this case it was present according to what is deduced from the report by Antonio Pereira de Lanzós, craftsman assigned the assessment of the altar piece by the University, for whom the animal did not have the adequate proportion in relation to the figure, for which reason it had to be corrected along with other details. The sculpture, of high quality, is the most nervous of all. In it style and iconography are well combined. The face, with wrinkled brow, the very marked cavities of the eyes, the sharp cheekbones, the sunken cheeks and ample beard set in dynamic, turgid corkscrews, have the typical vigor of the sculptor and transmit a convincing image of the concentration and wearing down of a man who dedicated an important part of his life to the study of the Holy Scriptures. But also the treatment of the cloth, more agitated than in Español, gives more life to the character, not lacking the unnatural features that allow us to see the body beneath the garments and confirm the importance that the treatment of the fabric has as a means of expression for the sculptor. The slenderness of the figure completes his personal nature, since his elongated canon not only obeys the demands of the composition in the overall organization of the altar piece, but also it is a question of style, which in his work on the apostolic choir seats will achieve some of the most representative examples of Spanish Mannerist sculpture by establishing canons of nine heads, and

more, which distances him from Juni, one of his major sources of information, and bring him closer to El Greco.

On discussing the choir seats of the Cathedral of Santiago there has not been so much said of the styles characterized as of the two poles which are identified with the personalities of Dávila and Español. In it multiple personal styles are cited which could be mixed in a single panel. In the altar piece of Fonseca the stylistic question is not at all as extensive, but in treating it we must remember the tendency of Dávila and Español to make the style uniform in their joint projects, a good example of what the companions of Saint Jerome offer us in this work.

(A.-A.R.V.)

BIBLIOGRAPHY
Fernández Sánchez, J.M. , Freire Barreiro, F. (1882)

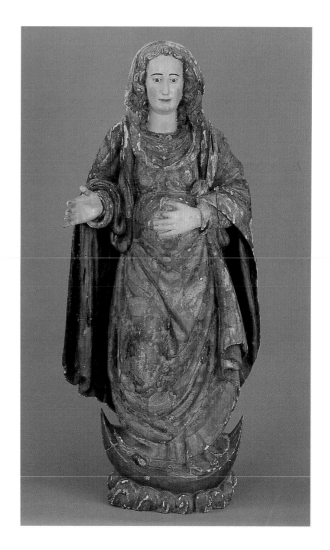

143
Expecting Virgin
ALONSO MARTÍNEZ
1601-1602

Polychromed wood
124 x 50 x 31 cm.
Cathedral of Tui (Pontevedra)

ARCHIVE AND DIOCESAN MUSEUM OF TUI (PONTEVEDRA)

Several pieces are conserved of the well-documented work done by Alonso Martínez for the Cathedral of Tui, among them this image of the Virgin. D. Lope García Sarmiento, precentor of this Cathedral, had acquired the Chapel of the Expectation or the Pregnant Virgin, and November 1, 1601, contracted Alonso Martínez to do the altar piece for it, which was to have a ymagen de Nuestra Señora de la anunciaçión. The altar piece, which judging by the documentation, was to be small, it not conserved, but the titular image is, and today is in the Diocesan Museum of the city.

It is a sculpture of smaller than life size, worked on the back side, as indicated in the agreement, with swollen belly as is customary in that type of representation, and with a half moon at the feet. The image is inscribed in a large oval, which helps reinforce both the circular placement of the folds, which extends toward the base, and the quarter moon that is beneath. The treatment of the fabrics is typical of the sculptor, with the well-known folds of conical section, and the enclosing zig-zags of the edges. The wide oval of the face, the automatic outline of the features, the innocuous expression, the plastically moulded hair masses, the strong cylindrical neck, the softness of the helicoidal rhythm or the accentuation of the contrast by means of a leg perpendicular to the background, are other common elements of his production.

(A.-A.R.V.)

BIBLIOGRAPHY
Gómez Sobrino , J. (1988)

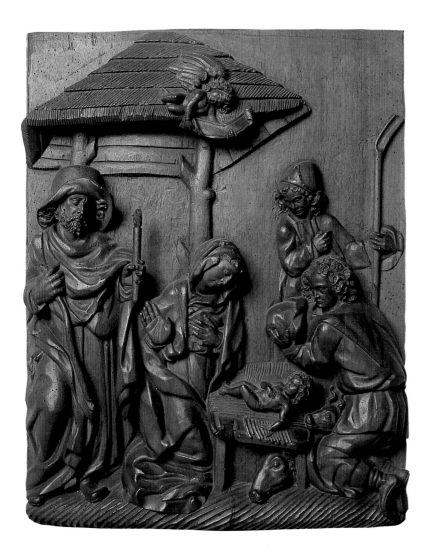

144
Choir Seats
ALONSO MARTÍNEZ
1606-1608

Walnut
Monastery of Santa María de Montederramo
(Ourense)

MONASTERY OF SANTA MARIA DE
MONTEDERRAMO. RISCO FAMILY AND
ARCHEOLOGICAL MUSEUM OF OURENSE

Since Martí and Mansó this choir has been
attributed to Isaac de Juni and Juan de Muniátegui,
artists of the circle of Valladolid, because in 1595
both contract with the abbot of Montederramo to do

the seats of the chapter that were concluded in
several months but which have not been preserved.
As Chamoso indicated, the attribution became
popular without taking into consideration that the
new church would begin three years later and that
the seats are perfectly adapted to their location. But
the definitive portrait of the assignment is that of
Ferro Couselo, establishing the sculptural paternity
as that of Alonso Martínez and showing the long list
of artists who worked under him and made it
possible to finish in two years, in 1608.

It is the author's most important work. There are
two sections of seats, the first with five along on
each side and four across and the second with
eighteen seats per arm and nine at the upper end,
with the emphasis on the central one because of its
great vaulted niche which in its day was presided by
an image of Saint Bernard, whose reform the temple

had undertaken in 1153. The finial is the
guardapolvo, although without a canopy, it would
be more correct to speak of a frieze or attic.

The architectural body of the choir seats is
dominated by that Classicist tendency which
controls an important part of the architecture of the
moment, as in the case of the building where it is
located and with which it shares similar designs,
since although the temple is defined by the showy,
monumental concept of masses and by the sobriety
of its plan, in the same way the choir has a rigid,
austere design which crystallizes in a serene, unified
product, although perhaps too cold and impersonal.
The work is practically reduced to its structure.
Only the central niche and the reliefs of the
guardapolvo lighten the rigid, monotonous
succession of elements that exalt the architectonic
object almost independently of all meaning since,
reduced to the decorated reliefs of the finial, to the
image of the vaulted niche and the monastic
emblem which crowns it, it does not destroy the
simplified, rational vision proposed for this choir
that above all aspires to be functional. It is too bad
that the deteriorated condition and the shameful
despoliation it has suffered have irremissibly
destroyed this valuable piece.

The choir centers its iconographic program
around the idea of the Redemption, expressing its
literary argument by the old theme of scholastic
roots, the parallelism of the two Testaments, which
had known its golden era in the Middle Ages but
which had also had an important development in the
XVIth century—recall the stained glass windows of
the New Cathedral of Salamanca or those of
Segovia and Granada—and which still would
survive in an ever decreasing trajectory throughout
the following century. This system of concordances,
which was no more than one of the multiple
applications of the symbolism, was based on the
fact that the universal history of humankind until
the arrival of Christ had been no more than a
prefiguration of his life or, if we prefer, that each
moment of evangelical history had been announced
in Jewish history prior to Christ. This manner of
allegorical exegesis, known as typological or
figurative, was then based on a play on types and
antitypes, and the interest of the method was
double, on the one hand a procedure for explaining
the Bible, considered to be a double divine
revelation and on the other, a means of
demonstrating the unity and truth it contained for
the very fact of concordance. The medieval
theologians attempted to demonstrate with this
system the identity of inspiration or at least the
parallelism between the Old and New Testaments,
and tried to inculcate this idea in the popular mind,
condensing it in mnemonic phrases that were truly
lapidary sentences. And we owe Saint Augustine
and the abbot Suger the most correct formulas or
slogans of the typological doctrine. Saint Augustine
will say that in the Old Testament the New one is
latent and in the New Testament the old one is
present. Suger will express this same idea in the
still shorter sentence: what the law of Moses veils,
the doctrine of Christ unveils. Medieval compilers
and glossers have done nothing more than develop

the scheme. However, the scholastic origin of this figurative system cannot hide from us the fact that the Middle Ages had been limited to systematizing, coordinating and developing a teaching received from the Biblical tradition which will not just point out in general terms a harmony between the two Testaments, but rather which left concrete examples of that conformity.

This is the principle which controls the iconographic ordering of the panels of Montederramo in which, the same as in the Middle Ages, the Old Testament continues to occupy the northern side and the New Testament the southern one. Thus if we take as example the relief of the Resurrection which closes the cycle dedicated to explaining the life of Christ and which is in its original location, we see that its parallel, which has not been moved either, is none other than the Liberation of Jonah from the belly of the whale, one of the clearest prefigurative scenes of the entire series. For the Jews, the figure of Jonah swallowed first and then freed by the whale was the image of the people of Israel, which after the exile during the captivity of Babylonia, had obtained its freedom through the work of God. For the Christians, on the other hand, it was a prefiguration of the burial and resurrection of Christ. And it was logical that it would be this way, when this parallelism had been established by Christ himself (Mat. 12.40), when he announced that just like Jonah spent three days and three nights in the belly of the whale, in the same way he would be three days and three nights in the heart of the earth. Neither the holy fathers nor the exegetes of the Bible could overlook such a consideration and thus Saint Augustine (City of God, bk. XVIII, chap. XXXII) will tell us that Jonah announced the death and resurrection of Christ, not in word but in deed, because why did the whale place him in its belly and throw him out again on the third day if not to tell us that Christ on the third day would rise up from the depths of hell.

If we now review the panel of the Meeting of Solomon and the queen of Sheba, which today is in a private collection, we would think that iconographically and formally its companion could only have been the Epiphany and we would not be mistaken in spite of the fact that it has disappeared. We could even describe, and correctly so, its place in the guardapolvo. But if we tried to complete the reading that would go from the bottom to the top in all its magnitude, we would then find that it would not be possible to do so in a satisfactory manner. On the one hand, we do not know the themes of the ten panels on the side of the Epistle and for the rest we only have five of the twenty two reliefs which it had in its day, three at the beginning and the other two at the end and on that of the Evangel, and also in an intermittent manner, fifteen. On the other hand, we cannot lose sight of the adaptive nature of the figurative system—let us recall that a same scene can prefigure different passages—, the fact that on occasion the harmony between type and antitype may have been established in Montederramo in terms of a formal relationship more than a semantic one and finally, that it is not easy to identify some of the scenes from the Old

Testament that we know. In view of this it is easy to conclude that for the time being it is not possible to do more than one approximate reconstruction and reading.

We obtain better results when we address the form and not the content. The number of panels preserved is more than enough to be able to evaluate the style and importance of the sculptor. Reliefs such as The Nativity, The Baptism, The Flagellation, The meeting of Solomon and the queen of Sheba, or Job and the three friends show us the true extent of his work. Some of them are especially expressive, as in the case of the panel of the Flagellation, where we can see the influence of Angés in the forced poses, the amplitude of forms or the type of flattened relief. But beside that insistence on the curvilinear rhythms which above all affect the position of the figures—observe the complementarity of the contours—the soft alignment of the drapery, the somewhat shortened proportions or the softness of forms denote a style characteristic of the art of Angés and Becerra—his style also seems to have a certain relationship to the Mannerism of the latter—cannot eliminate. But the virtues of the sculptor cannot make us forget defects such as the complete incapacity to coherently organize a space. As an example, the relief of Solomon and the queen of Sheba, probably inspired by an engraving—following that habitual practice among artists of seeking support at times in engravings and other times in the example of other

sculptors—where the spatial dislocation is noticeable. In spite of the fact that the leaf used could be satisfactorily formed, the sculptor shows off a clear heterodoxy in the perspective which allows him to elongate or diminish the figures as he wishes or create subjective projections. Besides, here as in the rest of the reliefs by Alonso Martínez, the environment is very simple, not very committed. Beside the neutral backgrounds, a rock or a tree are sufficient to provide a setting for an exterior scene, while in the interiors, it is difficult for the elementary architectural structure to carry out its intention. And in any event the number of planes is always very limited, with the scene being concentrated in the foreground.

(A.-A.R.V.)

RESTORATION NOTE:

Last Supper

State of Preservation:
• Serious damage by xylophagous insects, affecting the structure.
• Losses on the left side and prominent portions of the figures.
• In a previous restoration it was framed with a wood support by nails, crosspieces and glues.
• Accumulation of layers of wax.

Treatment Applied:
• Mechanical cleaning of dust.
• Disinfection with methyl bromide.

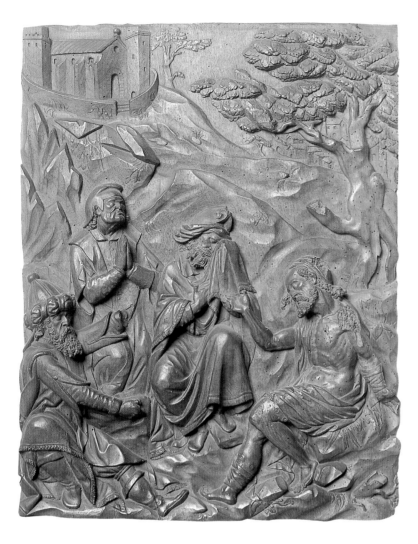

• Preventive treatment of the wood with Xilamón.
• Chemical cleaning of the surface with synthetic resins.

Additional Treatment:
• Study of a possible new support that will not create stress nor impede the natural movements of the wood.
• Follow-up of the state of preservation of the piece by control of the environmental conditions of preservation.

Flagellation of Christ

State of Preservation:
• Seriously damaged by xylophagous insects affecting the structure and causing great losses.
• In a previous restoration a piece of wood was placed on the right side, as a support for a large missing area, which has been attached by a crosspiece with two screws.
• There is also a graft between the body of Christ and that of a soldier with two rusted nails.
• It has been reinforced.
• There are losses on the part of the soldier's legs and Christ's foot, as well as the upper left area and the lower right one of the board.

Treatment applied:
• Mechanical cleaning of dust.
• Disinfection with methyl bromide in gas chamber.
• Preventive treatment of the wood with xilamón.
• Chemical cleaning of the surface dirt.

Additional treatment:
• Study of a new support and graft which will not create stress nor impede the natural movements of the wood.
• Following of the state of preservation of the piece by controlling the environmental conditions.

Circumcision of Christ

State of preservation:
• Serious damage by xylophagus insects which affects the structure and causes losses: the basket of the figure on the right, the staff of the male figure on the left, the Child's arm, the middle finger of the right hand, the upper left hand part and lower left hand part.
• In a previous intervention the lower left and upper right edges were reconstructed with wood paste.
• It has been reinforced and protected in the back with a coat of black grease.
• There is an accumulation of layers of wax.

Treatment applied:
• Mechanical cleaning of dust.
• Disinfection with methyl bromide in gas chamber.
• Preventive treatment of the wood with xilamón.
• Reinforcement of the wood in the weakest areas with synthetic resins.
• Chemical cleaning of the surface dirt.

Additional treatment:
• Chemical analyses to determine the composition of the substance that covers the back, if this would affect the future of the piece it would be eliminated.
• Following of the state of preservation of the piece through control of environmental conditions.

BIBLIOGRAPHY
Chamoso Lamas, M. (1947); Ferro Couselo, J. (1971); Martín González, J.J. (1964); Rosende Valdés, A.A. (1984)

145
Our Lady of Good Hope
CIRCLE OF ALONSO MARTINEZ
Beginning of the XVIIth century

Polychromed wood
128 x 52 x 29 cm.

CATHEDRAL OF TUI (PONTEVEDRA)

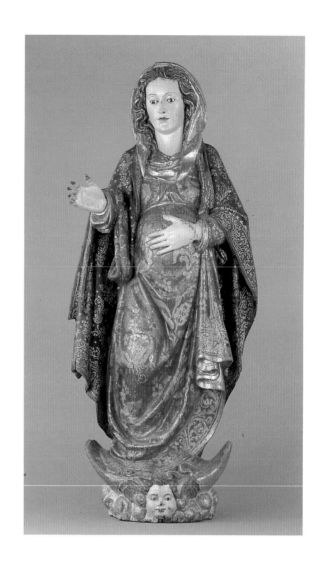

Up to 1930 there was another altar-piece dedicated to Our Lady of Good Hope in the cathedral of Tui. Located next to the main door, on the Gospel side, the altar-piece, before being demolished, was dominated by this image that replaced that of the Museum in the altar-piece of the Expectation.

Both sculptures share the same iconographic model and identical stylistic conventionalisms. The protruding belly, the position of hands—keeping even the proximity of the middle and ring finger of the left hand—the quarter moon at her feet, the disposition of the mantle and veil, the type of contrapposto, the wide oval in which the figure is inscribed, the curved rhythm ruling the disposition of the drapery, which draws ample round surfaces from which some folds of conic section stand out, in peculiar craft, the vigorous neck or the hair waved in plastic manner, confirm the proximity of both sculptures, to the point that one can be considered replica of the other. Little differences, like those of the mantle which hangs down further in the case of this image, its base decorated with a cloud which shows a winged head or the flatter zigzagging folds, do not introduce meaningful changes in its relationship. Other differences, without altering them, clearly individualize them. Thus, it is easy to observe how this sculpture presents a more concentrated volume, a more flexible fulfillment, a better understood plasticity and a greater naturalism of the face, less schematic and more soft and expressive. Besides, a better preservation contributes to improve a work of undeniably superior quality. Fact also proved by its polychromy, since if some parts, such as the mantle—today brown, but in the past it was blue—, have been changed a lot, on the contrary, in the dress a richer and better done coloring still is noticeable, which emphasizes the vegetable motifs—by a technique of pointing—on a striped background with thin and parallel lines that look like golden threads which give the ornament more magnificence and naturalism.

In spite of all this, the connection is evident and it is not easy to tell which of the two is the prototype. Perhaps, given their close similarity, it is possible to suppose that, if this sculpture were previous, it would be referred as a model at the moment of coming to an agreement about the primitive altar-piece of the Expectation. In any event, they are very close chronologically. And, due to the fact that this sculpture comes from the circle of Alonso Martínez, we could think either of a remarkable follower or of the master himself, but in this case it would be necessary to suppose a careful attention decidedly infrequent in him.

(A.-A.R.V.)

RESTORATION NOTE:

State of preservation:
• Support in good state of preservation.
• Scattered damage by xylophagus insects, centered in the base where there is dampness and the wood is weakened.
• The right hand of the Virgin is mobile and is joined by an fitted peg.
• Preparation of animal glue and compound with good internal cohesion and little adherence to support because of problems of contraction of the wood.
• Scattered losses of preparation.
• Polychromy in burnished oil in flesh areas covering a previous polychromy. Dress and garments gilded and painted on gilt ground in distemper with a thick layer of lacquer covering them.
• Dirt, dust and wax accumulated over the years.

Treatment applied:
• Mechanical cleaning of surface dust and wax on surfaces in best state of preservation.
• Fixing of the preparation and polychromies to the support.
• Chemical cleaning of the painted layer to eliminate lacquer and organic residue.
• Disinfection by methyl bromide vapors.
• System of presentation: stucco with small lacunae and bevelling in zones of greater losses.
• Reintegration of painted layer with neutral inks.

Recommended treatment:
• Study of the state of preservation of underlying polychromies for their possible recuperation.
• Following of environmental conditions of the piece's exhibition.

BIBLIOGRAPHY
Iglesias Almeida, E. (1990)

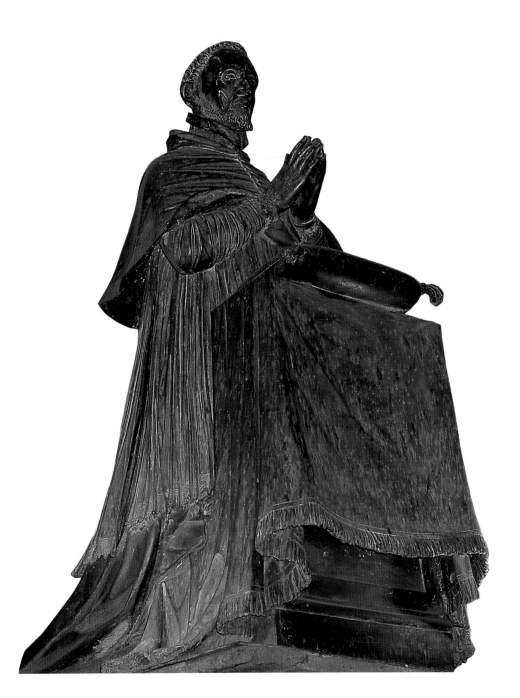

146
Sepulcher of Cardinal Rodrigo de Castro
JOHN OF BOLOGNA
1603

Bronze
172 x 71 x 164 cm.

CHURCH OF THE SEMINARY OF THE COMPANY OF MONFORTE DE LEMOS (LUGO)

Cardinal Rodrigo de Castro, founder and promoter of the Seminary of Monforte which bears his name and who was assigned to the Company of Jesus, expressed his desire to be buried in the church of this seminary, in the wall on the side of the chancel where the Gospel is placed. In 1603 the sepulcher was completed because in that year his mortal remains were moved from Seville.

Architecturally, it follows the model set years earlier in the royal sepulchers of the monastery of El Escorial, in which there is a scenographic frame that shelters and enhances the praying statue of the deceased, facing toward the main altar.

This architectural frame holds the effigy of the Archbishop, larger than natural size, in bronze that was gilded and molded in Italy by John of Bologna, according to the declaration made by Rodrigo de Castro himself in his testament. The plan for his funeral portrait was provided by the artists belonging to his circle of friends in Seville, specifically Pablo de Céspedes, who modelled the Cardinal's head for the casting in bronze.

The funeral image would then be cast in Florence, taking as its model for the head the one done by Céspedes in Seville. The Cardinal appears in a praying position, kneeling on a praying-desk and looking toward the main altar. He is wearing the cardinal's habits, portrayed in a very elementary fashion, using simple vertical lines. In the treatment of the head there is a certain hardness and rigidity of lines, like the triangularization of the cheekbones and the prominent brow line, which creates a dark area about the eyes.

(M.ª- D.V.J.)

BIBLIOGRAPHY
Cotarelo Valledor , A. (1945) ; Pacheco , F. (1599); Pardo Canalís , E. (1956) ; Tubiño , F. (1868)

147
Saint Roque
FRANCISCO DE MOURE
1598

Polychromed wood
95 cm. high

CATHEDRAL OF OURENSE

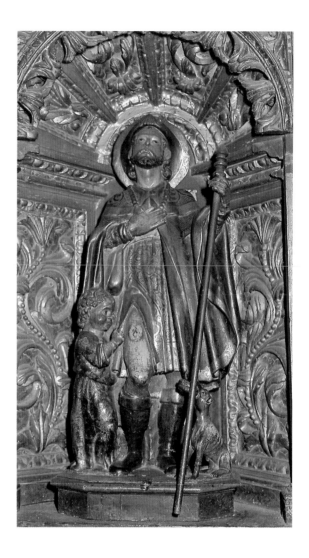

In 1598, when Moure must have been contracted as apprentice to Alonso Martínez, the Brotherhood of Saint Roque, associated with the Cathedral of Ourense, hires him to do the sculpture of its patron. Nevertheless, Moure creates a work which shows a rare mastery for an artist in formation. Manuel Dabelar does the polychromy.

The Saint appears dressed with the usual clothing of the noble pilgrims. He is wearing a cape, short cloak and wide-brimmed hat with a scallop shell and staff. He raises his gaze to the sky while placing his right hand on his chest. To his right is an angel, which is applying a balsam on the ulcer in his leg. To his left is his faithful dog with bread in its mouth. Thus it fits the usual form of representing the Saint from Montpelier.

Stylistically, the piece is still very linked to a Mannerist language. The helicoidal line which shapes the figure thanks to a well-achieved contrapposto, the theatrical gesture, almost declamatory, which he adopts, the forced pose, the thick plastic folds formed by the cape in its fall to the feet, which remind us of those by Juan de Juni, are an example of this root. Nevertheless, in this representation of the Saint we can see a 'new spirit' (Otero Túñez): it is reflected in both the intensity of his gaze and in that psychological penetration of his face.

(J.M.M.M).

BIBLIOGRAPHY
Cid Rodríguez, C. (1923-25); Fariña Busto, F e Vila Jato, M.-D. (1977); Otero Túñez, R. (1980); Vila Jato, M.-D. (s.d.) (G.E.G.)

148
Saint Anne
FRANCISCO DE MOURE
1608-1613

Polychromed wood
126 x 50 x 77 cm.

PARISH CHURCH OF BEADE (OURENSE)

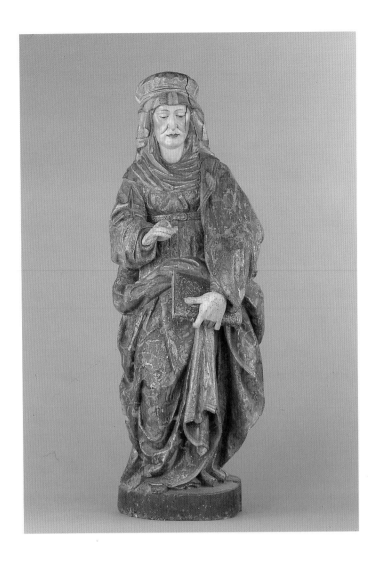

child in her arms or that of the so-called Triple Saint Anne.

With this work Moure advances toward a not very consolidated realism similar to that of Gregorio Fernández. Anne's pose, concentrated, her gaze lowered, absorbed in herself, shows a greater psychological penetration in the artist. The face has much more realistic and invidualistic features; he begins to emphasize the cheekbones, intensify the wrinkles above the nostrils, harden features. It is a realism very linked to Juan de Juni or a Burgundian tradition.

The folds of the fabric, which have also undergone a change in relation to previous works, become much more broken and rigid. Slight luminous games begin to be visible, like those produced by Saint Anne's headpiece, which creates an area of shadows surrounding her face, with which her expressiveness is intensified. The figure has still not been freed from the static nature which stiffened her from the helicoidal turn; the later instantaneity is not achieved here.

There is a beautiful original polychromy with grotesques and plant motifs, done with painting on gilt ground, customarily used in the XVIth century. This work was carried out by Carlos Suárez, who signed the contact at the same time as Moure.

This piece is definitely one which, recalling Hispano-Flemish figures, announces the advance toward total realism.

(J.M.M.M.).

RESTORATION NOTE:

State of preservation:
• The wood has serious damage by xylophagus insects, affecting it structurally in some parts and causing losses in the support (two fingers of the right hand, the quill, base and several folds).
• Unglued assemblies and cracks of various thicknesses (up to 2 cms.), produced by the shifting of the wood where there is a greater accumulation of dust and dirt (left side, headpiece and face).
• White preparation and red bole with good adhesion to the support and the polychromy, showing scattered losses, with the support becoming visible, coinciding with the areas that are most damaged by xylophagus insects.
• Painting over fine gold leaf (garments, mantle and headpiece) in distemper with losses at different levels due to the loss of adhesion and erosions to the point where the bole is visible.
• The polychromy of the flesh areas (there is no bole) is burnished oil.
• On the surface is a layer of lacquer that is very oxidized, especially that covering the flesh areas which affects the work aesthetically.
• There are also concretions of dirt and dust.

Treatment applied:
• Mechanical cleaning of surface dust and biological deposits.
• Disinfection and preventive treatment of the wood with xilamón and with methyl bromide vapors.
• Consolidation of the support in the most affected areas with synthetic resins.
• Surface chemical cleaning of the gold and painting on gilt ground.
• Chemical elimination of the lacquer which covered the flesh areas.

Additional treatment:
• Control of environmental conditions (humidity, light, temperature and biological damage).

It was part of a program for the altar piece of the church of Beade, which belonged to the Order of Saint John of Jerusalem, and opens the second period in the artistic life of Francisco de Moure.

Saint Anne is wearing a tunic which is covered with a greenish mantle, slanting, symbol of the hope of the world and immortality. In her left hand she carries a book, while in the right she could be carrying a quill, since she seems to be writing (Vila Jato). The head is covered by a coif indicative of her married status. It is a less common form of representation than that which shows the Virgin as a

BIBLIOGRAPHY
*Cid Rodríguez, C. (1923-25); Fariña Busto, F. ,
Vila Jato, M.-D. (1977); González Paz, J.
(1970); Otero Túñez, R. (1950); Vila Jato, M.-D.
(s,d,) (G.E.G.)*

149
Saint Bartholomew
FRANCISCO DE MOURE
1608-1613

Polychromed wood
112 x 60 x 44 cm.

PARISH CHURCH OF BEADE (OURENSE)

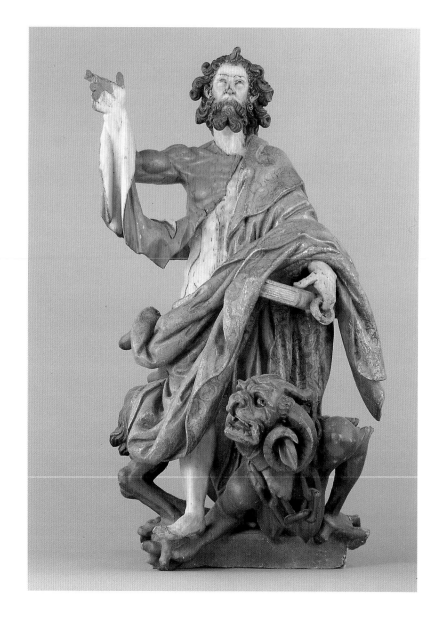

This sculpture is very representative of the style Moure cultivates in this second period. Today it is in a side altar piece of the church of Beade.

Iconographically, the form the artist selects to represent the Apostle is the traditional one in Spain. His right shoulder appears with an open wound, the same as the arm, from which the torn skin hangs to the chest, as symbol of his martyrdom. With his left hand he holds a book at the same time as he grasps a chain with which he controls the devil, situated at his feet and represented as a fantastic monster, with male goat horns, bulging eyes, open mouth and dark skin.

This image reveals to what extent Moure has advanced in the search for a realistic effect. We must note Saint Bartholomew's head, full of dramatism, expressive force and intensification of pathos, concerned with the individualization of the face, with the eyes turned heavenward, very distant from the sweet look of Saint Roque in the Cathedral of Ourense. The hair and beard form small rounded curls which vibrate with the light, with strong pictorial aspect.

The mantle crosses his entire waist and causes violent contrasts of light and shadow because the folds have become deeper, although they are still thick and wide. The swirl of the mantle over Saint Roque's hand is very interesting, and this element will often be repeated in other works of his.

The figure has a centrifugal movement which destroys the lines of the composition by dispersing them. (Vila Jato)

It recalls the survival of Junian art, related to that of Juan Bautista of the Museum of Valladolid (Martín González).

(J.M.M.M.)

RESTORATION NOTE:

State of preservation:
• Wood support with some damage by xylophagus insects.
• Loss of toes and fingers of right hand.
• Parts unglued with great separation.
• Layer of preparation and paint with good cohesion and general adherence, small lacunae and erosions.

• Layer of traditional preparation (compound and animal glue).
• Protective layer formed by lacquers and varnishes, oxidizing and leaks.
• Some colonies of fungi, dirt and dust accumulated through the years.

Treatment applied:
• Mechanical cleaning of dust and biological deposits.
• Disinfection with methyl bromide, preventive treatment of the wood with xilamón and of fungi with phenol.

• System of presentation: layers of neutral watercolor ink on the lacunae of the painted layer.

Additional treatment:

• Physical-chemical and photographic analysis.
• Gluing of parts.
• Elimination of lacquers and varnishes that are deteriorated and distort the reading of the work.
• Selection of the aesthetic treatment of the lacunae.

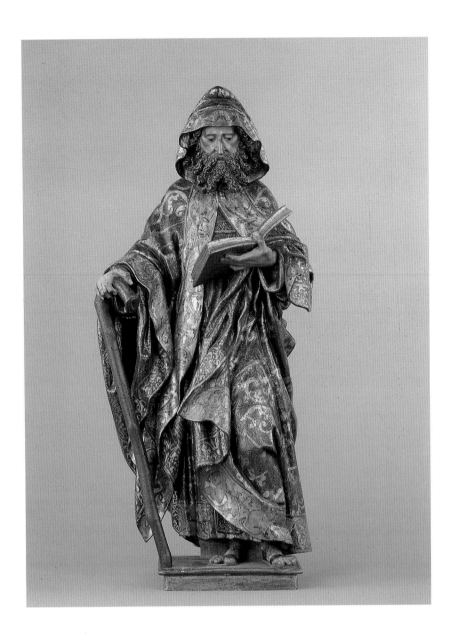

It was done for a collateral of the Chapel of Christ of the Cathedral of Ourense. There is no concrete documentation which allows us to certify that its author was Francisco de Moure. Nevertheless, it should be taken into account that since 1683 he has been attributed the work in the books of 'Accounts and Deliveries of Jewels and Goods" of this Chapel. Because of its formal characteristics the attribution seems correct.

It is wearing an ample mantle with hood that closes at the neck. It can be said that Moure captures him at the moment when he is strolling, absorbed in the reading of the book of his Order, using a cane to advance, as if trying to show a precise, fleeting moment in his life.

Technically it is the most successful of the works by the Ourensan artist in his second period. His virtuosity is seen in the anatomical study he does of the figure, modeling his body through the folds which arise as the mantle falls. These folds, small and breaking, form great wind-agitated masses, source of deep luminous contrasts which compose and decompose the image.

Nevertheless, the most outstanding is the Saint's face. In it Moure follows that realistic and expressive vein of his art which allows him to individualize the character represented by capturing his inner life. Thanks to the hood which surrounds his head an area of shadow is created which, together with the plasticity of the beard forces the spectator to concentrate on the face. On the other hand, the facial features if the Benedictine abbot continue to be the usual ones in the sculptures of this period.

It has a rich polychromy which covers the mantle of Saint Mauro, painted on gilt ground with plant motifs and swirls. It is a perfect complement to a great work.

(J.M.M.M.)

RESTORATION NOTE:

State of preservation:
• Support with important damage by xylophagus insects which has been treated in pervious restorations. Activity on small areas (staff).
• The white preparation layer has good internal cohesion, with losses and slight bare spots due to the damage of insects.
• Flesh areas have been repainted.
• The surface has remains of lacquer, wax, deposits of dirt and dust.

Treatment applied:
• Mechanical cleaning of the surface dust and biological deposits accumulated.
• Elimination of the wax deposits with Leister.
• Chemical cleaning of the surface in flesh areas.
• Disinfection of the support by injections of xilamón and by methyl bromide vapors in gas chamber.
• Consolidation of the support in some areas with synthetic resins.

Additional treatment:
• Following of state of preservation of the piece through control of the environmental conditions.

BIBLIOGRAPHY
Cid Rodríguez, C. (1923-25); Fariña Busto, F , Vila Jato, M.-D. (1977). Otero Túñez, R. (1980); Vila Jato, M.-D.(s.d.)

• Renewal of the protective layer.
• Following of its state of preservation by control of environmental conditions.

BIBLIOGRAPHY
Cid Rodríguez, C. (1923-25); Fariña Busto, F. , Vila Jato, M.-D. (1977); González Paz, J. (1970); Otero Túñez, R. (1980);Vila Jato, M.-D. (s.d.) (G.E.G.)

150
Saint Mauro
FRANCISCO DE MOURE
1615
Polychromed wood
91 x 41 x 19 cm.

CHAPEL OF CHRIST. CATHEDRAL OF OURENSE

151
Immaculate Virgin
FRANCISCO DE MOURE
1619-1621

Polychromed wood
180 x 70 x 40 cm.

CHURCH OF THE MONASTERY OF SAN XULIAN
DE SAMOS (LUGO)

Moure works on five altar pieces for the monastery of Samos, the largest during the abbotship of Friar Cristóbal de Aresti and other four while Miguel Sánchez was abbot. The figure of the Immaculate Virgin presided the altar piece of Our Lady, first situated on one of the altars of the head wall and today in the side nave of the north side, toward the feet of the old temple. It is integrated into one of the Baroque altar pieces of the transept.

The Immaculate Virgin is represented as a still young woman with her hands in a praying position before her breast, fingertips barely touching. Her face is surrounded by a white headpiece that shows her curly hair. She is wearing a red tunic covered by a greenish mantle. At her feet is the devil, represented by a serpent-shaped monster with an enormous mouth.

As can be seen, the artist follows an iconography similar to Andalusian sculpture or the Castilian Mannerist workshops and not the Castilian school in which Gregorio Fernández is of greatest importance.

In the stylistic aspect, Moure maintains his concern for the perception of light upon the face of his images, and for this reason he surrounds it with that white headpiece, producing an area of shadows about it. He continues to be interested in the study of the characters' psychology, and thus Mary has a sweet expression, full of love and serenity, which extends over her body by means of the contraposto where she is located.

On the other hand, the mantle which covers her body, pulled up over her right arm, forms small folds as it falls, which as a whole create great curved lines and cause a luminous vibration that blurs the figure's outline, besides reinforcing the effect of its excellent polychromy.

We must point out the Junian link in the devil (Martín González) and a survival of elements characteristic of the artist in the face: prominent eyes, rounded features and prominent, rounded chin (Vila Jato).

(J.M.M.M.)

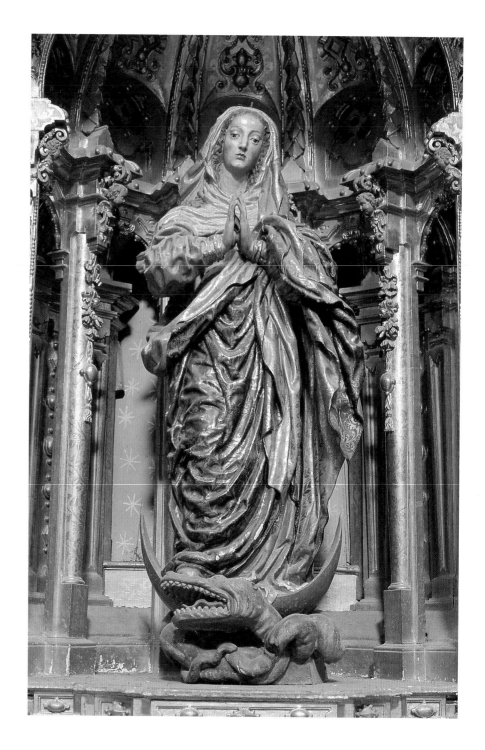

BIBLIOGRAPHY
Cid Rodríguez, C. (1923-25); Fariña Busto, F. , Vila Jato, M.-D. (1977); Otero Túñez, R. (1980);Vila Jato, M.-D. (1974-75); (1982); (s.d.)

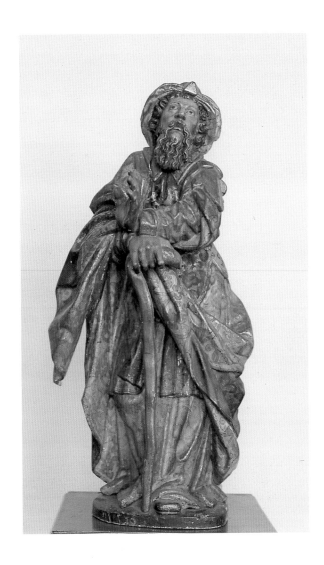

152
Saint Joachim
FRANCISCO DE MOURE
1619-1621

Polychromed wood
88 x 43 x 35 cm.

CHURCH OF THE MONASTERY OF SAN XULIAN
DE SAMOS (LUGO)

From the same altar piece as the Immaculate
Virgin, Saint Joaquín occupies the left panel,
forming a pair with an image of Saint Joseph. They
are smaller than the Virgin—in the central
panel—because above them are two reliefs related
to both saints: the Embrace before the Golden Door
and the Workshop of Nazareth.

Moure presents us an older man, as his features
indicate. He is covered with a turban and dressed
with a tunic and mantle of ankle length. His body
rests on a staff while he lifts a sweet gaze toward
the sky.

The work unites all the characteristics of the
Ourensan sculptor: his concern for detailed study of
the face, for realism, leads him to sharpen the
features accentuating the cheekbones and the
wrinkles in the nostrils. The work of the hair is
very interesting, since it forms small wavy locks
which because of the profundity of the carving
create powerful contrasts of light and shadow.

The treatment of St. Joaquín's clothing, of the
folds, also requires special attention, since alongside
thick folds, with soft texture like those of the
mantle, we find a tunic with other smaller, broken
folds, where we can see a more Baroque
appreciation of the luminous aspects. Moreover, we
should point out the cascade which the capes forms
in falling from his right arm as a trait of the author.
In it, the edges are hollowed out to achieve a
minimal thickness, revealing the technical dexterity
achieved by Moure.

His mastery is also clear in the composition of
the figure. It dominates its space; the lines of force
open, extending in all directions: gaze, shoulders
and hands are some of the points of that dispersion.

The magnificent original polychromy of the work
contributes to the emphasis of its beauty; it is done
by painting on gilt ground with volutes and other
plant motifs.

(J.M.M.M.)

BIBLIOGRAPHY
*Cid Rodríguez,C.(1923-25);Fariña Busto,F. , Vila
Jato, M.-D.(1977); Otero Túñez,R.(1980); Vila
Jato, M.-D.(1974-75); (1982);(s.d.)*

153
Saint Froilan
FRANCISCO DE MOURE ?
1615-1620

Polychromed wood
170 x 65 x 45 cm.

ALTAR PIECE OF THE CHAPEL OF SAINT
FROILAN. CATHEDRAL OF LUGO

Saint Froilán, bishop of León, was apparently
from Lugo, the city of which he is the patron saint
and where he has a regular cult, first in the chapel of
the nave of the Evangel and since 1773 in a chapel
adjoining the feet of the church, in the addition to
the area of the main façade done at that time.

The titulary image was placed in an altar piece of
stone, done by the sculptors Manuel Luaces and
Juan de Castro between 1795 and 1797, and is
attributed to Francisco de Moure, also author of the
choir of the same Cathedral. It represents the saint
dressed as bishop and blessing. Both in the
treatment of the face and in that of the clothing it
has obvious analogies with other coetaneous works
by Moure, as the case of the monastery of Samos
(Lugo): the hair that forms very plastic small curls,
the angular features of the face and the morbid
treatment of the skin, as well as the twinkling of the
slender folds which surround the body making the
anatomy visible, still twisting in an unstable
helicoidal form.

(M.-D.V.J.)

BIBLIOGRAPHY
Chamoso Lamas, M. (1984); Vila Jato, M.D. (1987)

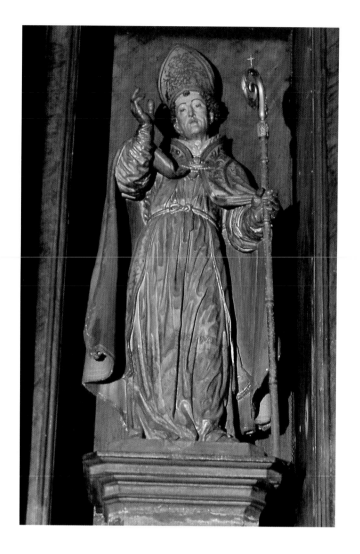

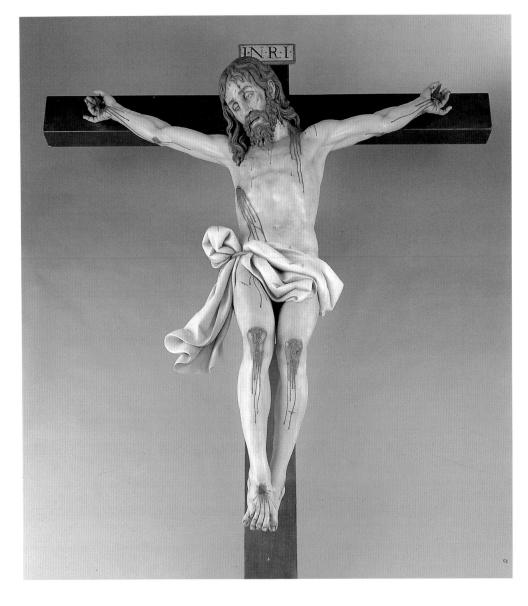

154
Christ of Conxo
GREGORIO FERNANDEZ
1628

Wood
349 x 193 x 55 mm.
Chapel of Christ. Church pf Santa María of
Conxo. (Santiago de Compostela)

CHURCH OF SANTA MARIA OF CONXO.
(SANTIAGO DE COMPOSTELA)

Neira de Mosquera, Palomiro, Ponz, Ceán
Bermúdez are among those who attribute this work
to Gregorio Fernández. In their favor are
documentary bases which support this opinion,
specifically in the Libro de la Cofradía y Esclavitud
de Nuestra Madre María Santísima de las Mercedes
a note in the margin has specific information as to
the origin of the sculpture: "Gregorio Fernández
made the Holy Image in Valladolid in 1628. And it
was brought to this convent in 1629." "And Father
Juan Pérez went to get it." The image was sent to
Santiago de Compostela and its presence caused
such fervor in the cult that in the XVIIIth century a
beautiful chapel was made to hold it according to a
project by Simón Rodríguez. The piece suffered
various changes, which caused certain reinterpretive
affirmations. Nevertheless, "The sculpture had the
beard and hair carved with the characteristics of the
sculptor and the loin cloth was wood and not
fabric." (A.B.) The last restoration was done
between 1981-83. Since then, the features of this
work of Gregorio Fernández stand out.

It is a Christ with three nails, of great realism and
vigorous constitution. The inclination of the dead
body is seen through delicate contorsions. Gregorio
Fernández knows how to reflect the dramatism that
reaches the spectator in the form of pain in a
peaceful face.

The statue, of good size and slenderness, shows
this Galician sculptor's love of the naked
body—only the loin cloth covers him.

The naturalism is seen in the representation of
the muscles and bones, which contrast with the dead
body, in which the soft flesh is apparent.

The head falls lightly over the shoulder in a
position of suffering, the half-open eyes accentuate
his pain, as do the wounds, from which blood
flows, and the weakly folded hands.

The eyes are made of quartz, the nails of bull
horn, the teeth of marble... classical affectations in
the area of Baroque sculpture. This Christ belongs
to the last artistic period of Gregorio Fernández, to
which the Christ of Light of the Chapel of the
Univeristy of Valladolid also belongs.

(C.G.F.)

BIBLIOGRAPHY
*Barral Iglesias, A. (s.d.); Caamaño Martinez, J.
(1975); Martín González, J.J. (1980). Otero
Túñez, R. (1957) (I); Placer López, G. (1975); Sá
Bravo, H. de (s.d.) (G.E.G.); Vila Jato, M.-D.
(s.d.) (G.E.G.)*

155
Immaculate Virgin
GREGORIO FERNANDEZ
1631 - 1636

Polychromed wood
75 cm. high

CONVENT OF THE CLARISSE NUNS OF
MONFORTE DE LEMOS (LUGO)

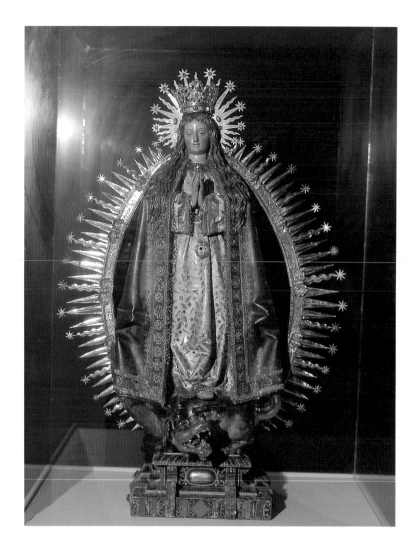

The promoter of the convent was the seventh
Count of Lemos, Pedro Fernández de Castro,
married to Catalina de la Cerda Sandoval, daughter
of the Duke of Lerma. The Count, who came to be
viceroy of Naples, founds the convent in 1622,
where Catalina de la Cerda professed as a nun after
becoming a widow.

Iconographically, the piece corresponds to the
model of the Immaculate Virgins of Gregorio
Fernández. Conceived with absolute frontal
position, she has her hands together, touching only
the ends of the fingers; her head is rounded, the
neck short, crystal eyes and extensive hair which
falls over the blue mantle, placed in rigid symmetry
and thick broken folds in the last lower third. She is
wearing a white tunic, decorated with leaves and
natural lace on the cuffs and on the edge.

She appears wrapped in a halo of rays that are
alternately straight and wavy and above her head is
a crown of fine embossed and engraved silver work.
At her feet are the half moon and a small dragon
with unfolded wings and open jaws. The
Immaculate Virgin is represented as a girl of
thirteen with an expression of candor and
innocence. It is a very precious piece which Martín
González attributes to Gregorio Fernández. Its
canon, short in comparison to other Immaculate
Virgins. allows us to situate it in the last period of
his work.

(A.C.F.)

BIBLIOGRAPHY
*Martín González,J.J.(1963);(1980); Otero
Túñez,R.(1957)*

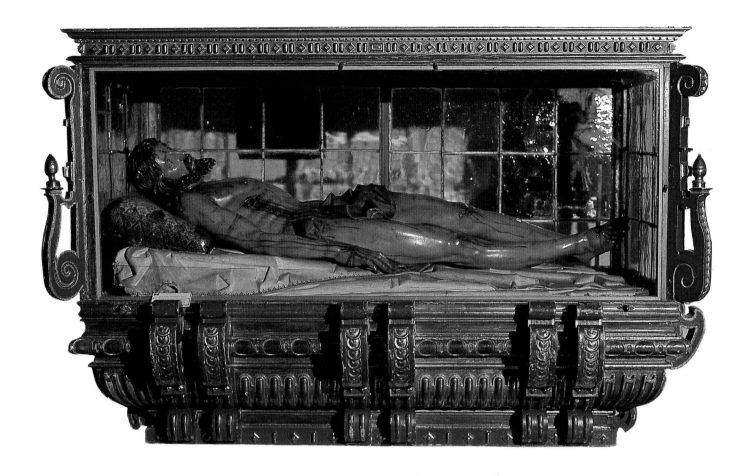

156
Reclining Christ
GREGORIO FERNÁNDEZ
1631 - 1636

Wood
188 cm. long

CONVENT OF THE CLARISSE NUNS OF
MONFORTE DE LEMOS (LUGO)

The Christ worshipped in the convent of
Monforte is well preserved, except for a few touch-
ups on the face. Carved in high relief, the shape of

the body is extremely sensual and shows the realism
of the work through its very careful anatomy. The
sculpture incites compassion. The fact that the
robust body, of strong complexion, is carved
independently of the bed, which has a pillow and
shroud, is outstanding.

Gregorio Fernández presents the image with the
head slightly elevated and the quartz eyes turned
upward as if he were still alive; also visible is the
careful sculptural work of the hair on the upper part,
which reaches virtuosity, just as occurs with the
carving of the beard. The classical affectations of the
Galician sculptor are seen on the hands and feet. The
fingers are slender and separated from the shroud.

The loin cloth, very angular, with hard breaks, is
painted with a flat color and edged with natural lace.

The dramatism of the figure is expressed in the
wound in the side, which is very open and whence
blood flows, and by the wrinkles in the skin of the
feet, result of the pressure of the nails.

Considered a work of high quality, from the
period 1631-1636, the urn in which it is preserved is
decorated with stones and egg-and-dart and
trimmed with crystals.

(C.G.F.)

BIBLIOGRAPHY
Martín González, J.J. (1963);(1980)

Choir seats of San Martiño Pinario

MATEO DE PRADO
1639-1647

Walnut

MONASTERY OF SAN MARTIÑO PINARIO.
(SANTIAGO DE COMPOSTELA)

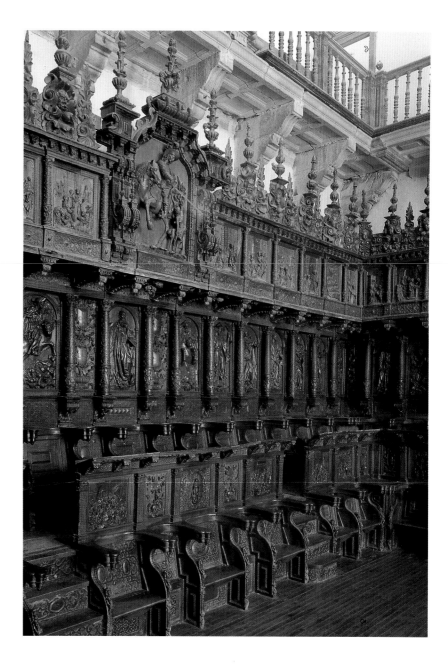

On August 2, 1639, the community of San Martiño comes to an agreement with Mateo de Prado to do the choir seats. At that time the reconstruction of the temple, which had been going on since the end of the sixteenth century, must have been quite advanced in regard to the church since the monks were concerned about furnishing it. The work, stipulated in several agreements, was finished eight years later judging by the inscription at the foot of the central image of the guardapolvo. Therefore, the date 1544 which is on one of the corners of the high choir is only applicable to that part.

The choir, set in the main chapel, and is very pronounced because of the intention of installing a low choir as in the Portuguese churches, so that the community would be facing the people, has two levels of seats. The first, which has thirty five seats and six entrances, is presided by a relief of the Immaculate Virgin, and the second, which has forty nine seats, by an image of Saint Benito. The guardapolvo has forty nine panels and in the center the patron saint, whose frame creates an expressive accent over the abbot's chair.

The architectonic design is inspired in the then neighboring choir of the Cathedral. The flat geometric motifs imitating marquetry, the young Atlases who strive to hold up the columns of the high level, the design of the columns and type of swirling motif that decorates them—in many cases literal—, the book support that runs above the lower level and which in the 1641 agreement is ordered that it be the same as the one in the Cathedral choir, or the decoration of rampants, brassards and a few misericords, have their clearest antecedent in the apostolic choir. The whole is harmonious and rich, although this might contradict the austere guidelines of Spanish architecture during the first half of the seventeenth century, announcing the impetuous resurgence of decoration in the low Baroque period, represented here by the vibrant completion that Diego de Romay added years later.

The reliefs of the low choir were devoted to the life of the Virgin. Through prolific narration, the monks of Pinario attempted to return the legend and beauty accumulated around her with the passing of time, as her figure had been so criticized by the reformists. It is true that in the Catholic Church itself some critical spirits had then questioned many passages referring to her life, but there were also many who decided to align themselves with the tradition, among them, and in a special way, the religious orders which, lacking all critical perspective, kept the heritage from the past intact.

It had gone so deep in certain sectors that it was no longer easy for them to tell the difference between legend and Evangel. Emotion dominated over reason, and the community of San Martiño resisted abandoning that fabulous world in which truth and fiction had shaped one of the most beautiful poems of Christianity. The result was the creation of the most beautiful visualized hymn that Galicia ever consecrated to the Mother of God, for which Mateo de Prado is going to use a wide cast of images of varying origin. Nevertheless, the newness of execution, the intense expressiveness and the picturesque sense of narration which always accompanies his reliefs, turn the work into an absolutely personal product, open and attractive, which easily captivates the person who observes it. Let us recall that the relief of the Offering of Saint Joachim which represents the moment when she is rejected haughtily by the high priest. Mateo de Prado was closely inspired on this occasion by the wood-engraving of the same name by Durero, belonging to the series of the Life of the Virgin, but he knew how to give it a different spirit, the same that we will find again in the panel of the Teaching of Mary in the Temple. The life of the Virgin in the temple had been basically dedicated to prayer and the study of the Holy Scriptures. And this is the activity which is shown in this relief. Seated on a bench, she listens attentively to the instructions of her teacher, while the rest of her companions review the lesson. It is one of the most attractive reliefs of the choir, a wonderful portrait because of its naturalism and spontaneity, in which the author has captured the process of a long class. While some young women pause to exchange impressions, others are reading. One does so standing firmly

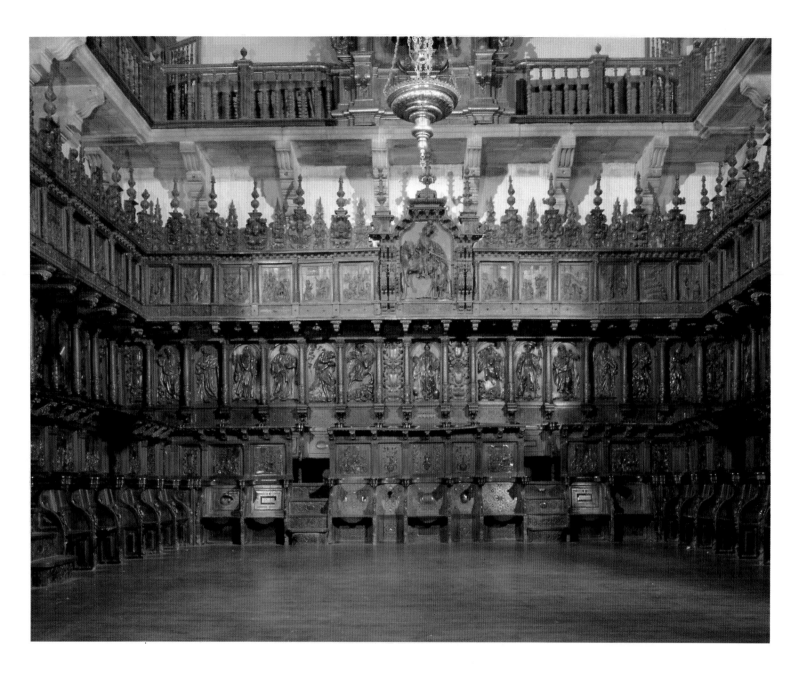

following the line with her index, another, hunched over in the back, is concentrating on the passage she is studying, and the youngest, sitting on the ground, appears to have some difficulty with the reading judging by the way she holds the book close to her. Undoubtedly this class, halfway between a kindergarten and a convent school, is both interesting and convincing. We do not know if the sculptor followed an engraving or if her preferred to allow his imagination to work freely, but even in the first case, I do not think it wrong to affirm that what he did not use as his model was that relaxed, pleasant and cordial tone, so characteristic of the sculptor, which immediately persuades us of the fact. And the same could be said of the Empadronamiento ('Registration'), a scene in which the noise and activity of the time, or of the relief of the Estancia de la Sagrada Family en

Egipto ('The Holy Family's Stay in Egypt'), again inspire in Durero and which lends itself so well to the sculptor's naturalistic taste. Otherwise let us look at Saint Joseph working at his carpenter's trade trying to fit some boards together with the help of a small cherub, who does not know whether to stay next to the old man or join his companions who diligently attend to the Virgin and Child, so that while one places the tablecloth and another, seated on the ground, tries to entertain the newborn baby with a small bird, a third is busy serving the table. In the background, other companions collaborate in the fixing of the house, apparently concentrating on the roof. Inspired by Durero, Mateo de Prado has introduced skilled changes which personalize the result, but above all that friendly picturesqueness that must be integrally incorporated into his work.

The examples could be multiplied, but then we

would run the risk of limiting the expressive capacity of the sculptor, to a type of friendly, pleasing naturalism, when in this same series of panels dedicated to the Virgin it is an indication of a broader level. Mateo de Prado has also been able to take the suffering image, with its tragic expression, using it in those scenes which recall the drama of Calvary, urged on by the evocation of those iconographical types developed by his master.

But through this cycle the Benedictines of Pinario not only sought to rehabilitate the figure of the Virgin. The Benedictine order had always, in all of its branches, had distinguished itself for its special fervor to the Mother of God. And it is certain that the Compostelan community accepted this devotion. Nevertheless, the determining why at the moment of constructing its present church, it became the temple of greatest Marian importance in

the city, must be sought in that chapel of Santa María de Corticela, where this monastical foundation had its origin and which the monks had controlled until the XVIth century. But Mary, Mother of the divine priesthood, Supreme Intercessor, is presented in the context of the choir seats and an image of the church. In this way, she, who is in charge of the militant church, which is represented in the second level, receives the members of the monastic community of San Martiño. Thus the arms of the seats may be seen symbolically as those of the Virgin, which extend to provide the members of the congregation joined there the same protection which had been offered to the characters of the upper level.

The ecclesiological context, expressed first in the figure of the Virgin, is ratified and complemented in the high choir, which is not limited to showing a great portrait of honor centered on the exclusive exaltation of the Order. The aspirations went further. Along this whole second section there was an attempt to show both the value and grandeur of the Order as well as the importance of the Compostelan temple, but under the protection of an institution which is defined as Catholic, Apostolic and Roman. When writing the program, there was an effort to show the well proportioned reference to the lives of the saints, which summarized the splendor of the Order, in the framework of a universal image of the church, aspect which was perhaps not unrelated to the proximity of the Cathedral choir. The monks of San Martiño, who since their entry in the Congregation of Saint Benito of Valladolid, which would act as the mother house of the blessed Galician monasteries affiliation with it, wanted to make their house a domus Dei, as worthy as possible, but at the same time they wanted to stress the superiority of their temple in regard to the rest of the Galician monasteries which depended on Valladolid, aspect which was reflected in the choir by that greater breadth of vision which leads them to understand an ecclesiastical symbolism of a general sort as the most appropriate way to underline the important contribution of the Order. Thus, after meeting the obligations of patronage—Saint Benito as founder if the order, Santiago as evangelizer and patron of Spain and the city which holds his remains—and after recalling Saint John the Baptist and Saint Joseph, privileged figures among the saints, the most outstanding notes of this ecclesiastical metaphor are developed through the apostles, as its firmest pillars, and the evangelists, as its doctrinal base. With the presence of the angels a second iconographic block was entered, which is nothing more than the development of the previous postulates. The doctors of the Latin church, who complete the iconographic line begun with the evangelists, the Benedictine saints or the founders of other orders, whose presence was almost obligatory, but which out of caution occupy the last places on the choir, completed the formation of the structure of this ecclesiastical building which shows the important role of the saints, officially considered models of virtue and spiritual intercessors next to God, by virtue of which a broad perspective for reaching sainthood was presented.

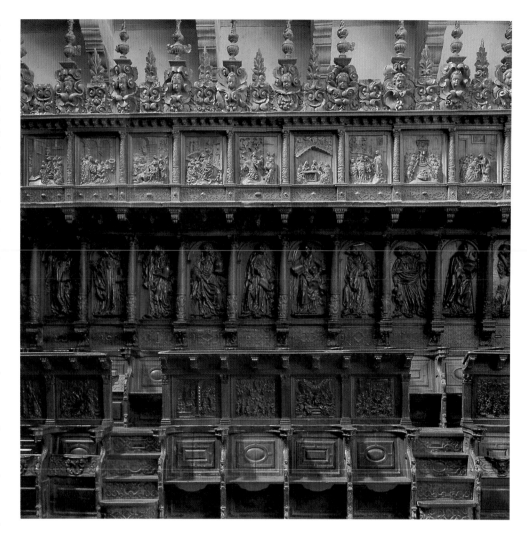

In general terms, these are the coordinates under which this iconographic discourse of the high choir operates, done by Mateo de Prado with models in Gregorio Fernández and in particular inspired in the nearby apostolic choir which as we have seen, had already dictated models in so many ways. But also here the personality of the author is tested. Let us recall the images of Santiago and Saint Millán, on both sides of the holy founder, who are not isolated figures but integrated into an overall representation of the Battle of Simancas. The Apostle, sword in hand, gallops over the defeated Moors who form a carpet over the ground. His cape and the mane of the horse waving in the wind act as an important signal of movement, well shown by the horse's pirouette. The pluridimensionality makes its sculptor succeed in a theme which demands a space that makes it the organic center. And the same thing happens with Saint Millán, where the Baroque thrust dynamizes both the gallop of the horse as well as the agitated fluttering of the clothing which breaks into multiple small folds. But here us a braver foreshortening which precipitates the image

of the Riojan Saint, formally and psychologically, into the existential space of the spectator. Mateo de Prado, probably the introducer of the equestrian style in Galician Baroque, created a group in which we must include the image of San Martiño sharing his cape with the poor man, which deserves to be recognized as one of the great achievements in the choir and which later will be repeated in the sumptuous retable-baldacchino designed by Fernando de Casas for this church. But if these images are expressive, no less so is that of Saint John the Baptist, inspired by the one by the same name done by the master for the Barefoot Carmelites of Valladolid and one of the best sculptures that came from his gouge. Also of great quality is the panel of Saint Bernard, whose model came this time from the choir of the Cathedral. These images and the remaining ones confirm that if in the first level narrative values had prevailed, here the sculptural ones absolutely dominate. And although the debt to other artists is obvious, his personality is shown in the elongated canon, the movement of postures, the expressive treatment of

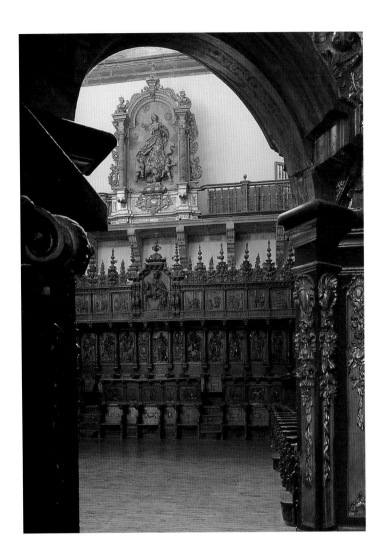

the face or placement of the drapery, always abundant, insistingly angular, hard, which peaked edges, and forming great hollows. Mateo de Prado took enormous advantage of the treatment of the cloth: he turns it into the main unifying element of all the images.

The guardapolvo was consecrated, except for the relief of San Martiño which presides it, to the founder of the Order, which means being within the most extensive cycle devoted to Saint Benito by a Spanish choir. Forty eight panels represent in detail his life and works with the purpose of holding him up to the community as an edifying example and teaching. Through his example the excellencies of the monastery life in all of its options are shown, although the accent is placed on the cenobitic, we do not move in vain in the area of a monastic community and around the life of the patriarch of western monasteries. As a result there is an emphasis of the major coordinates around which the lives of its members are organized, such as the divine rites, spiritual lectio or work, but also the virtues which must accompany the monk: obedience,

humility, poverty, chastity, renouncing the world and, of course, charity. But in addition, the founding saint was shown as the instrument used by God to do miracles. His whole life could be summarized by saying that it had been a miracle, which clearly indicated the power of one whose example had been imitated and who from the choir gave his protection to the monks gathered there several times a day for their primary occupation: the work of God.

To do this large number of Scenes, Mateo de Prado was inspired by the visualized edition of his life that was published in Rome in 1579 by the Congregation of Saint Benito of Valladolid. And in spite of the fact that the accommodation to the model is always very close, the freshness and liveliness which characterize him avoids bold plagiarism, reaching great stylistic uniformity even though the intervention of the workshop might have been broad. It is true that Mateo de Prado did not follow the correctness of the model, but on the other hand he avoided the cold, distant and excessively bookish tone of the Mannerist concept which was probably pointed out to him at the beginning. Let us

consider, for example, the panel which illustrates the construction of the monastery at Terracina. Saint Gregory had recalled how on one occasion Saint Benito, answering the demand of s devout person, ordered several monks to found a new monastery, assuring them that he would indicate the place and distribution at the appropriate time. Thus, one night he appeared to them in dreams in order to show them the details of the edification. But not believing the vision and as the holy abbot did not physically appear, they decided to return home. The Mannerist multiple themes was useful for Passaro in recalling the various moments of the story. Mateo de Prado, on the other hand, opted for centering himself on the vision, showing the four monks peacefully sleeping and the figure of Saint Benito floating in the air, although he seems more to be suspended from the ceiling. The interpretation of the model is not only abbreviated but also may seem naive, although undoubtedly it is effective. There has also been a notable lessening of the quality, frequent in the treatment of all the themes of the guardapolvo, resulting in a more ordinary work. The greater intervention of the workshop and the high placement of the reliefs will permit a sketchier procedure, since in the long run the overall idea was to prevail, it not being possible to foresee that one day zoom lenses and binoculars could ruin things.

The choir seats of San Martiño are undoubtedly the most important of the Baroque choirs in Galicia, which also has the largest series of this sort in Spain at the time. It gives as the true measure of its author's art. The loans from Gregorio Fernández are stylistically and iconographically undeniable; the debt to the Cathedral choir, obvious; and the use of engravings, an irrefutable fact. In spite of all this, Mateo de Prado sifted this ample source of information and gives it his own mark. The spontaneity of his carving, the expressiveness of his images, the picturesqueness of the narration, the goal as sculptor, the very slender and dynamic concept of the figure, a more vibrant luminous style in the drapery, the sketchy nature of the final boards have allowed him to emerge successfully from the test, confirming a personality able to give unity to a work in which different hands have collaborated and which is seen not only as the most important in eighteenth century Galician sculpture, but also as one of the most interesting groupings of Spanish art of its time, considering the scarce number of choirs that Spain has in this century.

(A.- A. R.V.)

RESTORATION NOTE:

State of preservation:
• The wood support has some damage by xylophagus insects.
• The structure in general is fairly good.
Treatment applied:
• General application of xilamón by a specialized company and protection with wax that was later burnished.
Additional treatment:
• Every six years, repeat the treatment against xylophagus insects.

BIBLIOGRAPHY

Lois Fernández, M.C. (1958); Martín González, J.J. (1964); Otero Túñez, R. (1956) (1); Rosende Valdés, A.A. (1990)

158
Immaculate Virgin
MATEO DE PRADO
1656

Polychromed wood
98 x 44 x 27 cm.
Cathedral of Ourense

MUSEUM OF THE CATHEDRAL OF OURENSE

In 1656 Mateo de Prado, in collaboration with Bernardo Cabrera, contracts to do the altar piece for the Chapel of Saint Paul or Deacon Armada. It is an intersting piece, raised on its base decorated with trimmed tablets and flanked by two pairs of bracketts which is comprised of a single body with high rlief between the two pairs of salomonic columns, whose shaft with stiff spirals is divided into thirds, the upper and lower covered with grapevine tendrils and bunches of grapes and the middle one with fine helicoidal striations, as in the columns in the tapestries by Rubens. These were a gift by Philip IV to the Cathedral of Compostela, and Bernardo Cabrera, author of the disappeared altar piece of the Relics of this Cathedral, which had the first salomonic columns in Spain, must have known well. The relief, disfigured by a very poor touch up, represents the Conversion of Saint Paul, conceived as a coextensive space with that of the spectator, as if it formed part of a single continuous reality, in accordance with the Baroque desire to break the frontiers between life and art. The relief, dense with figures and full of actions and emotions, only takes to their ultimate consequences types and statements previously made in the stalls of San Martiño Pinario. And above the dynamic cornice which completes this only body of the altar piece a small niche opens between the volutes of a curved split pediment which in its day was occupied by the image of the Immaculate Virgin that today is in the Museum of the Ourense Cathedral.

It is a small sculpture which closely follows the type popularized by Gregorio Fernández for whom it constituted a motif of serial production. Mateo de Prado represents her from a frontal position, her glance directed upward, her face childlike—which makes the image more complacent—, long hair symmetricaly placed over the cloak and praying hands. She is wearing a white tunic with belt and very hard folds, like those of the cloak, symmetrically placed forming a shell that hides the body and in which there are the typical lateral folds at the height of the lower third. She is resting upon a half moon and a throne of angels and seraphim. A rich polychromy illustrated with symbolic motifs and emphasized with an artificial lace border, which continues along the entire edge of the cloak and is repeated on the cuffs, complete the image that is seated on a base of egg-and-dart and volutes. From the linguistic point of view we can see a retrocession in comparison with the stalls of Pinario where, even though we might make similar statements, the image was more dynamic and expressive.

(A.- A. R.V.)

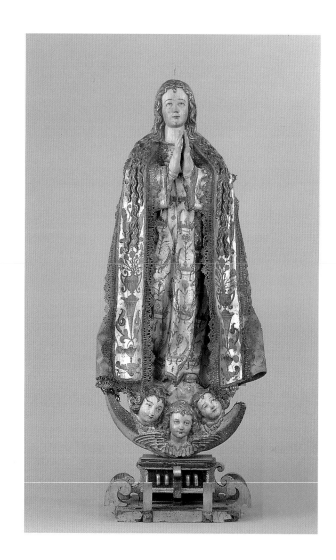

RESTORATION NOTE:

State of preservation:
• The support has serious damage by xylophagus insects, there are losses on the base and the corner of the moon.
• Unglued pieces.
• The preparation layer is traditional (compound and animal glue) and very fine, cracked on the face and hands because of the heat of the candles; it has good cohesion and small lacunae.
• Red bole. Painted layer with good cohesion and adhesion.
• There lacunae in the mantle with bole visible.
• The golds have overall cracking.
• The cloth adornments are in bad condition and loose.
• Lacquer in golds.
• The varnish protective layer has lost its function.

Treatment applied:
• Mechanical cleaning of dust.
• Disinfection with methyl bromide.

• Preventive treatment of the wood with xilamón.
• Reinforcement of the structurally affected areas due to damage by xylophagus insects (base) with synthetic resins.
• Gluing of loose pieces (middle finger of the left hand and base).
• Fixing of preparation and paint layer.
• Fixing of textile adornments.

Additional treatment:
• Physical-chemical and photographic analysis.
• Elimination of the varnishes that do not protect.
• Replacement of the protective layer.
• Following of the state of preservation of the piece by control of environmental conditions of preservation.

BIBLIOGRAPHY
Chamoso Lamas, M. (1943-44); Hervella Vázquez, J. (1988).

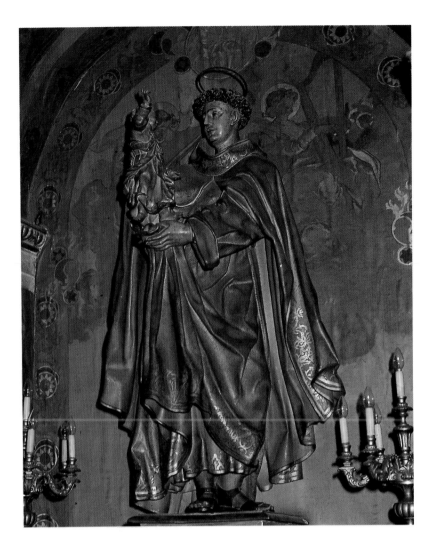

159
Saint Anthony of Padua
MATEO DE PRADO
1658

Polichromed wood
150 x 80 x 54,5 cm.

ALTAR OF SAINT ANTHONY. CATHEDRAL OF
OURENSE

Shelter beneath an arch of the ambulatory of the cathedral of Ourense is the altar of Saint Anthony, whose image, somewhat smaller than life-size, has been continuously attributed to Mateo de Prado by those who have studied it, and the date of 1658 given by Fernández Alonso as that of its execution has also been accepted. Its iconography fits the type of representation popular starting with the XVIIth century, according to which this contemporary of Saint Francis, active, polemicist, and predicator, later became static contemplator. For the XVIIth century the contact which he had once had in the house of an innkeeper had been the decisive moment of his life, practically limiting his existence to this vision. Since then the Christ Child became his principal attribute and the most common image is that in which he is holding the Child in his arms, as in Ourense. Covered with an ample mantle, he holds the body of the Child with one hand while with the other he clutches several folds of his habit to rest in them the tiny baby feet that he does not dare to rub. The tender devotion of the saint to the miraculous event contrats with the graceful movement of the childish gestures of his companion, who smiles sweetly at him. The sculptor has managed to portray the breath of spirituality typical of one who has distanced himself from reality.

The body turning to the right, the jovial naturalness of the Child and the movement of the clothing form a dynamic, expressive group of intense vitality but without grandiloquent gestures. The sculpture widens at the bottom and the folds bent rigidly like the straight, stiff planes characteristic of chiaroscuro. Once again, the sculptor has used the fabric as a determinig factor of the image. The sculptural volume in general has been satisfactorily resolved, but not certain details such as the Child. Mateo de Prado on reducing the theme of the child to a problem exclusively of size, created types that are scrawnier than real children, an aspect already visible in the panel dedicated to Saint Joachim in the choir seats of Compostela, although here the representation of the Virgin child becomes more natural, maintaining a more organic relationship with the figure of her elderly father.

(A.- A. R. V.)

BIBLIOGRAPHY
Fernández Alonso, B. (1928)

160
Saint Librada
MATEO DE PRADO ?
1642

Ploychromed wood
191 x 125 x 46 cm.
Main altar piece of the Monastery of Augustine
Nuns of Vistalegre.Vilagarcía de Arousa
(Pontevedra)

CLOISTERED CONVENT OF THE MONASTERY
OF AUGUSTINE NUNS OF VISTALEGRE.
VILAGARCIA DE AROUSA (PONTEVEDRA)

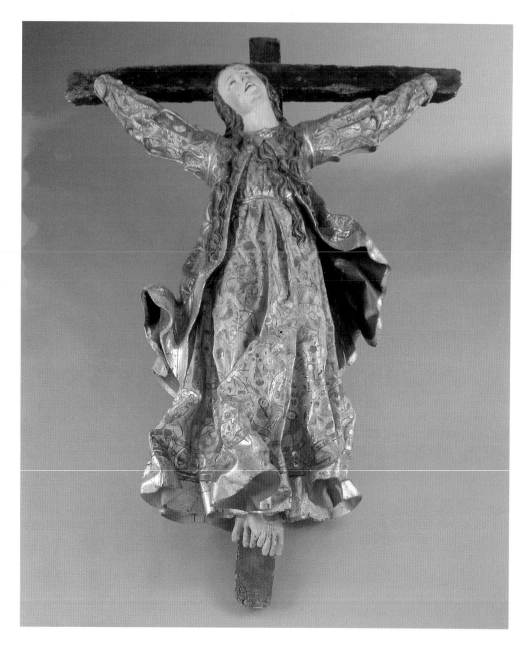

The Saint, suffering, dressed and crucified, is a clear example of Baroque paradox: she is wearing a raised embroidery tunic and a fluttering visor with such a joy in the combination of folds and figure that it constitutes an authentic song to youth. There is such dynamism in the sculpture of the figure and such sensual fervor in the overvest that we could speak of a true 'Crucified Ascent'. Saint Librada thus has a sublimation of the Immaculate aesthetic of Gregorio Fernández, and in it iconography, Trentine spirituality, Baroque poetry and protoclassic vitality are joined. Undoubtedly it anticipates the Ascent of the Cathedral of Ourense.

The iconography of the image may explain the novelesque character of the saint, but not the paradoxes which surround its appearance in the Galician devotional and artistic world, as well as the absurdity of the lack of roots for its cult in the region.

A very popular saint, with numerous names (Liberata, Kummernis, Vilgefortis, Debarras, Oncomemes...), she has several versions of her martyrdom and sainthood. To free herself from a marriage imposed upon her she requests and is granted a thick beard growing over her beautiful face. The sister of eight other damsels, born on the same day, she is martyred by her own father (who, enraged, crucifies her like Christ) or by pagans who also execute her sisters by decapitation on the same day. In any event, the bearded crucified saint (whom Schmürer identifies with an attempt to explain the Volto Santo of Lucca crucified in the line of the Evangel of Rabula and the Chapel of Theodoto of Santa María Antigua in Rome) is the patrimony of the European Center (Germany, Flanders, Bourgoundy, France) while in Spain the beheaded saint had a very discrete popularity.

The importance of the cult and the commissioning of the work was the initiative of the founder of the monastery in Vilagarcía, the prelate Fernando de Andrade y Sotomayor, who between 1640 and 1645 led the diocese of Sigüenza, in whose Cathedral the Saint was venerated in a very beautiful altar piece by Juan de Pereda (1526), restored by the prelate during his pontificate.

Nevertheless, the Saint of Vilagarcía is not the beheaded saint of Sigüenza, but rather the crucified saint of central Europe (although lacking the beard), barely known in Spain, while we cannot specify why one was preferred over the other. It is certain that, in spite of its novelesque nature and surprising iconography, the cult and devotion to the Saint did not take shape in the region, where it survived in an isolated corner and as an exotic product.

(S.A.E.)

RESTORATION NOTE:

State of preservation:
• In pretty bad condition
• Already intervened previously, to reinforce assembly and fix layers of preparation and polychromy.
• It shows assemblies which are out of place with danger of coming loose.
• Very important damage by xylophagus insects on the cross and less on the figure.
• Fungi on the figure.
• Traditional white preparation (animal glue and compound) with an irregular cohesion to the support.
• Flesh areas in burnished oil on top of original polychromy.
• Gilded garments in fine burnished gold and painted on gilt ground in distemper.
• The temper has lost the agglutinant and is very soluble in all types of liquid.
• Much dust and wax spot the polychromies.
• Flesh areas and dress spotted with oxidized lacquer.

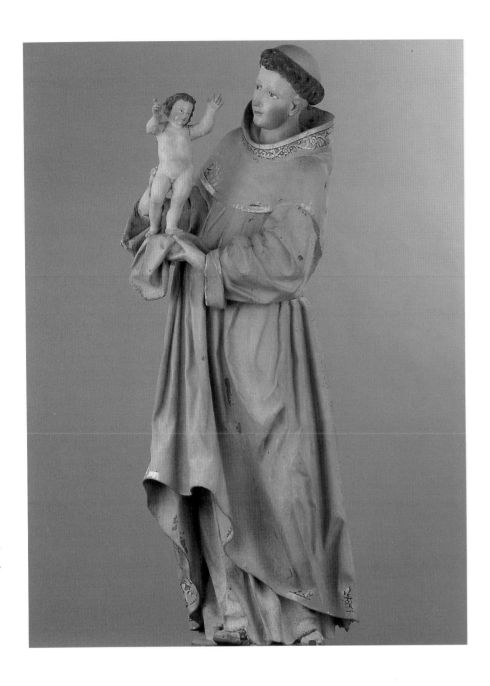

161
Saint Anthony of Padua
PEDRO TABOADA
Last third of XVIIth century

Polychromed wood
185 x 58 x 46 cm.

CHURCH OF THE COMPANY. SANTIAGO DE COMPOSTELA

The chapel of the Sacred Family, done by Peña de Toro at the end of the XVIIth century, is situated on the side of the Espistle of the Church of the Company. The altar piece it held until 1880 was from the same date, when it was substituted by another one, of Neoclassical style. The image of Saint Anthony of Padua belonged to that first altar piece, as did that of Saint Louis Gonzaga with which it was paired, and those of the Sacred Family, in the middle panel.

Taboada turns to traditional iconography to represent Saint Anthony: a beardless young Franciscan, with habit, rope belt and wide monastical tonsure, accompanied by the Christ Child. The Child and the friar seem to hold a warm dialogue in which both are enthused, although the effect is not entirely successful. The Saint holds the Child, who is naked and has raised arms, at the level of his right shoulder, placing the woolen cloth he grasps with his left behind the Child's feet. As a result of this position Saint Anthony turns his body toward Jesus and bends one of his legs, accentuating the slenderness typical of the figure.

The work shows the heritage which Taboada received from his master. He does not hesitate to use as a model the representation of the Portuguese saint that Mateo de Prado does for the Cathedral of Ourense—presently in that temple's ambulatory—. Nevertheless, we can see a series of new premises: an abandoning of pathos in favor of more friendly and tenderer environments; the canon of the figures has lengthened,—the hands, for example, are extremely narrow and fine—; the folds continue to produce deep contrasts of light and shadow but the line of the folds has become rounded, far from the hard, cutting peaks of the first and second third of the century. Even the faces of the characters are evanescent, becoming blurred and softer.

This piece has lost a great deal of its beauty. Its original polychromy has been covered over by a layer of grey paint, which uses the front part to do the fret of the lower levels and the chapel, places where we can guess as to the polychrome richness done in brownish and golden tones.

(J.M.M.M.)

Treatment applied:
• Mechanical cleaning of surface dust and wax.
• Fixing of preparation layers and polychromies.
• Chemical cleaning of the oxidized lacquer on flesh areas and dress.
• Disinfection with acetylene bromide gases.
• System of presentation: velatura of neutral ink in blank areas with loss of polychromy.

Additional treatment:
• An exhaustive analysis of the polychromies to determine composition and state of preservation of the original polychromy and to see the possibility of recovering it.
• Consolidation of the wood of the cross by injection of a stable resin.

• Exhaustive control of the environmental conditions of preservation of the piece to avoid a reactivation of the process of degradation.

BIBLIOGRAPHY
Bertarelli, L. y Ferrara, M. (1944); Cignitti, B. (1967); Chamoso Lamas, M. (1956) (1980); Gil Peces y Rata, F. (1986); Martín González, J.J. (1983) (II); Pérez Costant i, P. (1930); Rombant van Doren (1969); Schiller, G. (1972); Schmürer, G., Ritz, M. (1934); Vila Jato, M.- D. (s.d.) (G.E.G).

BIBLIOGRAPHY
Chamoso Lamas, M. (1956) (II); Fernández Sánchez, J.M. , Freire Barreiro, F. (1882); Ortega Romero, M.S. (1982). Otero Túñez, R. (1953) (I); Pérez Costanti, P. (1930); Ríos Miramontes, M.T. (1983)

162
Dolorosa
TOMÁS DE SIERRA
End of XVIIth century - beginning XVIIIth

Polychromed wood
67 x 52 cms. (without base)
Medina de Rioseco ?

CHAPEL OF CHRIST. CATHEDRAL OF OURENSE

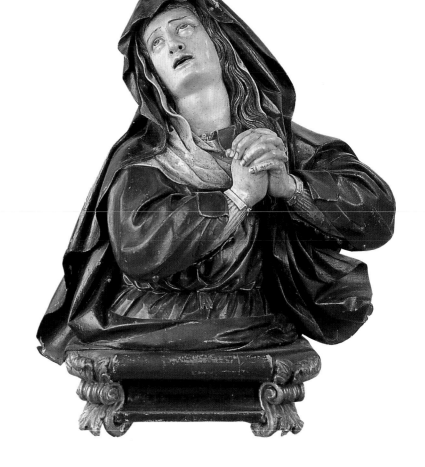

An example of the artistic relations established between the centers in Valladolid and Ourense is this image of the Dolorosa which is in the Chapel of Christ in the Cathedral of Ourense, donated by Bishop Diego Ros de Medrano, according to Muñoz de la Cueva, although in the report of 1708 José Martínez figures as the donor, who in 1697 ordered from Valladolid some paintings for the chapel.

The Dolorosa was attributed until a few years ago to the sculptor Gregorio Fernández, since it faithfully follows the style of the master from Castile. Nevertheless, Martín González relates it to the full-length Dolorosa if the float of Longinos in Medina de Ríoseco, work of Tomás de Sierra.

The sculpture is cut at the level of the waist, horizontally, and rests on a base from 1705. The Virgin lifts her gaze upward, with pleading eyes and half-open mouth, and long neck—characteristic of Gregorio Fernández—pushes her head upward, tilting it, and her hands are pulled in, clutched against the breast accentuating the effect of dramatic intensity in the face. Her hair is done in small locks, as if it were wet, on which she wears a dark mantle. The artist differentiates the textures of the fabrics and in this way the tunic and mantle form wide, stiff folds which create great chiaroscuro effects, while in the headpiece we can see how the folds become slightly smaller. The polychromy is done with flat colors, with the flesh color which now appears varnished, standing out, since in 1830 the sculpture underwent some fixing by the painter Cortés.

The work shows advanced Baroque features, which makes us think of a chronology near the end of the XVIIth century or beginning of the XVIIIth.

(A.G.T.)

RESTORATION NOTE:

State of preservation:
- Support generally in good condition, scattered damage by xylophagus insects.
- Small losses which correspond to the damage from xylophagus insects, especially on the edges of the mantle.
- Layer of traditional preparation (compound and animal glue) with good cohesion and adherence; there are small lacunae which coincide with the zones of damage by xylophagus insects.
- Painted layer with good internal cohesion and adherence to the support, scattered lacunae from erosion.
- The protective layer is formed by varnishes and waxes.
- Dust on the surface and in concretions.

Treatment applied:
- Mechanical cleaning of surface dust and biological deposits.
- Disinfection with methyl bromide in gas chamber.
- Consolidation of the support in scattered areas with synthetic resins.
- Chemical cleaning of surface grease.

Additional treatment:
- Removal of oxidized varnishes and waxes.

- Renewal of protective layer.
- Following of the state of preservation by control of the environmental conditions.

BIBLIOGRAPHY
Ferro Couselo, J. , Lorenzo Fernández, J. (1988); Martín González, J.J. (1961); (1968); (1980); (1983) (I); Muñoz de la Cueva, J. (1726)

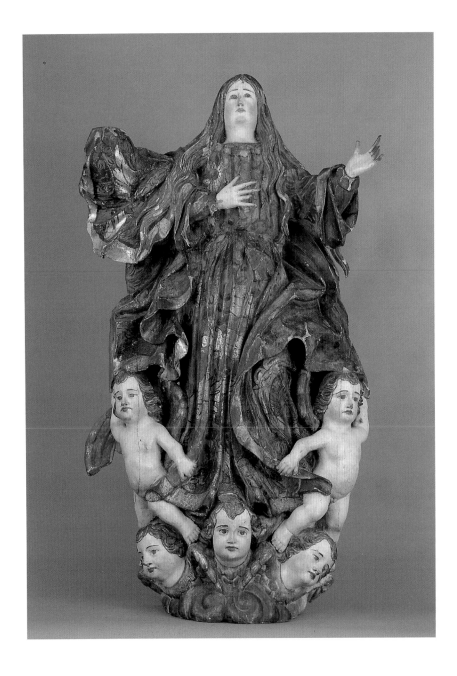

163
Virgin of the Ascent
FRANCISCO DE CASTRO CANSECO
1699-1701

Walnut
130 x 80 cm.
Choir seats of the Cathedral of Tui (Pontevedra)

DIOCESAN MUSEUM OF TUI (PONTEVEDRA)

The "Scripture of the choir seats of the Cathedral" purposely points out that Francisco de Castro will erect a body of architecture over the episcopal seat, "with a box in which and image of the ascent of our lady will be placed," the image being transferred in the third quarter of our century to a salon in the diocesan museum. It presided the choir seats at the level of the lid—last iconographic level—in whose panels the life of the Virgin is shown. The reason for this finish in a work dedicated chiefly to the 'life and miracles of the/life of Saint Peter González Thelmo Patron' of the bishopric, is due to the fact that the Virgin is titulary of the Cathedral, thus joining in the great work the two themes of Tui of greatest importance from the religious perspective.

The image represents Mary standing, on three angelical heads, with the right foot resting on the central head—as the master tends to do—, a composition which he completes with chubby "putti" on the sides, in dynamic postures, which reinforces the celestial tone. The clothing describes moving curves with the mantle which will cut across the space at the high point of the choir seats where it was located, effect which we cannot see in its forced placement in the museum. The flight for Castro y Canseco is concentrated in the chains and, in this case, in the right shoulder, emphasizing the thrust of the arm which, like the other, opens in a unitive gesture toward the celestial persons to whom she symbolically directs her gaze. On the other hand, toward her heels, the flying folds seem to shrink up, to open immediately in an expansive movement.

The choir seats for which it was done were contracted for 60,000, and it had to be done in two years. Decades afterward, August 2, 1742, Esteban da Silva, painter living in Braga (Portugal) is hired to varnish the work for 3,000 reales de vellón (small coins).

(F.-J.L.G.)

RESTORATION NOTE:

State of preservation:
• Support with scattered damage by xylophagus insects.
• Losses of pieces due to the coming unglued of the attachments.
• Open attachments and small cracks due to sharp movements of the support.
• Breakage of fingers of the left hand and right hand loose.
• The preparation layer is white (animal glue and compound) with lack of adhesion to the support.
• The painted layer has lacunae which coincide with those of the preparation layer; this layer is repolychromed.
• Protective layer formed by varnishes and oxidized lacquers.
• On the surface there is an accumulation of dust and concretions of dirt.

Treatment applied:
• Mechanical cleaning of surface dust.

- Preventive treatment of the wood with xilamón.
- Disinfection with methyl bromide gases in gas chamber.
- Fixing of preparation and painted layers.
- Gluing of right hand.
- Chemical cleaning of surface of dirt.

Additional treatment:
- Physical-chemical and photographic analyses to determine the existence and state of preservation of the original polychromy and its possible recovery.
- Selection of aesthetic treatment of lacunae.
- Following and control of environmental conditions which affect the work's preservation.

BIBLIOGRAPHY

Caramés González, C. (1972); Iglesias Almeida, E. (1989); Martín González, J. J. (1964); Pérez Costanti, P. (1930); Rosende Valdés, A.-A. (1980)

164
Virgin of the Rosary
FRANCISCO DE CASTRO CANSECO
1708-1709

Walnut
225 x 100 x 57 cm.

CHURCH OF SANTO DOMINGO
(SANTA EUFEMIA DO NORTE). OURENSE

From the contractual document we know how the piece of the Virgin of the Rosary adjusts to the agreed upon between the representatives of the Bortherhood and Francisco de Castro: "... in the hole and box of the middle... it is to hold an image of our lady of the Rosary sculpted full length... with the child (sic) in his left Arn (sic) and in his right hand his Rosary with a very attractive pier and crowns to said image and the child," even when both figures are lacking crowns.

Of very slender canon, with lisipian similarities although of undoubted Mannerist origin, the figure bends the left knee toward the center of the composition (base included), which the artist uses to make the folds fall in lines that in a way are angular, which end waving and diverging over the feet, a frequent technique if the master. The weight of the body is supported by the right leg, the foot resting firmly on the head of the central of the angelical busts, with strange wings in pincer form for arms, on the axis of the statue. The wide mantle waves in curves between the knees and the hips, held by the Child. The latter, naked except for a subtle veil, opens his arms in counterposition to the figure of the Mother. The outer hands of both elegantly hold rosaries (today only Mary holds it), which fell over the two images "which are to go parallel to the central box," which "are not to be from the account of said master," and iconographic scheme similar to that of the relief of the main altar piece—also by Castro Canseco—where the giving of the rosary to Santo Domingo de Guzmán and Santa Catalina of Sienna, respectively, is represented.

The image is in the altar piece of the southern arm of the transept (middle panel, lower section),

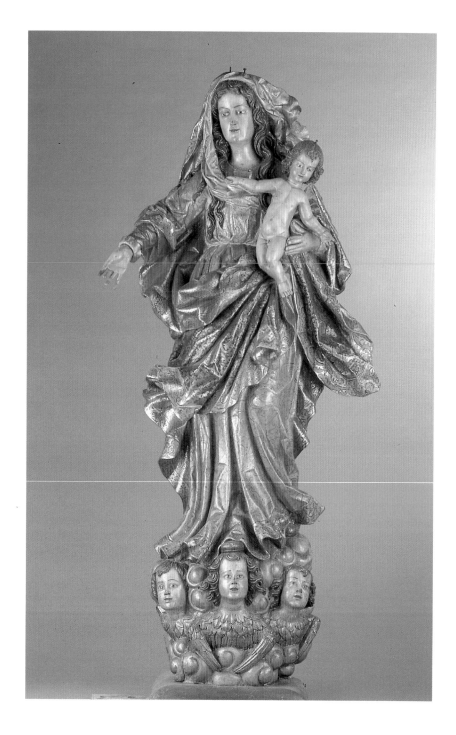

today without the salomonic columns that are 'very well cut out' which it had until its move to the chapel of the brotherhood. The angelical pages in child figures which finish it off would go above them. These figures are very typical of the master, as is the framing of the small cards, with stall decorated by the omnipresent palms, phylomorphic solution that until its arrival in Galicia was practically unknown. The altar piece has the five glorious mysteries in relief.

(F.-J.L.G.)

RESTORATION NOTE:

State of preservation:
- Wood support in good conditio, with a very pronounced crack on the face produced by natural movement of the wood.
- There are unglued attachments and the right hand is loose.
- Traditional preparation (compound and animal glue) and red bole, with good cohesion and adherence to the support.
- Painted layer with good cohesion and adherence, scattered erosion of folds and angels' faces.
- Protective layer formed by varnishes and lacquers in golds.
- There are also layers of wax on the garments. The layer of varnish is very thick and shiny.

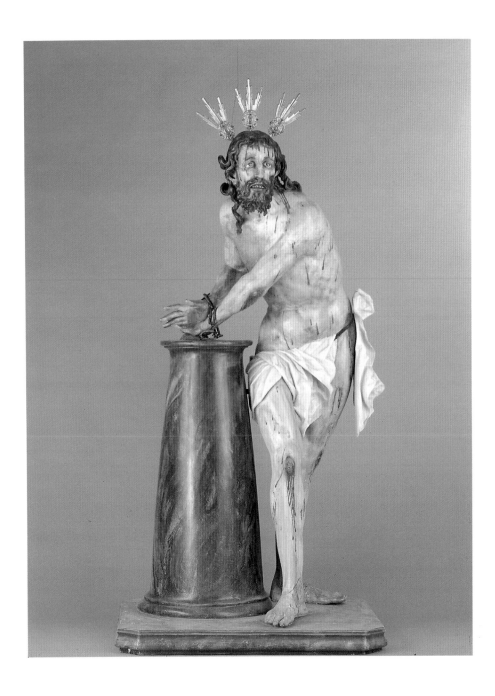

This work has been assigned by Murguía to Diego de Sande, and this has never been disputed. Nevertheless, there is no documentary base that allows this affirmation to be ratified.

The theme represented is that of the Flagellation: Christ appears tied to a low post, of cone-shaped trunk—reference to the relic that is preserved in the church of Saint Praxedes of Rome—, as was habitual throughout the Baroque. In this work Sande follows an iconographic type that during the XVIIth century and the beginning of the XVIIIth was imitated by a large number of sculptors: that of Vera Cruz of Valladolid (1619).

The artist shows great control of his craft. The piece, like those of Gregorio Fernández, is carved in a single block, achieving a very successful balance of composition between the post and the figure. The naked body allows him to do a careful anatomical study through some of the strokes of his gouge can be traced. Christ has a heavy, full musculature, less elastic than that of the piece by Vera Cruz, in which the shape is achieved by soft play of light and shadow. The veins are emphasized. Moreover, we should point out, as a characteristic of the artist, the roundness of the abdomen in the lower part, heightened by the fall of the loin cloth, as it is repeated in the Descent of the chapel of the Prima.

The treatment of the face deserves special attention, and is where all the expressive power of the image is concentrated as a sample of a tragic "pathos": he lifts his eyes toward the sky in a gesture of pleading, while his mouth remains half-open and his wet hair is arranged to leave the ear visible. Face and hands, in the same manner as the overall tone, present a shape fitting an eighteenth century taste, which the touch-ups of its polychromy destroy.

We should also mention the loin cloth above the femur, held by a cord, with very broken and deep folds, its hard outlines standing out.

(J.M.M.M.).

RESTORATION NOTE:

State of preservation:
• Scattered damage by xylophagus insects.
• In general the support has good painting on gilt ground.
• Layer of traditional white preparation (compound and animal glue), with good cohesion and adhesion.
• On the painted layer there are different polychromies, besides scattered touch-ups, with good adherence to the preparation layer.
• The lacunae that could have existed have been touched up in previous interventions; the quality of these touch-ups is poor.
• The protective layer is formed by varnishes and lacquers that are very oxidized.

Treatment applied:
• Mechanical cleaning of surface dust and biological deposits.
• Disinfection with methyl bromide (in gas chamber).
• Surface cleaning of grease with chemicals.
• Mechanical cleaning of drippings of lacquer on the surface.

Recommended treatment:
• Physical-chemical and photographic analyses to determine the state of the original polychromy and its possible recovery.
• Following of the state of preservation by control of the environmental conditions of preservation.

BIBLIOGRAPHY
Chamoso Lamas, M. (1941); Folgar de la Calle, M.C. (1989); Martín González, J.J. (1980); Murguía, M. (1884); Otero Túñez, R. (1980).

Treatment applied:
• Mechanical cleaning of surface dust.
• Disinfection with methyl bromide.
• Gluing of right hand.
Additional treatment:
• Removal of the layers of varnish, wax and lacquer which distort the reading of the work.
• Replacement of the protective layer.
• Following of the state of preservation by control of the environmental conditions.

BIBLIOGRAPHY
Caramés González, C. (1972); Cid Rodríguez, C. (1931); Limia Gardón, F.J. (s.d.); Pérez Costanti, P. (1930)

165
The flagellation
DIEGO DE SANDE
First third of XVIIIth century

Polychromed wood
188 x 92 x 70 cm.

CHURCH OF SAN AGUSTÍN. SANTIAGO DE COMPOSTELA

166
Main Altar Piece of the Church
of San Martiño Pinario
FERNANDO DE CASAS
AND MIGUEL ROMAY
1730-1733

Wood

CHURCH OF THE MONASTERY OF SAN
MARTIÑO PINARIO. SANTIAGO DE COMPOSTELA

In the main altar piece there is a combination of the originality of the design by Fernando de Casas and the mastery of the sculptor Miguel de Romay; not in vain are they the two figures of greatest prestige in their respective fields. Moreover, Romay, for a work of such range, had the collaboration of thirty four officials, some with the experience of Manuel de Leis, Domingo de Romay, Pedro de Romay, Francisco de Casas and Andrés Mariño. This team made it possible for the altar piece, contracted in June 1730, to be solemnly inaugurated on May 19, 1733, prolonging the festivities organized for this purpose throughout three days. But in 1733 part of the sculptural complement was missing, and Benito Silveira would be in charge of doing this between 1733 and 1742. Years later, in the decade of 1760, José Gambino adds the side chancels.

In the first place we must note the specific placement of the altar piece in the mouth of the deep main chapel, like a great iconostasis that separates the monks' choir from the upper end of the rest of the temple. Thus its character as double or bifrontal altar piece, treated with equal sumptuousness on both of its fronts.

The altar piece is comprised of two sections, the second, pyramidal and with sharp outline, ascends to the height of the vaults. It actually is a canopy-altar piece and thus in the documentation is cited as a "Tabernacle." A baldachin as central composition dominates the entire altar piece and intertwines with the side walls of the main chapel by means of curved entablatures, under which there were originally two wide openings that allowed the seats to be seen. Casas planned it as an open structure to generate a notable effect of depth, since the "machine", with the placement of different planes in its eight immense Salomonic columns, is projected toward the nave and the monastical choir. A proposal in which, following the norms for altar pieces of the XVIIIth century, the central panel is promoted, and within it, the exhibiting tabernacle and the niche destined for the titular saint.

It is surprising that in 1730 Fernando de Casas uses columns of helicoidal shaft as principal supports, especially because three years earlier Simón Rodríguez had opted in the main altar piece of the present church of the University for the peculiar eighteenth-century columns with plain shaft covered with ribbons and ovals, but as we shall see the Salomonic support is present in

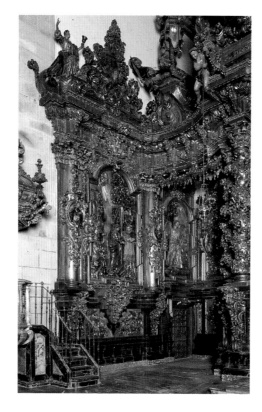
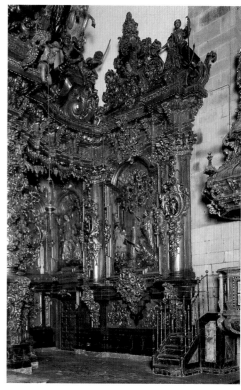

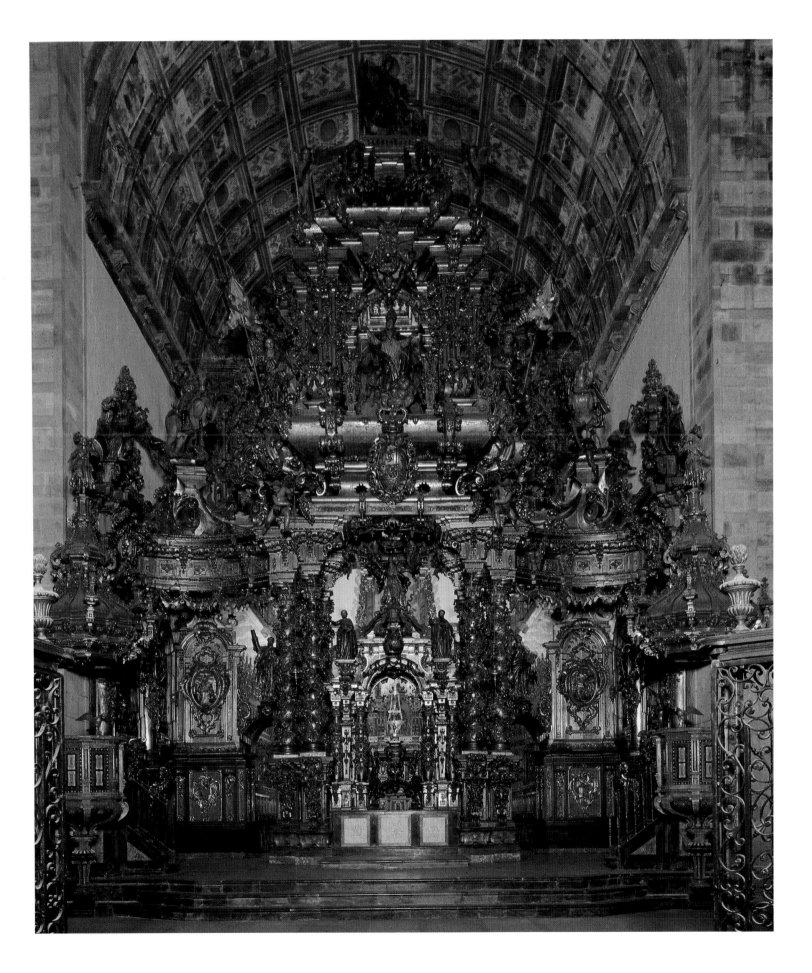

the four Baroque altar pieces of San Martiño. In contrast, in the tabernacle which holds the sacrarium and expositor, he uses supports in the taste of the period: stipites and columns whose shafts are made elegant by hangings, plant motifs and angels' heads. Again he turns to the multiplication of supports for the purpose of increasing the sense of depth, which generates the breakage of the netablature which visually prepares us for the undulating finish crowned by the group of the Virgin in Ascent and Coronation and the images of Saint Peter and Saint Paul on either side.

If in the main section of the altar piece Casas already shows his ability in the use of masses and vacuums within a scenographic conception in the spectacular upper part again shows off its Baroque sensitivity. There is a pyramidal solution as visual culmination of the ascending movement which the helicoidal shafts of the columns create in the first section. The structure recalls the coronation of the tabernacle of the main chapel in the Cathedral, but in the Benedictine church it is revalued because of the strong light which comes from the background. On that luminous background the image of San Martiño as bishop stands out in the central niche along with the angels which flank him, but also the figures of Santiago and Saint Millán on horseback, in the side ones, and Saint Martiño soldier as the finish of the interplay of volutes which closes the hollow niche. These images are attributed by Otero Túñez to Benito Silveira, except for the angels, which he considers to have been done by Miguel de Romay, the same as the images of Peter and Paul and the group of the Ascent of Mary.

We have referred to the resemblance with the tabernacle of the Cathedral but its overall effect of theatrical space must be related, the same as the work of Andrade, to ephemeral architectures. One facet of which Fernando de Casas would have experience because of having plannes some of the "altars of idea" raised in different squares and temples of Santiago for the festivities for the Cannonization of Saint Pius V in 1713, something probable as its principal promoter, together with the Dominicans, the archbishop Monroy, who already at that time had in Casas one of his trusted artists. And following that hypothesis we can suggest that at that time the architect acquired the book of Fernando de la Torre Farfán on the festivities for the Cannonization of King Ferdinand III celebrated in the Cathedral of Seville in 1671. Although the influence of the different "machines" erected in the Seville temple on the "altars of idea" of the Compostelan festivities cannot be proven, since there is no engraving in the printed book, nevertheless, we do know that in 1718 Casas had the book by Torre Farfán in his library and it is clear that its engravings—especially the entire Triumph, erected between the retrochoir and the main door of the Cathedral of Seville—suggests ideas to him which can be seen after 1721 in the Cathedral altar piece of the chapel of Our Lady of the Pillar. In the case of the main altar piece of San Martiño

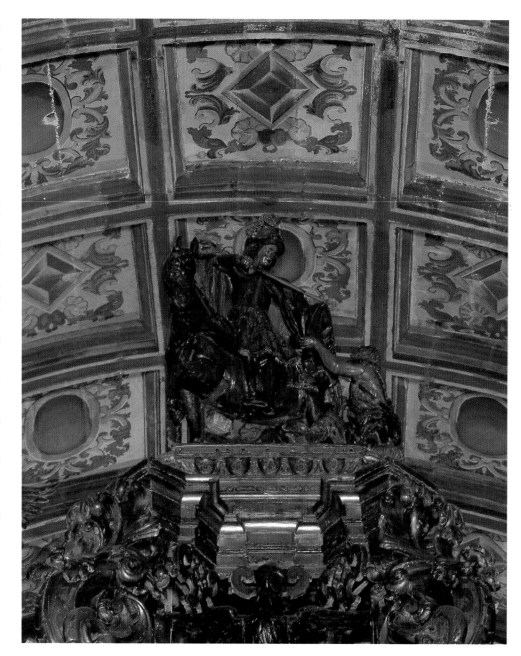

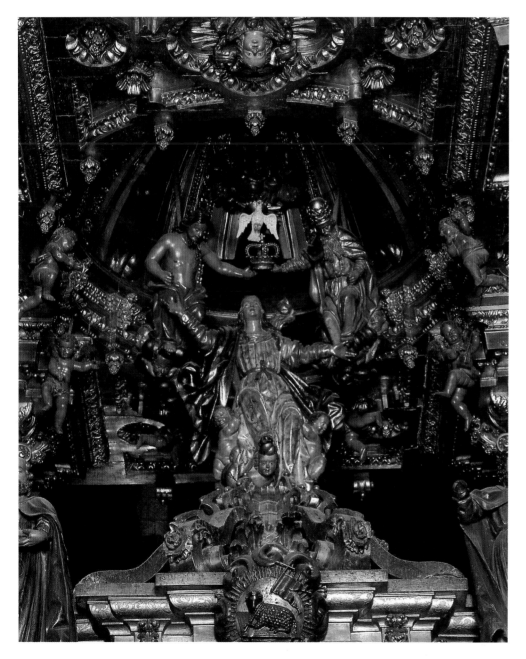

the similarity has been seen to a lesser degree with the screens which close the sides, but the evocation in the middle part with the solution of a centralized body and an attic is still clear. Moreover, although the arches of the Triumph are changed by Casas' hand into curved entablatures, their finishing off with the ascending effect of the equestrian statues again offers a clear comparison.

Outstanding in Casas' design is not only that diaphanous structure in movement, but also the wealth of the ornamental complement, naturalistic, with fleshy acanthus, strings of fruit, volutes, military trophies or curtains, motifs which, as in a large sampler and masterfully combined, he had before him in the tabernacle or the organs of the Cathedral of Santiago. But now, in full XVIIIth century, those motifs offer a more nervous design and are more prolix and tiny.

In the decade of 1760, when the altar piece had already been gilded, the Benedictines decided to close off the large lateral openings with screens. Thus to a great extent the diaphanous nature of Casa' project is lost, but in the same manner the main chapel acquires the character of an independent chapel for the monks. José Gambino is responsable for designing the doors and panels that form the curved screens, as well as carving the images and the reliefs that are in the prolongation of the altar piece toward the presbyterium. And it is in the covering with embossed leather of the doors or the panels where the rocks that are characteristic of Gambino's generation appear.

The main altar piece serves to place the scenographic note on the interior of the Benedictine temple, but it also acts as a support for a planned iconographic program, with the particularity that its character as a bifrontal altar piece promotes the existence of two programs: one is the principle one, planned for the people and the other, more punctual, for the monastical community.

The main side is conceived as an exaltation of Saint Martin of Tours because this is the dedication of the Compostelan monastery, but without forgetting the Virgin, her presence in a preferential place—the same as in the façade of the church or in the choir seats—is explained as a reference to the first chapel of Our Lady of the Corticela and also because the Benedictines are fervent diffusers of the Marian cult. And thus the group of Mary in her Ascent and Coronation finishes the tabernacle—expositor flanked by the images of Saint Peter and Saint Paul. But the importance of Saint Martin is obvious since as bishop he presides the upper niche and again is represented in the coronation as a soldier, dividing his cape with the poor man and forming a group with the figures, also on horseback, of Santiago and Saint Millán de la Cogolla which finish off the lateral panels.

When in the sixties José Gambino closes off the sides of the altar piece and extends its shape to the sides of the main chapel, the program is enriched and complemented with separated and relief figures. Above the two doors which lead to the area of the choir he situates the apostles Saint

Andrew and Saint John. In the next screens on each side, the two reliefs of asymmetrical frame and kidney-shaped forms can be seen. The reliefs of the base body are of emblematic character and in those of the upper section passages referring to the life of Saint Martin are narrated, or more specifically, to the transfer of his remains. The scene on the side of the Evangel appears to refer to an episode which includes Santiago de Vorágine, according to which Saint Perpetuo, sixty four years after the death of Saint Martin, decides to transfer his remains to a more sumptuous sepulchet, but in the impossibility of lifting the slab, in spite of the prayers of the people and the clergy gathered in the temple, they decide to give up the project, while at that moment an old man appears and touches the stone with his hand, and it can be removed. This passage with its spatial ambiguity is seen at the moment when the monks and the people ar gathered and the old man who has miraculously arrived rests his hand on the tomb. In the relief on the side of the Epistle the theme represented is the transfer of the relics to the new burial site. For the resolution of both scenes Gambino is inspired as far as the ocmposition by the panels of the high seats, specifically, by those which represent the Delivery of the Law and the transfer of the relics of Saint Benito.

The screens which cover the stone walls are articulated by large columns which frame high reliefs. In those situated over the doors which lead to monastical dependencies, are Saint Gabriel, on the side of the Evangel, and Saint Raphael. The other two are meant to emphasize the two most popular miracles of the bishop of Tours, miracles which meant the conversion of numerous infidels and which are depicted by Santiago de Vorágine. The one on the side of the Evangel refers to the dead child whose mother goes to bishop Martin pleading for him to bring him to life again and he, in the presence of the people, revives him. In the other is the representation of the miracle of the pine, a pine consecrated to the devil that was in a certain place near a pagan temple and which Saint Martin ordered cut down. The infidels accepted the proposal under the condition that he stay tied next to the tree at the part where it would fall, but when the pine tree "looked like it was going to crash over the saint, he made the sign of the cross, the tree straightened up, bent over again, but this time in the opposite direction from before." This "history" must have been chosen because it was related to the name of the monastery, when actually, as Alsina López points out, Pinario is derived from a toponym previous to the construction of the temple dedicated to Saint Martin.

Although in this part done by Gambino the exaltation of the patron of the monastery continues to dominate, also included—in a secondary place like the medallions superimposed on the column shafts—are four great saints of the blessed order: Saint Plácido and Saint Scholastica on the side of the Evangel, and Saint Mauro and Saint Gertrude on that of the Epistle. On the other hand, the image of Saint Benito is not represented

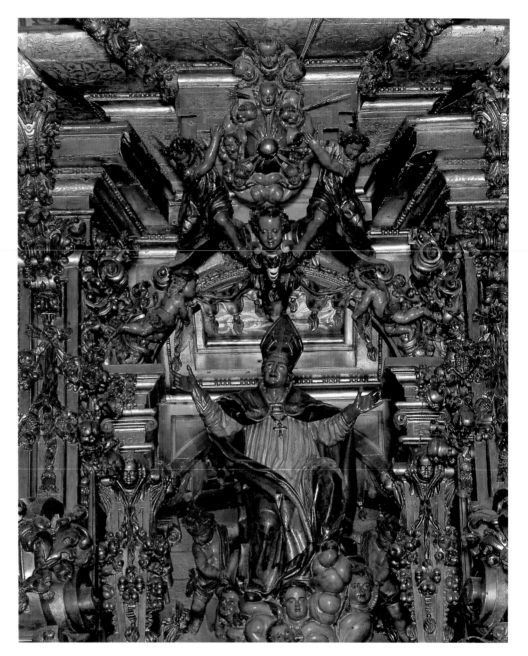

in the main altar piece, but there is an allusion to him by means of his most characteristic attribute: the crow with the poisoned bread that appears over the upper niche, repeated both on the main side and the back.

On the back of the altar piece the monastical retirement and adoration of the Most Holy shown in the monstrance, which is the main feature, becomes the center of attention. But also there are images of special veneration for the monks. The columns of the tabernacle end, in correspondence with Saint Peter and Saint Paul, two distinguished Benedictine monks: Saint Gregory, one of the

most outstanding doctors of the Latin çhurch, and saint Bernard, also a doctor and reformer of the Order, also one of the major promoters of the Marian devotion. In the upper niche, sharing a place with the bishop Saint Martin, is the image of Saint Joseph, whose devotion was promoted in a decisive manner by religious orders throughout the XVIth century and particularly in Spain.

On both sides the reliefs and images mentioned—to which we must add the seated figures of Faith and Hope above the columns nearest the transept, virtues around which the lives of these characters revolved—are combined with

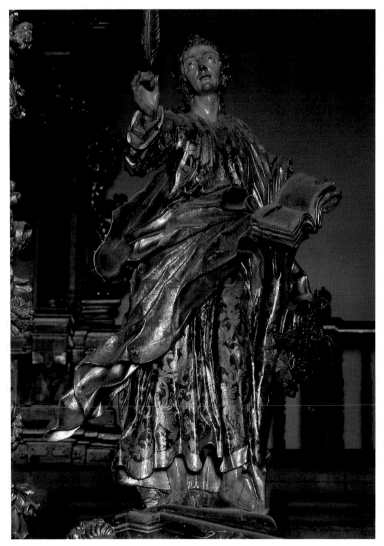 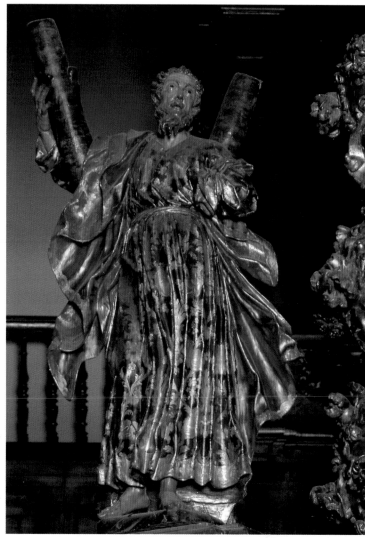

the emblematic pine tree of the monastery, the coat of arms of Spain and that of the Congregation of Saint Benito of Valladolid (detached over the "Stories" of Saint Martin) or the emblems of the military orders carried by the angels who watch over bishop Saint Martin and Saint Joseph.

The altar piece has a similar program, as A. Rosende indicates, to that of Mateo de Prado for the choir seats, although the figure of Saint Martin is promoted. Thus the lower part is presided by the Virgin while the high seats are by Saint Benito, flanked by the figures on horseback of Santiago, Saint Millán and Saint Martin, the latter

in the center of the guardapolvo. The altar piece repeats the equestrian triangle, but this time near the image of the patron of the church the presence of the Virgin is visible, as is that of the most important Benedictine saints, although the "histories" do not refer to the founder but rather to the Saint from Tours.

In this manner the main altar piece, the choir seats and the façade of the church correspond to the same propagandistic intention: to show the importance of the monastery of San Martiño Pinario in the Compostelan and the Galician context, but also to proudly recall those saints of

the Order who had an important historical mission.

In summary, in this great "machine: architecture and sculpture are associated with the complement of their polychromy and gilding, achieving this amazing effect which demands the interest of the visitor immediately upon crossing the threshold of the church door. Not in vain is it called the master work of Galician Baroque altar pieces, together with the main altar piece of the former church of the Jesuits in Santiago, and one of the most significant Spanish examples of this period.

(M.ª- C. F. de la C.)

RESTORATION NOTE:

State of preservation:
- In general, as far as the support, good. Only in some areas of the upper parts and upper sides is there damage by xylophagus insects.
- The polychromy, essentially in the gilded parts of the upper third, is in almost ruinous state.

Treatment applied:
- Elimination of dust and other strange materials.
- The plaster-glue layers gilded with gold leaf have been fixed with movilit in 10% solution in distilled water, after previous softening by injection of alcohol and distilled water.
- By pressure with plastified cotton balls the adhesion to its original support has been done.
- Overall it has been protected with a film of Paraloid B-72 with xylene in low concentration except for the high parts of the altar piece where the proportion of anylene capolymer has been more concentrated, in some cases reaching 15%.
- Application of xilamón in the parts that are not polychromed.

Additional treatment:
- An annual procedure is necessary, which could be partial, until the entire altar piece is fixed.

The pulpits

State of preservation:
- In general their state of preservation is good except for some small gilded areas coming loose in the interior lower part. In the lower areas, made of marble, there is only the disappearance of a small piece.

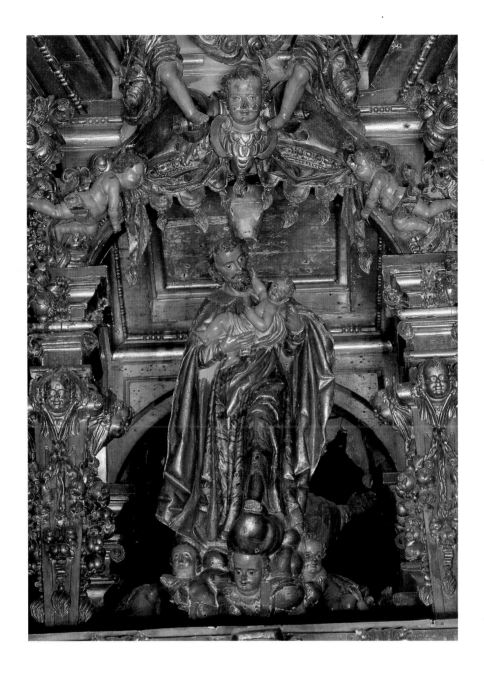

Treatment applied:

- It was cleaned both inside, relieving a sounding-board, as well as outside.

- The gilded part was completely fixed with polyvinyl acetate with distilled water, and its was protected with anylene capolymer in 7% solution of xylene.

Additional treatment:

- Essentially, periodical revisions should be done and maintenance programs in regard to cleaning.

BIBLIOGRAPHY

Martín González, J.J. (1987-88-89); Otero Túñez, R. (1956) (II); (1958) (II); Rosende Valdés, A.A. (1990)

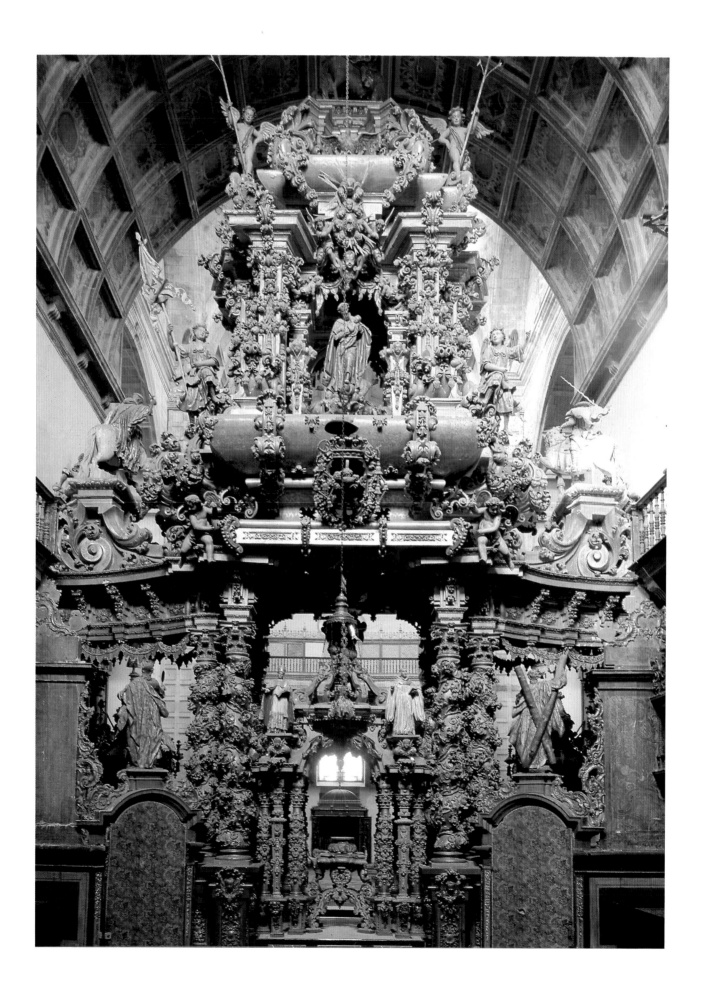

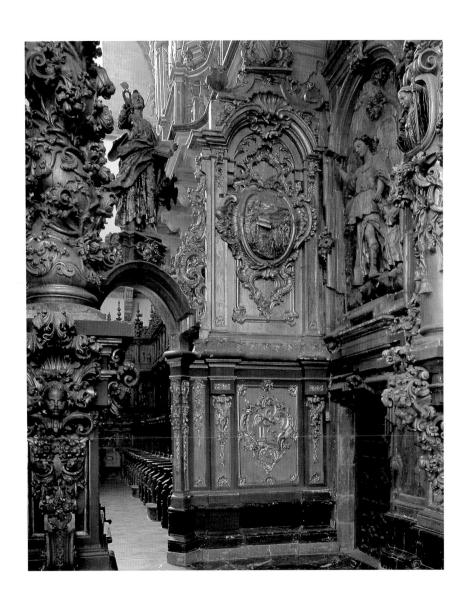

167-168
Altar Pieces of the Transept
of the Church of San Martiño Pinario
FERNANDO DE CASAS
1742

Wood

CHURCH OF THE MONASTERY
OF SAN MARTIÑO PINARIO

The main chapel is always the center of interest of the temple's interior, but the work of the altar piece tends to overflow the presbyterial area and is also found in the transept. In Saint Martin, while the main altar piece is dedicated to the patron of the monastery, the altar pieces of the transept are presided over by Saint Benito, as founder of the order, and by the Virgin, in memory of the chapel of Santa María da Corticela, origin of this monastical foundation. Their iconographic programs are different, as we will later see, but their design is identical.

Fernando de Casas, as titular architect of the monastery, plans them in 1742. Some of the carvers who had worked in the main altar piece with Miguel de Romay (who had already died in 1742) were hired to do the work, and Francisco de Casas signs the contract of the altar piece of Saint Benito and also probably took responsibility for the altar piece of the Virgin. Also working as officials with Francisco de Casas are Andrés Ignacio Mariño and Miguel García. The sculpting, except for the image of the Virgin, is, according to Otero Túñez, by Benito Silveira.

They are altar pieces of grandiose dimensions in agreement with the spatiousness of the transept. In his design Casas seems to evoke that of Domingo de Andrade for the altar pieces of the transept of the present church of the University: a high bench, Salomonic columns marking the panels of the first section and the attic, superposing of niches in the side panels. Nevertheless, the forty years which separate both designs and also, of course, the previous altar piece experience of Casas are noticeable. Thus the entablature loses its rectilinear and limiting character and turns in the development of the upper niches or breaks in the pediment of the pinacle.

As befits their condition of collateral altar pieces, their spatial development is more measured than in the main altar piece. There are limitations to physically break the plane of the background, but Casas tries to visually give it depth, for which he turns to concave niches and above all plays with the effect of the deep hollows generated in the side panels when the entablature turns over the columns.

It is significant, as in the main altar piece, that there is decorative exhuberance: the tininess and abundance of entwined plant motifs, in some cases with curled ribbons, or the cloths hanging over the central niche which appear to hold uneasy angels. Besides the carving of the main section is laterally prolonged with protruding volutes; other volutes,

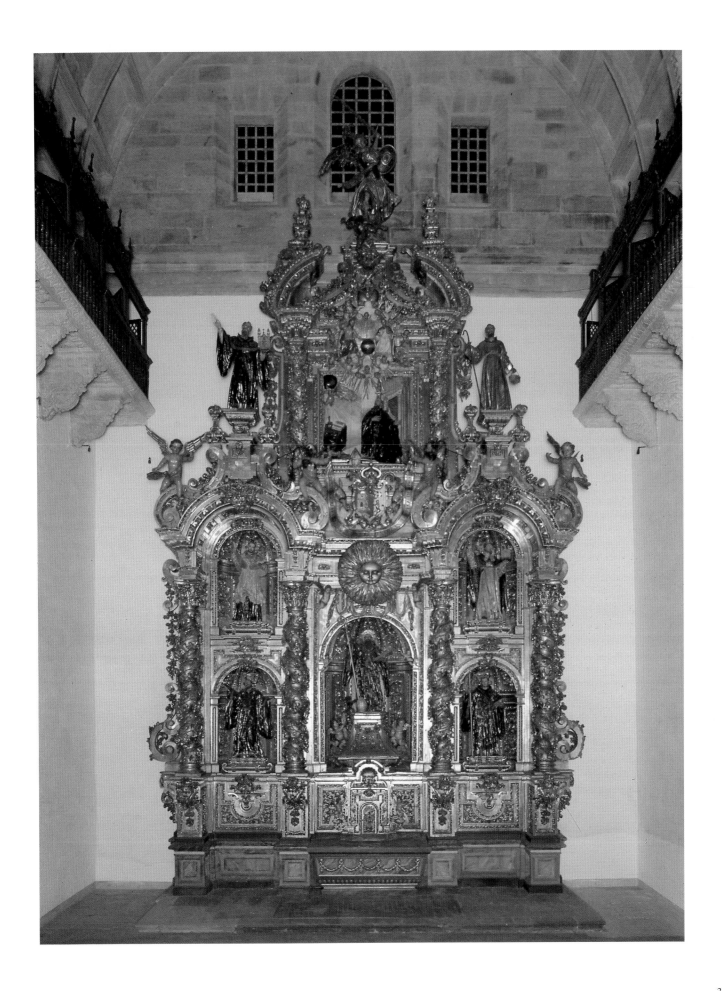

with their curving profile, finish and flank the bases of the images that crown the altar piece. All this contributes to a whole of pyramidal profile, with that strong ascending impulse which after the altar piece of the Cathedral chapel of the Pillar became characteristic of the altar pieces designed by Fernando de Casas.

The Saint Benito altar piece centers the northern wall of the transept and the middle panel is dedicated to the patriarch. His high relief figure reminds us, through the attributes of his authority and dignity (Crosier and miter) of his legislative work (book of Law) and his thaumaturgical power (a crow with a bread in its beak). In the attic relief is one of the outstanding episodes of his life, in which he receives divine assistance at the moment of writing the Law. In both cases Saint Benito is wearing an ample cowl recalling—together with the shield which separates both representations—that the monastery of San Martiño Pinario depended on the Congregation of Saint Benito of Valladolid. Likewise, in an attempt to emphasize his santliness, we must interpret the symbol of the Sun and the inscription "Sicut Sol reffulgens sic iste effulsit in templo Dei."

In the lateral niches Saint Plácido and Saint Mauro are below, and Saint Anselm and Saint Thomas of Aquinas above. Plácido and Mauro, as favorite disciples of Saint Benito and direct witnesses to his doctrinal work, are present in different points of the church. We had mentioned them when speaking of the main altar piece, but we must also remember that in the façade, as in this collateral, they are flanking the founder of the order. The presence and association of Saint Anselm and Saint Anselm must be understood as a reminder of the Benedictine contribution to science, since Saint Anselm is a great theologian of the order, the creator of the scholastic system which two centuries later the Dominican Saint Thomas would develop.

The altar piece is crowned in its center part, besides the mentioned scene of the extasis of Saint Benito, by the relief of the trinity and the image of Saint Michael triumphing over the devil. Saint Augustine and Saint Francis finish the side panels. While Saint Augustine, as doctor of the church and founder, has a quill and a model of the church as attributes, Saint Francis is shown carrying the pilgrim's staff and the small basket of fishes, alluding to his pilgrimage and the ceremony, still in force in the XVIIIth century, which recalled the ceding of lands by the Benedictines for the founding of the Franciscan convent, with the commitment to deliver a basket of fishes each year in payment.

The altar piece of the Virgin is presided over by a previous image repainted in the Baroque period and which an old tradition supposes to have been carved in England and brought by the Catholics exiled by Henry VIII. This could be, as Otero Túñez points out, a statue from around 1400, but its presence in the monastery is not documented until 1607, year in which Juan de Vila is hired to do an altar piece which would have a niche with "the image of Our Lady which had been in the altar piece of the main chapel." The Virgin Mother is here the center of the iconographic program. She is flanked by Saint Joseph and the Christ Child and Saint John the

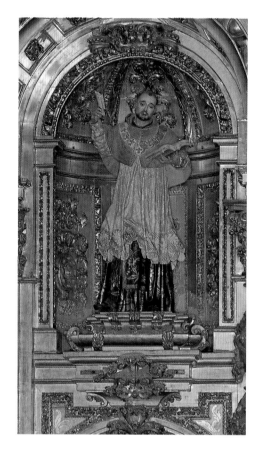
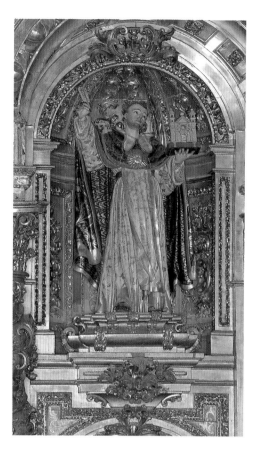

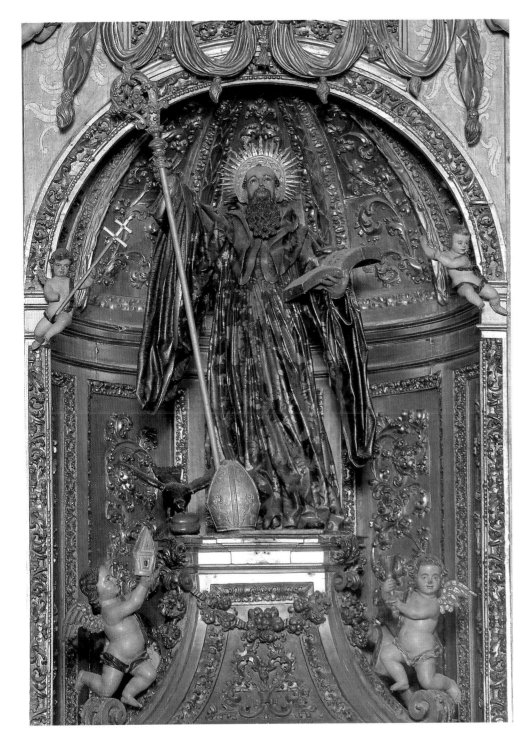

Baptist as precursor and his progenitors Saint Joaquin and Saint Anne. The attic reliefs again exalt Mary's figure with the scene of the Virgin placing the chasuble on Saint Ildefonso and the Coronation of the Mother of God. Finishing off is Saint Raphael, announcer of the Incarnation of Mary and bearer of the cartouche: "Ave María gratia plena."

If in the altar piece of Saint Benito the coat of arms of the Congregation of Valladolid is present, here that of the monastery appears. It is a coat of arms which surrounds a cartouche with the inscription "Quasi Luna plena in diebus suis lucet," which falls over the symbol of the Moon.

As in the collateral choir, two founding saints rise over the lateral panels: in this case Saint Domingo de Guzmán and Saint Ignatius of Loyola, and thus the effigies of the five great founders of religious orders are visible in the transept.

(M.-C.F.de la C.)

RESTORATION NOTE:

Altar Piece of San Benito

State of preservation:
- The state of preservation of the wood is good, except for some attachments to the wall, which in spite of serving perfectly, show certain surface rotting.
- The polychromy is in almost ruinous condition because of dampness and has suffered, because of this loss of paint from dampness, diverse partial repolychroming, such as the habit of St. Francis of Assisi.

Treatment applied:
- General cleaning of dust and wood.
- Fixing of 80% of the gilded area and polychromy of the clothing of the saints with movilit in 10% solution of distilled water and protection with Paraloid B-72 in xylene.
- Some attachments have bent.

Additional treatment:
- An annual treatment is absolutely necessary until the polychromy is totally fixed.
- Measuring of the dampness in the wood which is in contact with the wall.

Retable of the English Virgin

State of preservation:
- Its wood support is in general in good state of preservation, with some areas exceptionally attacked by xylophagus insects which always correspond to the upper third.
- Gilded area in nearly ruined state because the agglutinant of the base has lost its cohesive power.
- The angel of the pinnacle has polychromy coming loose nearly all over.
- Nevertheless, in general terms this retable is better preserved than that of San Benito.

Treatment applied:
- Fixing of 80% of the gilded area with movilit in distilled water.
- Elimination of dust and dirt.
- General protection with an anylic capolymer giving a light consolidation of the upper part of the woods. Solution with xilamón.

Additional treatment:
- A yearly procedure is necessary to do the complete fixing that could be carried out with a tower on wheels.
- Control of the humidity and temperature for its preservation.

BIBLIOGRAPHY
Otero Túñez, R. (1956) (III)

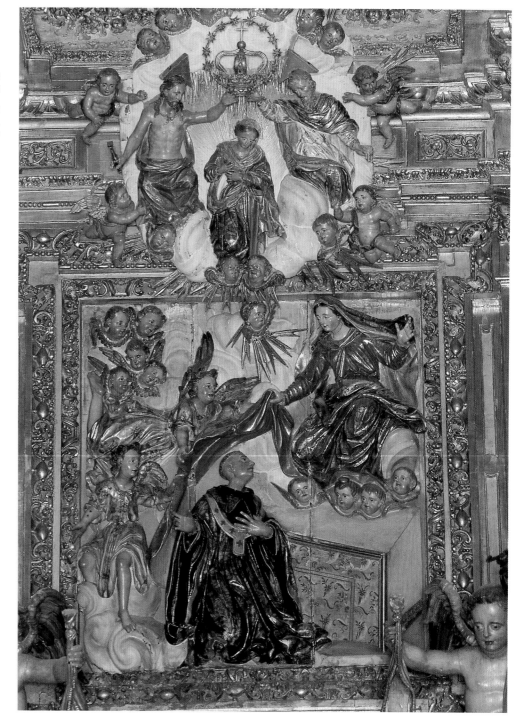

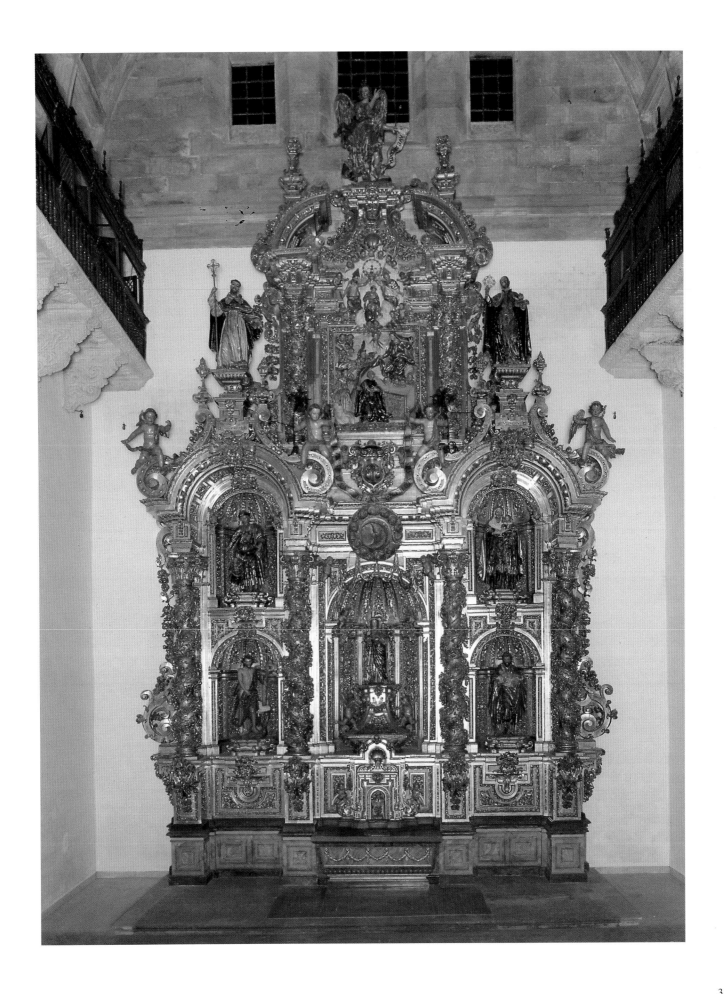

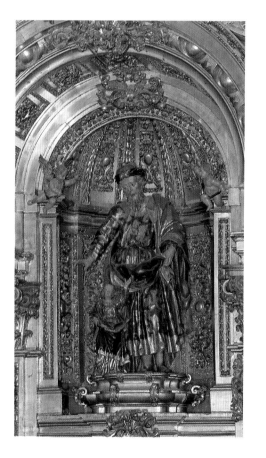
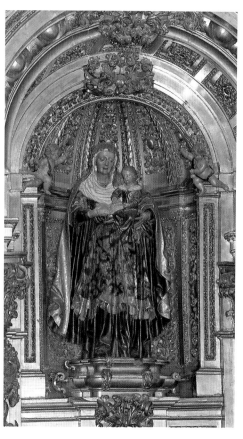
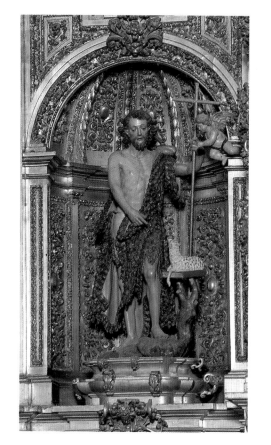
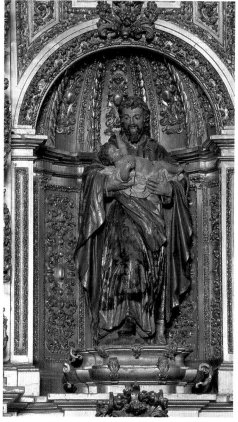

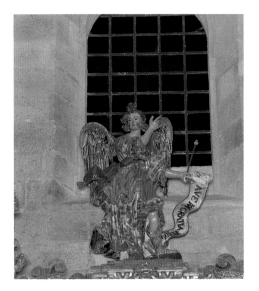
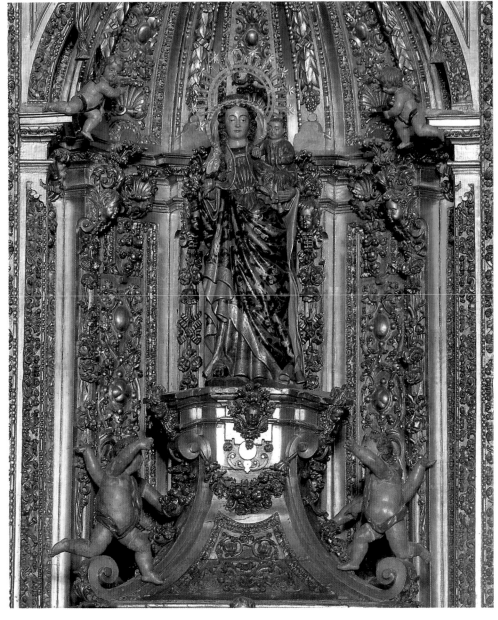

169
Altar Piece of the Chapel
of our Lady of Aid
FERNANDO DE CASAS
1739

Wood

CHURCH OF THE MONASTERY
OF SAN MARTIÑO PINARIO. SANTIAGO
DE COMPOSTELA

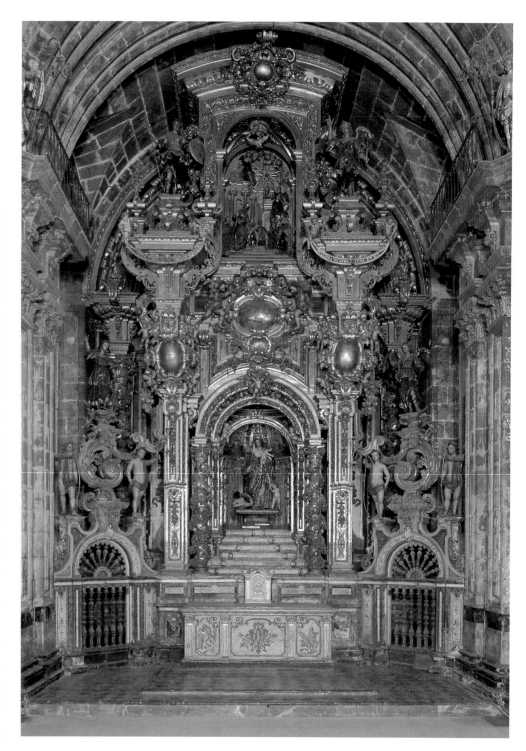

In 1668 the estremian monk Friar Juan Martínez de Mogollón founds the confraternity of Our Lady of Aid and orders the creation of an image which is placed on 'a portable altar... outside the grating of the church'. The advocation of Aid soon awakens great devotion and that requires the Benedictines to a chapel of the church to the altar of the Virgin. This fervor and the importance which the brotherhood acquires in the city with time, increased the income and allowed the construction of a new, spatious chapel. The architect Fernando de Casas is the one charged with drawing up the plan and the work would begin in 1739 under his direction. In 1746, after the building was finished, Casas himself plans the altar piece that presides the image of the Virgin of Aid done in 1668, an image attributed by Otero to the artistic circle of Mateo Prado and Pedro Taboada. The design of de Casas was carried out under the direction of Manuel de Leis; this is how it is shown in an inscription on the back of the altar piece, on the upper part: 'In the year 1749 this work was finished and the craftsman was Mr. Manuel de Leis. In the year 1749 Pedro de la Iglesia worked on it'. As in the previous altar pieces of this church planned by Casas, the grandiose nature of the 'machine' required the collaboration of a team of assemblers, since Andrés Ignacio Mariño and Miguel García worked with those already mentioned, as García declares in 1755 in an information dispatch about Mariño.

Upon planning chapel and altar piece together, Fernando de Casas places us before a space which corresponds to a unitarian feeling. Undoubtedly satisfied with the optical suggestions achieved with the conditioned placement of the main altar piece, he tries to repeat its effect of spatiality here and designs a headwall that is deep enough to allow the scenographic unfolding of the altar piece; thus the altar piece of the Virgin of Aid is not adjoined to the fore part but rather has a space behind it, visually suggesting a depth that in truth is smaller, although sufficient to allow the existence of a small chamber reached by the two side doors of the altar piece. That is, Casas tries to introduce the spectators into the Baroque machine and make them participate in its scenic environment, something he had already achieved with the main altar piece of San Martiño and the altar piece-chamber of the Virgin of the Big Eyes in the Cathedral of Lugo.

And again, as in the examples cited, the memory arises of the "Triumph" that Simón de Pineda had created for the festival of the canonization of Saint

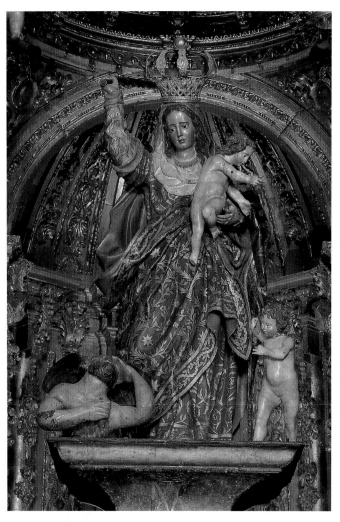

Ferdinand, its evocation noteworthy, for both the structuration centralized in the body of the altar piece with its coronation in pyramidal profile as well as the skewed placement of the two rounded openings and their ends in volutes and images.

On the formal level it is noteworthy that although here the articulating supports of the altar piece are pillars, in the central niche and on a secondary plane, Salomonic columns continue to be used; this use should be interpreted as a possible suggestion of the Benedictines and not as an archaism of Fernando de Casas, who in previous altar pieces had used the typical eighteenth century supports. The advanced stage of the century is noticeable in the small decoration of acanthus, strings of fruit and geometric interweaving.

This altar piece, like the main one, has lost its original sagrarium, although that of the chapel of Aid is preserved in the parish church of San Cibrao de Bribes (Cambre, A Coruña), ancient priorate of San Martiño Pinario.

The iconographic design is obviously of Marian exaltation. Above the figure of the patroness, in the Attic, a high relief with the scene of the Presentation of the Virgin, a theme selected because it was one of the liturgical feasts which the brotherhood celebrated with great solemnity; numerous angels court Mary, while her virtues are exalted with legends inspired in the litanies (Tuta formosa et suavis est; Pulcra ut Luna electa ut Sol) and symbols of emblematic character in the ovals of the altar piece and on the foundation of the very architecture of the chapel.

(M.-C.F. de la C.)

NOTE: The Sagrarium - because of the exhibition "Galicia through the Time"- came back to occupy the place for which it was originally made.

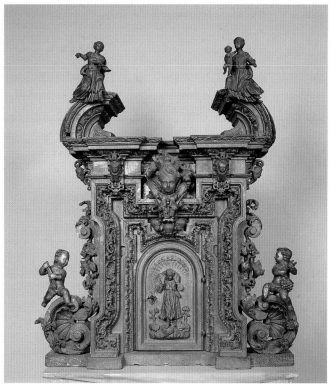

RESTORATION NOTE:

State of preservation:
• Bad on the upper part without reaching the ruinous state of the other three Baroque altar pieces of San Martiño Pinario.

Treatment applied:
• General cleaning of the dust. Fixing of the scales with plaster-glue and gold leaf of the upper part with an adhesive of rabbit glue base. It has also been fixed with polyvinyl acetate and distilled water with gelatin.
• Initially only the upper part was protected with an anylene capolymer of 5% solution in xylene.

Additional treatment:
• A yearly intervention is important until there is complete guarantee of stability, and disinfection should continue every six years.

BIBLIOGRAPHY
González García, M.A. (1980); Otero Túñez, R. (1958) (II).

Organs from San Martiño Pinario
MIGUEL DE ROMAY
XVIIIth century

Wood, gilded and polychromed

CHURCH OF THE MONASTERY
OF SAN MARTIÑO PINARIO. CHOIR.
SANTIAGO DE COMPOSTELA

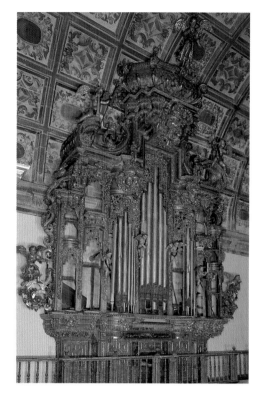
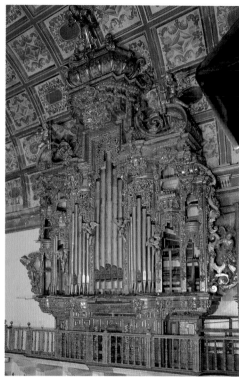

The organ was an indispensable instrument in the solemn liturgy of Cathedral and convent churches. In Spain, in general, they were placed above the choirs themselves and frequently were duplicated. This happens in San Martiño Pinario, which nevertheless places the choir in the fore part behind the main altar, as happens in Italy and other European nations.

The machinery of the organs, fundamental aspect when evaluating these works musically, was given showy façades which at the same time had an important ornamental mission. In San Martiño Pinario the instruments were the work of the monk from Tui, who professed in the great Compostelan abby November 9, 1714: Friar Manuel Rodríguez Carbajal. The Baroque cases of the Spanish organ, with profuse decoration and the characteristic placement of the pipes, not only vertically but also horizontally or in 'chamade', cooperate efficiently in creating a climate of sumptuousness which in this case forms a very interesting whole with the splendid choir and with the daring altar piece, at the same time like a lattice which interrupts the environment of the praying of the people and the community in the magnificent church.

Precisely this altar piece is the major work of the altar piece maker Miguel Romay, following designs by Fernando de Casas y Novoa. This circumstance, that of Romay's having worked on the case of the Cathedral organ and the quality and style of these cases lead us to attribute to him those of the Benedictine monastery which have seven panels, some missing the pipes now, progressively raising the height from the extremes to the center.

The façade is placed as an altar piece, the vaults force it to curve, and the floor shape is also dynamic. Numerous faces and angels playing instruments along with the profuse plant decoration form a whole that is full of life which perfectly meshes with the effectist music, full of chromatism which was composed and played during the time when they were produced.

(M.-A.G.G.)

BIBLIOGRAPHY
Bonet Correa, A. (1983); Bouza Brey, F. (1944); Couselo Bouzas, J. (1932).

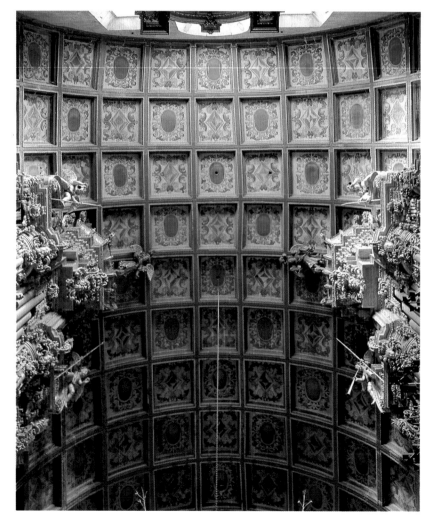

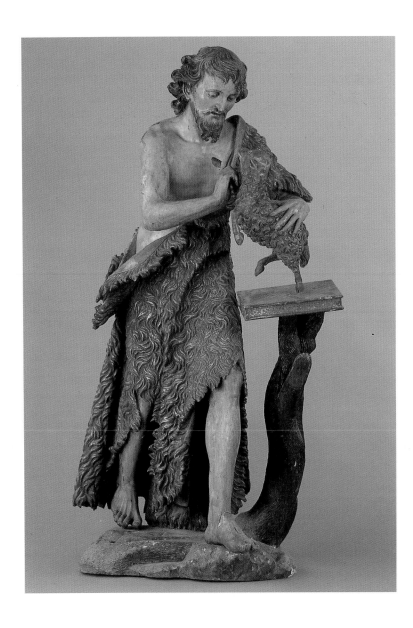

mental state of the characters, who seem to be having a dialogue, because while the Baptist leans toward the lamb, the latter rises up on its back quarters and moves one of its front legs. Besides, the instantaneity in the positions and gestures of both show a search for movement and the dynamic.

From a technical point of view, the work contains a series of Silveira's characteristics. The dry face, characteristic of a hermit, is charged with sweetness; his features sharpen, with the rounded eyes, wide apart, showing emphasis. The messy hair forms small locks, as does the beard, which end up in capricious placement. The anatomy persists in that search for realism, and thus shows extreme slenderness.

The magnificent polychromy which covers the figure stands out and manages to give us, in its flesh tones, the sensation of contemplating a bosy tanned by the sun. On the other hand, the gold shines among the hair of the camel skin which covers the Precursor, creating a deep fold of wide path.

Otero Túñez has noted the possible relationship of this piece to those of Duque Cornejo, whom it is possible that Silveira met on his trip to Seville.

(J.M.M.M.)

RESTORATION NOTE:

State of preservation:
• Losses on the support, part of the head of the lamb and the feet. These parts have been redone in a previous restoration with the wood showing through.
• Unglued anchorages, small cracks, thumb of left hand loose.
• A crack in the back part of the cloak has been filled with wood paste.
• Layer of traditional preparation (compound and animal glue), very fine, with good adhesion and adherence to the support, small lacunae.
• Painted layer has good cohesion and adherence, lacunae which coincide with those of the preparation layer (especially flesh areas). Protective layer with very oxidized lacquers.

Treatment applied:
• Mechanical cleaning of the surface dust and biological deposits accumulated.
• Disinfection with methyl bromide in gas chamber.
• Gluing of loose pieces.
• Fixing of preparation and paint layers on the edges of the lacunae.

Additional treatment:
• Physical-chemical and photographic analyses.
• Elimination of oxidized lacquers which distort the reading of the work.
• Selection of aesthetic treatment of the lacunae.
• Following of the state of preservation of the piece by control of environmental conditions of preservation.

171
Saint John the Baptist
BENITO SILVEIRA
Second third of the XVIIIth century

Polychromed wood
140 x 74 x 53 cm.

SIDE ALTAR PIECE. CHURCH OF THE
COMPANY. SANTIAGO DE COMPOSTELA

In one of the altar pieces on the side of the Epistle, which at first was dedicated to St. Luis Gonzaga, this piece by Benito Silveira is now situated.

It corresponds to the iconography habitual for St. John the baptist: the saint is covered with a camel skin, and the lamb, with the book upon a dry trunk.

The composition shows the hand of an artist who controls his technique. he manages to create a tender, friendly environment through capturing the

BIBLIOGRAPHY
Couselo Bouzas, J. (1932); Otero Túñez, R. (1953) (I) (1953) (II) (1956) (II) (1956) (III) (1980) (1986).

172
Saint John Nepomuceno
BENITO SILVEIRA
Ca. 1758

Polychromed wood
153 x 69 x 50 cm.

CHURCH OF SANTA MARIA DO CAMIÑO.
SANTIAGO DE COMPOSTELA

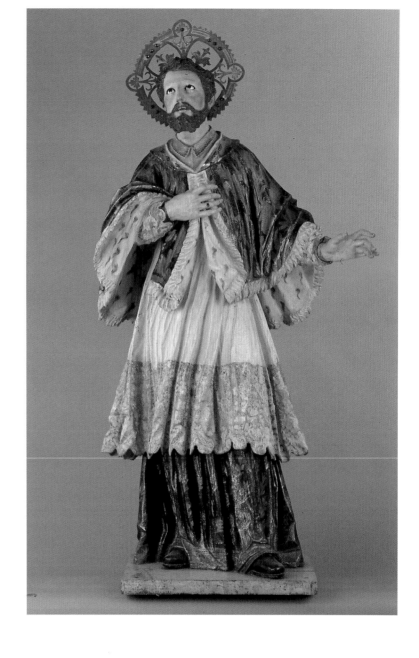

This piece, which today is found in an altar piece of later chronology, was conceived to occupy a place in the main altar piece that Silveira did in collaboration with Manuel de Leis in 1758. The grouping must have created a maginficent effect of grandeur, since the five sculptures that were in it were life size.

St. John Nepomuceno is dressed with an ankle-length tunic over which he is wearing an alb and a small ermine mantle, as vicar general of the archbishop of Prague, where he was regular canon. His advocation is late, as he was beatified in 1721 and cannonized in 1729, his cult being promoted throughout the XVIIIth century by the Jesuits; on the one hand, as protomartyr of the sacrament of confession, thus on many occasions he is represented with his hands on his mouth as a gesture of silence; on the other hand, as secondary patron saint of the order (1732), for which reason he bears an image of Christ Crucified in his hand—the original crucifix was recently robbed.

His face, turned skyward, has that intensity and sweetness characteristic of Silveira. His features are common to other works: rounded, prominent eyes, far apart, very developed labionasal angle and hair set in small locks.

It also repeats the same elements in the hands, with short, wide fingers, with that typical vein which runs along the back of them very close to the knuckles.

Special attention should be given to the treatment of the fabric, with tiny folds that reveal the figure's anatomy and the movement of his left leg, the skill with which he showed the different textures of the cloth, or that pyramidal aspect which is caused by the wide fall of his habit.

Finally, we must insist on the capturing of the moment, in that instantaneity which every figure has, giving it greater expressiveness, emphasized by the golds and colors of his clothing, very representative of the period.

(J.M.M.M.)

RESTORATION NOTE:

State of preservation:
• The support is in overall good condition.
• Loosening of the right hand and fingers.
• Losses on a piece of lace of the right cuff.
• There is very marked crack in the neck (caused by the shifting of the wood).
• Unglued attachments.
• Both the preparation layer as well as the painted one have good cohesion and adherence.

• The preparation layer is traditional (compound and animal glue) and red bole.
• The protective layer formed by varnishes and lacquers also has remains of wax.

Treatment applied:

• Mechanical cleaning of dust layers and biological deposits.
• Disinfection with methyl bromide in gas chamber.
• Gluing of loose pieces.
• Scattered fixing of gilded zones.
• Chemical cleaning of surface.

Recommended treatment:
• Removal of the oxidized lacquers which distort the reading of the work.
• Replacement of the protective layer.
• Following of the state of preservation by control of the environmental conditions.

BIBLIOGRAPHY
Couselo Bouzas, J. (1932); Otero Túñez, R. (1953) (I) (1953) (II) (1956) (II) (1956) (III) (1980) (1986).

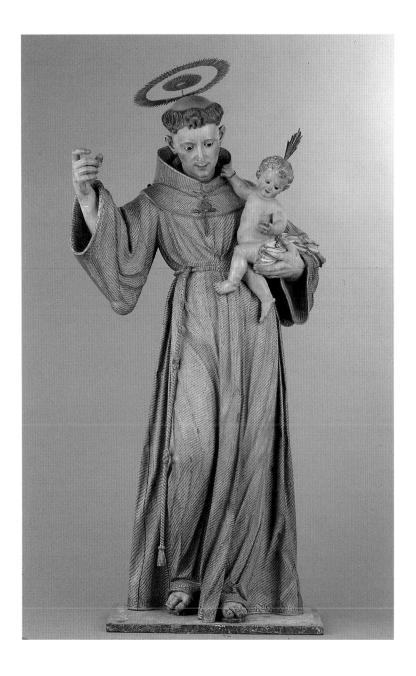

173
Saint Anthony
JOSÉ GAMBINO
1745-1749

Chestnut with polychromy
168 x 77 x 32 cm.
Main altar piece of the Convent of San Antonio
de Herbón (A Coruña)

CONVENT OF SAN ANTONIO DE HERBÓN
(A CORUÑA)

When Friar Antonio Herosa was guardian of the Convent, between 1745 and 1749, he commissioned Gambino to do the image of Saint Anthony which presides the main altar piece of the church. Probably he does it at the beginning of his artistic activity and it will be the first of those he will do for this Franciscan community.

The Saint is standing, in a pose of walking, slightly advancing the right leg, while the left one, behind it, supports the weight of the body, with curving outline, a common feature of this sculptor's work. In his right hand he holds a processional cross as a staff, and in the left a smiling Child Jesus. he is wearing the habit of the order and on his chest, carved in wood, a crucifix stands out. There is the characteristic cord tied at the waist, at too high a level, which helps elongate the figure and the folds, which fall vertically close to the body, thus showing the hidden anatomy, a characteristic of Gambino's style.

His 'classicist' similarities, derived from pyramidal composition, are completely atenuated by the clear opposition of existing forces which come from the counterposed movement of the Saint and the Child.

Gambino's style is especially obvious in the heads of Saint Anthony and Christ. The faces of both are full of life, rosy cheeks and cheekbones marked as is characteristic of his first period. Large, sweet eyes, full of unfathomable sadness. Their mouths, small and with fine lips, open halfway with a slight smile, showing extraordinarily well sculpted teeth. The children of the sculptor follow a definite typology: chubby bodies and soft flesh, smiling face, framed by curls, with a lock falling over the forehead. Sometimes they seem more dolls than real children.

The inconography of this Saint Anthony is interesting. The Christ Child does not appear· on a cloth, being rocked. Here he is held by one arm only, one of the innovations which Gambino contributed to Galician sculpture.

(M.S.O.R.)

BIBLIOGRAPHY
Herosa, A. (1756); Álvaro López, M. (1979)

174
Saint Famiano
JOSÉ GAMBINO
1753-1756

Polychromed wood
118 x 60 x 40 cm.

ALTAR PIECE OF THE TRANSEPT
OF THE CHURCH OF THE MONASTERY
OF OSEIRA (OURENSE)

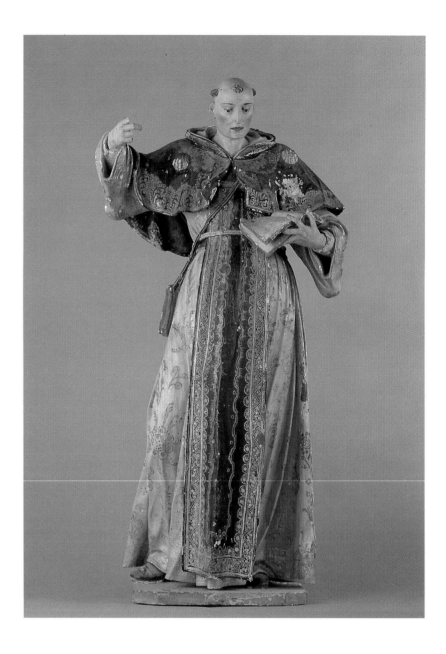

The beautiful image of Saint Famiano of the monastery of Oseira, to which we referred when discussing Santiago Pilgrim, is situated in the southern altar piece of the transept—joined by an arch with that of Saint Bernard—and forming a whole with that of Saint Benito and Santiago. It was done between 1753 and 1756 and, later, in 1762 the painter Simón Maceira gilded and polychromed it.

Saint Famiano comes on pilgrimage to Compostela and on returning from his pilgrimage he takes the habit in the monastery of Oseira, and is the first Cistercian saint. The revitalization of the cult to Saint Famiano is promoted in the Baroque era as a result of the protestants' rejection of devotion to the saints.

Gambino reproduces the Saint standing, with an extremely elongated canon to which is added the fold of his habit and the scapulary and, above all, the very high waist bound by the cord. His clothing is completed by the cowl and capelet with two scallop shells, symbols of the pilgrim, as well as the small purse, staff and book, where he would note the facts of his life, holding it to his waist with his left hand, surprising for the detailed modeling and asymmetric placement of the fingers. The same iconographic type is repeated in a Saint Francis of the church of San Lorenzo de Melia (Vilamarín-Ourense) and in the one on the stairs of the monastery at Oseira (this one with slight variations), whose author is unknown.

The naturalism of his head and neck are fascinating. The Saint seems distracted in spite of his open expression. The slight, tonsured neck increases the ascetism of his dry face; enormous oval eyes are clearly drawn; the lowered, engrossed gaze, with that air of sadness so typical of Gambino; rosy cheeks and half-open mouth showing an incipient smile on the edges of the lips. All this delicacy and the exquisiteness of the carving, as in the ornamentation of the clothes, with golden filigree on the cloak and scapulary, clearly correspond to a Rococo mentality.

The sculpture is splendid, but no less so is the altar piece where it is located—the same as that of Santiago Pilgrim—both for its design and decoration and for the shine of the golds. In relation to the iconography of the Saint above the niche which holds it is a relief which represents an extraordinary event of his pilgrimage: when one hot July day Saint Famiano, exhausted by weariness and heat but with great faith, knocked his staff on the rock where he was seated, a spring of crystaline water immediately burst forth. This occurred on Lojano (Italy).

(M.S.O.R.)

RESTORATION NOTE:

State of preservation:
- Wood support with damage by xylophagi.
- Loss of fingers on the right hand, the end of the cord and pilgrim's staff.
- Pronounced cracks, movements of the wood and attachments.
- Traditional preparation layer (animal glue and compound) with problems of adhesion to the support. In large areas it has been lost leaving the wood bare.
- Cracking which follows the movements of the wood.
- Where there are knots or the wood is very thin (the purse string) the preparation was reinforced with cloth.
- Light red bole (orange)
- The painted layer has problems in adhering which cause large bare areas (cloak, back part of the habit).
- Gold applied with relief technique.
- Rusting of the lacquer, general cracking.
- Wrinkled appearance in some areas because of defective technique (excess of grease medium).
- Serious blank areas in the painted layer of the base.

Treatment done:
- Disinfection with methyl bromide gases.
- Mechanical cleaning of the dust and biological deposits that have accumulated.
- Fixing of the layers of the preparation and polychromies.
- Surface chemical cleaning, cleaning of wax with Leister.
- Aesthetic treatment in velaturas in neutral tone.

Additional treatment:
- Chemical-physical analysis and photographic study (U.V. and I.R.). According to the result of this analysis, a diagnosis will be made and an appropriate restoration done.
- Following of the state of preservation, control of environmental conditions (R.H., temperatures and biological damage).

BIBLIOGRAPHY
Cid Rumbao, A. (1972); Couselo Bouzas, J. (1932); González Paz, J. (1978); Guía (1932); Limia Gardón, F. (1984); (s.d.); Yáñez Neira, D. (1980)

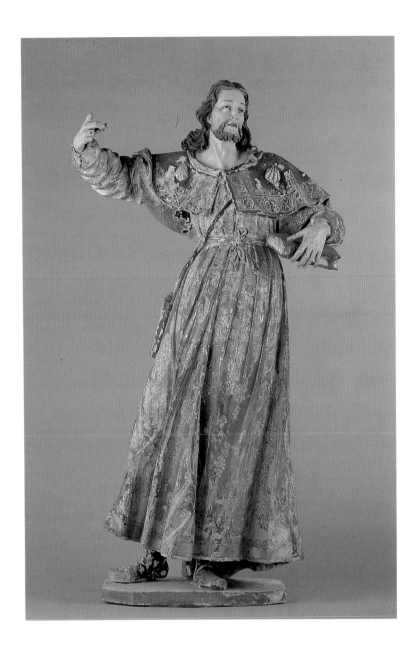

garments and has two scallop shells on his cape. A visible diagonal line is drawn by the cord of the pouch which crosses his torso. In his right hand he holds the pilgrim's staff and in the left a book which he supports on his waist. The high waist contributes to the elongation of the figure, as do the pointed vertical folds which widen and bevel toward the lower part, as frequently is seen in the work of Gambino.

He does an excellent analysis of the Apostle's head and hands. The wavy hair frames the face, with the aspect of moulded material. As is usual in his effigies the large melancholical eyes that look upward, the prominent cheekbones and the half-open mouth, framed by a short beard, stand out. The shining golds of the stamping and the lower border of the tunic are in close agreement with the Rococo sense.

Above the niche of the image is a relief that refers to the life of Santiago: the appearance of the Virgin of the Pillar to the Apostle. The iconographic theme was completed with the statue of Santiago Moorslayer, on a pedestal in the center of the arch that joins two small altar pieces, which crowned the overall work. Now it does not exist because the humidity has caused its deterioration.

(M.S.O.R.)

RESTORATION NOTE.

State of preservation:
• Scattered damage by xylophagus insects.
• Loss of three fingers on the right hand and part of the base.
• Cracks and unglued parts.
• Layer of traditional l preparation (compound and animal glue) with lack of internal cohesion and adherence to the support.
• Overall cracking.
• Dark and light red bole.
• Cracked painted layer with lack of adherence to the preparation layer.
• Superposition of two paint layers with lacquer in the middle and gold design in relief.
• Lacunae in both preparation layer and painted one.

Treatment applied:
• Mechanical cleaning of dust and biological deposits.
• Disinfection with methyl bromide.
• Preventive treatment with xilamón.
• Consolidation of the support with synthetic resins.
• Fixing of the preparation and painted layers.
• Chemical cleaning of the surface.
• System of presentation: velatura of neutral watercolor ink in the lacunae of the painted layer.

Additional treatment:
• Physical-chemical and photographic analysis which can clarify the problems of the painted layer.
• Elimination of the oxidized lacquers which distort the reading of the work (especially its drapery).
• Elimination of the aesthetic treatment of the lacunae.
• Following of the state of preservation of the piece through control of the environmental conditions of preservation.

175
Santiago Pilgrim
JOSÉ GAMBINO
1753-1756

Polychromed wood
125 x 65 x 35 cm.

ALTAR PIECE OF THE TRANSEPT
OF HE CHURCH OF THE MONASTERY
OF OSEIRA (OURENSE)

In the three years that abbot Friar Plácido Marrondo governed the monastery of Oseira (1753-1756), 'four altar pieces [were made] on the four altars of the transept, joining the two on each side of it with an arch that covers the buque of the apse-aisle. An effigy of Santiago in large relief, another corresponding to Saint Famiano and another of Saint Raymon on horseback which cost more than thirty thousand reals...', is a notice given by the chronicler of Tumbo B. He does not mention the images of Saint Benito and Saint Bernardo which correspond to Santiago and Saint Famiano, respectively, because they already existed and occupied other altar pieces in the same place.

We know that Gambino worked in Oseira and then would do the Apostle and Saint Famiano, since stylistically they correspond to this sculptor's gouge. In 1762 Simón Maceira painted and gilded them. Both saints appear joined, moreover, by the theme of their respective pilgrimages, an iconography which matches that for which they are symbols.

Santiago is represented with a slight S movement derived from resting himself on one leg and slightly placing the other forward. He is wearing pilgrim's

BIBLIOGRAPHY
Cid Rumbao, A. (1972); Couselo Bouzas, J. (1932); González Paz, J. (1978); Guía (1932); Limia Gardón, F. (1984); (s.d.); Yañez Neira, D. (1980)

327

176
Saint Raphael
JOSÉ GAMBINO
1757

Polychromed chestnut
94 x 62 x 28 cm.
Side altar piece of the church of the Convent of
San Antonio de Herbón (A Coruña)

CONVENT OF SAN ANTONIO DE HERBÓN
(A CORUÑA)

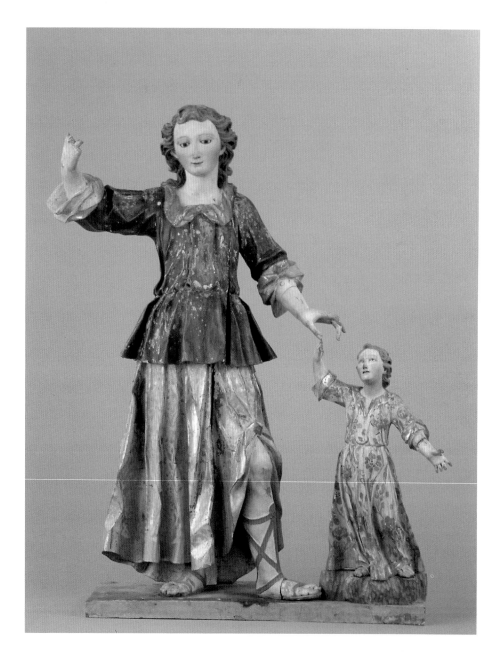

This sculpture formed part of the altar piece that
in 1757 was made for the infirmary of the Convent
of Herbón, as the Memorial of F. Herosa states.
Presently it is in the church, in the attic of the altar
piece in the right arm of the transept.

Saint Raphael is standing, facing the front, with
golden skirt and wine-colored cassock tied at the
waist and the lower part fluttered. The skirt, with
pointed folds and a tendency toward the vertical,
which elongates the figure's canon, is caught over
the left knee allowing the artist to be concerned
with anatomical study. The Archangel attempts to
show the child, whom he holds in his left arm, the
road to follow with his right arm.

The iconographic representation of the Archangel
and the Holy Guardian Angel is very similar.
According to Male, there is a mutation of meaning
between both. From a first representation of Saint
Raphael next to Tobias, slowly that model would be
used to symbolize with him the Holy Tutelary
Angel who leads the soul through the path of life.

The Gambino style is seen in all the composition.
Thus, the posture of Saint Raphael and the child
determine a visible diagonal and a notorious
dispersion of forces that are so much in Rococo
taste. The large eyes stand out in the face, the gaze
fixed and melancholy, the cheeks full, rosy, and the
beginning smile drawn on the lips. Straight, small
nose, forming a perfect arch with the lines of the
eyebrows. The child also shows Gambino's style.
Aside from the dispersion of forces and diagonal
which determines the position of his arms, the same
folds of the tunic show the outline of the legs. His
face, edged with curls and a lock over his forehead,
smiles and looks upward. It corresponds to the same
iconographic type of other children sculpted by this
artist. Specifically, the similarity with the child who
accompanies Saint Joseph of the Carmen de Arriba
(Santiago) is surprising, as is the child with Saint
Roque in the parish church of Cordeiro
(Pontevedra).

(M.S.O.R.)

RESTORATION NOTE:

State of preservation:
• The support shows scattered damage by xylophagus insects.
• There are two deep vertical cracks (natural shifting of the
 wood), unglued attachments, loss of fingers, part of a foot
 and attributes.
• The preparation layer is traditional white (compound and
 animal glue) and red bole, the internal cohesion is good but

has average adherence to the support. The painted layer
(distemper and oil) has poor adherence to the preparation
layer, especially the temper (loss of agglutinants), where
there are scattered lacunae and erosions.
• The protective layer is formed by varnishes and lacquers, wax
 drippings and lacquers on the surface.

Treatment applied:
• Mechanical cleaning of dust accumulations and biological
 deposits.
• Disinfection with methyl bromide in gas chamber.
• Preventive treatment of the wood with xilamón.
• Fixing of the preparation and painted layers.
• Chemical cleaning of surface.

• Removal of wax drippings with Leister.

Additional treatment:
• Physical-chemical and photographic analyses.
• Gluing of attachments.
• Replacement of preparation layer.
• Selection of aesthetic criteria for treatment of lacunae.
• Following of the state of preservation by control of the
 environmental conditions.

BIBLIOGRAPHY
*Álvaro López, M. (1979); Herosa, A. (1756); Mâle,
 E. (1932)*

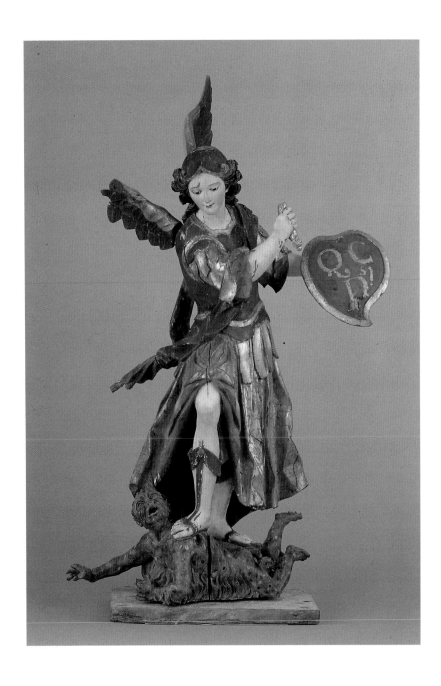

right hand he held the sword of which only the handle remains, and with the left the shield in the form of heart, bordered in gold. The letters Q.C.D., initials of "Quien como Dios" (Who but God) stand out in gold on the shield. Broad wings unfold on Saint Michaels's back with the right one missing the upper part. The wings favor the pattern of diagonals and the dispersion of forces, which together with the golds and other elements so characterised rococo and are frequent in Gambino's work.

The Archangel's head resembles a maiden's. His medium length hair of wavy curls reveals a face of soft form, full cheeks and, also as in Saint Raphael, the small straight nose forms a perfect arch with that line of the eyebrows.

Many other characteristic define the style of this sculptor: The placement of the folds in pointed vertical cloths only interrupted by the angles of the fabric which give it a very rococo air; the instability of the figure caused by the position of the right leg whose foot traps the devil whose head is turned toward the angel; the skirt pulled up over the thigh, which allows the pleasure of studying the human body; and the leaning of the body and the placement of the arms which contrast with the fluttering fabric that originates with the band.

It has strong iconographic analogies with another image of the Archangel Saint Michael which Gambino did for the convent of Carmen de Arriba (Santiago).

(M.S.O.R.)

RESTORATION NOTE:

State of preservation:
• Support in good condition.
• Slight damage by xylophagus insects.
• It has assemblies, unglued portions and several cracks.
• Loss of supports (hands, attributes, ends of folds).
• Traditional white preparation (compound and animal glue) and bole with good adhesion to the support.
• The gold has a cracking on the surface due to lacquer.
• The paint has a cracked appearance because of the movements of the wood, with slight losses chiefly in the flesh areas and lower part of the clothing where the bole is exposed.
• Repolychroming on the base and devil.

Treatment done:
• Mechanical cleaning of dust and biological deposits accumulated on the surface.
• Fixing of the layers of preparation and paint.
• Chemical cleaning of the deposits of dirt.
• Disinfection and preventive treatment of the support by injections of xilamón and methyl bromide vapors in gas chamber.

Additional treatment:
• Physical-chemical and photographic analysis (I.R., U.V. etc.) to determine the nature and extent of the original polychromy of the devil and its possible recovery.
• Following of the state of preservation by controlling the environmental conditions (relative humidity, temperature, biological damage).

BIBLIOGRAPHY
Herosa, A. (1756); Álvaro López, M. (1979)

177
Saint Michael
JOSÉ GAMBINO
1757

Polychromed chestnut
109 x 40 x 27 cm.
Side altar-piece of the Church of the Convent of San Antonio de Herbón (A Coruña)

CONVENT OF SAN ANTONIO DE HERBÓN (A CORUÑA)

Today this Archangel is located in the attic of the altar piece of the left arm of the transept and, as with Saint Raphael, was done in 1757 for the altar piece of the infirmary, according to the information of father Herosa.

Saint Michael is wearing military garb with a gilded tunic and over it a doublet or armor. A diagonal band crosses his torso and is knotted on his right side. As is traditional the Archangel is represented attacking the devil which in human form and painted red, is lying at his feet. In his

178
Saint Joseph
JOSÉ GAMBINO
1757

Polychromed chestnut wood
99 x 44 x 28 cm.
Church of the Convent of San Antonio de
Herbón (A Coruña)

CONVENT OF SAN ANTONIO DE HERBÓN
(A CORUÑA)

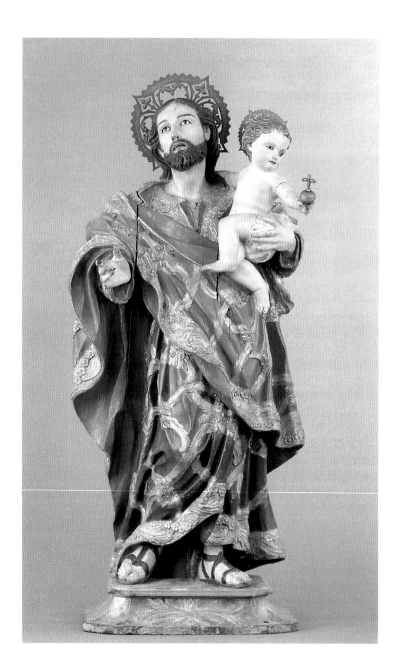

About ten years after Gambino finished his Saint
Anthony he works again for the Convent of Herbón.
He makes a Saint Joseph in 1757, which is at present in
the altar-piece del headwall in the right section of the
crossing, although, according to Father Herosa's
Memorial, must have been made for the retable of the
vestry. This work belongs to his second period in which
a clear evolution toward the Rococo ideal is noticeable.

Saint Joseph is wearing over his tunic, slanted on the
right shoulder, a mantle of almond color which wraps
him with fluttering and sharp folds. Both garments with
reticulate decoration, which is achieved by means of
golden strips, with carved acanthus leaves, which
crisscross forming small rhombi whose angles are
emphasized with tiny polychromed flowers. This
brilliant and exquisite ornamentation is very much in
agreement with the new Rococo ideas and contrasts
with the valorization of Gambino of the material in his
first works, as can be seen in his Saint Anthony.

Saint Joseph, standing, advances his right leg, in a
position which creates the soft, tiny fold of the tunic in
contrast with that of the mantle, wider and more
angular, so preferred by Gambino. In his right hand he
would carry the flowered wand, which no longer exists
today, and in the other he holds the Child. The latter
rests his right hand in back of the Saint's shoulder and
with his left hand he holds the globe, crowned with the
cross, symbol of power, toward which he turns his
head. This movement differs from that of Saint Joseph,
who leans his head in the opposite direction, stressing
with his gaze thrown upward the clear opposition of
forces which accentuate the waving, flowing folds of
the mantle.

Now the style of Gambino becomes more defined.
His head toward the back, gaze elevated and mouth
slightly open showing the teeth. His face with that
mixture of melancholy and serenity, tendency to
slenderness and prominent cheekbones, which will be
his constant after this period.

Iconographically, there is the same newness as in
Saint Anthony. The Child held with only one hand,
showing how between the hand and the body of the
Child a cloth is placed, because of that medieval
concept of not directly touching the divinity. This
image corresponds to the same type as the Saint Joseph
of the Orphan Girls' College, also Gambino's work.

(M.S.O.R.)

BIBLIOGRAPHY
Alvaro López, M. (1979); Herosa, A. F. (1756).

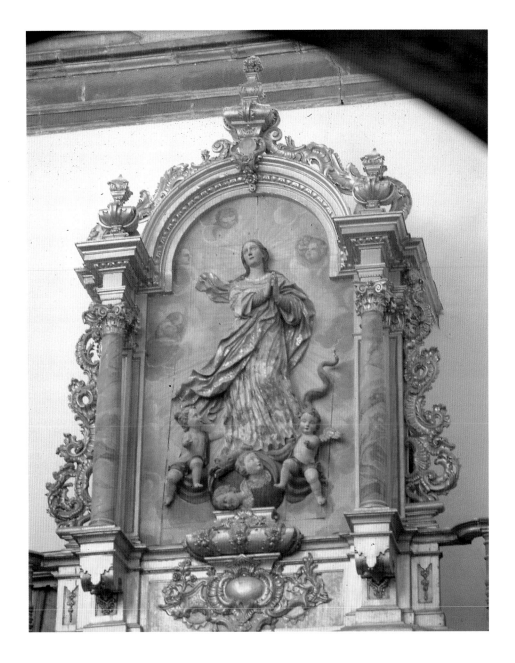

179
Immaculate Virgin
JOSÉ GAMBINO
1766

Polychromed wood
277 x 170 cm. (Width 130 cm.)
Main Chapel of the Church of the Monastery of
San Martiño Pinario. Santiago de Compostela

SAN MARTIÑO PINARIO. SANTIAGO DE
COMPOSTELA

Although the dogma of the Immaculate
Conception (of the Virgin Mary) was not defined
until 1854 by Pius IX, we know that many centuries
before, documentaly from the XIIIth century, there
already was in the Cathedral of Santiago an intense
cult. Thus, in the Jacobean city several
representations can be seen, which correspond to
various stylistic periods.

In the XVIIth century, with the "Sollicitudo" Bull
of Alexander VII, new enthusiasm will be produced
around the Immaculate Conception, which will serve
as a theme for the most outstanding of the time.
Some will take up the type created by Gregorio
Fernández, which is inherited by his disciple Mateo
de Prado, and others will base themselves on
Andalusian models following Alonso Cano.

In the last phase of the Compostelan Baroque a
new typology arises, represented by the Most Holy
Virgin of the Convent of Saint Francis, which today
presides the main altar of its church. Made in Rome
in 1750, by an unknown author, it can be related to
Felipe del Valle, sculptor who works in that city. It
is a piece in the line of Murillo: the gaze directed
upward, the hands placed together, and the
transversal mantle held by his left arm. This image
will be influential and create a school among the
Galician image-makers.

Fruit of this influence is the Immaculate Virgin
which presides the choir of San Martiño Pinario,
heading the choir seats by Mateo de Prado. Gambino
places the Most Holy Virgin on an exquisite little
altar piece which, with its gleaming gilding and
asymmetrical decoration of rocks and curving forms,
is a slect sample of the Rococo style. María, her
hands together, clearly forms an S shape. She appears
triumphant upon the half mood, with the horns
pointed downward, and treading on the serpent. The
composition is balanced by the agitated fabrics that
float toward one side and, toward the other, by the
undulating serpent that stretches out seeking a
parallel line with the transversal mantle. The figure
seems shaken by nervousness, which increases the
sinuous and slippery folds. Three little angels with
soft bodies and doll-like, smiling faces, very typical
of Gambino and similar to the heads which surround
the Virgin, frolic at her feet. They have symmetric
postures, but opposing, so in style at the time.

(M.S.O.R.)

BIBLIOGRAPHY
López Ferreiro, A. (1898-1911); Otero Túñez, R.
(1956) (I)

180
Saint John Nepomuceno
ANDRÉS IGNACIO MARIÑO ?
Ca. 1760

Polychromed wood
117 x 60 x 36 cm.
Side altar piece of the church of the Company.
Santiago de Compostela

CHURCH OF THE COMPANY. SANTIAGO DE
COMPOSTELA

Beatified in 1721, his cult was extended in the XVIIIth century by the influence of the Jesuits, who glorify him as protomartyr of the sacrament of confession and name him secondary patron of the Company in 1731. His image presides the altar piece dedicated to his cult in the former church of the Order in Santiago, today belonging to the University of Compostela.

Saint John lifts his gaze upward, his declamatory pose, almost theatrical, is reflected in his face and hands. His hair and beard seem orderd with little volume forming a cap. In spite of the clothing we can see an anatomical treatment with soft shaping. He is wearing a coral dress, the tunic falls to his feet and over it he is wearing a long rochet with a border and the mozetta lined with ermine. The folds, small and abundant, are peaked and their appearance almost metalic. The polychromy, splendid overall, continues to be the inheritor of the the Baroque manner, still using golds, although these have been reduced to some dots on the piece.

(A.G.T.)

RESTORATION NOTE:

State of preservation:
• Very scattered damage by xylophagus insects.
• The left hand and cross are loose.
• Glass eyes, the left one is loose and broken on the edge.
• The original protective layer is not visible due to the repolychromy that covers it.
• The former is in good state of preservation with small scattered liftings and losses.
• On the surface there are remains of varnish, oxidized lacquer, dust and biological deposits.

Treatment applied:
• Mechanical cleaning of surface dust and biological deposits.
• Chemical cleaning of surface of the dirt concretions.
• Fixing of the painted layer.
• Gluing of the left hand and eye.
• Preventive treatment of the wood with xilamón.
• Disinfection of the support with methyl bromide gas.

Additional treatment:
• Elimination of the oxidized lacquer on the surface.
• Physical-chemical analysis and photographic studies to determine the state of preservation.
• Possible recuperation of the original polychromy.
• Following of the state of preservation of the work by control of environmental conditions (relative humidity, temperature and biological damage).

BIBLIOGRAPHY
Otero Túñez, R. (1986)

181
**Sculptures of the monument
of Maundy Thursday**
JOSÉ FERREIRO
1772

Polychromed wood
182 x 90 x 50 cm.
Church of the Monastery of San Martiño Pinario.
Santiago de Compostela

MONASTERY OF SAN MARTIÑO PINARIO.
SANTIAGO DE COMPOSTELA

The 33 sculptures preserved form a set without parallel in Spain, if we except the Cathedral of Toledo. The plan of the Monument is that of Friar Plácido Caamiña, its production to the sculptor San Martín, its painting to Landeira and the sculptures to Ferreiro. Although Couselo Bouzas says that the cost of the work was around 12,600 reals, Barreiro Fernández believes it to have been much higher, taking into account that 'besides the wood which the monastery provided, bills paid in monthly installments were very frequent. But only on one occasion it seems they paid 60,000 reals'.

Stylistically they indicate the conscious assumption by Ferreiro of the break with Gambino's Rococo formulations after the problems arising during the making of the sculpture of the altar piece at Sobrado, for which reason we can catalogue these sculptures as the first Neoclassical ones in Galician art. To achieve this goal, Ferreiro will drink from sources directly or indirectly inspired in Italian Baroque, as shown by Otero Túñez, and will attempt to supress the polychromies rich in golds, at the same time as he will begin the elongation of the canon and the idealization of the facial features.

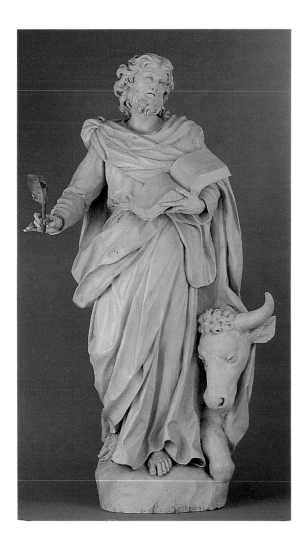

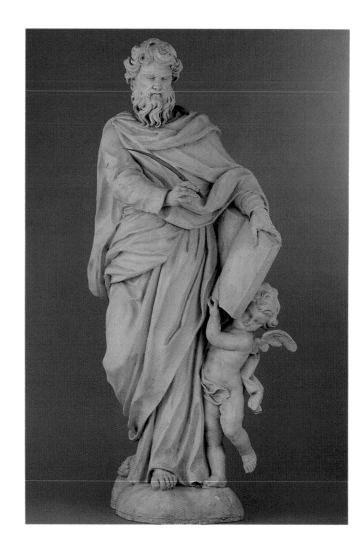

The works preserved representa angels with the instruments of the passion, the Evangelists and the Theological and Cardinal Virtues. Iconographically, the most interesting are the Cardinal Virtues, since except for Prudence which appears with its most frequent attributes (mirror and serpent), the others have variations, although clearly these are taken from the tradition codified from the Rennaissance onward. Thus Justice carries a bundle of rods and a sword as recommended by Ripa to represent the 'type of Justice exercised by the Judges and the Secular Body', Strength, in addition to the usual armor, carries a mace like that of Hercules (attribute which already appears in Ripa) and a parchment in which is the plan of a fortress, and finally Temperance carries only a branch whhich if it is laurel would be a substitution of the palm which, as Ripa points out, is the 'symbol of the prize which those who control their passions receive in heaven and rule and subdue themselves', although it could be a branch of penny royal, herb associated with Temperance through the anecdote of Heracleus represented by Alciatus in emblem XVI.

The Monument is a grand Eucharistical allegory. The Evangelists, notaries of the new alliance perennially renewed through the eucharist, are joined by the Virtues, the benefits which man obtains through it, and the angels, melodramatic reminders of the necessary sacrifice of Christ in Calvary.

(J.- M. L.V.)

BIBLIOGRAPHY

Barreiro Fernández, J.R. (1965); Couselo Bouzas, J. (1932); Murguía , M. (1884); Otero Túñez, R. (1958) (III)

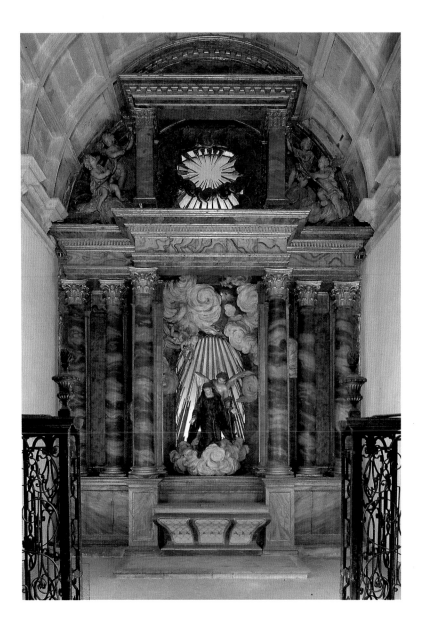

Altar Piece of Saint Scholastica
FRIAR PLÁCIDO CAAMIÑA
AND JOSÉ FERREIRO
Around 1779

Polychromed and gilded wood
Side chapel of the Church of the Monastery of
San Martiño Pinario. Santiago de Compostela

MONASTERY OF SAN MARTIÑO PINARIO.
SANTIAGO DE COMPOSTELA

Otero Túñez situates the creattion of this work in 1779, basing himself on one of the entries of the accounts for this year, but Barreiro Fernández believes it to have been done under abbot Bernardo Seoane y Saavedra, that is, between 1773 and 1777.

The altar piece was designed by Friar Plácido Caamiña. Its classicism, with a clear division of sections and panels and a polychromy that imitates jasper, still disguises a profound Baroque sense, since behind the classicist 'screen', the center panel extends vertically beyond the apparent division in sections and afterward across the transparente or stained glass window, which in addition to prolonging the space infinitely introduces another typicaly Baroque element, light. Again the models derived directly or indirectly from Bernini serve the Neoclassical Galicians to affirm their style which is indisputably classicist in comparison with the authochthonous Baroque.

The sculpture of the Death of Saint Scholastica is perhaps Ferreiro's masterpiece. In it we find all the characteristics of his sculpture already defined by Otero Túñez: slender canon; the tendency to leave one leg slightly behind and free of weight; features reminiscent of his wife Fermina's, in which their naturalism is idealized, full of sweetness, through a classical profile with the perfect arch of the eyebrows following the line of the nose, the slight depression at the temples, the sensuous shape of the small, emphasized mouth, the dimple dividing the prominent chin and the slight squint which fills the gaze with life and grace; the hair with large locks receives a luminous treatment; the slender hands have long nails that trace a marked curvature; the flesh areas are very soft, accentuated on the childlike bodies of the angels; the garments have deeply bevelled folds, imitating those of an emphatically pictorical marble sculpture, with very diverse placement but always emphasizing a central cloth that stands out considerably in the space between the legs, and another swirled in the lower part of the exonerated saint, in order to stress her underlying presence, the austere, naturalistic polychromy, even when as in this case the ornamentation on the garments of the angel is preserved. Also typical is a border of gilded rulers that trims the Saint's habit.

The iconographic type resembles the one omnipresent in Baroque, especially in the XVIIIth century, in which a saint is taken by angels above a mass of clouds. Otero Túñez identifies the

precedent in the Transfixion of Saint Teresa by Bernini. As for the placement of Saint Scholastica, it is repeated in inverted form from an engraving of Saint Gertrude, done by the famous Benedictine architect of Compostela Friar Gabriel de Casas and published in 1869 in the translation by Friar Leandro de Granada y Mendoza of the Life and revelations of Saint Gertrude the Great.

(J.-M.L.V.)

RESTORATION NOTE:

State of preservation:
• Some losses of polychromy and in some areas, touching the right side, there is superposition of flat paint from when this side was painted.
• There is loosening of paint on the lower part corresponding to the white cloud.

Treatment applied:
• Cleaning of dust and surface dirt.
• Disinfection with xilamón.
• Reintegration of paint in the small areas of losses.

Additional treatment:
• Only periodical disinfection every six years and careful observation of possible loosening.

BIBLIOGRAPHY
Barreiro Fernández, J.R. (1965); López Vázquez, J.M. (s.d.) (G.E.G.); Murguía, M. (1884); Otero Túñez, R. (1951); (1957) (II); (1958) (III)

183
Saint Rosendo
JOSÉ FERREIRO
Around 1779

Wood
250 x 123 x 66 cm.
Central nave of the church of the Monastery of San Martiño Pinario. Santiago de Compostela

MONASTERY OF SAN MARTIÑO PINARIO.
SANTIAGO DE COMPOSTELA

Based on a receipt, it is dated by Otero Túñez in 1979. Barreiro Fernández believes that it was done under abbot Bernardo Seoane y Saavedra and therefore dates it between 1763 and 1777.

The sculpture posses a clear monumental character, totally devotional. Placed at the entry of the monastical church, it must have had as chief purpose the underlining of the importance of the Benedictine order in Galicia and Santiago, through its most illustrious members, in this case Saint Rosendo, abbot and founder of the monastery at Celanova, bishop of Mondoñedo and Santiago, key

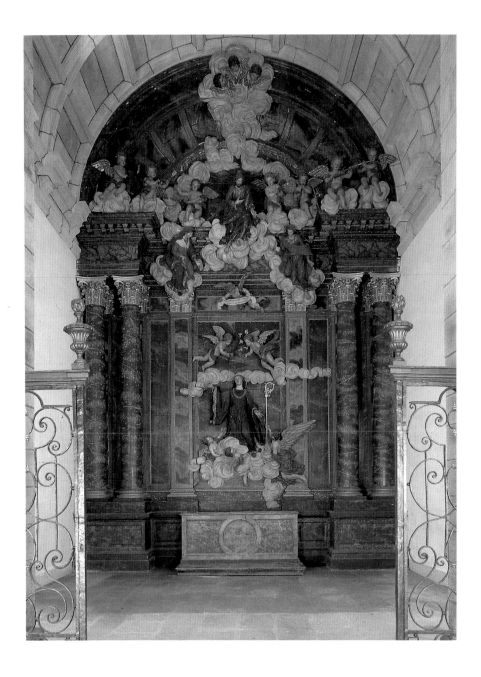

Dated, on the basis of a receipt, by Otero Túñez, in 1779. Barreiro Fernández believes it was made during the time of abbot

Bernardo Seoane y Saavedra and thus dates it between 1773 and 1777.

Like its pair, Saint Rosendo, this sculpture has an exclusively monumental character and obvious purpose of exaltation of the Benedictin order in Galicia and Santiago through its most outstanding personalities. We should recall that Saint Peter of Mezonzo, abbot of Sobrado and San Paio de Antealtares and bishop of Compostela is the restorer of the city after the invasion of Almanzor and is held to be the author of the celebrated Salve Regina oration. But even more to Saint Peter is owed the permission of the monks of San Martin to convert the small existing oratory in the monastery into a church of large dimensions. This would be a precedent of the present church, for which his representation was even more justified.

Stylistically it has the same characteristics as the statue of Saint Rosendo.

(J.- M. L.V.)

BIBLIOGRAPHY
Barreiro Fernández, J.R. (1965); Otero Túñez, R. (1953) (II).

185
Altar Piece of Saint Gertrude "The Great"
JOSÉ FERREIRO
1784

Polychromed wood
Side chapel of the Church of the Monastery of San Martiño Pinario. Santiago de Compostela

MONASTERY OF SAN MARTIÑO PINARIO.
SANTIAGO DE COMPOSTELA

The altar piece cost 24,000 reals paid by three monks of the monastery and was assigned to Ferreiro thanks to the decisive intervention of the abbot at the time, Juan Ron. In spite of its colossal dimensions, the altar piece is so intelligently designed that it can be completely folded, allowing direct access to the Cloister of the Processions, which has a door in this spot.

The typology of the altar piece resembles the large scenographic retables in style in the art of the Spanish court under the Bourbons, principally during the reign of Ferdinand VI and the first years of Charles IV. In this case, the model is chosen to represent the apotheosis of the Saint as she is shown in the Life and Revelations of Saint Gertrude the Great, according to the translation of Friar Leandro de Granada y Mendoza, a book that is inequivocally linked to the Compostelan monastery since, as has already been noted was illustrated by the architect Friar Gabriel de Casas: "With the arrival of the

figure in the repopulation and reconquest and defeater of Arabs and Normans. According to the chronicles, he was received in Santiago as its liberator.

Stylistically it shows a definitive consolidation of Ferreiros' mannerist style in the Classicist principles derived from the Baroque style of Bernini after the creation of the Monument of Maundy Thursday.

(J.- M. L. V.)

BIBLIOGRAPHY
Barreiro Fernández, J.R. (1965); Otero Túñez, R. (1953) (II); (1958) (III)

184
Saint Peter of Mezonzo
JOSÉ FERREIRO
Around 1779

Wood
250 x 123 x 66 cm.
Central nave of the Church of the Monastery of San Martiño Pinario. Santiago de Compostela

MONASTERY OF SAN MARTIÑO PINARIO.
SANTIAGO DE COMPOSTELA

day... the celestial spouse descends, so accompanied by courtesans from heaven, that it seemed they left it without people. He came with garments of great majesty and glory, accompanied by his mother, also full of delight. Saint John the Evangelist also came to the celebration, held for persons dear to Christ to honor the coronation of the dear wife. All were awaiting the last scene, and many nuns, seeing the solemn festival which was given for Saint Gertrude, when that celestial spirit of the body arrived and went straight to its Creator." The placement by Ferreiro of Christ, the Virgin and Saint John, following the traditional pattern of a deesis in which the evangelist simply substitutes the Baptist. Such placement allows the sculptor to form a pyramidal composition and close it on the upper part, as the classicist canons require. On the other hand, in spite of the fact that the Saint is represented with a staff, in reality she never was an abbess, this being a frequent error in her iconography through confusion with that of Saint Gertrude of Nivelles.

As for the stylistic features, we have nothing to add to that given for Saint Scholastica. In this case, the Italian precedent was already pointed out by Otero Túñez in the relief of Saint Catherine by Melchor Cafá. Neverthless, although the group coincides with this Roman work, numerous details such as the Saint's open arms, the angel theatrically placed with its back facing out, the profusion of angel musicians, etc., could be taken from the many illustrations of the Description Historique de L'Hotel Royal des Invalides of Abbot Gabriel Pérau, an book that was definitely known in Santiago as Fernández Castiñeiras has shown.

(J.- M. L.V.)

RESTORATION NOTE:

State of preservation:
• Quite good in spite of the losses in one part of the protective film.

Treatment applied:
• Cleaning and disinfection against xylophagus insects.

Additional treatment:
• Periodical disinfection every six years and observation of possible loss of polychromies which could occur because of inadequate environmental conditions.

BIBLIOGRAPHY

Barreiro Fernández, J.R. (1965); Otero Túñez, R. (1958) (III).

186
The Christ of Patience
JOSÉ FERREIRO
1784

Chestnut
225 x 220 cm.
Side Altar Piece of the Church of the Monastery of San Martiño Pinario. Santiago de Compostela

MONASTERY OF SAN MARTIÑO PINARIO.
SANTIAGO DE COMPOSTELA

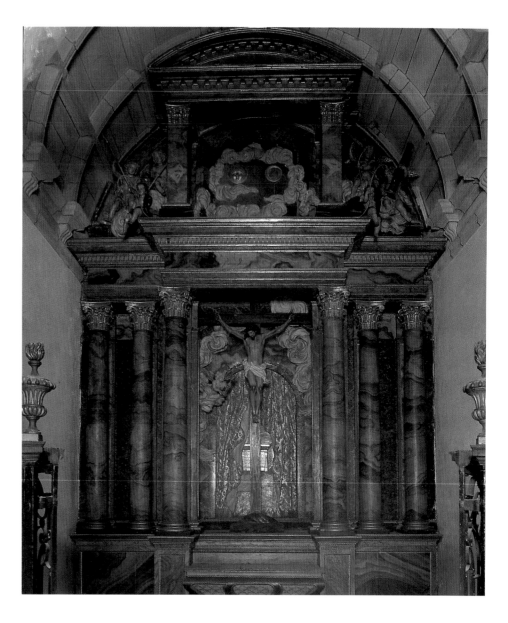

At the time this was the only work of those which Ferreiro sculpted for San Martiño Pinario which lacked date. The work of cleaning done for the present exposition allowed the reading on the back side, of one of the attic pillars, of the inscription "This altar piece and that in front were done and painted in devotion by a monk of this monastery. Year 1784." This appears to date the work, at least we may interpret that what really paid the monk was the altar piece and not its images. This hypothesis would be supported, first because in 1779 a Dolorosa is paid for which is placed in the Chapel of Holy Christ, which would already justify the preexistence of the Crucified figure to the altar piece, and second, because in the same report, the discharge of Saint Scholastica of the facing altar piece is given, the same as the monk says he has paid for, which leads us to definitely suppose that what was paid for by were the altar pieces and not their images. Nevertheless, first the Holy Christ, to

whose chapel reference may be made in this report, could be a different one than that mentioned here and let us point out in this sense that in the monastery itself one from the beginning of the XVIIIth century is preserved, and second, that although the monk might not have paid for it, it could also be that the image was done again.

For lack of other documentary proof, only stylistic reasons can justify the proposed endowment of 1784. The Christ of Patience has all the characteristics of the crucified figures of Ferreiro, already given by Otero Túñez as "the slight bending of the arms, the developed biceps, the marked arch formed by the ribs in the torso, the bony hardness of the hips, which contrasts with the softness of the soft parts of the belly; the manner of inserting the muscles into the knee and the rigid separation of the big toes of the feet." It only differs from the rest of the Crucified Christ by Ferreiro in its more or less near life-size dimensions, in the

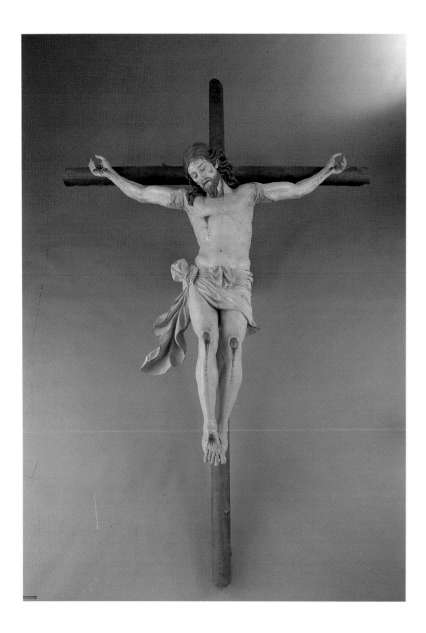

art and often appear together. The veil of the Sancta Sanctorum of the Temple which is torn from above to below, allows us to see the Coffer of Alliance, a relief which closes off the central panel of the main section of the altar piece, and in the attic, the depiction of the Sun and Moon, traditional iconography to indicate that the persisting darkness after the sixth hour (noon), began to lessen after the ninth hour (three o'clock in the afternoon), which is clearly indicated here with the dispersion of the clouds which no longer cover the stars, since their partial hiding behind them was a frequent pattern, although fairly naive, which the artists used to depict the eclipse. The clouds, on the other hand, allow Ferreiro to continue with fusionist criteria typical of a Baroque aesthetic, blending both sections of the altar piece and in addition, turning, as is characteristic of his style, to a Berninian element. The iconography of the whole is still finished off with the illustration of the allegory of the sacred Blood of Christ, through the tiny angel who bears the chalice, also of Bernini inspiration.

<div style="text-align:right">(J. - M.L.V.)</div>

RESTORATION NOTE:

State of preservation:
• Overall good state of preservation.

Treatment applied:
• Cleaning of dust and surface dirt.
• Disinfection with xilamón and small painting repairs where losses are minor.

Additional treatment:
• Periodical observation of the state of the polychromy and treatment against xylophagus insects.

BIBLIOGRAPHY
Murguía, M. (1884); Otero Túñez, R. (1951); (1953) (III)

187
Christ on the Cross
JOSÉ FERREIRO
End of the XVth century

Polychromed chestnut

MUSEUM OF THE GALICIAN PEOPLE.
SANTIAGO DE COMPOSTELA

Attributed to Ferreiro by Pérez Costanti, Otero Túñez considers it to be the culmination of the Crucifixes produced by this sculptor. Recently Cardeso Liñares discovered a crucifix in the parish of Barcala of San Mamede de Monte, dated in the accounts of the year 1769, which has the same iconographic characteristics and only differs, as is logical for this date, in the most naturalistic style, with heavier forms and shorter canon, which leads us to suspect if not the presence of the protoype of

originality of the placement of the loin cloth , which in the simplicity of its knot binding the pelvis departs from the formula of the others, letting it fall Baroquely sweep flanking the right leg and with a characteristic fold which protrudes in the middle of the upper part.

Among these Crucified Christs we can establish an evolutionary sequence, noticing elements which undergo a slow transformation such as, for example, the development of the thorathic cavity and the placement of Christ on the cross. The first of the crucified figures of Ferreiro, with the certain date of 1769, is the Christ of San Mamede de Monte, recently discovered by Cardeso Linares, and in which we find the type of Crucified Christs of the sculptor from Noya already fully formed. In this case, the figure has a wide torso and forms a curving silhouette on the cross and even, with an excessively violent twisting in the meeting of the ribs with the belly, which shows an expressivist interest that is typically Baroque. A further step is found in the monumental Christ of Saint

Francis of Santiago, dated around 1780; we still have an anatomical type that is very broad, but now the curvature on the cross has been reduced, becoming much more harmonious. That of Saint Martin, which we are now discussing, third in the sequence, supposes precisely the disappearance of the curvature. although the wideness and anatomical emphasis on the thorax are maintained if not increased. Finally, in the Christ of the Taking down from the Cross of Bonaval, the curvature has also been eliminated, but the anatomy is also stylized and sweetened and I would even dare say loses vigor in the carving, which shows a very late date.

The Christ of Patience reached us with touch-up and possibly a remaking of the cross. The altar piece which holds it completes his iconography with two of the miracles that occurred at the time of the Savior's death, signs of the day of Yahveh, taken up by the Synoptic Evangels (Matthew, Mark, and Luke) which on the other hand are the most represented in western

Gambino, at least the repeated use of an engraving by Ferreiro.

As a culmination of Ferreiro's crucifixes, we find in this Dead Christ all the characteristics that define them and which have been pointed out by Otero Túñez: the greenish cross with the vertically placed cartouche, the Christ with three nails, placed in a triumphant position on the cross, remaining erect, joined to it by his own will and not by the strength of the iron, thus his arms are slightly bent at the elbows and completely lacking intention, in spite of the great development of the biceps, the head full of serenity, with the hair shown as calligraphic and naturalist locks which curve to show the left earlobe; the fluid anatomy with a slender torso in which the arch of the prominent rib cage stands out and the upper part of the pelvis is slightly suggested; the broad loin cloth has a strange fold in the middle, is knotted and falls fluttering in a broken manner surrounding the right leg, which is almost entirely bare. The muscles are joined emphatically to the knees and the long toes are very separated with deeply incrusted nails.

(J.- M. L.V.)

BIBLIOGRAPHY

Cardeso Liñares, J. (1989); Otero Túñez, R. (1951); (1953) (III); (1957) (II); Pérez Costanti, P. (1930)

188
Santiago Pilgrim
MANUEL DE PRADO MARIÑO
End of XVIIIth century

Polychromed wood
170 x 71 x 55 cm.

PARISH CHURCH OF SANTA MARÍA DE CONXO.
SANTIAGO DE COMPOSTELA

This image of Santiago pilgrim was done for the altar piece of the side chapels of the church of Santa María de Conxo, which had been installed between 1787 and 1790. Its composition has great force and balance. The figure appears in the act of walking, and thus with each foot on a different plane. It is characterized by the typical pilgrim's garb: staff with gourd, on which hat and cloak are hung, decorated with the most characteristic Jacobean symbol: the scallop shell, and at the same time carrying the book of the Evangels, general attribute of the Apostles.

Overall it reminds us of works by Ferreiro—Saint Mark and Saint Rosendo of San Martiño Pinario—both in the placement of the feet as well as the manner of holding the book and mantle, this last element giving it great relevance; its chromatic contrast with the tunic—in spite of not being the original polychromy—mystically projects the figure, who rises because of pleading eyes. The drapery, treated with a softer form than by Ferreiro, with more rounded lines which slightly reveal the form of the body, emphasize even more this contrast.

Murguía attributed this sculpture to Antonio Fernández the Elder, although with little conviction, since he also considered its possible authors to be Bartolomé, his son, and even Ferreiro. Later, Chamoso and other historians have insisted on the authorship of the former. Otero Túñez suggested the attribution to Manuel de Prado, but with the early date of its creation, documented by Barral, he doubts in a recent article whether to attribute it to this sculptor or to assign it again to A. Fernández.

(C.P.V.)

RESTORATION NOTE:

State of preservation:

• Scattered damage by xylophagus insects, producing losses in the support (the right shoulder, fold of the mantle on the lower left part).

• Ungluing of pieces with loss of support (staff, hat, cape decoration).

• The right hand is unsteady, because it has lost its attachment.

• Crack in the mantle produced by movements of the wood due to sharp change in environmental conditions.

• The preparation and painted layers are not visible because of the repainting; only the gold leaf can be seen.

• On the surface there is a thick layer of lacquer and bitumen which darken the flesh areas.

Treatment applied:

• Mechanical cleaning of surface dust.

• Gluing and painting on gilt ground of the hat with wood paste, reintegrated with pigments and varnish.

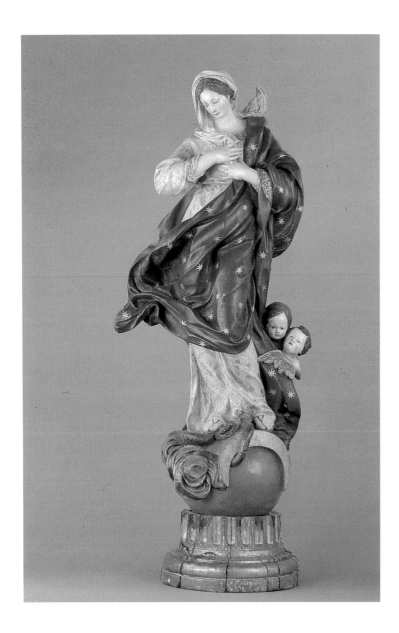

The canon is very stylized, and insinuates an almost imperceptible helicoidal twist. She is wearing a tunic and mantle from which merry cherub heads of great plastic quality emerge. The mantle, which hangs over the left shoulder—the right one is uncovered—creates a dynamic movement as it falls. Her attitude is one of absorption, with her gaze turned downward and her hands crossed over her chest, showing a profound concentration of force.

Iconographically, it follows the type dictated by the Academy, just as the one done by the same author for the Main Chapel of the Cathedral of Santiago, later done in silver by Francisco Pecul (1799). Both, according to his own words, refer to the one engraved by Isidro Carnicero.

From the stylistic perspective, it is characterized by the treatment of the drapery, with soft forms, which allow us to barely appreciate the proportioned forms of the body. The classical face, of oval outline, the tendency to rounded forms for the arms and the chromatic softness show a clear evolution regarding the typical Baroque manifestations.

Because of its composition and harmony, as well as its spirituality, it can be considered one of the most beautiful sculptures of the representation of Mary in all Galician imagery.

(C.P.V.)

RESTORATION NOTE:

State of preservation:
• The carving has two separate parts: base and statue. Very scattered damage by xylophagus insects on the base.
• There are different unglued pieces in the base with several openings of various millimeters. One of the pieces of the base is loose.
• Several cracks in the left arm and hand, rear part and right arm.
• The preparation layer of the base is white and somewhat thick, covered with gold leaf.
• It is not visible on the rest of the carving because of the re-polychroming.
• It is in good condition with small losses due to rubbing (Virgin's nose) and loss of adherence in scattered zones.
• Concretions of lacquer in skin areas.
• The back part has two screws to attach the orle.
• There are remains of wax, lacquer and concretions of dirt and dust on the surface.

Treatment applied:
• Mechanical cleaning of surface dust.
• Gluing of base.
• Fixing of the painted layer of the base and back.
• Chemical cleaning of dirt concretions on the surface.
• Cleaning of wax drops with Leister.
• Disinfection of the support with methyl bromide gases.

Additional treatment:
• Following of the state of preservation by control of the environmental conditions (temperature, relative humidity, biological damage).

• Fixing of the right hand with a wooden peg, stuccoing of its edges and reintegration.

• Disinfection of the support with methyl bromide vapors.

Additional treatment:
• Chemical analysis and photographic studies to determine the state of the original polychromy and its possible recovery.

• Following of the state of preservation by control of the environmental conditions (temperature, relative humidity, biological damage).

189
Immaculate Conception
MANUEL DE PRADO MARIÑO
Beginning of XIXth century

Polychromed wood
135 x 54 x 28 cm.

PARISH CHURCH OF SANTA MARÍA DO CAMIÑO. SANTIAGO DE COMPOSTELA

This work is documented by the author's own curriculum. It represents the Virgin on a base, formed by an Ionic column, truncated with Attic base and her own attributes: poised on the moon and defeating the serpent. She is thus the symbol of the New Eve of Paradise, after the evolution of the primitive iconographic reference of the apocalyptic woman.

BIBLIOGRAPHY
Barral Iglesias, A. (s.d.); Catálogo (1965); García Iglesias, J.M. (s.d.) (G.E.G.); López Vázquez, J.M. (s.d.) (G.E.G.); Murguía, M. (1884); Otero Túñez , R (1982); (1990).

BIBLIOGRAPHY
Couselo Bouzas, J. (1932); López Vázquez, J.M. (1988) (II); Otero Túñez, R. (1956) (I); (1963); (1982); Sánchez Cantón, F.J. (1965); Sobrino Manzanares, M.L. (1982); Trens, M. (1946)

190
Triptych of the Coronation of the Virgin
NARDON PÉNICAUD
First third of the XVIth century

Enamel
29 x 35 cm.

COLLECTION OF THE SANTA MARINA-TEMES
FOUNDATION. SAINT ANGEL ASYLUM
(OURENSE)

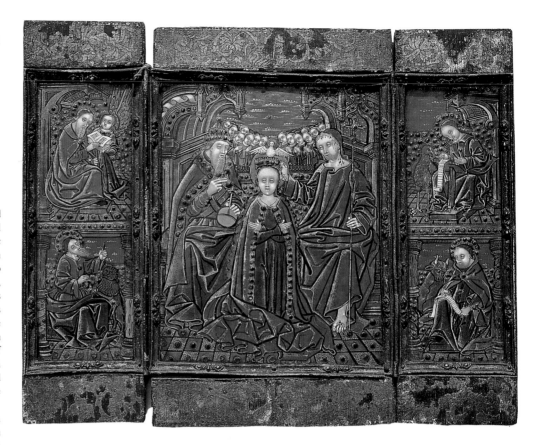

Triptych of painted enamel on copper, mounted
on a wooden framework. This technique of enamel
application, which consists in dressing the metallic
surface on both sides and putting enamel powder on
the principal, in such a way that there is no
separation between the colors of the composition,
appears in the Renaissance period and reaches its
greatest splendour in Limoges, for which reason is
commonly known as Lemosine enamel. The
triptych presents the typical framing of Nardon
Pénicaud's works, based on a narrow moulding of
copper, finished on the ends by the use of paint on
board with brocades of rich decorative effect and
jars between musician cherubs, of Renaissance
taste.

In the central plate of the triptych the coronation
of Mary is represented. The Virgin, kneeling and in
pious attitude, receives the crown from her Son's
hands and God the Father's blessing, with the Holy
Spirit resting on her head. A choir of angels pressed
together is present in the background of the scene.
The figures, whose model corresponds to the final
period of the Gothic, are framed by choir-seats with
conopial arches in the high seat backs, which are
outlined against the heavenly blue, made cheerful by
the characteristic little clouds of this master's works.
The doors of the triptych present the figures of the
Evangelists, at their desks and with their symbols,
dedicated to the task of writing the holy texts.

The drawing is meticulous and well done, with
fine black traces defining the outlines and delicate
shades. The cold blue, green and violet tones are
enriched with touches of gold and with cabochon in
relief covered with enamel, which emphasize the
decorative effects; the gildings reflect the light on
the fabrics, whose mass rests heavily on the ground,
linking with the Gothic tradition.

The triptych, property of Angela Santamarina
Alducín, marquee of the Atalaya Bermeja and
countess of the Valle de Oselle, was placed in the
Saint Angel Asylum in 1938, along with the
collection of works of art and personal souvenirs
gathered in her lifetime. With her death, the
collection came to be controlled by the Santa
Marina-Temes Foundation.

(Y.B.L.)

BIBLIOGRAPHY
*López Morais, A. , Casado Nieto, M.R. (1989);
Marquet de Vasselot, J.J. (1925); Martín Ansón,
M.L. (1984); Torralbal, F. (1963)*

191
Processional Cross
WORKSHOP FROM COMPOSTELA
Beginning of the XVIth century
(with later reforms)

Partially gilded jet
76 x 45 cm.
Santiago de Compostela

MUSEUM OF THE CATHEDRAL OF OURENSE

With circular barrel which by means of egg-and-
dart mouldings leads to the joint by several plates
with toothed edges progressively smaller in size on
which the castle sits. The latter is divided by a plate
which separates a lower section from an upper one
of smaller perimeter. On the joint the cross with
equal arms is set, finished in flattened egg-and-dart
spheres.

There is an abundance of architectural elements
of the ogival style—both in the barrel and in the
joint—in which the gilding appears to reinforce the
decoration. Only four of the figures of saints which
must have surrounded the *castillete are preserved.
The cross is simple, in the form of branches with
cut buds and blossoms at the ends which give this
typology the name of gajos.

It appears already mentioned in the account
done in the Cathedral in 1503. It is an important
piece of Compostelan jet work, since only four
others are preserved intact. The cross is later than
the joint which in fact could be from that date
(Filgueira).

These crosses were used in the tribunals of the
Inquisition, in the services for the deceased or in the
excommunication ceremonies. This one from
Ourense, concretely, was used in the burials of the
canons and curates of the church and in the general
processions of the Deceased.

(M.L.L.)

BIBLIOGRAPHY
*Catálago (1965); Filgueira Valverde, J. (1965);
Sánchez Arteaga, M. (1916)*

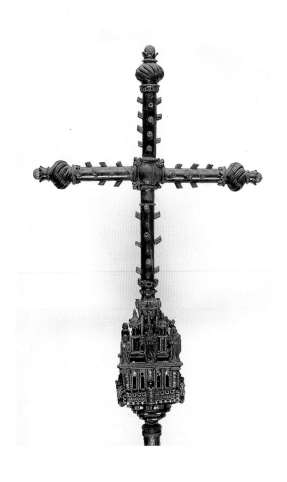

192
Processional Cross
ANONYMOUS
Beginning of the XVIth century

Gold-plated silver
100 cm.

PARISH CHURCH OF SAN FIZ DE SOLOVIO.
SANTIAGO DE COMPOSTELA

Circular barrel on which a cluster of moulding rests, in turn support for a castle joint which leads to the fork where the cross of equal arms and extremes with fleur-de-lis.

The cluster, with six-sided base, is adorned with designs. The castle, also hexagonal, shows a series of walls, progressively smaller, with merloned turrets on the corners and designs on the surfaces. The fork appears plain, which contrasts with the profuse decoration that covers the planes of the cross and the fields of the lises. In the quatrefoils which expand on the front side, there are four figures in relief—on backgrounds with a rough glossed surface—showing two thurifer angels on the arm of the cross, Santiago Pilgrim on the head and the Resurrection of Lazarus at the foot. The rectangular plate which covers the crossing of the arms shows a starry sky, the moon and the sun, the image of the seated Virgin with the Child and on the quatrefoils are Saint Anthony, Saint Mary Salomé, Saint Francis of Assissi and a bishop.

We know that it belonged to the Franciscan fathers of Santiago, who sold it in the XVIIth century.

(M.L.L.)

BIBLIOGRAPHY
Balsa de la Vega, R. (1912)

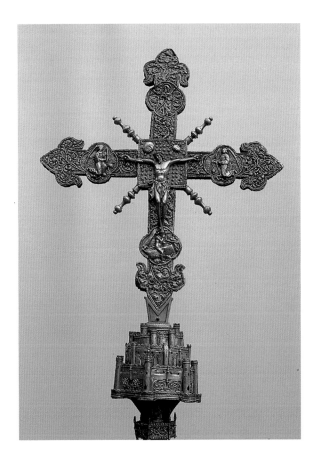

193
Pix
PEDRO RIBADEO ?
Beginning of the XVIth century

Gold-plated and natural silver
23 x 12 cm.
By the craftsman BO/PEDRO; contrast T/AuDI;
site (Valladolid)
Valladolid

PARISH CHURCH OF SANTIAGO. PONTEDEUME
(A CORUÑA)

On a polygonal socle is a niche protected by a canopy of Gothic moulding, flanked by two pinnacles, in whose interior the image of the Virgin with the Child is located.

The socle is trimmed with open-work geometric motifs, in whose front the tace cross of the Mendoza family is set. The canopy is comprised of a varied association of architectural elements of the purest Hispano-Flemish Gothic, with buttress arches, open-work windows, designs, pinnacles, etc. The figures of the Virgin and the Child are demi-relief surrounded by a border of beams in which straight and curving alternate. Although the folds of the clothing are carefully done, the faces and anatomies are clumsily interpreted. The Virgin is crowned as queen of the heavens, and at her feet is an enormous crescent moon, which was added later (Chamoso).

It was donated to the church of Pontedeume by captain Fernando de Andrade upon returning from campaigns in Italy. The craftsman's mark could belong to the prolific metal worker of Valladolid, Pedro Ribadeo.

(M.L.L.)

BIBLIOGRAPHY
Brasas Egido, J.C. (1983); Catálogo (1965)

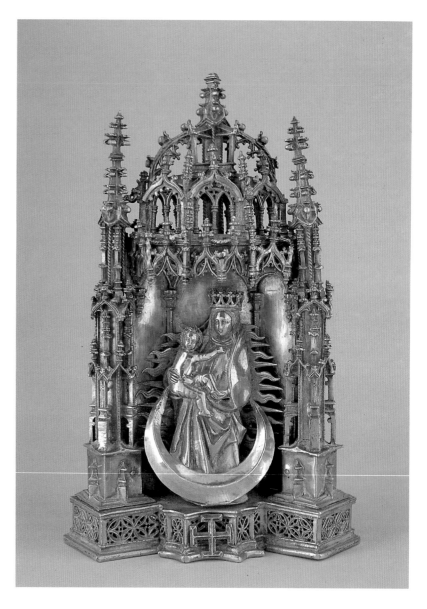

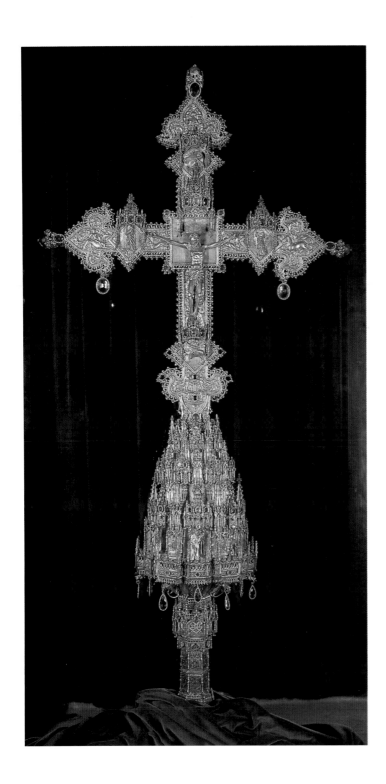

194
Processional Cross
ENRIQUE DE ARFE ?
Ca. 1515

Gold-plated and natural silver and enamel
143 x 73 cm.
Valladolid

MUSEUM OF THE CATHEDRAL OF OURENSE

Six-sided stem and joint of Gothic moulding, formed by three starred bodies—tapering—which end in a crown. The cross has nearly igual arms, with ends in fleur-de-lis and fleurons.

The shaft—divided in two areas by an impost of cresting—is decorated with swirls on all sides and on the upper part, six winged dragons appear to hold the weight of the cross. The architectural joint shows abundant flamboyant ornamentation with spires, pinnacles and capitals. Around the first body is a balcony of cresting. Above it, there are pinnacles alternating with figures on pedestals, protected by canopies and in front of great open-work windows. The clumsy fabrication of the figures contrasts with the skill with which the rest of the ornamental elements were done. The two upper bodies, formed by a series of gables, practically have no figures; only on the highest pinnacles five cherubs with bagpipes and the figure of a dancer recline. On the front side of the cross and on the rectangular plate of the cross is the figure of Christ beneath a small canopy—haloed and with his bearded head inclined to the right—with very marked anatomy and only three nails. In the rhomboidal expansions of the arms of the cross are demi-reliefs of the Virgin and Saint John, although beneath small canopies. On the head of the cross is a pelican which is ripping itself open to feed its children and at the feet the figure of Saint Martin on horseback in the gesture of sharing his cape with a poor man. The central figure of the back presents Saint Euphemia with a palm and doubly crowned as Virgin and martyr; in the expansions of the arms are the four Evangelists with their corresponding symbols. The surfaces of the cross and the fields of lises are completely covered with wreaths and winding designs in which human figures, fantastic animals and swirls can be seen, in a clear manifestation of "horror vacui". The perimeter of the cross is adorned with a row of three-leaved designs, like the rest of the ornamentation, of florid ogival style.

We know that this exceptional work was already in the Cathedral in 1543, and was called "the rich one"; it had been donated by the fifth Count of Benavente—in 1515—as a show of gratitude for the damage done in the attack on the Count of Lemos who had resisted him there. It was renovated and enriched with precious stones in a reform done at the beginning of this century.

(M.L.L.)

BIBLIOGRAPHY
Brasas Egido, J.C. (1983); Chamoso Lamas, M. (1956) (I)

195
Pix
ANONYMOUS
Ca.1515

Embossed silver
27 x 15 cm.
Place, Valladolid, below V A L ; another in
which is written I V A N (craftsman)
Valladolid

MUSEUM OF THE CATHEDRAL OF OURENSE

Pix in the shape of a small altar piece. In the center
of the Vth Anguish on a polygono pedestal, sheltered
by a canopy whose draperies are pulled back by two
cherubs set on the lateral pinnacles which hold an ogee
arch of concave moulding with plant trim.

The frame of this small altar piece, of obvious
flowery ogival style is shaped as a set of pinnacles, at
different heights and cresting with great care in the
details. The central theme is set beneath curtains of
detailed folds and fringe trim. The scene of the Pietà
has the coat-of-arms of the father of the donor, D.
Rodrigo Alfonso de Pimentel in the front and has a
cut-out geometric decoration on a smooth background
on either side and an upper end that is also cut out.
Behind the Pietà are the crosses of Calvary, with the
tortured images of the two thieves. The Virgin,
covered with a veil and a mantle of abundant drapery
turns her face toward the twisted and disproportionate
figure of her Son.

It is a very infrequent liturgical object because it is
no longer used. It was to be kissed by the faithful,
substituting the custom of the kiss of peace.

It is documented that in 1515 D. Alfonso de
Pimentel, V Count of Benavente, gave this pix to the
Cathedral of Ourense, fulfilling the wish of his father's
testament to compensate for the damage done to the
Church because of the battles against the Count of
Lemos in 1475. (M.L.L.)

The craftsman, from a family of Jewish
metalsmiths, belongs to the best Gothic metalwork of
Valladolid.

(M.L.L.)

BIBLIOGRAPHY
*Brasas Egido, J.C. (1983); Chamoso Lamas, M.
(1956)*

196
Processional Monstrance
ANTONIO DE ARFE
1539-1545 and 1573

Gold-plated silver and enamel
143 cm.
Emblems of "Arfe"; contrast Gonzalo Escobar;
place, Valladolid
ANTONIVS DE ARPHE HOC OPUS
ADMIRABILE FECIT ANNO 1544,
OMNIPOTENTIS GRATIA AVXILIOQUE
BEATI IACOBI.

TREASURE OF THE CATHEDRAL
OF SANTIAGO DE COMPOSTELA

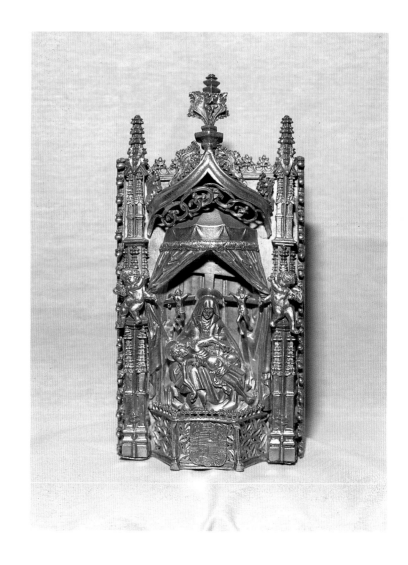

In 1539 the Compostelan Chapter, imitating the
major Spanish Cathedrals, decides to create the
monumental monstrance. They do not turn to Ruy
Fernández and the Cedeiras, silversmiths of the
Basilica, and they go to the workshop of the Arfes.
Led by the hand of the third Fonseca, the great
Maecenas, the Renaissance renovation of the
Cathedral and the city of the Apostle is decisive,
bringing together the most important group of artists.
The city and the capitular corporation took notice.

On April 24 of the same year, Antonio, the second
of the dynasty of the Arfes, presents the "sample and
plan" to the capitular commission and "the manner and
order it will follow, as to the work and place where it
will be done..." "with the imagery, pillars and other
things...", proposed by the commission. The contract
with the Cathedral College is closed, with the promise
not to leave Santiago until it was finished, in 1540.
Differences between Arfe and the Church Chapter

prolonged its termination and delivery until January
25, 1545. The exquisite pedestal, with which it is
endowed in 1573, is a late execution by Antonio de
Arfe, done in the city of the Pisuerga River, in which
the collaboration of his son Juan de Arfe may be
detected. Until the XVIIth century the monstrance is in
the incomparable frame of the main chapel,
accompanying the frontal, the tabula and the dais of
Xelmírez.

Deterioration has made changes in the monstrance,
which affected both the structure and the iconographic
program, and its very aesthetic. The most important
was that of Angel Piedra, in 1770.

In the inventory of 1567 there is a description of the
first placement: with four chapels, in the first is the
Last Supper with the figures of the twelve Apostles,
with the table in the middle..."; in the second, the Most
Holy Sacrament; in the third, the Resurrection; in the
fourth a small bell; finally, a crucifix," and the pedestal

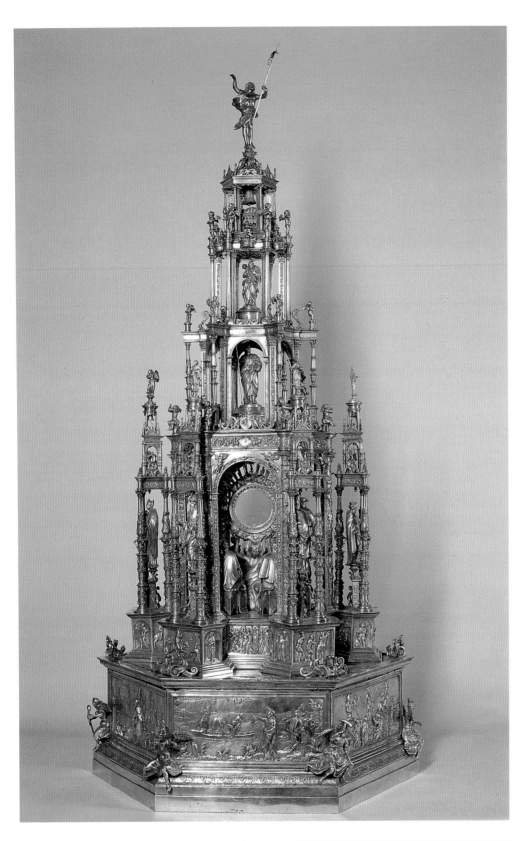

("six Saturday)" in the inventory of 1648 with its reliefs, and the angels with the insignia of the Passion. There is a change and different placement than its present appearance.

The Compostelan monstrance is a worthy example of silver work and one of the most beautiful pieces of Spanish silver work, as well as the most important piece of this art in Galicia. It has the singular feature of being the first work of the Arfe workshop which reaches the height of the new style and the prototype of the peninsular monstrances, which will unconditionally follow the model created.

In the monstrance of Santiago we can see a stylistic evolution from Plateresque to Classicism, carried out to his son Juan de Arfe. Together with the work of Enrique, his father, who is familiar with the transitions from Gothic to Renaissance, the entire process of Hispanic silver work in the XVIth century is typified. This evolution does not at all break the unity achieved in the magnificent union of its architectural structures and ornamentation, already fully Renaissance. The silver sculpture of the monstrance—even though in an artistic crossroads of the Peninsula, with different lines of force—is nevertheless one of the most splendid achievements of Antonio, "sculptor of silver and gold."

The monstrance—says Juan de Arfe—"is a rich temple, made for the triumph of Christ." Of hexagonal shape, on a somber pedestal, adorned with reliefs, the processional temple with four sections gentilely rises—with an especial attention to the horizontal organization of masses—in an interplay of pillars, arches and architraves, flanked by six small towers with triple balustered column of the most genuine stylistic sort. The delicate plant and figurative ornamentation extends over all the architecture in splendid Plateresque flowering, becoming simpler toward the upper parts. Rounded and pictorial, it is an exalted fantasy, dreaming of mythological caprices, expressive symbols of the royal presence, signalled by the Biblical characters which indicate it.

The pedestal is decorated "with the most beautiful reliefs of all Renaissance silver work." They are dedicated to the Apostle, consecrating the Jacobean traditions: the miraculous fishing and the Vocation, the Transfiguration, the Martyrdom, the Transfer to Galicia, the Persecution of the disciples (episodes of Duio-Fisterra and Negreira-A Coruña) and one of the most famous miracles of the Way, the hung man and the cock of Santo Domingo de la Calzada, narrated in the Liber Sancti Iacobi.

In each relief the episodes are multiplied, and the landscape, of wide perspectives and beautiful backgrounds, acquires all its interest, creating natural environments where the figures are inserted, standing out for their perfection and beauty, with elongated and undefined profiles. The scenes thus achieve a pictorial-narrative nature which takes us to the Italian artistic world of varying intensity: quattrocentismo, Raphaelism, Mannerism.

On the pedestal, the temple majestically rises. Its starred floor plan leads to a multifaceted dado, decorated with 36 reliefs, narrating the life of Jesus and flanked by the prophets who announce it. Divided in three groups, they are of different aesthetic quality. In the first one, with scaly background and tending to

simplification, the reliefs have scant and large figures, proportioned to the stage, seeking to value the body, with rounded musculature and clothing of wide, soft folds. The second group imitates it although its quality is inferior. The third consists of more complex reliefs, in forced, unnatural compositions, with a greater number of people. They are extremely elongated figures, their only deformation, since the treatment of faces and angular drapery are of astonishing realism, as authentic tiny portraits. Done with a punch point, each figure acquires all the force and expression which extracts from the scant background scenery. These reliefs remind us of El Greco.

In the inside of the first section of the temple are six seated Apostles—not twelve—around a glass carried by an angel, and not at the table of the Last Supper. In the frieze the mythical history of Dioscuros is narrated, symbol of Christ, God-Man, and the Eucharist, Bread and Wine, thus becoming present in this scene. In the section, a Santiago Pilgrim substitutes for the former glass. In the third is the figure of the Good Shepherd, in place of the Resurrected Christ; and in the fourth, the Apocalyptic Lamb accompanies the original bell. The monstrance is completed with a Resurrected Christ in place of the cross.

In the small towers which flank the temple, prophets and doctors of the church gesticulate, showing the presence of Christ. This series, together with the Apostles, carefully and beautifully done, very slender, is related to the reliefs of the third group of the dado. They are accompanied by figures of the virtues, saints and angels, which climb up over the towers to the end.

Santiago Pilgrim, the Good Shepherd, the Lamb and the series of angels, bearers of bunches of grapes and sheaths of wheat, must be a collaboration of Angel Piedra and Manuel de Prado y Mariño, the author of the mould of the Immaculate Virgin in the same Cathedral, piece which Pecul casts, since it follows models created by this sculptor, as can be compared with the Santiago of Conxo. The Resurrected Christ, of poor quality, is the work of Piedra. At the end of the monstrance Arfe placed the following legend: "Antonius de Arphe hoc opus admirabile fecit anno 1544. Omnipotentis Gratia auxilioque Beati Iacobi." Very much in line with Renaissance thought, it is nevertheless an indication of the author's lucidity and pride, because his work is truly admirable.

(A.-B.B.)

BIBLIOGRAPHY

Alcolea Gil, S. (1975); Arphe, J. de (1675); Brasas Egido, J.C. (1980); Couselo Bouzas, J. (1932); Chamoso Lamas, M. (1976); Filgueira Valverde, J. (1959); Hamilton, E. (1984); López Ferreiro, A. (1898-1911); Martín González, J.J. (1977); Morales A. de (1965); Pérez Costanti, P. (1930); Rosende Valdés, A.A. (1982); Sánchez Cantón, F.J. (1920); Trens,M.(1952); Vega y Verdugo, J. (1956); Vila Jato, M.D. (1983);Villaamil y Castro, J. (1907)

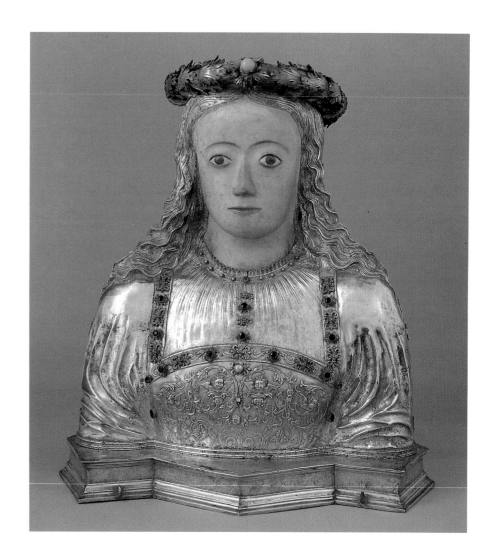

197
Bust-reliquary of Saint Pauline
JORGE CEDEIRA "THE ELDER".
WORKSHOP OF COMPOSTELA.
1553

Embossed and engraved silver, overgilded and cold-enamelled.
50,5 x 47 x 24,5 cm.
Santiago de Compostela

CHAPEL OF THE RELICS .CATHEDRAL OF SANTIAGO DE COMPOSTELA

The prelate of Compostela D. Gaspar de Zúñiga, on a trip to Germany with Carlos V (1543), receives from the archbishop of Cologne some relics of the legendary 'Eleven Thousand Virgins'—Saint Ursula and her companions, creating the bust-reliquaries of Saint Pauline and Saint Firina, works of the silversmiths Cedeira 'the Elder' and 'the Younger', respectively; a third bust-reliquary disappeared in the Fire of 1921.

Jorge Cedeira, head of a family of metalworkers established in Galicia, and a native of Portugal, where he was an apprentice, is in Santiago in 1542; he made the beautiful bust: 'this piece was made by Jorge Cedeira in 1553'. It is a completely Renaissance work in its concept, forms and

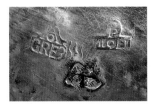

ornamentation. Of gilded silver, its embossing and engraving, with cold enamelling on the flesh areas, are noteworthy.

The base is meant for a maximum of movement with a broken design, prominent moulding and frieze decorated by engravings that must have celebrated the young Virgin with complex scenes, with intelligent use of mythical animals, cupids, and playful angel trumpeters, amid ribbons, flowers, and fruit bowls, in a landscape with trees. They surround three medallions which have martyr palms, a figure in profile of a young warrior, flanked by peacocks, the symbol of Christ, and a floral background framing the profile of a young woman, undoubtedly the Saint's apotheosis.

The bust is a precious Renaissance piece, its oval, dreamy face is shown with rudimentary facial features, idealized, protruding almond-shaped eyes and firm lips, denoting an uncontainable strength. It is framed by long golden hair, of parallel curly locks which fall over the shoulders and extend down the back. The plant crown, decorated with gems, which binds the Virgin's temple, is from the XVIIIth century and was substituted for a previous one.

The dress is an exquisite garment of wide ruffled sleeves and a low square neckline with a border trimmed with delicious jewels with precious gemstones overlaid. The tight bodice is

admirably decorated with gilded reliefs of tendrils, starting at a center of pearls and diamonds, and extends to cover the entire chest, ending in candelleri with winged angel heads. On the back is a sheaf of tendrils mingles among the curls.

The deep neckline reveals a tunic beneath, of silken brocade, fine volutes silhouetted in gold on a silverry background. It is caught at the neck with a ribbon decorated with precious stones and falls in fine folds. The button holes with small overlaid jewels which alternates with inlaid emeralds complete the dress.

The delicate piece is a fine example of the artist's exaltation of woman.

(A.-B.B.)

BIBLIOGRAPHY

Alcolea Gil, S. (1958); Filgueira Valverde, J. (1959); Franzen, A. (1975); Pérez Costanti. P. (1930)

198
Chalice
PEDRO MIGUEL
Second half of the XVIth century

Gold-plated silver
24,5 x 13,5 x 8.,5 cm.
P/MIGEL; A/GREZ; mark of place (Valladolid)
Valladolid

CATHEDRAL OF TUI (PONTEVEDRA)

The foot is formed by a vertical edge and semicircular calotte, from which a lathed stem rises, comprised of a set of fluted mouldings interrupted by plain plates which lead to an oval joint followed in turn by other moudlings of smaller diameter which support a conical-cylindrical cup and semicircular sub-cup.

In its decoration we notice the medallions and cabochons framed by cut out leather which is applied to the foot, the joint and the subcup. On the lower part of the joint egg-and-dart decorations of semicircular section stand out. On the subcup chiseled heads of cherubs are interspersed among the small cabochons. The background against which the mentioned motifs stand out is covered with a Renaissance style decoration of incised wedges, ribbons and plants.

The marks indicate its origin in Valladolid, its author being Pedro Miguel and the assayer Alonso Gutiérrez the Younger, and it was given by Bishop Torquemada (1562-1582) to the Cathedral of Tui.

(M.L.L.)

BIBLIOGRAPHY

Brasas Egido, J.C. (1983)

199
The flagellation
GASPAR BECERRA
Last third of XVIth century

Cast and engraved silver
21,5 x 19 x 12 cm.
Astorga (León)

CHAPEL OF RELICS. CATHEDRAL
OF SANTIAGO DE COMPOSTELA

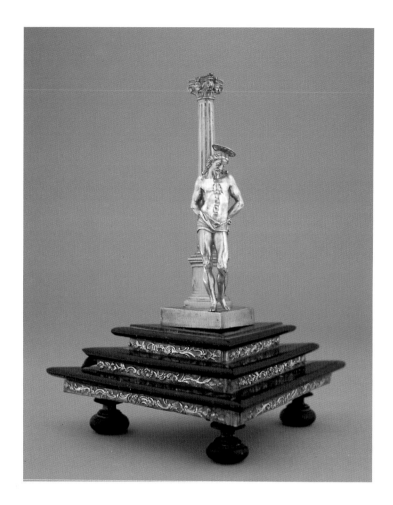

Delicate silvery sculpture in high relief. Its stylized aspect, accommodated to the fifth proportion, is compensated by a robust complexion, of a perfect anatomical study, of subtle textures in soft muscular passages, and with a certain sketching into planes, which give a vigorous vision of the delicious image.

With the stiff right leg, as axis for the body, and the left bent forward to rest on the tips of the toes, the figure bends in soft inclining posture to join with the column. The bent head has a solemn, classical beauty, with long face and rounded cheekbones. The beard, which runs along the facial lines, is composed of tiny locks. A full, curly head of hair frames the face, with a part in the middle, and falls in coiled locks which become separate, like tatted lace. The preference for the naked body which the author shows, is shown in a small way by a light loin cloth, with slightly bent plane, which is tied in a spiral knot in back.

In contrast, the half column, in order to join the wall, is gilded and set with the image on a step. (The ebony and silver pedestal is Rococo.) The form is a high smooth pedestal and bulbous column, decorated with acanthus leaves in its lower third and channelled in the upper part. The capital, of Corinthian origin, has angel heads, whose wings become volutes on the corner plates.

Characterized by the anatomical proportion and perfection, with massive forms and smooth skin, this is a sculpture which has great tranquillity, restfulness, without any disturbance in the face and which situates us the mannerist Romanism, introducing it in the area of the purest idealism in the style of Michelangelo—it was supposed to be by B. Cellini. The surprising technical virtuosity is attributed to Gaspar Becerra, the introducer of the beautifully calm and correct idealism in the Spain of the last third of the sixteenth century. The Christ of the Compostelan Cathedral is comparable to the lying Christ of the Lowering of the altar-piece in Astorga and to the crucified figures by Becerra, author of small effigies in silver and ivory.

(A.-B.B.)

BIBLIOGRAPHY
Azcárate, J.M. (1958); Filgueira Valverde, J.
(1959); Martín González, J.J. (1970) (I); (1977)

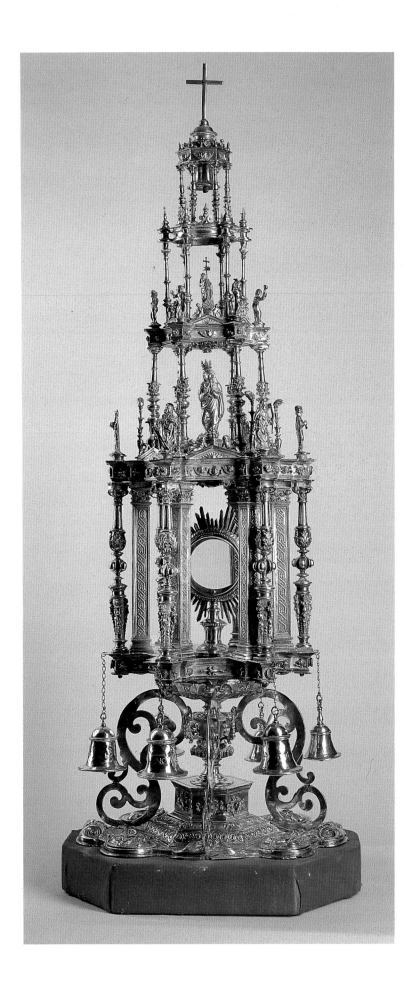

200
Seat Monstrance
BERNAL MADERA
1586

Silver
72 cm.
Santiago de Compostela

PARISH CHURCH OF SANTIAGO DE BETANZOS.
(A CORUÑA)

Lobed hexagonal foot with double moulding on which a six-sided pedestal is set. This leads to an urn joint which holds a semicircular segment with four hexagonal compartments rising above it, ending in a simple cross.

The foot and pedestal are adorned with plant motifs and cherub heads. The urn has applied handles and the segment has a decoration of flat ribbons. The four large braces are placed behind, possibly to make the tabernacle more stable. From the base of the first compartment six small bells hang, with the date 1614, after the date of the monstrance's creation. Above it are six balustered columns with their corresponding antes, on salient braces. The entablature is decorated with winged cherub heads and starred motifs and supports the small figures of the Apostles, on the vertical of the columns. Inside is the gilded glass bordered by clouds and gusts of beams. On the second, more balustered columns support a cover un der which is the image of the Immaculate Virgin. The third, with the same lines as the previous ones but simpler, holds the scene of the Resurrection of Christ—quite probably from a later date—surrounded by angels carrying the attributes of the Passion. The last one holds a bell—which occupies the place of a previous adornment—under its cupula. All this is ornamented with cherub heads, zoomorphic and plant motifs, scallop shells in relief, etc... which form a Plateresque decoration that fills the entire piece.

Commissioned to the silversmith Guillermo de Gante in 1572, his son Bernal Madera will be the one who finishes and delivers it in 1586. It was restored in Compostela in 1950.

(M.L.L.)

BIBLIOGRAPHY
Catálogo (1965)

201
Processional Cross
GONZALO DE CEA
1589

Silver
114 x 52 cm.
Cea

PARISH CHURCH OF VIANA DO BOLO
(OURENSE)

This work by Cea is a Latin cross with wavy arms that have trilobed ends with circular medallions. The surface of the arms is covered with Renaissance decoration, with angel heads and geometric forms.

Circular panels, on the front with an idealized representation of Jerusalem and the Sun and Moon. The crucified figure is done in high relief, with three nails. It has a slightly inclined body, horizontal arms, the head bent to the right and an anatomy that is carefully sculpted, as well as the rhythmically folded perizonium.

In the front panel is a relief of the Ascent of the Virgin, patron of the church, symmetrically surrounded by angels.

On the medallions of the ends the Eternal Father, Saint John the Evangelist, the Mater Dolorosa and the four Evangelists with their symbols are represented. Also at the crucified Christ's feet in the skull which alludes to Mount Calvary and Christ's triumph over death.

The foot has an architectural structure of two bodies, with fine ends, preferred as F covers with pediments, columns and niches with scallop shells which hold figures of apostles and saints.

It is a typically Renaissance or Plateresque cross, both in its structure and its figuration, strongly influenced by works which at the time were being produced in the workshops of important silversmiths in Valladolid, Palencia, and within Galicia, in Ourense. This work, whose technique is careful, is very valuable among the Galician silver work of its period.

(M.-A.G.G.)

BIBLIOGRAPHY
Unpublished.

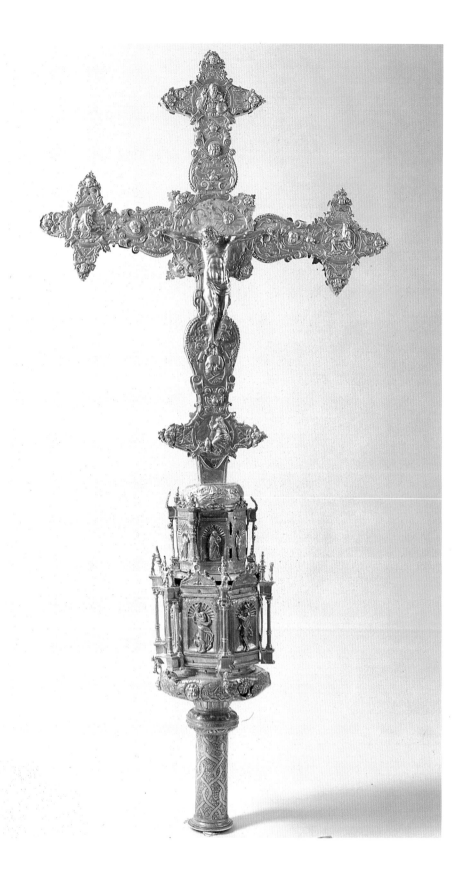

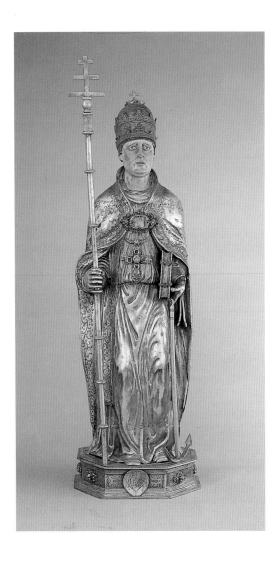

the Elder in the Compostelan workshop with an artistic production that is dated between 1589 and 1620.

Of gilded, molded and engraved silver, it shows an impressive mastery of the human figure, not common in the Compostelan workshops, which is enriched by cold enamelling on the skin areas and the application of jewels.

Dressed as Pontifice, the tunic falls in curved folds and deep hollows, giving the impression of soft, slippery fabric, breaking over the pedestal. The rain cape is caught at the chest with an exquisitely modeled brooch, made into a reliquary, of dynamic hollowed out plant forms, enamelled in green. The pectoral cross has tiny filigree and encrusted gems. The cape is adorned with bands and in the back part has a hood in high relief in which the prelate's shield is engraved; the field is covered with stylized pointed floral figures. In the right hand is the papal staff and the left a book and anchor, symbol of the Saint's martyrdom.

The octogonal base, with molding and a frieze decorated with engraved plant forms, has a jewel set on all sides, except for the front, which has the shield of Sanclemente. It is a cut out console with marquetry work, in counterplaced spirals, pierced by the classical circles that usually accompany them, and with plant fronds framing angels' heads.

The form of the gloved hands stands out, especially the left one, violently contorted in order to hold the book, as does the form of the imposing head, framed by the cape raised in the form of a "v" and the concentric folds of the tunic, which reveal a hardy neck and a smooth tiara.

The figure represents a mature man, with a strong expression and forceful character, with perfect anatomy, fine facial features, fixed expression, and wrinkled brow, utterly realistic.

Stylized and robust, with an equilibrium of shapes, full of quietude, elegant gesture, and a strength impregnated by his spirit, this is a balanced statue which fits the stylistic moment. The face, of contained passion, constitutes an authentic portrait in which thought is more important than feeling, within the Classicism of influence by Becerra and Juan de Juni, in the severe style of Philip II, which would last until the middle of the seventeenth century. In the small statue one observes the influence of the Council of Trent, with its sombre decorative geometries, subsituting the ornamentation of mythological origin, which his father, "o Vello" Cedeira, had used in the bust of Saint Pauline, in the same reliquary.

(A.B.B.)

202
Saint Clement
JORGE CEDEIRA "THE KID"
1593 ?

Glossed and enamelled silver
62 x 21 x 25 cm.
Santiago de Compostela

CHAPEL OF RELICS. CATHEDRAL
OF SANTIAGO DE COMPOSTELA

The statue was commissioned by Archbishop D. Juan de Sanclemente y Torquemada, whose coats of arms it bears, perhaps for the foundation and endowment of the Saint's feast (1593). The work, undoubtedly from the workshop of the Cedeiras, must be attributed to Jorge "o Mozo", author of the Saint Florina of the same reliquiary. The evidence of the engraved motifs and the shields, and especially the brackets of cut out angular shapes with leaves framing angel heads, are the same in both bases. Jorge Cedeira "the Younger", of Portuguese origin, succeeds his father Jorge Cedeira

BIBLIOGRAPHY
Alcolea Gil, S. (1975); Filgueira Valverde, J. (1959); López Ferreiro, A. (1898-1911)

203
Seat Monstrance
JUAN DE ARFE Y VILLAFAÑE
End of XVIth century

Gold-plated silver
113 x 39 cm.

MUSEUM OF THE CATHEDRAL OF LUGO

Piece with rectangular base on which a first section, formed by four round arches, resting on twelve columns with Doric capitals, is placed. The second section is eight-sided and has a very high rising cupula, which supports a small temple set on eight columns with Ionic capitals.

The decoration is very sparse because the intention is to emphasize the architectural nature of the elements which comprise the monstrance. The only concession is in the use of the decorative motifs preferred by the craftsman: small shields framed by brackets and tiny oval mirrors centered on the dados and on the outside of the cupula which is in turn adorned with scallop shells on the corners; open-work swirls on the lower arches, and baluster end adorned with pinnacles in both sections. The strongly emphasized columns have incised decoration of plant motifs on the lower part. Its height gives the work the impression of weightlessness. Under the niche of the second section, on a moulded pedestal, is an Agnus Dei with a banner, representation of Christ returned from the dead and glorified.

It is not known when Juan de Arfe did this monstrance, only that it was given to the Cathedral by bishop Diego de Castejón y Fonseca in 1636, and the craftsman had died in 1603. It may have been finished already in 1596, before Arfe's stay in Madrid (Chamoso).

(M.L.L.)

BIBLIOGRAPHY
Chamoso Lamas, M. (1984)

204
Chalice of the Evangelists
LUCAS DE VALDÉS
End of the XVIth century

Overgilded silver
25 x 16,5 x 9 cm.
Craftsman's emblem on the semisphere where the evangelists are seated
Córdoba

DIOCESAN MUSEUM OF TUI (PONTEVEDRA)

Circular foot with vertical, smooth edge and casquette with convex profile, with a dip in the center in which the stem is placed, composed of: pedestal with semispherical moudling which suports another cylindrical moulding that ends in a smooth, overhanging plate, several small mouoldings which lead to a jar knot and a moulding which supports the conico-cylindrical lower bowl and the bowl, both separated by a double fillet.

The piece follows the Mannerist aesthetic, both structurally and decoratively. The foot is covered with variegated ornamentation, a garland of leaves and fruit as border, and inset stones, flanked by double "C" motifs. The stem is also profusely decorated. On the semispherical egg-and-dart moulding there are four high relief figures, and on the pedestal another four, all in niches. In the lower oval section of the knot, another four full-length figures and decorations of handle shape on the end. The lower bowl has four ribs in rectangular section with mouldings, among which are ovals with figures.

The documentation notes that it was donated by bishop Tolosa and that it is the work of the Cordoban Lucas de Valdés, of whom we only know the period in which he carried out his work, between 1585 and 1634, and his trade, engraver and metalsmith.

In relation to the iconographic interpretation, we follow Professor Rosende Valdés' explanation. This is centered in the mass as the ceremony of the Passion. Therefore, the Evangelists, as narrators of the life of Christ and directly rellated to the Sacrament. That it is situated on the pedestal that holds the chalice may be interpreted as a metaphor of the Triumphant Church, sustained by the Evangelists. In the same manner as the four theologians of the Latin Church shown on the lower bowl, who, with their commentaries of the Evangels, enriched the doctrine. The four figures of the knot are Saint Francis and Saint Bonaventure on one hand, Saint Domingo and Saint Thomas Aquinus on the other. This is explained because Bishops Tolosa, as Superior of the Franciscan Order, would taken into account the most representative saints of the orders of the mendicant context to which they belonged.

(M.L.L.)

BIBLIOGRAPHY
Rosende Valdés, A. A. (1981)

205
Seat Monstrance
JUAN DE NÁPOLES, MARCELO
DE MONTANOS AND MIGUEL MOJADOS
1602

Gold-plated and natural silver
104 x 48 cm.

CATHEDRAL OF TUI (PONTEVEDRA)

Tower-shaped wafer box formed by three bodies of hexagonal shape. The first one is composed of six round arches on double columns in radial placement. The second has the same structure but a smaller perimeter. The composition of the third is maintained although it is disguised by a Baroque reform; and it rises from a semispherical calotte which ends in a small cupula on which the cross is set. The first ostensory was substituted by the present Baroque one, with circular form, moulded stem with jar joint and circular sun with straight, irregular rays.

The coats of arms are set on the ridge among cartouches with the coat of arms of the donating

bishop. At the front of the ledge, buttons gold-plated and intertwined, similar to those of the frieze. The rest of the base is decorated with ribbons and braces. The columns, whose shaft is divided in thirds, the middle one adjoining and the other two 'with a type of decoration very similar to that used by Juan de Benavente in his wafer boxes' (Brasas). Above them, large wings soften the passage to the entablature. The lower vault is decorated with ribbons, large flowers, lambrequins and braces. On the base of the second one are small temples of pyramid-shaped cover which hold little bells whose sound announced the presence of the wafer box. Above the entablature are decorative elements pf architectural character. The reform of the last body consists of a series of wings in the form of an S and plant motifs aplied to the original structure of Tuscan columns, in the interior of which is another bell. The ostensory is completely gold-plated and adorned with Baroque decoration of acanthus leaves.

The contract signed with the silversmiths in Tui the 2nd of January of 1602 at the request of bishop Tolosa, included the iconographic plan (now also changed). We know what the original must have been like through the inventories which mention the presence in

the first body of figures, of gilded and engraved silver, of the twelve Apostles, Saint Francis, Saint Domingo, Saint Bernadino, Saint Bonaventure and Saint Peter Telmo, "... an image with a stem and on the top a sun," which could be the original ostensory. In the second, an image of the Virgin. Later inventories indicate that the figures were used to make the cruets for the Holy Oil. This iconographic program tries to emphasize the triumphal apotheosis of the Eucharist as the way to Salvation (Rosende). The Apostles, as the first followers of Christ and spreaders of his doctrine. The most outstanding representatives of the teachings of the Church and the mendicant orders symbol of the militant Church. Saint Telmo as the patron of the city and the Virgin as mediator in the Redemption. The typology of Asunta which the image of the Virgin must have had is explained by the fact that this is the great festival celebrated by the Cathedral of Tui. The cross is a colophon to the idea of the church born from the sacrifice of Christ.

(M.L.L.)

BIBLIOGRAPHY
Brasas Egido, J.C. (1983); Rosende Valdés, A.A. (1981)

206
Processional Cross
GASPAR GONZÁLEZ
1614

Silver
132 cm.

PARISH CHURCH OF SANTA EULALIA
DE BANGA, CARBALLIÑO (OURENSE)

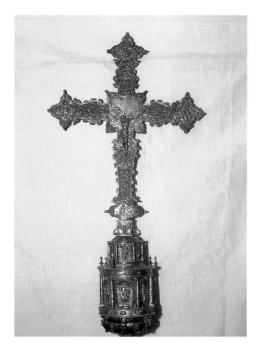
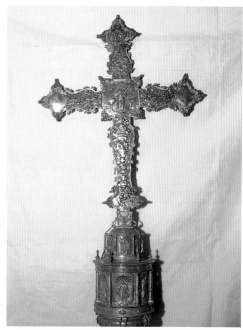

Circular cannon which holds the calotte on which a two-bodied joint rests—the upper one being smaller—above which the cross of trifoil ends rises.

The calotte seems to be egg-and-darted. Above it, in whose lower part niches with shells hold images of saints, separated by Doric columns ending in balustered pinnacles over the entablature. The upper part, formed by another six compartments, separated by columns, which also have images. The planes of the cross are entirely covered with plant ornamentation and the plate which covers the cross with arms decorated with trees anf large flowers on its vertices. The four Evangelists appear on the trifoil.

According to documented data, in 1614 the silversmith from Ourense Gaspar González was commissioned to do this cross, equal in form to the one he had made for Santa MarIa de Sobrado do Bispo.

(M.L.L.)

BIBLIOGRAPHY
Ramón y Fernández Oxea, J.(1948)

207
Processional Cross
ISIDRO DE MONTANOS ?
1648

Gold-plated and natural silver
95 cm. high

PARISH CHURCH OF SANTIAGO DE ZORELLE,
MACEDA (OURENSE)

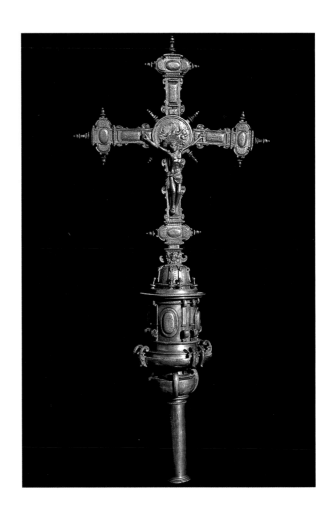

Circular cannon on which the joint rests, basically formed by a semicircular mouldng, neck and another cylindrical moulding that is larger and ends in a disk on which the cupula rests. The cross is a tace cross and its arms join in a circular central medallion with pinnacles at the angles, which also decorate the taces of the arms.

On the joint is a decoration of ribs with marked volume, both smooth anf phylomorphus, ending almost in volutes, among which are oval mirrors.

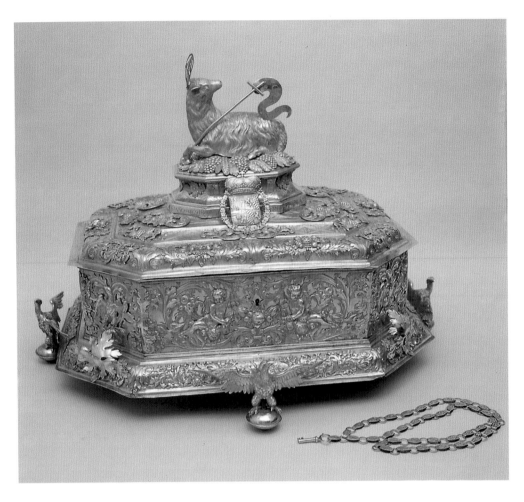

Coffer of eight-sided body on a protruding convex moulding suported on four feet. The lid is flat with convex edges and on it rests a pedestal, also eight-sided, on which the Agnus Dei rests.

The piece is made of engraved silver with decoration applied to the base of embossed and cut out pieces of natural silver. This decoration has plant motifs to which are added cherubs on the larger sides and eagles with open wings on the smaller ones. The chisel work is detailed in the eagles with unfolded wings which, on flattened balls, serve as base for the coffer. Embossed on the moulding beneath the box and on the lid, where there is also incised decoration in the form of a rhomboidal network with flowers. The pedestal has around the base the donor's inscription: (DONA MARIANA PALATINA GAVE THIS COFFER IN 1691). On the front rests the coat of arms of King Charles II, with the golden fleece. It sustains an Agnus Dei of engraved natural silver, with a gilded crown, cross and banner with inscription, which rests on a bed of wheat and clusters of grapes. The interior is also decorated. On the lid, in a central plate of natural silver, is the scene of a heavenly banquet with cherubs in dynamic postures which carry allusive objects, such as the basket of fruit, the lute, anf the flowers, on a background of clouds. In the back of the box there is a sunken center (to place the goblet) made of natural silver, weith embossed decoration of bunches of grapes and wheat joined by bows which form a border around a central floral motif.

The piece was donated by Marian of Neuburg upon her arrival in Spain, after disembarking in Mugardos on her way to Madrid, where she would marry King Charles II. The piece's German origin is corroborated by the punch of the city of Augsburg (fruit with seeds) used during this century. The use of eagles in the decoration is very fitting as an imperial symbol. The other punch, either that of the craftsman or the contrast, is unknown.

The use of very dynamic elements such as the Baroque vegetation of floral motifs and stylized acanthus, the eagles that appear to take off into flight, the cherubs in the most varied postures that form a decoration which entirely covers the piece, even on the back. The effects of lighht and color, produced by the use of overset plates and of two metals, confirm that this is a Baroque piece.

On the other hand, its intention for religious use is clear, both for its typology and for the continuous reference to the sacrament of the Eucharist in the presence of symbols like the grapevine, wheat spikes or the banquet.

(M.L.L.).

BIBLIOGRAPHY
Louzao Martínez, F.- J. (1989); Molist Frade, B. (1986).

Heads of winged cherubs are applied to the forked piece where the cross is attached. The planes of the cross, as well as the taces, are decorated with oval and rectangular mirrors and its perimiter with "C" motifs. In the central medallion is an engraved figure of Santiago Pilgrim.

The piece is attributed to the silversmith Isidro de Montaos, although it is missing the punch that would prove this.

(M.L.L.)

BIBLIOGRAPHY
Catálogo (1965).

208
Eucharistical Coffer
ANONYMOUS
1691

Embossed and natural silver
73 x 57,5 x 58 cm.
Fruit with seeds, on the protruding rim of the cover
DOÑA MARIANA PALATINA DIO ESTA ARCA AÑO DE 1691: ECCE ANUS.
Augsburg

ROYAL COLLEGIATE CHURCH OF SANTA MARÍA DO CAMPO. A CORUÑA

209
Portable Monstrance
ANONYMOUS
1695

Overgilded and natural silver
108 cm. total height; 38 x 31 cm. base; 69 x 49 cm. sun
Engraved IL on the rim of the base; engraved.
MARIA ANNA PALATINA REGINA
HISPANIARUM 1695
Augsburg (?).

ROYAL COLLEGIATE CHURCH
OF SANTA MARÍA DO CAMPO. A CORUÑA

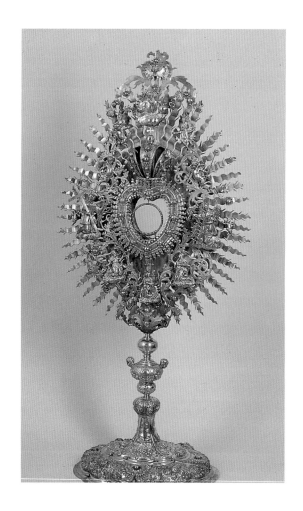

Monstrance of the sun type with oval base with lobed outline which combines a smooth rim, straight moulding and convex calotte. The base ends in a semispherical element. The stem is baluster type, composed of a narrow concave moulding, a jar knot and, again, a spherical element, this time smooth, with mouldings on its upper and lower portions, which leads to the sun. The sun has on oval silhouette, crowned by a simple, smooth, flat Latin cross. Thhe middle body is heart-shaped, trimmed on the upper part with a crown. The clear glass is circular.

The base and socle are covered with an embossed decoration of plant motifs and angel heads, extending over the surface or placed in fields as in the socle. The decoration on the stem is centered in the knot, where in addition to the plant elements there are small mirrors and angel heads of rounded form, separately engraved and applied. The box is surrounded by small wavy rays both inside and outside, and adorned in front by flowers similar to sunflowers whhich also cover the crown. The sun has blazing rays with applications of bouquets formed by flowers, leaves and clusters of grapes. Here the most important decorative theme is centered: a series of engraved overlaid figures, which from top to bottom and left to right are as follows: a dove, God the Father, a cherub with laurel, another with a lance, an angel with a cross and tongs, Saint John, Mary Magdalen, The Virgin, an angel with ladder and hammer, a cherub with a lance and sponge and, finally, another with a palm.

The donation of this piece is not recorded in a document, but the inscription reveals the name of the donor, Marian of Neuburg, with the date of 1695. The German city of Augsburg may be its origin, since it participates in both the technique and the decorative style of the liturgical coffer analyzed earlier. We do not know whom the punch IL, of the craftsman or contrast, represents.

The dynamism of the forms, structural as well as decorative, the chromatic contrast that accentuates the impression of richness, is increased here with the profusion of figures which are applied to the piece and float weightlessly above a line of clouds.

There are figures which allude to the Passion, Death and Resurrection of Christ, renewed in the sacrament of the Eucharist. On the one hand the Holy Trinity, the Holy Spirit (in the dove), the

instruments of the Passion, the Virgin and Saint John, present it, and others with palms and laurels, symbol of the Resurrection, toward which Magdalen, the first witness of it is looking.

(M.L.L.).

BIBLIOGRAPHY
Louzao Martínez, F.J. (1989); Molist Frade, B. (1986)

210
Monstrance of the Sanctuary das Ermitas
PEDRO GARRIDO
1696

Partially gilded silver
80 x 30 cm.

SANTUARIO DE NOSA SEÑORA DE AS ERMITAS (OURENSE)

This monstrance is especially interesting because of its unusual typology and technique, in which the embossing of the base is mixed with the filigree of the monstrance itself.

The rectangular base rests on four legs with medallions that are engraved and embossed with plant motifs and eucharistical symbols (grapevines) profusely decorate the various mouldings and the convex central section. On it rests an urn-shaped figure with large open-work wings, and a sun with alternating smooth and flame-shaped rays ending in eight pointed stars with gemstones in the center emerges from the upper part. This all ends in a cross. The frame of the glass is also decorated with stones and four lilies on the base add to its attractiveness, perhaps alluding to the use of this monstrance for the cult of Mary. The filigree technique is pure.

The base and monstrance are so different in technique and style that in spite of the documentary information we believe that the base, dated and signed by Pedro Garrido, in fact corresponds to the usual style and technique of this craftsman, while the monstrance itself could be by someone else and some other place, perhaps a pious donation to the sanctuary by some indiano (Spaniard who has been in the Indies), since it recalls American works from the XVIIth century. Whatever that may be, the

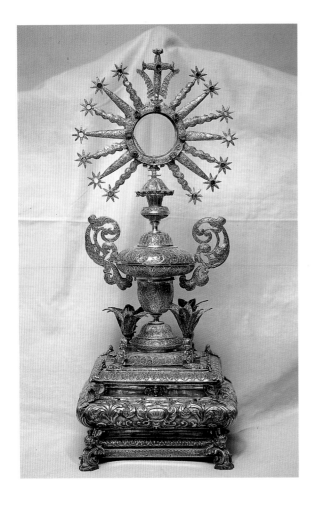

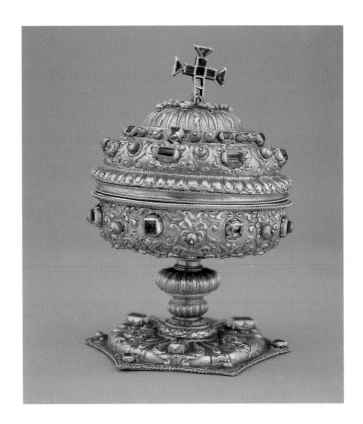

whole is harmonious and outstanding because of its originality.

(M.- A.G.G.).

BIBLIOGRAPHY

Bonet Correa, A., Carballo-Calero Ramos, M.V., González García, M.A. (1987); Brasas Egido, J.C. (1980); Couselo Bouzas, J. (1932).

211
Gobet
JUAN POSSE.
SCHOOL OF COMPOSTELA
1699

Gold, precious stones, pearls, and enamel
15 x 10,3 x 9,3 cm.
Santiago de Compostela

TREASURE OF THE CATHEDRAL OF SANTIAGO DE COMPOSTELA

It was commissioned in 1699 by the church chapter to the Compostelan metalsmith Juan Posse. A native of San Esteban de Suesto (Vimianzo, A Coruña), in 1683 he appears as an official in the workshop of Andrés de Calo y Castro, who must have been his master and teacher. An excellent silversmith, he carries out his professional work at the turn of the century (between 1683 and 1732). He left a deep mark on Galician silverwork.

The size of the piece corresponds to the narrowness of the sacrarium, which was the base of the monstrance by Antonio Arfe (still located in the main chapel of the Cathedral).

Its foot, a very flat circle, is inscribed in a hexagon with curved sides, whose spandrels are adorned with plant forms, and alternating pearls and emeralds. Divided in six strips by tears, the panels are occupied by heads of seraphins, combined with regraved caledonians. The small neck, of lathed baluster outline, has a crowned rebate moulding as base, and the double moulding of the knot is decorated with egg-and-dart. The short cup has a base decorated with radial tears broken by floral formations in spirals, leaving an open space in the front by way of a shield, in which emeralds, rubies and pearls are set. The cover is a delicate combination of curved mouldings, set opposite each other, with the same repertoir of precious stones repeated on each moulding. It is finished off with a spherical calotte with smooth, flame-shaped lines, trimmed with strings of irregular pearls.

The upper cross, with triangular ends, is decorated on one side with set emeralds and on the other with whitish enamels, in abstract forms and free design, in whites, reds, and greens, and the irregular, capricious forms of the small partitions in brilliant golds are set off against these colors.

Posse's goblet of beautifully simple lines and very good technique, is an exquisite work of art in which the color of the precious materials plays an important eye-deceiving role. For its typology and taste it is a totally Baroque work, with the return to decorated surfaces of excessive ornamentation, and to the use of precious stones and enamels of old Hispanic traditions.

(A.B.B.)

BIBLIOGRAPHY

Couselo Bouzas, J. (1932); Filgueira Valverde, J. (1959); López Ferreiro, A. (1898-1911); Pérez Costanti, P. (1930)

212
Monstrance
JUAN DE FIGUEROA Y VEGA.
SCHOOL OF SALAMANCA
1702

Gold, precious stones and enamel.
38,5 x 21 cm.
Salamanca

TREASURE OF THE CATHEDRAL OF SANTIAGO
DE COMPOSTELA

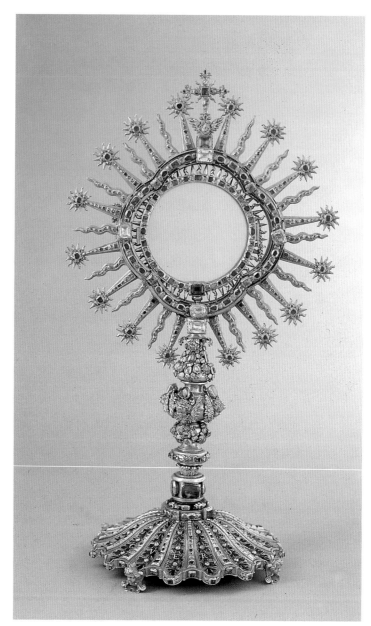

In 1687 the church chapter of Compostela agrees to make a "Vyril of gold and precious stones", carrying out an old aspiration of complementing the silver decoration of the main chapel done by the archbishop-Mycenas D. Antonio de Monroy, of the Kingdom of Mexico, and which had been done by the Salamancan metalsmith Juan de Figueroa y Vega, with whom this new contract is signed in 1701. They gave him 56 ounces of gold, 5 rubies, 22 sapphires, 18 emeralds, 195 diamonds, and 300 doubloons for the gold and stones that might be needed. According to Figueroa's designs, the monstrance would be flanked by two angels with baskets on their heads, which were eliminated, lowering the height of the piece.

Figueroa is one of the greatest representatives of the exuberant metalcrafting of Salamanca in the XVIIIth century. The monstrance bears the inscription: 'Figueroa F(ecit), in Salamanca, Year of 1702', and the stamp of the city, with an aqueduct in the upper field and a lion in the lower one.

The monstrance has the form of a sun or rayed halo, and is completely covered with precious stones and enamels. The circular base, set on three angel heads, has an undulated form, with concave grooves adorned with elongated lobed leaves, enamelled in green, and with a wide regraved edge with precious stones. The stem of baluster profile, is covered with a profusioon of stones and especially with enamels of leaves, baskets and tears and clumps of delicious fruit. The roses, of various bright colors, predominate, with reds and golds on white backgrounds. They are done with brush point, with pictorial aspect. Two sapphires on one side and two emeralds on the other form a link with the halo, which shows the rare feature of having four lobes. In it are set stones of various colors and beams of different combinations extend outward: flame-shaped with diamonds alternating with other straight ones, ending in stars set with rubies. It is finished off with a plant cross on the enamelled angel head. The circular clear glass is decorated with stones and small rays.

Because of its shapes and ornamentation of stones and enamel, reduced to simple decorative methods, the monstrance is included in the European Baroque currents, in the Genevan tradition of pictorial enamel. Nevertheless, the presence in the initial project of the angels with baskets of fruit on their heads is significant. They refer to another artistic center in Mexico, thus relating the piece to the American influence in Hispanic metalcrafting. Figueroa's work also

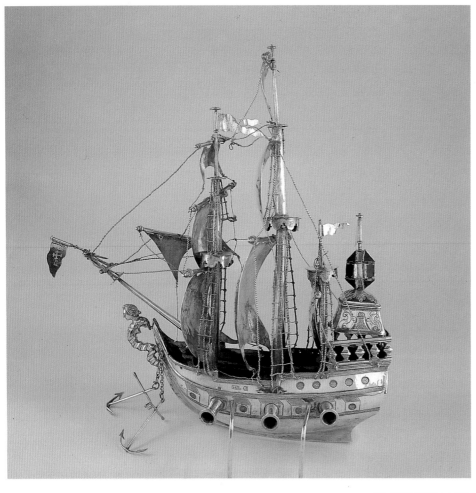

signifies another connection with the Salamancan and Compostelan silvercrafting, showing the influence here of these workshops.

(A.B.B.)

BIBLIOGRAPHY
Alcolea Gil,S. (1975); Couselo Bouzas, J. (1932); Filgueira Valverde, J. (1959); López Ferreiro, A. (1898-1911)

213
Saint Telmo's Ship
SIMÓN PÉREZ DE LA ROCHA
Middle of the XVIIIth century

Gold-plated and natural silver
44,5 x 28 x 10,5 cm.

CATHEDRAL OF TUI (PONTEVEDRA)

Caravel with smooth hull which has six cast cannons applied to engraved portholes—three port and three starboard—. Two are gilded silver and the middle one is natural silver. On the prow is the gold-plated figurehead, cast and engraved, and two anchors with chains. At the stern is a gilded balustrade surrounding the castle which ends in a lighthouse with red stones and a bannerole, decorated with engraved braces. The masts and spars are composed of a bowsprit, foremast, mainmast, mizzen-mast and yards, with their ropes, unfolded sails and raised flags. The interest in detail that makes the piece a small model is evident.

It was offered to Saint Peter González Telmo, patron of the diocese of Tui. The miracles attributed to it awoke the vocation of the sailors who, after the XVIth century began to call him Saint Telmo.

(M.L.L.)

BIBLIOGRAPHY
Sáez González, M. (1984)

214
Chalice
ANONYMOUS
XVIIIth century

Gold-plated silver
23,5 x 15,5 x 9,5 cm.

CATHEDRAL OF TUI (PONTEVEDRA)

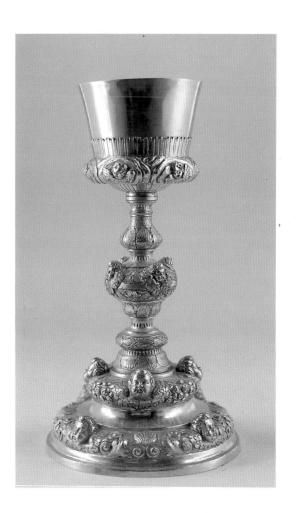

Very high trumpet-shaped foot composed by smooth concave mouldings and adorned convex mouldings. The stem is moulded and has a prominent urn joint. The cup is cylindrical-conical, with egg-and-dart decoration cut in its lower half and decorated around the middle with a semicircular moulding.

The decoration, which covers almost the entire piece, is varied. This is due in part to the use of different techniques such as carving and engraving. The most constant themes in Baroque Plateresque are abundant, such as the swirls with fleshy appearance which serve as a frame to the heads of cherubs with unfolded wings and the scallop shells interspersed among the foliage. The profiles of the piece, especially the stem, soften and become curving, losing the impression of compartimentation by pieces and creating the sensation of continuity.

(M.L.L.)

BIBLIOGRAPHY
Catálogo (1965)

215
Crucifix of Rajoy
ANONYMOUS
Second third of the XVIIIth century

Ivory and rosewood
27,5 x 7,5 x 4,2 cm.
Madrid

CHAPEL OF RELICS. CATHEDRAL OF
SANTIAGO DE COMPOSTELA

It belonged to the archbishop of Compostela Bartolomé Raxoi e Losada (1690-1772), the great Mycenas, situated at the crossroads of stylistic change, 'providing with his patronage a very early chronology for Compostelan Neoclassicism'.

The Crucifix is an outstanding and significant piece of the ivory sculpture of the period. Raxoi commissions the sculptor José Gambino to produce it and make some modifications.

The Rococo pedestal of twisted forms and a beautiful ivory and gold polychromy, ends in a sphere with serpent into which the cross fits. The latter has rosy-brown tones and has ivory incrustations of the instruments of the Passion, the cartouche of the INRI and corner-plates with spheres.

The Crucifix is formed by a single piece from which the body is carved, to which short arms are added. Following the curve of the tooth, it stands out for its slenderness and the details of a well-studied anatomy. The loin cloth, rounded and wrinkled, tied with a cord, is knotted at the front and raised to the left, leaving the body bare.

Christ is represented as alive, with a beautiful realistic face although excessively sweet, with a curly beard and hair in wide waves which separate in corkscrew curls over the shoulders.

It is a statue of Neoclassical rhythm, elegant and aristocratic, with serene forms, impassive in its cold expression, without dramatic exaltation.

This piece must come from the ivory workshop which Charles III had ordered organized in the Retiro Park of Madrid, where Italians and Spaniards worked. Among these Antonio Salvador (1685-1766) stood out. He was a Valencian sculptor formed in Rome, whose preferred works are those of ivory.

(A.B.B.).

BIBLIOGRAPHY
Alcolea Gil, S. (1958); Couselo Bouzas, J. (1932); Filgueira Valverde, J. (1959); López y López, R. (1955); Otero Túñez, R. (1977)

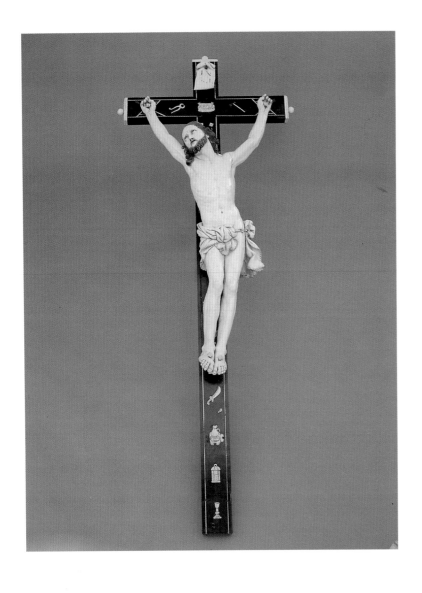

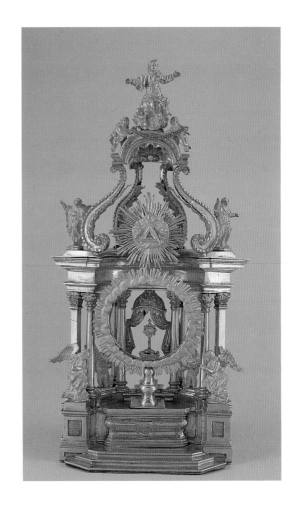

216
Portable Monstrance
ANONYMOUS
Second half of the XVIIIth century

Gold-plated and natural silver
33 x 14 cm.

PARISH CHURCH OF SANTIAGO. PONTEDEUME
(A CORUÑA)

From the high socle rise eight paired columns and Corinthian pillars which support an entablature in whose center is the symbol of the Holy Trinity on a field of clouds, sun beams and cherub heads.

Above the entablature, four stylized S forms with plant decoration, flanked by separate figures of angels, hold a semi-cupula with scallop shells above which the scene of the Ascent of the Virgin rises. On the altar is a glass with a very short baluster stem, surrounded by a border of clouds and gusts of beams and with adoring angels on the sides. Both structurally and decoratively it reproduces the main eucharistical altar of the Cathedral of Lugo.

It was given by the archbishop of Santiago, Bartolomé Rajoy y Losada, born in the town and benefactor of its church.

(M.L.L.)

BIBLIOGRAPHY
Catálogo (1965).

217
Saint Barbara
JUAN ÁLVAREZ. SCHOOL
OF VALLADOLID
1773

Glossed silver
58 cm. tall
Valladolid

CHAPEL OF RELICS. CATHEDRAL
OF SANTIAGO DE COMPOSTELA

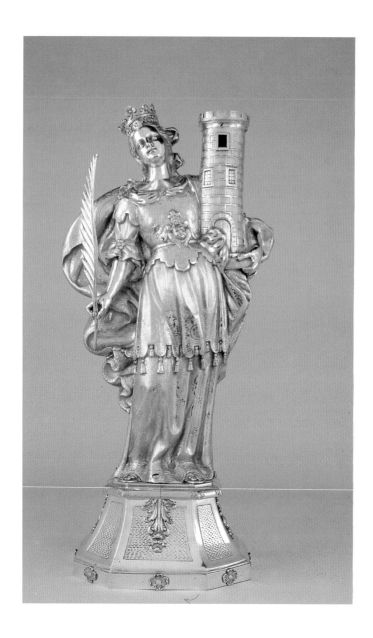

The image is a votive offering of the cathedral Chapter of Compostela for the Chapel of Relics, when the festival of the saint was established after the cathedral emerged unharmed by the lightning bolt which pierced it in 1731.

It is the work of Juan Alvarez, silversmith from Valladolid, done according to drawings by the Compostelan painter Juan Antonio García de Bouzas. The statue was delivered in 1733. The assignment must have been the result of a friendship between the painter and the metalcrafter, in a possible combination in the formative trajectory of both artists. Juan Alvarez stood out, in any event, from the group of metalworkers who worked in the city of the Pisuerga River.

The understanding in the aesthetic ideals between the two artists is evident in the harmonious figurine. The influence of García de Bouzas' drawing must be considerable. In the Rococo current, found in Compostela from the second quarter of the XVIIIth century on, Juan Antonio has an outstanding intervention. The beautiful silver statue, bathed in gleaming golds, today lost in part, stands out for its graceful slenderness, full of curves. The monumental figure, resting on the left leg ad with the right one bent, twists its boddy, lifting its head upward.

It carries the palm in the right hand and the temples fitted with a crown: symbols of his martyrdom and intercession. It carries a big tower, held closely with its left hand on its hip. Its monumentality is emphasized by a refined study of the garments, of perfect technique, tunic of curving folds, short over tunic, armored bodice of sharp geometric profile and open neckline, which is adorned with subtle fabrics, in combination with the wide sleeves, which leave the arms bare. Floral brooches are pinned on the fabric. The belt is of complex composition: angel head with large spirals and a tufted end which opens and rosettes. This intentional decoration of jewels is finished off by the detailed floral crown which borders a young oval face of distinguished features. A fluttering mantle frames the figure, falling in cascades of large spirals.

The treament of the cloth enriches the decoration, as silky brocades, in which geometric and floral designs are placed in deep incisions. The decorative grouping introduces the statue in the game of illusion of a pictorial nature, with shining golds. The pedestal is lengthened in soft curves, with sheaths of applied roses.

The sensitivity, refinement and decorativity of the piece already has all the gracefulness of Rococo.

(A.B.B.)

BIBLIOGRAPHY
Alcolea Gil, S. (1975); Couselo Bouzas, J. (1932);Filgueira Valverde, J. (1959); Ortega Romero, M.S. (1982)

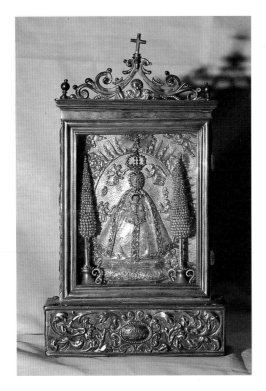 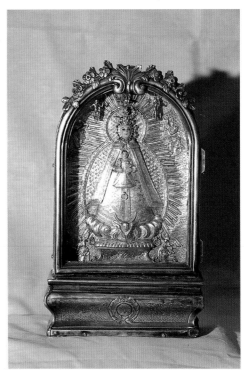

218
Three Alms Boxes
PEDRO GARRIDO AND JOSÉ
DE NÓVOA
XVIIIth century

Silver, enamel, wood, pearls and stones
Box 1: 40 x 22 cm. ; Box 2: 22 x 18 cm. ; Box 3:
33 x 17 cm.
Box 1: P. GARRIDO. Nuestra Sra de las Ermitas;
Box 2: VAL; Box 3: EN SANTIAGO AÑO DE
1784. NOBOA

SANCTUARY DE NOSA SEÑORA
DE AS ERMITAS. (OURENSE)

Of very different types, at least three may be established. Conceived as small altars with the embossed silver plate with the Virgin of the Hermitages as she is presented in her chamber, along with a box to receive the alms. The image usually is protected by glass and/or doors and has leather straps to place it over the chest. The silver may have gold-plated parts and the whole is enriched with enamels or semi-precious stones or pearls.

Stylistically, given the chronology of most of them, in the XVIIIth century—period of great economic splendor and devotion to the Hermitages—they belong to Baroque and Rococo creation. They are worked with delicacy and humor. They join a definite artistic value to a singular ethnographic and devotional one. These boxes were carried to very distant regions by the questores or collectors of alms for the sanctuary. In the XVIIIth century there were six and each one was in charge of asking in a specific region, carefully keeping the accounts of these contributions. This was an important means of spreading the venerated image whose sanctuary, of the patronage of the Bishops of Astorga, reached rightful fame, attracting many followers.

(M.-A.G.G.)

BIBLIOGRAPHY
*Bonet Correa, A., Carballo-Calero Ramos, M.V. ,
González García, M.A. (1987); Couselo Bouzas,
J. (1932)*

219
The Immaculate Virgin
MANUEL DE PRADO MARIÑO
AND FRANCISCO PECUL
1799

Cast and engraved silver and precious gems
53 x 23 cm.
Cathedral of Santiago de Compostela

MAIN CHAPEL OF THE CATHEDRAL OF
SANTIAGO DE COMPOSTELA

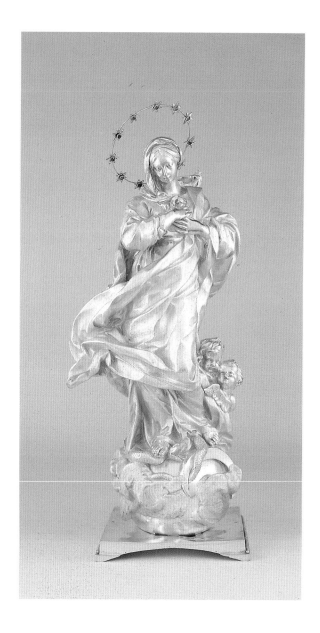

The Immaculate Virgin of the ciborium of the main chapel of the cathedral is a collaboration of the sculptor Manuel de Prado y Mariño, formed in Ferreiro's workshop, and the metalsmith from Compostela, Francisco Pecul, of French origin, resident in Madrid since childhood, who presented the image to the Academy of Saint Ferdinand and with it received the title of academician. The beautiful image is a good representation of the height of Hispanic Neoclassicism. In his "Curriculum," Manuel de Prado says that the Immaculate Virgin of Isidro Carnicero (Church of Saint Francis the Great in Madrid) served as his model.

The combination of sculptor's molding and the casting, engraving and quality of the metalsmith's treatment with burnished and matte finishes of different granulations, produced the excellent work of sculpture. The treatment of the silver, in flesh tones and cloth, has a certain pictorical air, as if it were a polychromy of white symphonies.

The globe, with clouds that are done with a palette-knife and granulated, situated on the classical smooth base, with a string of small spheres, has certain ethereal qualities. The Woman of the Apocalypse, with the moon as a bell, treads the serpent with realistic head, scaly body and subtle slithering movements. The Virgin is a stylized, graceful figure with Praxitelian form, which twists its body supported on the right leg, bending the left considerably, inclines its head and crosses its hands over the breast. It is a closed image of concentrated Baroque force.

The Virgin is wearing an ample tunic, tied at the waist, and a mantle that falls from the left shoulder, caught up under her arm and wrapping about the entire body, dragged by a strong gust of spiritual force into tense sharp-pointed forms of rustling fabric. In the hollow left by her body on the left, two entertaining, playful angel heads appear, compensating the asymmetry produced in the figure.

The oval face, with long, surved neck and extremely correct line, half-closed eyes and dreamy expression, is framed by the straight hair and topped by a fluttering veil, which the Lady clasps in her expressive hands of delicate shape. The crown is a band of twelve diamond and emerald stars.

It is an excellent piece of Spanish metalwork, in which realism and idealism, Baroque force and Neoclassical restraint, concentrated tranquillity and passion, are subtly blended in a most beautiful creation of careful, perfect technique and the best of design, full of the most exquisite spirituality.

(A.-B.B.)

BIBLIOGRAPHY
Alcolea Gil, S. (1975); Barral Iglesias, A (s.d.); Couselo Bouzas, J. 1932); Filgueira Valverde, J. (1959); Otero Túñez, R. (1977); (1982)

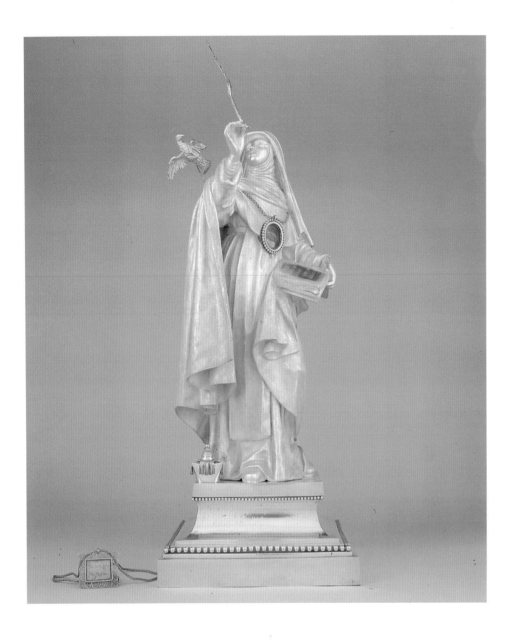

220
Statue-reliquary of Saint Teresa of Jesus
FRANCISCO PECUL
XVIIIth century

Natural color base, with gilded parts
57 x 24 x 24 cm.
Santiago de Compostela.

CHAPEL OF THE RELICS. CATHEDRAL
OF SANTIAGO DE COMPOSTELA

The image-reliquary was made to hold a tooth and an autograph of the Saint. It is a beautiful ecclesiastical work of the metalworker Francisco Pecul, of the silversmith family from Compostela. He lived in Madrid from his youth, where he studied and worked, with special dedication to the Royal Academy of Saint Francis, where he obtained the degree of academician, with the presentation of the Immaculate Virgin of the Cathedral in Compostela, done in collaboration with the sculptor Manuel de Prado y Mariño.

Lacking the exuberance of the Immaculate Virgin, and with a greater Neoclassical outline of somber form, it is an excellent work of metalcrafting. In it the study of the human body stands out, corresponding to his preferences ('the noble art of sculpture, engraved in the background and a branch of silverwork'), which he shows off in this small statue.

Of cast engraved silver, with noteworthy qualities in the treatment of the flesh areas and fabric, in burnished and matte finishes, the praxitelian silhouette is accentuated by the head which turns sharply upward toward the source of inspiration. It is accompanied by the gesture of the arm, which is raised holding a quill, while the open book rests on the left hip and is held by a strong hand. The image is set on a tall base, with fillet moulding and wide cavetto, accompanied by two rows of silvery pearls.

Wrapped in an ample carmelite robe, the cape stands out, hanging from the right arm and clasped beneath the book, while on the opposite side we see the derivation from the model of Gregorio Fernández in the treatment of the cloth, with slim, loose folds that fall to pointed and hollow peaks.

Added to her are the symbols of the Doctoress of the Church, mozetta and academic cap at her feet. The presence of the dove is obvious, as symbol of the Holy Spirit which flies to the Saint's right. This is a generalized motif in the XVIIIth century after the image of Antonio de Paz (Cathedral of Salamanca).

The result is a silvery sculpture full of refinement, with an elongated oval face, framed by the headpiece and veil, and with a delicate study of the hands.

(A.- B.B.)

BIBLIOGRAPHY
Couselo Bouzas, J. (1932); Filgueira Valverde, J. (1959); Murguía, M. (1884); Otero Túñez, R. (1977)

221
Chalice of Muzquiz
LUCAS DE FORO
1818

Gold and diamonds
27 x 14 base diam.
Treasure of the Cathedral of Santiago de
Compostela

CATHEDRAL OF SANTIAGO DE COMPOSTELA

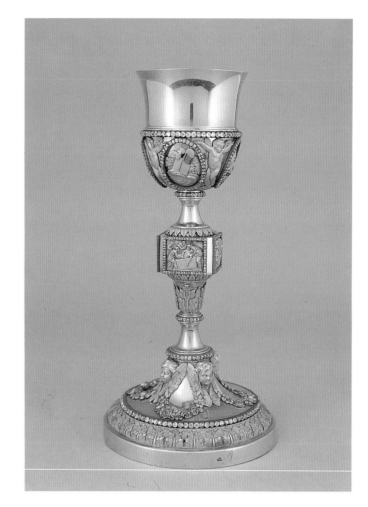

Two legends, on the front and back of the foot of
the chalice, tell us of its history: "This precious
chalice was donated to the Holy Apostle in the year
1819 by the Most Excellent and Illustrious Sir Don
Rafael de Múzquiz y Aldunate, Archbishop of
Santiago." "It was made in Madrid by D. Lucas de
Foro, native of the town of Albalate de Zurita, year
1818."

A precious piece of metalwork, of gold and
diamond trims, of Neoclassical exquisiteness, in
which are combined a clear, slender silhouette of
soberly elegant forms, with the ornamentation of
delicate acanthus leaves and floral wreathes, which
hang from winged angels' heads on the base. With a
column in combination of polished curves and
acanthus crowns, in which the novelty of the square
knot stands out. The sides are decorated with reliefs
of the Pasion of Christ: The Last Supper, the Agony
in the Garden, the Road to Calvary, and the Holy
Burial. The lower part of the chalice, of border with
ovals that bears Biblical symbols: the tablets of law,
the apocalyptic lamb, with rubies on the seven seals
of the book, the halo of Mount Carmelo, of Isaiah's
prophecy, and the allegorical ave phoenix of
classical mythology. On its spandrels, merry angels,
their entire body visible, hold the ovals.

The various parts of the chalice and their
iconographical and eucharistical programmation are
underlined with rows of diamonds.

(A.B.B.)

BIBLIOGRAPHY
*Filgueira Valverde, J. (1959); López Ferreiro, A.
(1898-1911); Otero Túñez, R. (1977)*

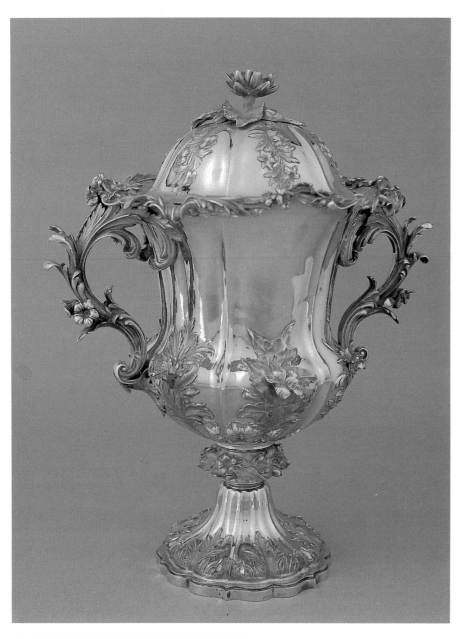

222
Cup of the National Offering
ANONYMOUS
1859

Gold-plated silver
46 cm. high and 40 cm. the diameter of the cup
Outside: JB/GC/WN; the figure of a lion; the
head of a fox/cat; T; silhouette of a man. Inside:
silhouette of a man; a lion; "t"
England

TREASURE OF THE CATHEDRAL OF SANTIAGO
DE COMPOSTELA

The National Offering, instituted by Philip IV in
1643, ratifying the Patronage of Santiago,
substituted the sending of objects. The offering of
the duke and duchess of Montpensier, royal
delegates of Isabella II in 1852, who accompanied it
with the cup, incorporated into the ceremony of the
25th of July and in which the cost of this Offering
was deposited.

It is a piece of English metal work, with exquisite
elegance and marked romantic character. The foot is
divided in six ogee arches. The interior and exterior
angles which are formed are accompanied with
concave and convex intersections which twist its
ascending surface into broad curves. It is decorated
with large acanthus leaves. The short neck is formed
by a scotia and a floral ring of lilies among its
waving leaves. From this the large cup opens
upward, its belly comprised of two counterplaced
curves: the lower one is convex and the upper one
concave. The angles of the foot now furrow the cup,
decorated with alternating palmettos and bundles of
carnations and lilies. Its raised perimeter becomes a
fine garland of delicate field flowers. The large
handles, counterplaced in "SS", are metamorphosed
into branches with leaves and flowers. The cover,
again with angles, ends in a crown with jazmines
and wild pineapple.

Only the bands of palmettos and the acanthus,
which adorn the foot and the cup, belong to the
Neoclassical repertoire. The formal treatment of the
cup and its decoration, an exhalted manifestation of
nature, with marked realism, situate it fully in the
romantic period.

(A.B.B.)

BIBLIOGRAPHY
*Filgueira Valverde, J. (1959); Neira de Mosquera,
A. (1950); Otero Túñez, R. (1977).*

THE NEW IDENTITY

CONTEMPORARY GALICIAN SOCIETY

X.R. Barreiro Fernández

I. GALICIA IN THE NINETEENTH CENTURY: AN EXHAUSTED SOCIETY

If art, especially architecture, is the reflection of taste and the economic health of a society, it is necessary to point out the decadence of Galician society throughout almost all the XIXth century. The five Cathedrals did not experience any progress during this century. The impressive monasteries of San Martiño Pinario, Oseira, Sobrado dos Monxes, Samos or Poio, or the prioral houses that were strategically situated throughout the rural areas, owe nothing to the XIXth century. The University of Compostela, from its conclusion at the beginning of this century, did not build even one wall. The barracks, hospitals, prisons, and schools continue to be those of the eighteenth century. The new liberal administration (city halls, courts, political leaderships) have to fit into the the old nationalized mansions due to the incapacity of the Ministry of Finance to erect new buildings.

Galicia stops being the opulent market for architects, statue-makers, master-builders of prime works, blacksmiths and metalsmiths. This decadence lays bare the fact that this country is economically squeezed and exhausted.

Let's see some of the causes of this situation.

Disentailment. When the disentailment is studied, in general some of its most prominent aspects tend to be emphasized, but little attention is paid to what in my opinion continues to be the nucleus of the problem: the brutal decapitalization that this meant. Villares Paz has quantified what Galicia had to pay the state for this between 1836 and 1867: 241 million reals. This enormous quantity went to pay for the lands that had always been worked in Galicia. That is, Galicia has had to rebuy, in this gigantic financial operation, the right to work the same lands which for centuries it had had. The Ministry of Finance in this case acted by draining off our surplus without receiving nearly anything in return, since, as is known, disentailment served to cover up the enormous budget deficit of the state and to cover the peremptory needs provoked by the first Carlist War. The state could not redistribute in the provinces what it had obtained from them.

Tributary pressure. The financial reform of 1845 designed a fiscal policy which directly taxed landed property, strategically freeing industry and commerce with the purpose of consolidating the bourgeoisie. Galicia will again be directly affected by this fiscal policy, as the land is its most important source of wealth. Tributary pressure from this moment on will act on the surplus, draining away a good part of it and causing its progressive decapitalization.

Political temporality. In the enumeration of the causes of Galicia's economic prostration we usually pay almost exclusive attention to those of a structural nature as far as they accent permanent situations, but at times we do not notice enough those apparently transitory circumstances which put pressure on the economic capacity of the population. Let's think,

for example, that Galicia has had to endure, almost uninterruptedly from 1808 to 1876, the weight of the extraordinary contributions of war to feed, dress, and arm the various forces that were being formed due to the temporary nature of the political regime.

From 1808 to 1814 Galicia contributed men and money to the war of Independence (even the gold and silver of its temples were sold), but in addition it had to face the contributions imposed by the French army (although only for six months), and the maintenance of the popular guerrillas.

Between 1820 and 1823 it had to suffer the first civil war between the liberals and the followers of absolutism who reorganized in the form of guerrillas. These guerrillas and the militias created to destroy them, weighed exclusively upon the Galician economy.

From 1834 and even 1840 Galicia lives a new civil war, known as the First Carlist War. Again it had to face a war economy, supporting two opposing armies. The people not only had to pay the contributions set by the State, but they also had to bear the contributions violently imposed upon them by the Carlist groups, arguing that since the regime of Isabel was an intruder it did not have the right to receive the taxes. But the people in practice had to face two parallel contributions. This situation was repeated in 1847 (Second Carlist War, although for a short time), and between 1871-1875 (Third Carlist War).

The military needs forced the government to create paramilitary armies (local and provincial militias, reconnaissance units, etc.), which had to be supported by the local treasuries through the use of their own funds and excise taxes (for which other needs had to be put aside, such as the schools paid for by these same funds), or by extraordinary contributions. Everything fell on the people who were economically exhausted.

This set of circumstances explains the decapitalization of our country and its economic asphyxiation. In summary we can say that:

- Disentailment, on taking income from the clergy, closed off the most important means of supporting the art market. The clergy canonically, unable to reroute its income toward industry or commerce, had for centuries oriented its enormous income power toward the construction and beautifying of its buildings.

- Disentailent, on facilitating the redemption of leased goods and the acquisition of incomes, attracted the economic interest of the Galician bourgeoisie and nobility that feverishly entered into this operation which, in the long run, was ruinous for them when they could not change the statutory relationship and had to conform themselves with a stagnated value clearly disproportionate to the investments made. Both social classes are decapitalized. Rural palaces and enormous mansions are no longer built, our nobles stop making pious foundations and building churches.

- The people on which all the tributary and income system falls is unable to face so many demands. It would be interesting to review the churches constructed in these years, the altars and images, the jewels. Probably the review would be depressing. Let us recall that these people have to adapt to the new situation of an impoverished clergy and the tithes which were eliminated will be substituted by the forced oblates, the funeral taxes and duties for services done by the clergy. And all this falls upon the people.

- Two words regarding the Galician bourgeoisie. From 1760 and as consequence of the opening of the trade from America through A Coruña and Vigo, a foreign bourgeoisie is installed in Galicia and soon, taking advantage of the optimum circumstances, is economically solidified. When we enter the nineteenth century the most progressive sector of this bourgeoisie is solidly established. Nevertheless, it was unable to create its own art. Let us think that the majority of these bourgeoisie had been hardware salesmen, junkmen, fabric dealers in the fairs who with audacity, savings, much work and business acumen were able to set up important businesses and industries. Their constructions were accommodated, as was their social behavior, to the model of the noble whom they had so close at hand and who looked down on them. Their houses were large mansions with no concession to luxury, with an enormous storage area and winecellar and many rooms, since it was common for all the employees and shopboys to live with the master. Inside their houses there were no paintings, nor books, nor valuable furniture. In the testamentary documents we find that the only luxury they sometimes allowed themselves was to have some silverware. With this austerity and always dreaming with some day obtaining the seal of nobility, these bourgeois lived. Only Ibáñez, the future marquis of Sargadelos, perhaps

because of his noble origin, was able to maintain a status in accordance with his economic situation.

Architecturally, the only thing that may be noted about this bourgeoisie is the construction of the tanning and preserving factories, in which functionality did not break with the geographical context in which they were installed.

This bourgeoisie which sociologically tries not to separate itself from the most representative social classes of Galicia, enters a crisis after the loss of the American market and that of the Baltic. It did not miss the opportunity to invest in desentailed goods, which, on turning them into financiers, assimilated them more than the nobles, and in this way with decapitalization and the lack of the regional market it enters a very grave crisis from which it will not emerge until the eighties. It was a bourgeoisie that left no mark on Galician art.

II. THE JOY OF LIVING RETURNS. A BOURGEOIS ART (XXth CENTURY).

After the 1880s, Galicia enters another economical and social horizon. Favored by the positive international opportunity, fed by the remittances of capital from America and with political instability eliminated, Galicia enters a phase which at least in the cities has symptoms of prosperity.

Our cattle enters the state market thanks to the conclusion of the railroad which joined us to Madrid; our fish becomes a valued product in Spanish cities and an ocean fishing fleet is created after 1900; our canned seafood, after a hard industrial reconversion, penetrates the world markets, and even our humble pine is exported to prop up the English mines.

We have spoken of the cities because it is here where social change is visible. A Coruña goes from 27,000 inhabitants in 1857 to 44,000 in 1900, to 62,000 in 1920 and to 104,000 in 1940. Possibly the most spectacular jump is that of Vigo, which in 1857 has only 8,000 inhabitants, 17,000 in 1887 and 41,000 in 1910. This growth attracts constructing companies which will equip the cities (water, sewers, etc.), provide electricity, lay tracks for the trolleys, construct the new buildings demanded by the banks, the neighborhood churches and the housing plans. The bourgeoisie of these cities (also those of Ferrol, Ourense and to a lesser degree Santiago) diversifies its business and lays the foundation for its economic consolidation.

This bourgeoisie opts for a European art that is provided by the generations of Galician architects who study abroad and who, directly or indirectly, are in contact with the artistic avant-garde. Businessmen such as Barrié, Marcelino Barreras, Simeón García, Alvaro López Mora, Antonio Alonso, Molina, Castromil, etc. wrapped their houses and stores in Modernist dress, bourgeois art par excellence in its Galician version.

The pioneers of the avant-garde, the young architects Barros, Escudero, Silva, Ferro and Julio Wenemburger who visited and studied in Vienna, Berlin, Paris at the beginning of the century and who possibly introduced the first Modernist formulations into Galicia, paved the way for other architects such as Antonio Mesa, Pedro Mariño, Gómez Román, Leoncio Bescansa, Julio Galán, Rafael González Villar, Ramiro Pascual, Franco Montes, Vidal y Tuasón, Antonio López, etc., who consolidate Galician Modernism , several evolving with time toward other artistic forms.

These architects have to satisfy a growing demand because everything is susceptible to beauty in Modernism. Not only housing (there are extraordinary examples in A Coruña and Vigo), but also the department stores (like that of Simeón García in Vigo), the canning factories (like that of Antonio Alonso in Vigo), the kiosks (like the magnificent grouping of La Terraza in A Coruña), cafeterias, restaurants, and even community halls like that of Vigo which are clad in Modernist garb. This art even reaches functional objects, such as street lamps, gratings, elevators, benches to sit on, etc. It is an art which recovers urban craft, because forgers, carpenters, plumbers, ceramicists, and painters are needed.

Our cities, and more specifically their bourgeoisie, opted for an avant-garde art that was skillfully fit to Galician reality by its architects.

In the twenties there is a new generation of Galician architects. The First World War and the period between the wars establish new aesthetic formulas which produce that architectural eclecticism in Galicia. It is also, the period of the building fever of the banks. The bankers group had gone through a revolutionary process as a result of the repatriation of capital from the Philippines and the Antilles after the Disaster. A process of a strong nationalism of the banks begins and it is then (beginning with the XXth century) that the large banks which still survive appear: Bilbao, Vizcaya, Santander, Hispano-Americano, Español de Crédito, etc. The gigantic proportions of their constructions, in American style, starts in Bilbao, Santander, Madrid and Barcelona. It was necessary to show the banks' solidity through architectural majesty. Always the pedagogical function of architecture, in this case, in its bank version.

Vigo and A Coruña will be the cities chosen by the banks to establish their branches and they will do so with the solidity which was the norm at the time.

In 1921 Tenreiro and Estellés construct the Banco Pastor of A Coruña, model for this type of architecture. Its lot occupies more than 1,000 square meters; it was necessary to raze 13 houses to make its construction possible; it is 38 meters high. The bank with its sign was to be visible from the sea and its silhouette was to be the first those arriving by train or highway would see. In its builders' objectives the bank signified the progress of the city until the period represented by the "scrawny buildings of superficial façades that argue with the most rudimentary maxims of aesthetics, which are a lamentable negation of public decoration and sadly make the most central streets uglier."

The gigantic nature of the banks continues with the Banco de La Coruña by Leoncio Bescansa (1923), The Anglo-South American Bank (1925) by Rodríguez Losada, today the Banco Español de Crédito (Spanish Credit Bank) of A Coruña, the Banco de Galicia, by Antonio Palacios (Vigo), etc.

Already in the thirties the most outstanding architects, like Tenreiro and Estellés, show a progressive loss of ecclesiastical vocabulary. There is a step toward rationalism thanks to the incorporation of the architect Rey Pedreira in 1930. Rationalism is led by Tenreiro, Caridad Mateo and González Villar himself, although in his evolution he generally mixtifies different aesthetic models, keeping eclecticism as the norm.

The institutional and ecclesiastic architecture did not have as much luck. Possibly because they considered that Modernism was a frivolous art, they turned to an archaic eclecticism which left large but cold buildings, blocks without grace. Whoever contemplates the buildings (institutes and schools) founded by D. Eusebio Da Guarda (in A Coruña), designed by Faustino Domínguez in 1889, the Banco de España, also in A Coruña, the School of Arts and Trades of Vigo (1897), or the García Barbón theater, also in Vigo (1911), will find noble buildings without souls, which contrast with the merry silhouette of the Modernist buildings. A worse case was that of the ecclesiastical construction, produced in the Neogothic or Neo-Romanesque style, like the temple of Santiago in Vigo (1895-1907), the church-school of the Sisters of the Unprotected Poor, also in Vigo (1892), the church of San Andrés in A Coruña, or the church of the Jesuits, in this same city.

Only some public buildings have been able to combine the nobility of their mass with an eclectic but living and attractive style. This is what happens with the City Hall of A Coruña, by the architect Pedro Mariño, in whose plan the Castilian Renaissance tradition is integrated into the functionality and aesthetics of the time. The work was done between 1908 and 1912, ending with the centuries long temporary status of the court-house, which changed places as its previous sites were torn down.

After 1936, there is a brutal break with the European currents which until the time directly or indirectly had influenced Galician architecture. Our architects, who knew their trade well, hardly allow us to glimpse a spark of genius amid so much mediocre architecture. For an instant the talent of Rey Pedreira shines in the very correct doorway of the stadium of Riazor, later destroyed; the mastery of González Villar is noticeable in works such as the Cine Avenida of A Coruña, but in general genius dies out and there are no spare artistic formulas.

We must wait until the seventies before a modern architecture aware of what is happening in the world and daring in its projects is reinitiated.

In conclusion: Galician artistic life (here we have only focused on the noble art of Architecture) enters this century with another face. Intimately connected to Europe and the distant Bostonian referent, our architecture testifies that we are a society that is full of energy, vitality, and strength, especially in the most avant-gard cities, A Coruña and Vigo.

III. A SOCIETY IN SEARCH OF ITS IDENTITY

Parallel to the economic development which progressively takes space from poverty, there is a process of ideological maturation which is articulated in several discourses. One of them is the Nationalist discourse. As a discourse it is possibly the most coherent, although it has little political resonance at a time when the latter is falsified by the local boss system.

Every nationalism, and especially that of Galicia, entrenched fron its beginnings in the intellectual sectors, has a wish for totality, especially in the cultural order. That is, nationalism tries to have the entire reality (including the artistic) explained through ethnicity. It is easy to go from this form to the reduction of valuing as one's own all that which in one way or another connects with that supposed ethnicity. We are not concerned with developing the theme now, but we do want to make some references to the attempt to make the ideological and political process of recuperating our identity coincide with an art that is considered Galician and not according to set formal or content connotations.

Already in 1885 Murguía in his work Los precursores and on referring to the painter Avendaño wrote the following:"For me there is nothing more certain than in art, as in poetry, as in all that which is the child of intelligence or the heart, the Galician race is differentiated essentially from the rest of those of Spain."

From this opinion of Murguía until the solemn proclamation of Galicia's aesthetic sovereignty in the Congress of Lugo in 1918, there is a long road traveled in the strictly discursive sense but not in the practical, at least until the generation of the Seminar of Galician Studies (1926-1936), when several artists coincide in the express intention of making an art rooted in Galician ethnicity.

The asymmetry between the totalizing nationalist discourse and the artistic reality of Galicia arises possibly from the existence of two opposing cultural models: the rural and the urban.

While rural society maintained its cultural model practically intact (the language, folklore, an architecture closely related to the habitat, uses and customs, social codes and behavioral rules that refer integrally to a traditional culture), urban society was incapable of generating an alternative model or of integrating itself in the same model, but urbanizing it. What made the urban society was a type of cultural mixture, product of superimposing "the modern" which came from outside (fashions, artistic creations, film, new collective forms of leisure, etc.) upon a cultural structure of a strongly ruralized traditional type.

The urban classes, aware of their obvious economic and social backwardness, in comparison with the development of other cities, unable to analyze the objective causes of this backwardness, tend to blame the rural world as generator of the general backwardness of the country, through a mechanism of self-exoneration. The rural is the symbol of the backwardness of Galicia and therefore, the cultural complex which the rural implies must "overcome" in order to enter modernity. For this reason the Galician language, as exponent of this cultural world, finds the doors closed in offices, courts, bars, in a word, in the cities. Even more, the urban classes generate mechanisms of self-defense against the rural and its cultural context, through expressions which mark this rejection: they are rústicos, paletos, pailanes.

Reality, nevertheless, is implacable and all this effort is in vain because these symbolic frontiers, invented in the cities, are continuously transgressed. They danced, dressed, enjoyed themselves and spoke according to "modernity", but continued to think, love and die according to the rules of millenary behavior submerged in the same social structure and which it was not easy to avoid.

The most lucid minds of nationalism immediately understood this asymmetry and developed an intense effort, more or less with good results, to create an integrative model.

Modernity yes, but strongly rooted in the rural values that for them symbolized Galician ethnicity.

We should not forget that, in spite of the rejection of the rural by the urban, it is precisely in the cities where the Galicianist intellectuals carry out their work, where they write and publish in Galician and where a model for the future is designed to avoid that absurd confrontation. It is thus that in the cities, especially after 1885, there emerges a Galician literature which for its quality is recognized at state level, a Galician theater, even Galician music and other artistic manifestations. Nevertheless, we must recognize its failure as far as an integrating model, and not precisely because of their fault, but because of the brutal reaction of those who thought they monopolized urban cultural representation. When the Galicianist cultural movement and the obvious literary renaissance arose in the cities, it received two types of reply: tolerate them as "enxebristas" (expression owed to an intellectual from A Coruña, Montero Riguera, whom no one remembers today); that is, as exponents of a dying culture, a sort of curious reserve which there was no need to annihilate—because it was dying on its own—or convert them from the beginning into museum objects, into glorious gods of Olympus (which happened with Rosalía, Curros, Pondal, whose statues appear in all the cities), mythifying them and thus manipulating them, since every process of mythification means polishing the rough spots of the personality of the honored individual in order to make it attractive to all citizens, persons and ideologies.

This is what was done with the figures, because for the others disqualifications were abundant, and in turn produced a negative effect: they isolated themselves in their Galicianist ghetto, in the literary groups and institutions they controlled, but with no role in the Galician social development. These groups (there was one in every city) turned once more to victimism as only explanation for their marginalization and the marginalization of the project, and turned to cultural ruralism, from urban settings, which can be a model but definitely was not the model initially designed by lucid minds of Galicianism when they decided to conquer the cities for "galeguidade" (Galician-ness).

This set of circumstances can explain the plurality of models which the art of our twentieth century reflects. Groups of works done with the philosophy of ethnicity (Asorey, Castelao, in a certain sense the architect Gómez Román, etc.), works or groups which respond to imported models, carried out without the least consideration for the human geographical habitat and, finally, groups which respond to foreign models but rationalized from Galicia, reelaborated according to our geography, our humor and the sense of trasncendency of the Galician, groups which in their day could seem strident (recall the challenges of the members of the Seminar of Galician Studies to art of American emigrant influence), but which were assumed by a collective conscious which, without ceasing to be the same, evolved according to the times.

PANORAMA OF THE ARTS
IN THE MODERN PERIOD

J.M. B. López Vázquez

I. NEOCLASSICISM

We know that Neoclassicism, the style with which the study of the arts in the contemporary period begins, is the mature product of the Enlightenment, and that it therefore attempted to form a new and better world, ruled by the unchanging laws of reason and justice and achieved by a regenerative process which, assimilating scientific progress, would employ the arts for didactic and moral ends; as for form, it would overcome the current aesthetic aberrations through the return to a primitive purity and simplicity. This would be achieved through an evolutionary process which would take place starting with a classicist revival around the middle of the XVIIIth century up to a classical one, at the beginning of the last third, and including a "more and more primitivistic purism" in the final decade of that century.

The vanguard of the new style is architecture, to the point where in Spain it is known as the "architectural style" (the term "Neoclassicism" would be invented by the French romantics considerably later, at the end of the second decade of the following century and with a clearly perjorative meaning).

It is surprising that in Galicia, a true Land's End not only in the physical sense, in that the latest cultural events tend to arrive somewhat later, the introduction of Neoclassicism in architecture took place quite early, unseating the prolific and original native Baroque, which afterward survived only in rural construction. The reasons for this early introduction must be attributed more to a conscious policy of our intellectuals and creators than to chance. First, the problems—possibly of a labor and economic nature—that arise between the town hall of Compostela and the master builders, will bring Domingo Lois Monteagudo, an architect, to Santiago. In spite of having been born in 1723 and belonging therefore to a generation of transition, because of his late and definitely academic preparation, he was an artist of the mature Neoclassicism, comparable in his work to men of the generation of 1740. He not only provided an original and pseudo-classicist solution to the Façade of the Azabachería, but also planned works of extraordinary purity such as the Chapel of Communion and the Pazo of Bóveda and the one which was not carried out in the new building of the University of Compostela. In these works he shows, in addition to the affiliation with his master Ventura Rodríguez, his knowledge in situ of Roman architecture and his inspiration, typical of the architecture of the time, in Palladio, as was observed by Vigo Trasancos. Second, the early introduction of Neoclassicism was due to the presence in Galicia of important members of the Corps of Military Engineers, equipped with a solid technical background and a rationalist aesthetic that shared the simple and somber functionalist principles demanded by Neoclassicism. These men came here with the Bourbon reformist companies, especially the construction of the Arsenal in Ferrol and its transformation into head of the Maritime Department of the North, in addition to the

construction of fortifications and the remodeling of the roads. For various reasons they were forced to carry out special works beside their daily tasks, such as the participation of Carlos Lemaur in the Cathedral of Lugo and the "Palace" of Rajoy, for which reason Sánchez Bort, in that Cathedral, in which they reflect the French "classicist" aesthetic of the former, and the Italian of the latter.

When this new aesthetic was accidentally introduced during the middle of the decade of the sixties in the eighteenth century, there was already, by the middle of the following decade, a conscious acceptance of it by the major artists, or it was imposed by the preceptive report of the Academy of Saint Ferdinand, which promoted the work of the architect Miguel Ferro Caaveiro, omnipresent in Galician architecture of the last quarter of the century, and even gave a "puristic" reformulation of the work of Melchor de Prado Mariño, which covers the entire first third of the nineteenth century.

The panorama of sculpture is more complex, since the passage from Rococo sculpture to Neoclassical within the same workshop, that of Gambino-Ferreiro, occurred without a break. The constant comparison of engravings and the Italianizing influence that tinged the master's works, together with the eclecticism that characterizes the Neoclassical tradition itself, made the evolution possible when the passing of time and the rejections of the academicians imposed upon the new aesthetic made "aggiornamento" necessary. According to Otero Túñez, Gambino replied to the first rejection, by Lois Monteagudo of the sculptures done for the façade of the Azabachería with the exacerbation of Rococo sensibility; Monteagudo would only use that belonging to the Faith and would send for the sculptor Máximo Salazar from Madrid in order to conclude the iconographic design. But with the second rejection, in 1770, with the rebuttal of the academician Lorenzana and the abbot's hypocritical attitude during the elaboration of the sculpture of the ambitious Main Altar-piece of Sobrado dos Monxes, the reply was Gambino's eclipse, as he even stops appearing in the documentation concerning this work. With this came the definitive protagonism of Ferreiro in the workshop, with the subsequent stylistic change sparked by his direct contact during six months with the sculptor and academician belonging to the first generation of Spanish Neoclassical sculptors, Manuel Alvarez. The latter, after a number of vicissitudes caused by the irregularity and lack of continuity in the behavior of the monks within the Academy, ended up taking charge of directing the production of the Sobrado altar-piece.

Galician sculpture in the last quarter of the XVIIIth century is thus definitely and totally linked to the personality of José Ferrreiro, an artist considered by Otero Túñez to be "like a sculptor with Neoclassical trappings and a Baroque soul," that is of course, if we understand "Neoclassical" in a very broad sense and chiefly as the conscious opposition to the sculpture of the period just prior to it, which is achieved by eliminating stuccos and ornamentation, substituted by a much more sober polychromy which even comes to be limited to the mimetic white of marble; a substantial lengthening of the canon; a slowing down of naturalism through the slight idealization of facial features; the incipient lessening of the dispersion in the compositions; the bevelling of the folds and, definitively, the following of models more or less derived from Bernini, which in the panorama of Galician sculpture were a novelty and illustrative of an extraordinary "Classicism". If such a broad usage of the term "Neoclassical" is surprising, it is well to remember that the early Neoclassicism was eclectic, and if it is unsettling to think that Bernini could be taken for a Classicist model, we should recall that the first period of David, the archetype of the true Neoclassical artist, can be defined without reticence as "Caravaggian".

The survival of the workshop as the only center of artistic preparation and creation, since Galicia had no Fines Arts Academy, and the fact that the almost exclusive client of the Galician sculptor continued to be the Church, influence our Neoclassical sculpture to the point of inserting it fully in the field of traditional image-making still into the first third of the XIXth century. The only novelty lies in certain historicistic sparks that can be detected in the work of Manuel de Prado Mariño, undoubtedly the best sculptor of the time, and the antiquation and baroque effects of Ferreiro's formulas on the artists who worked in his workshop.

The panorama of the painting of the period is frankly a desolate one. If we exclude the academician Gregorio Ferro, who had a courtly preparation and development, the level is very low and even just barely popular. The explanation could be located in the lack of a

pictorial Galician tradition, which did exist in architecture and sculpture, and in the inability of the only Galician baroque workshop, the very mediocre one of García de Bouzas, to adapt to the new times upon the master's death.

II. THE ROMANTIC PERIOD

Baudelaire said, perhaps as the best definition yet of the style, that Romanticism is a specific form of feeling. Only from this perspective are we able to understand the possibility of the existence of a Romantic Galician art.

The middle third of the XIXth century represents one of the darkest periods of our art. The Disentailment would deprive the Galician artist of almost his only client, the Church, while the Carlist wars and the investment in the disentailed goods would distract the remainder of a nobility and a bourgeoisie (the latter nearly nonexistent), who on the other hand had never distinguished themselves in Galicia for the acquisition of works of art. We should add to this that Spanish art itself, which Galician art had almost always echoed, was at a low point of creativity due to the cultural isolation and impoverishment of the Monarchy, unable to pay for the acquisition of foreign works of art or even the visits of outstanding foreign artists who would bring it up to date and make it more universal, as had occurred in previous centuries.

Poverty and inertial, then, are the creative vectors of our art. Architecture repeats the formulations of an unexciting classicistic historicism that only with the beginning of the second half of the century would be renewed with very provincialistic contributions of Isabeline architecture, as can be seen in the work of Manuel Prado y Vallo or in that of Faustino Domínguez, to name but two examples.

Still bleaker is the panorama of sculpture, set on degrading, by making them more and more perfunctory, the formulas of the angular, winding fabrics of the Prado Mariños' workshop, or tending clearly toward a neorococo "Gambinesian" style through the work of Francisco Antonio Rodeiro, the master of the main workshop of Compostela at the time, and whose personality was recently studied by Cardeso Liñares. Nevertheless, this Neorococo has nothing to do with the similar tendency seen in European art after the forties, but rather here is exclusively the product of the endogenesis of an art tha is inert and self-absorbed.

Painting, undoubtedly the most favorable to the style among the Fine Arts, acquires more openly romantic features, although it is a Classicist Romanticism, in the work of Juan Antonio Cancela, a very mediocre painter but already concerned with reaching the spectator's sensitivity and even with practicing genres such as landscapes, made fashionable by Romanticism to break the hierarchization of Classicist theory and allow for a more genuine expression of the artist's being, typically romantic demands. In this sense, the best representative of Spanish landscape painting is Genaro Pérez Villaamil of Ferrol, although in truth he is only Galician in his place of birth, since his formation and experience take place outside Galicia. A totally different case is that of the Asturian Dionisio Fierros, who studied in Madrid and arrived in Santiago in 1855, lived in various Galician cities and renewed, if not created, our modern day painting, with a good technique an a naturalism proper to his time, with which he produced portraits, landscapes and, above all, discovered the folkloric local color scene which would bring triumph in Madrid and would provide Galician art with thematic material for the next hundred years.

III. ECLECTICISM AND NATURALISM

The last quarter of the XIXth century and the first years of the XXth constitute a unit in Galician art. They entail the slow recovery of an artistic demand, promoted by the economic renaissance, seen first and mainly in the coastal cities, by the development of an incipient bourgeoisie, by the Concordat, etc.

But above all, the renovation of our art will be favored by the impulse given to technical-artistic training as a means of progress that would transform the old guild structures (something the intellectuals had attempted with the creation of the Economic Societies of Friends of the Country), which now became reality thanks to the new regenerationist ideas, with the creation of Schools of Arts and Trades. This would allow the appearance in major Galician cities of a group of artist-professors, natives or foreigners, with a solid academic preparation, in conjunction at times with stays abroad (fundamentally in Italy), and with a vocabulary appropriate for the official art of the period: a more or less eclectic naturalism, anecdotally or socially realistic, pompier, or even modernist, which would be used according to the genres and passing of time.

In the field of sculpture, then, Juan Sanmartín, Isidoro Brocos, Ramón Núñez and Rafael de la Torre stand out, and in painting, Fenollera, Román Navarro and Eduardo de la Vega, who totally follow the dominant school.

As for architecture, men formed in the Advanced School of Architecture begin to work, and broaden the range of historicisms, overcoming the Classicistic monotone at the same time as they tend definitely toward eclecticism. This together with a revolution in technique and materials will have as a result the incipient utilization of iron, glass and cement.

IV. FROM THE REGIONAL EXPOSITION OF 1909 TO THE CIVIL WAR

The period indicated in this section is one of extraordinary creativity, both on a merely quantitative level as well as on a qualitative one of conceptual and formal diversification.

The ideological basis must be traced in two conflicting nationalist processes which had developed in nineteenth century Spain. On the one hand, that of the construction of the "Spanish nation" that was to give justifying patriotic content to the central State in which Spain had been formed after the implantation of the Bourbon monarchy, and on the other hand, that of the different historical nationalities of the peninsula: Cataluña, Galicia, the Basque Country and, later, Andalusia.

The colonial disaster of 1898 would cause the centralist spirit to triumph in the first decade of the century, contradictorily melding under one regenerationist ideal, the desire to preserve the authochthonous values based on the tradition and components of national identity with a sincere desire for progress and modernization, which signified opening up to Europe and the World and to universalist aspirations.

The arts, then. become a perfect vehicle for defining the essence of Hispanism, at the same time integrating forms already well assimilated by contemporary European art, palpable signs of progress. Thus the vocabulary of Impressionism, Post Impressionism (chiefly in its luministic tendency), Modernism and, in exceptional cases, Expressionism, is used to describe the "race" and diversity of the folklore and landscape of the various peoples making up Spain. The result would be the birth of the then called Regional Schools and the even more important installation of an emphatically figurative art in very short time and perhaps favored by World War I, which deprives Spanish artists of the necessary contact with Europe, marginalized from the rapid, proteic evolution of the avant-garde movements beyond the Pyrenees.

Naturally, in Galician art the major representatives of this generation of 98 art are artists residing in Madrid, with a wide European formation and inspiring summer visits here. On the other hand, I don't know to what extent it is inevitable that painters be the first artists in this tendency, but it is certain that while Sotomayor and Lloréns are already working in it at the end of the first decade of the century, the Galician sculptors and architects of their generation will not do so until the following decade. In the first case, that of the sculptors, pure mimetism undoubtedly influenced them; in the second, that of the architects, the isolation due to the War may possibly have been decisive, as it deprived them from contact with Europe, not only directly, but also indirectly through specialized publications, and led them to a renovation that, after nineteenth century Eclecticism and Modernism (here it was but another eclecticism) were spent, arrived through the inspiration in traditional regional

architectures, following the way opened in Spain by regional architectures such as the "mountainesque" of Rucabado, the case of the work of Antonio Palacios.

Since with the passing of years, "Regenerationism" had no positive results as far as the modernization of Spain and the themes themselves of the generation of 98 had concentrated on the differences more than on the similarities which characterized the different peoples, nations and regions of the peninsula, in the middle of the second decade of the century, the alternative plan of the peripheral peninsular nationalisms is produced.

In the Galician case, the first movement which calls itself "nationalist" is formed, that of As Irmandades da Fala, crowning in this manner a long process which had its first landmark in the Provincialism of 1840. Originally, the Irmandades arise as a movement in defense of the Galician language and culture but almost immediately and thanks to the impulse of Porteiro Garea, they become a political movement with much more ambitious goals: the defense of Galicia and its economic, social and political recovery. The electoral failure of 1918 will cause a crisis in the Irmandades, among politicians and promoters of culture, which had been dormant since the very moment of its formation. The death of Porteiro, main mentor of the political tendency, would decide the ultimate triumph of the cultural tendency, determined to emphasize the historical, linguistic, and racial values, that is, the true arguments on which Galician identity being was based.

As a means of diffusion of these ideals, from 1920 on, the journal Nós is edited. It is controlled by Vicente Risco, who becomes the leader of the group and of a generation which in fact would end up bearing the name of the journal. The journal, in its first issue, already clearly outlined the goals which we have outlined earlier: "The collaborators of Nós can be what they wish... provided that they place above all the feeling of the land and the race, the collective desire for betterment, the proud satisfaction in being Galician." And although extraordinary artists such as Castelao or Camilo Díaz are among the collaborators of Nós, it will be precisely a sculptor, Francisco Asorey, who, as Filgueira Valverde says, is "for Galicians, the one who knew how to bring to the tactile forms the spirit of the Nós generation."

To achieve this, Asorey transformed the folklorism of the Generation of 98 in a "local color primitivism" which will develop facets natural to him. He turns thematically to the peasants (the idealization of rural life, symbol of the non degraded national community, was a point commonly emphasized by all the Iberian nationalisms of the period), underlines our customs, playing with the symbolic without relying too much on the anecdotal, which was anti-sculptural, and furthers racial differentiation, able to justify, with the existence of a language of its own, the desires for self-government. But above all, Asorey's success was based in giving these contents a "primitivistic" air that, besides participating in the poetics of the time, served to express Galicia with Galician material and an ancestral vocabulary which sunk its roots into of humanity.

With the success of Asorey, the painters of his generation transformed their Symbolist and Modernist formation into an art that influenced the transmission of the "soul" of the countryside or people of Galicia. And even the architects, such as Antonio Palacios, also favored by the same wartime factors, began to use, in addition to Modernist and Eclectic techniques, Neobaroque formulations derived from the rich authochthonous Baroque of the eighteenth century, such as the case of González Villar.

A third creative moment still must be added for the period of time covered by the section title. These are the final years of the third decade of the century, during which the Generation of 27 is formed. It is in this period that we again find a very strong nationalist ferment, fed by the experiences of the recent past and by the panorama sensed for the futur. Very soon it was made concrete under the Republican experience, which led all artists to ask about the need for an unmistakably Galician art, which joins, even in artists most ideologically aware, the simple inertia of themes often used by previous generations and still alive among the people. After all, as Constable said, there is also something called art, or in other words, art has its own life beyond the rapid changes in social conditioning.

Alongside this plainly Galician sentiment assumed by all the artists, as I said, either because of an ideological commitment or because of surviving previous formulations, or for both reasons, one can see in all the representatives of this generation a progressively greater tendency toward aestheticism. But above all, the greatest importance of this generation

resides in that some of its members (perhaps influenced by experiences in Madrid, guiding light of a great part of peninsular art at the time, as in the Salón de los Artistas Ibéricos) struggle to modernize Galician art: they renew contact with Europe and use the contributions of the avant-garde. Although it is also true that the avant-garde sources are less radical, such as the Picasso of the classical period, a domesticated Post Cubism under the aegis of Vázquez Díaz or expressionism, already worn out in its most radical tendencies, and even already in the decade of the thirties, a regression in the search of direct post impressionist sources is produced, particularly of Cézanne. A product of this greater escepticism and/or the avant-garde searches, there is a tendency to suppress literary references in the works and, on the other hand, a timid self-valuation of the means of formal expression begins, volume and matter being of greatest importance in sculpture, color, line, light, and pigment in painting, and the reflections on space in architecture.

Again the painters are the artists which appear to open the way and search for more diversified solutions. The sculptors are more mimetic, both in the academic elements retained in Acuña and in the Mediterraneanist renovation of Eiroa and in the popular naivetée of Faílde, although they also are familiar with the great creativity in the fun-poking expressionism of the first Bonome, whose work, I would even dare to say, is the most outstanding of the entire generation. Perhaps the premature death of Narciso Pérez Rey deprived us of the great sculptor, Bonome also having died of other causes, who would have been the paradigm of this generation, as Asorey had been for the previous one. For their part, the architects introduce the avant-gardism with its rationalist contributions, but, and maybe it is only my own obsession, they do so, just as they had done with Modernism, as if it were a question of just another eclecticism. The strongest proof is that the same architect, and we can include the most important ones, could work both on a rationalist building and on another that was completely regionalist. We should recall that it is during this period that the greatest number of Galician-authochthonous-baroque-eighteenth century style buildings are constructed. Nationalism, if not inertia and the artist's taste, continued to justify and promote this architecture.

V. A LONG SECOND THRID OF THE CENTURY

The Civil War and the subsequent National-Catholicism would break off the creative wealth that was forming in the first third of the century. Besides the logical traumatic effect, the war signifies the delay of ten years in the rhythm of the generational replacement. On the other hand, Francoism, reinforced in its effects by the Second World War, produces during the period of autarchy another cultural isolation and this time with much greater results, at the same time as it promotes a revivalist and anachronic aesthetic that we could term Neo-98. This will allow artists of the Generations of 98, 16, and 27, who were still actively producing, to continue without substantial changes creating the works they had been previous to the war. We thus have a Galician art in the second third of the century which is essentially a reiteration of that produced in the first third.

VI. THE LAST THIRTY YEARS

In the period indicated in the title two stages may be distinguished, with the institution of the Xunta Preautonómica as the hinge between them.

The first period, which corresponds to the last years of Francoism and includes the results of the Plan for Stabilization, is defined as the "economic miracle" and as a change of mentality promoted by the exchange of a national-syndicate ideology for a developing-technocratic one, together with a loss of influence by the army in the organs of power and a slow "opening", always imposed by the pressure of factors external to the government, although at times admitted by it, practicing the old aphorism of the need to introduce change so that everything would remain the same. As a result, the eternal values of race and the

imperial ideal are forgotten and the sublimation of the peasantry is put aside in favor of the progress predicated by the technocrats.

In the area of art the Generation of 98 aesthetic is abandoned and foreign models are again imitated, with the early promotion of abstract art, which so satisfied the aspirations of the country's intelligentsiae, since it favored the reintroduction of the avant-garde and the integration of our art in the evolutionary lines of the world, such as the government itself, because besides avoiding destabilizing effects which, both on the level of social protest and on that of nationalist reivindications, it could propose a figurative art, selling the image of "development", as progress was called in the vocabulary of the period.

Finally, it is necessary to outline a change in the art market with the appearance of a petit bourgeoisie with a capacity to consume and little knowledge, which favors the opening of the first Galleries in the major Galician cities. This is a galleryism without capital and dependent on the artist, completely amateurish and of little intellectual depth. Nevertheless, it attempts to be an artistic directive that cannot be established because of its weakness.

While architecture introduces the contributions of the International Style, painting and sculpture follow a similar path. In the case of sculpture—which interests us here—the most characteristic is that abstraction will bring as a result the fact that in comparison with volume, considered the essential value in he sculpture of the first half of the century, space will become the major element. On the other hand, the value of the material remains, although here too a variation takes place: it loses its nature as opposition to the mystified materials of finisecular sculpture and/or of nationalist reivindication that it had had in previous periods and is enlarged to a greater offering, upon recovering the traditional materials such as fired clay and bronze and introducing the new ones, while always showing off the aesthetic character of its qualities through the play of textures. Formally, the artists, in accordance with their formation and personal situations, fluctuate along the lines of the ongoing artistic movements, from abstract sculpture to surrealism, with a notable influence by organicism, under whose thrust the popular expressionist naivetée, last holdout of the aspirations of a sculpture sensitive to authentic Galician values, is transformed.

After Autonomy, the transformation of Galician as well as Spanish society was very rapid. In a short period our artists recovered lost time. The lack of an Advanced School of Fine Arts in Galicia forced them to go to the widest points of Spain, where on the level of instruction as well, there were desires for renewal. These universalizing perspectives were also promoted by the society of mass media and tourism, which directly or indirectly brought the entire art world, including the most recent, to us. As a result, here the youngest artists, in a very short space of time, recycled from the old American and German Expressionist avant-gardes to the most radical and newest conceptual movements and, what is more important, they themselves, integrated into the lastest events, were momentarily able to organize their own. This happened precisely because of the discovery of innate qualities, of the sub-worlds and customary backwardness of Galicia.

Nevertheless, this boom, except for important exceptions familiar to all, soon failed for lack of Galician structures which could accept and consume our art, because of the call of New York gold and the desire to be up with the latest, justified precisely by a need for survival in the intricate world of foreign galleries. Official assistance, in the broadest framework of institutional policy that was not always well understood, through the Xunta, the provincial and municipal governments, etc. supported the process and quelched valid experiences such as that of Atlántica, which in the first attempt to promote Galician art by its own creators, had managed to create the hope for an avant-garde but definitely Galician art.

223
The village taylor
ISIDORO BROCOS
1878

Fired clay
33 x 27 x 19 cm.

COLLECTION OF CAIXA GALICIA (A CORUÑA)

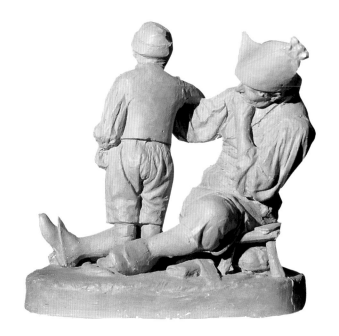

Besides being a renovator of the iconographica types in religious sculpture (facet still very little studied in the sculptor's production), the major contribution of Modesto Brocos to Galician sculpture is the introduction of the local color scene, expression of his "regionalism," but also characteristic of Spanish realistic sculpture, concerned for the representation of the intranscendent anecdote. This more typical of the literary or even the pictorial medium than of sculpture. In this case, we have an old man eating lunch, or what is the same, a mid-morning snack, a small meal eaten in the middle of the morning, coinciding with a pause in the work. To sculpt his anecdotes, Brocos uses a perfect middle space which invites the spectator to surround the figure to be able to contemplate it in its totality, introducing in this manner the sense of time in the perception itself of the work. He employs a naturalistic style of exaggerated realism, with which he exhaustively represents not only the psychology of the character but also the various qualities of the skin, hair and clothing, to which the small dimensions of the piece and the technique of fired clay contribute decisively, as they further and even invite one to descriptive detail

(J.-M.L.V.)

BIBLIOGRAPHY
Chamoso Lamas, M. (1985); López Vázquez, J.M. (1988); Fuente Andrés, F. de la, Cabrera Masse, M. F. (1989)

224
Here, here the flea
ISIDORO BROCOS
1880

Fired clay
33 x 29 x 22 cm.

COLLECTION OF CAIXA GALICIA (A CORUÑA)

In this work we see the repetition of the same characteristics as in "The Country Tailor," although in this case the theme of defleaing has a long artistic tradition which even goes back to antiquity.

(J.-M.L.V.)

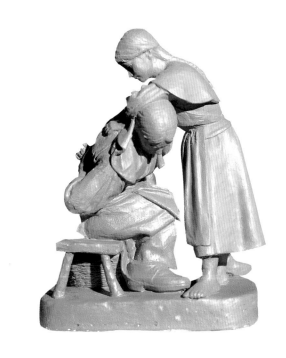

BIBLIOGRAFÍA
Chamoso Lamas, M. (1985); Fuente Andrés, F. de la , Cabrera Massé, M.F. (1989); López Vázquez, J.M. (1988)

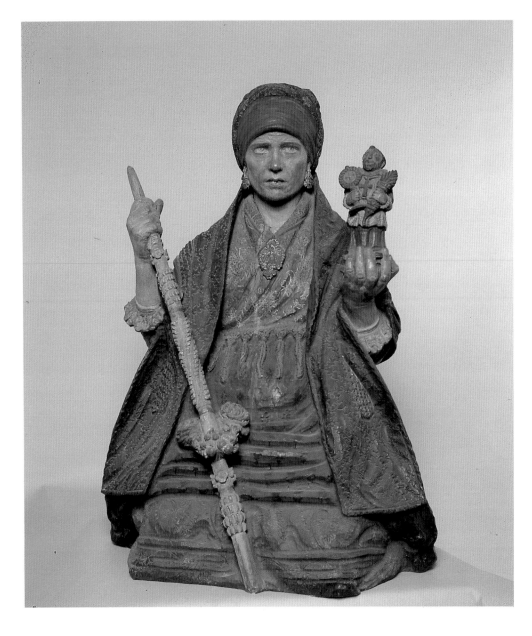

225
Offering to Saint Raymond
FRANCISCO ASOREY
1923

Polychromed wood with small upholstery nails
and metal beadwork
80 x 54 x 50 cm.
Private Collection

PROVINCIAL MUSEUM OF LUGO

This small sculpture, presented in the Automn
Salon of 1923 is perhaps, because of its excessive
anecdotism, the least interesting of the series of
masterful productions by Asorey in the decade of
the twenties. Nevertheless, in it are all the
Asoreyan characteristics: the sublimation of the
peasantry and woman, symbols of the Galician
community that was not degraded and the
matriarchal nature of Galician society, and above all
manifestation of a differentiating 'racial' peculiarity
based on typically Nordic features. From the
stylistic viewpoint, the sculpture signifies a total
break with nineteenth century academicism and the
pseudo-Rodinian echoes that still dominated the
panorama of Spanish sculpture of the period. Its
exacerbated realism seemed an abberation in
comparison with such precedents, but Asorey's
work also already participated in the sentiments
typical of the sculpture of the twentieth century,
such as the recuperation of the form, differing from
the current pictorial presumptions, and the volume
seen as a concretion of mass, achieved by a very
simple composition reducible to a pyramid with
deep 'primitive' roots in Egyptian art. Along with
this we have the appraisal of the material which
would lead Asorey to his most primitive
contributions, first because of the material itself that
was selected, wood, in comparison with the
mystified marbles and bronzes of the end of the
century, and second, because of the treatment it
receives, typically turning to the Spanish tradition,
polychromy, but at the same time, instead of
following that tradition faithfully, Asorey invents a
new formula which, abandoning stuccos, does not
conceal the qualities of the material's surface.
Moreover, it is a material which, 'savagely'
enlivened with nails and metal pieces, the most
avant-gard element of the work, materially
"horrified" the academic criticism of the period.
Finally, although Asorey does not use direct
carving, so typical of the post-Rodinian movements,
he does seem to value the process itself of
producing the work, leaving a perceptible trail of
the gouges and chisels which in its rhythmic curves
recalls the unhealthy cadences of modernist
expressionism.

(J.-M.L.V.)

BIBLIOGRAPHY
*López Vázquez, J.M. (1988); Otero Túñez, R.
(1959); (1987); (1989); Sobrino Manzanares,
M.L. (s.d.) (G.E.G.); (1982)*

226
Saint Francis
FRANCISCO ASOREY
1926

Polichromed wood
186 x 110 x 54 cm.
National Museum and Art Center "Reina Sofía".
Madrid

PROVINCIAL MUSEUM OF LUGO

First place medal in the National Exposition of
1926, this is undoubtedly one of the masterpieces of
Asorey and of Spanish sculpture of the XXth
century. Stylistically we find repeated here the same
techniques pointed out for the Offering to Saint
Ramon, although perhaps distilled to a maximum
mastery by the author. Nevertheless, the most
fascinating thing about the work is to see
represented in our century still the possibility of
creativity through religious sculpture. Asorey
manages not only to engender a new iconographic
type for the Saint of Assissi (now represented as a
true poor man intimately related to nature), but he
also manages to transmit an authentic mystical
feeling of deep religiosity.

(J.- M.L.V.)

BIBLIOGRAPHY
*López Vázquez, J.M. (1988); Otero Túñez, R.
(1959); (1987); (1989); Sobrino Manzanares,
M.L. (s.d.) (G.E.G.); (1982)*

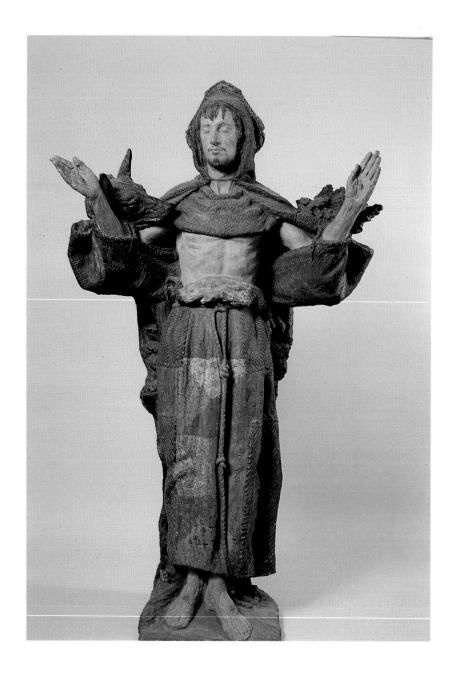

227
O Meigallo (The Spell)
SANTIAGO RODRIGUEZ BONOME
1925

Wood
53 x 40 x 14.5 cm.

PROVINCIAL MUSEUM OF LUGO

At a time when European sculpture was
searching for new manners of expression, Bonome
found inspiration in the timeless, in an artistic form
that was full of spontaneity.

The wood is worked with deep cuts which
produce large planes. These give the work great
expressiveness, both because of the schematization
and the contrasts of light and shadow which the
hard, cutting folds of those clothes which were once
typical of the Galician rural area. But this
expressiveness that is achieved through the
technique is accentuated with the figures' gestures
and poses, especially those of the central group,
who lift their faces in a pleading way.

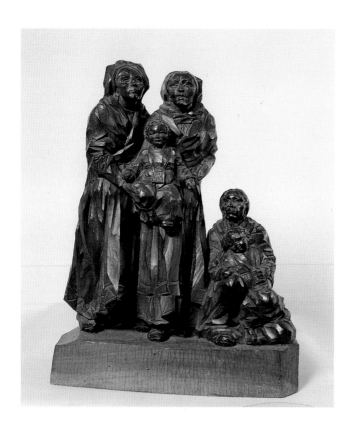

"The Spell" is related to the first phase of Asorey's production, when he too did small groups of figures based on figures carved in wood which narrated popular traditions ("Return from a burial," "Devout women's prayers"). It belongs to his Madrid phase.

(B.D.R.)

BIBLIOGRAPHY
Plástica Gallega (1981)

228
The Woman
XOSÉ EIROA
Ca. 1933

Alabaster
23 X 12,5 X 16,5 cm.

QUIÑONES DE LEÓN MUSEUM. VIGO
(PONTEVEDRA)

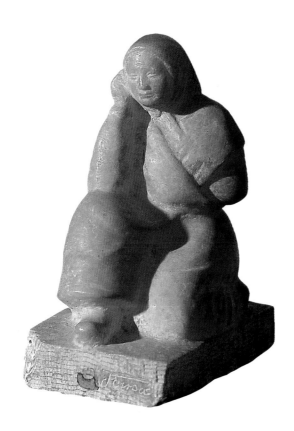

Again, as in Asorey, the theme of the peasant woman becomes predominant in Eiroa's production, perhaps explainable by the same nationalistic reasons, but its treatment is now totally different, as Eiroa bases himself on a sculpture that, starting with Catalonian 'Mediterraneanism", could distantly make use of certain avant-gard characteristics derived from the Picasso of the classical period. Thus, differing from Asorey. Eiroa renounces excesssive naturalism and softens the anecdote, seeking an essentialization that transmits the effect of timelessness, a fitting effect not only for the message intended—the figuration of an eternal Galicia—, but also for the scultpural method itself, which has instantaneity and static nature among its basic premises. On the other hand, Eiroa takes maximum advantage of volume, the sculptural feeling par excellence, emphatically valued in all the sculpture of the time. A volume which is again conceived of as the negation of the opening and concreteness of the mass, sculpted in variegated convexities that fit together with subtle evocative concavities of the Galician landscape, also taken as a fact to consider semantically, in a sculpture that attempts to transmit a clearly Galician sense. Finally, compared with the dexterity of technique if Asorey, and seeking the same rottedness in Galicia, simplicity is now valued, and even the ingenuity reminiscent of our stonecutters, thus obtaining a popular art, one genuinely Galician, not only for the theme but also the manner of creation.

(J.- M .L.V.)

BIBLIOGRAPHY

Catálogo Bienal Pontevedra, 1981; López Vázquez, J.M. (1974); (1988); Seone, L. (1957); Sobrino Manzanares,M.L.(s.d.)(G.E.G.);(1982)

229
Today you'll eat
JOSÉ MARIA ACUÑA
1925

Stucco
110 x 108 x 56 cm.

MOST EXCELLENT PROVINCIAL COUNCIL OF
PONTEVEDRA

In spite of having been born in 1903, and
therefore belonging to the same generation as Eiroa,
and to the following of Asorey, Acuña still recalls,
in his style, the axioms of the end of XIXth century.
Since, on the one hand Eiroa is characterized by a
local color that defines types and by an academic
technique, soberly naturalistic and proportionally
luministic, which recalls the canons of the artists of
the Generation of 98, who are Acuña's masters in
San Fernando, on the other hand, the anecdotal
nature of the work and the supposed social protest
shaped exclusively by the grandilocuent title, take
us even further back to a previous generation, since
these artists had their greatest manifestation in
Sorolla and his "... And they still say fish is
expensive!"

(J.- M.L.V.)

BIBLIOGRAPHY
*Catálago Bienal Pontevedra (1983); Castro, X.C.
(1986); Filgueira Valverde, J. (1983); López
Vázquez, J.M. (1973); (1988)*

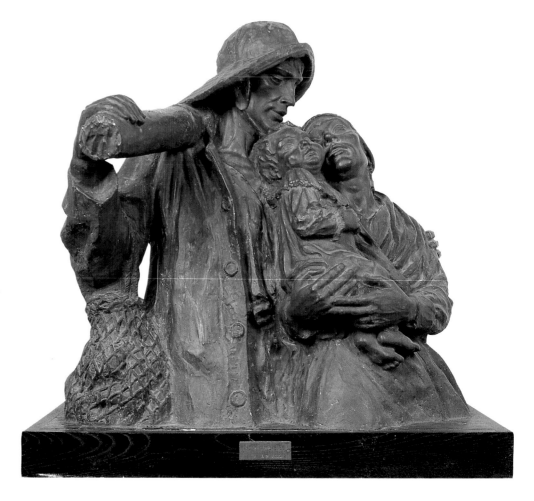

230
Nude with fish
CRISTINO MALLO
1933

White marble
200 x 73 x 50 cm.

NATIONAL MUSEUM AND ART CENTER
"REINA SOFÍA". MADRID

This work receives the National Prize for
Sculpture when its author was not yet 30. Although
it pertains to the early period of his sculptural
creation, in "Nude with Fish" the defininf elements
of Mallo's work are already present: the taste for the
representation of the human body, essentialization,
the concept of sculpture with a Mediterranean
tradition... On the other hand, we cannot see other
characteristics which will appear in his later
evolution, such as the tendency to do small pieces,
the capturing of the fleeting moment in the manner
of Degas...

The sculpture has a solid, decided anatomy, with
no concession to the anecdotal nor to the exhaustive
study of the body. The figure is made with the
space of natural but round form.

Mallo is not interested in the specific. but rather
in the general idea, and because of this produces a
simple, elementary sculpture. He uses polished
marble, with soft appearance and friendly shape,
with forces the light to slide over its forms.

Upon contemplating Mallo's nudes, it is
inevitable that we recall Maillol or the Spaniard
Clará, artists who are admired by the sculptor.

There is a certain tendency to monumentalism,
classical rigidity and frontalism, and a resemblance
to medieval art in the manner of holding the fish in
front of the body as if he were a knight from the
Middle Ages grasping his sword that rests on the
ground.

(B.D.R.)

BIBLIOGRAPHY
*Campoy, A.M. (1983); Castro Arines, J de. (1974);
Catálogo (1985) (II); Gaya Nuño, J.A. (1977);
Heilmeyer, A. , Benet, R. (1949); Plástica
Gallega (1981); Sobrino Manzanares, M.L.
(1982)*

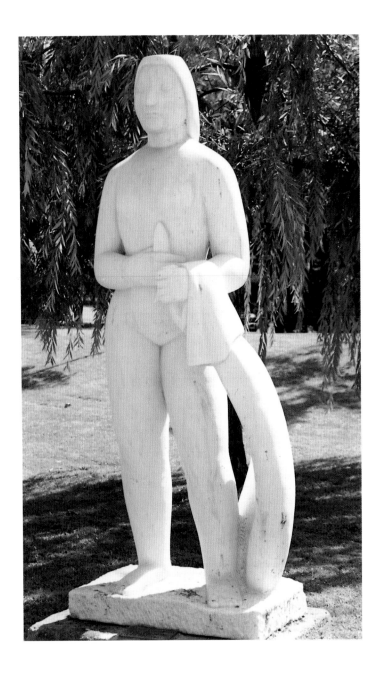

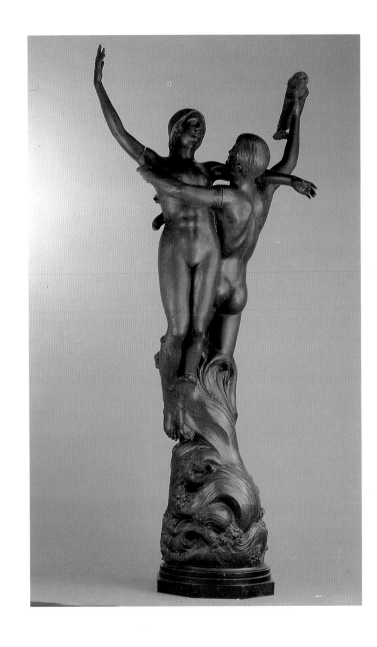

231
Sea storm
RAFAEL DE LA TORRE MIRÓN
1935

Wood
229 x 234 (with base) x 160 x 55 cm.
Private Collection

DESPOSITORY OF THE SCHOOL OF ARTS AND
TRADES. SANTIAGO DE COMPOSTELA

Rafael de la Torre is an eclectic sculptor; in this
work he tends toward a symbolist modernism
admitted as one more eclecticism. Although it was
done at a late date—it was made for the Galician
Regional Exposition of 1935, which confirms the
long survival of modernism in Galicia—, it is based
on a sketch for a hand mirror, done during the
author's residence in Paris.

The sculpture is archetypally modernist and is
perhaps the most outstanding work of this
movement in Galicia. We see the taste for the
materialization of an incomprehensible allegorical-
poetic content, acting upon an organic, sensual
theme in which the presence of a woman with
connotations of Venus and Parca (love and death)
plays an important role.

On the other hand, the composition repeats the
typical vertical format and in the importance of the
coil, whose helicoidal twist provokes the work's
multifaciality. This effect was used to the
maximum by Rafael de la Torre, who introduces a
device in the sculpture's pedestal which allows it to
revolve around itself. Finally, the technical
treatment is polished, setting the light effect of the
modeling, completely pasty and amorphous in the
hair, against the careful calligraphy of the waves
and the importance of the surrounding areas.

(J.-M.L.V.)

BIBLIOGRAPHY
López Vázquez, J.M. (1988)

232
Adoration
ANTONIO FAÍLDE
1968

Bas relief in granite
100 x 32 cm.

PRIVATE COLLECTION (OURENSE)

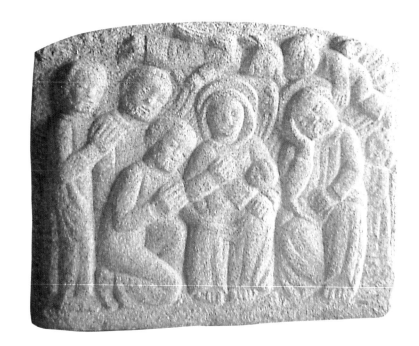

The figures of the Virgin with the Christ Child and Saint Joseph, which face the front, leave little space for the shepherds. Two winged angels, set horizontally over the heads of Joseph and the Virgin, fill the space at the same time as they adapt to the frame in a true "horror vacui".

Of simple but vigorous technique, the predominance of the mass, the slight attention to detail, and the manifest rejection of angular lines must be stressed. There is a static nature in the scene and the marked isocephaly on the heads of the worshippers. The primary technique in the use of the chisel, which leaves furrows in the hard granite, explains the unconscious romantic inspiration, so often confessed to by the artist.

This piece was in expositions in Madrid, the Goya Salon of the Circle of Fine Arts, in 1968, and in Vigo, in the Salon of the Municipal Savings Bank, in 1973. The first important version of the theme is the relief of 1957, in the pazo of San José in Vista Alegre (Tui, Pontevedra), the place where we find one of the most important groupings of Faílde's work.

(M.V.C.- C. R.)

BIBLIOGRAPHY
Carballo-Calero Ramos, M.V. (1986); Trabazo, L. (1972); (1978)

233
Torso
ANTONIO FAÍLDE
1979

Stone from Mondoñedo
65 x 33 x 40 cm.

PRIVATE COLLECTION (OURENSE)

The sculptor, at the end of his life, tries to conquer space in this torso from 1979. Although this does not mean a revision of his style, the effort made within the natural evolutionary process toward greater simplification and synthesis is evident. He has done away with all that could remain in his sculpture of the anecdotal or literary. The process was interrupted by the death of the artist, which occurred the same year as this piece was done.

(M.- V. C.-C.R.)

BIBLIOGRAPHY
Carballo-Calero Ramos, M.-V. (1986); Trabazo, L. (1972)

234
Eculpture
XOÁN PIÑEIRO
1979

Stone
92 x 102 x 44 cm.

COLLECTION OF XOAN PIÑEIRO. VIGO
(PONTEVEDRA)

A work from 1967 opens a new creative period, fruit of a process of synthesis of previous references: the original form of life. With the sculpture "Embryo," Piñeiro leaves figurative representation to direct that same humanist commitment to the most primigenial and elementary, the most universal expressive channels.

From here an extensive series of works emerges which in the "Sculpture" of 1979 intends to signify our existence with the search of pure essence of the embryonic forms at the same time as the artist culminates the investigation of intrinsically sculptural elements: form and matter.

The observation of Nature, of the biomorphic element, in pure state or metamorphosis, with rounded lines, curved, volumetric lines in continuous spatial development, emphasizes the sensuality, the tactile and even ductile features of hard materials which have been softly shaped.

The intervention of the human being in stone, worked to give the appearance of a slight organic manipulation, in a centripetal, rotund, rhythmic, balanced sculpture, underlines the architectural and monumental value of the sculptural work; the perforation of this material in the succession of concavities and convexities, the alternation of full and empty spaces, intact presences or those of erosion and wear, and finally the internal and external, polished and rough contrast of textures, as well as the light qualities of the surfaces coming from the alternation of light and shadow, are the elements which he tries to emphasize in the pure experimentation of the tridimensional object as plastic creation.

(C.P.A.)

BIBLIOGRAPHY
Piñeiro Álvarez, C. (1986)

235
A bum detained
IGNACIO BASALLO
1984

Wood
144 x 78 x 65 cm.

COLLECTION OF IGNACIO BASALLO
(OURENSE)

Basallo has preferred to experiment with his plastic language in the formal and spatial possibilities of wood. In Marouco Termado, two abstract elements of very simple organic forms are superposed in asymmetrical balance and rest on slender feet which, like a base, project them into space at the same time as they intervene as structural elements of the piece.

Its date (1984) is indicative of the change which his language begins toward more conceptual and abstract terms in which the features evoking a craft tradition, present in his previous works, are diluted, although these references are not eliminated. After works like this one a new plastic sense will arise toward what he himself defines as 'more furniture-like, with the appearance of furniture, with greater fragility, cleanliness and thinness'.

In this work that eminently spatial character is present, and is resolved like a linear drawing developed in space. The apparent lightness of its structure and the simplicity in the treatment of the material hold a complex play of formal asymmetries and balances. But in this abstract statement, the freedom with which the different elements are assembled goes beyond the purely aesthetic or structural to become a subtle and playful allusion to the world of the unfunctional. The emphatic elevation of the base underlines its image as an impossible instrument, and at the same time establishes an ambiguous poetic relationship with the reality of the artesan and the world of everyday objects.

(M.-L.S.M.)

BIBLIOGRAPHY
Castro, X.A. (1985) (I); Seoane, X. (1990); Sobrino Manzanares, M.L. (1982)

236
Kick
FRANCISCO LEIRO
1985

Polychromed wood
220 x 99 x 70 cm.

COLLECTION OF FRANCISCO LEIRO.
CAMBADOS (PONTEVEDRA)

This piece is representative of one of the most uneasy creative periods of Galician sculpture, when at the beginning of the decade he breaks into the contemporary scene, bringing his own specific version of the "spirit of the eighties".

Leiro is undoubtedly the protagonist of the movement which from Galicia, nourished by its own cultural roots, shaped a language in synchrony with European plastic creation and more specifically in German art. This work is from 1985, year which marked the discovery of the artist on an international level, where he is considered one of the most solid figures and one who has the most original language within the new Spanish sculpture.

Kevin Power writes that Leiro's works 'evoke states', that 'more than represent facts they recreate an emotional impact, a presence'. And, in effect, the sculpture Couce (Kick) obeys this concept of the presence with an impact of the sculptural.

This is a resting figure, solidly supported by its

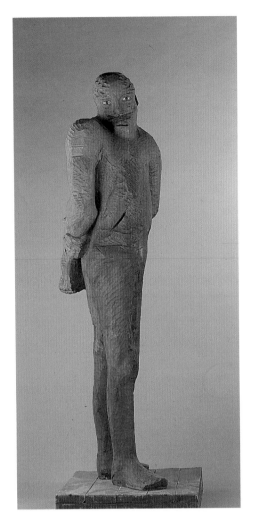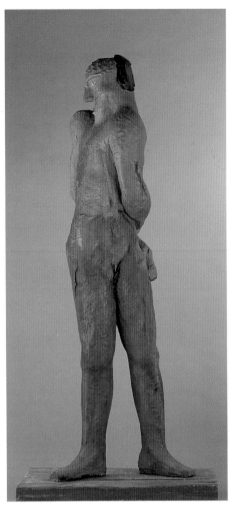

base, although this static position does not take away at all from the concentrated tension which comes from its internal state. Its expressiveness is manifested through the rude treatment of the material, which is defined by the quality of immediacy that comes from the artesan's mark in fabrication, evident in the enormous proportions of the body and the moderate displacement of its parts, and above all in the characteristic of formal excess which is immediately imposed upon the spectator.

With an iconography of Baroque echoes—perhaps a Saint Sebastian—not without a certain irony, Couce is defined by the relationship between its forms and the simple structure of the original block. And without reaching the forced, convulsive postures frequent in Leiro's work, it basically shows its distortion in the gesture and polychromy, the two focal points on which the dramatic effect is concentrated. Thus, the polychromy, as a consubstantial element of the piece, acts to emphasize its meanings or intentions. The red covering his legs and genitals may be symbolically understood by relating the figure to the idea of torture, although the gesture of the head counterarrests a supposed hypothesis of pathos with an almost comical turn..

(M.-L.S.M.).

BIBLIOGRAPHY
Castro, X.A. (1985) (I); (1985) (II)

237
Haystack
SILVERIO RIVAS
1987

Red granite from Zamora
110 x 120 x 150 cm.

PRIVATE COLLECTION (VIGO)

A dialogue is established in this sculpture, not articulated as is frequent in Silverio Rivas, but which shows a conception similar to the plastic purposes.

It belongs to a series of pieces in granite done in the last few years, comprised of two elements which set up a mutual relationship around the cut which separates them, and which is the principle nucleus that decides the subtle interrelationship of their parts. In this case, protagonism is given to one of the pieces, emphasizing its volume, while the other acts as a counterpoint whose purpose is to imitate and emphasize the first, expressing its origin as a block of stone by its less elaborated surface.

Overall the stone has a solid presence and its total structure is defined in an elementary geometry of volumes, beneath which lies, nevertheless, the organic mark of its origins, and the traces of the process which from the quarry forced it to be formalized in sculpture. But under this purely abstract concept of its appearance, something of the evocation of a sign is evoked. It is like an allusion to certain ancestral signs which were transformed by the artist in the contemporary period.

In addition to similar expressive referents, in this sculpture Silverio Rivas again takes up the idea of a dialogue, here conceived of as a warm dialectic between the two static elements from whose encounter arises a behavior similar to that of human beings. This activation of inert matter is expressed in the cadence of the volumes and the play of balances and symmetries; in the linking and displacement of the parts or the correspondence of them to the whole. It is likewise manifested in the relationship to the interior space which exists between them and which both pieces establish with the spatial environment, creating in their mutual coupling and rejecting a dynamic tension that gives the sculpture life..

(M.-L.S.M.)

BIBLIOGRAPHY
Castro, X.A. (1985) (I); Gamoneda, A. (1976); (1981); Seoane, X. (1988)

238
Complementary extraction
LEOPOLDO NÓVOA
1988

Rusted iron
27 x 46,5 x 60,5 cm.

COLLECTION OF LEOPOLDO NÓVOA

There is a similar work in the Olympic Park of Seoul (Korea), but the one here is none the less original. The artist concedes a value of its own to the material, without attempting to show it to us in an excessively prepared manner. He is not concerned with a careful presentation, but rather with its expressiveness, which relates Nóvoa's sculpture to his painting, which is related to Minimal, Informalism and Arte Povera tendencies.

Material and form make this a piece of impact. There is a continuous play of different planes, lights and shadows, curves and straight lines, hollow and volume... Sculpture is made with space and this stops being something aleatory to become a defining part of the whole.

The base has also stopped serving this function and has become an element that is perfectly integrated into the work, not only because of the coincidence of the material, but also because of the importance it has when creating planes and lines of flight.

The simplicity and purity of lines are characteristics which stand out at first glance, but on contemplating them carefully, this apparent simplicity becomes complex. Nóvoa appears to try to play with the spectator—something many contemporary sculptors try to do—and force him/her to go around his work. Thus, according to the position we take in relation to it, it provokes totally different sensations in us: if from one point of view the material takes on absolute importance, from another the hole is the protagonist. As the sculpture is slowly circled it acquires different forms and, what is more important, many times these are opposite.

The work is a clear example of the goals of today's art: to cause doubts as to what the reality and significance of the message the artist wishes to convey to us and to allow the spectators themselves to ask the questions and answer them. These principles have become one of the greatest attractions of contemporary art.

(B.D.R.)

BIBLIOGRAPHY
Logroño, M. (1977); Seoane, X. (s.d) (G.E.G.); (1989-1990)

239
Untitled
JORGE BARBI
1989

Wood
200 x 200 cm.

GAMARRA AND GARRIGUES GALLERY.
MADRID

The imposing of a geometric and purely visual order on objects that are organically shaped by time and nature is perhaps the most obvious note in this piece by Jorge Barbi.

This sculptor, whose public reputation is fairly recent, orients his projects toward a conceptualization of creative tenets in which found objects or certain materials have played a decisive role. Such is the case of this work on a flat support done in 1989. In effect, Barbi carries out a planned assemblage of organic elements, woods which after a distant use were modelled anew by the passing of time and sea waters. The full evocative weight of these materials, which like the remains of far off shipwrecks, contribute the enigma of their origins and their own history, is added to the new meaning they receive on being reused in the construction of the piece.

Thus they are vestiges which acquire a new presence formalized in the rigorous geometric placement in concentric circles and networks, playing openly with two opposing concepts. On the one hand, its original naturalness, made formally casual by the passing of time; and on the other, the artificial and rationalizing manipulation of its ordering caused by the intervention of the artist. Nevertheless, these entities neither confront nor neutralize each other, but rather reinforce their meanings. The materials do not lose their physical qualities nor the evocative connotations of their origins, but at the same time the accumulation and placement of their organization empties them of meaning and makes them behave like abstract elements, integrating the constructive order which artistic creation gives them.

(M.-L.S.M.)

BIBLIOGRAPHY
Catálogo (1989) (I); Olivares, R. (1989)

240
Bulwark for silence and wrath
PACO PESTANA
1989

Chestnut and birch with appliqués of metal
screen and tin
178 x 162 x 67 cm.

COLLECTION OF PACO PESTANA (LUGO)

In a sense the work seems to start with
primitivistic and surrealist criteria. There is a whole
created here and projected in all directions, invading
the spectators' space, provoking them.

The primitive aspect comes from the search for
what is ancestral, for the essence, the simplicity of
forms, which leads it, like the work of other
sculptors of Galicia (Basilio, Leiro...) to blend with
the mythic past of Galician culture. It is done
primarily in polished wood, the material with which
this sculptor works most comfortably, in addition to
being an element that defines our anthropology. It
also uses complementary metalic elements, like the
stocking which covers the leg and the tin which
covers the head of the totem. The clog is a direct
allusion to our rural environment.

The surrealism is suggested by the title: the
bulwark against silence and wrath, the door which
opens in the figure's torso, the leg which emerges
from something totally different from our
immediate knowledge, the ring on the upper part of
that leg, which has a relative chromatic force and
adds a certain erotic meaning. Pestaña seems to
want to link the rural world (the clog, the idol, the
use of wood) to life in the city, which is more
sophisticated (the stocking and garter).

There is a combination of wood and metal like
that seen in Galician sculpture since the beginning
of the century (Asorey) and there is something in
the formal treatment of the piece, the curved
working of the word, which reminds us of the
organicist theories.

In his life Paco Pestana seeks what is authentic,
the permanent contact with nature, the most
intimate elements of the human being... and this is
definitely what "Bulwark for silence and wrath"
tries to reflect.

(B.D.R.)

BIBLIOGRAPHY
Castro, X.A. (1985) (I); Seoane, X. (1988)

241
Lady of eight
ACISCLO MANZANO
1989-1990

Ibizan terracotta
50 x 90 cm.

COLLECTION OF ACISCLO MANZANO
(OURENSE)

Female torso covered with an invisible tunic that is insinuated by eight buttons. Rounded protruberances resembling organic elements are conterarrested by slight indentations at the ends of two imaginary diagonal lines. Idealism and poetry, possibly an inheritance from Antiquity and the Renaissance, free the piece from any connotation of the immediate present. From the middle of the decade of the 60s, female torsos covered with transparent tunics become one of the repeated themes in Acisclo's work. The volumetric and material concern together with the exquisite treatment of the textures are observable in his Ibizan terracottas.

(M.-V.C.- C.R)

BIBLIOGRAPHY
Pablos, F. (1981)

242
Venus of the Miño
MANUEL GARCÍA DE BUCIÑOS
VÁZQUEZ
1990

Granite and bronze
155 x 30 x 30 cm.

COLLECTION OF MANUEL GARCÍA BUCIÑOS
(OURENSE)

Done especially for this exposition, this sculpture is a sample of the evolution of Buciños' work in recent years.

It is an adolescent female nude coming out of the bath. The theme of woman has been treated by the artist on numerous occasions as man's companion, mother, or in scenes like this one in which the basic aspect is the exaltation of the female body in the classical manner.

There are similarities with impressionism in the theme—the bath—and the gesture of the figure with its arms held high, reminding us of Degas' famous ballerinas.

The difference with works from his previous periods is that Buciños has gone from a strong evaluation of hollowness to a combination of the heaviness of the stone block and the empty spaces produced by the cloak as it falls or the space formed between the arms.

Bronze is not the only material in his work now either. Here the very polished stone is the basic element, but the cloak, which theoretically is anecdotal, becomes the characteristic feature of the piece. The cloth, treated in a very naturalistic manner, gives the sculpture the touch of color and a rhythm and grace. The contrast between both materials is accentuated by their being treated differently—in this the characteristics of each one play a role—; while the stone simply insinuates the forms, the bronze is more worked and the folds are soft, giving the impression of a light fabric.

With this work Buciños pays homage to his land, and what better way to do so than dedicating it this "Venus of the Miño," which refers to the river which bathes her.

(B.D.R.)

BIBLIOGRAPHY
Plástica Gallega (1981); (s.d.) ; (G.E.G.) (IV); Sobrino Manzanares, M.L. (1982); Trabazo, L. (1978)

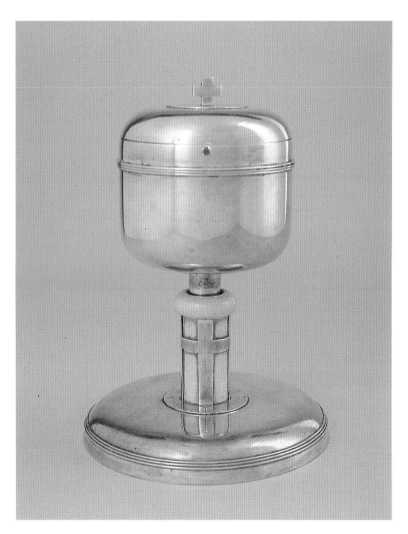

243
Goblet of Marshall Petain
ANONYMOUS
1943

Silver and ivory
22,7 high and 16 cm. base
Punches of the author with the initials "E"-slash-
"P" in rhomboid form, and of the city of Paris
with a bearded man with a short rounded haircut,
inscribed in a beveled rectangle
Paris

TREASURE OF THE CATHEDRAL OF SANTIAGO
DE COMPOSTELA

This is an offering by Marshall Pétain to the
Apostle, testimony of his passage through Spain as
Ambassador of France (1939).

It has scant, simple forms, a creation of soft
curved lines with low circular base and
counterplaced high cup, which in its precise design
is exclusively decorated with a strip of three
rounded mouldings and their intermediate grooves,
in a counterplacing of light. The cover, which also
has wide curves, ends in a Greek cross with thick
edge.

The harmonious conjunction of forms and
proportions of the goblet is emphasized by the
delicate combination of the stem: a cylinder of ivory
with thick neck, wrapped in raised cruciform plates
of silver.

The combination of materials with attractive
colors and abstract design in severe forms evokes
the sensitivity of the period. The metalsmith J.
Pulforcat is the one who starting in 1925 applies
precepts and logical forms of this "rigorously
modern style" to silver work. The only valid
elements of this work are the quality of the
materials, the purity of lines and the absence of
adornments. Pulforcat himself introduces the
modern style in sacred art, with favorable reception
among the great liturgical movements of the first
half of the century, leading to a complete renovation
of religious metal work.

Marshall Pétain's goblet is a "fine sample of
French metal work."

(A.-B.B.)

BIBLIOGRAPHY
Huyghe, R. (1977); Otero Túñez, R. (1977)

244
Catholic Action Cross
CRUZ CUYAUBE
1948

Gold-plated silver and ornamental stones
22 cm. high
Madrid

TREASURE OF THE CATHEDRAL OF SANTIAGO
DE COMPOSTELA

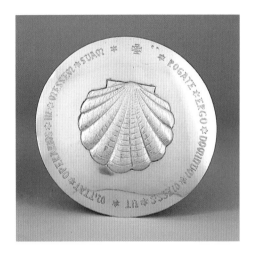

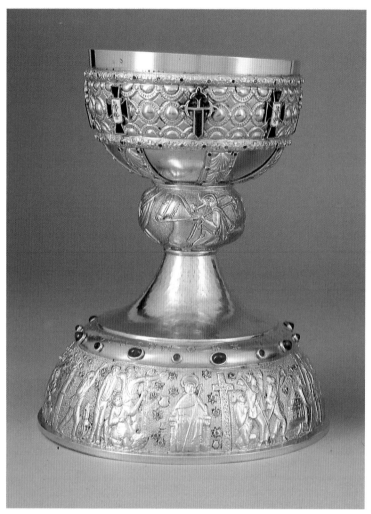

The history of this piece is recorded on its foot, which contains the following inscription: "This chalice with its base was offered by the High Council of the Association of Youths of the Spanish Catholic Action to the Holy Church of Compostela, depositary of the venerable remains of the Glorious Apostle Santiago, as a remembrance of the Great Pilgrimage of world Youth, on the XV Sunday of Pentecost of the Holy Year 1948." The piece is from the workshop of the metalsmith Cruz Cayaube, in Madrid.

The work is born from a cooperation between the artist and the group of young Spanish intellectuals who commission it. Of Romanesque inspiration, this piece of metalwork is an authentic creation of Spanish modernity in the last years of the forties. It has a characteristically expressionist configuration. The large cup is made of gold-plated silver, beaten and engraved, and decorated with polychrome stones. It has a wide circular foot, comprised of a ring serving as frieze, a rebate moulding as passageway and an opening opposite, in scotia.

The deed of the Catholic Action youths is shaped in the frieze, with a martyred nature of reconciliation and apostolate, carried out in the service of the Pilar and Santiago. Groups of pilgrims, accompanied by angels, march with their staffs, guided by the Milky Way—Saint James' Way—, studded with shining stars. Rubies rest in red quartz from Compostela, set around the Virgin and the Apostle, on a field of scallop shells. On the torus is the evangelical inscription "Potestis bibere... " and mounted stones, contrasting with the smooth scotia, done with martelet.

The round joint has two figures separated by braided bands: Santiago the Knight, with the sword and banner of Clavijo, according to the medieval model in the basilica of Compostela, and the angel of the Apocalypse, seated on a throne and bearing the cartouche with the words "Beginning and End." At his feet is the eagle, symbol of Saint John, author of the last book of the Bible.

The cup is decorated with six bands of scallop shells and stones, which join a wide strip, adorned with red and green stones. The paten has a large scallop shell in relief and a Biblical phrase.

The expressive figuration of the relief has its genesis in the sharpened existential circumstances of the civil war. It is realism which contemplates life in its own interior, in the inner regions of the tormented soul. As a consequence the outer form is not one of technical perfection, but rather the aesthetic manifestation of that interior world. The craftsman has captured the reality that motivated the work of art, and has expressed, with deformed shapes, the fundamental tragedy, but also hope: common coordinates for so many of his contemporaries of universal art. In the relief of Cruz Cayaube there is a resemblance to Picasso's Guernica, although in counterpoint.

(A.-B.B.)

BIBLIOGRAPHY
Martín González, J.J. (1970); Otero Túñez, R. (1977)

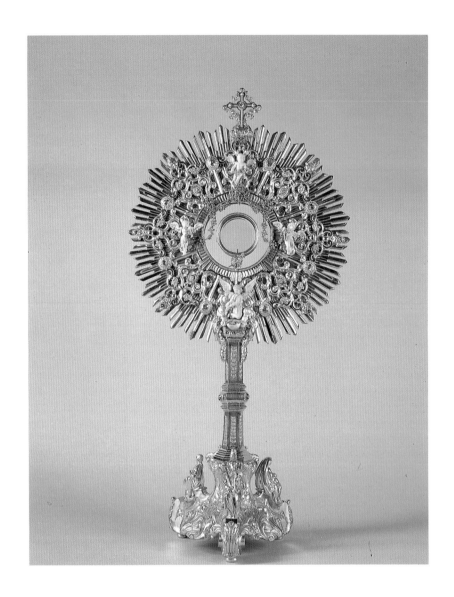

245
Wafer-box of Ferreyro de la Maza
RICARDO DE LA IGLESIA REY AND
CÁSTOR LATA
1958

Gold-plated silver, ivory and precious stones
91 x 26 x 46 cm.
Santiago de Compostela

TREASURE OF THE CATHEDRAL OF SANTIAGO
DE COMPOSTELA

The history of the piece is told by the inscription
inside the base: "Donated by the sister and brother
Petra and Ramón Ferreyro de la Maza. Made in the
Angel jewelry shop of Santiago, in 1958." To the
wealth of materials the family jewels have been
added, with their exquisite nineteenth century taste
in diamonds and pearls, mounted in silver and gold.
Necklaces, lockets, earrings and brooches adorn the
wafer-box.

Done in the Angel jewelers, it is a design by the
Compostelan sculptor Cástor Lata Montoiro, who also
made the moulds for the small statues of the
theological virtues and carved the ivory angels. The
metalcraftsman Ricardo de la Iglesia Rey, also from
Compostela and from a family of silversmiths, carried
out the project. We can still see the traditional models
of Baroque structures and forms in the piece.

The triangular base rests on ascending volutes
with fronds, where the female figures, symbols of
Faith, Hope and Charity, are situated. Wrapped in
tunics and long veils, they contrast with the
intermediate cambered spaces engraved in a sea of
foam of curled acanthus leaves, which spring from a
scallop shell. The volutes end in plant brackets, on
which the hexagonal stem rests, a stark geometric
design on the end. Its joint is decorated with three
jewels in which red quartz of Compostela is
mounted. Its capital has eggs (from the egg-and-
dart pattern) and is a strong column on which the
clear glass rests, showing the eucharistical mystery.

The glass, stark in form, is isolated within a
circle that has small rays (following the Baroque
model of Juan Posse of the same Cathedral). A
great crown of long, sharply profiled rays again
springs from it, ivory angels holding the rich jewels.

Grandiose and monumental, the ostensory is an
exquisite jewel in which golds, ivories, pearls and
diamonds, in symbolic formation are fused in rich
harmony, so preferred by the sculptor Cástor Lata.

(A.-B.B.)

BIBLIOGRAPHY
Otero Túñez, R. (1977)

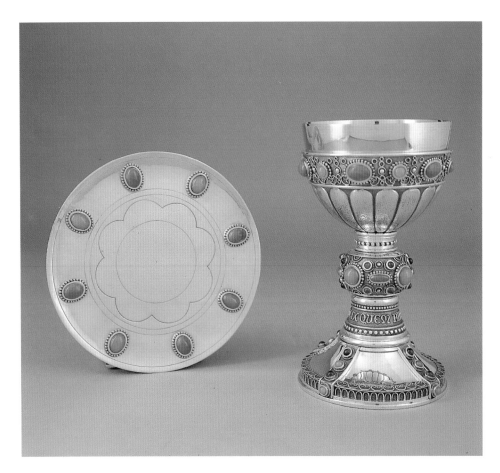

246
Chalice of the Holy Apostle
FERNANDO MAYER
1986

Silver and gold-plated silver, with precious stones
22,5 high x 18 cm. dimater of the cup
"F. Mayer" on the cover of the base
Santiago de Compostela

TREASURE OF THE CATHEDRAL OF SANTIAGO DE COMPOSTELA

The chalice is an anonymous gift to the Apostle, accompanied by another one in simplified version. Its design is a collaboration of R. Otero Túñez and A. Barral, using Romanesque models, done by the Compostelan metalcraftsman Fernando Mayer.

It has great decorative effect, with a circular foot with moulding, edged with tiny arches and kidney-shaped swirls, tiny cord filigree, and decorated with strips studded with precious stones.

The neck has horizontal bands, the first of which is conical, bearing the inscription: "Calix quem bibiturus sum," among rows of spheres. Its spherical joint is decorated with circular and oval stones and its spandrels are covered with filigree.

The gilded cup has an egg-and-dart subcup, and ends in a wide strip among fillets. It is decorated with colored stones and filigree.

The paten (18 cm. in diameter) is a small disk with a raised border. Its interior is decorated with cut circles and lobes, studded with oval stones, with alternation of reds and greens, in a cabochon of spheres.

(A.-B.B.)

APPENDIX

ARTISTS' BIOGRAPHIES

JOSÉ MARIA ACUÑA

Born in Pontevedra in 1903, but soon moves to Santiago to enter the Regional School of deaf-mutes. In this city he also receives his first artistic training: he attends the School of Arts and Trades and works in the workshops of the marble cutter Barral, the image-maker López Pedre and the sculptor Asorey, whom according to his custom, does not teach him any of his secrets of technique. After breaking with Asorey, whom he even accuses of having plagiarized his design for "The Treasure", Acuña returns to Pontevedra and obtains the assistance, thanks first to the Municipal government, and then, when it was instituted by La Sota, the scholarship that allows him to get a degree in the Academy of San Fernando of Madrid in 1928. Two years later he is named professor of the Regional School of Deaf-mutes of Santiago. Teaching absorbs him so much that after holding two individual expositions in 1933, one in Pontevedra and the other in Vigo, he will not do another until he retires in 1973. This year he organizes a commemoration in the Merchants' Circle of Santiago and, launched by his daughter, who becomes an excellent art-dealer, he enters a productive whirl, while reaching the maximum official support and as a culmination, the Castelao Medal.

(J.-M.L.V.)

BIBLIOGRAPHY: Castro, X.A. (1986); Catálogo Bienal Pontevedra (1983); Filgueira Valverde, J. (1983); López Vázquez, J.M. (1973); (1988); Sobrino Manzanares, M.L. (1982)

JUAN ANGES "THE YOUNGER"

Son of the French sculptor of the same name, member of the circle of Juan de Juni, he is born around the fourth decade of the XVIth century, knows Juni's and Gaspar Becerra's work, and works in León and Valladolid before moving to Ourense to do the Cathedral choir seats. Introducer of the Castilian Mannerist trend, he will carry out a fertile artistic activity in Ourense and its surrounding area. His style fits the forms of Juni with the grandiloquent expression and expressive tranquility of Esteban Jordán, in this way bringing us closer to the Baroque personified in Francisco de Moure. He dies between 1596 and 1597.

(A.-A.R.V.)

BIBLIOGRAPHY: Duro Peña, E. (1977); Martín González, J.J. (1962); Vila Jato, M.D. (1983)

PEDRO DE ARBULO

Outstanding master of Mannerism, in the opinion of Ceán native of Santo Domingo de la Calzada. Many facts about his early years and formation are not known. He worked with Gaspar Becerra on the main altar piece of the Cathedral of Astorga. From 1565 on he resides in La Rioja, where he does important works, such as the retables of Briones, San Asensio and Desojo, which have given him the nickname of "Michelangelo of the Rioja." He is considered the key master for the spread of Romanism in that region. He died in 1608 in the town of Briones.

(M.-A.G.G.)

BIBLIOGRAPHY. García Iglesias, J.M. (1986); González García, M.A. (1988).

ANTONIO DE ARFE

Born in León around 1510. Member of a very important line of silversmiths, he is the son of Enrique and father of Juan.

He learned his trade from his father and no work of his is known prior to 1539. From these early years the monstrance of Fuente Ovejuna—Córdoba—is attributed to him; the relationship to that of Santiago appears clear.

He was, according to his son Juan, the first who more closely followed the rules for Roman features in the design of his monstrances.

He does that of the Cathedral of Santiago—1539 to 1544—and at the same time works there on a gold chalice under commission by the Archbishop.

In 1552 he appears as a resident of Valladolid, period in which he did the monstrance of Medina de Ríoseco—1552 to 1554—and the bier for the monstrance of the Cathedral of León that his father had done.

Until 1574, when he appears as a resident of Madrid, no important works of his are known, only some lesser ones for the church chapters, the duke and duchess of Medina de Ríoseco or Alba and the marchioness of Cenete.

(M.L.L.)

BIBLIOGRAPHY: Alcolea Gil, S. (1975); Pérez Costanti, P. (1930).

Also documented are the processional crosses of San Adrián de Villacidaler (before 1510) and that of the Cathedral of León (1515 to 1517) which, like the monstrance, was transferred to Seville to mint it in 1809.

Other documented works are the incense-burner (around 1510) of San Adrián de Villacidaler and the casket of San Froilán and the scepters of the Cathedral of León (1518-1520).

The "cabbage" of Cádiz, the processional crosses of San Isidoro of León, that of the Cathedral of Córdoba (1515 and 1519), that of the Cathedral of Ourense (1515), Villamuño (León), Destriana (Gómez Moreno) and the base for that of Astorga are attributed to him. The scepters of Oviedo which he was paid for in 1527, the Lignum Crucis of San isidoro of León, the pix of the Royal Chapel of Granada and that of the Hispanic Society of New York and finally the plaques conserved in the Victoria and Albert Museum of London, which probably formed part of a monstrance and a processional cross are also attributed to him.

(M.L.L.)

BIBLIOGRAPHY. Mª-V. Herraiz Ortega (1988); C. Justi (1913); Rodríguez (1951); Sánchez Cantón (1920).

ENRIQUE DE ARFE

Born in Erkelenz (Bavaria) around 1475. His training in the trade of silversmith could have been both in German and Low Country workshops, where there was a great tradition in metalwork.

At the end of 1500 he appears working in León. The contact could have been produced by the many Flemish artists who were working for the Cathedral.

Great constructor of seat monstrances, he opts for the form of the tabernacle, inspired by the tower-shaped wood altars that, adjoined to a lateral church pillar, were used in Flanders to hold the Holy Sacrament. The first, chronologically, is that of the Cathedral of León (1501-1508), although he continued working some time after. With careful relief work, there are already some Renaissance decorative motifs such as wreaths and Grecian fret. While working on this one, he is commissioned to do the one for Córdoba (1514-1518), of which it is said that it reproduces the Gothic tower of San Romualdo de Malinas (Justi). Meanwhile, Cardinal Cisneros asks him to do the one for the Cathedral of Toledo (end of 1515 to beginning of 1516 until 1523, with some reforms in 1524), chose design resembles the Cordoban one. In the second half of the century he does the one for the monastery of San Benito de Sahagún, together with those of León, Córdoba and Toledo, as his work by his grandson Juan de Arfe in the "Varia Conmensuración", in which we can already see the separation between Gothic elements and Renaissance ones which, placed in this case in the secondary areas, will be the ones which with the passing of time will become primary.

JUAN DE ARFE Y VILLAFAÑE

Born in León in 1535. Around 1546 he moved to Valladolid with his father, Antonio, where he stayed until 1580. He knew the writings of Alberti and Durero, was especially interested in Bramante and Peruzzi, the architects of San Pedro, studied the proportions according to the Master of Nüremberg, the Italian and Spanish masters , especially Vigarni, Berruguete and Becerra, and acquired knowledge of anatomy basically through the book by Juan de Valverde illustrated by Becerra. Among his best works, from the first period in Valladolid, is the monstrance of Avila (1564-1571); from 1580 to 1587, residing in Seville; the Cathedral monstrance, commission that he obtained after winning the competition in which Francisco Merino also presented designs; back in Valladolid, a processional cross and a monstrance for the Cathedral (1588-1590), smaller and simpler than the one in Seville, another for Burgos (1590-1592), which has disappeared, and in 1592 another for the convent of Carmen in Valladolid. With him his son-in-law Lesmes Fernández del Moral always worked. In the last decade of his life he is named by Philip II as assayer in the Casa de Moneda of Segovia, does the monstrance of San Sebastián de los Reyes, Madrid (1596), sixty four reliquaries for El Escorial and the monstrances of Burgo de Osma (which has disappeared) and San Martín of Madrid. In 1602 he moves with the Court, again, to Valladolid, and signs the contract to do four praying statues in bronze, assignment for the Duke of Lerma for the church of San Pablo, which represent the duke and duchess and the archbishops of Toledo and Seville, of the same family, and which his son-in-law and Pompeo Leoni finished, since the Leonese artist dies in Madrid on April 1, 1603.

He is the author of two treatises, one on the level of purity of precious metals and stones, titled *Quilatador de la plata, oro y piedras* (Valladolid, 1572) and another on the proportions in architecture and sculpture, with the title *De varia conmesuración,* divided in four books. The fourth studies the proportions of the major pieces of service and cult in the churches. This work owed its success to its abundant illustration, whose lead plates for printing were done by the artist himself, and had great influence in the work of other craftsmen. Defender of classical proportions and cinquecentista severity, he makes no concessions to the decorative aspect, excluding the careful adornments of the Plateresque style and introducing for the first time small elements such as mirrors, enamelled or plain, framed by cartouches or braces. These new statements, both formal and aesthetic had little echo in their time, and often gave in to the requirements of the setting.

(M.L.L.)

BIBLIOGRAPHY: Cruz Valdovinos, J.M. (1982); Esteras Martín, C. (1980); Justi, C. (1913)

FRANCISCO ASOREY

Born May 4, 1889 in Cambados (Pontevedra). At fourteen he goes to Barcelona to study in the school of the Salesians in Sarriá, where he begins his career as a sculptor, under the tutelage of Perellada. Named professor of the college of Salesians in Baracaldo, he moves to this city and opens his first image-making workshop, with the collaboration of Julio Beobide and Juan Guraya. In 1909 the military service forces him to move again, this time to Madrid, where he will live until 1917. This year he decides to return to his land, installs himself in Santiago and in 1918 obtains the position as professor of anatomy of the School of Medicine. Later he marries and opens his first workshop in Compostela in the alley of Caramoniña, whence the works with which he is successful in competitions in Madrid and immense popularity in Galicia will come. Here he is recognized as the "sculptor of the race", with "Picariña" (1920), "Naiciña" (1922), scandalously only paid in the National Exposition with a travel grant. In Cambados there is an act of protest which becomes an affirmation of Galician nationalism "Ofrenda a San Ramón" (1923), "O tesouro" (1924), second prize and new act of protest, now in Sobrado; "A Santa" and "San Francisco" (first prize, this time, celebrated in Oseira). In the thirties, Asorey opens a new workshop, in Santa Clara, and begins a change in style characterized by schematicism. During the next decade he is named professor of the School of Arts and Trades, the School of Industrial Education, of which he was the first director, and the professorship of Design of the Rosalía de Castro Institute. Official recognition grows with the years: he is member of the

Royal Academy of the Rosary in 1944, the Galician Academy who in addition names him honored academician in 1957, adoptive son of Santiago and even the University itself pays homage to him on his retirement: it hangs a Víctor in the halls and publishes a monograph by Professor Otero Túñez. Victim of silicosis, Asorey died July 2, 1961. He was the first, and until now, the only, figure who received the honor of being buried directly in the Pantheon of Illustrious Galicians.

(J.-M.L.V.)

BIBLIOGRAPHY: Otero Túñez, R. (1959); (1987); (1989)

JORGE BARBI

Born in A Guarda (Pontevedra) in 1950. He begins painting, holding his first expositions since 1982. Nevertheless, his work begins to be recognized after the showing of his sculpture in the House of Culture of Baiona, for the eighth Biennial of Pontevedra in 1988. With this technique along which his work has developed, Jorge Barbi in a sense breaks the usual categories of the plastic arts, in an investigation of tridemensional forms and the spaces they reside in, combining the suggestive nature of the materials with conceptual statements.

In 1989 he has two important individual expositions in the House of the Grapevine in Santiago and in the Gamarra y Garrigues Gallery of Madrid, and one of his works is acquired for the Caixa Catalana collection. This same year he participates in the course and simultaneous exposition, "Presences and Processes. Latest Plastic Trends," organized by the University of Santiago de Compostela and the Xunta of Galicia.

(M.-L.S.M.)

BIBLIOGRAPHY: Olivares, R. (1989); Catálogo (1987)

IGNACIO BASALLO

Born in Ourense in 1952. He studies in the Provincial School of Arts and Trades and for a year in the Massana School of Barcelona. Nevertheless, he is a self-taught artist, doing research on his own on the possibilities of form and its position in space. The environment of his youth linked to his father's tarde, as employee in a wood factory, is related to his vocation. This material shapes his first sculptural references and will become the protagonist par excellence of his plastic experiences.

His presence in the Exposición Atlántica of 1980 signifies the presentation of his work and the sculptor's first important showing, participating thereafter in successive editions of this collective in Madrid (1981) and Santiago (1983), as well as in the more representative expositions, such as "Galicia panorama del arte moderno", organized by the Bank of Bilbao in 1982, "Encontros no espacio", "Imaxes dos 80", "A toda tela", of the Xunta of Galicia, Antropoloxía e Memoria of the Gulbenkian Foundation, as well as the Biennial Expositions of Pontevedra and Oviedo, among others, which were held in the first half of the decade and in which Galician art was revealed as one of the most uneasy and creative collectives of the Spanish panorama of the 80s.

(M.-L.S.M.)

BIBLIOGRAPHY: Castro, X.-A. (1985); Sobrino Manzanares, M.-L. (1982); Seoane, X. (1990)

JUAN DE BOLONIA (GIANBOLOGNA)

Flemish sculptor, born in Douai. He did his apprenticeship in Antwerp with master Dubrocq, who had visited Italy. Juan de Bolonia, like many Flemish artists, is attracted by the South. In 1521 he travels to Rome and after a brief stay, necessary to see the old works and those of classical Renaissance, he goes to Florence, where he enters into contact with the works of Michelangelo and the Florentine artists. He did not do his first marble statue until 1558, fifteen years after arriving in Florence; it was a life-sized Venus, strongly influenced by the first Michelangelo, which will serve to consolidate his artistic career, and he enters the service of prince Francisco de Médici. His reputation reaches Rome and in 1563, Pope Pius IV commissions him to do the Neptune Fountain of the city of Bologna, done in bronze because of influence by Cellini. In 1574 he conceives and produces the work that will bring him universal fame, the flying "Mercury", admired as a work of art and miracle of talent. His followers will expand upon his manner of working in bronze and his models throughout Europe. His art joins Michelangelo and Bernini, initiator of the Baroque in Italy.

(A.C.F.)

BIBLIOGRAPHY: Pijoan, J. (1951); Enciclopedia, (1987)

ISIDORO BROCOS GOMEZ

Born in Santiago April 4, 1841. He begins his artistic career at the side of his father, Eugenio, painter and engraver, and his uncle Juan, sculptor, with whom he also lived. Later he would be a student of Cancela in the Real Sociedad Económica de Amigos del País, institution in which Brocos would be assistant professor in 1862. Five years later he went to madrid, where he finished his training in the School of Fine Arts of San Fernando, with the sculptor Andrés Rodríguez. After his marriage to Rosa Tojo Vaamonde of Mondoñedo, of a wealthy family, he traveled to Rome in 1873. From here he goes in April 1874 to Paris, where he will stay until 1876. Here he presents in the Annual Exposition with The last moments of Herod (third prize) and in the Regional Exposition of Lugo (bronze medal). In 1879 he wins the professorship of Design in the Real Sociedad Económica of Santiago, but the following year he moves to A Coruña, first as interim assistant professor of the School of Fine Arts and after 1891 as full professor, and where he was Picasso's teacher, who always remembered him as a good professor. During his period in A Coruña, he receives another Third Place Medal in the National Exposition of 1881, for Here, Here and Village Tailor. He was named corresponding academician of the Academy of Fine Arts (1890) and the Royal Galician Academy (1904); he also participated actively in the Regionalist Movement and was a regular of the literary and political tertulias, such as the famous "A Cova Céltica" (The Celtic Cave). He died November 26, 1914.

(J.-M.L.V.)

BIBLIOGRAPHY: Balsa de la Vega, R. (1891); Murguía, M. (1879); Pereira, F. e Sousa, J. (1989)

MANUEL BUCIÑOS VAZQUEZ

Born in Buciños (Carballedo, Lugo) December 10, 1938. Obtained a degree in Fine Arts from the Advanced School of San Fernando in Madrid in 1962. He works with Pablo Serrano and Enrique Pérez Comendador, and learns casting techniques in the workshop of Mercader in Madrid. Since 1963 he resides in Ourense.

Author of numerous monuments and part of the sculptures of the García Barbón Cultural Center of Vigo. Among the prizes and awards he has obtained we can mention the Gold Medal at the Biennial Exposition of Pontevedra in 1975.

His evolution is an open regression to a Realism which he never completely abandoned. With the human figure as his basic theme, his work tends toward synthesis in the slight insinuation and suggestion of the form, full of dynamism. Presently he likes to combine stone with bronze, doing the entire process of elaborating the piece and thus joining the role of artist with that of artisan.

(M.-V.C.-C. R.)

BIBLIOGRAPHY: Plástica Gallega (1981); Sobrino Manzanares, M.L. (1982); (s.d.) (G.E.G); Trabazo, L. (1978)

FERNANDO DE CASAS NOVOA

Fernando de Casas is the most famous architect of the Galician Baroque and one of the great masters of Spanish Baroque. Although in general there are numerous facts about his life and work, few concern the first decades of his life. The place and date of his birth are not known, although it is believed that he was born in Santiago around 1680. Nor do we have information as to his training. Murguía, with no documentary base, considers him to be disciple of Domingo de Andrade and evidently both coincide in the idea of enriching the architectural elements, but they are of two different generations. Thus, in comparison with the turgid, plastic decoration of Andrade, that of Casas, also mostly naturalistic, is small and nervous. But at the same time we must consider that in 1708, in his first known work when he is in the cloister of the Cathedral of Lugo, he figures as Friar Gabriel de Casas' overseer. This makes us think that he was a man who observed and admired Andrade, although his architectural beginnings are linked to the expect Benedictine monk, who recommends him for the work in Lugo and whom he will succeed in the post of master builder of San Martiño Pinario. His naming three years later, June 22, 1711, as master builder for the Cathedral of Santiago, indicates that at that moment his professional prestige was recognized and his artistic personality already defined.

Although the theme of his practical formation is still to be studied, on the other hand we have an important source for his theoretical formation: the inventory of goods done in 1718, when he married, provides us with the names of the books in his library at that time. In this list there are various books of history and literature, books of travels, treaties of mathematics, solar clocks, religious or books of worship or of saints' lives. In the section of books of art works of Pliny, Vitrato, Alberti, Vignola, Serlio, Arfe, Father Lorenzo de San Nicolás, and Caramuel are mentioned; also cited are books of engravings, sometimes without specifying authors or titles, but other times in a more concrete fashion, such as for example, a "book of designs of ancient and modern buildings of Rome" or the book of Fernando de la Torre Farfán on the Festivities celebrated in the Cathedral of Seville for the canonization of King Ferdinand III. There are no authors such as Palladio, whose treatise could have been inventoried, simply as a book of drawings, nor the work of Domingo de Andrade, *Excellences of Architecture*. In any event, this is any early part of his career and moreover an inventory is never enough to know what comprised the artist's readings.

The majority of the great works that are undertaken in Galicia throughout the first half of the eighteenth century, are directly or indirectly related to Fernando de Casas. His post as master-builder of the Cathedral of Santiago led him to conclude works done by Andrade, like the chapel of the Pillar or the house of the Canonical church in the square of the Quintana, and to plan other new ones such as the façade of the corner of the Platerías and especially the façade of the Obradoiro, splendid colophon to his architectural trajectory and the work, begun the previous century by Vega y Verdugo, of "beautifying" the outside of the Cathedral. As master-builder of the works of San Martiño Pinario, he designed the main altar-piece and the two side ones for its church and constructed the vestry and the chapel of Aid; he also concluded the processional cloister and the façade of the monastery. His activity in Compostela—to which we must add his intervention in the College of Orphan Maidens, in the church of Belvís or in the convent of Sampaio—was combined with his participation in the churches of A Coruña of the Capuchines and the Company, in the church of the monastery of Vilanova de Lorenzá (Lugo) and especially the work of the chapel of the Virgin of the Big Eyes in the Cathedral of Lugo, because of the novelty of its design centered on the Galician context and the perfect harmony of architecture and retable.

(M.-C.F. de la C.)

BIBLIOGRAPHY: Bonet Correa, A. (1958); Couselo Bouzas, J. (1932); Chamoso Lamas, M. (1936); (1955) (I); Fernández del Hoyo, M.A. (1981); Filgueira Valverde, J. (1977) (I); Folgar de la Calle, M.C. (1982); (1984-1985); García Iglesias, J.M. (1988); (1990); Murguía, M. (1884); Ortega Romero, M.S. (1987); Ríos Miramontes, M.T. (1986); Vila Jato, M.D. (1989)

FRANCISCO DE CASTRO CANSECO

Native of Valderas (León), he is the most important sculptor of Galicia between the last decade of the XVIIth century and the first quarter of the next. He settled in Ourense, where he created an important workshop, head of a very active school until the middle years of the XVIIIth century. His first work on the Galician scene are the choir seats of Sobrado (1693). Afterward he went to Celanova, in whose Benedictine monastery he does the masterly main altar piece. Around that time he decides to move to Ourense, city where he constructs the disappeared town hall and is contracted by the church chapter to finish the baldacchino of the chapel of Holy Christ in the Cathedral, along with its two collateral reliefs. Upon returning from Tui, after doing the Cathedral choir (1699-1701), he completes the decoration, carving various reliefs and the corridor of the sibyls (1703), with which the interior of the holy space is transformed into a "marvelous grotto" of surprising scenographic effects. Between 1704 and 1706 he does the monumental chiselled façade of the Cistercian monastery of Oseira, the two lower sections, the work which closes his first known period.

In the next decade the artist begins to work especially for the mendicant convents of the bishopric. The contracts with the Dominicans of Ourense to do the images and retables today found in the transept, that of the Rosary and Saint Jacinto, between which, in the presbyterium, is the magnificent main altar, from the beginning of the second decade of the century. It is then that he does the main altar piece of the Dominican church of Ribadavia (1712) and a bit earlier some organ cases (the Cathedral, Celanova). And for the Franciscan convent, the choir seats, of lesser artistic pretensions, with some "processional floats" which the Brotherhood of Vera-Cruz commissions him to do. Also his are the retables of the Most Holy Christ and Our Lady of the church of the Benedictine nuns of Sampaio de Antealtares in Compostela, which may possibly be the last of his great works: the main altar piece (1714-16). The low choir of the monastery in Celanova, of uncertain and partial authorship, has chronological incongruencies.

413

The last decade of his life is spent in Ourense. These are the years of various Cathedral retables and works in the convents of Santo Domingo and San Francisco. The latter has one of his last interventions, the main altar piece of the church. He was buried there, in front of the altar of San Jacinto, September 20, 1724. Regarding his artistic formation, we only can hypothesize until 1693, a very late date to see a budding artist in him. In this respect we believe he had an apprenticeship in the Leonese/Castilian area, although he shows the assimilation of Galician and even Portuguese elements.

(F.-J.L.G.)

BIBLIOGRAPHY: Caramés González, C. (1972); Gallego Domínguez, O. (1980); Limia Gardón, F. (1989); Pérez Costanti, P (1930)

GONZALO DE CEA

Among the abundant list of names of Galician silversmiths in the dictionaries of Pérez Costanti and Couselo Bouzas and in other detailed studies of silversmiths, Cea does not appears. He engraves a splendid cross in Viana do Bolo, unpublished until now, and in a document of 1595 appears as a resident of that town. We know nothing more about him. The high quality of his work leads us to think that he learned from a famous silversmith and awakens interest in searching for other works he did, perhaps within the region mentioned.

(M.A.G.G.)

BIBLIOGRAPHY: Unpublished

JORGE CEDEIRA "O MOZO"

Son of Jorge Cedeira "the Elder", he appears residing in Santiago on the Azabachería street, at least after 1589.

He does a large number of processional crosses. These include San Esteban de Pedre (A Estrada), Santa María de Beariz (O Carballiño), San Jorge de Moeche (Ferrol), Santo Tomé de Alvite (Negreira), Santa María de Coiro (Touro), San Pedro de Parada (A Estrada), San Juan de Lázaro (Carbia), Santa Eulalia de Castro (Zas), San Martiño de Rioboo (A Estrada), Santa María de Lureda (Arteixo), Santa María de Gonzar (O Pino), San Martiño de Orto (Abegondo), Santa María de Ferreira (Coristanco), San Lorenzo de Agrón, Santa María de Troitosende (A Baña), Santa María de Fisterra, San Salvador de Covelo (Lama), San Pedro de Sarandón (Vedra), Santa María de Urdilde (Rois), Santa María de Rutis (Culleredo) and San Francisco de Cambados.

To accompany the bust-reliquary of Santa Paulina that his father did, he does another for the relics of Santa Florina (1594).

Other works of his are: the lamp of the church of San Francisco in Ferrol (1599), that of Santa María do Campo of Muros (1607) and a fountain for the chapel of the College of the University of Santiago de Compostela.

(M.L.L.)

BIBLIOGRAFIA: Pérez Costanti, P. (1930)

JORGE CEDEIRA "EL VIEJO"

Silversmith from Portugal and resident of the locality of Guimarães, he is the father of an important line of metalworkers, such as Duarte Cedeira "the elder", Jorge Cedeira "the younger" and Luis Cedeira.

He is residing in Santiago in 1542 and one of his first works is the chalice with the coat of arms of the Ulloa family for the chapel of Santa Catalina of the Cathedral of Santiago de Compostela.

He did a great number of parish crosses such as that of the Corticela of the Cathedral in Santiago—described in the report of a visit in 1608—which served as a model for that of Vilanova de Arousa—1552—and that of the Assembly of Redondela—1555. Also that of Santiago in Viveiro—1553—and that of Santa Eulalia de Camba—1561—like the one he did for the church of Salomé in Santiago.

He did the bust-reliquary of Santa Paulina, signed and dated on the base in 1553, for the chapel of the Relics of the Cathedral of Santiago and he is attributed the reliquary of San Cristóbal (Balsa de la Vega) and the pix of 1567 which belonged to Archbishop Velázquez.

In 1561, together with other persons, he formed a company for the discovery and exploitation of the gold, silver, tin and other metals in Galician mines.

(M.L.L.)

BIBLIOGRAPHY: Pérez Costanti, P. (1930); Balsa de la Vega, R. (1912)

JUAN DAVILA Y GREGORIO ESPAÑOL

Galician by birth but Castilian in his training, the first notice we have of Juan Davila in relation to Galicia dates from 1599 and links him to the choir seats of the Cathedral of Santiago, the sculptural project of greatest importance in the last third of the century in this area. In reality it can be said that his work has been reduced through time to this one and to his intervention in the altar piece of the University of Fonseca, so that the city of Compostela held, until the transfer of the apostolic choir seats to the monastery of Sobrado dos Monxes, the only pieces of his production which have been preserved. Before his departure, his activity after 1593 has been documented, year in which he works with Esteban Jordán for the Monastery of Montserrat. The information that has been gathered is scant still, but important enough to establish his artistic affiliation. The commitment to the church chapter of Compostela forces him to settle in the city, which he will not leave. Between 1603 and 1610, year of his death, he initiates a large number of works, some of which would remain unfinished. Sculptor, designer and assembler, Juan Davila is seen as an artist formed in Valladolid. Combining the influence of Junian Mannerism, certain vestiges of Berrugetean origin and the art of Esteban Jordán, he created his own style, full of technique and quality, which make him the best sculptor of his time in Galicia. And his art must already have been valued then, since in spite of Español and Solís' presence in Santiago, the church chapter calls him to take charge of what at the time appeared to be the greatest work of its Cathedral. He does the plans, executes a good part of the panels and directs the work.

His colleague is Gregorio Español, probably from Astorga, with a much broader range of activity, documented between 1585 and 1631. His presence in Galicia is even earlier, since it begins in 1596, when together with Solís he agrees to do the enlargement of the choir by Mateo with the addition of several seats. Associated with Davila, he will work in the Cathedral choir seats and the altar piece of the University, in addition to accepting other projects at the same time. When the choir is finished, which will also be his best work, he returns soon after to Astorga and continues his work there. In 1625 he returns to Compostela to collaborate with Bernardo Cabrera on the altar piece of the Relics of the Cathedral. Once there, he acquired other commitments, some of them also for the Cathedral, but on this occasion those who commissioned him were disappointed and let him know it. They were his last works for this area. Old and infirm he returns to Astorga where, without resting his gouge, he dies between 1631 and 1632. Behind him was a production which we know better and better and which, together with a Junian substratum, shows the strong impact of Becerra's work and the influence of Esteban Jordán, which will make the mark of the former even more intense.

(A.-A.R.V.)

BIBLIOGRAPHY: Chamoso Lamas, M. (1950); Fernández Sánchez, J.M., Freire Barreiro, F. (1882); González García, M.A. (1984); López Ferreiro, A. (1905); Llamazares Rodríguez, F. (1981); Martín González, J.J. (1964); Pérez Costanti, P. (1930); Rosende Valdés, A.A. (1978); Vila Jato, M.D. (1979); (1983)

XOSÉ EIROA

Gabriel Xosé Eiroa Barral was born on November the 30 1892 in Santiago de Compostela, the city where he spent the whole of his life. His father, a monumental mason, had his workshop at the Rua Nova, and through Sixto Aguirre, who lived in the last floor of the same house, Xosé Eiroa got in touch with the group of "novos" - new intellectuals and artists -, who persuaded him to devote himself to sculpture. He made very few works and almost all of them did not get the final material, as he prematurely died on February the 21st. 1935.

(J.-M.L.V.)

BIBLIOGRAPHY: López Vazquez, J.M. (s.d.) (G.E.G.); (1988) (III); Sobrino Manzanares, M.L. (s.d.) (G.E.G.); (1982)

ANTÓN FAÍLDE GAGO

Born in Ourense July 2, 1907. Apprenticeship with the marble-workers and sculptors Núñez and Piñeiro. Brief stay in Madrid, where, with a scholarship from Ourense, he attends the workshop of José Capuz. In 1936, on returning, he establishes himself as a marble-worker, at the same time as he does sculpture, alternating his residence between Ourense and Bamio de Cima, a village near the capital, although pertaining to the municipality of Cioles. In 1957 he is named corresponding academician of the Royal Academy of Fine Arts of San Fernando. Main expositions in Ourense (1949), Vigo (1950), Buenos Aires (1951), Madrid, again (1963 and 1968), and again in Vigo (1973 and 1979). Maternity, friars and the world of childhood are habitual themes in his sculpture. He died in Ourense June 8, 1979.

(M.-V.C.-C.R.)

BIBLIOGRAPHY: Carballo-Calero Ramos, M.V. (1986); Trabazo, L. (1972); (1978)

GREGORIO FERNÁNDEZ

We can say he was born in Sarria (Lugo) around 1576 or 1577, in a family of artisans, and that perhaps he is the son of the carver Gregorio Fernández. His first training took place in some Galician workshop (one of those which offers the greatest possibilities is that

of Ourense), although he would soon need to broaden the environment of his artistic apprenticeship. The true style of Fernández will only find complete satisfaction in the artistic context of Valladolid, where he settles at the beginning of the XVIIth century and where he will stay until his death, January 22, 1636.

Gregorio Fernández worked for several years in Francisco del Rincón's workshop, where he obtains a series of characteristics that are repeated in the beginning period of his personal production: a taste for elegant positions, soft modelling, helicoidal rhythm. It has also been noted that there was an early stay by Fernández in Madrid, where he was in contact with this artistic nucleus.

Fernández' art evolves along the line of a personal expression little related to his first production. In this new stage his deep penchant for realism predominates. He shapes the anatomy with details, and thus prefers the nude, and treats the clothing with extreme hardness, creating a type of tinny folds, used with an essentially illuminating, chiaroscuro purpose. Another defining characteristic is his special concept of the relief: he avoids pictorial relief and tries to model the real presence of the form in the sculpture.

In the iconographic aspect he is defined as the great creator of religious imagery and the initiator of the Castilian Processional Float. He does Dolorosas, Pietàs, Christs tied to columns.

The art of Gregorio Fernández does not remain static, but rather has three stages: The first, from 1605 to 1616, is a period of formation still linked to Mannerism; the second, which lasts until 1623, represents the passage to his mature style and is characterized by the naturalism of the figures; the third and last is the period of full Baroque in which the poses are tense and suffering.

The fame of Gregorio Fernández reaches the most diverse parts of Spain and his influence remains alive until late in the century. His art had a direct influence on Mateo de Prado, due to the presence in Galicia of some of his work, such as the Reclining Christ, the Immaculate Virgin of the convent of Clarisas of Monforte, the Dolorosa of the Cathedral of Ourense and the Christ of Conxo.

(C.G.F.)

BIBLIOGRAPHY: Vila Jato, M.D. (s.d.) (G.E.G.).

JOSÉ FERREIRO

Son of Domingo Ferreiro, possibly an obscure sculptor, and María Suárez, he was born in Noia on November 14, 1738. At eight, after his father's death, he moves to Santiago, where he will enter the workshop of José Gambino as a young boy. He will have a filial relationship with Gambino, reinforced when he married his master's oldest daughter, Fermina, in 1756, marriage from which two daughters will be born: María Josefa in 1761 and María Manuela in 1763. As a result, the importance of Ferreiro in his father-in-law's workshop will slowly grow, becoming obvious after

1770 with the execution of the main altar piece of Sobrado. Thus, when Gambino died in 1775, Ferreiro took over the workshop which will then have its maximum expansion and from which his brothers-in-law will gradually grow independent, both because of the possibilities of work offered by Ferrol and its shipyards as well as because of the recession in large assignments to the mother workshop as the change of century approached. Still, Ferreiro still receives a last large assignment with the execution of the Minerva for the University of Santiago. After a serious illness and making out his will in 1804, he manages to recover, but unable to obtain new jobs because of the war against the French, a widower and in debt, he has to sell his house on the Cuesta Vieja, dividing the inheritance with his son-in-law, the sculptor Vicente Portela, widower of María Josefa and father of two small girls, and with his other daughter María Manuela, married to the silversmith Jacobo Pecul, which will be begun January 13, 1812 and will end after a long process, documented by Barreiro Fernández, due to the disagreement on the part of Pecul who considered himself disadvantaged in relation to Vicente Portela, whom he thought was much favored by Ferreiro. The latter tries to put the matter off, moves to Hermesende (Zamora), "works on his trade as sculptor in a workshop near the house of the parish priest," refuses to return and the judge determines him "incompetent" in 1814, so that the two brothers-in-law had to come to an agreement. In 1816 the judge decides in favor of not executing a new division of goods, as Pecul had demanded. From the same document we learn that Ferreiro was in Monforte de Lemos as a "resident", although he will die in Hermesende on January 2, 1830, according to the death certificate published by Pérez Costanti.

(J.-M.L.V.)

BIBLIOGRAPHY: Couselo Bouzas, J. (1932); López Vázquez, J.M. (s.d.) (G.E.G.); Murguía, M. (1884); Otero Túñez, R. (1957)(II); Pérez Costanti, P. (1930)

JUAN DE FIGUEROA

Silversmith of great prestige, he does all his work in the workshop of Salamanca.

The urns of the main altar of the Cathedral in Salamanca are his work, as are the bier of the church of Saint Martin in the same city, those of the collegiate church of Toro (1681) and those of Our Lady of San Lorenzo of Valladolid (1682).

At the beginning of the XVIIIth century Monroy commissions him to do several works for the Cathedral of Santiago: the adornment and enrichment of the Apostle's altar, a monstrance (1702) and the staff, gourd and alms-box for the Holy Apostle.

(M.L.L.)

BIBLIOGRAPHY: Brasas Egido, J.C. (1975); Couselo Bouzas, J. (1932).

JOSÉ GAMBINO

The great personality of Galician Baroque sculpture in the second third of the XVIIIth century which defines Rococo art is José Gambino. Ceán affirms that he was the grandson of a Genoan sculptor and his father arrived in Galicia and installs a paper factory in the Faramello, where he marries and his son is born, who was baptized May 14, 1719 in the church of Santa Cristina of Ribasar. At 16 he goes to Portugal, according to Murguía, and enters the workshop of Almeida, "one of the most famous sculptors in wood of his time," trained in Rome, which would increase his relationship to Italian art, already familiar to Gambino thanks to the engravings his father had brought from Italy, as Ceán suggests. he returns to Santiago and in 1741 marries María de Lens, from a family of altar piece makers and sculptors who would facilitate his relationship with the major artistic centers of Compostela.

Gambino's work is numerous and quite varied. Normally he uses wood, but he also worked in stone. He collaborated in 1744-1745 with Fernando de Casas on the façade of the Obradoiro, who charged him with "removing and doing the image of San Juan Evangelista" and "rebuilding and composing the effigy of Santa Barbara." He does the cherubs and virtues for the controversial façade of the Azabachería, also in stone, in the decade of the sixties and with a more Rococo aesthetic; only Faith is preserved.

Between 1745 and 1749 he enters into contact with the Franciscans of the convent at Herbón. At that time he carves the Saint Anthony and a decade later Saint Joseph, Saint raphael and Saint Michael.

Around the middle of the century the change in Galician artistic mediums is notorious and the incipient Rococo is affirmed more and more. There are numerous works from the decade of the fifties which are impregnated with that grace and delicacy that are inherent to Gambino's work. Proof of this is the Saint Anthony of the convent of the Carmen de Arriba in Santiago, place where he would later do the Virgin of the Carmen, Saint Joseph and Saint Joaquín. The exquisite Santiago Pilgrim is from 1754, and is very much in accord with the sumptuous decoration of the Capitulary Hall of the Cathedral of Santiago. Two years later he does the images for the church of the Orphan Girls, magnificent carvings with Italian influence, presided over by the Ascent, unfortunately touched up. Also during the same period he would work on the Monastery of Oseira. Other works done in this decade have been lost, like the Christ Resurrected if the Collegiate church of Iria. Nevertheless, the very valuable carving of Saint Catalina is preserved, precedent of those he would later do for the same abby of San Martiño Pinario.

Undoubtedly the attacks launched by the recently created Academy of San Fernando against the style in vogue awakened in Gambino a greater disposition and sympathy toward Rococo. The collection he did in 1766 for the presbyterium of San Martiño Pinario is corroborated by the statues of Saint Andrew and Saint John the Evangelist, the splendid reliefs of the Archangels and the small retable of the Immaculate Virgin which head the choir. All this is controlled by the glass beads and polychromy with shiny gold.

Gambino's activity has no limits. In 1768 he works for Santa Cruz de Aranga. Two years later in Compostela he does, among other things, two processional images: the San Roque of the chapel dedicated to him and the dynamic equestrian Santiago of the Cathedral, erringly repainted, with the subsequent loss of Rococo golds which it must have had. In the same temple, in the chapel of Relics, the ivory crucifix (1772) which Archbishop Raxoi commissioned him to recompose, "giving life to the anatomy and some veins." The Pilgrim Virgin which this Prelate commissioned him to do has disappeared.

His placement between happy Rococo and sever Neoclassicism increases. When in 1770 Gambino does the retable of Sobrado dos Monxes with his son-in-law Ferreiro, the Academy intervenes. In 1774, he still assays the altar pieces of San Mamede of Carnota and the tympanum with the acroterium statue of the town hall of Santiago, work also supervised by the Academy and which Gambino will not finish, since on August 25, 1775 he was buried in the parish church of San Juan.

With his death the last sculptor of Galician Baroque disappears, since although until into the XIXth century, the school of image-makers created by him and represented by his son Thomas and his son-in-law José Ferreiro subsists, the work of these men will follow completely Neoclassical paths.

(M.-S.O.R.)

BIBLIOGRAPHY: Ceán Bermúdez, J.A. (1800); Couselo Bouzas, J. (1932). López Ferreiro, A. (1898-1911); Mariño Ferreira Alves, M. (1989); Martín González, J.J. (1983) (I); Murguía, M. (1884); Ortega Romero, M.S. (1966); (1982); Otero Túñez, R. (s.d.), (G.E.G.).

PEDRO GARRIDO

Silversmith from Valladolid, very active in Galicia at the end of the XVIIth century and first half of the XVIIIth. He did important works for major Cathedrals and churches, such as a monstrance and tabernacle for the Cathedral of Mondoñedo and stairs and small atrium for the main altar piece of the Cathedral in Ourense, as Couselo Bouzas affirms, along with a magnificent pediment.

For the sanctuary of As Ermitas he also did important works, such as the pediment, which today are lost. Knowledgeable in his trade, his works are done according to Baroque tastes, very well accepted by the people.

(M.-A.G.G.)

BIBLIOGRAPHY: Bonet Correa, A., Carballo-Calero Ramos, M.V., González García, M.A. (1987); Brasas Egido, M.C. (1980); Couselo Bouzas, J. (1932)

GASPAR GONZÁLEZ

Son of Enrique González, also a silversmith. Although a resident of Ourense, we know of his stay in Compostela, perhaps to perfect his trade with a Compostelan silversmith.

We know him above all for his processional crosses, which he did for San Pedro de la Torre (1611, Bande), Santa Coloma de Gargantos (1612, Ourense), with the same design as that of the Hospital of San Roque in Ourense, for the Cathedral of Ourense (1612), like that he had done for the monastery of San Rosendo of Celanova, that of San Pedro Félix of Solveira (1613, Xinzo), another for Santa Eulalia de Banga (1614, Carballiño), Sobrado do Bispo (Bardanes) and that of San Martín de Layossa (1624, Sarria). For San Juan de Río (1616, Tribes) he did the chalice, reliquary, fountain and silver cruets.

(M.L.L.)

BIBLIOGRAPHY: Pérez Costanti, P. (1930)

ALONSO GUTIÉRREZ VILLOLDO

Born around 1536, he is known as "the younger" to differentiate him from his father, also a prestigious silversmith, named Alonso Gutiérrez. In 1561 he appears as a metal worker in gold and an assaymaker of the Court, the first known metalworker who held this position in Valladolid. After the death of his father (1564), he uninterruptedly occupied his position as Village assayer until his death in 1599. Contemporary and relative of Juan de Arfe, he assayed the majority of his works.

(M.L.L.)

BIBLIOGRAPHY: Brasas Egido, J.C. (1980)

CORNIELLES DE HOLANDA

Between 1520 and 1547 the presence of a sculptor named Cornielles of Holland is documented in different parts of Galicia; he is undoubtedly from that Central European country and to him we owe the introduction into the area of a peculiar sculptural concept, half-way between Burgundian Gothic and the first Renaissance.

Little is known of his life and the presence in various parts of Spain, such as Avila or Seville, of two sculptors with the same name, who work at the same time, has even increased the confusion. The comparative analysis of their respective signatures shows them to be very different.

Traditionally his appearance in Ourense, after 1521, has been associated with the construction of the main altar piece of the Cathedral, which was being erected in 1516 and was concluded four years later. Although his intervention there is not documented, it is quite probable that it may have occurred that way, given the typological relationships between this altar piece and those of Oviedo, Toledo or Seville, probably also works of Central European sculptors. In any event, the arrival of Cornielles in Ourense must be related to the renovation which was done on the Cathedral during the early years of the XVIth century and to whom the personality of the cannon Alonso de Piña is related. Cornielles received other assignments from him, such as the altar piece of the church of San Pedro de Moreiras or the retable and choir of the monastery at Xunqueira de Ambía which, if they are not by him, at least must be included in the circle of his collaborations.

In 1521 he is commissioned to do a sarcophagus to place the altar piece of the chapel of Gutierre de Sandoval, in the monastery of San Francisco of Ourense. The avatars suffered by this building from Secularization caused the loss of a good part of the altar pieces and their sculptures, which makes it almost impossible to identify this work of Cornielles, which nevertheless contributed to reinforce his fame as a sculptor, to the point of being called in 1524 by the administrator of the Royal Hospital to do the altar piece of the vestibule of this institution.

The establishment of Cornielles in Compostela, at a time when the city was full of new items by Juan de Alava and his collaborators in the Cathedral cloister, determines the new phase in evolution which will lead him to combine Burgundian naturalism in sculptures with Plateresque decorativism in altar pieces and sepulchers, as is seen in the funeral site of the cannon Antonio Rodríguez in the chapel of the Prima in the Cathedral of Santiago, or in the magnificent altar piece of the chapel of Pedro de Ben in the church of Santiago of Betanzos, which reaffirms the sculptor in the usage of formulas "a la romana", employing a Plateresque typology, repeated by Cornielles in the main altar piece of the Cathedral of Lugo, which occupied the main wall of the church until 1769 when it was taken down and moved to the walls of the transept closing, with the loss then of the iconographic sequence and the possibility of a unified reading. Dedicated to the Virgin and Christ, it shows scenes from the life of Mary and the Passion of Christ, and it is closely related to the altar piece in Ourense as far as the importance of the narrative sense, although the differences are deep in regard to the type of support and decoration used in the piece's architecture, which has balustered columns, scallop shells in the place of canopies and bizarre motifs on the portals.

During the third decade of the century, Cornielles works on this piece in Lugo with several assignments in Santiago, entirely lost, such as the retable of the chapel of Alta in the Cathedral cloister. In 1538 he moves his center of activity to Pontevedra, on being assigned the altar piece of the convent of Santa Clara, also disappeared, and in 1541 he takes charge of the façade of the church of Santa María a Grande, which will occupy him during the last years for which we have information. Cornielles will give half of this work to the Portuguese stone-cutter Juan Noble, although it is probable that he did the general design and centered on the sculptures, leaving the architectural and decorative work to his colleague. In any event, at least we can see the intervention of both craftsmen in the sculptures: the one who works on the figures of the side of the Epistle is more Renaissance, while the sculptor who

works on the side of the Evangel is still much more strongly linked to a Gothic tradition. In 1547 the two masters are paid a total of 1,180 gold ducats, which seems to indicate that the work on the façade is concluded. After that time, all information on Cornielles of Holland ceases, which leads us to believe he died or left Galicia.

(M.-D.V.J.)

BIBLIOGRAPHY: Azcárate, J.M. (1958); Chamoso Lamas, M. (1973) (II); Filgueira Valverde, J. (1942) (I); Gómez Moreno, M. (1942); González Paz, J., Calvo Moralejo, G. (1977); (s.d.) (Redacción) (G. E. G. T. VII); Pérez Costanti, P. (1930); Rosende Valdés, A.A. (1982)

JUAN DE JUNI

The religious feeling that impregnated the Spanish society of the XVIth century was characterized by its multiple nature and, as a consequence, the religious image at its service simply reflected the different possibilities of experiencing it. And one of these ways, which undoubtedly dominated in the second third of the century, was that which defended a type of image which sought to cause an impact and shock the faithful person's imagination through pathetic and emotional accents as a speaker for a religiosity directed more to the heart than to reason and which has in Alonso Berruguete and Juan de Juni its best interpreters. Of French origin, perhaps from Joigny, city between Burgundy and Champagne, Juan de Juni will bring to the Spanish Renaissance his French vision of the dramatic content of the figure, probably distilled in Italy. Around 1535 he is installed in León and later settles definitively in Valladolid, city where Berruguete also works and which became the most important sculptural center of the period. He married three times and had several children, one of whom, Isaac de Juni, was the inheritor of his workshop but not his talent. Sculptor, carver and assembler, he was as skilled in using fired clay as alabaster or wood, always dominating the material as he desired. In his images volume and solidity, force and plethoric forms are affirmed. But like a good sculptor of pathos, he prefers movement—which in him is always synonym of agitation, distorting bodies and fabrics, in the suffocating density of the reliefs—where space is closed in, draperies and anatomies are shaken by the same impulse and the figures are violently flattened over the surface, ending up incrusted in each other—, or in the inadequacy of the frames which overwhelm the figures. Nevertheless, symmetrical composition is respected, so that all the movements are centripetal and not all his works are tormented. His personality is also reflected in the design of retables, which abandon the monotonous regularity of the Plateresque caissons and the rich decoration in favor of structural clarity, the affirmation of architectural elements and the legibility of the stories, establishing a new type of relationship between the image and the faithful although within a syntax that is completely outside Classical constructive logic. The irradiation of his art was enormous and, in regard to Galicia, we must remember that it will shape one of the most active currents which reached some of the best achievments in Galician sculpture of the XVIth century.

(A.-A.R.V.)

BIBLIOGRAPHY: Azcárate, J.M. (1958); Camón Aznar, J. (1961); Checa Cremades, F. (1983); Martín González, J.M. (1964); (1974); Weise, L. (1927)

FRANCISCO LEIRO

Born in Cambados (Pontevedra) in 1957. At age 16 he leaves Cambados for Santiago to learn stone work in the School of Arts and Trades. He is in Santiago for three academic years and at 19 goes to Madrid, where he takes classes in modeling, copy and nudes and attends workshops. Leiro works in stone at first, but soon begins to experiment with wood. His grandfather was a carpenter and his father cabinetmaker. Since the eighties -in 1988 he left to live in New York - he basically works in wood.

(B.D.R.)

BIBLIOGRAPHY: Castro, X.A. (1985)(I); (1985)(II)

BERNAL MADERA

He learned his trade from his father, also a famous Flemish silversmith, William of Gant, and was in turn the master of Juan Rodríguez Tarrío. He lived in Compostela and had his workshop there.

He did a silver bier for the convent of San Martín in Santiago (1584). For the Rector of the parish of San Cristóbal de Portomouro, he did two "porcelains" of silver, one gilded, and for San Salvador de Escuadro (Lalín), he did a silver cross in 1590. He finished the monstrance of the church of Santiago de betanzos, which his father had been commissioned to do, in 1586.

(M.L.L.)

BIBLIOGRAPHY: Pérez Costanti, P. (1930)

CRISTINO MALLO

Born in Tui in 1906. He lives in Gijón and Avilés, until his family definitively moves to Madrid in 1922. He studies in the School of Fine Arts of San Fernando and in the School of Arts and Trades, where he is the disciple of Julio Vicent and José Capuz. In 1933 he receives the National Prize for Sculpture with the work "Nude with Fish." He participates in the artistic and intellectual world of the Madrid of the period, attending the tertulias in the Café Gijón. He is elected to the Royal Academy of Fine Arts of San Fernando in 1973, but refuses the chair. That place is occupied by Pablo Serrano. He is considered one of the most important Spanish sculptors of our century.

(B.D.R.)

BIBLIOGRAPHY: Castro Arines, J. de (s.d.) (G.E.G.)

ACISCLO MANZANO FREIRE

Born in Ourense May 6, 1940. His first artistic steps were with the artists Xaime Quesada and Xosé Luis de Dios, also from Ourense. Brief stay in Santiago, in Asorey's workshop. He attends the clases of Liste in the School of Arts and Trades of Compostela. In the decade of the sixties he travels to Belgium, France, Italy. In 1971 he has an exposition in the Museum of modern Art in Mexico. Since 1969 he alternates his residence between Ourense and Ibiza, which has meant an important change at the same time as it has enriched his formal concepts, by incorporating into his iconographic repertoire in a definitive manner images extracted from the Greek classical and hellenistic world.

In his constant desire to renovate Galician plastic art, his work has followed a logical process of transformation, and after experimenting in areas more or less near to abstraction, has returned to figurative perspectives. Presently, the sculpture of Fidas, pieces such as "The Victory of Samotracia" or various hellenistic menades can be seen as his reference points.

(M.-V.C.-C.R.)

BIBLIOGRAPHY: Pablos, F. (1981)

IGNACIO MARIÑO ANDRÉS

Probably from Noia, he figures as a resident of Santiago, where he lives until 1765, when he was commissioned in Madrid by the church chapter of Compostela for the new project for the Azabachería façade.

In collaboration with other masters he works on some projects, such as the retables of San Benito and Our Lady of Aid in San Martiño Pinario, the altar of the capitular room (1735), whose design was done by Casas and Novoa, and finally, in 1752, the altar piece of San Vicente Ferrer in the church of Santo Domingo de Bonaval.

(A.G.T.)

BIBLIOGRAPHY: Couselo Bouzas, J. (1932)

ALONSO MARTINEZ DE MONTÁNCHEZ

Alonso Martínez de Montánchez or Montancha, who died in 1615, is a sculptor of Portuguese origin, active in Ourense at the turn of the century. There is news of him since 1594, when he is living in that city, already a professional sculptor judging from the fact that in August he admits Francisco de Moure, a youth between seventeen and twenty five years old, as he himself declares, as apprentice for five years. The latter would become the most important sculptor in Galicia in the first third of the seventeenth century, and the influence of Angés would be stronger than that of his own master, also indebted to the Castilian artist, because independently of his origin, Alonso Martínez has no loans from Lusitanian art and instead shows himself to be an artist formed around Juan de Angés, whose death in 1596 would allow him to receive a greater number of assignments. In his art, then, formulas of post-Junian Mannerism will join with a very personal tendency toward curved rhythms and the sensitive and fleshy nature of forms.

His work signifies the closing in the area of the Mannerist cycle of Junian base and, given the tight chronological framework in which he moves, he shares similar stylistic concepts, thus appearing very homogeneous, although different in the quality of form than the results. These reveal an acceptable personality but with uncertain success, although during his time he was highly considered. The abundant apprentice contracts which he has and the numerous assignments, which at times he will have to pass on because of the material impossibility of completing them, show his recognition, favored by the fact that, after the death of Angés, the panorama in Ourense did not give him an sort of artistic rivalry, which does not lessen his success as a sculptor. That he is a famous artist is shown by the fact that at the beginning of the century he was commissioned to do the choir seats for the monastery of Montederramo, and that the monks, after the work was done, record their satisfaction in a notary's document in which he is praised, not only on a professional level but also a moral one, creating a true success for the artist. It is a clear proof of the regard in which he was held. Unfortunately, both the documented and preserved work and the frame for the attributions will always move on a lower level

than that offered us by the panel of Montederramo, in which, as his best work, captivating because of its ingenuity of ideas, the limitations of his gouge are always present, and often, his complete inability to establish a coherent narrative.

(A.-A.R.V.)

BIBLIOGRAPHY: Chamoso Lamas, M. (1947); Ferro Couselo, J. (1971); Gómez Sobrino, J. (1988); González Paz, J. (1955); Iglesias Almeida, E. (1989); (1990); Martín González, J. (1964); (1983) (I); Pérez Costanti, P. (1930); Vila Jato, M.D. (1983)

MASTER MATEO

The biography of Master Mateo is, at least in part, the history of the Cathedral of Santiago de Compostela, of the Pórtico da Gloria.

There is no notice that would allow us to know his origin, although at some point it was thought that he could be Galician—a theory that today is totally rejected. His formation cannot not shed any light on this either; he has been linked to France—Burgundy, Aquitaine or Saint Denis—, to Avila or Italy. Nevertheless, we cannot affirm with certainty that he came from one of those places: we can simply show that he had a very precise knowledge of what was being done there. The justification of these different influences could reside in the presence, together with Mateo, of a large workshop where he would have brought together artists of the most diverse origins.

There is little information about the master of the Pórtico. In 1161, according to Llaguno, he is working on repairing the bridge of the Ulla River in Cesures (Pontevedra). In 1168 King Ferdinand II awards him a lifetime pension of 100 maravedis; at this time he is already working on the Cathedral, very probably on the crypt. In 1188, twenty years later, he signs the lintels of the tympanum of the Pórtico da Gloria, ... PER MAGISTRUM MATHEUM QUI A FUNDAMENTIS IPSORUM PORTALIUM GESSIT MAGISTERIUM. From the following years, 1189, 1192 and even 1217, there are documents which in some way are related to Mateo.

His artistic work is centered principally on the Cathedral: the Pórtico da Gloria, stone choir and cloister. To these works we would have to add those which may in some manner be related to his workshop: the cloister of the collegiate church of Santa María de Sar, Santa María de Cambre (A Coruña), San Xoan de Portomarín (Lugo), or San Lourenzo de Carboeiro (Pontevedra).

(J.M.M.M.)

BIBLIOGRAPHY: Filgueira Valverde, J. (1945); García Iglesias, J.M. e Rosende Valdés, A.A.(1980); López Ferreiro, A. (1896); Valle Pérez, J.C. (s.d)(G.E.G.)

MASTER OF SOBRADO

Toward the fourth decade of the XVIth century an anonymous sculptor must begin to work in Galicia, bringing an early and direct influence of Juan de Juni and whom, for lack of documentary information, we call the "Master of Sobrado" because he worked for this monastery. In spite of the lack of identification, his artistic relationship can be established with detail, as it clearly derives from Juni, from whom he takes not only the forms but also, especially, the spirit, that characteristic "pathos" of the sculptor from Valladolid, in such an obvious resemblance that it leads us to think the "Master of Sobrado" had a long stay in that workshop, specifically in the Leonese environment of Juni, since the style he brings to Galicia is that which derives from the choir seats of San Marcos in León or the clay groups of Medina de Ríoseco or Salamanca.

The possibility of establishing a dependency of the "Master of Sobrado" on the Leonese workshop of Juni allows us to set al least one approximate chronology, since this sculptural nucleus is dispersed after the departure of Juni from León in 1540, reason which could have this unknown sculptor to move to Galicia, where other works of his are found until the sixties, which indicates an important activity and the existence of a workshop that produced some of the sculptures which coincide with his stylistic peculiarities.

Regarding the works we know are his, the oldest ones must be the remains preserved from the primitive altar piece of the monastery of Sobrado: the Holy Burial, the Adoration of the Shepherds, the Birth of the Virgin and the Crucified Christ, which I believe can be dated between 1540 and 1550. Given that around this time in that monastery the choir seats were also being done and that the enigmatic Gil Probot, apparently of French origin, worked on them, we might think that this sculptor later received the assignment of the main retable and that therefore that was the Master of Sobrado's real name.

Once the monastical retable was completed, that anonymous sculptor must have moved his workshop to Ourense, working throughout the entire southern area of Galicia until his death around 1560, when the echoes of the Mannerism inspired by Gaspar Becerra or Esteban Jordán began to arrive.

Undoubtedly that workshop produced an important group of sculptures, of which we have the altar piece of the Fifth Anguish of the Cathedral in Ourense, the altar piece of the church of Pazos de Arenteiro or the figures which remain in the altar piece of Santa Eulalia de Banga. The most outstanding stylistic feature of this sculptor is his profound Junian influence, seen in the dramatism of the figures, the distortions which express a culminating moment of the action, the vitality of the muscles and veins which he must have learned from Juni, from which he nonetheless differs in the treatment of the fabric, flatter and with greater linearity and fineness of the crested folds, which resembles Diego Siloé and in general matches the technique of the folds of the second third of the century.

(M.-D.V.J.)

BIBLIOGRAPHY: Azcárate, J.M. (1958); Castillo, A. del (1921); Fernández Otero, J.C. (1983); García Iglesias, J.M. (1984); Martín González, J.J. (1966); Martín González, J.J., González Paz, J. (1986); Rey Escariz, A. (1922); Rosende Valdés, A.A, (1982); Sánchez Arteaga, M. (1916)

ISIDRO DE MONTANOS

He learned the silversmith trade with his father, the famous Marcelo de Montanos, and like him earned a great reputation, especially as a craftsman of processional crosses, of which we know numerous examples: that of silver and enamel for the convent of San Antonio of Monforte de Lemos (1629), that of Santiago de Rubiás in Vilameá (1633), Santa María de Lodosedo in Sarreaus, Santa María de Cesuris in Trives (1636), Santa María de Vilar de Ordelle in Alariz (1646), Santa María de Boazo in Trives (1647), Santiago de Zorelle in Maceda (1649), San Salvador de Sande in Cartelle (1661) and Santa María de Freás de Eirías in Celanova (1671).

He did some lamps in 1630 and 1631 for the convent of San Rosendo in Celanova, reliquaries for San Benito de Rabiño (1633) and the convent of San Martiño in Santiago (1636), a processional standard for San Pedro de Grixoa in Viana (1647) and some scepters and a monstrance for the Cathedral of Ourense.

(M.L.L.)

BIBLIOGRAPHY: Bouza Brey, F. (1935); Pérez Costanti, P. (1930)

MARCELO DE MONTANOS

Born in Valladolid, he was a craftsman - with Miguel Mojados - of Juan of Naples. His first mutual commission in Galicia was the execution of the silver urns for the monastery of Celanova and the monstrance of the Tui cathedral. After these works, the bishop of Tui recommended them to the Ourense chapter for the execution of the Cathedral monstrance. Juan of Naples came back to Valladolid and they carried out the work. In 1605 he appears as a resident of Ourense, with his workshop at the Olas square: he will be the master of Gregorio de Puga and his son Isidro, members of the long dynasty of silversmiths set up by Marcelo, and which will end up in the XVIIIth. century. Many works of his hand have lasted out : a sceptre, monstrance, reliquary and silvered amphoras for the Holy Oil, made for the monastery of Samos; more amphoras and a collecting bowl for Santa Mariña de Escornabois; a pix for Verín (1609) and another one for Santiago de Gustei (1608), chalices for Santiago de Vilela (1608) and Portovello (1631), crosses for Baion, Xinzo de Limia (16616 and 1628) and San Antonio de Ribadavia, and a silver monstrance for Verin.

(M.L.L.)

BIBLIOGRAPHY: Brasas Egido, J.L. (1980); Pérez Costanti, P. (1930)

FRANCISCO DE MOURE

Born in Santiago around 1575. His father, César Antonio, was Italian, while his mother, Lucía de Moure, was from a stone-cutter family of Ourense. This is why our artist settled in the city of the Burgas at a young age and why he is considered to be from Ourense.

In 1588 he must have been in Castile, as is deduced from the will of Francisco Dalba, step-father ; we do not know exactly what the reason was for his trip, but it could have made possible certain contacts with the artists working there at the time.

His training as a sculptor nevertheless begins with a contract signed by him and Alonso Martínez de Montánchez in 1594. Beside the teachings of the Portuguese master we must consider that Ourense at the time was a flourishing artistic center; here were Esteban Jordán, Juan Angés the Younger... and the work of Juan de Juni was known. By document we cannot show today the relationship between Juan de Angés and Moure, nevertheless, this nexus seems undeniable from the stylistic point of view.

The work done by this great sculptor, contemporary of Gregorio Fernández, is centered in Ourense, at least in his first two periods (1598-1608 and 1608-1615); after this date he moves to the province of Lugo, where he will culminate his career with the altar pieces of the monastery of San Xulián de Samos, the choir seats of the Cathedral of Lugo and the main retable of the church of the Company of Monforte de Lemos, place where he died in 1536.

This sculptor signifies the link between a Mannerist sculpture, profoundly related to Juan de Juni, and the naturalism which will dominate all Spanish Baroque art, represented by Gregorio Fernández.

(J.-M.M.M.)

BIBLIOGRAPHY: Cid Rodríguez, C. (1923-25); Fariña Busto, F., Vila Jato, M.D. (1977); González Paz, J. (1967); González Suárez, F. (1982); Martín González, J.J. (1983) (II); Otero Túñez, R. (1980); Vila Jato, M.D. (1974); (1978); (1980); (1984); (s.d.); (s.d.) (G.E.G.)

JUAN DE NÁPOLES MUDARRA

Born in Burgos around 1560, he moves to Valladolid, where he lived in the street of the Platería and was parishioner of the parish of Salvador. He trained as a silversmith in this city, perhaps with Juan de Benavente, disciple of Antonio de Arfe. He was married first to Marcela Montaos, sister of the silversmith Marcelo Montaos, for years his collaborator.

He was very active in both the province of Valladolid and in other regions. He brought his assistants from Valladolid, Miguel Mojados and his brother-in-law, to Galicia, so that they could help him with the silver urns for the monastery of Celanova (1598-1602)

and the monstrance of the Cathedral of Tui. Back in Valladolid, his style seems to have evolved, assimilating the proto-Baroque courtly tendencies, the so-called Philip II style. In 1615 he signed the contract to do the monstrance of the Cathedral of Oviedo, which disappeared during the French invasion. In Valladolid he worked for the monastery of San Benito, in the convent of Our Lady of the Laura, the Cathedral and various parishes in the city. He died around 1627.

(M.L.L.)

BIBLIOGRAPHY: Brasas Egido, J.C. (1980); Cruz Valdovinos, J.M. (1982)

LEONARDO NARDON PENICAUD

The initiator of a family dynasty of enamellers from Lemos who worked during the whole XVIth century. The most important part of his production is between the years 1495 and 1530. His name appears in 1503 as signature of an enamelled piece with the theme of the Calvary, preserved in the Museum of Cluny. This master's works usually have the form of a triptych with religious themes. Also by him, and signed, one of these triptychs with scenes from the Passion is in the Lázaro Galdiano Museum; another with the same theme, attributed to him, is in the Museum of Fine Arts of Granada. He is also the author of a Coronation of the Virgin and a Pietà, in the Louvre.

(Y.B.L.)

LEOPOLDO NÓVOA

Born in Salcedo (Pontevedra) in 1919. His father was Uruguayan, son of a Galician emigrant, and his mother Galician of Cuban origin. In 1938 he emigrates to Uruguay with his family, works in the ceramics industry, enters the School of Architecture and then that of Law, and in 1947 settles in Buenos Aires, where he begins to paint. He comes into contact with Luis Seoane and with his help holds his first pictorial exposition. Again in Montevideo, he devotes himself to formalism as a political illustrator. After 1965 he settles in France and presently lives in Paris and Pontevedra. The name Leopoldo Novoa is traditionally associated with his pictorial work (he does the large project for the mural in the Cerro Stadium of Montevideo between 1962 and 1965). His sculpture is a prolongation of his painting and has similar characteristics.

(B.D.R.)

BIBLIOGRAPHY: Logroño, M. (1977); Seoane, X. (s.d.) (G.E.G.)

FRANCISCO PECUL Y CRESPO

He is a member of a large family of Compostelan metalworkers—of French origin—headed by Claudio Pecul, his father.

Born in 1755, he learns the trade in the family workshop, where he acquires the elegant, delicate character that distinguishes him from his contemporaries. His formation continues in the Royal Academy of San Fernando in Madrid, repeatedly appearing in the books of proceedings of the academy which from 1782 supports his work, giving him financial assistance. He participates in various competitions and in 1784 wins first prize for "background engraving." Among his works as a student are two silver goblets done in 1788. In 1799 he applies for graduation as an Academician, presenting five metal pieces: an image of the Immaculate Conception, two sets of cruets and two chalices, which earned him his degree. In 1802 he appears as "beginning helper," thus initiating his career within the Academy.

He is the author of three amphoras for the Holy Oils of the Cathedral of Lugo (1798) and a silver crucifix—copied from one in bronze by Alonso Cano—which perhaps is the one done for the oratory of Mr. Bringas. He is attributed the silver statue of Saint Theresa, preserved with the Immaculate Virgin in the Cathedral of Santiago and other works of his in bronze for Aranjuez, Madrid and Jaén, are known.

(M.L.L.)

BIBLIOGRAPHY: Alcolea Gil, S. (1975); Couselo Bouzas, J. (1932); Otero Túñez, R. (1963)

SIMÓN PÉREZ DA ROCHA

Born in 1722, but until 1750 we have no news of him. He then figures as steward of the brotherhood of San Telmo. In the land register of the Marquis de la Ensenada he appears as master silversmith and faithful assayer. Between 1755 and 1769 he does several works for the Cathedral of Tui: the silver steps for the altarpiece of the main chapel, a pediment, an arch of silver and others of lesser size, such as a ship, a pilgrim's cloak, a goblet, a chalice, candelabras, etc. His activity is interrupted in 1762, when he was mobilized for war. He died in 1769 and was buried, according to his wishes, in the chapel of Solitude of the Cathedral.

(M.L.L.)

BIBLIOGRAPHY: Fernández-Valdés Costas, M. (1970); Sáez González, M. (1984)

PACO PESTANA

Born in 1949 in Castroverde (Lugo). He travels through different places in Spain and abroad. At 28 he settles definitively in Galicia and decides to devote himself to sculpture. Previously he had been in contact with poetry, but he himself declares that he "hadn't enough patience to sit down and write." He lived in Lugo, in close contact with nature, which provides his material and inspires his work.

(B.D.R.)

BIBLIOGRAPHY: Castro, X.A. (1985) (I); Seoane, X. (1988)

XOÁN PIÑEIRO

Born in 1920 in a small village of the town of Cangas do Morrazo. In spite of the difficulties due to his humble origins and an unfavorable environment for his artistic curiosity, Piñeiro devotes himself to his sculptural vocation.

His biographic information can be established by an inevitable period of apprenticeship, perfectioning and maturity both in his vital attitude and in his artistic development, from when he left his native area in 1947, passing through Santander, to his installation in Madrid and later his definitive return to Galicia in 1961-62, first in Vigo and later in a workshop in Goián, where the artist will live until his death in 1980.

The themes and sculptural fields which Piñeiro treated throughout his life are numerous and diverse. He is an artist with an extensive production of portraits, civil and religious monuments, in which what prevails is the clarity of composition within a figuration which varies in accordance with his artistic concepts.

In his personal works, the formulations will evolve from traditional realism to the simplification and figurative essentialization. Receptive to the Galician plastic tradition, he will penetrate characteristically sculptural concepts, assimilating the contributions of the most important movements of art in our century with a very coherent style within his stylistic trajectory. In his last years, he will dedicate his efforts to investigating the expression of plastic form through multiple organic references provided by Nature.

(C.P.A.)

BIBLIOGRAPHY: Piñeiro Alvárez, C. (1986)

XOÁN POSSE

As recorded in his will, his parents were residents of San Esteban de Suesto (Vimianzo, A Coruña), but we do not know if he was born there or in Santiago.

His formation in the trade is Compostelan, perhaps with Andrés de Calo y Castro whom he served as official in 1683. He was a silversmith for the Cathedral, for which he did most of his works, which include the candlesticks (1698), the goblet for the monstrance (1699), the catches of the torch stands for the Main Altar, three cruets for the Holy Oil (1700), the silver portraits of King Philip V and his wife, a gift from them to the Cathedral, two book rests for the Main Altar and a lamp for Our Lady of Solitude.

Other works of his are the goblets for the parish churches of San Pedro de Ribeira (1695), San Jorge de Codeseda (1696), Santa Marina (1696), Santa Eulalia de Lañas (1696), Salgueiros, Gándara, Cequiril, Argalo, Arteixo and San Furctuoso of Santiago. Biers for the monastery of San Martiño Pinario—like those already in the church—and the parish cross of Santa María of caldas.

(M.L.L.)

BIBLIOGRAPHY: Couselo Bouzas (1932); Pérez Costanti (1930).

MATEO DE PRADO

Native of San Xulián de Cumbraos (Sobrado, A Coruña), Mateo de Prado is the most important sculptor of the XVIIth century in Galicia. Everything seems to indicate his training in Valladolid in the circle of Gregorio Fernández. The first notice we have of him situate him in 1632, working in the collegiate church of Vilagarcía de Campos, but we cannot determine what he was actually doing. Between 1632 and 1635 he is residing in Valladolid. In this last year he works in the monastery of Our Lady of Aránzazu (Guipúzcoa) with the painter Diego Valentín Díaz, polychromist of Gregorio Fernández' sculptures and of whom he was close friend, and with the sculptor Andrés de Solanes, also collaborator of the great Castilian image-maker; his presence has been justified by seeing him as intervening in the works Gregorio Fernández was doing at the time for the monastery. But as important as his collaboration might have been, if it is correct—as everything seems to confirm——to include him in Fernández' workshop, it is almost impossible to isolate his work. To do so we must wait until 1639, the year in which he contracts to do the choir seats of San Martiño Pinario in Santiago, where he is shown to be a sculptor at the height of his maturity. His presence in Galicia can be justified in relation to the death of his master, which would necessarily signify the dispersion of the workshop; nevertheless, the choir of the Benedictine temple would be the next motive which determines his settlement in Compostela. This work deserves special consideration not only for its intrinsic value, but because it allows us to establish for the first time the stylistic features of his art and because it signifies the start of the implantation of Gregorio Fernández' style in the area. This work guaranteed his future as a sculptor whose good work brought prestige to the center in Compostela, since in spite of the fact that his activity covers a wide geographical region, he would never leave Santiago. Markets as tempting as Ourense,

where his work was so well received, were not reason enough to leave the city, so that all his works would be done here. The documentation allows us to draw a broad sculptural trajectory, even though not all the documented works are preserved. But it would be enough to recall some works, such as the choir of San Martiño, the sculptures done for the Cathedral of Ourense, the main altar for the monastery of Montederramo or the stone relief of the convent of Mercedarian nuns of Santiago, to prove he is the most talented sculptor of the century in Galicia. He died in Santiago in 1677 and was buried in the church of San Francisco.

(A.-A.R.V.)

BIBLIOGRAPHY: Bouza Brey, F. (1956); Chamoso Lamas, M. (1956) (II); Hervella Vázquez, M. (1988); Martín González, J.J. (1983)(I); (1983)(III); Otero Túñez, R. (1980); Pérez Costanti, P. (1930)

MANUEL DE PRADO MARIÑO

There is no testimony that is more exact than the "curriculum" of the Compostelan sculptor himself to provide a brief synopsis of his biography. This curriculum—published some years ago by Professor Otero Túñez—had been presented to the Academy of San Fernando when he was applying for the directorship of the School of Drawing in the Real Sociedad Económica of Santiago, where he had been a student and professor.

His training in this center, where he learned drawing and engraving, would later be completed with studies of mathematics in the Compostelan University. He was a pupil of his brother, the architect Melchor de Prado, with whom he learned not only sculpture, but also principles of architecture. All this is combined with a profound knowledge of Ferreiro's work. He manages to give his work its own characteristics and importance, being considered by Otero Túñez as "one of the most important figures of Spanish Neoclassical imagery."

The work of Manuel de Prado, significantly expressive of the second generation of Galician Neoclassicism, is numerous inside and outside Galicia, especially in Santiago and the surrounding areas. In Compostela he did the surprising reliefs of the chapel of the Souls, done with a special technique. We can also cite the Immaculate Conceptions of the Cathedral and Santa María do Camiño, the floats of the Meeting of Saint Michael dos Agros, the Dolorosas of this same church and the Bishop's Palace in Lestrove. Outside Santiago, near Ourense, we find the extraordinary group of the church of Vilamarín.

(C.P.V.)

BIBLIOGRAPHY: Couselo Bouzas, J. (1932); López Vázquez, J.M. (1988)(II); Otero Túñez, R. (1956)(I); (1963); (1982); Sánchez Cantón, F.J. (1965); Sobrino Manzanares, M.L. (1982); Trens, M. (1946)

PEDRO RIBADEO

Many pieces with his emblem are known. He was the craftsman of some of them, but in many others he only serves as assayer. He is documented as being in Valladolid in 1497.

Pedro Ribadeo did a large number of processional crosses, such as those of Mucientes, Pesquera de Duero, Camporredondo, the collegiate church of Osuna (Seville) and Vertavillo, all with abundant Gothic decoration. The monstrance of the parish church of Palacios de Campos, if it is his work, is from a later period because it begins to abandon the Gothic style in favor of Plateresque. The Gothic pix of the parish church of Santiago in Pontedeume is also attributed to him.

(M.L.L.)

BIBLIOGRAPHY: Brasas Egido, J.C. (1980)

SILVERIO RIVAS

Born in Ponteareas (Pontevedra) in 1942. He begins to work in his father's cabinet-making workshop at age 12. At 14 he attends night classes in the School of Arts and Trades of Vigo. In 1969 he participates in the Biennial of Pontevedra. There he meets Xoán Piñeiro and decides to go work with him, moving his workshop from Goián. In 1970 he receives a grant from the Provincial Government to study in the School of Arts and Trades in Madrid, also attending night classes in the Fine Arts Circle. Xoán Piñeiro places him in contact with Paco Barón, with whom he works until 1972, when he moves to Paris. He returns to Vigo in 1973. In 1976 he attends the summer course organized by Sargadelos. The Seminar of Cermaic Studies of Sargadelos awards him a scholarship to do research on articulated pieces. In 1979 he moves again to Paris, where he currently resides.

(B.D.R.)

BIBLIOGRAPHY: Castro, X.A. (1985); Gamoneda, A. (1976); (1981); Seoane, X. (s.d.)(G.E.G.); Sobrino Manzanares, M.L. (1982)

SANTIAGO RODRIGUEZ BONOME

Born in Santiago in 1901. His training begins in the workshops of the sculptors José Rivas, Enrique Carballido and Asorey. In 1924 he moves to Madrid where he will have the support of José Francés. In 1929 he settles definitively in Paris. In 1933 he stops holding

expositions after 1940 devotes himself solely to ceramics. Bonome's work presents daily life in the rural Galician region using popular types and traditions (Antroido, Meigallo, Enterro). He also does caricatures of famous characters (Valle Inclán, Camilo Díaz...) which recall the drawings of Castelao and Bagaría.

(B.D.R.)

BIBLIOGRAPHY: Gerpe Blanco, M.T. (s.d.); López Vázquez, J.M. (1988)(I); Sobrino Manzanares, M.L. (1982); (s.d.)(G.E.G.)

MIGUEL ROMAY

Active and outstanding master from Santiago, born in the last third of the XVIIth century and who must have died before 1750. Novel in his solution of retables, some designed by him, like that of the Third Franciscan Order, and others by figures as extraordinary as Simón Rodríguez or Fernando de Casas.

He is the author of the case for the organ of the Evangel of the Cathedral, together with Antonio Alfonsín, of the reredos for the chapel of the Pillar and San Martiño Pinario, designed by Casas, and that of the church of the Company, designed by Simón Rodríguez.

He is one of the most extraordinary altarpiece makers of the time.

(M.-A.G.G.)

BIBLIOGRAPHY: Couselo Bouzas, J. (1932)

DIEGO DE SANDE

Little is known of the life of Diego de Sande. He could have been born in Padrón or Noia, as Murguía says. He works in Santiago, where he dies in a street fight. His artistic work is marked by the premises of the XVIIth century—recall that he is considered to be the continuer of Mateo de Prado—and by the characteristics of the century in which he worked, the first third of the XVIIIth.

Among his documented works we can point out the Praying Santiago of the Chapel of the Pillar of the Compostelan Cathedral, attributed to him by Chamoso Lamas, and his participation in the altar pieces of the Prima (Cathedral of Santiago, 1722) and the Company (1727), both designed by Simón Rodríguez. In addition, the Ecce Homo of the Chapel of the Third Order and the Christ tied to the Pillar of San Agustín is attributed to him.

(J.-M.M.M.)

BIBLIOGRAPHY: Chamoso Lamas, M. (1941); Folgar de la Calle, M.C. (1989); Martín González, J.J. (1980); Murguía, M. (1884); Otero Túñez, R. (1980)

TOMÁS DE SIERRA

From Santalla (El Bierzo), he in all probability receives his first training in Valladolid and later settles in Medina de Ríoseco, where there was an important workshop since the XVIIth century and where he lives until his death, Januery 23, 1725. He marries Inés de Oviedo in 1681, with whom he has five children, some of whom will form part of his workshop.

In his sculptural production we see the influence of Juan de Juni and Gregorio Fernández. His first documented works date from 1692. He fixes the float of Longino for the Confraternity of the Fifth Anguish, works for the collegiate church of Villagarcía de Campos on numerous sculptures and reliefs, but undoubtedly one of his most complete works is the main retable of the church of Santiago in Medina de Ríoseco.

(A.G.T.)

BIBLIOGRAPHY: Ferro Couselo, J. e Lorenzo Fernández, J. (1988); Martín González, J.J. (1961); (1968); (1980); (1983) (I); Muñoz de la Cueva, J. (1726)

BENITO SILVEIRA

Benito Silveira is born in San Xulián dos Cabaleiros (A Coruña). He begins his apprenticeship under Miguel de Romay. Later, he will travel with Felipe de Castro to Portugal, Seville and Madrid, where he worked on the Royal Site of San Ildefonso (1729-1733), thus completing his training in the Court. After Felipe de Castro left for Italy, Silveira, possibly because of his character, returns to Compostela, after having done solitary work without disciples to continue on.

The nature of his artistic production was modified as he became more involved in it. Presently works that can be considered his are: the second section of the main retable and the two of the transept of San Martiño Pinario (1733-1743), the main altar piece of Santa María do Camiño (1756) and that of San Antonio Abad of San Bartolomé in Pontevedra.

(J.-M.M.M.)

BIBLIOGAPHY: Couselo Bouzas, J. (1932); Murguía, M. (1884); Otero Tuñez, R. (1953) (I); (1953) (II); (1956) (II); (1956) (III); (1980); (1986)

PEDRO TABOADA

Pedro Taboada, assembler and sculptor, is still an obscure figure within Galician and Compostelan Baroque art. We have nothing about his life, except his link to the workshop of Mateo de Prado, with whom he collaborated closely.

His artistic work throughout the last third of the XVIIth century is also uncertain, the scarcity of documentation, which allows us to identify his works, makes his curriculum chiefly one of attributed items. Among the documented pieces is the retable of the Chapel of the Rosary in Santo Domingo de Bonaval (Santiago, 1666) and that of the church of Santo Domingo of Ourense (1670). The attributions are more numerous: the retable and images of St. Ildefonso in Santa María de Iria Flavia (A Coruña), that of St. Eulalia in Vilagarcía de Arousa (Pontevedra), or those of the Chapel of St. Theresa in St. María Salomé, that of the Sacred Family in the church of the Company and that of St. Augustine, all in Santiago de Compostela.

(J.- M. M.M.)

BIBLIOGRAPHY: Chamoso Lamas, M. (1956); Fernandez Sánchez, J.M. e Freire Barreiro, F. (1882); Ortega Romero, M.S. (1982); Otero Túñez, R. (1953)(I); (1958)(I); (1980); (1986); Pérez Costanti, P. (1930); Rios Miramontes, M.T. (1983)

RAFAEL DE LA TORRE MIRÓN

Born in Madrid May 4, 1871, he was formed in the School of San Fernando, where he was the student of Arturo Mélida, with whom he would collaborate on the Monument to Columbus of the Cathedral of Seville. In the final years of the century he moved to Paris to complete his studies. In 1900 he wins the post of full professor of Drawing in the Institute of Santiago; in 1902 that of the School of Arts and Trades and in 1904 that of anatomical sculptor of the School of Medicine.

De la Torre Mirón obtained honorable mention in the Historical European Exposition of the IV Centennial of the Discovery of America, second place medals in the National Expositions of 1897 and 1911 for Arte Decorativa, Luis XV and Flores y Frutos and the Grand Prize and Gold Medal in the Great Galician Regional Exposition of 1909 for a relief map. He died in Santiago June 15, 1937.

(J.-M.L.V.)

BIBLIOGRAPHY: López Vázquez, J.M. (1988) (III)

BIBLIOGRAPHY

A

Actas (1977)
Actas del Coloquio Internacional sobre el Bimilenario de Lugo. Lugo

Actas (1984)
"La documentación Notarial y la Historia", *Actas del segundo Coloquio de Metodología Histórica Aplicada.* Santiago

Actas (1988)
Actas del Primer Congreso Peninsular de Historia Antigua, II. Santiago

Acuña Castroviejo, F. (1974)
"Notas sobre la morfología y la decoración en las aras y estelas de Galicia en la época romana", *Studia Archaeologica*, XXXIV, 17-31

Acuña Castroviejo, F. (1976)(I)
"La Cultura en la Galicia Romana, la Romanización", *Cuadernos del Seminario de Estudios de Sargadelos*, 16, 63-76

Acuña Castroviejo, F. (1976)(II)
"Las Formas del Arte Provincial Romano", *Cuadernos del Seminario de Estudios de Sargadelos*, 16, 85-92

Acuña Castroviejo, F. (1976)(III)
"Sobor da representación do tema Ulises e as sireas na estela de Vilar de Sarria (Lugo)", *Boletín Auriense*, 6, 107-113

Acuña Castroviejo, F. (1980)
"A Prehistoria e a Edade Antiga", *Historia de Galicia*, I, Barcelona, 31-106

Acuña Castroviejo, F., Calo Lourido, F. (s.d.)
"Cultura Castrexa", *Gran Enciclopedia Gallega*, VIII, 99-100

Acuña Castroviejo, F., Casal García, R. (1981)
"La Estela Funeraria de Antes", *Brigantium*, II, 273-280

Acuña Fernández, P., Calo Lourido, F., Fariña Busto, F. (s.d.)
"Escultura Romana", *Gran Enciclopedia Gallega*, X, 125-132

Acuña Fernández, P., Valle Pérez, J.C. (s.d)
"Los relieves de Amiadoso" (en prensa)

Ainaud de Lasarte, J. (1973)
Museo de Arte de Cataluña. Arte Románico, Guía. Barcelona

Alba, L. de (1943)
"Teoría del Barroco Gallego", *Arte y Letras*, 12,12-13

Alcolea Gil, S. (1958)
La Catedral de Santiago. Madrid

Alcolea Gil, S. (1971)
"Relieves Ingleses de Alabastro en España. Ensayo de Catalogación", *Archivo Español de Arte*, XLIV, 137-153

Alcolea Gil, S. (1975)

Artes decorativas en la España Cristiana, Ars Hispaniae, XX. Madrid

Alonso Romero, F. (1981)
"La nave romana de la estela de Vilar de Sarria (Lugo)", *Brigantium*, II, 281-282

Álvarez Blázquez, J.M. (1953)
"Hallazgo de estelas funerarias romanas en Vigo", *Actas del III Congreso Nacional de Arqueología*, 462-475

Álvarez Blázquez, J.M., Bouza Brey, F. (1961)
"Inscripciones romanas de Vigo", *Cuadernos de Estudios Gallegos*, XVI, 5-42

Álvaro López, M. (1979)
El convento de San Antonio de Herbón. Tesis de Licenciatura Inédita, Santiago

Anati, E. (1968)
Arte Rupestre nelle regioni occidentali della Peninsola Ibérica. Brescia

Andrade, D. de (1956)
"Excelencias, antigüedad y nobleza de la Arquitectura", F. J. Sánchez Cantón, *Opúsculos Gallegos sobre Bellas Artes de los siglos XVII-XVIII.* Compostela, 55-113

Andrejova, I. (1975)
Les Bijoux Antiques. Praha

Anzoni, G. (1987)
Diccionario dell'Arte italiano. Milano

Ares Espada, S. (s.d.)
El Sebastián Camarasa. (Inédito)

Ares Vázquez, N. (1983)
"La inscripción de una patena visigótica del Museo de Lugo", *Boletín do Museo Provincial de Lugo*, I, 209-212

Arias Vilas, F. (s.d.)
"Cristianización", *Gran Enciclopedia Gallega*, VIII, 30-31

Arias Vilas, F. (s.d.)
"Romanización", *Gran Enciclopedia Gallega*, XXVII, 90-93

Arias Vilas, F. (1977)
"Novedades Arqueológicas del Museo de Lugo", *Boletín de la Comisión Provincial de Monumentos Histórico-Artístico de Lugo*, LXXXVII, 72-73; 78

Arias Vilas, F. (1977-1978)
"Un interesante relieve aparecido en Santa María Magdalena de Adai (Lugo)", *Boletín de la Comisión Provincial de Monumentos Histórico-Artísticos de Lugo*, X, 18-24

Arias Vilas, F. (1981)
"Unha estela antropomorfa do Castro de As Coroas de Reigosa (Pastoriza, Lugo)", *Brigantium*, II, 257-265

Arias Vilas, F., Le Roux, P., Tranoy, A. (1979)
Inscriptions romaines de la province de Lugo. París

Arphe, J. de (1675)
Varia conmensuración para la escultura y arquitectura. Madrid

Azcárate, J.M. de (1951)
"El cilindro motivo típico del Barroco compostelano", *Archivo Español de Arte*, XXIV, 193-202

Azcárate, J.M. de (1958)
Escultura del s. XVI, Ars Hispaniae, XIII. Madrid

Azcárate, J.M. de (1963)
"La Portada de Platerías y el programa iconográfico de la Catedral de Santiago", *Archivo Español de Arte*, XXXVI, 1-20

Azcárate, J.M. de (1965)
"El Hospital Real de Santiago. La Obra y los Artistas", *Compostellanum*, X, 873-878

B

Balil Illana, A. (1960)
"Plástica provincial en la España romana", *Revista de Guimarães*, LXX, 107-131

Balil Illana, A. (1974)
"Sobre la escultura de época romana en Galicia", *Studia Archaeológica*, XXXII, 43-48

Balil Illana, A. (1975)
"Sobre los mosaicos romanos de Galicia. Identificación de un taller Musivario", *La Mosaique Greco-Romaine II* (Vienne), Paris, 259-263

Balil Illana, A. (1976) (I)
"Algunos aspectos y problemas de la Galicia Romana", *Cuadernos de Estudios Gallegos*, XXVIII, 161-180

Balil Illana, A. (1976) (II)
"Frammenti di sárcofago cristiano nel nord-ouest della penisola Ibérica", *Rivista di Archeologia Cristiana*, LI, 313-316

Balil Illana, A. (1978)
"Esculturas de época romana en Galicia (Aspectos y problemas)", *Revista de Guimarães*, LXXXVIII, 147-157; 197

Balil Illana, A. (1979) (I)
"Esculturas romanas de la Península Ibérica. II", *Studia Archaeologica*, LIV, 14-16

Balil Illana, A. (1979) (II)
"Esculturas romanas de la Península Ibérica. III", *Boletín del Seminario de Estudios de Arte y Arqueología*, XLV, 227-257

Balil Illana, A. (1981)
"Esculturas romanas de la Península Ibérica. IV", *Studia Archaeologica*, LXVIII, 10-11

Balil Illana, A. (1983)
"Esculturas romanas de la Península Ibérica. VI", *Boletín del Seminario de Estudios de Arte y Arqueología*, XLIX, 215-265

Balsa de la Vega, R. (1891)
Artistas y críticos españoles. Siluetas de 'pintores, escultores y críticos. Barcelona

Balsa de la Vega, R (1909)
"Enigma arqueológico", *Boletín de la Real Academia Gallega*, XXVI, 27-31

Balsa de la Vega, R. (1912)
"Orfebrería gallega", *Boletín de la Sociedad Española de Excursiones*, XX, 160-174

Bandera Romero, M.L. de la (1986)
"Introducción al estudio de la joyería prerromana peninsular", *Habis*, XVII

Bango Torviso, I. (1978)
"Aportación a una catalogación de la imaginería gótica de Pontevedra", *Museo de Pontevedra*, XXXII, 95-104

Bango Torviso, I. (1979)
Arquitectura románica en Pontevedra. A Coruña

Bango Torviso, I. (1987)
Galicia románica. Vigo

Bango Torviso, I. (1989)
Alta Edad Media. De la tradición hispanogoda al románico. Madrid

Barral Iglesias, A. (s.d.)
El Monasterio de Santa María la Real de Conxo. (en prensa)

Barreiro, B. (1988)
"El clero de la diócesis de Santiago: Estructura y comportamientos (siglos XVI-XIX)", *Compostellanum*, XXXIII, 469-508

Barreiro Fernández, J.R. (1965)
"Abadología del monasterio benedictino de San Martín Pinario en Santiago de Compostela (1607-1855)", *Studia Monástica*, VII, 147-188

Barreiro Somoza, J. (1987)
El señorío de la iglesia de Santiago de Compostela. A Coruña

Barrio Gozalo, M. (1985)
"Perfil socio-económico de una élite de poder (III): Los obispos del reino de Galicia (1600-1840)", *Anthologica Annua*, XXXII, 11-107

Barros, C. (1990)
Los Irmandiños. Badrid

Beccherucci, M.L. (1962)
"Manierismo", *Enciclopedia Universal dell'Arte*

Bertarelli, L., Ferrara, M., (1944)
Toscana. Milano

Blanco Freijeiro, A. (1949)
"Dioses bicornes", *Cuadernos de Estudios Gallegos*, IV, 429-431

Blanco Freijeiro, A. (1956)
"Cabeza de un castro de Narla. Notas sobre el tema de la cabeza humana en el arte céltico", *Cuadernos de Estudios Gallegos*, VI, 33-42

Blanco Freijeiro, A. (1957)
"Origen y relaciones de la orfebrería castreña", *Cuadernos de Estudios Gallegos*, XII, 5-28; 137-157; 267-301

Bonet Correa, A. (1958)
"El urbanismo barroco y la plaza del Obradoiro en Santiago de Compostela", *Archivo Español de Arte*, XXXII, 215-227

Bonet Correa, A. (1965)
La arquitectura en Galicia durante el siglo XVII. Madrid

Bonet Correa, A. (1967)
Arte Prerrománico Asturiano. Barcelona

Bonet Correa, A. (1983)
"La evolución de la caja de órgano en España y Portugal", *El Organo Español. Actas del Primer Congreso*. Madrid

Bonet Correa, A., Carballo-Calero Ramos, M.V., González García, M.A. (1987)
El santuario de Nuestra Señora de las Ermitas. Ourense

Borgna, C.G. (1973)
"Studio metódico-cronológico del repertorio di preistoride della zona di Fentáns, Galizia-Spagna", *Cuadernos de Estudios Gallegos*, XXVIII, 90-102

Bouza Brey, F. (1932)
"O emprazamento de unha célebre estatua galaica", *Nos*, XIV, 107, 199-200

Bouza Brey, F. (1934)
"O brazalete Posthallstáltico de Toén", *Boletín dela Universidad de Santiago, homenaje al Profesor Rodríguez Cadarso*, 441-446

Bouza Brey, F. (1935)
"Aportacións ao diccionario de artistas na Galicia dos séculos XVI ao XIX", *Nos*, XII, 126-137

Bouza Brey, F. (1941)
El tesoro de Caldas de Reyes. Informes y Memoria. Madrid

Bouza Brey, F. (1942)
"El peine del tesoro de Caldas", *Boletín de la Real Academia Gallega*, XXIII, 187-203

Bouza Brey, F. (1944)
"Monjes organistas, organeros y cantores mayores del monasterio de San Martín Pinario", *El Museo de Pontevedra*

Bouza Brey, F. (1946)
"Vestio Alonieco, nueva deidad galaica", *Archivo Español de Arqueología*, LXIII, 110-116

Bouza Brey, F. (1951)
"La cabeza céltica de Ocastro (Silleda, Pontevedra)", Cuadernos de Estudios Gallegos, VI, 33-42

Bouza Brey, F. (1956)
"Noticias biográficas del escultor Mateo de Prado", *Cuadernos de Estudios*

Gallegos, XI, 449-453

Bouza Brey, F. (1982)
"Fortuna de las Canciones de Gesta y del héroe Roldán en el románico compostelano y en la tradición gallega", *Compostellanum*, X, 663-690

Bouza Brey, F., D'Ors, A. (1949)
Inscripciones romanas de Galicia. I. Santiago

Brasas Egido, J.C. (1983)
La platería vallisoletana y su difusión. Valladolid

Briard, J. (1965)
Les depôts bretons et l'Age du Bronze Atlantique. Rennes

Bueno, P., Fernández Miranda, M. (1980)
"El Peñato de Vidiago (Llanes, Asturias)" *Altamira Symposium*, Madrid, 451-467

Burgo López, C. (1985)
Un dominio monástico femenino en la Edad Moderna. El Monasterio Benedictino de San Paio de Anteaaltares, Tesis Doctoral Inédita. Santiago

C

Caamaño Gesto, J.M. (s.d.)
"Conventos jurídicos", *Gran Enciclopedia Gallega*, VII, 102-107

Caamaño Gesto, J.M. (s.d.)
"Vías", *Gran Enciclopedia Gallega*, XXX, 31-33

Caamaño Gesto, J.M. (1984)
As vías romanas, Cadernos Museo do Pobo Galego, III. Santiago

Caamaño Martínez, J.M. (1957)
"La Portada de San Jerónimo en Compostela", *Cuadernos de Estudios Gallegos*, XII, 167-178

Caamaño Martínez, J.M. (1958)
"Seis tímpanos compostelanos de la Adoración de los Reyes", *Archivo Español de Arte*, XXXI, 331-338

Caamaño Martínez, J.M. (1960)
"El arzobispo compostelano Don Lope de Mendoza (+ 1445) y sus empresas artísticas", *Boletín del Seminario de Estudios de Arte y Arqueología*, XXVI, 17-68

Caamaño Martínez, J.M. (1962)
Contribución al estudio del gótico en Galicia (Diócesis de Santiago). Valladolid

Caamaño Martínez, J.M. (1975)
"Analogías artísticas a propósito de Gregorio Fernández", *Boletín del Seminario de Estudios de Arte y Arqueología*, XL-XLI, 389-401

Caamaño Martínez, J.M. (1977)
"El gótico", *La Catedral de Santiago de Compostela*, Santiago, 249-288

Calo Lourido, F. (s.d.)
"Lourizán", *Gran Enciclopedia Gallega*, XIX, 203-204

Calo Lourido, F. (1983)
"Arte, decoración, simbolismo e outros elementos da cultura material castrexa. Ensaio de sintes". *Estudos de Cultura Castrexa e Historia Antiga de Galicia*, 159-185

Camón Aznar, J. (1943)
El escultor Juan de Ancheta. Pamplona

Camón Aznar, J. (1945)
La arquitectura plateresca. Madrid

Camón Aznar, J. (1961)
La escultura y la rejería españolas del siglo XVI, Summa Artis, XVIII. Madrid

Camón Aznar, J. (1978)
La arquitectura y la orfebrería españolas del siglo XVI, Summa Artis, XVII. Madrid

Campoy, A.M. (1973)
Diccionario crítico del arte español contemporáneo. Madrid

Caramés González, C. (1972)
"El escultor y entallador Francisco de Castro Canseco", *Boletín Auriense*, II, 167-192

Carballo Arceo, L.X. (1986)
"Povoamento castrexo e romano da terra de Trasdeza", *Arqueología/Investigación* 2, 39-40; 118

Carballo Arceo, L.X., Vázquez Varela, X.M. (1984)
"Nuevos hallazgos de arte megalítico en la provincia de Pontevedra. A Mámoa da Braña", *Gallaecia*, 7/8, 245-259

Carballo Calero-Ramos, M.V. (1976)
Museo Provincial de Lugo, Catálogo de escultura. Lugo

Carballo Calero-Ramos, M.V. (1986)
Antonio Faílde Gago. Ourense

Cardeso Liñares, J. (1989)
El arte en el valle de Barcala. Siglos XVI-XX, Tesis Doctoral Inédita. Santiago

Cardozo, M. (1949)
"Algunas observaciones sobre el arte ornamental de los 'castros' del noroeste de la Península Ibérica", *Crónica del IV Congreso Arqueológico del Sudeste de España. Elche, 1948*, Cartagena, 345-367

Cardozo, M. (1949)
Especímenes de svásticas do Museo Arqueológico de "Martíns Sarmento" en Guimarães (Portugal). Barcelos

Carro García, J. (1930)
"O tímpano da Capela de Dona Leonor", *Arquivos do Seminario de Estudos Galegos*, V, 147-152

Carro García, J. (1931)
"Os piares do Mosteiro de San Payo" *Boletín de la Real Academia Gallega*, XX, 225-233

Carro García, J. (1941)
"Las inscripciones de San Lorenzo de Carboeiro", *Archivo Español de Arqueología*, XIV, 387-396

Carro García, J. (1944)
"Un nuevo relieve románico compostelano", *Cuadernos de Estudios Gallegos*, I, 39-44

Carro García, J. (1947)
"La Vida del Apóstol Santiago en un retablo del siglo XV", *El Correo Gallego*, (25, Julio, 1947)

Carro García, J. (1961)
"El canónigo Don José de Vega y Verdugo, propulsor del Barroco en Compostela", *Cuadernos de Estudios Gallegos*, XVI, 194-217

Carro García, J. (1963)
"Vega y Verdugo y el revestimiento barroco de la Catedral de Santiago", *Cuadernos de Estudios Gallegos*, XVIII, 167-189

Carro García, J. (1966)
"Vega y Verdugo sirviendo a la S. I. Compostelana en Granada y Madrid", *Cuadernos de Estudios Gallegos*, XXI, 153-159

Cartailhac, E. (1886)
Les âges préhistoriques de L'Espagne et du Portugal. Paris

Casal García, R. (1979)
"Algunos entalles de la Colección Blanco Cicerón", *XV Congreso Arqueológico Nacional*, Zaragoza, 1107-1120

Casal García, R. (1980)
"Pedras de anelo do Noroeste Peninsular", *Gallaecia*, VI, 101-110

Casal García, R. (1983)
"Anillo de bronce romano de Allariz (Orense)", *Boletín Auriense*, XIII, 69-74

Casal García, R. (1984)
"Uso y significado de las gemas en el mundo romano", *Gallaecia*, VII, 149-156

Casaseca Casaseca, A. (1988)
Rodrígo Gil de Hontañon. Salamanca

Castellá Ferrer, M. (1609)
Historia del Apóstol de Iesus Christo Santiago Zebedeo, Patrón y Capitán General de las Españas. Madrid

Castillo, A. del (1921)
"La escultura en Sobrado", *Boletín de la Real Academia Gallega*, XII, 225-231

Castillo, A. del (1925)
"Un crismón del siglo V", *Boletín de la Real Academia Gallega*, XV, 227-234

Castillo, A. del (1928)
"Los restos visigóticos de Lugo y Saamasas", Boletín de la Real Academia Gallega, XVII, 257-269

Castillo, A. del (1931)
"La iglesia de Pungín y el sepulcro de San Vintila", Boletín de la Real Academia Gallega, XX, 34-39

Castillo, A. del (1949)
El Pórtico de la Gloria. Santiago de Compostela

Castillo, A. del (1972)
Inventario de la Riqueza Monumental y Artística de Galicia. Santiago

Castro, X.A. (1985)(I)
Expresión atlántica. Arte Galega dos 80. Santiago de Compostela

Castro, X.A. (1985)(II)
"Leiro, la fuerza tranquila", Lápiz, 23, 56-60

Castro, X.A. (1986)
Renovación e avangarda en Galicia (1925-1933). Os Pensionados da Deputación de Pontevedra. Pontevedra

Castro Arines, J. de (s.d.)
"Mallo, Cristino", Gran Enciclopedia Gallega, XX, 73-74

Castro Nunes, J. de (1958)
"Uma estela lucense de inspiração neoplatónica", Zephyrus, IX, 234-238

Catálogo (1965)
Catálogo. Museo de las Peregrinaciones.Exposición Inaugural. Imaginería Jacobea, Orfebrería, y otras Artes, relacionadas con el culto a Santiago en Galicia. Santiago

Catálogo (1975)
Jacopo della Quercia nell'arte del suo tempo. Mostra Siena, Firenze

Catálogo (1982)
 Catálogo general de la 5º Bienal Internacional de Arte de Pontevedra. Pontevedra

Catálogo (1983)
Catálogo general de la 6º Bienal Internacional de Arte de Pontevedra. Pontevedra

Catálogo (1985)(I)
Santiago de Compostela: 1000 ans de Pèlerinage Européen. Gand

Catálogo (1985)(II)
Exposición Homenaje Cristino Mallo. Madrid

Catálogo (1988)
"O Pórtico da Gloria e o seu tempo", Catálogo da Exposición Conmemorativa do VIII Centenario da colocación dos dinteis do Pórtico da Gloria da Catedral de Santiago de Compostela. Santiago

Catálogo (1989)(I)
"Expolio", Catálogo exposición. Jorge Barbi. Santiago

Catálogo (1989)(II)
Exposición Isidoro Brocos. A Coruña

Catálogo (1990)
Los bronces romanos de España. Madrid

Ceán Bermúdez, J.A. (1800)
Diccionario histórico de los más ilustres profesores de la Bellas Artes de España, I. Madrid

Cid Rodríguez, C. (1923-25)
"El escultor Francisco de Moure", Boletín de la Comisión Provincial de Monumentos Histórico-Artísticos de Orense, VII, 273-300

Cid Rodríguez, C. (1931)
"El altar del Rosario de Santo Domingo", Boletín de la Comisión de Monumentos Histórico-Artísticos de Orense, IX, 248

Cid Rumbao, A. (1972)
Crónica y guía del Monasterio de Osera. Ourense

Cignitti, B. (1967)
"Liberata", Bibliotheca Sanctorum, VIII

Colini (1933)
Il fascio Littorio. Roma

Colombás, G.M. (1980)
Las Señoras de San Payo. Santiago

Conde-Valvís, F. (1950-51)
"La 'Cibdá' de Armeá en Santa Marina de Aguas Santas", Boletín do Museo Arqueolóxico Provincial de Ourense, VI, 25-89

Costa Clavell, X. (1981)
"La pintura gallega de los siglos XVII-XVIII-XIX", Plástica Gallega, Vigo, 12-15

Cotarelo Valledor, A. (1945)
El Cardenal D. Rodrigo de Couto y su fundación de Monforte de Lemos. Madrid

Couselo Bouzas, J. (1932)
Galicia artística en el siglo XVIII y primer tércio del XIX. Santiago

Crema, L. (1959)
"La architettura romana", Enciclopedia Clásica, XII

Cruz Valdovinos, J.M. (1982)
"Platería", Historia de las Artes Aplicadas e industriales en España. Madrid, 65-158

Cuadrado Sánchez, M. (1986)
"En torno a Vega y Verdugo", Boletín del Instituto y Museo Camón Aznar, XXV, 103-109

CH

Chamoso Lamas, M. (1936)
"La fachada del Obradoiro de la Catedral de Santiago", Archivo Español de Arte y Arqueología, XXXVI, 209-238

Chamoso Lamas, M. (1941)
"La capilla del Pilar de Santiago", Archivo Español de Arte, XIV, 194-201

Chamoso Lamas, M. (1943-44)
"El retablo de la Capilla de Armada en la Catedral de Orense", Boletín de la Comisión de Monumentos Histórico-Artísticos de Orense, XIV, 295-299

Chamoso Lamas, M. (1947)
"El Monasterio de Montederramo (Orense)", Archivo Español de Arte, LXXVIII, 78-94

Chamoso Lamas, M. (1950)
"El coro de la Catedral de Santiago", Cuadernos de Estudios Gallegos, V, 189-215

Chamoso Lamas, M. (1955)(I)
La Arquitectura Barroca en Galicia. Madrid

Chamoso Lamas, M. (1955)(II)
"Santa Mariña de Augas Santas", Cuadernos de Estudios Gallegos, X, 41-88

Chamoso Lamas, M. (1956)(I)
"Museo de la Catedral de Orense", Boletín de la Comisión Provincial de Monumentos Histórico-Artísticos de Orense, XVIII, 255-265

Chamoso Lamas, M. (1956)(II)
"El escultor Mateo de Prado", Cuadernos de Estudios Gallegos, XI, 423-448

Chamoso Lamas, M. (1961)
Santiago de Compostela. León

Chamoso Lamas, M. (1968)
"El Conde Santo Don Osorio Gutiérrez", Cuadernos de Estudios Gallegos, XXIII, 136-144

Chamoso Lamas, M. (1969)
"El Sarcófago del Conde Santo, Don Osorio Gutiérrez, fundador del Monasterio de Villanueva de Lorenzana", Temas Españoles, 501, 912

Chamoso Lamas, M. (1973)
"El escultor Cornielis de Holanda", Abrente, V, 5-30

Chamoso Lamas, M. (1976)
"Arte", Galicia, Madrid, 149-376

Chamoso Lamas, M. (1977)
"Las excavaciones del castro de Villadonga y la problemática que plantean sus resultados", Actas del Coloquio Internacional sobre el Bimilenario de Lugo, 41-46

Chamoso Lamas, M. (1979)
Escultura Funeraria en Galicia. Ourense

Chamoso Lamas, M. (1980)
La Catedral de Orense. León

Chamoso Lamas, M. (1981)
Tuy. León

Chamoso Lamas, M. (1984)
La Catedral de Lugo. León

Chamoso Lamas, M. (1989)
"Isidoro Brocos", *Catálogo de la Exposición*, A Coruña, 57-69

Chamoso Lamas, M., et alii (1973)
Galice Romane. La Pierre qui-Vire

Chao Espiña, E. (1988)
Historia de Vivero. A Coruña

Chauncey Ross, E. (1933)
"O esmalte cloisonné da Crús de Allariz", *Nós*, 112, 99-101

Checa Cremades, F. (1983)
Pintura y Escultura del Renacimiento en España (1450-1600). Madrid

Checa Cremades, F. (1989)
Arquitectura del Renacimiento en España (1488-1599). Madrid

Cheetham, S. (1984)
English Medieval Alabasters. With a catalogue of the Collection in the Victoria and Albert Museum. Oxford

Chueca Goitia, F. (1953)
Arquitectura del s. XVI, Ars Hispaniae, XI. Madrid

D

D'Ancona, P. (1953)
Humanismo et Rinascimento. Torino

Daremberg, Ch., Saglin, E. (1873-1919)
"Anuius Annuis", *Dictionaire des Antiquites Grecques e Romaines*

Delgado Gómez, J. (1976)
"Tapa de sarcófago paleocristiano en Santa María de Temes, Carballedo, Lugo", *Rivista di Archeologia Cristiana*, LII, 303-324

Delgado Gómez, J. (1979)
"El complejo de Temes. ¿Un monumento paleocristiano?", *Actas del XV Congreso Nacional de Arqueología*, Zaragoza, 1143-1154

Delgado Gómez, J. (1982)
"Dos relieves medievales de la Resurrección inspirados en un apócrifo", *Brigantium*, III, 277-286

Dias, P. (1986)
"O Gótico", *Historia da Arte em Portugal*, IV. Lisboa

Díaz y Díaz, M.C. (1976)
"La Cristianización en Galicia. La romanización de Galicia", *Cuadernos del Seminario de Estudios de Sargadelos*, XVI, 105-120

Díaz y Díaz, M.C. (1977)
"Orígenes cristianos de Lugo", *Actas del Coloquio Internacional sobre el Bimilenario de Lugo*, 237-250

Donapetry Yribarnegaray, J. (1953)
Historia de Vivero y su concejo. Vivero

D'Onofrio, M. (1983)
Roma et Aquisgrana. Roma

Durany Castrillo, M. (1988)
"Aportacións a Historia Medieval de Galicia", *Historiografía Galega*, 115-142

Durán Sempere, Ainaud de Lasarte, J. (1956)
Escultura Gótica, Ars Hispaniae, VIII. Madrid

Duro Peña, E. (1972)
El Monasterio de San Pedro de Rocas y su colección documental. Ourense

Duro Peña, E. (1977)
El Monasterio de San Esteban de Ribas de Sil. Ourense

E

Eguileta Franco, J.M., Rodríguez Cao, C., Xusto Rodríguez, M. (1988)
"Arqueoloxía na Baixa Limia: o encoro de Lindoso e o seu medio histórico (Lobios, Ourense)", *Arqueoloxía. Informes 2* (en prensa)

Eguileta Franco, J.M., Rodríguez Cao, C., Xusto Rodríguez, M. (1989)
Informe preliminar da prospección arqueolóxica na Baixa Limia: a barragem de Lindoso e o seu entorno. Memoria mecanografiada inédita

Eiras Roel, A. et alii (1977)
Las fuentes y los métodos. Santiago

Eiras Roel, A. et alii (1981)
La Historia Social de Galicia en sus fuentes de Protocolos. Santiago

Enciclopedia (1987)
"Giambologne", *The Encyclopaedia of the Renaissance*

Estella Marcos, C.M. (1984)
La escultura de marfil en España. Madrid

Esteras Martín, C. (1980)
Orfebrería de Teruel y su provincia. Madrid

Exposición (1990)
Los bronces romanos de España, Exposición. Madrid

F

Fariña Busto, F. (1978)
"El Museo Provincial de Orense", *Orense*, 2, 82-104

Fariña Busto, F. (1979)
"As fíbulas de 'Longo Travessão sem espira' nos castros do NW. Peninsular", *Boletín Auriense*,IX, 27-49

Fariña Busto, F. (1981)
"Romanización", *Galicia Eterna*, I, Barcelona, 61-91

Fariña Busto, F. (1983)
"Panorámica general sobre la cultura castrexa", *Estudos de Cultura Castrexa e de Historia Antiga de Galicia*, 87-97

Fariña Busto, F., Calo Lourido, F., Acuña Fernández, P. (s.d.)
"Escultura Castrexa", *Gran Enciclopedia Gallega*, X, 116-125

Fariña Busto, F., Filgueira Valverde, J. (1973)
"Excavaciones en A Lanzada", *Museo de Pontevedra*, XXVIII, 83-86

Fariña Busto, F., Suárez Otero, J. (1988)
"Arqueoloxía medieval en Galicia: unha aproximación", *Trabalhos de antropología e etnología*, 28 (separata)

Fariña Busto, F., Vila Jato, M.D. (1977)
Francisco de Moure. Catálogo de la Exposición del IV Centenario de su nacimiento. Ourense

Fernández Alonso, B. (1918-22)
"San Munio de Veiga", Boletín de la Comisión Provincial de Monumentos Histórico-Artísticos de Orense, 137-141

Fernández Alonso, B. (1928)
"Efemérides para la historia de la provincia y diócesis de Orense", *Boletín de la Comisión Provincial de Monumentos Histórico-Artísticos de Orense*, VIII, 146-153

Fernández del Hoyo, M.A (1981)
"Casas y Novoa y la iglesia coruñesa de la Compañia", *Boletín del Seminario de Arte y Arqueología*, XLVII, 480-486

Fernández Otero, J.C. (1983)
Apuntes para el inventario del mobilario litúrgico de la diócesis de Orense. A Coruña

Fernández Posse, J.A. (1984)
Memorias del cura liberal don Juan Antonio Posse con su discurso de la Constitución de 1812. Madrid

Fernández Sánchez, J.M., Freire Barreiro, F. (1882)
Santiago, Jerusalén, Roma. Diario de una peregrinación a estos y otros Santos Lugares de España, Francia, Egipto, Palestina, Siria e Italia en el año del Jubileo Universal de 1875. 3 tomos, Santiago

Fernández-Valdés Costas, M. (1970)
"Artistas de Tuy durante el siglo XVIII", *Boletín de la Real Academia Gallega*, 425-429

Ferreira de Almeida, C.A. (1981)
"Nova estátua de guerreiro galaico-minhoto (Refojos de Bastos)", *Arqueología*, III, 111-116

Ferreira de Almeida, C.A. (1983)
"O castrejo sob o dominio romano a sua transformação", *Estudos de Cultura Castrexa e de Historia Antigua de Galicia*, 187-198

Ferreira de Almeida, C.A. (1986)
"Arte castreja. A sua lição para os fenómenos de assimilação e resistencia a romanidade", *Arqueología*, XIII, 161-172

Ferreira Priegue, E. (1988)(I)
Galicia en el comercio marítimo medieval. A Coruña

Ferreira Priegue, E. (1988)(II)
Los caminos en la Galicia Medieval. Ourense

Ferro Couselo, J. (1971)
"Las obras del convento e iglesia de Montederramo en los siglos del XVI y XVII", *Boletín Auriense*, I, 145-186

Ferro Couselo, J. (1972)
"Estatuas sedentes y una columna miliaria de Xinzo de Limia", *Boletín Auriense*, II, 329-335

Ferro Couselo, J. , Lorenzo Fernández, J. (1988)
"La Capilla y el Santuario del Santísimo Cristo de la Catedral de Orense", *Boletín del Museo Arqueológico Provincial de Orense*

Filgueira Valverde, J. (1942)(I)
"El escultor Cornielles de Holanda en Pontevedra", *El Museo de Pontevedra*, I, 20-25

Filgueira Valverde, J. (1942)(II)
"Dos obras de la escuela del Maestro Mateo", *El Museo de Pontevedra*, I, 219-223

Filgueira Valverde, J. (1948)
"Datos y conjeturas para la biografía del Maestre Mateo", *Cuadernos de Estudios Gallegos*, III, 373-403

Filgueira Valverde, J. (1959)
El Tesoro de la Catedral Compostelana. Santiago

Filgueira Valverde, J. (1965)
"Azabachería", *Cuadernos de Arte Gallego*,Vigo

Filgueira Valverde, J. (1977)
"El Barroco", *La Catedral de Santiago de Compostela*, Barcelona,331-378

Filgueira Valverde, J. (1983)
"El Escultor", *El Escultor José María Acuña*. Diputaciones de A Coruña - Pontevedra,15-34

Filgueira Valverde, J., Blanco Freijeiro, A. (1954)
"Nuevas joyas prehistóricas gallegas. El tesoro Bedoia", *Cuadernos de Estudios Gallegos*,IX, 161-180

Filgueira Valverde, J., Blanco Freijeiro, A. (1958)
"Camafeos y entalles del Tesoro Compostelano", *Cuadernos de Estudios Gallegos*, XIII, 137-145

Filgueira Valverde, J., D'Ors, A. (1955)
Inscripciones romanas de Galicia III. Museo de Pontevedra. Santiago

Filgueira Valverde, J., García Alen, A. (1977)
"Inventario de monumentos megalíticos", *El Museo de Pontevedra*, XXXI, 51-130

Filgueira Valverde, J., González, S. (1940)
"San Lorenzo de Carboeiro", *Archivo Español de Arte*, XIV, 59-68

Filgueira Valverde, J., Ramón Fernández-Oxea, J. (1987)
Baldaquinos Gallegos. A Coruña

Fita y Colomé, F. (1910)
"Nuevas lápidas romanas del Noroeste de Galicia", *Boletín de la Real Academia de la Historia*, LVI, 351-363

Folgar de la Calle, M.C. (1982)
'Un inventario de bienes de Fernando de Casas", *Cuadernos de Estudios Gallegos*, XXXIII, 535-547

Folgar de la Calle, M.C. (1984-85)
"La Puerta de los Carros del Convento de San Pelayo de Antealtares: Fernando de Casas y Lucas Caaveiro", *Cuadernos de Estudios Gallegos*, XXXV, 480-499

Folgar de la Calle, M.C. (1985)
Arquitectura gallega del XVIII: Los Sarela. Santiago

Folgar de la Calle, M.C. (1989)

Simón Rodríguez. A Coruña

Fontaine, J. (1972-74)
"Le distique du Chrismón de Quiroga: sources littéraires et contexte spirituel", *Archivo Español de Arqueología*, XLV-XLVII, 557-585

Fontaine, J. (1977)
L'Art preroman hispanique I. La Pierre-qui-vire

Fortes, J. (1905-08)
"Ouros protohistóricos de Estela", *Portugalia II*, 605-618

Fraguas y Fraguas, A. (1956)
Historia del Colegio de Fonseca. Santiago de Compostela

Franzen, A. (1975)
"Santa Ursula y sus compañeras", *Gran Enciclopedia Rialp*, XXIII, 135-136

Fuente Andrés, F. de la, Cabrera Massé, M. (1989)
Exposición Isidoro Brocos. Catálogo. A Coruña

G

Gaborit Chopin, D. (1978)
Ivoires du Moyen-Age. Fribourg

Gaillard, G. (1938)
Les débuts de la sculpture romane espagnole. León-Jaca-Compostelle. París

Gaillard, G. (1972)(I)
"Le Porche de la Gloire á Saint-Jacques de Compostelle et ses origines espagnols", *Etudes d'Art Roman*, París, 320-332

Gaillard, G. (1972)(II)
"Les statues-colonnes d'Antealtares", *Etudes d'Art Roman*, París, 311-319

Gallego Domínguez, O. (1949)
"Plata labrada que en 1601 había en Orense", *Boletín del Museo Arqueológico Provincial de Orense*, V, 93-148

Gallego Domínguez, O. (1980)
"Las casas consistoriales de la ciudad de Orense", *Boletín Auriense*, X, 107-114

Gallego Lorenzo, J. (1989)
"San Martín de Tours, San Marcial de Limoges, y Santiago en el llamado 'Frontal de la Catedral de Orense'", *Los caminos y el arte*. Actas del VI Congreso Español de Historia del Arte, III, *Caminos y viajes en el Arte: Iconografía*. Santiago, 61-69

Gamoneda, A. (1976)
"Silverio Rivas", *Gaceta del Arte*,Junio

Gamoneda, A, (1981)
Silverio Rivas. Cuadernos de Arte Gallego, Madrid

García Alén, A., Peña Santos, A. (1980)
Grabados rupestres de la provincia de Pontevedra. A Coruña

García Bellido, A. (1940-41)
"El caldero de Cabarcerno y la diadema de Ribadeo. Relaciones con las Islas Británicas", *Archivo Español de Arqueología*, XIV, 560-563

García Bellido, A. (1943)
La Dama de Elche y el conjunto de piezas arqueológicas reingresadas en España en 1941. Madrid

García Bellido, A. (1967)
"Sobre un tipo de estela funeraria de togado bajo hornacina", *Archivo Español de Arqueología*, XI,110-119

García Bellido, A. (1969)
"Esculturas romanas de Galicia", *Cuadernos de Estudios Gallegos*, XXIV, 27-34

García Gainza, C. (1980)
"Escultura del Renacimiento", *Historia del Arte Hispánico*, III, Madrid, 93-166

García Iglesias, J.M. (s.d.)
"Santiago. Iconografía Jacobea", *Gran Enciclopedia Gallega*, XXVIII, 48-50

García Iglesias, J.M. (1982)
"Edad Media", *Historia del Arte Gallego*. Madrid, 201-227

García Iglesias, J.M. (1984)
El Pintor de Banga. A Coruña

García Iglesias, J.M. (1986)

La Pintura manierista en Galicia. A Coruña

García Iglesias, J.M. (1988)
"La creación de nuevos espacios urbanos en el entorno de la Catedral de Santiago en los tiempos del Barroco", *La ciudad y el mundo urbano en la historia de Galicia*, Santiago, 241-252

García Iglesias, J.M. (1988)
Pinturas murais de Galicia. Santiago

García Iglesias, J.M. (1990)
A Catedral de Santiago e o Barroco. Vigo

García Iglesias, J.M., Rosende Valdés, A.A. (1980)
"Arte: Escultura y Pintura Románica", *Historia de Galicia*, I, Madrid, 219-228

García Martínez, M.C. (1975)
"Datos para una cronología del arte rupestre gallego", *Boletín del Seminario de Estudios de Arte y Arqueología*, XL-XLI, 477-500

García Martínez, M.C. (1980)
"Prehistoria", *Galicia Eterna*, I, Barcelona, 941

García Oro, J. (1977)
Galicia en la Baja Edad Media. Iglesia, Señorío y Nobleza. Santiago

García Oro, J. (1981)
La nobleza en la Baja Edad Media. Las casas nobles y sus relaciones estamentales. Santiago.

García Oro, J. (1987)
Galicia en los siglos XIV y XV. Santiago

García Rollán, M. (1966)
"El Castro de Castromao", *Archivo Español de Arqueología*, XXXIX, 197-200

García Rollán, M. (1971)
"Memoria de la Excavación Arqueológica de Castromao (Caeliobriga)", *Archivo Español de Arqueología*, XLIV, 196

García Romero, C. (1909)
"Las Lápidas romanas de la Ciudadela", *Boletín de la Real Academia Gallega*, XXXI, 147-149

Gaya Nuño, J.A. (1968)
Historia y Guía de los Museos de España. Madrid

Gaya Nuño, J.A. (1977)
Arte del Siglo XX, Ars Hispaniae, XXII. Madrid

Gran Enciclopedia Gallega (s.d.)
"Buciños", *Gran Enciclopedia Gallega*, IV, 66

Gelabert González, J.E. (1982)
Santiago y la Tierra de Santiago de 1500 a 1640. Sada- A Coruña

Gerloff, S. (1975)
The early Bronce Age Daggers in Great Britain. Munich

Gerpe Blanco, M.T. (s.d.)
El escultor Bonome, Tesis de Licenciatura inédita, Santiago

Gil, M. (1961)(I)
"Arquivolta", *El Arte Románico. Exposición organizada por el Gobierno Español bajo los auspicios del Consejo de Europa. Catálogo*, Barcelona y Santiago, 545

Gil, M. (1961)(II)
"Estatua masculina", *El Arte Románico. Exposición organizada por el Gobierno Español bajo los auspicios del Consejo de Europa. Catálogo*, Barcelona y Santiago, 549-550

Gil, M. (1961)(III)
"Fragmento de jamba", El Arte Románico. *Exposición organizada por el Gobierno Español bajo los auspicios del Consejo de Europa.Catálogo*, Barcelona y Santiago, 543-544

Gil Peces y Rata, F. (1986)
La Catedral de Sigüenza. Madrid

Gimeno García-Lomas, R. , Perles Fontao, J.J. (1990)
"Estela megalítica de la necrópolis medieval de Poio", *Actas do IV Coloquio Galaico-Minhoto*, Lugo, (en prensa)

Gómez Moreno, M. (1934)
El Arte Románico Español. Esquema de un libro. Madrid

Gómez Moreno, M. (1942)

"Sobre Cornielles de Holanda", *El Museo de Pontevedra*, I, 76-77

Gómez Moreno, M. (1961)
"Prólogo", A García Guinea, M.A., *El Arte Románico en Palencia.* Palencia, IX-XVIII

Gómez Moreno, M. E. (1958)
Escultura del Siglo XVII, Ars Hispaniae. XVI, Madrid

Gómez Sobrino, J. (1986)
"Inventario artístico de la catedral de Tuy del siglo XVI a través de las visitas pastorales", *Tui, Museo y Archivo Histórico Diocesano*, IV, 169-210

Gómez Sobrino, J. (1988)
"La obra del escultor Alonso Martínez Montanchez en la Catedral de Tuy", *Cuadernos de Estudios Gallegos*, XXXVI, 181-191

González Fernández, J.M. (1990)
Historias de Fisterra. A Coruña

González García, M.A. (1980)
"Datos para la historia de Nuestra Señora del Socorro de Santiago de Compostela", *Boletín del Seminario Fontán-Sarmiento*, VI-VII-VIII, 16-22

González García, M.A. (1984)
La obra del Escultor Gregorio Español en tres Arciprestazgos de la diócesis de Astorga, Tesis de Licenciatura inédita, Santiago

González García, M.A. (1988)
"Los retablos manieristas de Casaio y Casoio en Valdeorras (en Orense)", *Porta da Aira*, I, 21-50

González García, M.A. (1989)
"La Navidad en el Arte Orensano", *Nadal en Orense*, O, 19-26

González Lopo, D. (1989)
"Aspectos de la religiosidad tudense en el siglo XVIII", *Tui, Museo y Archivo Histórico Diocesano*, V, 211-232

González Paz, J. (1967)
"San Matías, nueva imagen de Francisco de Moure", *Cuadernos de Estudios Gallegos*, XXII, 126-127

González Paz, J. (1970)
"Nuevas esculturas de Moure", *Cuadernos de Estudios Gallegos*, XXII,126-127

González Paz, J. (1975)
"El retablo de Santa María de Medeiros (Orense)", *Abrente*, 7, 65-67

González Paz, J. (1978)
"Iconografía y mártires jacobeos", *Compostellanum*, XXIII, 297-298

González Paz, J., Calvo Moralejo, G. (1977)
"El escultor Cornielles de Holanda en Orense", *Abrente*, 9, 35-42

González Suárez, F. (1982)
"Hallazgo de nuevas esculturas de Moure", *Abrente*, 14, 193-201

Grodecki, L. et alii (1963)
El siglo del año mil, El Universo de las Formas.Madrid

Gudiol Ricart, J., Gaya Nuño, J.A (1948)
Arquitectura y escultura románicas, Ars Hispaniae, V. Madrid

Guerra Mosquera, J. (1967-68)
"Los restos visigodos de Saamasas y Lugo", *Boletín de la Comisión Provincial de Monumentos Histórico-Artísticos de Lugo*, VIII, 137-145

Guía (1932)
Guía de Osera. Ourense

H

Hamilton, E. (1984)
La mitología. Barcelona

Harrison, R. (1974)

"Ireland and Spain in the Early Bronze Age, Frech enden ce for irish and british contacts with the Proto-Atlantic Bronze Age in Spain in the Second milenium B.C.", *Journal of the Royal Society of Antiquaires of Ireland*, 104, 52-73

Hartmann, A. (1982)
Prahistorische Goldfunde aus Europe. II. Spektral analytische Untersuchungenaus deren Auswertung. Berlín

Heilmeyer, A., Bentet, R. (1949)
La escultura moderna y contemporánea. Barcelona

Henig, M. (1974)
A corpus of Roman Engraved Gemstones from British siles. Oxford

Henkel, F. (1913)
Die romisdnen Fingerringe der Rheilande und der benachbarten Gebele. Berlín

Hernando, A. (1989)
"La orfebrería durante el Calcolítico y el Bronce Antiguo en la Península Ibérica", *Trabajos de Prehistoria*, XL, 85-138

Herosa, A. (1756)
Memorial de Hechos notables del Colegio Seminario de Herbón. Inédito

Herráez Ortega, M.V. (1988)
Enrique de Arfe y la Orfebrería gótica en León. León

Hervella Vázquez, J. (1988)
"Mateo de Prado y su Escuela en Orense. Obras documentadas", *Porta da Aira*, I, 51-70

Hildburgh, W.L. (1926)
"A datable English Alabaster altar-piece at Santiago de Compostela", *The Antiquaries Journal*, VI, 302-307

Hildburgh, W.L. (1944)
"Some Presumably Datable Fragments of an English Alabaster Retable, and some Assembled Notes of English Alabaster Carvings in Spain", *The Antiquaries Journal*, XXIV, 27-37

Hoyo del, J. (s.d.)
Memorias del Arzobispo de Santiago, Edición preparada por Rodríguez González, A. y Varela Jácome,B. Santiago de Compostela.

Hurtado, A. (s.d.)
"La orfebrería durante el Calcolítico y el Bronce Antiguo en la Península Ibérica", *Trabajos de Prehistoria*

Huyghe, R. (1966-67)
El Arte y el Hombre, 3 vols. Barcelona

I

Iglesias Almeida, E. (1989)
Arte y artistas en la Antigua Diócesis de Tui. Tui

Iglesias Almeida, E. (1990)
"Iconografía y culto de la Virgen 'do Libramento' en el Suroeste Galaico", *Boletín de Estudios del Seminario Fontán-Sarmiento*, 11, 39-44

Imhoof, Blumer, Keller (1972)
Tier und Planzenbilder auf Munzen und Gemmen des Klassischen Allertums. Hildesheim

Inventario (1975-1983)
Inventario artístico de Lugo y su provincia, 6 vols. Madrid

J

Jiménez Gómez, S. (s.d.)
"Feudalismo", *Gran Enciclopedia Gallega*, XII, 224-256

Jordá Cerdá, F. (1977)
Prehistoria de Asturias. Salinas

Jordá Cerdá, F. (1978)
"Arte de la Edad de Piedra", *La Antiguedad I, Historia del Arte Hispánico*, I. Madrid, 3-153

Juliá, D. (1971)
Etude épigraphique et iconographique de stèles funéraires de Vigo. Heilderberg

Justi, C. (1913)
"Estudio sobre la familia de los Arfes", *La España Moderna*, 84-88; 93-98

K

Knowlton, J.H.B. (1939)
The romanesque sculpture of the Platerias Portal of the Cathedral of Santiago de Compostela. New York

L

Lambert, E. (1925)
"La influencia de Saint-Dennis y la iglesia de Carboeiro", *Arquitectura*, VI, 181-190

Leirós Fernández, E. (1936-38)
"Las Consagraciones del Altar Mayor de la Catedral de Orense", *Boletín de la Comisión Provincial de Monumentos Histórico-Artísticos de Orense*, XI, 314-319; 353-367

Leisner, G. (1934)
"Nuevas pinturas megalíticas en España", *Investigación y progreso*, VIII, 146-152

Leite de Vasconcelos, J. (1913)
Religôes da Lusitania III. Lisboa

Lema Suárez, J.M. (s.d.)
"Santa Baia de Tines", *Gran Enciclopedia Gallega*, XXIX, 84-85

Limia Gardón, F. (s.d)
"¿Una aportación iconográfica del Monasterio de Oseira al Cister? El Culto a San Famiano (Diócesis de Orense)" (en prensa)

Limia Gardón, F. (s.d.))
"Un ejemplo de exaltación mariana dieciochesca: el culto al Rosario a través de dos retablos dominicos dieciochescos", *Actas del III Coloquio Galaico-Minhoto* (en prensa)

Limia Gardón, F. (1984)
"La escultura en el Monasterio de Oseira en la Edad Moderna (1545-1835)", *Actas del II Coloquio Galaico-Minhoto*, II, Santiago, 97-113

Limia Gardón, F. (1989)
"El autor de la fachada del monasterio cisterciense de Santa María la Real de Oseira (San Cristobal de Cea-Ourense)", *Porta da Aira*, II, 85-107

Logroño, M. (1977)
Nóvoa. Vigo

Lois Fernández, M.C. (1958)
"La Historia de San Benito en el coro bajo de San Martín Pinario", *Boletín de la Universidad Compostelana*, 66, 74-94

López, R. (1990)(I)
"Las Cofradías Gallegas en el Antiguo Régimen", *Obradoiro de Historia Moderna*. Universidad de Santiago

López, R.. (1990)(II)
"Arte y Sociedad. La religiosidad de Galicia durante el Antiguo Régimen a través de algunos elementos monográficos", *XIII Congreso Español de Historia del Arte*. Cáceres

López Alsina, F. (1976)
Introducción al fenómeno urbano medieval gallego a través de tres ejemplos: Mondoñedo, Vivero y Ribadeo. Lugo

López Alsina, F. (1988)
La ciudad de Santiago de Compostela en la Alta Edad Media. Santiago

López Cuevillas, F. (1932)
"Os torques do Noroeste Hispánico", *Arquivos do Seminario de Estudos Galegos*, IV, 97-130

López Cuevillas, F. (1933)(I)
"Prehistoria", *Terra de Melide*, 58-61

López Cuevillas, F. (1933)(II)
"A área xeográfica da cultura norte dos castrejos", *Homenajem a Martíns Sarmento*, 99-107

López Cuevillas, F. (1939)
"Una nueva arracada posthallstática", *Boletín de la Comisión Provincial de Monumentos Histórico-Artísticos de Orense*, XII, 141-148

López Cuevillas, F. (1951)(I)
Las joyas castreñas. Madrid

López Cuevillas, F. (1951)(II)
"La diadema áurea de Ribadeo", *Cuadernos de Estudios Gallegos*, VI, 23-31

López Cuevillas, F. (1951)(III)
"Esculturas zoomorfas y antropomorfas de la Cultura de los castros", *Cuadernos de Estudios Gallegos*, VI , 177-203

López Cuevillas, F. (1953)
La civilización céltica en Galicia. Santiago

López Cuevillas, F. (1955)
"El comienzo de la Edad de los Metales en el Noroeste Peninsular", *Cuadernos de Estudios Gallegos*, X, 5-39

López Cuevillas, F. (1957)
"Las estatuas de Logrosa", *Cuadernos de Estudios Gallegos*, XII, 131-135

López Cuevillas, F., Bouza Brey, F. (1929)
"Os Oestrimnios, os Saefes e a ofiolatría en Galicia", *Arquivos do Seminairo de Estudos Galegos*, II, 22-165

López Ferreiro, A. (1883)
Galicia en el último tercio del s. XV. Santiago

López Ferreiro, A. (1898-1911)
Historia de la S.A.M. Iglesia de Santiago de Compostela, XII vols. Santiago

López Ferreiro, A. (1901)
"La Orfebrería Compostelana a principios del s. XV", *Galicia Histórica*, I, 99-103

López Ferreiro, A. (1905)
O niño de Pombas. Santiago de Compostela

López y López, R. (1955)
Santiago de Compostela. Santiago

López Monteagudo, G. (s.d.)
"La diadema de San Martín de Oscos", *Revista de la Universidad Complutense 105. Homenaje a García Bellido*, III, 99-108

López Morais, A., Casado Nieto, M.R. (1989)
Viaje por los pequeños Museos de Galicia. León

López Pereira, J.E. (1989)
El primer despertar cultural de Galicia. Cultura y Literatura en los s. IV-V. Santiago de Compostela

López Valcárcel, A. (1963)
"San Martín de Mondoñedo", *Boletín de la Comisión Provincial de Monumentos Histórico-Artísticos de Lugo*, VII, 198-207

López Vázquez, J.M. (s.d.)
"Escultura Neoclásica", *Gran Enciclopedia Gallega*, V, 48-50

López Vázquez, J.M. (s.d.)
"Eiroa, Xosé", *Gran Enciclopedia Gallega*, IX, 246-247

López Vázquez, J.M. (s.d.)
"Ferreiro", *Gran Enciclopedia Gallega*, XII, 129-134

López Vázquez, J.M. (1973)
"La Exposición de J. Acuña", *Faro de Vigo* (3-11-1973)

López Vázquez, J.M. (1988)(I)
"El Barroco", *Enciclopedia Temática de Galicia: Arte*, Barcelona, 83-111

López Vázquez, J.M. (1988)(II)
"El Neoclasicismo y el s. XIX. La segunda generación de los escultores neoclásicos gallegos (1770): Los Prado Mariño", *Enciclopedia Temática de Galicia: Arte*, Barcelona, 113-149

López Vázquez, J.M. (1988)(III)
"El Arte Contemporáneo", *Enciclopedia Temática de Galicia: Arte*, Barcelona, 151-240

Lorenzo Fernández, J. (1953)
"La capilla visigótica de Amiadoso", *Archivo Español de Arqueología*, XXVI, 424-433

Louzao Martínez, F.J. (1989)
"La orfebrería", *La Real Colegiata de Santa María del Campo de La Coruña.* A Coruña, 184-257

Lucas Álvarez, M. (1957)
"La colección diplomática del monasterio de San Lorenzo de Carboeiro", *Compostellanum*, II, 199-223

Lucas Álvarez, M. (1964)
El Hospital Real de Santiago 1499-1531. Santiago

Luengo Martínez, J.M. (1954-56)
"Noticias sobre las excavaciones del castro de Elviña", *Noticiario Arqueológico Hispánico*, III-IV, 90-113

Luengo Martínez, J.M. (1979)
"El Tesoro de Elviña y tres torques coruñeses", *Trabajos de Prehistoria*, 36, 213-227

LL

Llamazares Rodríguez, F. (1981)
"Gregorio Español: un escultor leonés desconocido", *Tierras de León*, 42, 57-73

M

Maaskant-Kleibrink, M. (1978)
Catalogue of the Engrave Gems in the Royal Coin Cabinet. The Hague, The Green, Etruscan an Roman Collections. The Hague

Macías, M. (1921)
"Importante hallazgo arqueológico", *Boletín de la Comisión Provincial de Monumentos Histórico-Artísticos de Orense*, VI, 335-336

Macwhite, E. (1951)
Estudios sobre las relaciones atlánticas de la Península Hispánica en la Edad del Bronce. Madrid

Mâle, E. (1932)
L'art religieux après le Concile de Trente: Etude sur l'iconographie de la fin du XVI siècle, du XVII, du XVIII siècle. París

Maluquer de Motes, J. (1973)
"La originalidad de la cultura castreña", *Trabalhos de Antropología e Etnología*, XXII, 335-344

Maluquer de Motes, J. (1975)
"Formación y desarrollo de la cultura castreña", *Actas de las I Jornadas de Metodología aplicada a las Ciencias Históricas. I, Prehistoria e Historia Antigua*, Universidad de Santiago, 269-284

Manzanares Rodríguez, J. (1964)
Arte prerrománico asturiano. Oviedo

Marías Franco, F. (1989)
El largo siglo XVI. Conceptos fundamentales en la Historia del Arte Español. Madrid

Marinho Ferreira Alves, N. (1989)
A arte da talha no Porto na época Barroca. Artistas e clientela. Materiais e técnica. II, Porto 341-342; 521

Mariño Beiras, M.D. (1983)
Señorío de Santa María de Meira (siglos XII-XVI). A Coruña

Marquet de Vasselot, J.J. (1925)
Les émaux Limousins de la fin du XV siècle et la première partie du XVI siècle. París

Marquina , E. (1910-1913)
"Objetos de la antigua liturgia que se conservan en el monasterio de Celanova", *Boletín de la Comisión Provincial de Monumentos Histórico-Artísticos de Orense,* IV, 92-95

Marshall, F.H. (1907)
Catalogue or the Finger Rings, Green, Etruscan an Roman, British Museum

Martín Anson, M.L. (1984)
Esmaltes en España. Madrid

Martín González, J.J. (1961)
"Esculturas Vallisoletanas en la Catedral de Orense", *Cuadernos de Estudios Gallegos*

Martín González, J.J. (1962)
"Juan de Juni y Juan de Angés el Mozo en Orense", *Cuadernos de Estudios Gallegos*, XVII, 70-76

Martín González, J.J. (1963)
"Dos Esculturas inéditas de Gregorio Fernández", *Cuadernos de Estudios Gallegos,* 250-252

Martín González, J.J. (1964)
Sillerías de Coro. Vigo

Martín González, J.J. (1966)
"El Maestro de Sobrado", *Boletín del Seminario de Estudios de Arte y Arqueología,* XXXII, 67-70

Martín González, J.J. (1968)
"En torno a Gregorio Fernández: obras inéditas o poco conocidas", *Revista Goya*

Martín González, J.J. (1970)(I)
Historia de la Escultura. Madrid

Martín González, J.J. (1970)(II)
Historia de la Pintura. Madrid

Martín González, J.J. (1974)
Juan de Juni. Vida y Obra. Madrid

Martín González, J.J. (1977)
"El Renacimiento", *La Catedral de Santiago de Compostela.* Santiago, 303-304

Martín González, J.J. (1980)
El Escultor Gregorio Fernández. Madrid

Martín González, J.J. (1983)(I)
Escultura Barroca en España. 1600-1770. Madrid

Martín González, J.J. (1983)(II)
La escultura española del s. XVII. Madrid

Martín González, J.J. (1987-88-89)
"Avance de una tipología del retablo barroco en el retablo español", *Imafronte, Revista del Departamento de Historia del Arte de la Universidad de Murcia*, 3-4-5, 111-156

Martín González, J.J. , González Paz, J. (1986)
El Maestro de Sobrado. Ourense

Martínez Porto, D. (1974)
El Escultor Sanmartín, Tesis de Licenciatura inédita, Santiago

Martínez Sueiro, M. (1918-22)
"Corneles de Holanda y su retablo de Orense", *Boletín de la Comisión Provincial de Monumentos Histórico-Artísticos de Orense*, VI, 74-84

Martínez Tamuxe, X. (1983)
Citania y Museo Arqueológico de Santa Tecla. Sociedad Pro-Norte, Servicio Central de Publicaciones de la Xunta de Galicia, 177

Maya González, J.L. (1987-88)
"La cultura material de los Castros Asturianos", *Estudios de la Antigüedad*, U.A.B., 4/5

Mayán Fernández, F. (s.d.)
"Corcubión", *Gran Enciclopedia Gallega*, VII, 131-133

Mayán Fernández, F. (1958-59)
"Arte Inglés en la Catedral de Mondoñedo", *Arte Español*,XXII, 206-209

Mergelina Luna, C. (1943-44)
"La citania de Santa Tecla. La Guardia (Pontevedra)", *Seminario de Estudios de Arte y Arqueología*, XI, 13-54

Molist Frade, B. (1986)
La orfebrería religiosa de los siglos XVII-XIX en la ciudad de La Coruña: Catalogación, Tesis de Licenciatura Inédita. Santiago

Monteagudo García, L. (1952)
"Torques castreños de alambres enrollados", *Archivo Español de Arqueología*, XXV, 287-296

Monteagudo García, L.(1953)
"Orfebrería del Noroeste Hispánico en la Edad del Bronce", *Archivo Español de Arqueología*, XXVI, 269-312

Monteagudo García, L. (1954)
"Joyas del castro de Elviña (La Coruña) y soluciones museológicas generales", *Archivo Español de Arqueología*, XXVII

Monteagudo García, L. (1981)
"Petroglifos de Lagea das Rodas (Louro, S.W. Prov. La Coruña)", *Primera Reunión Gallega de Estudios Clásicos*, Santiago, 46-100

Moralejo Álvarez, S. (1969)
"La primitiva fachada Norte de la Catedral de Santiago", *Compostellanum*, XIV, 623-668

Moralejo Álvarez, S. (1973)
"Esculturas compostelanas del último tercio del siglo XII", *Cuadernos de Estudios Gallegos*, XXVIII, 294-310

Moralejo Álvarez, S. (1975)
Escultura Gótica en Galicia (1200-1350). Santiago

Moralejo Álvarez, S. (1977)
"Saint-Jacques de Compostelle: les portails retrouvés dela cathédrale romane", *Les Dossiers de l'archéologie*, XX, 87-103

Moralejo Álvarez, S. (1980)
"Ars Sacra' et sculpture romane monumentale: Le Trésor et le chantier de Compostelle", *Les Cahiers de Saint-Michel de Cuxa*, 11, 294-296

Moralejo Álvarez, S. (1981)
"Marcolfo, el Espinario, Príapo: un testimonio iconográfico gallego", *Primera reunión gallega de Estudios Clásicos.* Santiago, 331-355

Moralejo Álvarez, S. (1988)
"A arte compostelá antes do Pórtico da Gloria", *O Portico da Gloria e o seu Tempo. Catálogo da Exposición.* Santiago, 97

Morales, A. de (1765)

Relación del viaje que Ambrosio de Morales chronista de S.M. hizo por su mandato el año de 1572. Madrid

Muñoz de la Cueva, J. (1726)
Memorias de la Catedral de Orense. Madrid

Muñoz Párraga, M.C. (1987)
"Un nuevo alabastro inglés en la Península", *Boletín del Museo e Instituto Camón Aznar*, XXX, 63-67

Murguía, M. (1879)
"Los últimos momentos de Herodes. Estatua en yeso de D. I. Brocos", *La Ilustración gallega y asturiana*, I, 88

Murguía, M. (1884)
El arte en Santiago durante el siglo XVIII. Madrid

Murguía, M. (1888)
Galicia. Barcelona

Museo de Pontevedra (1976)
"Memoria 1975", *El Museo de Pontevedra*, XXX, 16

N

Naesgaard, O. (1962)
Saint-Jacques de Compostelle et les débuts de la grande sculpture vers 1100. Aarhus

Neira de Mosquera, A. (1950)
Monografías de Santiago. Santiago

Niero, A. (1967)
"Mario", *Bibliotheca Sanctorum*, VIII

Nieto Alcaide, V. , Checa Cremades, F. (1980)
El Renacimiento. Formación y crisis del modelo clásico. Madrid

Nos (1927)
"A Riqueza artística de Galiza, Duas esculturas de Xan de Xuni", *Nos*, 46,23/24

Novelli, M.A. (1966)
Niccolò dell'Arca. Milano

Novo Cazón, J.L. (1986)
El Priorato santiaguista de Vilar de Donas en la Edad Media (1194-1500). A Coruña

Novo Cazón, J.L. (1988)
O legado santiaguista de Vilar de Donas. Santiago

Núñez Rodríguez, M. (1976) (I)
"Las artes metálicas de la Galicia prerrománica", *Boletín de la Comisión Provincial de Monumentos Histórico-Artísticos de Lugo*, IX, 283-291

Núñez Rodríguez, M. (1976) (II)
"Estudio estilístico de los capiteles de los siglos V al VII en Galicia", *Conimbriga*, XV, 45-54

Núñez Rodríguez, M. (1976) (III)
"Aproximación al estudio de las formas ornamentales en Galicia durante la época visigoda", *Revista de Guimarães*, LXXXVI,177-186

Núñez Rodríguez, M. (1977)(I)
"Algunas aportaciones al estudio del arte en la Gallaecia durante la época Sueva", *Bracara Augusta*, XXXI, 165-183

Núñez Rodríguez, M. (1977) (II)
"Enterramientos y sarcófagos de la Galicia prerrománica", *Archivos Leoneses*, LXII, 359-379

Núñez Rodríguz, M. (1977) (III)
"Algunas inscripciones de la Galicia prerrománica", *Boletín Auriense*, VII, 173-194

Núñez Rodríguez, M. (1978)
Arquitectura prerrománica. Madrid

Núñez Rodríguez, M. (1985)
La idea de inmortalidad en la escultura gallega (la imagen funeraria del Caballero, s. XIV-XV). Ourense

O

Olivares, R. (1989)
"Jorge Barbi", *Lápiz*, LXII, 72

Ortega Romero, M.S. (1966)
Arquitectura Barroca del siglo XVIII en Compostela. Santiago (inédita. Apéndices documentales, 426-427)

Ortega Romero, M.S. (1982)
"El Barroco", *Historia del Arte Gallego*. Madrid, 283-385

Ortega Romero, M.S. (1987)
"Un proyecto de Fernando de Casas para el Tribunal de la Inquisición de Santiago", *Jubilatio*. Facultad de Geografía e Historia. Universidad de Santiago, 653-668

Osaba y Ruíz de Erenchun, B. (1946) (I)
"Restos mozárabes de Vilanova dos Infantes en el Museo de Orense", *Memorias de los Museos Arqueológicos provinciales*, VII, 113-116

Osaba y Ruíz de Erenchun, B. (1946) (II)
"Relieve visigótico inédito y dos cruces mozárabes también inéditas", *Boletín del Museo Arqueológico Provincial de Orense*, II, 7-23

Osaba y Ruíz de Erenchun, B. (1947)
"Restos arqueológicos de San Juan de Camba en el Museo de Orense", *Boletín del Museo Provincial de Orense*, III, 4-23

Otero Túñez, R. (s.d.)
"Gambino, José", *Gran Enciclopedia Gallega*, XV, 106-109

Otero Túñez, R. (1951)
"Un gran escultor del siglo XVIII: José Ferreiro", *Archivo Español de Arte*, XXIV, 35-47

Otero Túñez, R. (1953) (I)
"Los retablos de la Iglesia de la Compañía de Santiago", *Cuadernos de Estudios Gallegos*, VIII, 397-408

Otero Túñez, R. (1953) (II)
"¿Benito Silveira o José Ferreiro?", *Cuadernos de Estudios Gallegos*, VIII, 57-64

Otero Túñez, R. (1953) (III)
"El estilo y algunas esculturas de Ferreiro", *Archivo Español de Arte*, XXVI, 51-62

Otero Túñez, R. (1955)
"Las primeras columnas salomónicas de España", *Boletín de la Universidad Compostelana*, 63, 335-344

Otero Túñez, R. (1956) (I)
"La Inmaculada Concepción en la escultura santiaguesa", *Compostellanum*, I, 206-235

Otero Túñez, R. (1956) (II)
"El Retablo Mayor de San Martín Pinario", *Cuadernos de Estudios Gallegos*, XI, 229-243

Otero Túñez, R. (1956) (III)
"Los retablos del crucero de San Martín Pinario", *Boletín de la Universidad Compostelana*, 64, 277-286

Otero Túñez, R. (1957) (I)
"Evolución estilística de Gregorio Fernández", *Boletín de la Universidad Compostelana*, 65, 203-216

Otero Túñez, R. (1957) (II)
El escultor Ferreiro (1738-1830), Catálogo de la X Exposición del Instituto 'Padre Sarmiento' de Estudios Gallegos, Santiago

Otero Túñez, R. (1958) (I)
" Virgenes 'Aparecidas' en la escultura santiaguesa", *Compostellanum*, III, 167-192

Otero Túñez, R. (1958) (II)
"Miguel de Romay, retablista", *Compostellanum*, III, 193-220

Otero Túñez, R. (1958) (III)
"El Barroco Italiano en la obra de José Ferreiro", *Boletín de la Universidad Compostelana*, 95-111

Otero Túñez, R. (1959)
El Escultor Francisco Asorey. Santiago

Otero Túñez, R. (1963)
"Algunas noticias sobre Francisco Pecul", *Cuadernos de Estudios Gallegos*, XVIII, 247-250

Otero Túñez, R. (1965)
" Problemas de la Catedral románica de Santiago", *Compostellanum*, X, 961-996

Otero Túñez, R. (1977)
"La Edad Contemporanea", *La Catedral de Santiago de Compostela*, Santiago, 379-399

Otero Túñez, R. (1980)
"Escultura", *El Barroco y el Rococó*, Historia del Arte Hispánico, IV.Madrid, 95-243

Otero Túñez, R. (1982)
"El 'Curriculum' del escultor Manuel de Prado", *Homenaje al Prof. Dr. Hernández Díaz*, I, Sevilla, 485-502

Otero Túñez, R. (1985) (I)
Rastreando los orígenes de mi Universidad. Santiago de Compostela

Otero Túñez, R. (1985) (II)
Domingo de Andrade. Leipzig

Otero Túñez, R. (1986)
El Legado Artístico de La Compañía de Jesús a la Universidad. Santiago

Otero Túñez, R. (1987)
"Asorey, 25 anos despois", *Asorey*, Cambados, 11-33

Otero Túñez, R. (1989)
"O Escultor Francisco Asorey. Vida e Obra", *Centenario Francisco Asorey*, Santiago, 23-79

Otero Túñez, R. (1990)
"Manuel de Prado y el retablo de Villamarín", *Homenaje a Don José González Paz*, Ourense, 201-213

Otero Túñez, R., Yzquierdo Perrín, R. (1985)
"Reconstructión de trois stalles de choeur", *Santiago de Compostela: 1000 ans de Pèlerinage Européen*, Gante, 219-224

Otero Túñez, R., Yzquierdo Perrín, R. (1990)
El coro del Maestro Mateo de la Catedral de Santiago. A Coruña

P

Pablos, F. (1981)
Acisclo. A Coruña

Pacheco, F. (1599)
Libro de descripción de verdaderos retratos de ilustres memorables varones. Sevilla

Palol, P. de (1967)
Arqueología cristiana de la España romana. Madrid

Pallares Mendez, M.C. (1979)
El monasterio de Sobrado. Un ejemplo del protagonismo monástico en la Galicia Medieval. A Coruña

Pallares Mendez, M.C. , Portela Silva, E. (1980)
"Edad Media", *Historia de Galicia*. Madrid, 61-139

Pardo Canalís, E. (1956)
"La estela de Juan de Bolonia en el Museo Lazaro Galdiano", *Goya*, XIII, 2-7

Pardo Villar, A. (1953)
Los Dominicos de Santiago. Santiago

Peinado Gómez, N. (1960-61)
"De criptología",*Boletín de la Comisión Provincial de Monumentos Histórico-Artísticos de Lugo*, VII, 10-12

Peinado Gómez, N. (1972)
La antigua catedral de San Martín de Mondoñedo (Foz). Lugo

Peinado Gómez, N. (1975)
Torques celtas. Lugo

Peña Santos, A. de la (s.d.)
"Petroglifos", *Gran Enciclopedia Gallega*, XXIV, 227-230

Peña Santos, A. de la (1976)
"Asociaciones entre zoomorfos y círculos o espirales: datos para una iconografía de los grabados rupestres gallegos", *Gallaecia*, II, 99-116

Peña Santos, A. de la , Vázquez Varela, J.M.(1979)
Los petroglifos gallegos. A Coruña

Perea Caveda, A. (1986)
"La orfebrería púnica de Cádiz",*Los fenicios en la Península Ibérica*, II

Pereira, F. , Sousa, J. (1989)
"La carrera artística de Isidoro Brocos (1841-1914)", *Catálogo Isidoro Brocos*, A Coruña, 28-51

Pérez Costanti, P. (1930)
Diccionario de artistas que florecieron en Galicia durante los siglo XVI-XVII. Santiago

Pérez Outeiriño, B. (s.d.)
"Punxín", *Gran Enciclopedia Gallega*, XXVI, 8-9

Pérez Outeiriño, B. (s.d.)
"Torques", *Gran Enciclopedia Gallega*, XXIX, 107-110

Pérez Outeiriño, B. (1980)
"Os ornitomorfos no conxunto dos motivos decorativos da orfebrería castrexa", *Boletín Auriense*, X, 9-24

Pérez Outeiriño, B. (1982)
"De ouriversaria castrexa,I. Arracadas", *Boletín Auriense*, Anexo I.

Pérez Outeiriño, B. (1989)
"Orfebrería castreña", *El oro en la España Prerromana*, Madrid

Peroni, A,. (1976)
"Per la tipoligía architettonica dell' età carolingia nell' area lombarda", *Roma a L'età carolingia*

Pijoán, J. (1951)
Juan Bologna, Summa Artis, XIV.Madrid, 215-224

Pingel, O. (1985)
"Bemerkungen zuden schatzfunden von Caldas de Reyes", *Madrider Mitteilunqen*, XXVI, 26-44

Piñeiro Álvarez , C. (1986)
A plástica de Xoan Piñeiro , Tesis de Licenciatura inédita. Santiago

Pita Andrade, J.M. (1950)
"Un estudio inédito sobre la portada de las Platerías", *Cuadernos de Estudios Gallegos*, V, 446-460

Pita Andrade, J.M. (1952) (I)
Monforte de Lemos. Santiago

Pita Andrade, J.M. (1952) (II)
"Un capitulo para el estudio de la formación artística de Maestre Mateo: la huella de Saint-Denis", *Cuadernos de Estudios Gallegos*, VIII, 371-383

Pita Andrade, J.M. (1954)
La construcción de la Catedral de Orense. Santiago

Pita Andrade, J.M. (1955)
"Varias notas para la filiación artística del Maestre Mateo", *Cuadernos de Estudios Gallegos*, X, 49-69

Pita Andrade, J. M. (1958)
"Don Alonso de Fonseca y el Arte del Renacimiento", *Cuadernos de Estudios Gallegos*, XIII, 173-193

Pita Andrade, J.M. (1968)
"Realizaciones Artísticas de Don Alonso de Fonseca,", *Cuadernos de Estudios Gallegos*, XXIII, 29-44

Pita Andrade, J.M. (1976)
"El coro pétreo de Maestre Mateo en la Catedral de Santiago", *Actas del XXIII Congreso Internacional de Historia del Arte*, I, Granada, 449-451

Pita Andrade, J.M. (1985)
"Statue de Saint-Jacques Assis dans le portail du Paradis", *Santiago de Compostela: 1000 ans de Pèlerinage Europèen*, Gante, 328-329

Pita Andrade, J.M. (1988)
"La Catedral de Orense en la encrucijada del arte protogótico", *II Ciclo de conferencias sobre Historia del Arte*, Ourense, 73-100

Pita Andrade, J.M. , Álvarez Lopera, J. (1982)
La arquitectura española del siglo XVII, Summa Artis, XXVI, Madrid, 429-652

Placer López, G. (1975)
"Historia de la capilla y cofradía del Santo Cristo de Conjo", *Boletín Provincial de Castilla*, 41, 32-44

Plástica Gallega (1981)
Compendio resumen de las exposiciones de artistas gallegos realizadas en las salas de arte de la Caja de Ahorros Municipal de Vigo, a lo largo del año 1980. Vigo

Pope-Hennessy, J. (1966)
Il Cinquecento. Milano

Pope-Hennessy, J. (1989)
La escultura italiana del Renacimiento. Madrid

Portela Silva, E. (1976)
La región del obispado de Tuy en los siglos XII a XV. Una sociedad en la expansión y en la crisis. Santiago

Portela Silva, E. (1981)
La colonización cisterciense en Galicia. 1142-1150. Santiago

Portela Silva, E. , Pallares Méndez, M.C. (1988)
"Historiografía sobre la Edad Media de Galicia en los últimos diez años (1976-1986)", *Studia Histórica. Historia Medieval*, 6, 7-25

Porter, A.K. (1923)
Romanesque sculpture of the pilgrimage roads. Boston

Q

Quintana Prieto, A. (1968)
"El monasterio de San Juan de Camba", *Compostellanum*, XIII, 241-285

R

Raddotz, K. (1969)
Die schatzfunde der Iberischen halbinsen. Berlín

Ramil, J. , Vázquez Varela, J.M. (1983)
"Primer hallazgo de arte-mueble paleolítico en Galicia", *Ars Prehistórica*, II, 191-193

Ramón y Fernández-Oxea, J. (1948)
"Santa Eulalia de Banga", *Cuadernos de Estudios Gallegos*, III, 71-80

Ramón y Fernández-Oxea, J. (1969)

"La Iglesia de San Pedro de Moreiras", *Cuadernos de Estudios Gallegos*, XXIV, 84-93

Regal, B. (1973)
Galicia Románe. La Pierre qui-vire

Rey Castelao, O. (1985)(I)
"La renta del Voto de Santiago y las instituciones Jacobeas", *Compostellanum*, XXX, 323-368

Rey Castelao, O. (1985)(II)
La historiografía del voto de Santiago. Recopilación crítica de una polémica historiográfica. Santiago

Rey Escariz, A. (1922)
"El retablo mayor de Sobrado", *Boletín de la Real Academia Gallega*, XII, 329-335

Riccomini, E. (1966)
Guido Mazzoni. Milano

Rielo Carballo, N. (s.d)
"Temes", *Gran Enciclopedia Gallega*, XXIX, 66

Rielo Carballo, N. (1975)
"Cangas, (San Fiz), Pantón", *Inventario Artístico de Lugo y su Provincia*, II, Madrid, 35-40

Ríos Miramontes, M.T. (1983)
"La Colegiata de Santa María de Iria Flavia", *Archivo Iberoaméricano*, 171-172, 365-380

Ríos Miramontes, M.T. (1986)
Aportaciones al Barroco Gallego. Un gran mecenazgo. Santiago

Rivas Fernández, J.C. (1971)
"Algunas consideraciones sobre el prerrománico gallego y sus arcos de herradura geminados", *Boletín Auriense*, I, 61-126

Rivas Fernández, J.C. (1976)
"Un inédito e interesante vestigio de la iconografía visigótica en Galicia, procedente de la iglesia prerrománica de San Martiño de Pazó", *Boletín Auriense*, VI, 169-182

Rivas Fernández, J.C. (1981)
"Vestigios prerrománicos de algunos olvidados monasterios y eremitorios orensanos", *Boletín Auriense*, XI, 49-100

Rivera Vázquez, E. (1989)
Galicia y los Jesuitas. Sus colegios y enseñanza en los siglos XVI al XVIII. A Coruña

Rodríguez, R. (1951)
"Enrique de Arfe en la Catedral de León", *Archivos Leoneses*, X, 131-153

Rodríguez Álvarez, M.P. (1981)
"Sincretismo de la religión indígena y la religión romana visto a través de las estelas antropomorfas", *Brigantium*, II, 73-82

Rodríguez Blanco, R. (1879)
Apuntes históricos de la Santa Iglesia Catedral, ciudad y antigua diócesis de Tuy. Santiago

Rodríguez Casal, A. (s.d.)
"Megalitismo", *Gran Enciclopedia Gallega*, XX, 215-220

Rodríguez Casal, A. (1988)
La Necrópolis Megalítica de Parxubeira (San Fins de Eirón, Galicia). Campañas arqueológicas de 1977 a 1984. A Coruña

Rodríguez Colmenero, A. (1977)
Galicia meridional romana. Bilbao

Rodríguez Colmenero, A. (1985)
"Excavaciones arqueológicas en Ouvigo, Bancos (Ourense). Campañas 1977-1981", *Noticiario Arqueológico Hispánico*, 24, 265-372

Rodríguez Colmenero, A. (1987)
Aquae Flavia I. Fontes Epigráficas. Chaves

Rodríguez Colmenero, A. ,Carreño, M.C. (1984)
"Estelas romanas del Convento Bracaraugustano. Nuevos ejemplares de las riberas de Tamega", *Lucerna, Nova serie,* I, 213-237

Rodríguez Gonzalez, A. (1980)
"Edad Media", *Historia de Galicia,* I, Barcelona, 107-200

Rodríguez Lage, S. (1974)
Las estelas funerarias de Galicia en época romana. Ourense

Rombant von Doren (1969)
"Vilgefortis", *Bibiotheca Sanctorum,* XII

Romero Masiá, A.M. (s.d.)
"Elviña", *Gran Enciclopedia Gallega,* X, 4-5

Romero Masiá, A.M. (1987)
Castro de Borneiro. Campañas de 1983-84. Santiago

Romero Masiá, A.M. , Pose Mesura, J.M. (1987)
Galicia nos textos clásicos. A Coruña

Rosende Valdés, A.A. (1978)
"El Antiguo Coro de la Catedral de Santiago", *Compostellanum,* XXIII, 215-246

Rosende Valdés, A.A. (1980)
"Una obra del taller de Juni en Tuy", *Tui, Museo y Archivo Histórico Diocesano,* III, 67-96

Rosende Valdés, A.A. (1981)
"Orfebrería tudense: la munificencia del Obispo Tolosa", *Cuadernos de Estudios Gallegos,* XXXI

Rosende Valdés, A.A. (1982)
"El Renacimiento", *Historia del Arte Gallego.* Madrid, 193-272

Rosende Valdés, A.A. (1984)
Estudios iconográficos de las sillerías de coro gallegas (Renacimiento y Barroco), Tesis doctoral. Santiago

Rosende Valdés, A.A. (1986)
"La vida de la Virgen en la sillería de la catedral de Tuy. Un testimonio iconográfico gallego de pervivencia medieval en el Barroco", *Tui, Museo y Archivo Histórico Diocesano,* IV, 109-130

Rosende Valdés, A.A. (1989)
"Los retablos mayores de la catedral de Tui", *Tui, Museo y Archivo Histórico Diocesano,* V, 67-85

Rosende Valdés, A.A. (1990)
La sillería de coro de San Martín Pinario. A Coruña

Ruíz-Gálvez Priego, M. (1978)
"El tesoro de Caldas de Reyes", *Trabajos de Prehistoria,* XXXV, 173-192

Ruíz-Gálvez Priego, M. (1979)
"El bronce antiguo en la fachada atlántica peninsular: un ensayo de periodización", *Trabajos de Prehistoria,* XXXVI, 151-172

Ruíz-Gálvez Priego, M. (1984)
"La península ibérica y sus relaciones con el círculo cultural atlántico", *Trabajos de Prehistoria,* XLI, 85-138

Russoli, F. (1972)
La scultura italiana. Il Rinascimento. Torino

S

Sá Bravo, H. de (s.d.)
"Conxo", *Gran Enciclopedia Gallega,* VII, 116-117

Sá Bravo, H. de (1972)
El monacato en Galicia, II. A Coruña

Saavedra Fernández, P. (s.d.)
Historia Moderna de Galicia, las fuerzas productivas, la organización de la sociedad y el ejercicio del poder. (en prensa)

Saavedra Fernández, P. (1985)
Economía, política y sociedad en Galicia: La provincia de Mondoñedo, 1480-1830. Santiago de Compostela

Saavedra Fernández, P. , Villares Paz, R. (1985)
"Galicia en el Antiguo Régimen. La fortaleza de una sociedad tradicional", *España en el s. XVIII. Homenaje a Pierre Vilar.* Barcelona

Sáez González, M. (1984)
"La platería de Tuy en el s. XVIII: artífices, obras y marcas", *Actas del II Coloquio Galaico- Minhoto,* II, Santiago de Compostela, 137-157

Sánchez Albornoz, C. (1981)
Estudios sobre Galicia en la temprana Edad Media. A Coruña

Sánchez Ameijeiras, R. (1989)
"Circulación de modelos y talleres itinerantes: el papel de artistas y comitentes en la evolución tipológica de la escultura funeraria en la Galicia Medieval" *VI Congreso Español de Historia del Arte, Los Caminos y el Arte,* II, *El Arte en los Caminos,* Santiago, 233-239

Sánchez Arteaga, M. (1916)
Apuntes histórico-artísticos de la catedral de Orense. Ourense

Sánchez Cantón, F.J. (1920)
Los Arfe, escultores de plata y oro. Madrid

Sánchez Cantón, F.J. (1956)
Opúsculos gallegos sobre Bellas Artes de los siglos XVII y XVIII. Santiago

Sánchez Cantón, F.J. (1965)
La Escultura y la Pintura del siglo XVIII, Ars Hispaniae, XVII. Madrid, 45-330

San Cristobal Sebastián, S. (1980)
"Arquitectura", *El Renacimiento,* Historia del Arte Hispánico, III. Madrid, 3-70

Sández Otero, R. (1945)
"Museo Diocesano de Santiago de Compostela (Coruña)", *Memorias de los Museos Arqueológicos Provinciales,* VI, 179-181

Santa Clara de Allariz (1986)
"Santa Clara de Allariz.7º Centenario da Fundación", *Boletín Auriense,* Anexo V

Santos, R. dos (1948)
A Escultura em Portugal, I. Lisboa

Santos Yanguas, N. (1988)
El Ejército y la Romanización en Galicia. Oviedo

Scott Ryberg, I. (1955)
"Rites of the state religion in Roman Art", *Memoirs of the American Academy in Rome,* XXII

Schiller, G. (1972)
Iconography of Christian Art. London

Schmürer, G. , Ritz, M. (1934)
Sant Kümmernis. Volto Santo. Düsseldorf

Schlunk, H. (1945)
"Relaciones entre la Península Ibérica y Bizancio durante la época visigoda", *Archivo Español de Arqueología,* XVIII, 177-204

Schlunk, H. (1947)
Arte Visigodo. Arte Asturiano, Ars Hispaniae, II. Madrid, 227-416

Schlunk, H. (1948)
"La decoración de los monumentos ramirenses", *Boletín del Instituto de Estudios Asturianos,* II, 55-94

Schlunk, H. (1964)
"Byzantinische Bauplastik aus Spanien", *Madrider Mitteilungen,* V, 245-247

Schlunk, H. (1970)

"Die frühchristlichen Denkmäler aus dem Nord-Western der iberischen Halbinsel", *Legio VII Gemina*, León, 493-502

Schlunk, H. (1977)
"Los monumentos paleocristianos de Gallaecia, especialmente los de la provincia de Lugo", *Actas del Coloquio Internacional del Bimilenario de Lugo*, Lugo, 193-236

Schlunk, H. (1981)
"Spätrömische und germanische Kunst in Galicien", *Primera Reunión Gallega de Estudios Clásicos*, Santiago 277 - 317

Schlunk, H. , Hauschild, Th. (1978)
Die Denkmäler der frühchristlichen und westgotischen Zeit. Mainz am Rheim

Seoane, L. (1957)
Xosé Eiroa. Vigo

Seoane, X.(s.d.)
"Nóvoa, Leopoldo", *Gran Enciclopedia Gallega*, XXII, 222 - 223

Seoane, X. (s.d.)
"Rivas, Silverio",*Gran Enciclopedia Gallega*, XXIV, 174

Seoane, X. (1988)
"Paco Pestana: do gran teatro do mundo ao bosque animado", *Luzes de Galiza*, X-XI, 16-19

Seoane, X. (1989-90)
"Nóvoa", *Catálogo de la exposición celebrada en el Palacio Municipal de Exposiciones Kiosco Alfonso*, A Coruña

Seoane, X. (1990)
"Identidade e convulsión. Palavra e imaxe da nova arte galega", *Luzes de Galiza,* 25

Shee, E.A. , García Martínez, C. (1975)
"Tres tumbas megalíticas decoradas en Galicia", *Trabajos de prehistoria*, XXX, 335-347

Sicart Giménez, A. (1982)
"La iconografía de Santiago ecuestre en la Edad Media", *Compostellanum*, XXXVII,11-32

Sierra Rodríguez, J.C. (s.d.)
"Edad del Bronce", *Gran Enciclopedia Gallega*, IX, 209-214

Silva Coelho Ferreira, A. da (1986)
A cultura castreja no Noroeste de Portugal, Paços de Ferreira

Silva Matos, M.F. da (1986-87)
"Sulsídios para o Estudo da Arte Castreja. Arte Decorativa Arquitectónica", *Revista de Ciências Históricas*, I, 31-68; II, 121-147

Sobrino Manzanares, M.L. (s.d.)
"La escultura contemporánea en Galicia", *Gran Enciclopedia Gallega*, X, 173-180

Sobrino Manzanares, M.L. (1982)
"La Edad Comtemporánea", *Historia del Arte Gallego*, Madrid, 389-513

Steppe, J.K. (1985)
"L'Iconographie de Saint-Jacques le Majeur", *Santiago de Compostela: 1000 ans de Pèlerinage Europèen*, Gand, 129-153

T

Taboada Cid, M. (1988-89)
"Estela funeraria antropomorfa do Muiño de San Pedro (Verín)", *Boletín Auriense*, XVIII-XIX, 79-93

Taboada Chivite, J. (1946)
"El castro de Folderey Vello (Viladervós) y sus interesantes hallazgos", *Boletín del Museo Arqueológico Provincial de Orense*, II, 37-43

Taboada Chivite, J. (1948)
"Esculturas de verracos en Galicia", *Archivo Español de Arqueología*, LXXII, 291-294

Taboada Chivite, J. (1964)
"Grupo escultórico romano de Mourazos", *Cuadernos de Estudios Gallegos,* XIX, 137-142

Taboada Chivite, J. (1965)
Escultura celto-romana . Vigo

Torelli,M. (1982)
Typology and structure of Roman Historical Reliefs. Michigan

Torralba, F. (1963)
"Esmaltes en el Museo Lázaro Galdiano", *Goya*, 55, 14-29

Torre Farfán, F. de la (1671)
Fiestas de la S. Iglesia Metropolitana ... de Sevilla al... Rey S. Fernando... Sevilla

Torres Balbás, L. (1954)
Los monasterios cistercienses de Galicia. Santiago

Torres Rodríguez, C. (1977)
Galicia sueva. A Coruña

Torres Rodríguez, C. (1982)
La Galicia romana. A Coruña

Toynbee, J. (1973)
Animals in Roman life Art. Londres

Trabazo, L. (1972)
A. Faílde. Madrid

Trabazo, L. (1978)
Piedra, barro, bronce en tres escultores gallegos frente a la estética de lo deleznable. Ourense

Tranoy, A. (1981)
La Galice Romaine. Recherches sur le Nord-Ouest de la Péninsule Ibérique dans l'Antiquité. París

Trapero Pardo, J. (1958)
"Un ejemplo de Patena visigótica en el Museo de Lugo", *Boletín de la Comisión Provincial de Monumentos Histórico-Artísticos de Lugo*, IV, 285-289

Trapero Pardo, J. (1960)
"Museo. Escultura de diversas épocas. Arte castreño y Arte popular", *Lucus*, VI, 18-21

Trens, M. (1946)
María. Iconografía de la Virgen en el Arte Español. Madrid

Trens, M. (1952)
Las custodias españolas. Barcelona

Tubino, F. (1868)
Pablo de Céspedes. Madrid

V

Valdivieso González, E. (1978)
"Arquitectura", El Barroco y el Rococó, Historia del Arte Hispánico, IV. Madrid, 3-73

Vales Villamaril, F. (1951)
"El retablo mayor de Santa María de Azogue", *Anuario Brigantino,*137-156

Valle Pérez, J.C. (s.d.)
Sobre el comienzo de la Catedral románica de Tui. Consideraciones a propósito de algunas piezas insuficientemente valoradas. (en prensa)

Valle Pérez, J.C. (s.d.) (I)
"Escultura Paleocristiana y prerrománica", *Gran Enciclopedia Gallega*, X,132-140

Valle Pérez, J.C. (s.d.) (II)
"Escultura románica", *Gran Enciclopedia Gallega*, X, 144

Valle Pérez, J.C. (s.d.)
"Gótico", *Gran Enciclopedia Gallega*, XVI, 147-153

Valle Pérez, J.C. (s.d.)
"Maestro Mateo", *Gran Enciclopedia Gallega*, XX, 38-40

Valle Pérez, J.C. (1981)
A Escultura en Galicia durante a Edade Media. Vigo

Valle Pérez, J.C. (1984)
"Las cornisas sobre arquitos en la arquitectura románica del noroeste de la Península Ibérica", *Compostellanum*, XXIX, 291-353

Valle Pérez, J.C. (1985)
"Autel portatif", *Santiago de Compostela: 1000 ans de Pèlerinage Europèen*, Gante, 218-219

Valle Pérez, J.C. (1988) (I)
"El Renacimiento", *Enciclopedia Temática de Galicia: Arte*, 65-81

Valle Pérez, J.C. (1988) (II)
"A transcendencia do Pórtico da Gloria fora de Santiago", *O Pórtico da Gloria e o seu tempo. Catálogo Exposición*, Santiago, 135

Varela Arias, E. (1983)
"El Salvador de San Pedro Felix de Muxa (Lugo)", *Boletín do Museo Provincial de Lugo*, I, 213-220

Vázquez Núñez, A. (1902-1905)
"La iglesia parroquial de Santiago de Gustey", *Boletín de la Comisión Provincial de Monumentos Histórico-Artísticos de Orense*, II, 177-181

Vázquez Pardo, E. (1927)
"La escultura románica en España y Kingsley Porter", *Boletín de la Comisión Provincia de Monumentos Histórico-Artísticos de Orense*, VIII, 121-135

Vázquez de Parga, L. (1961)
"Columna", *El Arte Románico. Exposición organizada por el Gobierno Español bajo los auspicios del Consejo de Europa. Catálogo*, Barcelona y Santiago, 42-43

Vázquez Saco, F. (1947-49)
"Iglesias románicas de la provincia de Lugo. Papeletas arqueológicas. Papeleta 90. Iglesia parroquial de Santiago de Vilar de Donas", *Boletín de la Comisión Provincial de Monumentos Histórico-Artísticos de Lugo*, III, 164-173

Vázquez Saco, F. (1950)
"Iglesias románicas de la provincia de Lugo. Papeletas arqueológicas. Papeleta 118. Iglesia parroquial de San Fiz de Cangas", *Boletín de la Comisión Provincial de Monumentos Histórico-Artísticos de Lugo*, IV, 110-115

Vázquez Saco, F. (1953)
La Catedral de Lugo. Santiago

Vázquez Saco, F. , Vázquez Seijas, M. (1954)
Inscripciones romanas de Galicia II, Provinica de Lugo. Santiago de Compostela

Vázquez Seijas, M. (1932-34)
"Curiosa escultura románica", *Boletín de la Real Academia Gallega*, XXI, 272-274

Vázquez Seijas, M. (1936)
"Una curiosa placa-ídolo en pedra granítica", *Boletín de la Real Academia Gallega, XXII*, 281-283

Vázquez Seijas, M. (1939)
Lugo bajo el Imperio Romano. Lugo

Vázquez Seijas, M. (1947-49)
"Pendiente visigótico", *Boletín de la Comisión Provincial de Monumentos Histórico-Artísticos de Lugo*, III, 326-327

Vázquez Seijas, M. (1956-1957)
"Interesante broche de cinturón visigótico", *Boletín de la Comisión Provincial de Monumentos Histórico-Artísticos de Lugo*, VI, 176-177

Vázquez Varela, J.M. (s.d.)
"Paleolítico", *Gran Enciclopedia Gallega*, XXIII, 236-238

Vázquez Varela, J.M. (1980)(I)
"Cistas decoradas en Galicia: una nueva manifestación artística de la Edad del Bronce", *Brigantium*, I, 41-48

Vázquez Varela, J.M. (1980)(II)
"La estela de Troitosende. Uso y abuso de los paralelismos en el arte prehistórico", *Brigantium*, I, 83-91

Vázquez Varela, J.M. (1982)
"Arte prehistórico", *Historia del Arte Gallego*, Madrid, 1- 52

Vega y Verdugo, J. (1956)
"Memoria sobre obras en la Catedral de Santiago 1657-1666", Sánchez Cantón, F.J. *Opúsculos Gallegos sobre Bellas Artes de los siglos XVII-XVIII*, 23-30

Vidal, M. (1926)
El Pórtico de la Gloria de la Catedral de Santiago. Santiago

Vila Da Vila , M. (1986)
La iglesia románica de Cambre. A Coruña

Vila Jato, M.D. (s.d.)
Gran Enciclopedia Gallega, XII, 27-30

Vila Jato, M.D. (s.d.)
"Mateo de Prado", *Gran Enciclopedia Gallega*, XXV, 199-201

Vila Jato, M.D. (s.d)
Francisco de Moure, Manuscrito Inédito

Vila Jato, M.D. (1974-75)
"El antiguo retablo mayor del monasterio de San Julián de Samos", *Cuadernos de Estudios Gallegos*, XXIX, 141-146

Vila Jato, M.D. (1977)
"Gregorio Español en el retablo de la Capilla de las Reliquias de la Catedral de Santiago", *Archivos Leoneses*, XXXIII, 123-132

Vila Jato, M.D. (1978)
"El retablo de Vilar de Sandiás, obra de Francisco de Moure", *Liceo Franciscano*, XXXI. 255-260

Vila Jato, M.D. (1980)
"Nuevas esculturas de Francisco de Moure", *Boletín Auriense*, X, 217-226

Vila Jato, M.D. (1982)
"La obra del escultor Francisco de Moure en el Monasterio de Samos (Lugo)", *Homenaje al Prof. Dr. Hernández Díaz*, I, Sevilla, 741-748

Vila Jato, M.D. (1983)
Escultura Manierista. Santiago

Vila Jato, M.D. (1987)
"Notas sobre el primitivo retablo de San Froilán", *Boletín do Museo Provincial de Lugo*, XLIX

Vila Jato, M.D. (1989)
El Barroco en Lugo. Lugo

Villaamil y Castro, J. (1865)
La Catedral de Mondoñedo

Villaamil y Castro, J. (1866)
Descripción histórico-artístico arqueológica de la catedral de Santiago. Lugo

Villaamil y Castro, J. (1892)
Catálogo de los objetos de Galicia. Madrid

Villaamil y Castro, J. (1895)
"Báculo y calzado del obispo de Mondoñedo Don Pelayo", *Boletín de la Sociedad Española de Excursiones*, III, 165-167

Villaamil y Castro, J. (1896)
"Exposición regional de Lugo de 1896", *Boletín de la Sociedad Española de Excursiones*, IV, 168

Villaamil y Castro, J. (1904)
Iglesias Gallegas. Madrid

Villaamil y Castro, J. (1907)
Colección de artículos sobre el mobiliario litúrgico en las iglesias gallegas en la Edad Media. Madrid

Villares Paz, R. (1982)(I)
La propiedad de la tierra en Galicia 1500-1936. Madrid

Villares Paz, R. (1982)(II)
Foros, frades e fidalgos. Vigo

Villares Paz, R. (coordinador) (1988)
La ciudad y el mundo urbano en la Historia de Galicia. Santiago

Vives, J. (1969)
Inscripciones cristianas de la España romana y visigoda. Barcelona

Vives, J. (1971)
Inscripciones latinas de la España romana y visigoda. Barcelona

W

Weise, G. (1927)
Spanische Plastik. Rentlingen

Weise, G. (1966)
Il Manierismo. Bilancio critico.... Firenze

Weyler, A. (1924)
"La Catedral de Orense", *Boletín de la Sociedad Española de Excursiones*, XXXII, 166-178

Y

Yañez Neira, D. (1980)
El Monasterio de Osera. León

Yarza Luaces, J. (1980)
La Edad Media, Historia del Arte Hispánico, II. Madrid

Yarza Luaces, J. (1984)
El Pórtico de la Gloria. Madrid-Cuenca

Yarza Luaces, J. (1989)
"La capilla funeraria hispana en torno a 1400", *La idea y el sentimiento de la muerte en la Edad Media*. Santiago, 67-92

Yzquierdo Perrín, R. (1978)
"La iglesia románica de Santa María de Bermés", *El Museo de Pontevedra*, XXXII, 85-94

Yzquierdo Perrín, R. (1983)
La arquitectura románica en Lugo I. A Coruña

Yzquierdo Perrín, R. (1986)
"El monasterio de Carboeiro", *Monacato Gallego. Sexquimilenario de San Bieito. Actas do Primeiro Coloquio*, Ourense, 1981, *Boletín Auriense*, Anexo VI, 121-155
Yzquierdo Perrín, R. (1988-1989)
"Nueva imagen abridera. Parroquia de San Salvador de Toldaos (Triacastela, Lugo)", *Boletín do Museo Provincial de Lugo*, IV, 19-30

Yzquierdo Perrín, R. (1989)
"Aproximación al estudio del claustro medieval de la catedral de Santiago", *Boletín de Estudios del Seminario Fontán-Sarmiento*, X, 15-42

Z

Zazoff, P. (1983)
Die Antiken Gemmen. München

CONCLUDING A FIRST STAGE

To close a catalogue such as that of GALICIA THROUGH TIME does not necessarily mean ending the proposal that should be carried out according to its name.

Promoting an exposition of this type obviously means making costly efforts regarding the picking up of works and their presentation in an attractive and educational arrangement. But this, which is the common denominator of any exposition of a certain size, has been secondary in this case or at least from the point of view of the General Office of the Historical and Documentary Heritage.

What has been the most important for us? There is a whole different mentality, applied to the project of an exposition, which must be emphasized. In this case, there has been an effort to revitalize the historical setting in Santiago of San Martiño Pinario in its church, with an exceptional collection of altar pieces, and in part of its monastery, to do adequate treatment or conservation of the images and metal work selected, to propose new goals for preservation through a scientific diagnosis of each and every one of the pieces... And all of this in a work context which should not at all be limited to the "time" of an exposition.

For this reason, on referring to GALICIA THROUGH TIME, from this General Office, this is perhaps our most ambitious and novel cultural project. On its horizon of action we can imagine new and brilliant goals forged in favor of a Galicia which, from the Xunta, accepts within its possibilities the challenge of preserving the illustrious path of its history; with its language and its landscapes, this is undoubtedly the best testimony of its identity.

Where does GALICIA THROUGH TIME lead? If a country like ours wishes to see better futures for its enormous historical and documentary patrimony, it first needs to promote and create the different types of infrastructures which make both the care and the cultural evaluation of that patrimony possible. Forming professionals, collaborating in the task of giving strength—and even creating—museums and archives which will preserve the knowledge of this patrimony, developing a program of expositions which will further the knowledge of the Galician cultural patrimony, these are the goals which, from this General Office, are assigned to this Cultural Project. And a date, 1993, is set now as a new point of reference in time to see whether the hopes this proposal offers us are justified in the manner we hope they will.

J. Vicente Solarat López
General Director of Historical Documentary Heritage

TECHNICAL FILE

Chief Director	D. José Manuel García Iglesias
Director for the Rehabilitation of the building and the Organisation of the Exposition "The Splendor", "The New Identity" (Modern and Contemporary Era)	D. Angel Sicart Giménez
Director for the treatment of works. "The Roots" (Antiquity and High Middle Ages)	D. Francisco Fariña Busto
Director for the didactic material. "The Way" (Low Middle Ages)	D. José Carlos Valle Pérez
Coordination	Angeles García Terrón Carmen Pérez Vicente
Technical team	Alicia Carpente Fernández Aser Angel Fernández Rey Belén Domínguez Román Carmen Gallego Fernández José Manuel Castaño García Juan Manuel Monterroso Montero Mariel Larriba Leira María Lourdes Martínez Sapiña-Llanas Yolanda Barriocanal López
Secretary	Sofía Quiroga Limia
Administration	Manuel García Pita Pilar Raposo Mosquera
Press	Eva Veiga Torres Xesús Villamil Vázquez

Plan and Direction of the work	Iago Seara Morales *Director of the Service of Architecture* *Ministry of Cultura and Youth*
Technical Architects:	José Antonio Reboredo Iglesias Cesáreo Sánchez Iglesias
Collaborators	Gonzalo Crecente Maseda Carmen Rey López
Construction Company	Neor, S.A.
Technical Director	Gonzalo Rey Lama *Engineer*
Assistant	Saúl Alvarez Mosquera
Contractors	Manuel Andrade Montes Cayo Néstor Cobas Gómez
Preservation	Josep María Xarrié i Rovira *Head of the Service of Restauration* *Generalitat of Cataluña* Analía Clara Caiazza Dip Anna Nualart Torroja Anna Ruiz de Conejo Viloria Carles Espinalt Castel Clara Prats Canals Elisa García i Plans Elisa García Vidal Esperanza González do Nascimiento Esther Martínez Gil Eva González Pareja Eva Moya González Eulalia Soler Puig Ignacio Márquez Vieira Irene Sen Campmany José Francisco López Noya Josep Paret Pey José Ramón Pinal Rodríguez Jesús Zornoza Esteban Lidia Balust Claverol Lourdes Bonastre Thió Manuel Delgado Rodríguez M. Carmen Admellá Baulies M. Flora Paredes Villaronga M. Inmaculada Pere i Miró Marta Serra Majem M. Carmen Sandalinas Linares Marta Torner Solá Nuria Cañameras Tomás Roser Moreno Caañeras Sergi García i Plans Silvia Samaniego Son Teresa García Baquero Victoria Arias Díaz-Emil Vidal Herrero García Xosé Luis Castro Nouche Ricardo de la Iglesia López
Desinfection	Promax

Design of the Exhibition	Macua & García-Ramos
Direction of the Installation	José María Martín de Argila
Installation	Macarrón, S.A.
Light	Lledó, S.A.
Insurance	Plus Ultra
Transportation	S.I.T.
	Souto
Security	Biservicus
Audio-visuals	Kotler, James & Asociados
Video	T.V.G.
Music	Milladoiro

Design of the catalogue	Macua & García-Ramos
Coordination of the Edition	Mercedes Aznar López
	Luz de Gaztelu y Quijano
Paging	Paloma Muñoz Muñoz
	Santiago Santiago Molina
Secretary of Edition	Concha Yllán
Photography	Fernando del Río Martínez
	Gerardo Gil Fernández
	Xenaro Martínez Castro
	Ricardo Font
	Museo Arqueológico Nacional
	Centro de Arte Reina Sofía
Castilian-Galician Translators	Xosé Mariño Rodríguez
	Xosé Ramón Fandiño Veiga
French Translator	Cristina García
	José María Proupín
English Translator	Katleen March
Italian Translator	Nadia Poloni
	José Manuel de Prado Díez
German Translator	Ulrike Kudrass
Portuguese Translator	José Souto Cabo
Typesetting	Cromotex
Separating of the colours	Lucam
Printed	Julio Soto

INDEX

This Catalogue has been printed
on november the 11th 1990,
Feast of San Martiño,
patron Saint of San Martiño Pinario, seal of
GALICIA THROUGH TIME